The W H

About the Author

Terry Breverton is the author of twenty books of Welsh interest, five of which have been awarded 'Welsh Book of the Month' by the Welsh Books Council (more than any other author). He lives in Maesycrugiau in Carmarthenshire.

Praise for Terry Breverton

Owain Glyndŵr: The Story of the Last Prince of Wales
'Accessible and highly readable' *THE WESTERN MAIL*

An A–Z of Wales and the Welsh
'A comprehensive overview of Wales & its people' *THE WESTERN MAIL*

100 Great Welshmen
'A celebration of the remarkable achievements of his countrymen' *THE GUARDIAN*

100 Great Welsh Women
'A fascinating read' *THE DAILY MAIL*
'Breverton's breadth, generosity and sheer enthusiasm about Wales are compelling'
THE SUNDAY EXPRESS

The Welsh Almanac
'A must for anyone with a drop of Welsh blood in them' *THE WESTERN MAIL*

The WELSH
THE BIOGRAPHY

TERRY
BREVERTON

AMBERLEY

First published 2012

Amberley Publishing
The Hill, Stroud
Gloucestershire, GL5 4EP

www.amberley-books.com

Copyright © Terry Breverton 2012

The right of Terry Breverton to be identified as the Author
of this work has been asserted in accordance with the
Copyrights, Designs and Patents Act 1988.

British Library Cataloguing in Publication Data.
A catalogue record for this book is available from the British Library.

ISBN 978 1 4456 0808 2

Typesetting and origination by Amberley Publishing
Printed in Great Britain

Contents

Mae'n wir angenrheidiol bod Llais Werin Bobl Cymru yn gael ei glywed heddiw… ni allwn ddibynnu ar ein gwleidyddion i gynorthwyo ni.

It is truly essential that the voice of the common Welsh people is heard today… we cannot rely upon our politicians to assist us.

Introduction

The Romans wrote of the Silures in the south-east and southern marcher counties; the Demetae in Dyfed, the south-west; the Cornovii in the Cambrian Mountains of Powys and marches of central Wales; the Deceangli in the north-east and northern marches; and the Ordovicii in much of western Powys, the north-west and Anglesey. Wales has the oldest unbroken Christian heritage in the world, with four of these tribal areas having their own bishoprics at Llandaff, St David's, St Asaff and Bangor, which remain today as our oldest British cathedrals. The importance of Wales to the Romans was shown in their great legionary fortresses and settlements of Wroxeter, in the heartland of the Cornovii and Gloucester on the eastern Silures borders. These were succeeded by Caerleon and Chester on what are now the Welsh borders in Silurian and Deceangli lands. Two of the three British legions were permanently stationed here. Later, fortresses and towns were also built at Carmarthen and Caernarfon, established on Demetae and Ordovician territories. The Romans used the Dee Valley to penetrate Deceangli territory by 48 CE, beginning to mine lead, and heading for the abundant copper mines at Great Orme and the agricultural riches of Anglesey. Legions followed the Severn to move westwards to secure the gold deposits at Dolaucothi and exploit lead and silver deposits. From Mid Wales and the plains of Monmouth and Glamorgan they headed westwards to establish Carmarthen.

After the Romans finally left in 410, Germanic barbarian invasion and expansion progressively hemmed the Christian British into Wales, the West Country, Cumbria and Strathclyde. The remaining British were known as 'Welsh' to the invaders, a word of Germanic origin meaning 'foreigners'. In the British language, they called themselves 'Cymry', meaning comrades. The unconquered part of Britain became known as Cymru to its indigenous people, and as Wales to the Angles, Saxons, Jutes and assorted pagan tribes. For 650 years, Wales kept the Germanic tribes largely out of their country, while also fending off seaborne attacks by the Danes and Irish. With the rapid end of Anglo-Saxon rule in England following the Norman Conquest of 1066, there was again a sustained defence against overwhelming French and English forces. All of England capitulated in four years, and its French-speaking kings established the Marcher Lordships of Chester, Shrewsbury and Hereford. The only expansion of wealth and power for these lords was into Wales, and the rich lowlands

of south Glamorgan and south Pembroke were soon uneasily colonised. However, it was not until the treacherous murder of Llywelyn II in 1282 that French rule was established in Wales. This was not the end – there were several rebellions, and the prolonged War of Independence of Owain Glyndŵr from 1400–15 gave Wales its sense of nationhood once again. With the French, he actually invaded England, a fact strangely ignored by English history books. Finally, we see the last successful invasion of England. In 1485, a largely Welsh army led by Henry Tudor overthrew the Yorkist Richard III, and the reign of the Tudors assimilated Wales into England. Henry VIII's Act of Union of 1536 abolished Welsh customs and laws and tried to extirpate the language. Wales during Tudor times became a Protestant nation, and progressively turned to Nonconformism, what has been called 'a sweet and sour addition to the national psyche'. While this undoubtedly saved the language, the more radical forms of Nonconformism did their best to destroy much of Welsh folk culture, and innumerable songs, dances and tunes were lost.

This book will be criticised by some politicians and historians. One expects and even hopes so. It will make a great deal of sense if the reader is Welsh. It is inspired by Iolo Morganwg's 'Y gwir yn erbyn y byd' – 'the truth against the world'. It is critical of not only what has happened to Wales, but what is happening and what will happen. It is unlikely to appear in school or college syllabi because it is not blandly apolitical, but hopefully critical and informative. Hopefully it will be also read by other nationalities, as it is written by a Welshman who has a different perspective on Wales to many previous writers. As such, the volume is uneven. The minimal contribution of hundreds of churchmen who fill the *Dictionary of National Biography* is skipped over, while men like Hywel Dda, Bart Roberts, Henry Morgan, Robert Owen, David Davies, John Charles and Jimmy Wilde are given disproportionately longer entries. Henry Morgan, possibly Britain's greatest military leader, vastly outnumbered in six expeditions deep into Spanish territory, is seldom mentioned. Yet without his successes, Charles II may have been toppled from the throne, and the United States of America could have been Spanish-speaking. It is also a book which will not totally please academics, as to fully index, annotate and reference it would lead to an uneconomic volume of at least twice the length. Much has to be omitted from over two millennia of history.

Thus this book is incomplete – the most informative and instructive parts of Welsh history have been included, as always by this author from a Welsh perspective. This is a deliberate attempt to rewrite our national history, not blinkered by the standard Germanic version of British history, which usually begins with the German pagan invaders variously known as Saxons, Angles, Frisians and Jutes. Even the most recent television programme on the history of Britain – the historian Michael Wood's 2012 TV series *The Story of Britain* – begins with the leaving of the Romans and the Germanic invasions. It is always unacknowledged that the British-speaking Britons were here at least a millennium prior to that date. Many people mock the British language, Welsh, but Brythonic was the language of Britain for well over 2,000 years before modern English evolved in Tudor times. Most Welsh history books neglect the distant past, and this work aims to rectify that situation, with more content on the times before the Normans came, and less on the better-known seventeenth to twentieth centuries. There is also the author's opinion upon whether Wales as a

nation has any future in the final chapter, on the twenty-first century.

To the sins of omission of early British/Welsh contributions to British history, we can trace a deliberate path of manipulation, distortion, suppression and destruction by Normans through to Hanoverians and Victorians, in a desperate attempt to gain legitimacy for conquering a nation. This sad strategy has been normal for all victorious countries – the Chinese in Tibet, the English settlers over Aborigines and native Americans, the Indonesians over East Timor, the Spanish in South America, and so on and so on. Very few early artefacts or early writings remain compared to Eire. Much of what we know about the early saints, pre-dating by hundreds of years the Roman Church of England, comes from the Breton *Vitae* (Lives of Saints). Many Welsh standing stones have been broken up, taken away or covered over. Old treasure hoards, showing remarkable Celtic artistry, have been lost or melted down.

As the Normans took over the great monasteries at Llancarfan and Llanilltud Fawr (Llantwit Major), their treasures were taken to English abbeys, but their ancient libraries to the Tower of London. When Welsh princes were imprisoned in the Tower, they took their libraries with them, where the books stayed. This priceless information from the Dark Ages onwards was burnt, supposedly by a monk called Ysgolan, in 1300. Early non-Roman religion was suspect, tarred with the brush of Pelagianism. Incidentally, this wonderful doctrine tells us that people could be Christian without giving money to the Church, and that unbaptised children could go to heaven. Ancient Welsh books also conflicted with the view that Britain was heathen before Rome and Augustine came to save its citizens. Of course, Viking raids such as those on St David's, Llancarfan and Llanilltud had damaged libraries, but much was recollected through the oral traditions and mnemonics that enabled the bards and monks to remember history. The next great threat was the Reformation, and the Dissolution of the Monasteries. These events, along with the burning of the great libraries at Raglan and St Donat's castles, have destroyed many Welsh sources. The one man who did more to put everything back together, Edward Williams of Flemingston (Iolo Morganwg), has been savaged by academics, many with no Welsh language capabilities.

Richard II (1367–1400) attempted to ban writing in Wales. His deposer Henry Bolingbroke (Henry IV) had an Act of Parliament passed which prohibited the importation of all writing materials and equipment into Wales. Richard III saw the danger of the invention of the printing press, and prohibited its use in Wales. Even though a Welsh King, Henry VII, defeated Richard III in 1485, it was not until 1694 that an Act of Parliament allowed printing presses to be set up in Wales. The Stuart and Hanoverian kings and queens related themselves back to Scottish origins, and had little interest in Welsh traditions and history, and even less in the language. When the German George Hanover somehow became King of England in 1714, history changed in its teaching and emphasis. The *Bruts* (Chronicles) and the twelfth-century *History of the Kings of Britain* were no longer used as source materials. The Stuarts were still trying to regain the throne, backed by two Scottish rebellions in 1715 and 1789. The new German dynasty, from a place the size of the Isle of Wight, had to be established in its rightful place as heirs to the Crown to prevent nationalist feelings flaring up in England. The 1789 French Revolution reinforced this view, and the *Bruts* disappeared into the backwaters of knowledge.

The marriage of Queen Alexandrina Victoria of Hanover to her first cousin Prince Albert of Saxe-Coburg and Gotha sparked a 'Saxon' revival, with a cult growing up around King Alfred, who led the Anglo-Saxons against the Vikings in the ninth century. Because of the paucity of learned Saxons, Alfred asked for Welsh scholars to set up what later became Oxford University, and insisted that the Welshman Asser, Bishop of St David's, moved to England to work with him as his advisor. The Victorians suffixed Alfred as 'the Great'. Their historians then used Alfred's court's version of early British history, the *Anglo-Saxon Chronicle*, rather than earlier or concurrent Welsh sources, for the early history of Britain. For instance, although Welsh sources identify King Arthur with Arthmael ap Meurig ap Tewdrig in South Wales, he is not mentioned in the *Anglo-Saxon Chronicle*, so real history was ignored. They also omitted Saxon defeats as they cut their way through Britain over the centuries. Successful invaders become conquerors, and as has often been said, conquerors write their own history.

Britain and Wales were depicted as barbarian hell-holes before the Romans and Saxons came to civilise and unify England and Wales. Kings who were treacherous, devious illiterate murderers, such as Guillaume le Bâtard, Guillaume the Bastard, were transmogrified into William 'the Conqueror'. A better term would be Guillaume 'the Conqueror of England', because he could not defeat or invade the other three nations. Edouarde I d'Angleterre was known as Edward 'Longshanks', and invented a new and crueller version of hanging, drawing and quartering for Prince Dafydd of Wales. Like Edward I, Richard 'the Lionheart' could only speak French, needlessly massacred 2,700 Muslim hostages and probably had Conrad, King of Jerusalem assassinated. Even Bishop Stubbs, that arch-apologist for all kings of England, calls Richard 'a bad son, a bad husband, a selfish ruler, and a vicious man'. He is, however, portrayed as a pious crusader, and an icon of chivalry. Richard not only rebelled twice against his father Henry II, he possibly killed him. These men are heroes of English history, as British history was displaced and neglected. History became revisionist, ever moving away from historical fact, with each generation of historians regurgitating greater distortion.

After 'The Treachery of the Blue Books', Welsh teachers were replaced with English ones, and the disgusting 'Welsh Not' instituted in schools for children caught speaking Welsh. In 1866, Bishop William Stubbs wrote *The Constitutional History of England*, revolutionising the teaching of British history from the time of the 'noble' and civilising influence of the Romans, up to 1485. His Germanophile book was written to be the official curriculum for *all* schools – the history of Romans, Anglo-Saxons and Normans – not the history of the British people. Bishop Stubbs wrote, in his *Select Charters from the Beginning to 1307* (Oxford 9th edition, published in 1951), the following piece of pre-Hitlerian dogma. The Welsh were a

tolerated remnant ... The English nation is of distinctly Teutonic or German origin. The Angles, Jutes and Saxons ... Entered upon a land ... whose inhabitants were enervated and demoralised by long dependence, wasted by successive pestilences, worn-out by the attacks of half-savage neighbours and by their own suicidal wars: ... This new race was the prime stock of our forefathers, sharing the primaeval German pride of purity of extraction ... and strictly careful of the distinction between themselves and the tolerated

remnant of their predecessors … It is unnecessary to suppose that any general intermixture either of Roman or British blood has affected this national identity … from the Briton and the Roman of the fifth century we have received nothing … The first traces, then, of our national history must be sought not in Britain but in Germany.

Stubbs' work is still the basis of what is taught (and unfortunately believed) today. The Open University 'Welsh History and its Sources' course begins with Edward I. There appears to be no Welsh History GCSE examination. No wonder that the politicians Kim Howells and Neil Kinnock have asserted that Wales has no history.

The above demonstrates the worthlessness of the British, i.e. Welsh people. They count for nothing in history, and their 'Age of Saints', fighting off the pagan Saxons, was merely 'enervating'. Welsh history of the 'Age of the Saints' and King Arthur was wiped from the record and replaced by the so-called 'Dark Ages', not worthy of mention. British heroes are not great men like Owain Gwynedd and Llywelyn the Great, nor betrayed princes like Llywelyn the Last, nor intelligent warriors like Glyndŵr, nor the fabulous Owain Llawgoch, so feared that the Crown had to have him assassinated. Instead they are illiterate oafs, like the bloodthirsty Richard 'the Lionheart', the non-existent Robin Hood, and that illiterate butcher of the North, William the Conqueror. Holding out against the torturing Norman, Angevin and Plantagenets for hundreds of years is not worthy of attention. Wales has its own patron saint, the vegetarian ascetic David. The English had to find a Lebanese one, George and his mythical dragon. Wales had an organised and honest church at least 150 years before the English were Christianised. Welsh Christianity was far nearer to Christ's teachings than the Roman version adopted by England.

Wales had the most civilised laws in the world, while the rest of Europe based its laws upon repression and violence. Wales has one of the world's oldest languages. England has a modern one. Wales has the oldest national flag in the world. England has a modern one. Wales had equality for women, whereas England suppressed women until recently. Wales set more store by music and poetry than aggression. England did not. Wales has always been a nation. England is becoming a set of regions. No-one asked why, if Stubbs' Romans were so wonderful, society collapsed in England upon the leaving of the legions. No one asked why, if Stubbs' marvellous Saxons had such spirited purity, they were overwhelmed immediately by a small Norman force. It took William's small army of Danish/Viking/French three years to overcome mighty Anglo-Saxon England, but the Norman-French took from 1066 until around 1415 to finally subdue Wales. The Normans combined with fresh waves of Frenchmen, Anglo-Saxons, Flemings and mercenaries from all over Europe to present a far mightier force than ever faced England, against little Wales and its independent princedoms. However, this 'lesser breed' of A. J. P. Taylor survived and survives.

One can only care about the past if one has knowledge of its reality. In summer 1997, *The New Welsh Review* carried two excellent articles upon the Celtic Church in Wales. The first, by Patrick Thomas, the former Rector of Brechfa in Carmarthenshire, is titled 'Not a Man of God'. It 'explains why not all Welsh Christians have been celebrating the 1,400th anniversary of St Augustine's landing in Britain'. The second article is by Brian Davies, the curator of Pontypridd's Historical and Cultural Centre:

'Archaeology and Ideology, or How Wales Was Robbed of Its Early History.' The following is the conclusion of the article by Brian Davies:

> Only a few years later *The Times* in a reply to a polite letter from Matthew Arnold asserted that: 'An Eisteddfod is one of the most mischievous pieces of sentimentalism which could possibly be perpetrated ... Not only the energy and power, but the intelligence and music of Europe have mainly come from Teutonic sources ... The sooner all Welsh specialities disappear from the face of the Earth the better.' This is a clear enough agenda, which will be familiar to many. What may not be fully appreciated is that, although most of the Welsh were Nonconformist by the 19th century, the early history of the Church in Wales was still a prime target for these Teutonic racists. For them it was an uncomfortable problem that the foundation of the Church of England can only be pushed back to 597 AD when Augustine landed in Kent, while the major figures of the Welsh 'Age of the Saints' were active between half a century and a century earlier.
>
> *Christian civilisation in Britain had to be presented as an achievement of the English.* The Welsh Church could only be allowed some vitality after the time of Alfred, the celebrated founder of the Saxon state. In order to create the 'Dark Ages' required by Saxon triumphalism the evidence of the continuous history of the Welsh Church back to Roman times, preceding the foundation of the 'national' Church of England by several centuries, had to be pushed to the margins of consciousness and if possible be literally buried. This of course was unacceptable to many of the Welsh clergy, and the story of the tensions within the Anglican church over matters of Welsh history is a book waiting to be written. It is unfortunate that present day medievalists do not normally study nineteenth-century history. If they did they would realise that the basic framework of interpretation of early British history which they still innocently use is not the product of calm, objective collection and assessment of data. It is a politically motivated construct; a falsification of history for the purposes of English nationalism. It is surely time for archaeologists and historians of post-Roman Wales to emancipate ourselves from these prejudices of nineteenth-century 'Saxon' nationalism. We need to write post-Imperialist history free of this Victorian master race theory. Then the superb surviving examples of early Welsh monumental art at Llanilltud Fawr, Margam, Coychurch and Merthyr Mawr in Glamorgan and a dozen other locations elsewhere in Wales may be re-interpreted in the light of the available evidence, and an unnecessary gap in Welsh history be filled.

To this author, the period from the leaving of the legions until the Norman invasion is the most intriguing and exciting period in the history of Cymru. Somehow, against all odds, the British nation survived, albeit in an area a tenth of its former size. (We include around a third of the area of Scotland as previously being Brythonic.) This was achieved against unending attacks by Irish, Germans and Danes. Not only was the British nation saved, but its language. Importantly, the British gave Ireland Christianity with St Patrick and other missionaries, and hence helped with missionary work across Europe in the Dark Ages. A case can easily be made for Britain, in the form of Wales, having the longest unbroken Christian heritage in the world. This author wrote the 600-page *The Book of Welsh Saints* without the

help of internet research, and would wish to return to research the area, but time militates against such a task. The book was recommended highly by the Archbishop of Canterbury, but one academic quibbled that there was no index or footnotes. The book made no money. With an index and footnotes it would have been three times as long, it would have lost thousands of pounds and would have been unaffordable except to a few university libraries. This is the problem in writing upon Wales – there is no real market and it is declining rapidly. This author has also never been able to find any Welsh publisher for his works over the years, despite their constant receipt of publishing subsidies from the Welsh Books Council. The largest town in Wales after Cardiff, Newport and Swansea is Barry, with a population of 50,000 and it has no bookshop. Neither has nearby Bridgend, with 40,000 people. Outside Cardiff, there are possibly only three prosperous towns in Wales, with thriving high streets, delicatessens and book shops, all without a massive hypermarket nearby. They are Llandeilo, Cowbridge and Hay-on-Wye.

Because of the brevity of this book in covering over two millennia of history, it is events-driven rather than a series of biographies, and the more recent history of the country is compressed. Of more interest to most readers are battles and sieges, rather than committee meetings of politicians and religious-legal wrangles, and this is the spirit of the book – to make history more exciting. It is also unashamedly pro-Welsh. This history tells you that Glyndŵr's was a legitimate war of independence against an illegal regime, not a 'rebellion' or 'revolt' as in all other books; that King Llywelyn II was betrayed by the Mortimers, led into a trap and murdered in cold blood along with his army; that Wales was not conquered and quiescent after his murder, and so on. The story of the Welsh is one of defending the nation against overwhelming odds, and of a major contribution to European literature. Its tenth-century laws are acknowledged as the most progressive in the world until the later twentieth century. Almost uniquely in the world, Wales has had heroines as well as heroes, princesses as well as princes who contributed to its progress. Wales has given heroes such as Owain Glyndŵr, who are better recognised across the globe than in England, and men such as David Lloyd George, to whom Hitler attributed the winning of the First World War. The character of the Welsh – their pacifism, literary abilities and influence – is described in this study of the Welsh as a people.

The Earliest People & the First Tribes
250,000 BCE–43 CE

Nennius was an eighth-century British monk who copied older documents from Old Welsh into Latin. He covers early British history from 1400 BCE to the time of Vortigern and the Anglo-Saxon incursions of the sixth century. Nennius tells us that the Britons 'came to Britain in the third age of the world; and in the fourth, the Scots took possession of Ireland: The Britons who, suspecting no hostilities, were unprovided with the means of defence, were unanimously and incessantly attacked, both by the Scots from the west, and by the Picts from the north. A long interval after this, the Romans obtained the empire of the world.'

The Origins of the British

The earliest history of the Welsh is the history of the British. 800,000 years ago, Britain was joined to Europe, and early humans were living at Happisburgh in Norfolk. In 2010, flint tools were discovered there. The first human evidence in Wales is from 250,000 years ago in Pontnewydd Cave, Denbighshire, where some Neanderthal bones were found, along with rough stone tools such as axes, spear-points and flesh scrapers. This is the most north-western site in Eurasia for the remains of early hominids, Neanderthals who hunted game in the Elwy Valley. These Stone Age Neanderthals used flint and stone tools, but *Homo sapiens* did not evolve until around 200,000 years ago. A jawbone found in Kent's Cavern, Torquay in 1927, was dated in 2011 to around 45,000 years ago, and determined to be *Homo sapiens*, not *Homo neanderthalis*, making it the earliest modern human fossil found in north-west Europe. There is still no significant evidence of Neanderthal man breeding with modern humans. Thus modern man probably arrived in Britain only in the last 50,000 years. Neanderthal man died out around 36,000 years ago.

In 1822 the famous 'Red Lady of Paviland' was found in Goat's Hole Cave on the Gower Peninsula in Wales, a ceremonial Palaeolithic Age interment. Radiocarbon dating confirms an age of around 29,000 years. Although now on the coast, the burial was then 60 to 70 miles away from the sea. Such burials are now known from Moscow to Portugal, but this was the first such burial ever to be found, and also the first human fossil ever to have been recovered at that time. It was later found to

be the skeleton of a young man, probably weighing 11 stone, and 5 foot 8 inches in height. His bones had been stained with red ochre. His grave-goods of ivory rods, ivory bracelets, and perforated periwinkle shells were also deliberately stained with haematite, iron oxide. Prehistoric burials possibly used the stain to represent a ritual rebirth, with the pigment representing the Earth Mother giving birth. There was also a mammoth skull and limestone blocks around the skeleton. Goat's Hole Cave has traces of human presence, such as flint tools, covering over 20,000 or more years of the Palaeolithic Era.

The molecular biologist Bryan Sykes has demonstrated that the Paviland skeleton has a DNA sequence corresponding to the commonest extant lineage in Europe. The finding supports the argument that the origins of modern Europeans lie not with indigenous Neolithic farmers, but with the arrival into Europe of modern human populations, replacing the Neanderthals. The journal *Science* (11 November 2000) reported that four out of five men in Europe share a common male ancestor who lived as a primitive hunter on the Continent, around 40,000 years ago. An analysis of a pattern found in the Y chromosome taken from 1,007 men from twenty-five places in Europe shows that about 80 per cent of Europeans arose from the Palaeolithic people who first migrated to Europe. The Y chromosome is inherited only by sons from their fathers.

It appears that Stone Age humans came to Europe, probably from Central Asia and the Middle East, in two waves of migration beginning about 45,000 years ago. Their numbers were small and they used crudely sharpened stones and fire. About 24,000 years ago the last Ice Age began, and Palaeolithic Europeans retreated before the ice, finding refuge in three areas: Spain, the Balkans and the Ukraine. Wales was virtually completely covered by ice around 20,000 years ago, at the peak of the Ice Age. When the glaciers melted, about 16,000 years ago, the rest of Europe was resettled. Y chromosome mutations occurred among people in each of these Ice Age 'refuges', and the pattern that developed in Spain is now most common in north-west Europe.

A Danish ice-drilling project – the NordGrip drilling project in Greenland – has conclusively determined that the last major Ice Age ended precisely 11,711 years ago. Ice-core researcher Jørgen Peder Steffensen explained, 'Our new, extremely detailed data from the examination of the ice cores shows that in the transition from the ice age to our current warm, interglacial period the climate shift is so sudden that it is as if a button was pressed.' Thus, from around 10–11,000 years ago, as the ice sheets receded, people returned to Britain, with genetic research suggesting that they came from the northern part of the Ice Age refuge of Spain. Of the other two refuges, the Balkan genetic pattern is most common in Central Europe, and the Ukraine pattern is mostly in Eastern Europe. About 8,000 years ago, the more advanced Neolithic people began migrating to Palaeolithic Europe from the Middle East, bringing with them a new Y chromosome pattern. They transformed humankind with their development of agriculture. About 20 per cent of Europeans now have the Y chromosome pattern from this migration. Thus the British are mainly the descendants of Palaeolithic people from Spain, and partially of Neolithic people from the Middle East.

We refer to the period from 8000–4500 BCE as the Mesolithic Era. There are far more Mesolithic than Palaeolithic sites in Wales, probably because of the destructive

effects of the earlier glacier sheets, but also the population was probably lower. Most Mesolithic sites are sited near the coast, which suggests that many were drowned by rising sea levels. The latest research, as reported in *The Sunday Times*, 17 June 2012, is headlined 'DNA Shows Welsh and Cornish to be "Purest Britons"'. Variations in DNA were noted from thousands of people living in rural areas. The results showed that 'the Welsh, followed by the Cornish, remain among the most genetically distinct of all the groups on mainland Britain. They carry DNA that could date back to the tribes that colonised Britain after the last Ice Age 10,000 years ago.' The people of Wales and Cornwall are different from the rest of southern and central England," said Peter Donnelly, professor of statistical science at Oxford University and director of the Wellcome Trust Centre for Genetics.' The most distinctly different are the inhabitants of the Orkneys, whose genes show them to be Scandinavian. Welsh genes, similar to the French and Irish, suggest strong links to pre-Roman settlers. The Cornish are genetically different to neighbouring Devonians. Scots and Northern English have genetic similarities, whereas the Central and Southern English show strong Anglo-Saxon and Danish links.

The DNA of Welshmen and the Link with Tutankhamen

Research for a BBC TV series on the Vikings in 2003 revealed strong genetic links between the Welsh and Irish Celts and the Basques of northern Spain and southern France. It suggested a connection between the Celts and Basques dating back tens of thousands of years. The gene patterns of the three races passed down through the male line are all 'strikingly similar', researchers concluded. Basques can trace their roots back to the Stone Age and are one of Europe's most distinct people, fiercely proud of their ancestry and traditions. The Basque language, Euskara, is the last remaining descendant of the pre-Indo-European languages of Western Europe. The research adds to previous studies which have suggested a possible link between the Celts and Basques, dating back tens of thousands of years. Professor David Goldstein of University College London told *BBC News*, 'The project started with our trying to assess whether the Vikings made an important genetic contribution to the population of Orkney.' He and his colleagues looked at Y-chromosomes of Celtic and Norwegian populations, and found them to be quite different. 'But we also noticed that there's something quite striking about the Celtic populations, and that is that there's not a lot of genetic variation on the Y chromosome,' he said.

To try to work out where the Celtic population originated, a team from UCL, the University of Oxford and the University of California at Davis also studied the Basques. 'On the Y-chromosome the Celtic populations turn out to be statistically indistinguishable from the Basques,' Professor Goldstein stated. The comparison was made because Basques are thought to be very similar to the people who lived in Europe before the advent of farming. Goldstein stated, 'We conclude that both of these populations are reflecting pre-farming Europe.' The team studied the genetic profiles of 88 individuals from Anglesey, North Wales, 146 from Ireland with Irish Gaelic surnames, and 50 Basques. 'We know of no other study that provides direct evidence of a close relationship in the paternal heritage of the Basque- and the Celtic-

speaking populations of Britain,' the scientists stated in the journal *Proceedings of the National Academy of Sciences*. However, it is still unclear whether the link is specific to the Celts and the Basques, or whether they are both simply the closest surviving relatives of the early population of Europe. What is clear is that the Neolithic Celts took women from outside their community. When the scientists looked at female genetic patterns as well, they found evidence of genetic material from Northern Europe. This influence helped to even out some of the genetic differences between the Celts and their Northern European neighbours.

The Basques, along with the Welsh, are in the highest Y-chromosome haplogroup of R1b1b2, as seen in the table below. A referenced article in *PLoS Biology*, published online on 19 January 2010, was headlined 'A Predominantly Neolithic Origin for European Paternal Lineages':

The relative contributions to modern European populations of Palaeolithic hunter-gatherers and Neolithic farmers from the Near East have been intensely debated. Haplogroup R1b1b2 (R-M269) is the commonest European Y-chromosomal lineage, increasing in frequency from east to west, and carried by 110 million European men. Previous studies suggested a Paleolithic origin, but here we show that the geographical distribution of its microsatellite diversity is best explained by spread from a single source in the Near East via Anatolia during the Neolithic. Taken with evidence on the origins of other haplogroups, this indicates that most European Y chromosomes originate in the Neolithic expansion … Arguably the most important cultural transition in the history of modern humans was the development of farming, since it heralded the population growth that culminated in our current massive population size … Much debate has focused on the origins of agriculture in Europe some 10,000 years ago, and in particular whether its westerly spread from the Near East was driven by farmers themselves migrating, or by the transmission of ideas and technologies to indigenous hunter-gatherers.

This study examines the diversity of the paternally inherited Y chromosome, focusing on the commonest lineage in Europe. The distribution of this lineage, the diversity within it, and estimates of its age all suggest that it spread with farming from the Near East. Taken with evidence on the origins of other lineages, this indicates that most European Y chromosomes descend from Near Eastern farmers. In contrast, most maternal lineages descend from hunter-gatherers, suggesting a reproductive advantage for farming males over indigenous hunter-gatherer males during the cultural transition from hunting-gathering to farming … Anatomically modern humans, originating in East Africa, colonized Europe from the Near East around 40,000 years ago, then during the last glacial maximum populations retreated into the peninsulas of Iberia, Italy, and the Balkans, followed by northward recolonisation from these refugia 14,000 years ago. The most important cultural transition was the adoption of agriculture originating in the Fertile Crescent in the Near East at the start of the Neolithic [Age], 10,000 years ago. It spread rapidly westwards via Anatolia, reaching Ireland by 6,000 years ago, accompanied by the development of sedentary populations and demographic expansion.

Mitochondrial DNA analysis also shows a Near Eastern Neolithic origin for domestic cattle, and no indication of the domestication of native European aurochs.

In genetics, haplogroup R1b is the most frequently occurring Y-chromosome haplogroup in Western Europe. Western Europe is dominated by the R1b1a2 (R-M269) branch of R1b, of which the point of origin is thought to be Western Asia. In 2000, researchers argued that R1b had been in Europe before the end of Ice Age, and had spread north from an Iberian refuge after the Last Glacial Maximum. However, 2010 studies suggest a Neolithic or younger advance into Europe, from 4,000 to a maximum of about 10,000 years ago, suggesting a migration from Western Asia via south-eastern Europe. In Japan, there is no R1b1a2 in the population, and Wales has a greater proportion than any other part of Europe. All the leading samples are given below, with obvious correspondences with the Welsh, Cornish, Basques, Irish, Catalans and Bretons/north-west French:

Country	Sampling	sample	R1b1a2
Wales	National	65	92.3%
Spain	Basques	116	87.1%
Ireland	National	796	85.4%
Spain	Catalonia	80	81.3%
France	Ile et Vilaine	82	80.5%
France	Haute-Garonne	57	78.9%
England	Cornwall	64	78.1%
France	Loire-Atlantique	48	77.1%
France	Finistère	75	76.0%
France	Basques	61	75.4%

The haplogroup R1b1a2 arose about 9,500 years ago in the surrounding area of the Black Sea. The migration of this haplogroup into Europe started at the earliest with the spread of agriculture since 7,000 BCE. It is probable that it is connected to the Indo-Europeans who spread over Europe in several waves of migrations. In Egypt the contingent of this haplogroup is below 1 per cent and partially caused by European immigration during the last 2,000 years. The haplogroup R1b1a2 was widespread in the Indo-European Hittite Empire in Anatolia. This culture spread to Europe. From the time of Akhenaton or Tutankhamen, a letter from an Egyptian queen is known from the Hittite archives. She asks the Hittite king for one of his sons as a new Pharaoh because her husband had died, leaving her without a male heir. The identity of the queen is unknown, but perhaps the eighteenth dynasty was related to the Hittites. In 2009, DNA tests were carried out on the mummy of Tutankhamen and other members for his family. These were only partially been published in February 2010. Tutankhamen was the last Pharaoh of the eighteenth dynasty, ruling about 1332–1323 BCE. His paternal lineage begins with Pharaoh Thutmose I, who ruled from about 1504–1,492 BCE. The German genetics company

iGENEA reconstructed the Y-DNA profile of Tutankhamen, his father Akhenaton and his grandfather Amenhotep III for a TV documentary on the Discovery Channel. Tutankhamen belongs to the haplogroup R1b1a2, which more than 50 per cent of all men in Western Europe, and 70 per cent of British men belong to. Around 70 per cent of Spanish and 60 per cent of French men also belong to the genetic group of the Pharaoh. It is believed that the common ancestor of 92.3 per cent of Welshmen lived in the Caucasus about 9,500 years ago.

An assembly of huge stone slabs found in Egypt's Sahara Desert that date from about 6,500 to 6,000 years ago has been confirmed by scientists to be the oldest known astronomical alignment of megaliths in the world. Known as Nabta Playa, the site consists of a stone circle, a series of flat, tomb-like stone structures and five lines of standing and toppled megaliths. Nabta predates Stonehenge and similar prehistoric astronomical sites around the world by about 1,000 years. It is roughly contemporary with the Goseck Circle in Germany and the Mnajdra megalithic temple complex in Malta. It is thought that early Egyptian Pharaohs could have originated in Sumeria or Syria, and the spread of megaliths through North Africa, along the Mediterranean and through Europe seems to resonate with the theory that the Celts originated in Anatolia and took their religion, building techniques and agriculture in their diaspora. The Sumerians built stepped pyramids, like the first Egyptian pyramids.

Interestingly, in both Scottish and Irish mythology, Scota was the name given to two different daughters of Egyptian Pharaohs to whom the Gaelic tribes traced their ancestry. According to legend, the Gaels are a tribe descended from 'Gaedhal of the Very Gentle and the Shining Armour'. Gaedhal was a general of the Egyptian Pharaoh in ancient wars including a great war against the Ethiopians. When the Hebrew slaves deserted their Egyptians overlords, Gaedhal and his people supported the Hebrews. As a result they were exiled from the Egyptian lands. However, the Phaoraoh's daughter, Scota, married into the tribe of Gaedhal (Gaels). Eventually, with recommendation from their Druids, they travelled to Spain and eventually to Ireland. The Romans called Irish raiders 'Scotti', and these Irish invaders into Scotland gave it its name. Scotia's Grave is a circle of large stones in County Kerry, Ireland.

Wales and the Flood

During the Ice Age, Britain had been abandoned by humans. The sea level was then lower, with Britain still connected by land to Europe and Ireland. With the ending of the Ice Age, the seas rose, and Britain was separated from Ireland 10,000 years ago and from Eurasia 8,000 years ago. There was also the catastrophic collapse of a glacial ice dam in Canada more than 8,000 years ago, which we can link with the rapid spread of agriculture across Europe around the same time. This massive discharge of freshwater from Lake Agassiz, covering much of central Canada, raised global sea levels by over a metre in few months. This contributed to the breaching of the thin strip of earth between the then landlocked Black Sea and the Mediterranean Sea in 5,600 BCE. There was extensive flooding of the Black Sea shoreline as the Mediterranean poured in. Calculations suggest the inundation could have caused

a giant waterfall, many times bigger than Niagara Falls, pouring enough seawater into the freshwater lake to cause its surface to expand by more than a mile a day. Many believe that this event was the origin of the Great Flood in Babylon (*The Epic of Gilgamesh*), the Eastern Mediterranean (The Bible) and other writings. People lived around the fertile shores of an ancient freshwater lake before the area was transformed into the Black Sea.

A structure at the bottom of the Black Sea off northern Turkey lends credence to the Noah's Flood event. Marine archaeologists have found evidence to suggest that the floor of the Black Sea was inhabited about 7,500 years ago, until it was flooded from the Mediterranean. Stone tools, wooden branches and beams are among well-preserved remnants of the structure 300 feet down, and 12 miles off the coast. The farming community fled the rising waters, which could have prompted stories of a giant flood. Dating from this incredible flood, we can see the migration and resettlement of farmers heading westwards across Europe. Archaeologists have mapped and dated the locations of the earliest known agricultural settlements, showing the spread of farming from Anatolia (Turkey) throughout the Mediterranean. Across the rest of Europe, men now altered their food gathering from hunting herds of mammoth and reindeer. They changed to hunting deer, fishing and collecting plants for food.

Wales has its own folk legends of the incoming seas drowning Cardigan Bay, and songs like 'The Bells of Aberdyfi' refer to the rise of sea levels. There is also the *Mabinogion* tale of Bran leading his soldiers across the sea to Ireland. There are fossils of submerged trees all along the Welsh coastline, with the submerged forest at Borth, north of Aberystwyth dating from around 4000 BCE. The stumps of pine, birch, alder, oak and hazel appear after winter storms at low tides, in the midst of fossilised peat beds.

Paviland Cave was once over 60 miles from the sea, and even in the seventeenth century, a regular stagecoach service went over the Menai Straits to Anglesey at low tide. There are flood stories in nearly all ancient cultures, and climate change is not something new, as the more sensible of today's scientists realise. There was what is known as a mini Ice Age from the thirteenth to early nineteenth century across Europe.

Europeans had evolved from hunters to hunter-gatherers, but now farming practices spread eastward around the shores of the Mediterranean and through Europe, reaching Britain about 4500 BCE. Humans had returned permanently to Britain around 9000 BCE, after the end of the Ice Age. Along with new crops and domesticated animals came the introduction of pottery and the development of trade routes, which stretched right across the British Isles. Farming peoples probably settled temporarily in different parts of the landscape, moving to different locations with their flocks and herds of domesticated animals according to the seasons of the year. The gradual introduction of new farming methods and storage of crops led to permanent settlements and the rise of ruling families. We see the first tombs being built and the development of the use of metals such as copper, bronze, gold and then iron.

The Celts

In most history books, the origins of the British are obscured. It was thought that the Celtic culture arrived with some kind of invasion or waves of immigration from Gaul (France and Germany) as late as 500 BCE, give or take a few centuries, and that pre-Celtic peoples were the builders of the barrows, mounds, cairns and megaliths which cover the British landscape, especially in Wales. However, there was never an invasion or mass immigration. Groups of Celts arrived in various parts of the hardly populated British Isles, bringing their language and agricultural practices. The British adopted P-Celtic (Brythonic) throughout England, Wales and southern Scotland. Q-Celtic (Gaelic) was the language spoken in Ireland by the Picts, and later in northern Scotland. The steppes to the north of the Black Sea have been suggested as the original homeland of the Indo-European language family, of which Celtic is a member, with others believing that European languages evolved from either the Caspian Sea area or Anatolia. The legendary kings of Britain are said to be descended from Brutus, the grandson of Aeneas of Troy. Troy is on the Hellespont in north-west Anatolia (Turkey), and its fall in 1184 BCE seems too late to account for this foundation of British sovereigns.

The first recorded reference to 'Keltoi' (by Hecataeus of Miletus) was about the people living near Marseilles, in 517 BCE, and it seems that the Keltoi were now merely a tribe of Galli, or Gauls, the people who lived across much of Europe. However, over the following centuries the terms Gaul/Gallic and Celt/Celtic were used interchangeably. Without any factual basis, we have been informed by historians that the mysterious 'Celts' arrived from Continental Europe around 500–100 BCE, possibly displacing or interbreeding with the native populations. Their arrival supposedly coincided with the Iron Age in Britain. However, the best hypothesis is that the Anatolian Diaspora influenced the Britons, Gauls etc. millennia before the supposed date of a few hundred years before the Romans. We could make a case for calling these peoples from the Black Sea and Eastern Mediterranean the unifying factor in the vast Gallic empire, encompassing many different peoples all over Northern Europe. To the Greeks, the tribes to the west, with their organised culture and developed social structure, were 'Keltoi'. The Romans named them as 'Galli'.

In 55–54 BCE, Julius Caesar referred to the inhabitants of Britain as Britons, when he briefly invaded with five legions and 2,000 cavalry. In Caesar's *Gallic Wars Book 5*, we read,

> The interior portion of Britain is inhabited by those of whom they say that it is handed down by tradition that they were born in the island itself: the maritime portion by those who had passed over from the country of the Belgae for the purpose of plunder and making war; almost all of whom are called by the names of those states from which being sprung they went thither, and having waged war, continued there and began to cultivate the lands.

Caesar only mentions the south-eastern tribes of the Trinobantes, Cenimagni, Segontiaci, Ancalites, Bibroci and the Cassi. The main Roman invasion of 43 CE

again makes no reference to Celts, but only to the many named tribes across Britain. 'Celt' and 'Celtic' were not terms used for the earliest known Britons until 1707 with the writings of Edward Lhuyd and others. Lhuyd discovered that the non-English island languages were related to that of the ancient Gauls. 'Celtic' was then extended to describe monuments, art, culture and peoples and the 'Celtic' identity was born.

Edward Lluyd was keeper of the Ashmolean Museum, working on *Archaeologia Brittanica*, and its first volume, subtitled 'Glossography', was published in 1707. He recognised that Welsh, Breton, Cornish, Irish and Gaulish (Gaelic) were the same language group, which he termed 'Celtic'.

In 1882 John Rhys, Jesus Professor of Celtic at Oxford, published *Early Britain: Celtic Britain*. He asserted that Goidelic Celts were the first to arrive from the Continent, into Southern Britain, from where they also moved to Ireland. Later, he thought that the Brythonic Celts arrived in the south, accelerating the Goidelic shift westwards and northwards. Hecataeus of Miletus had first mentioned Celts in the late sixth century, in the region from north-west Italy to the Straits of Gibraltar, and inland north from the Mediterranean coast as far as was known. Herodotus, around 430–425 BCE, noted the Celts living along the Ister (Danube), beyond the Pillars of Hercules (Straits of Gibraltar), and that they were the most westernmost inhabitants of Europe except for the Cynetes. The Cynetes or Conii occupied the south of what is now Portugal. It seems that the Greeks believed that the Celts occupied a wide region encompassing at least France, Spain and northern Portugal.

The traditional model, based upon Celtic place-names, is that the Celts originated in Central Europe and spread outwards. However, Barry Cunliffe and John T. Koch have proposed that they originated in the western Iberian Peninsula, moving to north-western France and the British Isles, excluding western Ireland. They also think that while the language was common, the Druidical system originated in Britain. Cunliffe also asks whether the Celts were the original British people, and if the later Anglo-Saxons committed genocide, pushing the Celts to the western fringes of Britain. He concludes that the Celts came after the Neolithic farmers, contributing under 10 per cent of the gene pool, and that there was no genocide.

There are two main theories of the origin of the Celts. The original theory was that they came in waves in the first millennium BCE. The most accepted version of this theory is that they originated in the Hallstadt culture in Austria (*c.* 600–450 BCE). This was succeeded by the La Tène culture of 450 BCE until the Roman Conquest of Europe, reaching its maximum expansion around 275 BCE. Celtic culture was thereby assimilated over only four centuries among tribes across most of Europe. Cunliffe and Koch give us a second scenario of Celts moving in the opposite direction, from the Western extremes of Europe, bringing their language with them. This seems, again, a short time-span for dissemination of language and culture across heavily forested lands. Such a fast transmission and adoption seems only possible via sea and waterways. The author is familiar with over thirty years of linguistic, archaeological, cultural, scientific and historical research on an unpublished theory of the origin of the Celts, and would like to put forward a third proposal.

The Mesolithic Age of hunter-gatherers ended in Britain around 4500 BCE. Incoming farmers brought new crops and methods of tending animals, along with an Indo-European language that was the ancestor of Brythonic, or Welsh. There is

a compulsive case that these earliest farmers, from 4500 BCE, were Celts, settling in a largely deserted Britain, from the Orkney Islands to Cornwall. Their architecture, religious beliefs, language, farming practices etc. spread throughout the British Isles. This was the genesis of the Neolithic Era (about 4000–1900 BCE). Neolithic farmers began clearing extensive forests, extending clearances into open spaces for grazing animals, who kept down any tree/shrub growth. In the Palaeolithic and Mesolithic ages, men did not use polished stone for implements. A polished stone axe is as effective as steel when used on softwoods, and quarries in the Preseli Hills and Penmaenmawr near Bangor are the site of Neolithic 'axe factories' for this time. New farming methods evolved alongside the knowledge of new crops from Turkey.

It seems that gradual immigration, trade and exchanges over thousands of years led to Celticism spreading around Europe and into Britain. A common Celtic language was used across Europe from 4000 BCE, based upon the need for communication owing to increasing trade. Celtic people were established from Turkey in the East to Spain, Portugal, Britain and Ireland in the West. They did not suddenly appear in Britain in 500 BCE, as a common architecture existed from Anatolia to Wales, which has been dated to over 4,500 years ago. Common myths, art and religion were established, and with the Celts had come agrarian settlements and widespread metalworking.

The basic unit of Celtic life was the clan, a sort of extended family. It seems that the Celts practised a different form of childrearing, whereby children were actually raised by foster parents. The foster father was often the brother of the birth-mother. Clans were bound together very loosely with other clans into tribes, each of which had its own social structure and customs, and possibly its own local gods. They lived in huts of arched timber with walls of wicker and roofs of thatch. The huts were generally gathered in loose hamlets. In several places each tribe had its own coinage system. Celtic lands were owned communally, and wealth was based largely on the size of cattle herd owned. The lot of women was a good deal better than in most societies of that time. Women were technically equal to men, owned property, and could choose their own husbands. They could also be war leaders, as Boudicca demonstrated. Celts relied on oral transmission of culture, primarily through the efforts of bards and poets. Much of what we know of their traditions comes to us today through old tales and poems that were handed down for hundreds of years before eventually being written down.

When Did the Celts Come to Britain?

Professors Ryan and Pitman of Columbia University (*Noah's Flood*, 1999) provided evidence for a cataclysmic disaster, which caused the ancient Black Sea freshwater lake to flood with salt water. The earth's oceans measurably reduced in a matter of months, as they crashed through the Bosporus. All freshwater life in the great lake, once known as Pontos, was destroyed, creating a sulphurous, uninhabitable lower stratum, as found even today. In 5600 BCE Ryan and Pitman believe that the flood survivors escaped to three regions. Firstly, the inhabitants went north and west along the great European rivers feeding ancient Pontos – the Danube, Don, Dnieper, Dniester and Kuban. At the same time others moved and settled south across

Anatolia and Dalmatia to the Levant, Mesopotamia, Egypt and the Mediterranean. The third direction was east to the Tarim Basin and Asia. The sudden appearance of new technologies, agriculture and burial practices across Northern and Eastern Europe and the Near East in the mid-sixth millennium BCE trace their migrations.

Ian Wilson, in *Before the Flood* (2003), discusses how the Black Sea flood occurred in what is now credited as the 'cradle of civilisation', Anatolia (Turkey). The region included Gobelki Tepe, the oldest megalithic temple complex in the world (9500 BCE); Nevali Cori (8300 BCE), Cayonu (7200 BCE) and Hacilar (7040 BCE), the earliest Neolithic agricultural settlements. Çatalhöyük (Fork Mound) is the largest and best-preserved Neolithic site in the world. It is the world's oldest town (7600–6000 BCE) and had an estimated population of several thousand, three times that of Neolithic Jericho. Climate change due to a mini Ice Age in the seventh millennium BCE had forced the inhabitants of Çatalhöyük to abandon their arid Anatolian plains. No historian knows where they went. The ancient, pre-Flood people of Çatalhöyük and Anatolia worshipped an Earth Mother Moon Goddess and her associated bull cult, just as the Minoans did, much later in Crete. They used ritual excarnation (removal of flesh and organs) and re-interment of bones within their timber-framed, plaster-walled dwellings – symbolically painted in red, white and black.

Their belief in the Earth Mother Goddess was adopted by later civilisations, such as the Phoenicians, Egyptians, Sumerians and the Britons. Burial practices at Skara Brae (Orkney) and elsewhere in Britain involved ritual excarnation and reburial in the home, exactly as practised at Çatalhöyük around 7000 BCE. Even today the Berbers of North Africa, a matrilineal, once Caucasian people, continue this tradition to communicate with their dead ancestors through dreams. Similarly, megaliths were constructed in Britain using symbolic red, white and black stones. These common rituals, practised across the post-Flood ancient civilisations of Europe, the Mediterranean and Near East, are highly significant and yet remain a mystery to mainstream historians. It would be thousands of years before the belief in a patriarchal, warlike Supreme Being would appear. Ovid wrote of four ages of man: first the golden age of Cronus, of Earth Goddess worship, peace, hunting & gathering; then a silver age of Zeus, of farming and feasting; followed by a Bronze Age of piety but violence; and lastly an Iron Age of boundaries, demarcation, nations and warfare.

Diodorus of Sicily tells of megaliths being erected on Samothrace, at the mouth of the Bosporus, to commemorate the survival of their ancestors from the 5600 BCE flood. By 5200 BCE, megalithic building had spread to Malta, known in ancient times as Gaulometin, and, incredibly, to Britain. In fact identical megaliths appear all along the coastal escape-routes of the colonists who survived the flood: along the Mediterranean coasts and islands, up the Atlantic seaboard to Brittany and Britain and similarly along the great, northern rivers into Central Europe. These monuments were used for astronomy as well as for ritual purposes. Passage graves and burial chambers represented the womb of the Earth Mother. A ray of light from the sun god would enter the passage at the sacred solstices to impregnate the Earth Mother Goddess and fertilise the Earth for another year. They were built over underground water sources, believed to be linked to the

underworld and its sacred oceans, providing sustenance in the afterlife.

The great megaliths continued to be built across many parts of the globe, even as late as the first millennium BCE, as the knowledge, beliefs and ancient peoples themselves migrated. Step pyramids were constructed in Sumer and later in Egypt. Europe's largest man-made ancient mound is at Silbury in southern Britain, near Avebury and Stonehenge. The level of skill and the resources required to complete these thousands of monuments was colossal. Yet their builders remain a mystery, as if wiped from the historical record. It is this author's belief that the Celts did not mysteriously appear in Britain a few hundred years before the Romans – they had been here for millennia.

Furthermore, the widespread use of Celtic river names throughout Europe and the Near East is further testimony to the ancient origins of the Celts. Despite academic dating of the Celts to *c.* 600 BCE, rivers would not have been named as late as the first millennium BCE. Clearly they would have been named many millennia earlier: Rhone, Rhine, Rhion (Georgia), Don, Danube, Saone, Seine, Severn, Derwent (Oak), Thames (Tamesis, as in Mesopotamia – between the rivers), Plym, Exe, Usk, Esk, Douro, are just a few examples.

Britain and Ireland separated from the European landmass only 8,000 years ago. Within a few hundred years, migrants from the Black Sea inundation had travelled to the islands, bringing their advanced spirituality, technology and language. When they arrived (*c.* 5300 BCE) the islands were virtually uninhabited, with a population of a few thousand coastal hunter-gatherers (Richards 1997). There is substantial archaeological evidence that Neolithic settlers first arrived by travelling along the western European seaboard to the west of Britain and Ireland (Cunliffe *et al.*). Within 1,000 years of their arrival Britain had developed as a major civilisation, based on Earth Mother Goddess worship, bull cults, megaliths, astronomy, mining, metalworking and agriculture, just as it had in its Black Sea homeland and in defined places on colonising paths from Anatolia. The country's spiritual and technological leaders were Druids. Early British Christianity was a form of Gnosticism, as archaeological evidence is now confirming, and therefore related to the religion of the writers of the Dead Sea Scrolls, discovered by a shepherd boy in Qumran. Francis Pryor (*Britain AD*, 2006) describes murals in Romano-British villas as evidence of Britain's Gnostic past and ancient writers describe an unmistakably Gnostic philosophy in Britain. The Druids brought their knowledge of the 'Megalithic Yard' from the Near East. There is not the scope in this volume to extend the concept that the Celts were in Britain well before the first millennium BCE, but the evidence appears to be compelling.

Monuments and Buildings

Paleolithic man left little mark on the landscape, but throughout the Mesolithic, Neolithic, Bronze and Iron Ages, the landscape in Wales was progressively cleared and farmed, tending towards separation into tribal territories. People came to settle in roundhouses on small, enclosed farmsteads, in which have been found iron tools, spindle whorls and quern-stones for grinding corn. These roundhouses evolved into strong, wind-proof structures, as we can see in the reconstructions at St Ffagans

and Castell Henllys. In later times, they were clustered together within hill-forts or defended enclosures, as a tribal society with leaders evolved. There are over 3,000 stone circles remaining in Britain, but most of their wooden predecessors have vanished. Only eight timber temple sites remain, one of which, at Stanton Drew outside Bristol, is as old as Stonehenge, but twice as large. Experts think it would have taken as much as 1.5 million man-hours to construct the bank and ditch at Avebury in Wiltshire, and place its sarsen stones, which required a high degree of organisation. The bluestones at Stonehenge come from the Preseli Mountains in Pembroke, nearly 250 miles away, so there was probably cooperation with various tribes to somehow transport them. There were about eighty of them, weighing up to 4 tons each. The thirty upright stones came from the Marlborough Downs, 20 miles away, and weigh 50 tons each.

Human habitation from the Neolithic period does not survive in Wales. Possibly the inhabitants used wood for dwellings or lived in turf huts which have long since decayed, or they may have made seasonal dwellings from skins. On the Orkneys, however, stone huts from the time of Stonehenge survive, probably because of the lack of timber on the islands. In the later centuries before the Roman invasion, most people lived in enclosed – but not strongly defended – farmsteads with cattle corrals, linked by field systems and trackways. Many were overshadowed by major hill-forts. Hill-forts were used from around 1000 BCE into the first millennium as defensive structures to protect lands and livestock, cattle being not only the main livestock but the first form of money.

Because of their predominantly lowland location, most of these settlements have been destroyed by later activity, such as ploughing, but many have been found as crop or soil marks. We can sometimes make out Iron Age fields by their stone banks, mainly on uplands. 'Lychets' can also be seen, formed by soil loosened by cultivation. Time and weathering force the earth to move gradually downhill, forming banks when it piles against a stone field boundary. Networks of trackways, the precursors of historic droving routes, connected communities across Britain and ports. Salt came from the Cheshire plain, and there were imports from across the Mediterranean and Gaul. Roman armies later quickly established bases and supply depots across Wales, and penetrated the hills through mountain passes, probably using existing routes. The fact that the Romans brought roads to Britain is a myth – they usually improved what was already in place.

Anatolia is the Asian part of Turkey, bordered by the Black Sea, the Bosporus, the Mediterranean, Syria, Iraq, Iran, Armenia and Georgia. It was the most advanced civilisation on Earth, with its first known structures at Göbekli Tepe being built as early as 10,000 BCE. The 25-acre arrangement of at least seven stone circles, plus temples and monuments is the oldest man-made place of worship yet discovered. It pre-dates Stonehenge by about 7,000 years. From this particular civilisation stems not only crop farming and advanced agricultural techniques, but the worship of Mother Earth and the cult of the bull. Anatolians were seafarers who left colonies and built their distinctive stone monuments in Italy, Minorca, Malta, North Africa, Spain, Portugal, France, Brittany, Britain and Ireland. These huge stone and timber structures, the megaliths, stone circles, stone avenues, cursuses, causeways, enclosures, henges, chambered-tomb cromlechs, dolmens and menhirs cover the landscape of

much of Wales even today. ('Maen hir' means tall stone and refers to standing stones). Many sites have been ploughed or built over, and stones buried, broken up for roads or limestone cement/fertilizer, but the many remaining prehistoric monuments cannot be adequately described in a general history.

The period up to the Bronze Age, around 4,000 years ago, was the time that saw the building of dolmens and stone circles across the western fringes of Europe. A dolmen, or cromlech, is a prehistoric megalith typically having two or three upright stones and a capstone. They are thought to be burial chambers and according to historians they are the earliest permanent structures built by people, older than the pyramids of Egypt. Many have been destroyed, but there are over 150 remaining dolmens in Wales. The evocative Castell Carreg (Stone Castle), Llech-y-Filiast (Slab of the [Greyhound] Bitch), also known more prosaically as Tinkinswood burial chamber, lies north of Barry. It was constructed at the same time as the early earthworks at Stonehenge, 4,500 years ago. Its burial chamber is 130 feet long, with the sides being held in place with a dry stone wall. It has been estimated that 200 people were required to lift the 46-ton capstone into place, 7 feet above ground level. It may be the heaviest in Europe, but hardly anyone knows or visits the site adjoining the magnificent Dyffryn Gardens and St Lythan's Cromlech (a portal dolmen similar to Pentre Ifan in Pembroke). The entrance to the Tinkinswood tomb was in the shape of a pair of horns, possibly providing a forecourt for offerings to the gods of nature or Mother Earth. Pottery and tools were buried with at least fifty men, women and children, for the journey into the afterlife. Druids believed in reincarnation. Many such sites seem to be placed over underground watercourses, supplying drink for the journey. The finding of beakers suggests that the site was used until well into the Bronze Age.

Bronze Age people are often known as 'Beaker People' from the drinking vessels buried with them in round barrows. More than 400 such barrows have been excavated in Glamorgan alone, and there were probably many more, either destroyed or still awaiting exploration. Dolmens such as St Lythan's Cromlech are generally three or more large, upright stones supporting a table stone. The Welsh name for the dolmen is Gwâl y Filiast, Kennel of the (Greyhound) Bitch, and it is about a mile away from the Llech-y-Filiast, Tinkinswood chamber. The stars known as Canes Venatici represent two dogs, two hounds, or two greyhounds, on a leash held by the Bear Driver as they pursue the Great Bear, Ursa Major. Around 150 CE, Arrian described the Vertragus, a Celtic hound named for its swiftness, the ancestor of the modern greyhound. The 'grey' of greyhound is Old English for a dog, usually a bitch, not a colour, so the word meant hound bitch. A greyhound, or a scenting dog, was called a 'brach', meaning a bitch hound. How the word greyhound is attached to the burial chambers is a mystery. There is sometimes a hole drilled into one of the supporting stones, such as at St Lythan's, possibly to allow the soul to escape. The word dolmen comes from the Breton *taol maen*, long table. The word cromlech is said to come from the Welsh *crom llech*, for bent flagstone, but may have its origin in *crommen*, or vault. Cromlechs are dolmens or chambered cairns, but confusingly also can mean stone circles in Europe. Burial chambers were built to bury and honour the dead, but may also have served, according to Francis Pryor, 'to socialise, to meet new partners, to acquire fresh livestock and to exchange ceremonial gifts'. Corpses of the dead were

probably left exposed to the gods of nature, before the bones were moved into the burial chamber.

There are two other favourite prehistoric sites in Wales for this author. In Anglesey, Barclodiad y Gawress (Apronful of the Giantess) is a cruciform passage grave of around 2400 BCE with decorated stones. These stones are similar to the tombs around Newgrange in Ireland, and have no counterpart in the rest of England and Wales. Its name may that mean earth once covered the passage to the tomb of the Earth Mother. After excavations in 1952–3, the chamber was re-roofed with concrete and covered with turf to resemble the original structure. Two cremated young male burials were found within a side-chamber, and the central main chamber contained the remains of a fire on which had been poured a stew including wrasse, eel, frog, toad, grass-snake, mouse, shrew and hare, then covered with limpet shells and pebbles. Five stones with carvings (spirals, zig-zags, lozenges and chevrons) were known, but a sixth stone with carvings was not discovered until 2001.

Also in Anglesey is Bryn Celli Ddu (the Mound in the Black Grove) burial chamber, dating from around 3500–3000 BCE. On Midsummer Day, a shaft of light from Father Sun penetrates along the passage of Mother Earth, to fertilise the land for the growing season. The later stones at Stonehenge of 2500 BCE are also aligned with the longest day. Another notable Welsh monument is the Sarn-y-Bryn Caled cursus near Welshpool, built in phases from 3800 BCE to 2500 BCE. It is a double-ditched monument over 400 yards long, with multiple causeways to allow access. The largest wooden palisade in Britain has been found at Hindwell in Radnorshire, requiring about 6,300 tons of oak in its construction. There were 1,400 spaced posts, each weighing around 4.5 tons, set in holes over 7 feet deep. It is nearly 2 miles in circumference, and in Europe is only surpassed in size by one near Koblenz.

The Bronze Age

It appears that around 2000 BCE during the Bronze Age, new groups of Celts came to Britain, since named 'Beaker-folk' because of their fine pottery. They may have introduced copperworking to Wales. Beaker people were semi-nomadic sheep and cattle herders, burying their dead in mounds called tumuli or barrows. There are about 140 of these Bronze Age tumuli in the small county of Flintshire alone. During the Neolithic Age, farmers had used stone tools in Wales until around 2000–1900 BCE, when metal tools and objects became common across Wales. There had been copper objects from 2300, gradually replaced by bronze, which is basically copper hardened by the addition of tin. Both elements were plentiful in Britain – copper in Wales and tin in Cornwall. The Bronze Age began in the Aegean around 3200 BCE and in Britain about 2000 BCE. Tin was thought to have been taken from Cornwall to Cyprus, where copper was mined and alloyed with tin to form bronze. However, copper was mined at Parys Mountain and traded from Wales as well, copper and bronze being used for implements and weapons. Probably Wales was producing bronze at this time. The name given to the Early Bronze Age in Britain was the Bedd Branwen Period, dating from 1650 BCE–1450 BCE. The Penard Period of around 1275–1140 BCE saw increased metalworking across Britain,

with bronze being traded locally and overseas. The period was named after a site on Gower where a hoard of bronze tools was found. The cylinder sickle and new types of sword and spearhead were developed, along with new lead-rich alloys.

During this time, transportation and communication from one region to another in Wales was difficult, leading to the development of several different tribal areas. Communal burials became generally replaced by individual or family-group burials, suggesting the growth of a class of religious and tribal leaders. The invention of the wheel and the development of iron ploughs led to greater agricultural productivity. A warmer climate made possible cereal cultivation upon Welsh uplands. (It is a pity that politicians do not study history or science – they would have probably blamed the warm climate upon the increased use of wheels.) With a worsening climate, people later retreated from the upland areas, leaving them for summer grazing. Because of this, many of these Bronze and Iron Age settlements and field patterns above 1,500 feet can still be seen. There are many Bronze Age cairns, standing stones and stone circles in existence. It is well worth the climb to see three huge stone cairns on the summit of Foel Trigarn (the Bald Hill with Three Cairns) in the Preseli Mountains in Pembrokeshire. They were later enclosed by the ramparts and ditches of an Iron Age hill-fort.

Burial practices in the Bronze Age differed from the communal tombs of the Neolithic period, with a change to burial in round barrows and the provision of grave-goods. Inhumation was soon replaced by cremation and in Wales the cemetery mound with a number of burials had become the standard form by about 2000 BC. Very few weapons have been found in Early Bronze Age graves in Wales compared with other objects, and the lack of traces of earlier Bronze Age settlements is thought to indicate that farms or hamlets were undefended. The Late Bronze Age saw the development of more advanced bronze tools, with weapons becoming increasingly common. There are pronounced regional variations in the styles of tools, particularly axes, and upon the basis of tool types, Wales could be divided into four regions: the south-east, south-west, north-west and north-east. The areas correspond to the territories of the tribes recorded in these areas by the Romans: the Silures, Demetae, Ordovices and Deceangli. From around 1250 BCE the climate deteriorated, and this change became more marked from around 1000 BCE. Higher rainfall and lower summer temperatures led to an increase in peat formation and the abandonment of many upland settlements. This new pressure upon resources may have led to conflict and to changes in social organisation into larger tribes, with the earliest hill-forts appearing around 800 BCE.

Agriculture

Agriculture first began with the planned sowing and harvesting of plants which had previously been gathered in the wild. The earliest agriculture began around 7000 BCE in the 'Fertile Crescent' of Egypt, Phoenicia, Assyria and Mesopotamia. The first cultivation in the Old World included the 'Neolithic founder crops', the plant species of emmer wheat, einkorn wheat, hulled barley, peas, lentils, bitter vetch, chick peas and flax. Thus flax (for oil, clothing and cord), three cereals and four pulses formed the basis of systematic agriculture. Net fishing of rivers, lakes and ocean shores

brought in essential protein, and these new methods of farming and fishing started a human population boom. Farms based on agriculture began the large-scale use of animals for food and skins, and oxen (castrated male cattle) were used for pulling carts and tilling soil. By 5000 BCE, core agricultural techniques had developed in Sumer, allowing the growth of cities. Sumerians were the first civilisation to practise year-round, large-scale intensive cultivation of land, mono-cropping (growing a single crop year after year on the same land), with organised irrigation, and the use of a specialised labour force. The farming of domesticated species of plants and animals created surpluses of storable food, allowing the development of fixed settlements rather than nomadic camps. People no longer migrated looking for fresh crops and grazing land for their animals. It also allowed for a much greater population density, and in turn required an extensive labour force and the more efficient division of labour. People began living together in much larger groups, in towns, in more permanent structures.

Agriculture in Wales was only possible at this time along the fertile south coastal plain, the river valleys and deforested parts of Anglesey. Through the rest of Wales, existence was pastoral, looking after travelling flocks of cattle and sheep. Cattle were prized not only as sources of wealth, but for pulling ploughs and carts. Pigs and goats were also kept, and domesticated animals provided meat, dairy products, leather, and wool. They also helped to maintain pasture against the return of forests. From around 1000 BCE people began grouping around large hill-forts for protection. Grain mills have been found in these forts, giving evidence of harvesting and storage of cereals and vegetables. However, stock husbandry was more important across most of Wales, upon the evidence of the remains of animal bones.

Early ploughs had been basically a thick wooden stick with a pointed end harnessed behind two oxen, for 'scratch agriculture' upon light upland soils. Heavier iron ploughs now made it possible to cultivate rich valley and lowland soils. It usually required a team of eight oxen to pull these heavier and more effective ploughs. Thus, to avoid the difficulty of turning, Celtic fields tended to be long and narrow. This ancient field pattern can still be seen in some parts today. Woodland management, hunting and fishing supplemented the agricultural economy and diet.

An article by Rhona Wells in March 2008 was headlined 'To Celebrate Its 20th Anniversary, the Institut du Monde Arabe in Paris Chose to Explore the Phoenician Enigma':

> Accomplished sailors and renowned traders, the Phoenicians criss-crossed the Mediterranean for centuries. Living on the Levant Coast, present day Lebanon, they established – during the first Millennium BC – trading posts from Cyprus to Italy to North Africa, and on towards the Atlantic coastal areas of Spain, Portugal and Morocco. They travelled northwards trading tin with the Welsh, leaving leeks – today, the Welsh national emblem – as their legacy. Their trade was based on precious metals: gold, silver, copper, ivory and ebony, as well as textiles…

The theory that Phoenicians brought Wales the leek is new to this author, but welcomed as potentially further proof of Celtic trading systems.

Mining, Artefacts and Trade

We can see increasing signs of trade into and from Europe and the eastern Mediterranean. Around 20 CE Strabo mentions the export of hunting dogs, hides, metals and slaves from Britain. Roman sources also indicate grain exports from Britain.

Copper and Bronze

As well as the movement of civilisation along the Mediterranean and around the Iberian Peninsula, there was similar progress from Anatolia and the Black Sea via the Danube and along the Rhine in Germany. This manifested itself in metalworking. We know that from the fifth century BCE, Greeks, Phoenicians and Carthaginians traded for Cornish tin, and probably Welsh copper and gold, with the Greeks referring to Britain as the Cassiterides, or 'tin islands'. The Carthaginian Himilco and the Greek Pytheas visited Britain in the fifth and fourth centuries BCE respectively. The Sicilian-Greek historian Diodorus Siculus (*c.* 90–30 BCE) quoted Pytheas, who had sailed around Britain: 'The inhabitants of that part of Britain called Belerion [Land's End] from their intercourse with foreign merchants, are civilized in their manner of life. They prepare the tin, working very carefully the earth in which it is produced … Here then the merchants buy the tin from the natives and carry it over to Gaul, and after travelling overland for about thirty days, they finally bring their loads on horses to the mouth of the Rhône.' Copper and gold were mined, smelted and worked in Wales during the third millennium BCE, as proved by finds of bronze tools and weapons, and torcs and bracelets of gold. Metalworking, combined with a change of climate, seems to have had an effect on the religious practices of the British. They stopped erecting dolmens and stone circles – perhaps their energies went into building hill-forts and defensive enclosures. Bronze, iron, gold, silver and copper objects now seemed to become part of a religion, as they were given as offerings to the gods. We see metal hoards, from weapons to domestic utensils, at the bottom of ancient lakes, such as Llyn Fawr and Llyn Cerrig Fach.

Metal tools had first appeared in Wales around 2500 BC, initially copper, much of it from the Great Orme mines, and then bronze. Welsh bronze tools were innovative in both design and metallurgy, particularly axe-heads, and were widely exported, with examples being found along the Continental coast from Germany to Brittany. The Great Orme (Pen y Gogarth) Copper Mines at Llandudno was the greatest excavation in the world, well before the Romans exploited it. Only accidentally rediscovered in 1976, the mines date back to over two millennia before the Roman invasion. They were abandoned in 600 BCE, reopened in 1692 and finally closed in the late nineteenth century. 4 miles of prehistoric tunnels have so far been surveyed, and over 2,500 stone hammers have been found. Around 200 tons of metal were produced, some for export. If added to tin from Cornwall, this could have made 10 million bronze axes. This largest prehistoric mine in the world has reopened, and the Bronze Age mine workings are now a fee-paying attraction. It has also been possible to show that there was pre-Roman lead or copper mine-working at twenty-two sites including Parys Mountain in Anglesey, Nantyreira, Nantyricket and Cwmystwyth

in Mid Wales and the Great Orme in North Wales. Cymystwyth mine at Gopa Hill shows early Bronze Age extraction of copper sulphide ores, using mine drainage systems as sophisticated as those of Rome. Copper was mined here around 4,000 years ago, and it seems that the world's first example of mine drainage was found here, with hollowed-out logs being used to take out the water. The 4,000-year-old copper mines at Parys Mountain were only discovered in 2002.

The largest hoard of Celtic treasure discovered in Britain was the Llyn Cerrig Fach hoard on Anglesey. This was found in the Second World War during RAF construction. Workmen recovered over 150 bronze and iron objects from the peat which had formed in a former lake. The first item pulled up by a harrow was an iron chain. It was so strong that it was used to pull a tractor out of the mud before its true nature was ascertained. It was a slave-gang chain of iron with neck shackles. The hoard includes iron swords, shield fragments, spear heads, horse harnesses, chariot fittings, a bronze plaque, a trumpet, iron chariot wheels, fragments of cauldron and two iron slave-gang chains. Many of these items are now in the National Museum of Wales. It is believed that these valuable objects were thrown into the lake by Druids as offerings between the second century BCE and 60 CE. The iron swords were typically bent, thus making it impossible for them ever to be used again. Tacitus described Mona (Anglesey) as the European centre for Druids and their training, and Druids were the spiritual advisers of Celtic chiefs. Some believe the objects were thrown in when the Romans invaded Anglesey to wipe out the Druids, as a relic of their last stand. Tacitus also described the sacred oak groves of the island.

Gold

The only known Roman gold-mine in Britain is at Dolaucothi, south of Lampeter, a large hollow lined with wooded crags. The Ogofau (Caves) Pit marks the site of an enormous Roman opencast mine. However, there is now evidence that the opencast working at Dolaucothi may have begun 1,000 years before the Romans came, and could have been a major reason for the Roman invasion. The Romans listed gold as one of the attractions that drew them to Britain, and Dolaucothi was the largest goldmine in the British Isles. Romans began serious mining in 75 CE, using thousands of slaves to extract gold for the Imperial Mint at Lyon. The National Trust, which owns and operates the site, sadly and wrongly states on its information boards and in leaflets that Dolaucothi was 'first exploited by the Romans 2,000 years ago'. The *Cambridge Schools Classics Projects* also says the mines were 'started by the Romans'. However, gold extraction here dates from Bronze Age washing of the gold-bearing gravels of the River Cothi. As regards opencast mining, there is sixth-century BCE dating for material found beneath spoil near Carreg Pumpsaint. Only recently, French archaeologists working at Dolaucothi said they had made a discovery 'as important as Stonehenge', and that they thought that 'most of the gold had been taken away before the Romans got here'. They believe that the Romans built their largest network of leats and aqueducts in Britain at Dolaucothi, to look for new lodes of gold in the quartz. Gold from these mines can be found in artefacts across Europe. The National Trust's head of archaeology, David Thackray, said, 'This work

shows Dolaucothi is a site as archaeologically significant as Stonehenge and Sutton Hoo, which are the National Trust's most important archaeological properties and which are World Heritage Sites.' The attraction is little known, with small visitor numbers.

For prehistoric artefacts, the National Museum of Wales in Cardiff has an excellent contextual collection, and some of the more noted finds include the 4,000-year-old Banc Ty'nddôl 'sun-disc', found in 2002 at Cwmystwyth. It was probably a funerary ornament as it was found with a skeleton in a cairn. It is the earliest gold artefact discovered in Wales. Made of 94 per cent gold and 6 per cent silver with a copper trace, it is also probably Wales' oldest surviving metal artefact. The Mold Gold Cape is one of Britain's most famous treasures, and one of the most important European Bronze Age finds. In 1833, workmen were digging for stone in a mound at Bryn yr Ellyllon (Hill of the Ghosts), near Mold, when they uncovered a stone-lined burial chamber. The cape was crushed and was further damaged as it was shared out between the finders. Initially, the cape was dated to the Dark Ages, as it was seen as too ornate to be dated before the Romans, and its style was obviously not Roman. In the late nineteenth century, academics finally realised that the Bronze Age came before the Iron Age, and the cape was dated to around 1950–1550 BCE. It weighs 20 ounces and was hammered from one ingot of gold. Recent research indicates that it may have been designed for a woman, and the grave-goods, especially amber beads, also point to its owner being female.

There are a number of internationally important finds from the Bronze Age in north-east Wales: the Caergwrle Bowl (a shale, tin and gold bowl, the design of which forms a boat); the Westminster Torc (a twisted gold neck ornament); the Rossett Hoard (a socketed axe and pieces of a gold bracelet and two pieces of a knife); the Burton Hoard (a hoard containing a unique collection of bronze palstave axes and gold jewellery of great craftsmanship); and the Acton Hoard (a collection of bronze axes that point to a strong bronze-working tradition in this area). Like the sun disc, the Caergwrle Bowl was also found near Mold, at Hope, and may be twelfth-century BCE. This beautiful gold-foil decorated bowl (around 7 inches across the rim), was found in a bog at the foot of Castle Hill, Caergwrle. It is possibly the most extraordinary piece of gold-work found in Wales, made of shale, with a design deeply cut into it. Originally all the elements in the design were filled with tin, over which was placed decorated gold foil. The decoration has been interpreted as forming the gunwales, oars and keel of a boat with waves running along its hull.

Sadly, over the centuries, gold hoards and torcs have been found and melted down across Wales, for instance in the early nineteenth century at Llantwit Major near the great Roman villa of Caermead. The priceless torc was sold for £100 and melted down. Ireland has never been as devastated as Wales over the centuries, despite their history books, as evidenced by the survival of their ancient manuscripts in Trinity College, and by the number of gold torcs in Dublin Museum. A recent television programme attempted to find the source of the gold in Ireland's treasures, and could not find an Irish source. It is possible to identify the source of gold. The researchers did not consider Wales, as Irish history is mute upon the hundreds of years of raids and settlements by the Irish in Wales. It is strongly believed by this author that much 'Irish' gold has its provenance in Wales.

Stone

Apart from metals, Wales traded in stone. The 'Neolithic Axe Factory' of Graig Lwyd is sited upon an extinct volcano above Penmaenmawr, Conwy. Rocks were broken off the cliff in workable blocks, then flakes were broken off using hammer-stones to get the stone closer to the desired shape. The semi-shaped rock was then removed from the mountain for final shaping and the much longer task of polishing, being then placed in the end of a long wooden handle. All over England and Wales axe-heads from this location have been found, pointing to widespread trading routes from the early fourth millennium BCE. Mynydd Rhiw on the Llŷn Peninsula also produced tree-felling axes for Neolithic agriculture in England and Wales, but the men who made them show their Mesolithic, hunter-fisher ancestry in the distinctive domestic tools of heavy scrapers, knives and choppers. The most interesting products, however, are adzes and predominantly light and slender axes, intended for woodworking rather than tree-felling. It seems that specialised tools were made for boat-building, and also to kill and strip seals, whales and other sea life. Carefully made discoidal and lanceolate stone knives could be used for flensing (stripping blubber) and other sea-hunting purposes.

Language

Because of the need to develop a system of recording barter and exchange of crops and animals, Sumer (Southern Mesopotamia, modern Iraq) saw the earliest development of writing around 3500 BCE. The westward spread of agricultural methods and trade, especially by Phoenician ships, led to the development of an international, and much simplified, trading language. From around 1500 BCE, the Phoenician script, consisting of only about two dozen symbols, was developed. This made the script easy to learn, and Phoenician seafaring merchants took the script across the known world. Phoenician then gave way to a number of new writing systems, including the Greek alphabet from 800 BCE, and Aramaic. The Greeks borrowed the Phoenician alphabet and adapted it to their own language. The letters of the Greek alphabet are the same as those of the Phoenician alphabet, and both alphabets are arranged in the same order. The Greek adapter of the Phoenician system also added three letters to the end of the series, called the 'supplementals'. The word alphabet comes from the Latin word *alphabetum*, which in turn originated in the Greek *alpha* and *beta*, the first two letters of the Greek alphabet. *Alpha* and *beta* in turn came from the first two letters of the Phoenician alphabet, and meant 'ox' and 'house' (early man's two most important possessions) respectively.

The origins of most alphabetic writing systems can be traced back to the Phoenician alphabet, including Greek, Etruscan, Latin, Arabic and Hebrew, as well as the scripts of India and East Asia. Aylett Sammes (*c.* 1636–79) was an English antiquary, derided for his theories of Phoenician influence on the Welsh language, but like all Indo-European languages Celtic/Welsh is descended from Phoenician. The Celtic linguistic contribution to European culture was incredibly important. There were survivals of megalithic languages in Europe – Finnish, Hungarian, Basque

and Etruscan – but the language of the Celts was taken up at an early stage across most of Europe. Trade, travel, and communication with settlers made a common tongue a sensible solution. Later, Latin served as a lingua franca across Europe, and more recently English has served the same purpose. Roman conquests effectively eliminated the Celtic tongue from nearly all of Europe.

There is simply no evidence to link the coming of the 'Celtic' languages of Brythonic (in Wales, Cornwall, Brittany, Strathclyde and Cumbria) and Gaelic/ Goidelic (in Ireland, the Isle of Man and Scotland) with any Celtic invasions during the Iron Age. Very few modern European languages are derived from Celtic, despite its former widespread use across Europe and in Britain. After the Roman conquest of Britain, the Celts there held on to much of their customs and especially to their distinctive language, which has survived today as Welsh. The original Celtic tongue was spoken over a wide area, gradually dividing into Goidelic (or Q-Celtic) now spoken in Ireland and Scotland, and Brythonic (P-Celtic) spoken in Wales, Cornwall and later exported to Brittany in France. The Celtic languages are said to have arrived in Britain around 1000 BCE, but because of Britain's extensive trading links, would have been used much earlier. It is this author's belief that it is even older in Britain, as the Celts settled here long before this date. From all evidence, this author believes that the British were a Celtic people long before modern historians believe. They have no theory for who was here originally, only a belief that there were small numbers of Celts coming here from around 500 BCE. Cornish, Welsh and Breton arose from a group of languages known as Brythonic (Gaelic – Irish, Scots and Manx – derives from Goidelic). With increasing incursions of Germanic peoples, the Celts were driven to the north and west. After the Battle of Chester in around 613, the Welsh found themselves cut off from their compatriots. At around this time, the word *Cymry* first appears in a poem (Cymry meaning the Welsh), and at the same time we can begin to talk of Welsh as opposed to Brythonic.

Religion

By 300 BCE Celts were by far the dominant race of the western world, with their associated Iron Age culture established from the Bosporus to the Atlantic. They were crop and cattle farmers, never establishing an empire, and remaining a grouping of tribes. These tribes were connected by a family of languages, and a polytheist religion, with a Druidical priesthood. Celtic culture was diluted under the Romans but remained largely intact in Wales, which seemed to be the remaining centre for European Druidism. To protect their power, it may be that Druids forbade any written language, so culture was only transmitted orally. Thus there is a lack of knowledge about them prior to their contact with the literary civilisations of Greece and Rome. The ancient Celts were a literate people, contrary to popular belief, as commented by Julius Caesar, 'They consider it improper to commit their studies to writing, although they use Greek letters for almost everything else…' Unfortunately, the Romans especially were propagandists of history rather than factual recorders. To be fair, to write of Roman defeats or of a cowardly emperor would be signing the writer's death warrant in many cases. From Greco-Roman sources we believe that

all knowledge was committed to memory, and that it took twenty years of learning to become a Druid.

We may discount as propaganda many tales of blood-stained Druidical altars, child sacrifice and 'wicker men'. Druids were an upper class of priests, political advisers, teachers, healers, and arbitrators. They had their own colleges, where traditional knowledge was passed on by rote. They had the right to speak ahead of the chief or king in council, and may have held more authority than the king. They acted as ambassadors during wars, composed verse and upheld the law. The Romans tell us that Druids held religious ceremonies in woodland groves and near sacred water, such as wells and springs. There were gods of rivers, springs, seasons, flora and fauna, much like Native American beliefs. Three was a sacred number, and votive offerings such as purposely bent swords were placed in water. There was a bull cult, as in the Black Sea, and probably Celts carried on the prehistoric worship of an Earth Mother and a Sun Father. The Earth Mother belief probably helped to secure the relative equality of women in society. After battle, Celts might cut off the heads of their enemies and display them as trophies. Heads were revered, as the seat of spiritual power was the head. By taking the head of a vanquished enemy, his power was appropriated. The Isle of Anglesey seems to have been the centre for European Druidism, and Tacitus describes graphically the invasion of this religious stronghold in 60 CE. The raid effectively marked the end of Druidism as an effective force in Britain, but worship of Celtic gods was tolerated under the Roman regime. Druidism may have been established in Britain before the arrival of the Celts.

As recently as 1996, the grave of an Iron Age Druid from around 40–60 CE was found at Stanway. 'The Druid of Colchester' is among a number of graves of eminent people of the Catuvellani tribe, believed to be buried around the time of the Roman invasion of Britain in 43 CE. In the wooden-chambered burial site, archaeologists uncovered cremated human remains, and a board game with glass counters laid out as if to play. The Druid had a cloak decorated with brooches, a jet bead believed to have magical properties, medical equipment, a tea strainer still containing some kind of herbal brew, and some mysterious metal rods believed to be used for divining. His medical kit included scalpels, needles, a probe, sharp and blunt retractors, hooks, forceps and a surgical saw. His cup had traces of mugwort, possibly smoked to enable a trance-like state, or used as a herbal remedy. Mugwort featured many times in the recipes of the medieval remedy books of the Welsh 'Physicians of Myddfai'. The tea strainer had *Artemisia* pollen, which is used today in alternative medicine and was also recommended by the Myddfai doctors. The only named Druid we know is Diviciacus or Divitiacus, a leader of the Aedui who asked for Roman aid at the Roman Senate in 63 BCE. The Aedui were a powerful nation in Gaul, under attack by other tribes. He stayed with Cicero, who named him as a Druid and seer, and wrote of Diviciacus's knowledge of divination, astronomy and natural philosophy. Julius Caesar used him as a diplomat.

Lloyd writes,

> It may be surmised that in Britain, as in Gaul, the Druidic order included a guild of *bardi* or professional minstrels, for this is the readiest explanation of the fact that when *beirdd* first make their appearance in Welsh history, in the Laws of Hywel the Good, they are

found to be united in a regular organisation. Another character assumed by the British Druid was certainly that of diviner and magician; this is the ordinary sense of the word *derwydd* in early Welsh literature, as in the lines of Cynddelw: 'Nis gwyr namyn Duw a dewinion byd/A diwyd Derwydon/O eurdorf eurdorchogion/Ein rif yn Riweirth afon.' (None knoweth, save God and the world's diviners and Druids assiduous, how many were of us, that golden torqued host, at the river of Rhiweirth). Druidism, in short, represents, not the high-water mark of early British civilisation, but a survival from the less civilised past.

Dorian Williams noted,

The Celtic gods of territory were often of topographical origin: woods, rivers, mountains, springs. However, it is worth noting that these are specific places of holiness, each with their own numinous presence. The Christianisation of such individual places was facilitated by the Christian cult of the saints: many Christian wells, for example, are of pre-Christian origin, a phenomenon which shows the anthropological roots of the Catholic-local traditions of Welsh spirituality. Such a sense of locative holiness is connected to the religious psychology in which the whole territory of a tribe is considered as a sacred place: as we have seen, national territory tends inexorably to assume a mantle of separateness and holiness.

Miranda Green, in her *Dictionary of Celtic Myth and Legend*, points out that

the Celts were a very religious people. This variety and complexity is due largely to the essential animism upon which Celtic religion is based. Everything in the natural world was numinous, containing its own spirit. Thus the gods were everywhere. The topographical nature of some divine spirits is shown by the occurrence of a god whose name ties him to a particular sacred place. Of the more than 400 Celtic god-names known through inscriptions, 300 are recorded only once. Places of worship were often not built shrines, but *loci consecrati* or natural sacred places.

The Iron Age and the Building of Hill-Forts

The average lifespan was thirty for men and twenty for women. Women tended to marry at around fourteen, often dying in childbirth, with about 50 per cent of the children dying before reaching twelve years old. Most people lived in thatched roundhouses, generally built of stone or wood (in highland areas) or with wattle-and-daub walls (in the lowlands), a central fireplace and sometimes a porch. These houses were often inside hill-forts, together with rectangular structures which were probably raised above the ground on posts to store grain and other agricultural produce, also protecting food from rats, mice and the like. The reconstructed roundhouses at Castell Henllys in Pembrokeshire, built on their original foundations within the Iron Age hill-fort, give a clear idea of how these structures would have looked. There are also excellent reconstructions at the National History Museum at St Ffagans near Cardiff.

The Iron Age (c. 750 BCE–50 CE) saw a huge increase in enclosed and strongly defended settlements, which suggests that their inhabitants feared being attacked. Many began to be built in the later Bronze Age (c. 900 CE), for example the Breiddin, Montgomeryshire and others along the Welsh borderlands. There was climatic deterioration in the Late Bronze Age. Increased rainfall and cooler climates made it harder for the population to feed itself, probably leading to attacks for food. However, most hill-forts were probably built in the final three centuries BCE as the productivity of the land increased again. It appears that powerful tribal leaders had emerged to consolidate larger territories. Most defended enclosures were built on hilltops, and Wales has (as with castles), the highest density of such structures in the world.

They were constructed in strong, naturally defensible positions, with the earliest ones tending to be constructed with a single (univallate) line of defence, such as a palisade or stout fence. This was later developed into multiple (multivallate) lines of defences and outworks, consisting of banks and ditches, often revetted and topped with stone walls. Revetments are retaining walls to support the interior slope of a parapet. Additional protection outside the ramparts was sometimes provided by a *chevaux de frise*, a curtain of upright stones designed to foil a charge by mounted enemies or chariots. Good examples of these extraordinary defences can be seen at Carn Alw and Castell Henllys in Pembrokeshire. There is a superb collection of promontory forts and hill-forts all along the Welsh coastline to meet danger from the seas, but many are crumbling with the cliffs. Farms on low ground, such as those excavated at Biglis and Whitton in the Vale of Glamorgan, were turned into fortified homesteads. In the event of a serious assault, the population and their livestock retreated into larger forts, situated at key points on high ground. These strongholds were supplied with grain stores, prepared in advance to withstand a lengthy siege.

The earliest of the hill-forts is at Dinorben, dated to about 1000 BCE. They ranged in size from large communal sites of over fifteen acres to small rings encircling a single farmstead. Wales has only 8.4 per cent of the area of Britain, but 20 per cent of its hill-forts. They seem to have served a variety of purposes, such as acting as defensive settlements, temporary refuges at times of crisis, exchange centres or religious and social meeting places. Excavated finds reveal that many hill-forts were armed with the extremely effective sling-stone. In experienced hands these were accurate and deadly, with a range of over 100 yards. Castell Moel (Castle on the Bald Hill) is in a field overlooking the Roman Road (now the A48) south of the Old Post pub, Bonvilston in the Vale of Glamorgan. This small Iron Age hill-fort was later castellated by Normans, but any stonework has been robbed. Many stone slingshots and stone balls for ballistas have been found here, indicating an unknown battle between the Romans and Celts. The eminent Welsh pathologist and novelist Bernard Knight lived near here, and has a collection of the shot from his gardens, authenticated by the National Museum of Wales.

This author's favourite hill-fort is that at Tre'r Ceiri (Town of the Giants) on the northern Llŷn Peninsula. The ramparts are even now up to 10 feet in height, surrounding over 150 stone huts. This is the most spectacular and impressive hill-fort in Wales. The 5-acre fort occupies one of the twin peaks of Yr Eifl (the Rivals). Some buildings are round-houses, and others are larger, being rectangular or oval. The huts

are grouped together in four or five bands across the fort, varying in size from 10 to 25 feet. Set on the narrow summit of the hill, there are two conserved entrances, and the site is topped by a Bronze Age cairn. It is a miraculous place with views from Cardigan Bay to Anglesey.

British Historians

Bishop of Oxford Williams Stubbs (1825–1901) was the historian universally acknowledged as the head of all English historical scholars, also honoured across Europe for his *Constitutional History of England*. It traces the development of the English constitution from the Teutonic invasions of Britain until 1485, and ignores previous British history, regarding it as worthless. He advanced the Germanic civilising theory for no less than sixty-two pages before his barbarians take over Britain in a couple of pages. At this time, according to him, the British had lost the Latin tongue, although tomb inscriptions disprove this. The rest of his book is a German reading of history, religiously followed in all schools, universities and curricula to the present day. His rationale was basically to promote his own advancement via praise of the new German monarchs of Britain. The Hanovers had come from a country the size of the Isle of Wight, and proceeded to interbreed for the next 200 years with inconsequential minor royals, all from tiny German states. To Stubbs, nothing mattered before the Germans came to Britain. British Christianity was worthless compared to that of Rome. German genocide of the British was part of a master-plan for a master-race. History is not only written by those with greater armies and more aggression; it is believed when that version is taught by academics.

Stubbs' master-race theory has affected all British historians ever since.

> The English are not aboriginal, that is, they are not identical with the race that occupied their home at the dawn of history. They are a people of German descent in the main constituents of blood, character, and language, but most especially, in connexion with our subject, in the possession of the elements of primitive German civilisation and the common germs of German institutions. This descent is not a matter of inference. It is a recorded fact of history, which these characteristics bear out to the fullest degree of certainty. The consensus of historians, placing the conquest and colonisation of Britain by nations of German origin between the middle of the fifth and the end of the sixth century, is confirmed by the evidence of a continuous series of monuments. These show the unbroken possession of the land thus occupied, and the growth of the language and institutions thus introduced, either in purity and unmolested integrity, or, where it has been modified, by antagonism and by the admixture of alien forms, ultimately vindicating itself by eliminating the new and more strongly developing the genius of the old…
>
> The four great states of Western Christendom – England, the Germanic races France, Spain, and Germany – owe the leading principles which in Europe generally have worked out in their constitutional history to the same source. In the regions which had been thoroughly incorporated with the Roman empire, every vestige of primitive indigenous cultivation had been crushed out of existence. Roman civilisation in its turn fell before the Germanic races: in Britain it had perished slowly in the midst of a perishing

people, who were able neither to maintain it nor to substitute for it anything of their own. In Gaul and Spain it died a somewhat nobler death, and left more lasting influences.

Our problem is that Stubbs' version of history is followed today – the native British were worthless, uncivilised barbarians. To the majority of today's British historians, history begins either with the Romans, the Saxons or the Normans. Michael Wood's 2012 TV series *The Story of Britain* begins, 'The Romans named us … This is the story of Britain over 1,500 years.' Thus Wood makes an error in the first sentence (Ynys Prydain preceded the Insula Britannia), and begins his 'British' history with the non-British Anglo-Saxons. Thomas Clancy, Professor of Celtic at Glasgow, has written that it is

correct to say that the 4th century BCE explorer Pytheas was the first to use the term Prettanic Islands … The Pritani/Priteni were the inhabitants of the whole island, and were the P-Celtic speakers he mentions. [P-Celtic is Welsh, not Gaelic]. It seems the southern inhabitants of Britain favoured the form 'Pritani' and those from what is now Scotland beneath the Forth favoured 'Priteni'. From Pritani came the Welsh name for Britain – Prydain – and the Roman name, Britannia. From Priteni came the name used by the Welsh for the Picts of northern Scotland: Prydyn. The similarity of these names is one piece of evidence among many in the argument that the language and 'ethnicity' of Picts and Britons was the same, and only drifted apart during the Roman rule of southern Britain.

Wood's programme continues, 'It's the story of the people who have come and made us what we are', and then the camera pans from the photogenic Woods to a black gospel choir. The commentary continues, 'If you want to understand the story of Britain, you have to start with the Romans, because it was they who brought civilisation to us.' If civilisation is equated with invasion and slaughter, this is quite an Anglo-centric view, which explains to some extent England's love of war and colonisation. Woods says the story 'started with Long Melford in East Anglia because it is a classic English small town'. He tells us, against all DNA evidence, that the Anglo-Saxons only added 10 per cent to the population of England, not mentioning that they totally wiped out the British language. A major problem with most historians is that they regurgitate what their great-great-grandparents were taught, ignoring scientific evidence. Wood also tells us that 'Bede was a fun-loving man'. Bede wrote in gloating terms of the massacre of Christian Welsh monks at Bangor-is-Coed by pagan Germans. Wood carried out postgraduate research in Anglo-Saxon history, which along with Stubbs' work has taken him to a Germano-centric view of Britain's history.

Simon Schama's recent fifteen-part BBC TV series and book *The History of Britain* should also be renamed *The History of the English*, not even of England. He starts his history with the Venerable Bede (673–735), when England had been occupied by the Germans, before going on to its occupation and conquest by the Danes and then the Normans. The British, i.e. Welsh are not mentioned. In the second episode Shama states that 'foreigners' (Normans) attacked Anglo-Saxon England, but in the first episode did not refer to Anglo-Saxons as foreigners when they invaded after the Romans left. Schama never mentions that the British people had inhabited the island for thousands of years, speaking Old Welsh. He does not explain that the Anglo-Saxons called the

British inhabitants 'wealas', meaning foreigners, or that Welsh was spoken north as well as south of Hadrian's Wall, or that Boudicca spoke Welsh. Perhaps a final insult was upon a map with an area stretching from Leicester to Cardigan Bay labelled Mercia.

Neither Woods nor Schama mention the faint scraps of the British language left in place-names in England and Scotland. The Scots were Gaels who came from Ireland to Argyll around 500, but before them the language was British/Welsh. In Scotland, Glasgow (Glas Gau) is Welsh for Green Hollow; Troon (Trwyn) is Nose; Perth is Thicket; Lanark (Llannerch) was Glade; Strathclyde (Ystrad Clud) means Vale of the River Clyde; and even Bathgate was Baedd Coed (Boar Wood), according to Watson's *Celtic Place-Names of Scotland*. The last Welsh King of Strathclyde died in 1018. Caledonia stems from the Welsh *caled* (hard), referring to the rocky ground of North Perthshire. Schama showed a map which implied that the Scots had always been in Scotland, the Welsh had always been in Wales, etc., which is simply wrong. Like Ed Miliband, Schama is the London-born son of Eastern European Jewish immigrants. To a great extent, it is difficult to understand a country or a nation if one's roots are not there. In England, Dover is Dwfr, Welsh for water; Morecambe is Môr Cam, curved sea; and so on. The Germans referred to certain Welsh places in their own tongue: Wallasey is Wealas Ey, island of the foreigners, or Welsh; and Walton is Wealh Tun, town of the Welsh. Walden and Walford also denote Welsh enclaves. Cornwall means the Welsh of the Corn, or peninsular.

Decline and Fall of the Roman Myth

Terry Jones and Alan Ereira, in *Barbarians* (2006), have a different perspective upon history. The Greeks, when they could not understand a foreign language, said it sounded like 'ba ba ba', and the Romans adopted the Greek word to form 'barbarians'. The unknown barbarians later were named Scythians, Persians, Gauls, Syrians, Britons and the like. Rome managed to conquer the barbarian societies of traders, craftsmen, hunters and farmers and build the world's first Western empire for one simple reason: it had the world's first professional army, trained soldiers well-equipped with standardised weapons. However, when the Romans came to Britain, they discovered that the barbarians had designed significantly better war chariots, and were superior to their charioteers in horse-handling. The Celts also had better helmets and shields than the Roman armies. The British had agricultural implements, crop-storage systems, pottery and abundant coinage before the Romans came. They had peaceful agrarian settlements.

'Before the Roman came to Rye/Or out to Severn strode/The rolling English drunkard/Made the rolling English road.' G. K. Chesterton's memorable lines ignore the fact that Angle-Land did not exist until after the Roman legions left. However, the Isles of Britain – Prydein – did. More importantly, ancient trackways were the underpinning of the Roman road system in Britain. Romans did not build the roads in Britain – they improved existing routes. Only in the last thirty years has it been understood that there are pre-Roman Iron Age roads, some built of oak planks on birch runners, enabling two carts to pass each other. The first important Roman road was the Appian Way of 312 BCE, but the Upton Track, a wooden road laid along the mudflats on the Severn Estuary in South Wales, dates from the fifth century BCE. The Celtic

British also mastered metal technology in bronze and iron well before the Romans, developing sophisticated agricultural systems. Iron ploughshares exist from around 400 BCE. There was even a harvesting machine to beat the ears of corn and deposit them in a container.

Julius Caesar's Expeditions of 55 BCE and 54 BCE

Julius Caesar had come, seen, but certainly not conquered in 55 and 54 BCE. As Nennius recounts,

> Then Julius Caesar, the first who had acquired absolute power at Rome, highly incensed against the Britons, sailed with sixty vessels to the mouth of the Thames, where they suffered shipwreck whilst he fought against Dolobellus, (the proconsul of the British king, who was called Belinus, and who was the son of Minocannus who governed all the islands of the Tyrrhene Sea [the waters between western Italy and the islands of Corsica, Sardinia and Sicily]), and thus Julius Caesar returned home without victory, having had his soldiers slain, and his ships shattered.

After conquering Gaul, Caesar invaded Britain, as he believed that its people had been assisting the Belgic Celtic continental tribes against him. His first expedition into Kent was harmed by storm damage to his ships and he returned to Rome to celebrate his triumph on the Continent and in Britain. He returned with a larger force the following year, and managed to take some hostages and tributes in exchange for peace. There was no Roman presence established, but he had brought the south-east of England under Rome's political influence. Augustus was emperor from 26 BCE until 14 CE. He planned three times to invade, but continued diplomatic and trade relations instead. Tiberius followed him until 37 CE, but made no attempt to expand the Roman Empire.

In Britain, Tasciovanus (Teuhant or Tenvantius) was King of the Catuvellauni and issued coins from his capital of Colchester. Around 9 CE the Roman general Varus was famously slaughtered with his three legions in the Teutoburg Forest in Germany. Cunobelinus, or Cynfelin (Shakespeare's Cymbeline), the son of Tasciavanus was called Rex Britannorum (King of the Britons) by Suetonius, ruling much of south-east England and probably a large part of the West Country. Cunobelinus sensed Rome's weakness in Gaul, and promptly conquered the territory of the neighbouring Trinovantes. He added the kingdom of the Catuvellauni when his father died in 9–10 CE, and ruled until 40 CE when he was possibly incapacitated by a stroke. Cunobelinus minted his own coins both at the capital of the Trinovantes, Colchester, and at the capital of the Catuvellauni, St Albans. He used the title *rex* (king), had diplomatic relations with Rome, and his court imported luxury goods such as Italian wine and drinking vessels, olive oil and fish sauces from Spain, glassware, jewellery and Gallo-Belgic tableware. Strabo noted that Britain exported in turn grain, gold, silver, iron, hides, slaves and hunting dogs.

The Welsh & the Romans
43 CE–390 CE

… at the tribunal, he [Caractacus] spoke as follows: 'Had my lineage and my rank been matched by my moderation in success, I should have entered this city rather as a friend than as a captive; nor would you have scorned to admit to a peaceful league a king sprung from famous ancestors and holding sway over many peoples. My present lot, if to me a degradation, is to you a glory. I had horses and men, arms and riches: what wonder if I lost them with a pang? For if you would rule the world, does it follow that the world must welcome servitude? If I were dragged before you after surrendering without a blow, there would have been little heard either of my fall or of your triumph: punishment of me will be followed by oblivion; but save me alive, and I shall be an everlasting memorial of your clemency.' The answer was the Caesar's pardon for the prince, his wife, and his brothers; and the prisoners, freed from their chains, paid their homage to Agrippina also – a conspicuous figure on another tribunal not far away – in the same terms of praise and gratitude which they had employed to the emperor. It was an innovation, certainly, and one without precedent in ancient custom, that a woman should sit in state before Roman standards: it was the advertisement of her claim to a partnership in the empire which her ancestors had created…

Tacitus, recording the captured Caractacus speaking to the senate and emperor in Rome.

The Claudian Invasion of 43 CE

Verica of the Atrebates tribe controlled Hampshire, Surrey and West Sussex. He had been recognised by Rome as a client-king, reigning from around 15 CE, issuing his own coinage, and having diplomatic and trade links with Rome. Coming to power from around 9 CE, Cunobelinus ruled the Trinovantes of Essex and Surrey, and the Catuvellauni of Cambridgeshire, Northamptonshire, Hertfordshire, Bedfordshire, Buckinghamshire and Oxfordshire. Cunobelinus had three sons: Adminius, Togodumnus and Caractacus (Caradog). His brother Epaticcus pushed into the lands of Verica's Atrebates, taking the capital of Silchester by 25 CE. Epitaccus died around 35 CE and Caractacus completed the conquest of the Atrebates. Caractacus' brother Adminius became king of Kent around this time, minting coins, but was banished

by his father Cunobelinus, who finally died around 43 CE. Emperor Caligula gave Adminius refuge and brought his legions to the coast of Gaul to invade Britain in his support, but instead they collected seashells before returning to Rome in 'triumph'. Caligula was murdered soon after. Verica had also fled to Rome. In 43 CE the new emperor, Claudius, gave orders to invade the south-east territories of Britain, on the pretext of supporting his client-king Verica. It would solidify his tenuous grip on the Empire, making him popular with Rome's senators and citizens, and also give access to English grain, Welsh copper, gold, silver, lead, slate and Cornish tin.

Aulus Plautius gathered four legions from across Europe, the IX Hispana, II Augusta, XIV Gemina and XX Valeria Victrix. With auxiliaries, this gave an invasion force of 40,000 soldiers. The initial opposition to the Claudian Conquest was led by the brothers Caractacus and Togodumnus. They fought at least two major engagements against Aulus Plautius in 43 CE and Togodumnus was either killed during the two-day Battle of the Medway, or died from his wounds shortly after. The Catuvellauni continued to wage guerilla warfare, falling back to the Thames. Claudius arrived in Britain and celebrated the victory at the Medway with a triumph in the capital of the Catuvellauni, Camulodonum (Colchester). This was symbolically made the capital of Roman Britain, as the legions took over the south of the country. Their main opposition was from the Durotriges, with evidence of heavy fighting around the great hill-forts of Dorset.

Caractacus and the Campaigns in Wales

Caractacus was forced to retreat to Wales, where he organised tribes, particularly the Silures and Ordovices, against Roman expansion. By 47 the East Midlands, East Anglia and Southern England were under Roman occupation, and the legions headed westwards to take Wales. From 47–52 there were campaigns to extend the new province, in East Anglia, the Pennines, South Wales, north-east Wales and Cheshire. Legio XX moved to Gloucester. The Silures, Ordovices and Deceangli of Wales were the main opposition and the main focus of Roman might for decades, as great tribes like the Brigantes of Yorkshire and the Iceni of East Anglia swiftly accepted roles as client-kingdoms of Rome. However, Caractacus continued to lead a guerilla campaign against the new Governor Publius Ostorius Scapula, making Britain the most unsettled of all the Roman provinces.

Ostorius was now determined to disarm all the native tribes, even Rome's nominal allies, the client-kingdoms. This policy prompted the Iceni to revolt in 47, although they were soon defeated. Ostorius next advanced into Wales and had nearly reached the Anglesey when, in 48 CE, there was a similar uprising by the Brigantes, the largest tribe in Britain, and he was obliged to break off his campaign to quell the disturbance. Tacitus tells us that

> by the Icenian defeat all who were wavering between war and peace were reduced to quietude, and the army was led against the Ceangi [the Deceangli, in north-east Wales]. The country was devastated, booty collected everywhere, while the enemy declined to risk a battle, or, if he made a stealthy attempt to harass the marching columns, found his

treachery punished. And now Ostorius was within measurable distance of the sea which looks towards Ireland, when an outbreak of sedition among the Brigantes recalled a leader who was firm in his resolution to attempt new conquests only when he had secured the old. The Brigantian rising, it is true, subsided on the execution of a handful of men, who were beginning hostilities, and the pardon of the rest; but neither severity nor clemency converted the Silurian tribe, which continued the struggle and had to be repressed by the establishment of a legionary camp. To facilitate that result, a colony was settled on conquered lands at Camulodunum [Colchester] by a strong detachment of veterans, who were to serve as a bulwark against revolt and to habituate the friendly natives to their legal obligations.

Following the short-lived revolts of the Iceni and the Brigantes in 47–48, Scapula turned his attention fully to the Silures. Tacitus recorded that Scapula received the submission of the Deceangli of north-east Wales on the River Dee in 49, enabling him to head towards South Wales. During the change in Roman administration in 47, Caractacus had led the Silures in a brilliant attack deep into the Roman-held territory of Gloucestershire. Tacitus described only this tribe in Britain: 'the swarthy faces of the Silures, the curly quality, in general, of their hair, and the position of Spain opposite their shores, attest the passage of Iberians in old days and the occupation by them of these districts'. They inhabited the wooded uplands of south-eastern Wales, living in hill-forts and fortified settlements, and were Rome's most determined opponents. Ostorius Scapula advanced to the Dee in 48, by which time there were five known tribal groupings across Wales. Silures occupied South East Wales, parts of Gloucester and Hereford and most of Brecon. West of Glamorgan, the Demetae were in the south-west. The Cornovii were on the central borders of Wales, and the Deceangli (Ceangi) in north-east Wales, Cheshire and Staffordshire. The Ordovices controlled the north-west and much of central Wales. East of the Silures were the Dobunni in Gloucester, the West Midlands and down to Somerset. The main part of Legio XX Valeria was moved from its base at Colchester into a new legionary fortress near Gloucester; to enable the movement of the legion west without leaving the east of Britain undefended, a Colonia of veteran soldiers was established at Colchester.

Caractacus and his family were said to have lived at the present Dunraven (Dindrafyn) hill-fort overlooking Southerndown. 'The march then proceeded against the Silures, whose native boldness was heightened by their confidence in the prowess of Caratacus.' In 49 the Silures were attacked, with Caractacus seemingly organising their resistance. The Romans built early forts at Usk and Monmouth, using the Wye and Usk valleys to penetrate into Silurian lands. Ostorius moved Legio XIV from its base in Leicestershire to a new legionary fortress at Viroconium (Wroxeter, Shropshire), close to the Mid Wales border. This legion marched west and was joined by the Legio XX marching from Gloucester in the south, heading for the forces of Caractacus. Tacitus tells us that

the march then proceeded against the Silurians, whose native boldness was heightened by their confidence in the prowess of Caractacus; whose many successes, partial or complete, had raised him to a pinnacle above the other British leaders. But on this occa-

sion, favoured by the treacherous character of the country, though inferior in military strength, he astutely shifted the seat of war to the territory of the Ordovices; where, after being joined by all who feared a Roman peace, he put the final chance to trial. The place fixed upon for the struggle was one where approaches, exits, every local feature would be unfavourable to ourselves and advantageous to his own forces. On one side the hills rose sheer; and wherever a point could be reached by a gentle ascent, the way was blocked with stones composing a sort of rampart. Along the front ran a river with a precarious ford, and bands of warriors were in position before the defences.

In addition, the tribal chieftains were going round, haranguing the men and confirming their spirits by minimizing fear, by kindling hope, and by applying the various stimulants of war. As for Caractacus, he flew hither and thither, protesting that this day – this field – would be the prelude to their recovery of freedom or their eternal servitude. He invoked the names of their ancestors, who had repelled the dictator Caesar, and by whose valour they were immune from the taxes and the tributes and still preserved inviolate the persons of their wives and children. To these appeals and the like the crowd shouted assent, and every man took his tribal oath to give way neither for weapons nor for wounds.

This ardour disconcerted the Roman general; and he was daunted also by the intervening river, by the added rampart, the beetling hills, the absence of any point that was not defiant and thronged with defenders. But the soldiers insisted on battle; against courage, they clamoured, no place was impregnable; and prefects and tribunes, employing the same language, intensified the zeal of the army. After surveying the ground to discover its impenetrable and its vulnerable points, Ostorius now put himself at the head of the eager troops and crossed the river without difficulty. When the embankment was reached, so long as the struggle was carried on by missiles, most of the wounds, and numerous casualties, fell to our own lot. But a mantlet was formed; and, once the rude and shapeless aggregate of stones had been demolished and matters came to an equal encounter at close quarters, the barbarians withdrew to the hill-tops. Yet even there the light and heavy troops broke in, the former skirmishing with their darts, the latter advancing in closer, while the British ranks opposite were in complete confusion: for they lacked the protection of breastplates and helmets; if they offered a resistance to the auxiliaries, they were struck down by the swords and javelins of the legionaries; if they faced against the legionaries, they fell under the falchions and lances of the auxiliaries. It was a notable victory; and the wife and daughter of Caractacus were taken, his brothers being admitted to surrender.

Many experts place the hill-fort of Old Oswestry as the place of battle, but it may have been the Breiddin near Welshpool, Craig Rhiwarth or Cefn Carnedd near Llanidloes. It is likely that a substantial part of the Ordovician and Silurian army was destroyed or captured. After his defeat, Caratacus, his wife and children were captured and he escaped through the lands of the Deceangli in north-eastern Wales, seeking refuge amongst the Brigantes in northern England. Queen Cartimandua, however, in accordance with her agreement as a client of Rome, ordered him bound in chains and handed over to Ostorius. For his part in the capture of the renegade British king, Ostorius Scapula was awarded triumphal insignia. Tacitus records,

Caractacus himself – for adversity seldom finds a refuge – after seeking the protection of the Brigantian queen Cartimandua, was arrested and handed to the victors, in the ninth year from the opening of the war in Britain. Through that resistance, his reputation had gone beyond the islands, had overspread the nearest provinces, and was familiar in Italy itself; where there was curiosity to see what manner of man it was that had for so many years scorned our power. Even in Rome, the name of Caractacus was not without honour; and the Caesar, by attempting to heighten his own credit, added distinction to the vanquished. For the populace were invited as if to some spectacle of note; the praetorian cohorts stood under arms upon the level ground in front of their camp. Then, while the king's humble vassals filed past, ornaments and neck-rings and prizes won in his foreign wars were borne in parade; next his brothers, wife, and daughter were placed on view; finally, he himself. The rest stooped to unworthy entreaties dictated by fear; but on the part of Caractacus not a downcast look nor a word requested pity.

Caractacus's family was led in triumph before the Emperor Claudius in Rome, usually the precursor to a public execution of captured opponents. Uniquely, he was pardoned by the Emperor Claudius, and after seven years' captivity is said to have been allowed to return to his base at St Donat's or Dunraven near Llanilltud Fawr. His family was housed in the British Palace in Rome, which possibly became the centre for the new Christian religion. Caractacus was not recorded as a saint, but has an important place in the legends of early Christianity in Wales. His father Bran was also supposed to have been kept hostage at Rome for seven years, and returned with the saints Ilid, Cyndaf, Arwystli Hen and Mawan, who preached the gospel in the first century from around 58. Caradog's daughter Eurgain married Lucius Fawr, was recorded as the first female saint in Britain, and was said to have founded its first monastery at Llanilltud Fawr. Another daughter, Gwladys Claudia may have been extremely influential in the early Christian Church in Rome. Caractacus's great-grandson Lleurwg ap Cyllin was said to be the saint who erected the first church in Britain, at Llandaf, and sent to Rome for Elfan, Dyfan, Medwy and Fagan to evangelise Britain. Whatever the truth, Christianity could well have been established in Wales in the first century, and remained as the religion through the Dark Ages of England and the rest of Europe.

War in Wales and a Great Roman Defeat

In the 50s, the renowned XIV Gemina Legion was fighting the Silures, Ordovices and Deceangli, from its fortress at Viroconium (Wroxeter on the River Severn). Tacitus informs us that the Romans had expected opposition to fall away after the capture of Caradog (Caractacus);

> With the removal of Caractacus, our energy in the field had been slackened in the belief that the war was won, or possibly sympathy with their great king had fired the enemy's zeal to avenge him. A camp-prefect and some legionary cohorts, left behind to construct garrison-posts in Silurian territory, were attacked from all quarters; and, if relief had not quickly reached the invested troops from the neighbouring forts – they had been

informed by messenger – they must have perished to the last man. As it was, the prefect fell, with eight centurions and the boldest members of the rank and file. Nor was it long before both a Roman foraging party and the squadrons despatched to its aid were totally routed.

This happened possibly during the building of the vexillation fortress at Clyro in 52, with the near annihilation of the XIV Legion (or possibly the XX):

Ostorius then interposed his light cohorts; but even so he failed to check the flight, until the legions took up the contest. Their strength equalized the struggle, which eventually turned in our favour; the enemy escaped with trivial losses, as the day was drawing to a close. Frequent engagements followed, generally of the irregular type, in woods and fens; decided by individual luck or bravery; accidental or prearranged; with passion or plunder for the motives; by orders, or sometimes without the knowledge of the leaders. Particularly marked was the obstinacy of the Silures, who were infuriated by a widely repeated remark of the Roman commander, that, as once the Sugambri had been exterminated or transferred to the Gallic provinces, so the Silurian name ought once for all to be extinguished. [The Sicambri lived on the opposite bank of the Rhine to the Cambri, fought Julius Caesar and helped exterminate Varus's three legions. In 11ce, a minority of the tribe was forced to move by Nero.] They [the Silures] accordingly cut off two auxiliary cohorts which, through the cupidity of their officers, were ravaging the country too incautiously; and by presents of spoils and captives they were drawing into revolt the remaining tribes also, when Ostorius – broken by the weary load of anxiety – paid the debt of nature; to the delight of the enemy, who considered that, perhaps not a battle, but certainly a campaign had disposed of a general whom it was impossible to despise.

On receiving the news of the legate's death, the Caesar [Claudius], not to leave the province without a governor, appointed Aulus Didius to the vacancy. In spite of a rapid crossing, he found matters deteriorated, as the legion under Manlius Valens had been defeated in the interval. Reports of the affair were exaggerated: among the enemy, with the hope of alarming the commander on his arrival; by the commander – who magnified the version he heard – with the hope of securing additional credit, if he settled the disturbances, and a more legitimate excuse, if the disturbances persisted. In this case, again, the loss had been inflicted by the Silurians, and they carried their forays far and wide, until repelled by the advent of Didius.

Under the command of Gaius Manlius Valens, it next appears that the XX legion was badly defeated by the Silures as it moved to relieve the defeated XIV and allow its withdrawal back to Wroxeter. This second battle could also have been at Clyro in 52. In 52/53 the Silures stormed the legionary base at Gloucester and killed the commander in charge. We are still unsure which legions were defeated by the Silures in these battles, but it is probably both. The Deceangli and Ordovices rose again and were defeated. Didius Gallus, the newly appointed governor (52–57) then concentrated upon fighting the Silures in South Wales. However, Gallus was forced to leave Wales. The Brigantes in the North of England were a client tribe of Rome. Their queen, Cartimandua, asked Gallus to support her in civil war between her own clan and factions loyal to her estranged husband, Venutius. Tacitus called Venutius

'the best strategist' since Caractacus, and he now led British resistance in England. Nero came to power in 54 and briefly thought about abandoning the province, but was determined to conquer the Welsh for their mineral riches. Tacitus tells us that the next governor, Quintus Veranius (57–58), 'after harrying the Silures in a few raids of no great significance, was prevented by death from carrying his arms further'. Suetonius Paulinus next became governor (58–61) and carried on where Veranius left off, fighting his way through Wales.

The Destruction of the Druids, 60 CE

The Druids appear to have been a prominent force in fomenting anti-Roman sentiment. Nero personally ordered that Anglesey be taken, and Tacitus describes the burning of the sacred Druidic groves:

> Suetonius Paulinus … He therefore prepared to attack the isle of Mona which had a powerful population and was a refuge for fugitives. He built flat-bottomed vessels to cope with shallows, and uncertain depths of the sea. Thus, the infantry crossed, while the cavalry followed by fording, or, where the water was deep, swam by the side of their horses. On the shore stood the opposing army with its dense array of armed warriors, while between the ranks dashed women, in black attire like the Furies, with hair dishevelled, waving firebrands. All around, the Druids, lifting up their hands to heaven, and pouring forth dreadful imprecations, scared our soldiers by the unfamiliar sight, so that, as if their limbs were paralysed, they stood motionless, and exposed to wounds. Then urged by their general's appeals and mutual encouragements not to quail before a troop of frenzied women, they bore the standards onwards, smote down all resistance, and wrapped the foe in the flames of his own brands. A force was set over the conquered, and their groves, devoted to inhuman superstitions, were destroyed.

It may be that the naturalist religion of Druidism originated in Britain. The Welsh word for wizard or Druid is *derwydd*, which is closely related to the Welsh for oak tree, *derwen*. Julius Caesar noted that the Druids worshipped in oak groves, and the Romans cut down the many oak groves they found on Anglesey. The political power of the Druids was destroyed, but the British continued to worship native gods, a practice tolerated by Rome. To avoid incurring the wrath of native British gods, Rome seems to have paired off Roman gods with their British equivalents, erecting joint-shrines. For example, the Romans built a shrine around the hot springs at Bath in 54, on the site of a much earlier temple built by the Britons. The original goddess was named Sul and she was combined with her Roman equivalent Minerva to create a 'composite deity' at the new Roman baths, named Sulis Minerva.

A garrison was established on Anglesey, but Boudicca (Buddug) led a revolt in England, so the Romans could not consolidate their gains in Wales. Paulinus was in Anglesey when he received news of the new uprising. In 60, Prasutagus, the King of the Iceni, had died, and his wife Boudicca led her people in revolt. Paulinus rushed to Londinium to confront the Iceni, and Wales was relieved of attack for some years.

Bouddica's Revolt, 60 CE

Tacitus tells us that Prasutagus had left a will leaving half his kingdom to Nero, believing that the remainder would be left untouched. Rome violently seized the Iceni tribe's lands in full. Boudicca (Buddug in British-Welsh) protested, but she and her daughters were punished by flogging and rape. The Iceni rose, joined by the Trinovantes, and annihilated the Roman colony of veterans at Colchester. They then defeated part of the IX Legion that was sent to relieve the burning settlement. Suetonius Paulinus raced from Wales to London, but decided it could not be defended. London and Verulamium (St Alban's) were destroyed. Between 70,000 and 80,000 people were killed in the three Roman cities. Suetonius regrouped with two legions, chose a battlefield, and despite being heavily outnumbered, defeated the rebels somewhere along Watling Street. Boudicca died not long afterwards, possibly by self-administered poison or by illness. Nero again considered withdrawing Roman forces from Britain altogether. The destruction of the revolt was such that almost a decade passed before Rome resumed its policy of conquest in Wales.

The Conquest of Wales

The year of 69 is known in history as 'the Year of Four Emperors', as civil war raged through Italy and Gaul. In Britain, a series of weak governors had led to Venutius taking over the north of England. When Vespasian finally emerged as a powerful new emperor, his orders were emphatic. His first two appointments as governor, Petilius Cerialis and Julius Frontinus, were given the tasks of breaking the Brigantes and Silures respectively. The Legio II Augusta was moved to Gloucester as its base for fighting the Silures. From 69–78 there was a massive effort against the Silures and the Ordovices by Cerialis (71–74), Julius Frontinus (74–77) and then Julius Agricola. In 71, Petilius had finished any resistance from the Brigantes. From 74 to 78 the legions campaigned through Wales, beginning with the Silures. Frontinus eventually extended Roman rule to all of South Wales, beginning the construction of a new legionary fortress at Caerleon by 75. He initiated exploitation of the mineral resources, such as the Dolaucothi gold-mines. Frontinus built Caerleon as the legionary headquarters for the II Legio Augusta, next to the Silurian hill-fort capital at Llanmelin. Tacitus tells us that 'after a hard struggle, Frontinus conquered the powerful and warlike nation of the Silures, overcoming both the valour of his enemies and the difficulty of the terrain'.

Three of the four Roman legions were now stationed against the Welsh borders. Frontinus began building the great legionary fortress at Chester. The XX Legion was at Uriconium (Wroxeter), the II Augusta was at Isca (Caerleon), and the XX Adiutrix at Deva (Chester). The Silures had agreed peace by 75, and Frontinus now concentrated upon other Welsh tribes. The Silures left their hill-fort and settled in the new Roman town of Caerwent near Caerleon, as a self-governing community of non-citizens (*civitate peregrina*). The Silures became the most Romanised of the Welsh tribes, paving the way for Meurig and Arthur to become Pendragons in the years after the Romans left Britain. With South East Wales secure, Agricola moved

north to avenge a Roman defeat by the Ordovices and 'cut to pieces the whole fighting force of the region'.

What Frontinus did not accomplish was completed by Julius Agricola (77–83/84 CE), who had been a military tribune on the staff of Paulinus. In his first year as governor, Agricola defeated the Ordovices and forced the surrender of the island of Anglesey, when his auxiliaries swam across the strait with their horses in a surprise attack. Tacitus tells us that

> the tribes of the Ordovices, shortly before Agricola's arrival [winter 77–78 CE], had crushed almost to a man a regiment of cavalry encamped among them; and this first stroke had excited the province. Those who wanted war applauded the precedent, and waited to see how the new governor would react ... He gathered the detachments of the several legions and a small force of auxiliaries, and then, when the Ordovices did not venture to descend from the hills, led his army to the uplands, himself marching in the van ... He almost exterminated the whole tribe.

Forts were built across Gwynedd and Mid Wales, and Wales was occupied.

However, the next 300 years were never completely quiet in Wales. Great new stone forts at Chester, Caerleon, Carmarthen (Moridunum) and Caernarfon (Segontium) ensured a general peace. Unlike more 'settled' colonies of Rome across Eurasia and Africa, very few Roman villas have been found in Wales, denoting that there was danger away from the more Romanised areas. Professor Euros Bowen noted that several Roman villas were found near the sites of Cadog's Llancarfan, Illtud's Llanilltud and Dyfrig's foundations. St Tathan was also active at Caerwent, which leads to Bowen's conclusion that the group of Celtic saints largely confined to South East Wales represented a church that was locally established in late Roman times. This was the only part of Wales where Roman urban and country-house culture was deeply rooted, and later Romano-British leaders carried on the Christian tradition rather than relying upon missionaries from Gaul.

There had been at least thirteen separate campaigns against Wales and its borders between 48 and 79, which explains the multiplicity of Roman forts, fortlets, marching camps, roads and civil ruins dotted over much of Wales. Indeed, during the period 70–78 there were no less than 30,000 Roman troops in Wales. A thousand years later, during the Norman Conquest of England, the population of Wales was only around 150,000, so this demonstrates the importance of Wales to Rome. Legions were typically made up of 5,500 men, so this is incredibly the equivalent of six legions, or a fifth of the Roman Empire's armed forces.

As mentioned, Wales was never completely subdued by the Romans. Two of their three (sometimes four) British legions were permanently stationed on the Welsh borders, at Deva (Chester) and Isca Silurum (Caerleon). Just one other legion was generally required, based at York, to control all of England and much of Scotland. Isca Silurum had been built, with Venta Silurum (Caerwent) to keep the Silures down, while Caerfyrddin (Carmarthen) was the in heartland of the Demetae tribe.

Its Welsh name of Caerfyrddin refers to its Roman name of Maridunium (or Moridunum) Demetarum. The fort was built to pacify the Demetae after the Silures in the south-east had agreed to stop fighting. Julius Agricola completed the Roman

inroads into Wales, building the forts at Carmarthen and Caernarfon as the new limits of imperial power. Caerleon, Cardiff and Carmarthen are the oldest towns in Wales. Of the nineteen definite Roman amphitheatres known in Britain, seven were in Wales or on its borders: Caerleon, Caerwent, Carmarthen, Chester, Cirencester, Tomen-y-Mur and Wroxeter.

It had taken Rome more than thirty years to subdue the Welsh. There were over 600 miles of Roman roads, the highest density in Britain, connecting marching camps, around thirty auxiliary forts, major forts and settlements. Some auxiliary forts, such as the 43-acre site near the Hindwell Cursus in Radnorshire, could hold up to 13,000 men. The marching camp at Arhosfa Garreg-Lwyd in Carmarthenshire enclosed the same massive area as Hindwell. In contrast, the more heavily defended fort with four gateways at Cicucium (Y Gaer, near Brecon), covered only 6.5 acres. Temporary camps marked the initial Roman campaigns throughout Wales, but around 60 CE, large forts were being built in Clyro and Usk. From 75 the huge legionary fortress at Caerleon was constructed, and its great amphitheatre, holding 6,000 spectators, led to the tales of Arthur's Round Table. The most intense period of garrisoning followed the final conquest of Wales, but some military units were then moved to the north of Britain, the process being accelerated in 110–125 to defend the Scottish borders.

From 75–300, the Legio II Augusta was stationed at Caerleon (Fortress of the Legion), in Gwent. From 79, Chester was the base of the Legio II Adiutrix Pia Fidelis, and the camp came to be known as Deva Victrix. In 89, the Legio XX Valeria Victrix was moved from Scotland to replace the Legio II Adiutrix, remaining at Chester until the withdrawal of the legions in the late fourth century. For three centuries two legions remained on the Welsh borders, with the third British legion being based in York. Four legions were used to invade Britain, but only three were permanently stationed across the country. In all, thirty legions of around 5,500 men in each were based around the Roman Empire at this time. Few historians have seemed to query this disposition of Roman armies, with two permanently on the Welsh border, but it seems clear that the two 'Welsh' legions were placed there to safeguard trade. There are forty-one known forts and fortlets scattered across Wales, with an extensive network of Roman roads. The only known Roman port in Britain outside London has recently been discovered at Caerleon. Archaeologists digging on the banks of the River Usk in 2011 have found the main quay wall as well as landing stages, wharves and dockside tracks. Other public buildings and bath houses are still being discovered in Caerleon, which has the finest amphitheatre in Britain, and the most substantial remaining Roman barracks in the world.

Romanised Wales

The Roman armies on campaign were lodged in temporary marching camps. Once an area was pacified the troops were billeted in forts of various sizes, from which they could patrol and collect levies. The headquarters of the legions responsible for maintaining Pax Romana (the 'Roman Peace') were the fortresses of Chester and Caerleon. The second Augustan legion drained the Gwent levels to supply pasture

for horses. Military bases attracted settlements of merchants, craftsmen, entertainers and also the troops' unofficial spouses. Such settlements were called *canabae* outside legionary fortresses or *vici* outside auxiliary forts. A system of roads was constructed under army direction in the decades after the Flavian conquest. The two settlements that developed into urban centres (*civitates*) for the tribes of the Silures and Demetae were Venta Silurum and Moridunum, respectively Caerwent and Carmarthen. In areas of civil control, such as the territories of a *civitas*, the fortification and occupation of hill-forts was banned as a matter of Roman policy. Caerwent had many of the features of Roman cities, such as a forum, temples and well-appointed houses. Carmarthen's best-known feature is the amphitheatre outside the north-east gate. Besides acting as relatively secure homes for those of the tribal aristocracy who accepted imperial rule, the cities were centres of trade, manufacture and tax collection. Small towns were a common feature of Roman Britain, but in Wales they were mainly confined to the south-east, usually developing at former army sites. Usk, Monmouth, Cardiff, Abergafenni, Cowbridge and probably Chepstow are examples. The continuing presence of military and imperial officials who required supplies, the development of a money economy and the growth of new markets around towns in the south encouraged agricultural production.

Sparsely settled, mountainous Wales and Scotland were not easily settled, being regarded as 'the frontier'. Military garrisons were strategically placed to guard the northern and western extremities of the empire. Wales would have been left alone if it had not been for its valuable mineral deposits, including lead, tin and gold. Britain was rich in resources such as gold, silver, lead, tin, copper, iron and salt, especially in what is now Wales and its borders. Cornwall and Wales had been trading with the Mediterranean for centuries before the Roman invasion. Rome used pewter for tableware, which was made from tin with some lead or copper. Lead was also needed for piping water in aqueducts, plumbing, coffins and gutters. By 70, lead mines in Wales, the Mendips and North West England made Britain the leading lead-producing province in the empire. There was often silver to be processed from lead ore, especially in north-east Wales, and Roman coinage was based upon silver. Silver ingots were sent from Britain all over the empire to be smelted into coins. Ingots, mines and settlements have been found at Prestatyn, Ffrith and Pentre in Flintshire.

Britain's famous gold-mines were located in Dolaucothi, and Romans expanded the workings from 78, building a fort at Pumsaint nearby. The fort was abandoned around 125, but the mine was worked until the third century or possibly later. There was iron ore in the Forest of Dean, along with plentiful wood to produce iron to make Roman armour, weapons and implements. Ingots of gold and iron were exported in quantity. Slate was used to roof Segontium Roman fort and was exported. Copper mining was important, like gold mining, from the Bronze Age on. We know of Roman copper ingots from Parys Mountain, Anglesey and Caernarfonshire and adits at Llanymynech on the Montgomeryshire–Shropshire border. Several manufacturing industries were stimulated by the needs of the military and the growing taste for Roman goods, particularly in the south-east. The army needed tiles, and kilns were built near bases, for example at Holt, to supply the twentieth legion at Chester.

The number of villas in Silurian territory reflects the wealth of a class of landowners who had allied with Rome. These were masonry buildings, with tile or stone roofs, a bath house, a hypocaust heating system, mosaics and wall-paintings. Only recently, however, a fourth-century Roman villa has been found at Abermagwr near Aberystwyth, the most north-westerly villa found in Wales. It has a decorated slate roof and glazed windows, and is near Trawscoed Roman fort, which had been abandoned by 130. The 'discovery raises significant new questions about the regional economy and society in late Roman Wales, and raises the possibility of future villa discoveries in the surrounding countryside'. In upland areas, there was localised crop growing but mainly cattle and sheep were raised. In the lowland valleys and coastal areas there was much more likelihood of arable farming. By the third and fourth centuries fewer forts in Wales were garrisoned. In the south, the tribes were granted a form of self-government with their own council, but the rest of Wales remained under constant military surveillance.

Christianity in Britain

The Diocletian Persecution lasted from 303 to 311 but Gildas notes that the British were mainly Christian from the end of the reign of Tiberius (14–37 CE):

> Meanwhile these islands, stiff with cold and frost, and in a distant region of the world, remote from the visible sun, received the beams of light, that is, the holy precepts of Christ, the true Sun, showing to the whole world his splendour, not only from the temporal firmament, but from the height of heaven, which surpasses every thing temporal, at the latter part, as we know, of the reign of Tiberius Caesar, by whom his religion was propagated without impediment, and death threatened to those who interfered with Its professors. These rays of light were received with lukewarm minds by the inhabitants, but they nevertheless took root among some of them in a greater or less degree, until nine years' persecution of the tyrant Diocletian, when the churches throughout the whole world were overthrown…

Nennius related that 'after the birth of Christ, one hundred and sixty-seven years, king Lucius, with all the chiefs of the British people, received baptism, in consequence of a legation sent by the Roman emperors and Pope Evaristus'. Evaristus was the fifth Pope, holding office around 99–107. Bede later tells us,

> Mark Anthony Verus, the 14th from Augustus, with his brother Aurelius Commodus, were chosen Emperors, in the year of our Lord 156. In whose reign, when Eleutherius, a holy man, presided as Pontiff over the Roman church, Lucius, King of the Britons, sent a letter to him, requesting that by his means he might become a Christian. He immediately obtained the effect of his pious request; and the Britons preserved in peace, entire and unviolated, the faith which they had received, till the time of the Emperor Diocletian.

Commodus became emperor in 180 (measuring years from Christ's birth). All three of these early sources, along with research carried out by Cardinal Baronius, state that Christianity came to Britain in its very early years.

There seems to be a mystery about the great monastery and religious centre of Llanilltud Fawr, Lantwit Major. It appears that St Illtud, after his vision on the banks of the nearby Dawen (Thaw), founded the monastery on the site of the earliest Christian monastery in Britain, which may even have still existed at this time. If this is the case, Wales can claim something very special in world history – the oldest educational establishment in the world up until 1100 and the Norman invasion. Caradog had been pardoned by Emperor Claudius, and after seven years' captivity is said to have been allowed to return to his base at St Donat's, near Llanilltud Fawr. Caradog's residence in Rome was known as 'The British House' and was the first house used for Christian worship in Rome. It is thought that his daughter Eurgain married a Roman, as did Gwladys (Claudia). It is said that Eurgain brought Christianity to Wales, founding a monastic settlement called Cor Eurgain in Llanilltud Fawr. 'Cor' is a very early version of Llan, meaning a monastic college. Another version is that she stayed in Rome, and the Cor was set up in her honour, first at Llanilid around 60 CE then transferring to Caer Mead (Cor Eurgain) Roman villa at Llanilltud. One story was that Caractacus came back to St Donats with Eurgain and was buried at Llanilltud. St Paul was said to be a friend of Eurgain and Gwladys, and in legend came as St Ilid in 61 and 68. Gwladys is mentioned in Epistle 2 Timothy 4–21 as Claudia. (Paul was said to have visited Galicia, which may be Wales rather than the Spanish province.) Other versions relate Ilid as Joseph of Arimathea, remembered at Llanilid in the Vale of Glamorgan.

Aaron and Julius were executed in Caerleon for following a proscribed religion, Christianity, in the early fourth century. Christianity was formally adopted across the Roman Empire by Emperor Constantine in 313 following the Edict of Milan. After the Emperor Constantine declared for Christianity and his guards decorated their shields with the chi-rho motif, the newly Established Church in Rome began to form a hierarchy and a bureaucracy that came to be known as the Roman (Catholic) Church. It spread through the whole empire, eventually becoming a requirement for Roman citizens in 400. The earliest places of Christian worship in Britain were not churches, but meeting places in domestic buildings, such as Lullingstone villa in Kent, with Christian wall-paintings. Romano-British buildings that may have been churches have been found in the towns of Silchester, Caerwent, Canterbury, Colchester, Exeter, Lincoln and St Albans. By the time of the leaving of the legions, Christianity was the leading faith in Europe. In Britain, the early Roman Christian Church was managed by bishops and assistant presbyters (priests) based in a city. Tertullian noted in 208 that 'places in Britain … though inaccessible to the Romans, have yielded to Christ', and the statements of Origen (239), Sabellius (250) and Eusebius (319) also refer to the presence of Christianity in Britain. In 314, three British bishops attended the Conference of Arles. Other councils had British bishops participating, at Nicaea in 325, Sardica in 347 and Rimini in 359.

The Provinces of Britain, Macsen Wledig and the Exit of the Legions

Britain was divided into two provinces by Caracalla in the early third century, Wales being assigned to Britannia Superior, governed from London. This covered Wales

and the south of England through to East Anglia. Britannia Inferior was generally the north of England to the fluid boundary with Scotland, governed by a legate from Eboracum, York. In 293, there was another administrative division of Roman Britain. Britannia Superior was divided into the provinces of Maxima Caesariensis, with London at its centre, and Britannia Prima, including Wales, was governed from Corinium (Cirencester in Gloucestershire). Britannia Inferior became Flavia Caesarensis, with its capital at Lindum (Lincoln), and Britannia Secunda was governed from York. Although changes were made to the military dispositions, for example by returning Legio II Augusta in strength to Caerleon, the low troop density of the second century continued, and after 230 it dropped further. The later part of the third century saw a new threat; having to defend the coast from raiders. The Romans built a Saxon Shore-style fort at Cardiff and refortified elsewhere. It is not clear when the legionary garrison at Caerleon was finally withdrawn, possibly by the end of the century, although it may have left a skeleton force there as late as the mid-fourth century.

There were only around thirty legions across the Roman Empire until the late third century, when Diocletian increased the number to sixty. In the first century, Britain's garrison was three to four legions, but from the mid-80s stabilised at three legions, garrisoned at Caerleon, Chester and York. With an equal number of auxiliary troops, the British army was around 36,000 to 48,000 soldiers, making it not only one of the largest in the empire, but a potential threat to Rome itself. Detachments from legions or auxiliary regiments, operating on their own or with other detachments were known as vexillations, usually of 1,000 men. The British legions involved with Wales included the Second Augustan Legion, which left Strasbourg in 43, to invade Britain. In 48 it manned the legionary fortress at Isca Dumnonorum, Exeter and in 67 moved to Glevum, Gloucester, near the mouth of the Severn. In 75, the legion moved to the strategically valuable fort and port at Isca Silurum, Caerleon. It remained in Britain for the whole time that Britain was in the Empire.

Clodius Albinus, the governor of Britain, took troops to Gaul in 195 but committed suicide when defeated by Severus. In order to maintain security, the province required the presence of three legions; but command of these forces provided an ideal power base for ambitious rivals. Deploying those legions elsewhere, however, would strip the island of its garrison, leaving the province defenceless against uprisings by the native Celtic tribes and against invasion by Picts, Scots and Germanic tribes.

Carausius took control in Britain from 286–93, declaring himself emperor and ruling Britain and Northern Gaul. Carausius is probably commemorated at Penmachno in Caernarfon, where a monument reads, 'Carausius lies here in this stony mound.' He was assassinated by Allectus, who ruled for three years before the forces of Constantius Chlorus killed him. Emperor Constantius Chlorus, the father of Constantine the Great, died at York in 306. He had reconquered Britain for Rome after the rebellions of Carausius and Allectus. Nennius said that Constantius' 'sepulchre, as it appears by the inscription on his tomb, is still seen near the city named Cair segont' (near Carnarvon). In legend, Constantius had a Christian British wife, Elen, who is celebrated as a saint. She is said to have brought the 'True Cross' to Wales, which was later appropriated by Edward I. Constantius repudiated her in 292 for political reasons when he was proclaimed emperor. Her son Constantine

the Great was born in 274, and was proclaimed emperor by his legion at York in 306. After winning the Battle of Milviam Gate in 312, he converted to his mother's religion. Elen then proselytised Christianity and founded churches throughout Europe, visiting the Holy Land where she died. Constantine the Great, who died in 337, was commemorated in the British Celtic Church as St Cystennin.

Increasing attacks on forts in the fourth century at Cardiff, Caernarfon (Segontium), Holyhead and Caerhun seem to have been by Irish raiders. New defensive installations at Cardiff and Holyhead and the maintenance of larger garrisons at sites like Caernarfon were an attempt to counteract the raids. The fort at Forden underwent a major change of plan in 364–78 in response to some crisis inland. As peace and stability were threatened and coins ceased to circulate, the Roman economic system probably broke down rapidly.

In 367 barbarian tribes had mounted a concerted invasion (sometimes called the 'Barbarian Conspiracy') by land and sea, and breached Hadrian's Wall. As Ammianus states, 'The Picts and Saxons and Scots [Irish] and Atecotti harassed the Britons with continual afflictions.' Count Theodosius, sent to fight the invasion, rebuilt Hadrian's Wall and restored peace to Britannia. However, as the fourth century progressed there were increasing attacks from the Saxons in the east and the Scotti (Irish) in the west. Nennius records another invasion of the Continent by British troops:

> The seventh emperor was Maximus. He withdrew from Britain with all his military force, slew Gratian, the king of the Romans, and obtained the sovereignty of all Europe. Unwilling to send back his warlike companions to their wives, children and possessions in Britain, he conferred upon them numerous districts from the lake on the summit of Mons Jovis, to the city called Cant Guic, and to the western Tumulus, that is, to Cruc Occident. These are the Armoric Britons [Bretons], and they remain there to the present day. In consequence of their absence, Britain being overcome by foreign nations, the lawful heirs were cast out, till God interposed with his assistance.

Rome had been heavily defeated at the Battle of Adrianople in 378, and its forces were in disarray. Magnus Maximus, Dux Britanniarum (the Roman leader of Britain), declared himself emperor at Caernarfon and crossed the English Channel in 383. He gained support across much of the western empire, and returned to fight a successful campaign against Picts and Scots in 384. Magnus had largely countered the Pictish threat by enlisting the British tribes between Hadrian's Wall and the Antonine Wall as federate allies (*foederati*) of the empire. His conquests of Gaul, Spain and Africa required troops from Britain, and it appears that forts at Chester and elsewhere were abandoned in this period, triggering raids and settlement in North Wales by the Irish. He was defeated and killed by Theodosius in 388, and in legend many of his British troops failed to return. Nennius tells us they went to Brittany. Magnus possibly married Elen of Segontium, and is remembered in 'The Dream of Macsen Wledig' in the *Mabinogion*. Most remaining military posts seem to have been abandoned around 393 when soldiers were needed to counteract a rebellion in Gaul. There is evidence, however, that some troops may have been left to guard the towns of Chester, Carmarthen and Caerwent into the fifth century. In the preceding half-century there had been a number of large-scale raids by barbarians:

the Picts from north of the Antonine Wall, the Scots from Ireland and the Saxons (a generic term used in the Roman world for Angles, Jutes and Frisians as well as Saxons) from Germany and Denmark. Around 398 the empire was forced to despatch an expedition to restore order and peace to Britain, led by General Stilicho. Part of his rescue may have included arranging the migration of one of the British tribes (under Cunedda) north of Hadrian's Wall to Wales, to expel the Scots who had captured large parts of western Britain at that time. By 400, the Diocese of Britain (the part of the island south of Hadrian's Wall) had been part of the Roman Empire for over three centuries, and all free-born Britons had been Roman citizens since 212. Christianity was well established and the cities remained populated, but far less prosperous than in the past.

Honorius, the son of Emperor Theodosius, had become the Western Roman Emperor in 395, aged only ten. General Stilicho was now the empire's military ruler, subduing a revolt led by Gildo's Roman legions from North Africa in 397–398. With Stilicho absent in Africa, Alaric's Visigoths tore into Italy in 401, forcing the boy-emperor Honorius to move his capital from Milan (Mediolanum) to a more defensible site at Ravenna. Stilicho now recalled the legions from Gaul and Britain to defend Italy, defeating Alaric twice in 402. Britain had effectively been abandoned by Rome, as barbarian tribes were now invading Gaul, Spain and Italy. Radagaisus led the Goths across the Danube and into Italy in 405. The Goths had been themselves displaced by invading Huns from the east. Stilicho defeated the Goths and recruited many of them into his depleted legions. We must remember that during the process of conquest, Rome could not supply enough troops, and the majority now were from conquered territories. Their loyalty was possibly to their general, their homeland and Rome in that order.

While the Goths were being beaten off in Italy, an enormous army of Vandals, Ostrogoths, Suevi, Quadi and Alans crossed the frozen Rhine, invading Gaul and then Italy in 405–6. They were driven out of Italy, but rampaged through Gaul towards Spain, arriving in 409. In 408, Stilicho had paid Alaric not to invade Italy with an army of Goths and Visigoths. However, the extremely capable General Stilicho was now unfairly executed on charges of treason, and many of his troops joined Alaric. Alaric thus again invaded in 409, sacking Rome in 410. Britain was now isolated, as its remaining Roman soldiers had supported revolts by Marcus (406–7), Gratian (407) and Constantine III. Constantine thus invaded Gaul in 407 with British troops, while his son Constans became ruler of Britain. The Romano-Britons desperately requested help from Rome, but in 410 Emperor Honorius informed the Britons that there could be no longer be help from Rome against constant pagan attacks and invasions. Emperor Honorius 'sent letters to the communities of Britain, bidding them defend themselves'. The Roman Empire was in meltdown, with Roman generals fighting each other across Gaul and Spain to try and secure control of the Empire.

Constantine III (Cystennin the Tyrant) was elected Emperor by the troops in Britain in 407 or 408. Also known as 'Constantine the Usurper', he had led the remaining legions into Gaul, aided by his son Constans and Geraint (Gerontius). Constantine III lost a battle against Stilicho, and sent Constans to Spain to take it from troops loyal to the Emperor Honorius. Honorius now accepted Constantine as co-Emperor, and Constantine entered Italy but had to return to Spain as Gerontius

had defected. Gerontius killed Constans and besieged Constantine in Arles until Honorius raised the siege. Honorius then put Constantine to death near Ravenna in 411. Gerontius appears to have retired to Spain (possibly Galicia) with his British troops.

Zosimus describes a Saxon incursion after Constantine II had left, and a subsequent British revolt in 408–9:

> The barbarians beyond the Rhine, attacking in force, reduced the inhabitants of Britain and some of the Celtic tribes to the point where they were obliged to throw off Roman rule and live independently, no longer subject to Roman laws. The Britons therefore took up arms and, braving the danger on their own behalf, freed their cities from the barbarians threatening them. And all Armorica [Brittany] and the other Gallic provinces followed their example, freed themselves in the same way, expelled the Roman rulers, and set up their own governments as far as lay within their own power. The revolt of the provinces of Britain and Gaul occurred during Constantine's tyranny because the barbarians took advantage of his careless government…

Zosimus later mentions a letter from Honorius to the Britons, apparently a response to a petition for military aid: 'Honorius wrote letters to the cities in Britain, bidding them to take precautions on their own behalf.' The seeming disparity of the province revolting in 409 and then appealing to Rome for military aid in 410 may be the result of a change in emperors.

Gildas states that, in 410,

> from Britain envoys set out with their complaints, their clothes (it is said) torn, their heads covered in dust, to beg help from the Romans … The Romans … informed our country that they could not go on being bothered with such troublesome expeditions; that Roman standards, that great and splendid army, could not be worn out by land and sea for the sake of wandering thieves who had no taste for war. Rather, the Britons should stand alone, get used to arms, fight bravely, and defend with all their powers their land, property, wives, children, and, more importantly, their life and liberty. Their enemies were no stronger than they, unless Britain chose to relax in laziness and torpor; they should not hold out to them unarmed hands, but hands equipped with shields, swords and lances, ready for the kill. They then bid them farewell, as men who never intended to return. This was the Romans' advice.

The *Bern Codex* relates, 'In the year 409 [actually 410], Rome was taken by the Goths, and from that time Roman rule came to an end in Britain, except for some, who were born there, and who reigned for a short time.' Nennius records the break-up of Roman Britain: 'Thus, agreeably to the account given by the Britons, the Romans governed them four hundred and nine years. After this, the Britons despised the authority of the Romans, equally refusing to pay them tribute, or to receive their kings; nor durst the Romans any longer attempt the government of a country, the natives of which massacred their deputies.' By 410, the island was completely estranged from Roman control, and it was during the following years that the Welsh nation came into being.

Celtic Tribes of Iron Age and Roman Britain

Between Penbryn and Tresaith on the Ceredigion coast was found the Corbalengi Stone. It is notable because it remembers an Ordovician, a tribe from North Wales, and has been translated as 'The Heart of Balengus the Ordovician lies here'. The pillar stone was placed upon a Roman cremation cairn. An urn containing ashes and a Roman gold coin dating to 69 CE was found, along with silver and bronze coins.

Roman-britain.org is a superb website for Celtic tribes and the Roman occupation, and the following is a synopsis of the tribes of Wales, its borders and the West Country.

The Cornovii

These lived east of the Ordovices, with the great Roman bases of Chester (Deva) and Wroxeter (Viroconium Cornoviorum) being built to control the area. Wroxeter was the fourth-largest town in Roman Britain, occupying the same site as a former legionary fortress, originally built by the XIV Legion around 47 CE. Huge tribal lands covered Shropshire, a large part of southern Cheshire, western Staffordshire, the West Midlands, eastern Clwyd, small parts of north-east Powys and northern Hereford and Worcester. No pre-Roman tribal centre has been identified, although the Wrekin hill-fort above Wroxeter is possible. Copper was mined at Llanymynech, and lead and silver on Shelve Hill (Shropshire). Salt was also mined around Middlewich and Northwich in Cheshire. On the southern side of the Berwyn range, there is a hill-fort at Craig Rhiwarth deep in the Tanat valley at the extreme northern tip of Powys. This fort marks the boundary between the Cornovii and the Ordovices, and could be the site of the last stand of Caractacus and his forces in Wales in 50 CE.

The Ordovices

The tribe inhabited mainly south Gwynedd and south Clwyd, and probably parts of western Shropshire and Hereford. Their lands are full of great hill-forts, and they were bordered to the north-east by the Deceangli, to the east by the Cornovii, to the south-east by the Silures and to the south-west by the Demetae. The tribe may have been administered from Leintwardine, and there were Roman settlements at Caernarfon, Pennal, Caer Gai, Caersws, Llanfor, Tomen y Mur and Brithdir.

The Gangani

This was a minor tribe on the Llŷn Penninsula, and possibly the fort at Pen Llystyn marks the territorial boundary between the Gangani and the Ordovices. Ptolemy gave a Roman name for the Llŷn Peninsula, Ganganorum Promontorium. The Gangani appear to have been an Irish tribe living around the mouth of the River Shannon, of which part had settled on the peninsula.

The Segonti(i)/Segontiaci

This tribe is thought to be a sub-tribe of the Ordovices, based in the area of modern Caernarfon, who gave their name to the Roman fort and minor settlement of Segontium. They were possibly Celtiberian settlers originally from Hispania Tarraconensis (Northern Spain), where there are important towns named Segontia, Segovia, Segobriga and Sagunto.

The Ceangi, Deceangi or Deceangli

This tribe is not mentioned in Ptolemy's *Geographia*, but its territory was in the northern coastal region of Clwyd and Gwynedd. They occupied hill-forts, notably along the length of the Clwydian Range. The main tribal centre seems to have been at Caerhum, the Roman Canovium on the River Conwy. Like their southern neighbours, the Ordovices, they were probably placed under military government following Agricola's campaign of 78 CE. The tribal name Deceangli is phonetically connected with the Tegeingl district of Flintshire. The lead deposits of the Halkyn Hills were known by the Romans before they arrived in the area, and pigs of lead have been unearthed in Cheshire and Staffordshire. The most notable export of the Deceangli tribe was lead and silver, which was mined in the form of the ore galena, notably at Pentre Flint, Halkyn and Meliden. The great copper mines at Pen y Gogarth, Orme's Head, were probably administered from Canovium, and the silver/lead mines from Chester.

The Demetae

They occupied the territories of Dyfed in South West Wales. A Roman fort was built at Leucarum, Loughor to control a river crossing. The main tribal centre and *vicus* was Moridunum Demetarum, Carmarthen. Dolaucothi gold-mine was in Demetae territory, and Gildas wrote of 'Vortipor, tyrant of the Demetae ... the spotted leopard'. In 1876, a memorial stone was discovered in Castell Dwyran chapel, on the Pembrokeshire–Carmarthenshire border. There is a hill-fort nearby. Its Latin inscription reads 'Memoria Voteporigis Protictoris' (Monument of Voteporigas the Protector). Its Ogham inscription has the Goidelic form of name, Votecorigas. The use of Goidelic shows that the Irish language was still in use at that time in the area. The chapel is decaying, and certainly seems to be on a Celtic *clas* site.

The Silures

The Silures tribe inhabited Glamorgan, Gwent and probably southern Powys. Their hill-forts, like those of their western neighbours the Demetae, are similar to those in south-west England. To the north were the Ordovices of central Wales, and to the east were the Dobunni. The principal tribal centre and *civitas* capital was Venta Silurum, Caerwent, and the 'Civitas Silurum' stone altar can be seen in the portico of Caerwent church. There was also a tribal centre and polis at Usk, where the Romans

built the large fort of Burrium. It is believed that Llanmelin Wood, north of Caerwent, was the major pre-Roman tribal centre. There were Romano-British settlements at Machen (probably associated with lead mining) and Cardiff. Large, decorated villas have been discovered at Ely (Cardiff), Llanilltud Fawr and Llanfrynach. Iron mines around Monmouth and the Forest of Dean were in the lands of the Silures, but administered from Ariconium (Weston under Penyard) in Dobunni territory.

The Dobunni

This tribe had a principal tribal centre at Cirencester (Corinium) in Gloucester, and their lands covered the present counties of Gloucester, Avon, west Oxfordshire, north Somerset and parts of southern Hereford, Worcestershire and Warwickshire. Cirencester was once the second-largest town in Roman Britain, and became the provincial capital of Britannia Prima. Apart from Ariconium, mentioned above, there were major settlements and forts at Gloucester (Glevum), Kenchester (Magnis), Droitwich Spa (Salinae, because of its major salt industry) and Worcester (Vertis, important for a Severn crossing and potteries).

The Dumnonii

Their territory incorporated the modern county of Cornwall along with Devon west of the River Exe, and intermarriage with other tribes was uncommon. They traded in tin from a port at Ictis (St Michael's Mount) from the Bronze Age onwards, were friendly to strangers but aggressive when threatened. The Romans built a fort at Isca Dumnonorium, Exeter, to administer the territory.

3

The Invasion of Britain, Arthur &
the Age of the Saints
410–600

Gildas gives us a terrifying account of the strife in these years:

> As the Romans went back home, there emerged from the coracles that had carried them across the sea-valleys the foul hordes of Scots and Picts … They were to some extent different in their customs, but they were in perfect accord in their greed for bloodshed: and they were readier to cover their villainous faces with hair than their private parts and neighbouring regions with clothes. They were more confident than usual now that they had learnt of the departure of the Romans and the denial of any prospect of their return. So they seized the whole north of the island from its inhabitants, right up to the [Hadrian's] wall. A force was stationed on the high towers to oppose them, but it was too lazy to fight, and too unwieldy to flee; the men were foolish and frightened, and they sat about day and night, rotting away in their folly. Meanwhile there was no respite from the barbed spears flung by their naked opponents, which tore our wretched countrymen from the walls and dashed them to the ground. Premature death was in fact an advantage to those who were thus snatched away; for their quick end saved them from the miserable fate that awaited their brothers and children. I need say no more. Our citizens abandoned the towns and the high wall. Once again they had to flee; once again they were scattered, more irretrievably than usual; once again there were enemy assaults and massacres more cruel. The pitiable citizens were torn apart by their foe like lambs by the butcher; their life became like that of the beasts of the field. For they resorted to looting each other, there being only a tiny amount of food to give brief sustenance to the wretched people; and the disasters from abroad were increased by internal disorders, for as a result of constant devastations of this kind the whole region came to lack the staff of food, apart from such comfort as the art of the huntsman could procure them.

Invasions

Ethelwerd's Chronicle was written by a descendant of Alfred's brother, and may be based on a version of the *Anglo-Saxon Chronicle* that has since been lost. It tells us the following for the year 418, when the last Romans left Britain: 'In the ninth year also after the sacking of Rome by the Goths, those of Roman race who were left in

Britain, not bearing the manifold insults of the people, bury their treasures in pits thinking that hereafter they might have better fortune, which never was the case; and taking a portion, assemble on the coast, spread their canvas to the winds, and seek an exile on the shores of Gaul.' In 427, Gildas records,

> So the miserable remnants sent off a letter again, this time to the Roman commander Agitius [Flavius Aetius, commander-in-chief of the Roman army in Gaul, and Rome's last great military leader], in the following terms: 'To Agitius, thrice consul: the groans of the British.' Further on came this complaint: 'The barbarians push us back to the sea, the sea pushes us back to the barbarians; between these two we are either drowned or slaughtered.'

However, Rome simply did not have the resources to send help – it was itself in its dying throes. In 429 Gildas tells us that some Britons had begun fighting back against the Picts, Irish and Germans:

> Meanwhile, as the British feebly wandered, a dreadful and notorious famine gripped them, forcing many of them to give in without delay to their plunderers, merely to get a scrap of food to revive them. Not so others: they kept fighting back, basing themselves on the mountains, caves, heaths and thorny thickets. Their enemies had been plundering the land for many years; now for the first time they inflicted a massacre on them, trusting not in man but in God. The enemy retreated from the people.

The Romano-Britons seemed to have been left with leaders in 410, and also with some ability to defend themselves. The tribal divisions in Britain were still intact when Rome left, and there seems to have been a Pendragon, a war leader, who may have replaced the Dux Britanniarum. Hadrian's Wall, the Saxon Shore fortresses and fortified ports such as at Cardiff helped to prevent wide-scale invasion. All levels of military and civil government had vanished, so administration and justice reverted to tribal leaders. It seems that Romano-British warlords gradually emerged, aspiring to Roman ideals and conventions. Villas continued to be inhabited, and agriculture was continued. Trade carried on with the other Celtic nations, with Europe and the Near East, olive oil and wine amphorae, tableware, glass beakers and jewellery being found at the defended settlement at Dinas Powys in Glamorgan and other places. Copper coins are very rare after 402, although minted silver and gold coins from hoards indicate they were still present in the province, even if they were not being spent. By 407 there were no new Roman coins going into circulation, and by 430 it is likely that coinage as a medium of exchange had been abandoned. Pottery mass production probably ended in the 420s. The nobility continued to use metal and glass vessels, while the poor probably used leather or wooden ones. As across all the empire, the secret of manufacturing Roman cement died out, and has never been rediscovered. Roman mortar can last over two millennia, but modern cement possibly two centuries. Some 1950s and 1960s cement lost structural integrity within forty years.

The greatest achievement of the Britons was the successful defence of its inheritance in Wales and the western extremities of Britain. In this the Cymry,

the Welsh Britons, were almost alone in the Western Roman Empire. All other conquered regions (exceptions being the Hungarians and Basques) adopted Latin as the basis for their oral language, with Latin being the lingua franca of the written language for well over a millennium. Welsh has some borrowing from Latin, as over the centuries it has had some borrowings from English, but is still essentially the British language of the time of Rome. By contrast, the English of Chaucer's time is unrecognisable to modern readers, and we have to look to the time of Shakespeare before English developed into the language we know today. The British language moved with emigration to Brittany in the couple of centuries after the legions left, and Wales became a nation of small, self-sufficient states, based upon the four main tribal areas.

Cunedda

Cunedda Wledig was a British chief or sub-king of the Gododdin, who ruled the Brythonic kingdom of Manaw Gododdin on the Firth of Forth around Clackmannan. He seems to have had Roman ancestors, his father being Aeternus (Edern), his grandfather Paternus of the Red Robe (Padarn Beisrudd) and his great-grandfather Tacitus (Tegid). Paternus may have been the Romano-British commander of the Votadini (Gododdin) troops under Magnus Maximus, protecting the frontier against the Picts. With his eight sons and a large war band, Cunedda moved to North Wales. It seems that he was invited to come, possibly in the last days of Roman rule. The Uí Liatháin Munster tribe of Scotti are known from both British and Irish sources, to have colonised Wales and Cornwall. Cunedda's sons Meirion, Ysfael, Rhufon, Dunod, Ceredig, Afloeg, Einion Yrth, Dogfael and Edern drove out these Irish settlers, as far south as Ceredigion, Carmarthenshire, Pembrokeshire and Gower. Cunedda settled at Rhos in Gwynedd, and his family founded royal dynasties in the regions stretching from the Dee to the Teifi, named after his sons: Meirionydd, Ysfeilion, Rhufoniog, Dunoding, Ceredigion, Afflogion, Dogfeiling and Edeyrnion. It may be that Vortigern invited Cunedda and his Votadini Britons to migrate to Wales to expel the barbarians, as he had elsewhere asked the Saxons to help stabilise south-east England. Cunedda came to Wales some time between 370 and 430, with the life of his descendant Maelgwn Gwynedd seeming to favour the later date.

The hill of Allt Cunedda near Cydweli in Carmarthenshire attests to Cunedda's campaigning. There is an Iron Age hill-fort here, and several collapsed stone cists. One of the tumuli was covered by a huge hexagonal stone 'shield' and is known as Banc Benisel. It is said to be the grave of Sawyl Benisel (Penuchel), King of the Britons, whose court was here. Genealogies place Sawyl as the father of St Asaff, and the son of Pabo Post Prydain. Sawyl's daughter married Maelgwn Gwynedd. Pabo ab Arthwys, the 'Pillar of Britain', was a north British king driven from his homeland by the Gwyddyl Fichti (Pictish Goidels), who received lands in Powys from Brochwel Ysgythrog (Brochwel the Fanged). Brochwel the Fanged fought against the pagan invaders at Chester in 613. Pabo founded churches in Anglesey and Caernarfon, and is remembered in place-names around Llangystenin. At Llanbabo church there is a large, sculptured slab, with his figure and the inscription in Lombardic capitals: 'HIC

IACET PABO POST PRVD'. The stone was only found, 6 feet underground, in 1730 and there must still be hundreds of important monuments buried across Wales. Pabo's son, St Dunawd, died in 595. The history of Wales is reflected more by names in the landscape than by (mostly destroyed) written records, and there are links with Cunedda's family across Wales.

The Irish Influence

From 350–400 there were Irish settlements along the west coast of the British Isles from Scotland to Cornwall – the Irish Deisi tribe settled in Pembrokeshire, and the Irish Scotti came in waves from 350–550 into the Llŷn Peninsula and parts of Anglesey. Ceredigion also had Irish incursions. The Trenecatus Stone was found in 1808 in chapel ruins at Crug-y-Chwil, Llanwenog, with Irish personal names. The stone was probably looked upon as a pagan monument, and may have been used in the chapel foundations or walls. This is a few yards from the River Teifi on the Ceredigion side. About 1,500 years old, it provides evidence for the strength of Irish settlement in Wales. It is inscribed in both Latin and ogham (ogam) – an Irish script made from notches and lines carved along a stem line – on the edge of the stone. The Latin reads, 'Trenacatvs/(h)ic iacit filius/Maglagni' (Trenacatus, here he lies, the son of Maglagnus). The ogham reads, 'TRENACCATLO'. Around 400 stones survive with ogham script, the vast majority in the south of Ireland. Only thirty-one are known in Wales of which twenty-three have inscriptions in both Latin and ogham. The Welsh tales now known as the *Mabinogion* include legendary characters from both sides of the Irish Sea. This author lives within view of Crug-y-Chwil (also spelt Crugywil, meaning Burial Mound of the Beetle or Snail), and was drawn towards it because it is a huge unnatural mound in a glacial river valley. It is an elongated conical hill, and may have been an Iron Age fort, but there are no indications of this, and it is not sited strategically for defence.

As with Twyn y Glog (Hill of the Cloak) overlooking Ynysybwl in Glamorgan, the Google Earth satellite map shows it to be a different height to that indicated upon Ordnance Survey maps. Crug y Chwil has a height of 97 metres on Google Earth, but 114 metres on Ordnance Survey maps, a difference of over 50 feet. Similarly, the discrepancy at Twyn y Glog is 278 metres on Google Earth, and 294 metres on Ordnance Survey maps, again a distance of around 50 feet. The point is that Google Earth shows the actual land height above sea level. If one looks at New York City on the website, one will find that it is only a few metres above sea level. The measurement does not spike to several hundred feet when placed over skyscrapers. What we see at Crug y Chwil is an artificial hill at least 50 feet high, indicating that it is man-made. If CADW or a university had the resources to satellite-scan mounds and hillocks across Wales, and compare against Ordnance Survey readings, the archaeology would vastly widen our understanding of history and lead to the discovery of valuable artefacts. Equally, ground-sensing technology could discover lost inscribed stones at places like Llancarfan in the Vale of Glamorgan.

Vortigern's Story

The name Vortigern may stem from 'Mawr (mutated to Fawr) Tigern', 'Great Monarch', so we may not know his real name. His Welsh name, Gwrtheyrn, literally means 'Man Monarch', and his is the first name that emerges from the unclear period after the Romans left. The *Anglo-Saxon Chronicle* tells us that in 443 the Britons asked Rome again for assistance, who could not help, and then Vortigern asked the Angles to come to his assistance in the fourth year of his reign. The *Gallic Chronicle* for around 441 or 445 notes that 'the British provinces, which up to this time have suffered various catastrophes and misfortune, yielded to the power of the Saxons [i.e. Angles]'. For 450, the *Anglo-Saxon Chronicle* states, 'In their days Hengest and Horsa, invited by Vortigern, King of the Britons to his assistance, landed in Britain in a place that is called Ipwinesfleet [Ebbsfleet]; at first to help the Britons, but later they fought against them.' Nennius uses the same date: 'After ... the end of the Roman Empire in Britain [410], the British went in fear for 40 years ... Then came three keels [vessels], driven into exile from Germany. In them were the brothers Horsa and Hengest ... Vortigern welcomed them, and handed over to them the island that in their language is Thanet.'

Gildas tells of the awful consequences:

> Then a pack of cubs burst forth from the lair of the barbarian lioness, coming in three keels, as they call warships in their language. The winds were favourable; favourable too the omens and auguries, which prophesied, according to a sure potent among them, that they would live for three hundred years in the land towards which their prows were directed, and that for half that time, a hundred and fifty years, they would repeatedly lay it waste. On the orders of the ill-fated tyrant, they first fixed their dreadful claws on the east side of the island, ostensibly to fight for our country, in fact to fight against it.

The German mercenaries came to aid Vortigern's battles against Picts and Scots (Irish Gaels who had settled in Scotland) from the north. They were permitted to settle in the Isle of Thanet, and were soon joined by further reinforcements. It may be that Vortigern had taken the role of the Roman Dux Britanniarum, with a council of sub-Roman consuls and *civitates* (city representatives). Bede names the Germanic tribes as Saxons, Angles and Jutes. Nennius tells us that there was a final war between the Britons and the Romans, which the Britons won and Guorthigirnus (Vortigern) assumed power in Britain, which may have been as early as 420. There is a 446 date for Vortigern's rise to power, but it may have been earlier. The Germans fought for Vortigern, but because of their increasing numbers, he was unable to feed them. Hengest was said to have offered Vortigern his daughter in exchange for Kent, which he accepted. The Saxons now began to advance across the country, with reinforcements coming from Holland and Germany. Vortigern fought four battles against them, during which Horsa and Vortgern's son Cadeyrn were killed. In the excerpt from the *Anglo-Saxon Chronicle* Manuscript A below, the native British are referred to as 'Walas', foreigners, but have been translated as Welsh:

449 Hengest and Horsa, invited by Wyrtgeorne [Vortigern], king of the Britons, sought Britain on the shore which is named Ypwinesfleot [Ebbsfleet, on the Isle of Thanet, Kent] ... 455. In this year Hengest and Horsa fought against Wyrtgeorne, the king, at the place which is called Agælsthrep [probably Aylesford, Kent]; and his brother Horsa was there slain; and after that Hengest succeeded to the kingdom [of Kent], and Æsc his son ... 457. In this year Hengest and Æsc his son fought against the Britons at the place which is called Crecganford [possibly Crayford], and there slew 4,000 men; and the Britons then forsook Kent, and in great terror fled to London. 465. In this year Hengest and Æsc fought against the Welsh near Wippedesfleote [unidentified]; and there slew 12 Welsh chieftains; and one of their thegns was there slain, whose name was Wipped. 473. In this year Hengest and Æsc fought against the Welsh and took countless booty; and the Welsh fled from the English as fire.

Ethelwerd's Chronicle records the ongoing pressure of German inroads into British territories:

A. 477. Ella landed in Britain from Germany with his three sons, at a place called Cymenes-Ora, and defeated the Britons at Aldredes-league. A. 485. After eight years, the same people fight against the Britons, near a place called Mearcraedsburn. A. 488. After this, at an interval of three years, Aesc, son of Hengest, began to reign in Kent. A. 492. After three years, Aella and Assa besieged a town called Andreds-cester, and slew all its inhabitants, both small and great, leaving not a single soul alive. A. 495. After the lapse of three more years, Cerdic and his son Cynric sailed to Britain with five ships, to a port called Cerdic's-ore, and on the same day fought a battle against the Britons, in which they were finally victorious. A. 500. Six years after their arrival, they sailed round the western part of Britain, which is now called Wessex. A. 501. Also after a year Port landed in Britain with his son Bieda.

A. 508. Seven years after his arrival, Cerdic with his son Cynric slay Natan-Leod, king of the Britons, and five thousand men with him. A. 514. Six years after, Stuf and Whitgar landed in Britain at Cerdic's-ore, and suddenly make war on the Britons, whom they put to flight, and themselves remain masters of the field. A. 519. Five years after, Cerdic and Cynric fought a battle against the Britons at Cerdic's-ford, on the river Avene, and that same year nominally began to reign. A. 527. Eight years after, they renew the war against the Britons. A. 530. After three years, they took the Isle of Wight, the situation of which we have mentioned above: but they did not kill many of the Britons. A. 538. When he had reigned four years, the sun was eclipsed from the first hour of the day to the third. A. 540. Again, two years after, the sun was eclipsed for half-an-hour after the third hour, so that the stars were everywhere visible in the sky. A. 547. In the seventh year after this, Ida began to reign over the province of Northumberland, whose family derive their kingly title and nobility from Woden.

Heartened by Vortimer's death, possibly from poisoning, and with reinforcements, Saxons under Hengest had returned in force to Britain, and had won a major battle in 465. A great peace conference was now arranged. In Nennius' history, Hengest told his followers to hide their daggers in their shoes, and when he called out, 300 British chieftains and leaders were killed. Vortigern was taken prisoner and gave Essex, Sussex

and Middlesex in exchange for his life after this, the 'Treachery of the Long Knives'. Vortigern left, in fear of his life, for the land later known as Gwtheyrnion, north of the River Wye in Mid Wales. He was then pursued west by Ambrosius Aurelianus and/or St Garmon (Germanus of Auxerre) to Caer Gwrtheyrn (Vortigern's Castle), near Llandysul on the River Teifi in the lands of the Demetae. A fire descended from heaven to burn Caer Gwrtheyrn, destroying all its defendants. The hilltop fort, also known as Craig Gwrtheyrn, can still be seen. Another legend places Vortigern's downfall at Tre'r Ceiri, the great hill-fort above Nant Gwrtheyrn on the Llŷn Peninsula, and Castell Gwrtheyrn was a place-name near there. Vortigern is also supposed to have died at a third place, Little Doward hill-fort near Ganarew in Hereford. This may be the Caer Guouthigern in Nennius' *Twenty-Eight Towns of Sub-Roman Britain*. However, in this author's *The Book of Welsh Saints*, we discover that Vortigern was not killed but went to Quimperlé in Brittany, where he was known as St Gurthiern. His relics lie in its cathedral. The Vitalianus Stone in St Brynach's churchyard at Nanhyfer (Nevern) is said to be Vortigern's gravestone. Vortigern's third son, Pascent, ruled Buellt (Builth) and Gwrtheyrnion and it is from Pascent that the rulers of Powys were descended. The elaborate Eliseg's Pillar, near Valle Crucis Abbey, records that Garmon blessed Vortigern rather than fought him, and does not mention him marrying Hengest's daughter, but instead the daughter of Magnus Maximus. However, Vortigern seems to have been anti-Roman, which may explain the antipathy to him in some early sources.

Geoffrey of Monmouth wrote of a grim future for 'the people of Britain', the Welsh, in the following passage upon Vortigern. He used the metaphor of the Red Dragon of Cadwaladr and the White Dragon of Wessex and England:

> While Vortigern, King of the Britons, was still sitting on the flank of the pool which had drained of its water, there emerged two dragons, one white, one red. As soon as they were near enough to each other, they fought bitterly, breathing out fire as they panted. The white dragon began to have the upper hand and to force the red one back to the pool. The red dragon bewailed the fact that it was being driven out and then turned upon the white one and forced it backwards in its turn. As they struggled on in this way, the King ordered Ambrosius Merlin to explain just what this battle of the dragons meant. Merlin immediately burst into tears. He went into a prophetic trance and then spoke as follows: 'Alas for the red dragon, for its end is near. Its cavernous den shall be occupied by the white dragon, which stands for the Saxons whom you have invited over. The red dragon represents the people of Britain, who will be overrun by the white one: for Britain's mountains and valleys shall be levelled, and the streams in its valleys shall run with blood.'

Constant Attacks

There was continuity from the British tribes in the pre-Roman and Roman periods to the kingdoms that formed in the post-Roman period. Apart from the attacks from Ireland and Scotland, there were sea-borne raids and later settlement by the Angles, Saxons and Jutes. There may be several reasons why they left their homelands. The

sea was encroaching upon the land settled by the Saxons in Frisia (modern north-west Germany and the Netherlands). East Anglia was one of the first places to be settled after Kent, with flat lands similar to Frisia. A second reason may have been overpopulation on the Continent, but a more likely reason is that the pressure of invasions of Huns, Goths, Visigoths, Alans, Vandals etc. from Eastern Europe and Asia was forcing Western European tribes to move westwards and northwards. There were German mercenaries operating as Roman auxiliaries in Britain from the first century onwards, who would have told their families and tribes in Frisia and Old Saxony of great opportunities in Britain when the legions left.

The native Britons were left with three choices as reinforcements arrived constantly upon their southern and eastern coasts. They could try and assimilate, but this could lead to death and slavery. They could stand and fight, with the same possibilities. It is known that there were several waves of Brythonic migration into Armorica (Brittany) at this time, most probably from Devon and Cornwall using established trading routes. It seems that the bulk of the surviving population slowly lost ground and moved west and north to Strathclyde, Cumbria, Wales and the West Country. In Wales, the Silures, Cornovii, Ordovices and Demetae still remained powerful, but the Deceangli had been severely reduced by Rome. The Picts attacked from what is now Scotland, the Gaels invaded from Ireland, and the Angles, Saxons and Jutes began to colonise the south and east of England. Over the centuries the German invaders took over England, forming the kingdoms of Northumbria, Lindsey, East Anglia, Essex, Kent, Sussex, Wessex, and the largest, Mercia, which bordered Wales. On the west coast the Britons were hemmed back to Cornwall, Dumnonia (Devon and Somerset), Rheged (Cumbria), Gododdin (on the Firth of Forth) and Ystrad Clud (Strathclyde in Scotland). The Brythonic nation was eventually compressed into small kingdoms now stretching from Southern Scotland, through north-west England, Wales, Somerset, Devon and Cornwall.

The Mystery of Riothamus

This Romano-British leader took an army to France in 470 to help the Roman Empire against the Visigoths. The sixth-century Greek historian Jordanes called Riothamus 'King of the Britons', and the name translates to 'supreme king':

> Now Euric [Evaric, *c*. 440–84] king of the Visigoths, perceived the frequent change of Roman Emperors and strove to hold Gaul by his own right. The Emperor Anthemius heard of it and asked the Brittones for aid. Their King Riotimus came with twelve thousand men into the state of the Bituriges by the way of Ocean, and was received as he disembarked from his ships. Euric, king of the Visigoths, came against them with an innumerable army, and after a long fight he routed Riotimus, King of the Britons, before the Romans could join him. So when he had lost a great part of his army, he fled with all the men he could gather together, and came to the Burgundians, a neighbouring tribe then allied to the Romans. But Euric, king of the Visigoths, seized the Gallic city of Arvernum [Clermont-Ferrand]; for the Emperor Anthemius was now dead.

Gregory of Tours relates the same battle: 'The Brittani were driven from Bourges by the Goths and many of them perished at the village of Déols.' Some believe that the story of Riothamus explains Geoffrey of Monmouth's belief that Arthur went to France and attacked Rome. Léon Fleuriot argues that Riothamus is actually Ambrosius Aurelianus, and that 'Riothamus' is a title of overlordship of all the Brythonic territories. Ambrosius could fit the time-scale, and Fleuriot states that after the defeat he then returned to Britain to continue the war against the Saxons. Riothamus also appears in Breton history at this time.

Prydein Fychain (Little Britain) is Brittany, and there was considerable movement between Brittany, Cornwall and Wales in the 'Age of Saints'. The West Country (Dumnonia) was a useful crossing area for both nations. Breton saints (the 'Armorican Mission') came to Wales in the sixth century, and the families of the sons of Emyr Llydaw (King Budic of Brittany) fought for Arthur ap Meurig when dispossessed by the Franks. The waves of the British movement into Brittany began with the 'first migration' in 388 of the remnants of Macsen Wledig's legions. Cynan Meiriadog and Gadeon were said to be Elen's brothers and thus Macsen's brothers-in-law. After staying loyal to Rome as Duke of Armorica (Brittany) for some time, Cynan claimed independence for Brittany in 409, dying in 421. From 440–450 there was more migration from England as the Saxons pressed through the country, and 458–460 saw the 'second migration' of British nobles and their followers, led by the fabled Riothamus. It is thought that his defeated army escaped from central France to Brittany in 470. The 'third migration' was from 530–540, a mass emigration from the west of Britain, when the Welsh saints Armel and Samson fought Conmire to restore Iuthael (Iudicael) to the Breton crown. Also, in 547, it seems that many Welsh saints fled to Brittany to avoid the Yellow Plague.

The Time of Arthur

William of Malmesbury (*c*. 1095–1143) wrote,

> When he [Vortimer, the son of Vortigern] died, the British strength decayed, and all hope fled from them; and they would soon have perished altogether, had not Ambrosius, the sole survivor of the Romans, who became monarch after Vortigern, quelled the presumptuous barbarians by the powerful aid of warlike Arthur. It is of this Arthur that the Britons fondly tell so many fables, even to the present day; a man worthy to be celebrated, not by idle fictions, but by authentic history. He long upheld the sinking state, and roused the broken spirit of his countrymen to war. Finally, at the siege of Mount Badon, relying on an image of the Virgin, which he had affixed to his armour, he engaged nine hundred of the enemy, single-handed, and dispersed them with incredible slaughter. On the other side, the Angles, after various revolutions of fortune, filled up their thinned battalions with fresh supplies of their countrymen; rushed with greater courage to the conflict, and extended themselves by degrees, as the natives retreated, over the whole island: for the counsels of God, in whose hand is every change of empire, did not oppose their career. But this was effected in process of time; for while Vortigern lived, no new attempt was made against them.

Vortigern was thought to be was anti-Roman compared to Emrys Wledig (Ambrosius Aurelianus), whose victories allowed Wales to remain independent of the pagans. Francis Pryor noted,

> That is why there is such a remarkable difference between the sustaining of an unbroken tradition in Welsh society and the great collapse in England and indeed the destruction in every other part of Europe. In few countries has the native way of life continued unbroken from the time of Christ until our own day ... The splendour of the history of Wales is that the tradition of the nation has persisted through thousands of years ... Spiritual life was revolutionised and throughout the land people were imbued with Christian values as the life of no other nation was imbued.

William of Malmesbury credits Arthur with the victory of Mount Badon, which created a peace which lasted for decades. However, the Angles and Saxons continued to pour forth from their homelands and the Britons were gradually forced back.

There is a Welsh triad which reads,

> Three tribal thrones of the Island of Prydain. Arthur the Chief Lord at Menevia, and David the chief bishop, and Maelgwyn Gwynedd the chief elder. Arthur the chief lord at Kelliwic in Cerniw, and Bishop Betwini the chief bishop, and Caradawg Freichvras the chief elder. Arthur the chief lord in Penrionyd in the north, and Cyndeyrn Garthwys the chief bishop, and Gurthmwl Guledic the chief elder. (*Peniarth MS* 54)

This seems to place Maelgwn Gwynedd in the land of the Demetae, West Wales, rather than in Gwynedd, with St David as bishop. Much confusion has arisen over Cerniw, with nearly every scholar confusing it with Cornwall, but Gelliwig is probably Llanmelin; Cerniw has always been the area around Cardiff, Newport and Caerwent; Bishop Bedwyn may have been Arthur's brother, with Caerleon/Caerwent as his see; and Caradog Freichfras was a Monmouth/Brecon warrior/elder. The subject of Arthur is extremely complex, owing to much later legends, traditions and appropriations, and this author will return to it in a dedicated book. Penrionydd is probably Stranraer in Strathclyde; Cyndeyrn Garthwys was St Kentigern, or Mungo of Strathclyde, to whom Maelgwn Gwynedd gave lands to found St Asaff Cathedral; Gwrthmwl Wledig was a chief of North Britain, who sought refuge in Wales and was probably killed in Ceredigion. He is mentioned in the *Mabinogion* and said to be buried alongside St Briafel.

Nennius recorded,

> Then it was, that the magnanimous Arthur, with all the kings and military force of Britain, fought against the Saxons. And though there were many more noble than himself, yet he was twelve times chosen their commander, and was as often conqueror. The first battle in which he was engaged, was at the mouth of the river Gleni. The second, third, fourth, and fifth, were on another river, by the Britons called Duglas, in the region Linuis. The sixth, on the river Bassas. The seventh in the wood Celidon, which the Britons call Cat Coit Celidon. The eighth was near Gurnion castle, where Arthur

bore the image of the Holy Virgin, mother of God, upon his shoulders, and through the power of our Lord Jesus Christ, and the holy Mary, put the Saxons to flight, and pursued them the whole day with great slaughter. The ninth was at the City of Legion, which is called Cair Lion. The tenth was on the banks of the river Trat Treuroit. The eleventh was on the mountain Breguoin, which we call Cat Bregion. The twelfth was a most severe contest, when Arthur penetrated to the hill of Badon. In this engagement, nine hundred and forty fell by his hand alone, no one but the Lord affording him assistance. In all these engagements the Britons were successful. For no strength can avail against the will of the Almighty. The more the Saxons were vanquished, the more they sought for new supplies of Saxons from Germany; so that kings, commanders, and military bands were invited over from almost every province. And this practice they continued till the reign of Ida, who was the son of Eoppa, he, of the Saxon race, was the first king in Bernicia, and in Cair Ebrauc [York].

A recent theory is that a near miss by a comet nearly 1,500 years ago caused a catastrophic change in the global climate, leading to famine, plague, the end of the Roman Empire, the birth of the Dark Ages and even the legend of King Arthur. Debris from the near miss in 540 bombarded the Earth with meteors, which threw enough dust and water vapour into the atmosphere to cut out sunlight and cool the planet, causing crop failures across the northern hemisphere. The famines weakened people's resistance to disease and led to the great plague of the Emperor Justinian. It could also be responsible for Arthurian stories about gods appearing in the sky, followed by a fertile kingdom becoming a wasteland. Evidence for a sudden global climate change around 540 comes from the study of tree rings, which highlight the years when plant growth was poor or non-existent. Researchers believe that the event of 540 could have caused the Dark Ages. It was a catastrophe which shows up in trees from Siberia, Scandinavia, Northern Europe, North America and South America. Tree rings round the world clearly indicate a major climate change unprecedented in the past two millennia. This could have cooled the Earth by a few degrees, enough to cause crops to fail for several years in succession.

It may be that, as well as the monastery (re-founded later by St Illtud) the Irish destroyed the fabulous fifteen-room Roman villa at Caer Mead, a mile from Llanilltud. After Macsen Wledig left with the legions in 383, this was taken over by the local prince or king, and there is evidence of forty-one Christian burials on the site in the Age of the Saints. It is thought that the kings of Glamorgan and Gwent, from Tewdrig through his son Meurig to his son Arthmael or Arthrwys, may have used it as their palace. Arthmael, the Arthur of legend, has always been associated with being born at nearby Boverton, which claims to the Caput Bovium of the Romans (Cowbridge being Bovium). The Caer Mead site covers 2 acres, and one room (the court?) was a massive 60 by 50 feet. There are superb mosaics there, and coins, pottery and glass were discovered. Excavated in 1888, it has since been covered over and ignored, though it could hold the key to the legend of Arthur. A gold torc was found nearby, early in the nineteenth century, but sold for £100 and melted down. CADW should excavate this priceless site, and preserve it as a tourist attraction. On the nearby Llandow Airfield site, many tumuli were flattened without being excavated.

Maelgwn Gwynedd and the Tyrants of Gildas

The great king, Mailcun, reigned among the Britons, i.e. in the district of Guenedota, because his great-great-grandfather, Cunedda, with his twelve sons, had come before from the left-hand part, i.e. from the country which is called Manau Gustodin, one hundred and forty-six years before Mailcun reigned, and expelled the Scots with much slaughter from those countries, and they never returned again to inhabit them. (*Historia Brittonum* 62)

King Maelgwn (517–49) of Gwynedd may have been instrumental in the death or disappearance of Arthur. Maelgwn Gwynedd was also known as Maglocunos and Maelgwn Hir (the Tall). He was King of North Wales at the time of Arthur. Like Arthur, he features in many of the legends of the saints, and famously argued with St Curig. He called all the northern chiefs to Ynys Las, near the beach still called Traeth Maelgwn on the Dyfi Estuary. Maelgwn 'the Ambitious' then asked them to join him in a contest to sit on their thrones on the sands as the tide rolled in. The longest to remain seated would be overlord of North Wales. Maeldaf Hen had constructed a huge chair for Maelgwn, coated with waxed feathers, which floated on the incoming water. The chieftains recognised his ingenuity, and Maelgwn became their overlord. This story is 500 years older than that of the Danish King Cnut (Canute), who died in 1035. The Canute story first surfaced in 1130, told by Henry of Huntingdon, and was based upon Maelgwn's legend.

After the death of Einion Yrth ap Cunedda, the kingship of Gwynedd passed to his sons Cadwallon Lawhir (Long Hand) and Owain Ddantgwyn (White Teeth). After Cadwallon's death, his son Maelgwn had Owain assassinated. (Owain has been equated by some historians with Arthur, because of his friction with Maelgwn.) Portrayed as ruthless, Maelgwn once retired to a monastery, possibly Llanilltud Fawr, for some time before returning to his court at Deganwy to resume his rule. There is a Bryn Maelgwn near Deganwy. Taliesin prophesied Maelgwn's death at the hands of the 'Yellow Beast', and the Yellow Plague ('Fad Felyn') spread northwards through Britain from Europe. In 547, Maelgwn shut himself in his palace of Llys Rhos, forbidding anyone to come in or out. However, he looked through the keyhole when he heard his name called and recoiled, dying in agony, saying, 'The Yellow Beast!' This high king, or Brenhin Pennaf, was left in the palace by his fleeing courtiers, and his body was left for weeks before anyone dared recover it for burial. The event is remembered in the saying 'Hir hun y Faelgwn yn Llys Rhos' – 'the long sleep of Maelgwn in the palace of Rhos'. The ruins of a medieval hall, Llys Euryn, can still be seen on the spot where Maelgwn was said to have perished, near Rhos-on-Sea. Maelgwn is associated by some with Lancelot, who had an affair with Gwenhwyfar and eventually fought against Arthur. He also argued with St Tydecho, the Breton who moved into his lands, and with St Padarn. It seems likely that there was a power struggle between Arthur and Maelgwn. Maelgwn's daughter married Elidr ap Cynfarch, King of Rheged, and Elidir appears to have been killed around 560 by Rhun ap Maelgwn. Urien ap Cynfarch, who took over Rheged from his brother, is associated with fighting for Arthur as 'Sir Urience'.

Maelgwn is said to have founded the monastic college at Caergybi, the priory at Penmon, and also endowed Bangor, making it a bishopric. The *Brut* states that in 546 he was elected nominal sovereign (Gwledig) over the Britons, adding six islands (Ireland, Iceland, Gothland, Orkney, Llychlyn [Norway] and Denmark) to British possessions. Gildas hated Maelgwn, possibly because of his Pelagian leanings, but called him 'Maglocunus, draig yr ynys' (Maelgwn, dragon of the island), probably meaning that he became Pendragon soon after Camlan (*c.* 539). Could Camlan have been a battle of a force of Saxons and Pelagian Celts against Arthur's 'Romanised' Silures of Glamorgan/Gwent and their Dumnonian allies? A poem, 'Ymddiddan Myrddin a Thaliesin', in the *Black Book of Carmarthen* records an attack by Maelgwn Gwynedd on Dyfed. Around 538 he had also invaded north-east Wales, fighting his cousin King Cynlas Goch of Rhos. It may be that Maelgwn was trying to replace Arthur as high-king, Pendragon or leader of the British, who took forces to meet him for the final battle at Camlan in North Wales. After Arthur's disappearance from Camlan, Maelgwn was referred to as 'High-King' and asked for tribute from Gwynlliwg (Arthur's territory in South East Wales). Maelgwn's men captured the daughter of the warrior-saint Cadog's steward at Llancarfan, and full-scale war almost broke out. Maelgwn's son Rhun also led a war band that burned Cadog's monastery, showing the antagonism between the houses of North and South Wales. Gildas states that Maelgwn killed his own wife, then murdered his nephew and married the widow. It is important to note that Gildas was writing around 540, during the lifetime of Maelgwn.

Of all the British kings, Maelgwn was the most despised by Gildas:

And likewise oh thou dragon of the island who hast deprived many tyrants as well of their kingdoms as of their lives and though the last mentioned in my writing, the first in mischief, exceeding many in power and also in malice, more liberal than others in giving, more licentious in sinning, strong in arms but stronger in working thy own soul's destruction, Maglocune … Thy sensual mind … hot and prone runneth forward with irrecoverable fury through the intended fields of crime … The former marriage of thy first wife was now despised by thee … and another woman; the wife of the man then living, and he no stranger but thine own brother's son, enjoyed thy affections … That stiff neck of thine is now burdened with two monstrous murders – the one of thy aforesaid nephew, the other of her who was once thy wedded wife … Afterwards also didst thou publicly marry the widow … and take her lawfully as the flattering tongues of thy parasites with false words pronounced it, but as we say most wickedly…

Aberffraw on Anglesey seems to have been first used as a palace by Cunedda, whose grandson Cadwallon finally drove the Irish out of North Wales. It became a royal court of the King of Gwynedd in the time of Maelgwn ap Cadwallon, and later the great Rhodri Mawr (844–78) ruled over most of Wales from there. It was attacked by Vikings in 968, but was the court of Llywelyn the Great and the palace remained intact until 1316 when its timbers were used to carry out repairs to Caernarfon Castle. Once an important port, it has now silted up.

Gildas denounced four other kings of the time for not forcing the Saxons back out of Britain and fighting amongst themselves. Cyngen the Renowned, the son of

Cadell Ddyrnlug, was King of Powys and is thought to be Aurelius Caninus. Gildas accused him of immorality, murder and causing civil war in Britain. However, he was a patron of saints and gave generous endowments to the church. He was apparently buried with in St Cadfan's church, Tywyn. His memorial stone, a slender pillar over 7 feet long, is now broken but carries inscriptions on all four faces. These have been read as, 'The body of Cingen lies beneath Egryn, Malteg, Gwaddian, together with Dyfod and Marchiau.' It had been used as a gate post for a pigsty and was broken before being brought to the church in 1761. The inscription is written vertically on all four sides. It reads both downwards and upwards. It is of such importance as it is the only inscription in Welsh among the early stone monuments of Gwynedd and is the earliest record of the Welsh language as it emerged as a distinctive form of British Celtic.

Constantine, King of Dumnonia, is also criticised by Gildas. This may have been in the north of England, but more probably south-west, as on his death in 443 Constantine's kingdom was split into Dumnonia and Cerniw and given to his sons. Constantine was believed to have killed the two sons of Arthur's nephew, Mordred. Cuneglasus, or Cynlas Goch was the son of Owain Ddantgwyn, and was deposed by Maelgwn Gwynedd. He was King of Rhos around Denbighsire, possibly based at the hill-fort of Llandrillo-yn-Rhôs or Dineirth in Gwynedd. Gildas noted Cynlas as trying to free Rhos from Gwynedd in civil war. Vortipor was the fifth king in Gildas' tirade. The tombstone of Vortepor the Protector (a Roman military title), ruler of the Demetae, was found at Castell Dwyran in Carmarthenshire, with a Latin inscription, a cross and a parallel Irish script. Hundreds of such stones exist, and are still to be discovered underground, but many have been smashed over the centuries and used for walls. One such stone was discovered by Iolo Morganwg, buried deep in St Illtud's churchyard, Llantwit Major in 1789. This tall 'Samson Pillar' has a badly eroded inscription to Samson the Abbot, Artmail (possibly King Arthur) and Ithel.

Towards the end of the sixth century, the German tribes were still pressing hard against the British, pushing towards the borders of what is now Wales. Ethelwerd recorded, 'A. 552. Five years after, Cenric fought against the Britons near the town of Scarburh [Old Sarum], and, having routed them, slew a large number. A. 556. The same, four years afterwards, fought with Ceawlin against the Britons, near a place called Berin-byrig [Banbury?] A. 560. At the end of about four years, Ceawlin began to reign over the western part of Britain, which is now commonly called Wessex.' The *Anglo-Saxon Chronicle* gives us the following events, showing Saxon expansion, bearing in mind that Saxon defeats were rarely recorded:

A.D. 571. This year Cuthulf fought with the Britons at Bedford, and took four towns [royal cities, according to Ethelwerd], Lenbury, Aylesbury, Benson, and Ensham. And this same year he died. A.D. 577. This year Cuthwin and Ceawlin fought with the Britons, and slew three kings, Commail, and Condida, and Farinmail, on the spot that is called Derham, and took from them three cities, Gloucester, Cirencester, and Bath. [This was a turning-point in Welsh history. The Battle of Dyrham near Bath effectively cut off the Britons in the West Country from those in Wales, and the Saxon kingdom of Wessex (the West Saxons) gradually extended into Wiltshire, Somerset and Devon.]

A.D. 584. This year Ceawlin and Cutha fought with the Britons on the spot that is called Fretherne. There Cutha was slain. And Ceawlin took many towns, as well as immense booty and wealth. He then retreated to his own people. [This is possibly Hereford, formerly called Fenley.] There Cutha was slain. And Ceawlin took many towns, as well as immense booty and wealth. And he returned to his people in anger.

The *Life of Maedoc of Ferns* recounts the same year in a very different way: 'The English raised a great army and came to Britain ... The British assembled quickly against them, and sent to St David, to ask him to send them Maedoc ... Maedoc came ... and, since the British were engaging in battle ill-prepared, Maedoc ... prayed to God for the British against the English: the English were forthwith put to flight, and the British pursuit lasted for seven days, with great slaughter.' The *Anglo-Saxon Chronicle* also tells us the following:

A.D. 591. This year there was a great slaughter of Britons at Wanborough; Ceawlin was driven from his kingdom, and Ceolric reigned six years. [Ethelwerd records slaughter 'on both sides'.] A.D. 596. This year Pope Gregory sent Augustine to Britain with very many monks, to preach the word of God to the English people. A.D. 597. This year began Ceolwulf to reign over the West-Saxons [Wessex]; and he constantly fought and conquered, either with the Angles, or the Welsh, or the Picts, or the Scots ... This year came Augustine and his companions to England.

The Age of the Saints

Wales is covered with hundreds of holy wells dating back around 1,500 years, but they are neglected and forgotten. St Baruc's sixth-century holy well, with healing traditions, was covered by a housing estate at Barry Island in the 1980s, and other cases of corporate vandalism of Welsh heritage abound. What is known as the Dark Ages across the whole of Europe has always been the Age of the Saints in Wales. Monasteries and churches were founded across Wales, while England's British population came under increased attacks from Germanic invaders. There are over 1,000 documented Celtic saints in Wales from this time alone. They were often foundations of the Romano-British nobility. Elder sons took ownership of lands, while other sons and daughters founded religious institutions, often based upon Roman sites. The royal family of Brychan Brycheiniog, whose kingdom included Breconshire, was one of the most important. Many of his children and grandchildren became saints – Clydog, Cynog, Berwyn, Gwladys, Tudful, Tybie, Dwynwen, Cain, Ceingar, Cynidr and Meleri the grandmother of Dewi were amongst them. The *llannau*, or holy places of saints, are remembered in nearly every place in Wales that begins with 'llan', e.g. Llandeilo for St Teilo, Llanfeuno for St Beuno and so on. Again, many wells remember these men and women, e.g. Ffynnon Ddwynwen, Ffynnon Gadog, etc.

Holy wells existed in their thousands in the British Isles and were reputed to be places where a god or goddess could be approached with human pleas. These wells were Christianised by being attributed to the same god or goddess, now replaced

by a saint. They are rarely known or in use today, but some people who are in need of healing leave a cloth token of some sort by the well and believe that as it decays the disability will go too. The author has seen many such ribbons on a tree by West Kennett Burial Chamber in Wiltshire. Churches were often built upon pagan sites, and Celtic festivals were retained under a Christian disguise. Imboic became Candlemas, (St Brigid's Day); Lughnasadh became the Harvest Festival; Samhain was translated into All Saints' Day and All Souls' Day; Easter refers to the ancient spring festival, Christianised as the time of the ascension of Christ; and Christmas, the birth of Christ, was established to give a Christian meaning to the millennia-old celebration of the winter solstice.

Dyfrig (Dubricius of Llandaf) was the most energetic saint in South East Wales. Like many other saints he was originally buried in Enlli (Bardsey Island), where saints became hermits after their work was finished. Enlli became the haunt of pilgrims, and three pilgrimages to Enlli were the equal of two to St Davids and one to Rome. Great monasteries developed at Llanbadarn Fawr, Llanilltud Fawr (where David, Samson, Gildas and Cadoc studied), Llancarfan, Llandeilo and elsewhere. In the Celtic Church marriage was not illegal for churchmen and women, so generations of saints came from the same families. Most churches were sited, for fear of attack from the pagan Irish and Vikings, out of sight of the sea. Thus the claimed Celtic church on the beach at Mwnt in Ceredigion would not have been dated from this age. On the other hand, churches like Merthyr Dyfan, set in a hidden hollow near fresh water, date from the sixth century and could be even earlier. Wales, or at least Britain, provided Ireland with St Patrick around 465 when he was captured by the Irish.

Hundreds of Welsh saints travelled to Brittany to found churches, and four of the five 'founder saints' of Brittany are Welsh-British (the other is Cornish-British). Missionaries also went to France (a separate country), such as Armel to the court of Childebert in Paris. Welsh saints went to Cornwall, and Cadoc to Scotland. Incidentally, David is recognised as a saint by the Catholic Church, but Patrick is not. Following the Welsh example, Christianity rooted itself in Ireland, Scotland, Cornwall and Brittany during this period. P. A. Wilson has written that it was the obstinacy and heroic confidence of the Welsh, and in particular the southern and western Welsh, that provided the impetus for the great missionary Celtic Christian, which found its greatest renown in Ireland and through this spread outwards across Europe.

In 597 Augustine came to Britain to try and Christianise the English pagans. This is further proof that Christianity moved westward with the Britons. However, he was furious that Welsh bishops offered no help for his new church of Canterbury in their former homelands. Christianity in Wales had survived the leaving of the Roman legions between 380 and 410, whereas in the next few decades Christianity was wiped out all over the rest of Europe, except for a few anchorites living on islands off Ireland. Later writers such as Bede resented the survival of this church when the rest of Britain was finally Christianised, as its power would reduce that of Rome in Britain. Apart from the form of tonsure and the timing of Easter, the other major difference was that the Welsh would have nothing to do with the new Italian faith of the Saxons. The Germanic tribes had overrun England, and cut off Wales, which had been fighting the barbarian Irish, Scots, English and Vikings for centuries. Why should the Welsh give

up their faith and take up that of their enemies? Although the Irish took up a Welsh type of Christianity in the sixth century, and relations improved considerably with the Irish, the other invaders were still alien and so was their faith.

A letter by Aldhelm, the Saxon Catholic priest and later Bishop of Shelborne, to Geraint, King of Cornwall survives. It shows that the differences were small, and Cressy's translation reads,

> But beside these enormities (The Tonsure and the Paschal cycle) there is another thing wherein they do notoriously swerve from the Catholic Faith and Evangelical Tradition, which is, that the Priests of the Demetae, or South-West Wales, inhabiting beyond the bay of Severn, puffed up with conceit of their own purity, do exceedingly abhor communion with us, inasmuch that they will neither join in prayers with us in the Church, nor enter into society with us at the Table; yea moreover the fragments which we leave after refection [dining] they will not touch, but cast them to be devoured by dogs and unclean Swine. The Cups also in which we have drunk, they will not make use of, till they have rubbed and cleansed them with sand or ashes. They refuse all civil salutations or to give us the kisses of pious fraternity, contrary to the Apostolic precept, 'Salute one another with a holy kiss.' They will not afford us water and a towel for our hands, nor a vessel to wash our feet. Whereas our Saviour having girt Himself with a towel, washed his Disciples' feet, and left us a pattern to imitate, saying 'As I have done to you, so do you to others.' Moreover if any of us who are Catholics do go among them to make an abode, they will not vouchsafe to admit us to their fellowship until we be compelled to spend forty days in Penance … Since therefore the truth of these things cannot be denied, we do with earnest humble prayers and bended knees beseech and adjure you, as you hope to attain to the fellowship of Angels in God's heavenly kingdom, that you will no longer with pride and stubbornness abhor the doctrines and Decrees of the Blessed Apostle St Peter, nor pertinaciously and arrogantly despise the Tradition of the Roman Church, preferring before it the Decrees and ancient Rites of your Predecessors…

The Welsh abbots met Augustine and were astounded by his arrogance and lack of humility.

In Wales Christianity was monastic and rural, but in England it was priestly and urban. There was no real religious authority in Wales, as everything was decentralised and communal. Everything was gathered within the *llan*, which means an enclosed place, as in *ydlan* (rickyard) and *gwinllan* (vineyard). The ascetic St David (515–85) was known as David the Waterdrinker as he and his followers drank no wine, ate no meat and had no possessions. Monasteries consisted of the *clas*, a sort of commune usually ruled by a married abbot or abbess. Women and children were respected and educated. David was descended from Cunedda on his father's side and Brychan Brycheiniog on his mother's. Other members of Cunedda's family evangelised in Gwynedd, amongst them Seiriol, Einion Frenin, Meirion, Eurgain and Edern. To mention just one saint, Llanhilleth is now dedicated to Illtud, but was originally called Llanhilledd Vorwyn (Holy Place of Hilledd/Heledd the Virgin). She was the sister of Cynddylan, who died in battle against the Saxons at Pengwern (Shrewsbury). The Saxons then burned his great palace on the site of the Roman town of Wroxeter. The great saga poem first written down in the ninth century, *Canu Heledd*, or Song

of Heledd, represents this destruction, especially in the part 'Cynddylan's Hall'. The poem was originally attributed to Llywarch Hen, as part of the *Red Book of Hergest*, but the intense emotions shown mean that it may have been the work of Heledd, making her the first known woman poet. She describes an eagle tearing Cynddylan's flesh open on the battlefield:

> The eagle of [River] Eli, his cry is piercing [tonight],
> he has drunk [from] a stream of blood:
> the heart blood of Cynddylan the Fair.
> The eagle of Eli was crying out loudly tonight,
> it was wallowing in the blood of warriors.
> He is in the wood; heavy sorrow overwhelms me.
> The eagle of Eli I hear tonight,
> he is gory; I shall not defy him.
> He is in the wood; heavy sorrow overwhelms me...

Religion

Although initially banned, Christianity had become the official religion of the Roman Empire. In tradition, Christianity arrived in Wales in the first century, with St Ilid (perhaps Joseph of Arimathea) and others. The first known Christian martyrs in Wales, Julian and Aaron, were killed early in the fourth century at Caerleon. The earliest Christian object found in Wales is a vessel with the symbol of the chi-rho, dated 375 and found in the Roman town of Caerwent, where there was also a Christian temple. By the end of the fourth century, Christianity had become the official religion of the Roman Empire. By the time of St Augustine's mission in 597 to convert the Germanic tribes of south-eastern Britain, Christianity had been long established in Wales, Cumbria, the West Country and Strathclyde, as demonstrated by the poems of Taliesin and *Y Gododdin*.

The Roman Church was organised on the basis of bishops located in cities, each bishop with his own clearly defined diocese and a hierarchy of officials. The Celtic-speaking countries had virtually no urban centres. The Welsh abbot in his monastery had little time for Romanised bureaucracy. Arnold Toynbee wrote that the Celtic religious tradition was the central feature of what he called the 'Far Western European civilisation'. It is thought that the only place in Britain where Christianity survived completely was South East Wales and Herefordshire, as Irish incursions into Wales and coastal areas and the Saxon invasion wiped it out in other areas. Dyfrig, the first known saint of the Celtic church, had the centre of his monastery (*clas*) at Henllan (Hentland-on-Wye, now in Herefordshire) some time after 425. His successor as the leading figure among the British Christians was Illtud, founder of the monastery at Llanilltud Fawr, where there is a remarkable collection of early monumental stones. St Dyfrig and St Illtud introduced monasticism, the concept that the best path to holiness is to retire from the world and live in a community dedicated to prayer. The Llanilltud monastery stressed learning as well as devotion and was the early main centre of Christianity for the Celtic-speaking countries. St Samson, the father of

Breton monasticism, left Llanilltud for Brittany around 540. A fellow student was St Pol Aurelian, who evangelised Cornwall, and from Illtud and his successors the Irish sought guidance on matters of ritual and discipline.

Monasticism reached the British Isles first in south-west Britain and South Wales and then, during the early sixth century, Ireland. They lived retired lives in separate huts, coming together for communal prayer and special ceremonies. Almost all the islands around the western coast of Britain and Ireland have traditions of saints of this period. 'Saint' was the term used at that time of any educated cleric or religious person. In Welsh, the word *merthyr* means an anchorite's retreat, as well as the place of martyrdom of a saint. Equally the prefix *cil-* in Welsh, like the Gaelic *kil-*, originally was a monastic cell or a hermit's retreat. Together with the increase in number of anchorite cells came the increase in the numbers and popularity of monasteries. As with their early development in the Near East, they did not depend for their support, like the established Roman Church, on an urban organisation or the official church bureaucracy recruited from the curial class. When fully developed, these monasteries consisted of a small church or churches, individual huts for the monks, a communal dining hut, kitchen and a scriptorium, the whole surrounded by a bank or enclosure known as a *llan*. Scriptoria were important because the monks needed to duplicate gospels and other religious books for their own use. In this manner, they became the bearers and disseminators of literacy and Christian culture. Churches with circular churchyards are almost always very early. Such llanau left the devil nowhere to hide.

In 457 the Bishop of Rome issued the 'Victorinus table', changing religious dates to those practised in Alexandria. The Frankish bishops in Europe adopted the new dates, but they were not accepted in Britain. St Columbanus argued cogently for the British case based on the Jewish calendar, while the Latin Church changed to the days celebrated in Africa. The British version was based upon the date of the Jewish Passover, but its bishops were anathematised by the Nicene Council for keeping this pre-Roman belief. The Celtic Church of Spanish Galicia conformed to the reformed Easter at the Council of Toledo in 663, and Louis the Pious ordered the Abbot of Landevenec, in the Crozon Peninsula of Brittany, to adopt the Roman tonsure and Rule of St Benedict in 818, but Brittany held out longer than all the other Celtic areas except in altering Easter. Wall gives the adoption of Roman Easter by the Celtic Church as follows: Southern Ireland 634; Northumbria 664; Strathclyde 688; Northern Ireland 692; Somerset and Devon 705; Iona 710; Picts 710; North Wales 768; South Wales 777 to 850; and Cornwall not until 925–40.

The Gwlad

Because of the difficulties of communication and travel within the heavily forested and hilly country, regions became power bases, and there was no permanent and central position of 'high king' or *bretwalda*, unlike in Irish and Saxon society. There was a common language, set of laws and society, but no great push towards unity. The few kings who were able to enlarge their lands generally only achieved their ends through force, and their gains were lost soon after their deaths. Davies writes,

Wales, therefore, was a geographically fragmented country, a land of contrasts national, regional, and local. In such a fragmented country it was the locality or district which was often the most meaningful and basic unit of loyalty and obligation. *Gwlad* or *bro* were the loose vernacular terms used to refer to such a district. A gwlad might be a kingdom or a former kingdom; alternatively or additionally, it might coincide with the local subdivisions of *cantref* or *cwmwd* which came to figure prominently in the history of medieval Wales. Yet it is not its political or administrative identity which gave the gwlad its cohesion so much as the fact that it was a territorial unit shaped by geography, history, and sentiment, and one which contemporaries recognised and with which they could identify … It was the region, large or small, which was often the most obvious focus of communal identity and loyalty for many of its inhabitants. Its boundaries demarcated the horizons of their social contacts and territorial claims, its mother church and its patron saint the focus of their religious affections, its traditions and lore the framework of their collective memories. This attachment to region was all the stronger in a world where political hegemonies and dynastic fortunes were so brittle…

Language

From the early fifth century, Brythonic or Old Welsh changed into Welsh throughout Scotland, north-west England, Wales and Cornwall. This was an inner change, not influenced by other languages, and probably helped by the Christian movement. As Brythonic was an oral tradition, little is known of it. Dumnonia (Devon) was Welsh-speaking and held out against the Saxons until around 900. The Cornish still spoke Welsh until the eighteenth century, and Cornwall was not annexed by England until 930. The British of Cumbria (the modern-day Lake District) until recently counted their sheep in a variation of Welsh. Cumbria was annexed to England in 1170. The Britons of Strathclyde (*ystrad*, or 'district' of the River Clyde) were still counted as 'Wallenses' or Welsh among the subjects of the Scottish King David the Lion (1124–53). William Wallensis, known as 'Braveheart' was of Welsh stock. Not until the thirteenth century was the British language replaced in the Glasgow bishopric of Cumbria by the dialect of Anglo-Saxon now known as 'lallans' or Lowland Scottish. Celtic Brittany was independent of France until the fifteenth century, had been evangelised by Welsh saints and settlers, and Welsh speakers can still be understood there. Equally, Bretons came and established dynasties of saints in Wales and helped Arthur in his struggles.

Nennius and the Ancient Cities of Britain

Nennius (Nynniaw), a disciple of Elfod, Bishop of Bangor, wrote the *Historia Brittonum* on early British history and geography around 800: 'The island of Britain derives its name from Brutus, a Roman consul … These are the names of the ancient cities of the island of Britain. It has also a vast many promontories, and castles innumerable, built of brick and stone. Its inhabitants consist of four different people; the Scots, the Picts, the Saxons, and the ancient Britons.' (* Indicates that the name was in the earliest list.)

1.* Cair ebrauc - York	17.* Cair grauth - Grantchester, Cambridge
2.* Cair ceint -Canterbury or Ceint, Anglesey	18.* Cair daun or dauri – Doncaster, Yorkshire or Dorchester
3. Cair gurcoc - Ceirchiogg, Anglesey	19.* Cair britoc or briton – Bristol; or St Colan, Cornwall; or Dumbarton, Strathclyde
4.* Cair guorthegern - Gwytheryn in Denbighshire; or Caer Gwrtheyrn, Carmarthenshire; or Little Doward at Ganarew in Hereford	20.* Cair meguaid – Meifod, Montgomeryshire
5.* Cair custoeint -Llangystenin, Caernarfon, or a hillfort in Dumnonia (the West Country)	21.* Cair mauiguid or maunguid – Manchester; or Menigid, Anglesey; or Mwynglawd, Denbighshire
6.* Cair guoranegon or guiragon – Worcester, or Warrington, Cheshire	22.* Cair ligion – Chester, or Llanlligan in Montomeryshire
7.* Cair segeint - Silchester, or Segontium (Caernarfon)	23.* Cair guent – Caerwent, Monmouthshire
8.* Cair guin truis or guinntguic – Winchester; or Gwynnys, Cardiganshire; or Norwich	24.* Cair colon or colun – Colchester in Essex; or St Colan, Cornwall, or Llangollen in Denbighshire
9. Cair merdin - Carmarthen	25.* Cair londein - London
10.* Cair peris – Llan Peris (Llanberis) in Caernarfonshire; or Caer Beris near Builth Wells; or Portchester in Hampshire	26. Cair guorcon – Warren, or Woran, in Pembrokeshire
11.* Cair lion - Caerleon-upon-Usk, Monmouthshire	27.* Cair lerion - Leicester
12.* Cair mencipit – St Albans, Hertfordshire, or Mansell in Herefordshire	28.* Cair draithou – Dunster in Somerset or Drayton, Shropshire
13*. Cair caratauc – Catterick, Yorkshire; or Carrog, Ceredigion; or Cary Craddock near Sellack in Hereford; or one of two sites named Caer Caradoc in Shropshire. One is near Knighton and one near Church Stretton	29.* Cair ponsavelcoit – Pevensey in Sussex; or Penselwood near Wincanton in Somerset; or possibly Ilchester in Somerset
14. Cair ceri – Cirencester in Gloucestershire, or Kerry, Montgomeryshire	30. Cair teim - Cardiff, Glamorgan; or Teyn-Grace in Devon
15.* Cair gloui – Gloucester, or Gluvias, Cornwall	31.* Cair urnahc or guricon – Wroxeter in Shropshire; or Llanfyrnach in Pembrokeshire or Cowbridge in Glamorgan
16.* Cair luilid or ligualid - Carlisle in Cumbria	32.* Cair colemion – Cilmaen-Llwyd in Pembrokeshire or South Cadbury (Camelot) in Somerset
	33.* Cair loit coit – Wall (Letocetum), near Lichfield in Staffordshire; or Lincoln; or Ludlow; or Lytchett in Dorset

The other cities mentioned in early texts are: Caer anderida (Pevensey), Caer baddan (Bath), Caer correi (Caistor), Caer conan (Conisburgh), Caer eityn (Edinburgh), Caer fawydd (Hereford), Caer lind colun (Lincoln), Caer paladur (Shaftsbury?), Caer portus (Portchester), Caer sallog (Old Sarum or nearby Salisbury), Caer uisc (Exeter) and Caer weir (Durham).

Gildas and Pelagius

St Gildas left Wales and founded a monastery in Brittany, St Gildas de Rhuys. He is considered to be a founding father of British monasticism. His history, *De Excidio*

et Conquestu Britanniae (The Ruin and Conquest of Britain), was written around 550 CE and spurred the development of the monastic system in Britain. It is the only extant narrative account of Britain in the sixth century. Gildas tells us first-hand what is happening: 'the siege of Bath-Hill, when took place also the last almost, though not the least slaughter of our cruel foes, which was (as I am sure) forty-four years and one month after the landing of the Saxons, and also the time of my own nativity'. The book was probably written in Brittany, considering his scathing criticism of Welsh kings. Returning to Wales would have been difficult for him. He tries to demonstrate that the invasions of Britain by the Scots, Picts, and Saxons were punishment from God for faithlessness, moral failings and the hiring of Saxon mercenaries. Gildas, like the later Nennius, attributes the fall of the Isle of Britain to the 'proud tyrant' (probably Vortigern) who invited the Saxons to Britain. Some historians have suggested that Gildas may have slandered Vortigern because he was a Pelagian. Gildas also narrates the efforts of the British king, Ambrosius Aurelianus (identified by some with King Arthur), to repel the Saxons.

In 429 Prosper of Aquitaine wrote, 'Agricola, a Pelagian, the son of the Pelagian bishop Severianus, corrupted the British churches by the insinuation of his doctrine. But … Pope Celestine sent Germanus, bishop of Auxerre, as his representative, and having rejected the heretics, directed the British to the catholic faith.' Constantius writes of the same time:

> About this time a deputation from Britain came to tell the bishops of Gaul that the heresy of Pelagius had taken hold of the people over a great part of the country and help ought to be brought to the Catholic faith as soon as possible. A large number of bishops gathered in synod to consider the matter and all turned in help to the two who in everybody's judgement were the leading lights of religion, namely Germanus and Lupus [Garmon and Bleiddian].
>
> And it was not long before these apostolic priests had filled all Britain, the first and largest of the islands, with their fame, their preaching and their miracles; and, since it was a daily occurrence for them to be hemmed in by crowds, the word of God was preached, not only in the churches, but at the cross-roads, in the fields and in the lanes. Everywhere faithful Catholics were strengthened in their faith and the lapsed learnt the way back to the truth.

Pelagius, or Morgan, appears in this author's *100 Great Welshmen* as his approach to Christianity did not involve bureaucracy. The philosopher supposedly studied at Bangor-is-Coed, and preached and wrote that man possessed free will, and should have considerable responsibility for his own destiny. At first his teachings were accepted across Europe, but St Augustine made it his life's work to impress the Roman system of religion upon Christians. Pelagius believed that man did not need the church to control people, and that payments to the Church were intrinsically corrupt. He taught that God should judge us, not a system of paid officials. His teachings were vigorously denounced by various influential church leaders such as Germanus, Bishop of Auxerre. In 429, with Lupus, Bishop of Troyes, Germanus came to Britain especially to fight the 'heresy'. Germanus made a second trip, accompanied by Severus, the new Bishop of Trier in 448, with the same purpose. Roman Christianity, like the Roman

Empire, was in the main an urban device, the organisation of which was based on Roman bureaucracy. Popes, cardinals and bishops reflect the Roman view of 'proper' hierarchical organisation. If the Christian Church had taken the Pelagian route, there would have been less bloodshed over the centuries, as income generation, worldly power and domination of souls were no part of his philosophy.

The Great Plague of 540

Because the Britons were still trading internationally, the Great Plague which spread through Europe decimated the British population, allowing the non-trading Germanic nations to make further westward gains. Between the end of the fourth century and the beginning of the sixth, the Roman Empire had lost Britain, Spain, France, and Italy to a series of barbarian invasions. However, between 532 and 540, the Empire had reconquered North Africa, southern France, Italy, and Spain. Rome was set to re-establish itself over almost the entire territory ruled by Augustus when plague struck. The Plague of Justinian (541–2) is the first known pandemic on record, the first firmly recorded pattern of bubonic plague. It was nearly worldwide in scope, striking Central and South Asia, North Africa and Arabia, and Europe as far north as Denmark and west to Ireland. The plague would return with each generation throughout the Mediterranean basin until about 750. The plague, named after the Eastern Roman Emperor Justinian I, had a massive impact on the future course of European history. The outbreak may have originated in Ethiopia or Egypt (some say China) and moved northward until it reached the Constantinople. The city imported massive amounts of grain to feed its citizens, mainly from the then fertile plains of Egypt, and grain ships may have been the original source of contagion, with the enormous public granaries nurturing the rat and flea population.

Procopius records that, at its peak, the plague was killing 10,000 people in Constantinople every day, and there was no room to bury the dead, with bodies being left stacked in the open. As the plague spread to port cities around the Mediterranean, it gave the Goths new opportunities in their conflict with Constantinople. The plague weakened the Byzantine Empire at the critical point when Justinian's armies had nearly wholly retaken Italy and could have reformed the Western Roman Empire. Italy was decimated by war and fragmented for centuries as Lombard tribes invaded the north. The initial plague went on to destroy up to a quarter of the human population of the eastern Mediterranean. New, frequent waves of the plague continued to strike throughout the sixth, seventh and eighth centuries. A figure of 25 million dead for the Plague of Justinian is considered a reasonable estimate. Some researchers suggest a total European population loss of 50–60 per cent between 541 and 700. After around 750, major epidemic diseases would not appear again in Europe until the Black Death of the fourteenth century. The plague brought trade to a near halt, destroyed an empire and helped bring about the Dark Ages.

Plague facilitated the Anglo-Saxon conquest of Britain, since its aftermath coincided with the renewed Saxon offensives in the 550s, after a period during which the Saxons had been contained. Irish and Welsh sources from this period report plague, but Saxon ones are silent. The Romano-British may have been disproportionately

affected because of continuing trade contacts with Gaul and the Mediterranean. Also, British settlement patterns were more dispersive than those in England, which 'could have served to facilitate plague transmission by the rat'. Additionally, there was little interaction between the displaced British and the German invaders. The *Annales Cambriae* note that in 539 (the date is slightly wrong) 'the battle of Camlann, in which Medrasut and Arthur fell. And there was plague in Britain and Ireland.' Later, in 549 we read of 'the great death in which Maelgwn, king of Gwynedd died. Thus they say "the long sleep of Gwynedd in the court of Rhos". Then was the Yellow Plague.'

The *Anglo-Saxon Chronicle* reports a total eclipse in July 540, which has been corroborated by NASA findings. This may be linked to the extreme weather events of 535–536, the most severe cooling in the Northern Hemisphere in recorded history. Caused either by volcanic eruption at Krakatoa or elsewhere or by debris from space impacting upon Earth, there were crop failures and famines worldwide. Procopius recorded the dullness of the sun, and the *Annals of Ulster* and the *Annals of Innisfallen* record 'a failure of bread' from 536–9. Tree-ring analysis of Irish oak shows abnormally little growth in 536 and another sharp drop in 542, and in the polar regions there is evidence of an extensive acidic dust veil at this time. The evidence of sulphate deposits in ice cores strongly supports the volcano hypothesis. The sulphate spike is even more intense than that which accompanied the climatic aberration in 1816, known as the 'Year without a Summer'. It seems that famine and plague severely weakened the British population from 536 onwards, to the benefit of the Germanic tribes of England.

Anglo-Saxon Ethnic Cleansing?

For centuries it has been thought that the virtual wiping out of British place-names and words in the English language was proof of either genocide of the British, or of their being pushed westwards into Wales, the West Country, Cumbria and Strathclyde. The answer is probably a combination of the two. We have the story of St Beuno moving westwards to escape the foreign language, and other remnants of Welsh history, such as the burning of the hall of Cynddylan (Wroxeter) and the legends of Arthur. Recently, Dr Mark Thomas of the Centre for Genetic Anthropology at University College London and a team of genetic scientists claim to have finally found proof that the Welsh are the 'true' Britons, and that Celtic Britain underwent a form of ethnic cleansing by Anglo-Saxon invaders following the Roman withdrawal in the fifth century. It suggests that between 50 per cent and 100 per cent of the indigenous population of what was to become England was wiped out in the fifth to seventh centuries, with Offa's Dyke acting as a 'genetic barrier', protecting those on the Welsh side. A mass migration of foreigners replaced this 50–100 per cent of the male population.

Academics at UCL compared a sample of men from the UK with those from an area of the Netherlands, where Anglo-Saxons are thought to have originated. The scientists found the English subjects had genes that were almost identical to those in the Netherlands, but there were clear differences with the genetic identity of Welsh

people studied. The research team studied the Y chromosome, which is passed almost unchanged from father to son, and looked for certain genetic markers. They chose seven market towns mentioned in the Domesday Book of 1086 and studied 313 male volunteers whose paternal grandfathers had also lived in the area. They compared this with samples from Norway and with Friesland, now a northern province of the Netherlands. The English and Frisians studied had almost identical genetic make-up, but the English and Welsh were very different. The researchers concluded the most likely explanation for this was a large-scale Anglo-Saxon invasion, which devastated the Celtic population of England but did not reach Wales, had occurred in the fifth to seventh centuries.

The study reinforced the Welsh histories, indicating the Welsh were the true indigenous Britons. The UCL research into the recent Anglo-Saxon period suggested a migration on a huge scale: 'It appears England is made up of an ethnic cleansing event from people coming across from the Continent after the Romans left.' Archaeologists after the Second World War had rejected the traditionally held view that an Anglo-Saxon invasion pushed the indigenous Celtic Britons to the fringes of Britain. This event is related by Gildas, in Old Welsh poems and in the lives of the Welsh saints. Instead, they believed that the arrival of Anglo-Saxon culture could have come from trade, or from a small ruling elite. This latest research from UCL, 'using genetics as a history book', supports the original view of a massive invasion of England, suggesting that the Welsh border area was the genetic barrier to the Anglo-Saxon Y-chromosome gene flow, rather than the North Sea. Dr Thomas stated, 'Our findings completely overturn the modern view of the origins of the English.'

4

The Royal Families &
the Continuing Saxon Invasion
600–1066

The British Isles now found itself being gradually divided into four areas that later became Brythonic Wales, Germanic England, Gaelic Scotland and Gaelic Ireland. The regions were firmly established by the time that Bede wrote his *Ecclesiastical History of the English People* around 731, giving an account of the beginnings of the Germano-English kingdoms. Brythonic kingdoms survived only in Strathclyde, Cornwall and Wales. The *Annales Cambriae* were compiled around 960, and included pedigrees of Welsh royal families. The completion of Offa's Dyke during the last years of the eighth century ensured that a physical boundary would permanently exist between the Celtic people to its west and the Germanic people who, by the time of Bede, had conquered most of the land to its east. Offa's Dyke was the longest man-made boundary in medieval Europe, and played an important role in forming the extent and identity of Wales. The years following the Age of the Saints were turbulent. Wales was constantly under attack, but the law of gavelkind meant that land was divided equally among children. Thus brothers disputed Welsh kingdoms and sub-kingdoms, sometimes allying with foreign mercenaries to try to ensure that their dynasties survived. In preceding centuries, there seems to have been a more orderly handover of power. The favourite or most capable, not necessarily the oldest son, was often handed power while the king was still alive, to ensure a peaceful succession. The king could then retire to a monastery, while the other children joined the church and with an income from church lands were often remembered as local saints. However, the growing threat of invasion forced the consolidation of larger kingdoms to fight off the threat of invasion and settlement. Not until the middle of the eleventh century did Wales have an overlord, Gruffydd ap Cynan, recognised as King of Wales. For various reasons, dates below will sometimes conflict by one to three years with those in the annals and chronicles.

The Seventh Century

The following entries from *Annales Cambriae* amply demonstrate the constant fighting across Wales in this period:

601 – The synod of Urbs Legionis [Chester]; 613 – The battle of Caer Legion [Chester]. And there died Selyf son of Cynan; 626 – Edwin is baptised, and Rhun son of Urien baptised him; 629 – The besieging of king Cadwallon in the island of Glannauc [Priestholm Island off Anglesey]; 630 – On the Calends of January the battle of Meigen [Hatfield Moor]; and there Edwin was killed with his two sons; but Cadwallon was the victor; 631 – The battle of Cantscaul [near Hexham] in which Cadwallon fell; 632 – The slaughter of the Severn and the death of Idris; 644 – The battle of Cogfry [Oswestry] in which Oswald king of the Northmen and Eawa king of the Mercians fell; 645 – The hammering of the region of Dyfed, when the monastery of David was burnt; 649 – Slaughter in Gwent; 656 – The slaughter of Campus Gaius [Caer Gai]; 657 – Penda killed; 658 – Oswy came and took plunder; 662 – Brochwel Ysgythrog [the Fanged] dies; 665 – The first celebration of Easter among the Saxons. The second battle of Badon. Morgan dies; 682 – A great plague in Britain, in which Cadwaladr son of Cadwallon dies.

Ethelwerd's Chronicle also records for this period:

> A. 615. Afterwards Cynegils received the kingdom of the West-Angles [Wessex], and, in conjunction with Cuichelm, he fought against the Britons at a place called Beandune, and having defeated their army, slew more than two thousand and forty of them. [Probably Bindon, near Axmouth in Devon. This battle took place in 614.] A. 629. Fourteen years after, Cynegils and Cuichelm fought against Penda at Cirencester; A. 658. After three years more, the kings Kenwalk at Pionna renewed the war against the Britons, and pursued them to a place called Pederydan [Petherwin, Cornwall, named after the Welsh St Padarn]; A. 682. After two years king Kentwin drove the Britons out of their country to the sea.

The *Anglo-Saxon Chronicle* tells us that St Augustine went on a mission to England in 601 to convert the pagan Germans, with Edwin of Northumberland being converted and two bishops being consecrated in 604. Its timings differ with Welsh records for 613, for in 607 it states that 'Ethelfrith led his army to Chester; where he slew an innumerable host of the Welsh; and so was fulfilled the prophecy of Augustine, wherein he saith "If the Welsh will not have peace with us, they shall perish at the hands of the Saxons." There were also slain two hundred priests, who came thither to pray for the army of the Welsh. Their leader was called Brocmail, who with some fifty men escaped thence.' The armies of Gwynedd, Powys, Pengwern & Dumnonia rose to repel Ethelfrith, but were bitterly defeated at the Battle of Chester. King Iago of Gwynedd, King Selyf Sarffgadau (the Serpent of Battles) of Powys and Prince Cadwal Cryshalog of Rhos were killed. Ethelfrith ordered his army to massacre the unarmed British monks of Bangor-is-Coed, who had come to pray for a British victory. Bede claimed that 2,100 monks came to pray and about 1,200 were killed, but the Chronicle tells us 200 monks were killed and only fifty troops escaped, along with Brochwel Ysgythrog (the Fanged).

Bede celebrated this victory by pagan Saxons against Christian Britons, the Welsh, because Welsh bishops had refused to carry out missionary work among the Saxons, or alter their rites to those of Rome. The great monastery at Bangor-is-Coed was sacked, and could never be used again. The *Anglo-Saxon Chronicle* also record a battle in 614 against Powys and perhaps Gwynedd by the Northumbrians, leaving the Northumbrians with lands around Chester. Battles around Chester cut off Wales from their fellow Britons

in Cumbria and Strathclyde, just as the Battle of Dyrham of 577 had cut Wales off from the Britons in the west of England. In 614 Bledric ap Cystennin, King of Dumnonia, died at Bindon in Devon as Cynegils of Wessex expanded westwards. Fortunately, growing enmity between the kingdoms of Northumbria, Mercia (Southumbria) and Wessex helped the British cause.

Penda of Mercia defeated the West Saxons (Wessex) at Cirencester in 628, taking over what is now Gloucestershire. However, Mercia was being threatened in the north by Edwin of Northumbria's expansion. Edwin was also a threat to Cadwallon ap Cadfan, King of Gwynedd, besieging him on Priestholm in 629, and taking Anglesey. Cadwallon escaped, regrouped his army, and recovered to push Edwin out of Wales. Gwynedd and Mercia joined forces around 630, taking the offensive against Northumbria. They killed Edwin and his son Osfrith at the Battle of Hatfield Moor, near Doncaster. Penda and Cadwallon carried on attacking Northumbria, with Cadwallon pushing up to York. However, around 633 Cadwallon was killed by Oswald of Northumbria and possibly a Scots army at Cantscaul (near Hadrian's Wall near Hexham). It is amazing to see a Welsh army of this time campaigning on the borders of Scotland, over 200 miles from Cadwallon's court at Deganwy. Bede tells us that Cadwallon's intention had been to exterminate the English race. The *Brut* records, 'And from that time onwards the Britons lost the Crown of the kingdom and the Saxons won it.' The site was renamed Heavenfield by the English in gratitude. Oswald next pushed down to Oswestry, where he was killed by a combined Mercian–Welsh force under Penda at Maes Cogwy, Oswestry in 642.

Penda's allies probably included Cynddylan ap Cyndrwyn of Powys, as the 'men of Pengwern' were involved in the battle. Pengwern, now known as Shrewsbury, was Cynddylan's capital, along with Wroxeter. Cynddylan later allied with Morfael of Caer Lwydgoed (Lichfield) and died during the defeat of an Anglo-Saxon army under the walls of the town, possibly in 655. According to poems, Cynddylan and his brothers stood and fought at the ford of the River Tren, which may have been the Tern or the Trent. Cynddylan also features in a wonderful series of poems about his palace burning when Wroxeter was sacked. He may have died at either Wroxeter or Lichfield, both parts of Powys until the Saxon incursions. From around 655 onwards the Angles and Mercians began converting to Christianity. In 658, the Britons of the West Country were defeated in Cornwall.

At Llangadwaladr church in Anglesey, there is a seventh-century memorial to Cadwallon's father, reading, 'Catamanus rex sapientisimus opinatisimus omnium regum' (King Cadfan wisest and most renowned of all kings). Cadwallon's son Cadwaladr reigned from 655 to 682, when he died of the plague. Geoffrey of Monmouth said that he was the last in the line of the legendary kings of Britain, and Cadwaladr was 'culted' as a saint. The Welsh flag, Y Ddraig Goch (The Red Dragon) is recognised as the oldest national flag in the world, and is commonly referred to as 'The Red Dragon of Cadwaladr'.

The Eighth Century

Around 720, there was contact between Yvi of Brittany and the Welsh Church, which was the last known link between the two countries. From *Annales Cambriae* we read,

722 – the Beli son of Elffin dies. And the battle of Hehil among the Cornish [against Wessex, this gave respite to the West Britons of Devon and Cornwall, and allowed the British language to survive until the nineteenth century] the battle of Garth Maelog [probably Caer Faelog, near Llanbister in Radnorshire, or near Llantrisant in Glamorgan], the battle of Pencon among the south Britons [this is posited to be in Carmarthenshire, but is surely too far west], and the Britons were the victors in those three battles; 728 – The battle of mount Carno; 750 – Battle between the Picts and the Britons, that is the battle of Mocetauc. And their king Talorgan is killed by the Britons [battles between the Picts and the Britons of Alt Clut (Strathclyde), are recorded in 744 and again in 750, when Kyle (East and South Ayrshire) was taken from Alt Clut by Eadberht of Northumbria. The 750 battle between the Britons and the Picts is probably at Mugdock, near Milngavie, north of Glasgow. Talorgan was the brother of Óengus I, King of Pictland. The story of the Britons of Ystrad Clud is fascinating, ruling from or Alt Clut, now known as Dumbarton Rock. The British-speaking kingdom survived until the mid-eleventh century, and its leaders were recorded as Kings of the Britons in the *Irish Annals*.]; 754 – Rhodri king of the Britons dies [this is Rhodri Molwynog, King of Gwynedd]; 760 – A battle between the Britons and the Saxons, that is the battle of Hereford and Dyfnwal son of Tewdwr dies [there had been decades of hostility between the kingdoms of Gwent, Brycheiniog and Powys with Coenred of Wessex and Aethelbald of Mercia. The Mercians were badly beaten, and halted the fighting for some years.]; 768 – Easter is changed among the Britons on the Lord's Day, Elfoddw, servant of God, amending it [the Welsh Church, following the example of the Irish bishops, finally decided to conform to the Rules of Rome. Elfoddw was Bishop of Bangor. Dyfnwal was the King of Strathclyde and his death is probably unrelated to the battle. The recording of the event shows that the British still thought of themselves as a single people]; 778 – The devastation of the South Britons by Offa; 784 – The devastation of Britain by Offa in the summer; 796 – Devastation of Rheinwg [possibly a sub-kingdom in Radnor] by Offa. The first coming of the gentiles [Norsemen, Danes] among the southern Irish; 797 – Offa king of the Mercians and Maredudd ap Tewdws king of the Demetians [Dyfed] die [neither in battle], and the battle of Rhuddlan; 798 – Caradog king of Gwynedd is killed by the Saxons.

In the second half of the century, Offa of Mercia kept threatening Wales from the start of his reign in 757 until his death in 796 (not 797 as recorded above). The son of the wonderfully named Thingfrith, Offa was at first defeated at Hereford in 760, but campaigned in Wales in 778, 784 and 796. Offa was a formidable enemy, Charlemagne calling him his 'brother'. Offa took a large part of Powys, including the capital of Pengwern (Shrewsbury). From 776 Offa was the most powerful Anglo-Saxon king until Alfred the Great, ruling over Kent, Sussex, East Anglia and the Midlands, and allied with Wessex. The Welsh rulers of Gwynedd, Powys and Dyfed tried to regain control of Flintshire from Mercia in the Battle of Rhuddlan in 796. The result is unknown, but Maredudd, King of Dyfed was killed. In 798, Coenwulf of Mercia (reigned 796–821) invaded Wales in 798, possibly killing Caradog ap Meirion, King of Gwynedd. Coenwulf of Mercia had responded to Welsh attacks in their former lands. Coenwulf was a particularly unsavoury character, for when he captured Eadberht of Kent, he cut off his hands, gouged out his eyes and took him in chains to Mercia.

Wat's and Offa's Dykes

Aethebald of Mercia (reigned 716–57) was thought to have built Wat's Dyke, with a deep ditch on the Welsh side. It runs for 40 miles from Basingwerk Abbey on the Dee Estuary, past Oswestry to Maesbury on the Severn in Shropshire. It is a little east of Offa's Dyke, and later excavations indicated that it was built later, around 820, in Coenwulf of Mercia's reign. In 1999 archaeologists dated it to 446, but today's consensus is 820. Offa's Dyke is one of the most remarkable monuments in Europe; the largest construction of its time, and the only one anywhere in the world that serves as a division between two nations.

Perhaps around 780, Offa of Mercia ordered the building of another defensive dyke from the north-east coast to the south-east coast, stretching 150 miles from Chepstow to Prestatyn. 80 miles of it can still be seen and walked. In the *Gwentian Chronicle* of Caradoc of Llancarfan, there were Welsh victories at Hereford in 735, 754 (where Cyfelach, Bishop of Glamorgan was killed) and 757 (where the valiant Dyfnwal ap Tewdwr was killed). It also recounts for 765:

> The Cymry devastated Mercia, and defeated the Saxons and spoiled them more sorely: on which account Offa, king of Mercia, made the great dyke called Offa's Dyke, to divide Wales from Mercia, which still remains. 766 – The men of Gwent and Glamorgan rose and razed Offa's Dyke level with the ground, and returned with great spoil ... 784 – Mercia devastated by the Cymry, and Offa made a dyke a second time, nearer to him, leaving a province between Wye and Severn, where the tribe of Elystan Glodrydd is situated, where they became one of the royal tribes of the Cymry.

The earthwork was dug with the displaced soil piled into a bank on the Mercian side. Where the dyke encounters hills, it passes to the west of them, constantly providing an open view from Mercia into Wales. The earthen embankment is still up to 20 feet high with a ditch on either side, indicating the new frontier between the Germanic tribes and the British. It showed the power of Offa, but was also a defensive measure, giving his territories a well-defined western boundary. Behind this barrier, the people of Wales began to think of themselves as a separate nation, and continued the effort to retain their language and culture. Within a generation of its construction, for the first time most of the people of Wales had a single ruler.

The Ninth Century

In this century the political stability west of Offa's Dyke fell apart. The ruling dynasty of Dyfed-Deheubarth fell in 814, that of Gwynedd in 825, and that of Powys in 855. Hywel Farf-Fehinog (Greasy-Beard) was around thirteen when his father Caradog was killed by Coenwulf, and the Kingdom of Gwynedd was seized by the family who had it before Caradog. In 813, Hywel raised an army and marched on Anglesey, being defeated by Cynan. However, in 814 he defeated Cynan, finally killing him in battle in 816. Coenwulf again entered Wales, rampaging as far as Snowdonia and taking control of Rhufuniog in 816–7. There was another battle in Anglesey around 817, and then Coenwulf invaded

as far as Dyfed around 818. It is possible that the *Book of Teilo* was taken from Wales at this time to Lichfield. At Bagillt or Basingwerk in 821, Coenwulf was at last killed. The power of Mercia now declined, with Wessex becoming the leading German kingdom. However, Saxon England began to be invaded in its turn by the Vikings. The first Viking raid in Wales had been in 798. The inexorable Danish/Viking conquest of England now fortunately gave the Welsh nation some breathing space to consolidate. Cyngen of Powys died in 855 and his memorial commemorated Eliseg (Elisedd) freeing Powys from Mercian attacks and domination. In 891 a Viking army captured Chester and marched through Flintshire but was beaten back by the men of Gwynedd and Powys.

We can see below the reporting of the two main sources of historical information for this time. The Welsh source, *Annales Cambriae*, reports for the early part of the century:

810 – The moon covered. Mynyw burnt [by Vikings]. Death of cattle in Britain; 812 – The fortress of Degannwy is struck by lightning and burnt; 813 – Battle between Hywel and Cynan. Hywel was the victor; 814 – And Gruffydd son of Cyngen is killed by treachery by his brother Elisedd after an interval of two months. Hywel triumphed over the island of Mona [Anglesey] and he drove Cynan from there with a great loss of his own army; 816 – Hywel was again expelled from Mona. Cynan the king dies. Saxons invaded the mountains of Eryri and the kingdom of Rhufoniog; 817 – The battle of Llan-faes; 818 – Cenwulf devastated the Dyfed region; 822 – The fortress of Degannwy is destroyed by the Saxons and they took the kingdom of Powys into their own control.

The *Anglo-Saxon Chronicle* relates the years following:

A.D. 823. This year a battle was fought between the Welsh in Cornwall and the people of Devonshire, at Camelford ... ; A.D. 828. ... King Egbert led an army against the people of North-Wales, and compelled them all to peaceful submission;

A.D. 835. This year came a great naval armament into West-Wales, where they were joined by the people, who commenced war against Egbert, the West-Saxon king. When he heard this, he proceeded with his army against them and fought with them at Hengeston, where he put to flight both the Welsh and the Danes.

West Wales is actually Cornwall, where the Britons joined Danish Viking invaders in fighting Egbert of Wessex. In mid-century, *Annales Cambriae* records, '844 – Merfyn dies. The battle of Cetill This is Merfyn Frych, the Freckled, of Gwynedd. It is not known if he died at Cetill; 848 – The battle of Ffinnant. Ithael king of Gwent was killed by the men of Brycheiniog; 849 – Meurig was killed by Saxons; 850 – Cynin is killed by the gentiles. [The *Chronicle of Ystrad Flur* says 'black gentiles']; 853 – Mona laid waste by black gentiles [Norwegian Vikings from Dublin].'

The *Anglo-Saxon Chronicle* next informs us, 'A.D. 853. This year Burhred, King of Mercia, with his council, besought King Ethelwulf to assist him to subdue North-Wales. He did so; and with an army marched over Mercia into North-Wales, and made all the inhabitants subject to him.' *Annales Cambriae* then relates the following:

864 – Duda laid Glywysing [coastal part of Glamorgan] waste; 869 – The battle of Bryn Onnen [possibly Cowbridge]; 870 – The fortress of Alt Clud was broken by the gentiles; 873 – Nobis the bishop and Meurig die. The battle of Bannguolou; 876 – The battle of Sunday in Mona; 877 – Rhodri and his son Gwriad are killed by the Saxons; 880 – The battle of Conwy. Vengeance for Rhodri at God's hand. The battle of Cynan; 894 – Anarawd came with the Angles and laid waste Ceredigion and Ystrad Tywi; 895 – The Northmen came and laid waste to Lloegr [England] and Brycheiniog [Brecon] and Gwent and Gwynllywg [Glamorgan].

The *Anglo-Saxon Chronicle* tells us more about 895:

> In this year, went the [Viking] army from Wirheal into North Wales; for they could not remain there, because they were stripped both of the cattle and the corn that they had acquired by plunder. When they went again out of North Wales with the booty they had acquired there, they marched over Northumberland and East Anglia, so that the king's army could not reach them till they came into Essex eastward, on an island that is out at sea, called Mersey. And as the army returned homeward that had beset Exeter, they went up plundering in Sussex nigh Chichester; but the townsmen put them to flight, and slew many hundreds of them, and took some of their ships. Then, in the same year, before winter, the Danes, who abode in Mersey, towed their ships up on the Thames, and thence up the Lea. That was about two years after that they came hither over sea.

The Danes and Norwegians began exerting so much pressure upon England, eventually conquering it, that Wales again had a breathing space against the threat of conquest by its mightier neighbour. In this period, there emerged the 'High Kings' of all Wales.

Rhodri Mawr, 820–878

The first 'High King' was Rhodri ap Merfyn Frych, and Nora Chadwick has called Rhodri 'the greatest of all the kings of Wales'. Rhodri the Great created a dynasty based in Gwynedd, and is the first ruler to claim the title of King of the Welsh. Rhodri became King of Gwynedd in 844, of Powys following the death of his uncle in 855, and of Seisyllwg (including Ceredigion and Ystrad Tywi, Carmarthenshire), after the death of his brother-in-law in 872. Dyfed, Seisyllwg and Brycheiniog were henceforth known as Deheubarth. Rhodri had thus taken over all Wales except Glywysing (Glamorgan and the area around Newport) by his death in 878. He constantly fought the Vikings and English, preventing them from settling in his lands. By uniting the three principal kingdoms of Wales under his rule, he showed that an independent Wales could exist without paying homage to England. Rhodri moulded the separate parts of Wales, which had existed for 1,000 years, into a Welsh nation. He was killed in 878 fighting against the English of Mercia. His six sons were, in the words of Lloyd,

> a vigorous brood, working strenuously together for the overthrow of the remaining dynasties of the south. In Dyfed, Hyfaidd ap Bledri, himself the terror of the wealthy *clas* of St David's, dreaded the violence of the new lords of Seisyllwg; in Brycheiniog, Elise ap

Tewdwr, of the line of old Brychan, also feared for his crown; and, though for the moment Hywel ap Rhys of Glywysing and Brochwel and Ffernfael ap Meurig of Gwent were chiefly perturbed by the activity of the Mercians, they too had much to apprehend from any revolution which might establish the house of Rhodri in Brycheiniog. Thus arose the political situation which is described by Asser as having existed for a good many years at the date of his composition of the life of Alfred in 893. That great king's famous victory over the Danes in 878 had given him a commanding position in Southern Britain ... It was but natural that the minor Welsh kings should seek from Alfred the protection which his known love of justice would dispose him to give, and thus it came about that Hyfaidd, Elise, Hywel, Brochwel and Ffernfael all placed themselves under his patronage...

Lloyd was using Asser as his reference, and Asser explained that he left St David's to work for Alfred of Wessex (and write his *Life*), in order to work for the interests of his monastery and his overlord, Hyfaidd ap Bledri of Dyfed. Lloyd continues:

It was now the turn of Anarawd ap Rhodri and his brothers to find their power fettered and their triumphant progress brought to a stand. With Mercia they had contended not unequally; a raid upon Eryri conducted by Ethelred in 881 had been arrested by Anarawd at the mouth of the Conway, and the victory of Cymry the day of divine vengeance for Rhodri had been won, with great slaughter of the foe. In order to secure himself against further attacks from Mercia, Anarawd had then entered into an alliance with the Danish king of York, whose realm, embracing as it did the ancient Deira, extended to the Mersey and possibly took in also the peninsula of Wirral. But the Danes proved indifferent allies, and gradually Anarawd came to the conclusion that it was his interest also, no less than that of the minor chieftains of the country, to make his peace with the strong ruler of Wessex. He found Alfred in no wise loth to respond to his advances; paying him a ceremonious visit at his court the first of the kind on record paid by a Welsh to an English king he was received as befitted his rank and treated with marked generosity. It was a part of Alfred's statesmanship to lead the other Christian princes of the island to regard him as their natural lord and protector against heathen attack, and thus it was that Wales came formally under the supremacy of Wessex; Gwynedd under Anarawd was recognised as standing in the same relation to the West-Saxon king as did Mercia under Ethelred, and the basis was laid of the homage which in later ages was regularly demanded from all Welsh princes by the English Crown.

It made sense to ally with Alfred at this time, because of massive Viking attacks upon England and Wales. In 870 Ivar the Boneless captured King Edmund and may have sacrificed his heart to Odin in the horrific blood-eagle ritual, adding East Anglia to the area controlled by the Danes. It was performed by cutting the ribs of the victim by the spine, and breaking the ribs so they resembled blood-stained wings. The beating lungs were then pulled out through the wounds in the victim's back, and salt sprinkled in the wounds. After the Battle of York in 867, whereby the Vikings gained Northumbria, it was said that Ivar had carried out the same torture on Aella of Northumbria, for killing Ivar's father. Having been badly defeated at Leuven (Louvain, in what is now Belgium), the Continental Viking army turned its attention to England. Their leader Haesten combined his forces with the Danes of Deira (their conquered kingdom between the

Humber and the Tees) and those of East Anglia to invade Southern Britain from 892–6. Moving westwards, possibly to link with the Danes in Ireland, there was a great battle at Buttington (probably near Chepstow) in 893. The Welsh, Mercians and West Saxons repelled the Viking army, chasing it back to Essex.

However, Lloyd tells us that later in 893, the Danes,

> after a long march which was not suspended by night or by day, had taken possession for the winter of the ruined walls of Chester. The Mercians followed hard upon its heels and cleared the country round of all supplies of food; hence it was forced early in 894 to replenish its stores by a raid on North Wales. It may be conjectured that Anarawd received some English help to repel this invasion; he had at any rate English troops at his command when in the following year he plundered Ceredigion and Ystrad Tywi, a blow directed most probably at his brother Cadell. During most of 894 and 895 the Danes were busy in the neighbourhood of London; at the end of the latter year they were once more in the Severn valley, encamped for the winter at Quatbridge, which cannot have been far from the modern Bridgenorth. This became the starting-point for the last great raid, in the spring of 896, which devastated not only the adjacent parts of Mercia, but also the Welsh districts of Brycheiniog, Gwent and Gwynllwg. In the summer of this year the great confederacy was dissolved; the men of Deira and East Anglia returned to their homes, while the wandering pirates turned their attention once more to the banks of the Seine.

The Tenth Century

Alfred the Great died around 902, and had expanded Wessex to include Mercia and Kent, as the Danelaw existed across the north and east of England. The Vikings had taken control of London and ruled all the lands north of a line from London to Liverpool. After Alfred's death, the Welsh had to face more invasions from Mercia and the Norsemen. Unfortunately for the future of an independent Wales, Rhodri Mawr's death in 878 had been followed by internal strife. The Vikings were expanding from Danelaw territories, forcing the Mercians southwards and westwards into Wales. The kings of Brycheiniog, Glwysing and Gwent all needed alliances, not just against the Mercians but against Rhodri's sons. Vikings also had settled in the Llŷn, Anglesey, Ceredigion and Pembrokeshire, and it took decades to expel them.

In 902, the Irish Celts won a temporary triumph over the Norwegian Vikings, clearing them out of Dublin. Led by Ingimund, they tried to settle in Anglesey but were forced back to the region of Chester, which was reinforced and defended by Aethelflaed of Mercia, daughter of Alfred. In 916 Aethelflaeda's army invaded Brycheiniog, taking the king's wife and forty-three prisoners from the royal crannog which still exists on Llyn Safaddon, Llangorse Lake. It had been a court from 860, and presumably the lady captured was the wife or mother of Tewdwr ab Elise of Brycheiniog. Upon her death in 918, Lloyd writes that Aethelflaeda's brother, Edward the Elder of Wessex,

> at once seized upon the opportunity which was now afforded him of becoming direct ruler of the whole of Mercia and was thus brought into immediate relations with the princes of Wales. His policy was that of his father, one of friendship and protection in return for sub-

mission and homage. He had already given proof of kindly sentiments towards the Welsh people. In 915 a Viking host had sailed from Brittany into the estuary of the Severn, and, landing on the southern coast of Wales, had spread ruin over Gwent and Glywysing; their daring onslaught carried them as far as Erging, and here, not many miles from Hereford, they captured Bishop Cyfeiliog of Llandaff, and, rejoicing in their good fortune, led him a prisoner to their ships. Edward at once came to the relief of the hapless prelate, and, on payment of a ransom of forty pounds, obtained his release from the clutches of his heathen captors, nor was it until this transaction was complete that vigorous measures were taken for the expulsion of the Danes, who ultimately withdrew by way of Dyfed to their kinsmen in Ireland. Thus it was only to be expected that on Ethelflaed's death the Welsh princes should readily acknowledge the sway of the West-Saxon king; 'Hywel and Clydog and Idwal,' according to the official chronicle kept at Winchester, 'with all the North Welsh (i.e., Welsh) race, sought him as their lord.' A new generation of chiefs had arisen since the days of Asser; of the sons of Rhodri, Merfyn had died in 904, Cadell in 909 (or 910), Anarawd in 916. Idwal the Bald, son of Anarawd, now ruled over Gwynedd, Hywel and Clydog, the sons of Cadell, in the south.

In 919 it was reported that King Clydog was killed, and in 921 there was a battle at Dinas Newydd, which is thought to be Tredegar Park, Newport. The *Anglo-Saxon Chronicle* reports for 922, 'And the kings in North-Wales, Howel, and Cledauc, and Jothwel, and all the people of North-Wales, sought him [Edward the Elder] for their lord.' Typically, the *Anglo-Saxon Chronicle* does not report the death of Edward the Elder, father of Athelstan. He had retaken south-east England and the Midlands from the Danes. In 923, the *Anglo-Saxon Chronicle* records that the Scottish King Constantine II recognised Edward as 'father and lord'. The following year, Edward was killed in a battle against the Welsh near Chester. Alfred's grandson, Aethelstan of Wessex, became the first king of all of England, ruling from 925 to 939. He took Northumbria in 926, and according to the *Anglo-Saxon Chronicle*, 'governed all the kings that were in this island:- First, Howel, King of West-Wales [Hywel Dda]; and Constantine, King of the Scots; and Owen, King of Monmouth; and Aldred, the son of Eadulf, of Bamburgh'.

William of Malmesbury records that in 927,

He compelled the rulers of the northern Welsh, that is, of the North Britons, to meet him at the city of Hereford, and after some opposition to surrender to his power. So that he actually brought to pass what no king before him had even presumed to think of: which was, that they should pay annually by way of tribute, twenty pounds of gold, three hundred of silver, twenty-five thousand oxen, besides as many dogs as he might choose, which from their sagacious scent could discover the retreats and hiding places of wild beasts; and birds, trained to make prey of others in the air. Departing thence, he turned towards the Western Britons, who are called the Cornwallish, because, situated in the west of Britain, they are opposite to the extremity of Gaul. Fiercely attacking, he obliged them to retreat from Exeter, which, till that time, they had inhabited with equal privileges with the Angles, fixing the boundary of their province on the other side of the river Tamar, as he had appointed the river Wye to the North Britons. This city then, which he had cleansed by purging it of its contaminated race, he fortified with towers and surrounded with a wall of squared stone.

Around 938, at the Battle of Brunanburh, Athelstan faced an allied army. It comprised the forces of the Celtic Briton Owain of Strathclyde, which also encompassed Cumbria and who owned some land in Wales; the Celtic Constantine mac Aed of Alba, which was most of Scotland except Strathclyde; the Viking Earls of Northumberland and northern Yorkshire; and Olaf Guthfrithsson, the Viking King of Dublin who ruled a large part of Ireland. Lloyd calls it the Battle of Bamburgh: 'No slaughter yet was greater made e'er in this island, of people slain, before this same, with the edge of the sword; as the books inform us of the old historians; since hither came from the eastern shores the Angles and Saxons, over the broad sea, and Britain sought – fierce battle-smiths, overcame the Welsh, most valiant earls, and gained the land.' Five kings were said to have been killed and seven earls slain in Athelstan's victory. The date may have been at any time between 934 or 939, and competing sites for the battle are the Wirral, near Beverley in Yorkshire, Bamburgh in Northumberland, and on the banks of the Humber in Lincolnshire. From the *Annales Cambriae* we see mayhem across Wales after this battle: '943 – Cadell son of Arthfael was poisoned. And Idwal son of Rhodri and his son Elisedd are killed by the Saxons; 946 – Cyngen son of Elisedd was poisoned. And Eneuris bishop in Mynyw died. And Strathclyde was laid wasted by the Saxons; 950 – Hywel king of the Britons called the Good died; 951 – And Cadwgan son of Owain is killed by the Saxons. And the battle of Carno between the sons of Hywel and the sons of Idwal; 952 – Iago and Idwal the sons of Idwal laid Dyfed waste.'

Hywel Dda and the Laws

Hywel ap Cadell ap Rhodri Mawr (890–950) was known as Howell Dda (the Good), reigning from 904–50. He established a predominance of Dyfed-Deheubarth among the various Welsh kingdoms, and thus was only the second overlord of Wales. He strategically kept peace with England, subservient to the first king of all England, Athelstan. However, in Gwynedd his cousin Idwal Foel ab Anarawd ap Rhodri began fighting the Saxons. Idwal was forced into exile from 924–9, and died fighting the English around 942. Idwal Foel (Idwal the Bald) was called King of the Britons by William of Malmesbury. He inherited the throne in 916, and allied himself with Athelstan, the most powerful Saxon King to date. Idwal visited the court of Athelstan three times, and in 927 was a witness to charters agreeing to campaign with Athelstan against the Scots.

Athelstan was accompanied by Hywel Dda, Idwal Foel, and Morgan ab Owain of Morgannwg. Eógan of Strathclyde was defeated. By Christmas 935, Eógan was at Athelstan's court along with Idwal and Hywel. Athelstan died in 939 and was replaced by his half-brother, Edmund. Idwal Foel seems to have judged this an opportunity to counter Hywel Dda, believing that Hywel's prime motive for his Saxon alliance was to take over Gwynedd. Therefore, in 942 Idwal launched an attack on the Saxons, but with his brother Elisedd was killed in battle. His cousin Hywel Dda, with Saxon help, now invaded Gwynedd and drove Idwal's sons from the kingdom. Hywel then annexed Gwynedd, before taking the kingdom of Brycheiniog. By the time of his death, Hywel Dda controlled all Wales except Glamorgan and Monmouthshire. Hywel is described in the *Brut y Tywysogion* (Chronicle of the Princes) as 'the chief and most praiseworthy

of all the Britons'. Welsh law and literature was praised throughout Europe; he is best remembered for his brilliant codification of Welsh law.

This was a national systematisation of legal customs that had developed in Wales over many centuries, now known as 'Cyfraith Hywel' (the Law of Hywel). The codification probably took place at Hendy-Gwyn (Whitland) around 940. The law of Wales was traditional and not king-made law, and its emphasis was upon ensuring reconciliation between kin groups rather than upon the keeping of order through punishment. The law-books contain fascinating details about life in early medieval Wales. For centuries to come, living under the Law of Hywel would be one of the definitions of the Welsh people. The codification was incredibly far in advance of English and European law, giving status to women and rights that did not become part of the laws of England for over a thousand years.

Cyfraith Hywel is notable for its elements of mercy, common sense and a great respect for women and children that has been lacking in many legal systems of other countries right up to the present day. A woman had the right to seek compensation if struck by her spouse without cause; she could also receive up to one half of the family property upon divorce. The majority of the surviving documents are in Welsh, with only a few in Latin, a sign of the legitimacy of the language. The one problem was that the law known as gavelkind specified that a father's estate was to be divided among all his sons, rather than be given intact to the eldest son. This led to wars between brothers, and prevented the creation of a unified, powerful state such as took place in England, where the whole kingdom was inherited by a single heir (primogeniture). Because of its law and literature, a French scholar called the Welsh 'the most civilized and intellectual people of the age'.

Civil Wars

Of the three sons of Hywel the Good who fought with the sons of Idwal at Nant Carno, Rhodri died in 953 and Edwin in 954. This left Owain as ruler of Deheubarth until his death in 988. It was always important for Welsh princes to 'legitimise' their position and Owain had ensured that he recorded his descent from Cunedda, Maelgwn Gwynedd and Rhodri the Great on his father's side. The line of Owain's mother went back to Voteporix of Dyfed and Agricola Lawhir (of the Long Hand). He inserted other pedigrees, giving the lineage of the old princes of Powys, Strathclyde, Morgannwg, Ceredigion, Meirionydd, and other districts. There is evidence of the presence in 955 of Welsh princes at the court of the Saxon King Edred, Morgan Hen of Morgannwg, Owain ap Hywel Dda of Deheubarth and Iago ab Idwal of Gwynedd, carrying on with strategic alliances. However, when Edgar came to the throne, Welsh kings and princes stopped attending the courts of the English kings completely.

After the relative stability of Hywel Dda's reign, there was fighting between Gwynedd and Deheubarth, and more English attacks to take advantage of the internal strife. In 951, Cadwgan ab Owain, Prince of Ceredigion and grandson of Hywel, was killed by Saxons. Iago and Ieuaf, the sons of Idwal Foel, regained control of Gwynedd, and in 951 it seems that they defeated Hywel Dda's sons at Nant Carno. These sons of Idwal appear to have taken part of Powys, as well as Gwynedd, back under their control, and

in 952 devastated Dyfed. Edwin and Owain, the sons of Hywel, retaliated in 954 with a march into the Conwy Valley, but were defeated near Llanrwst and chased back into Ceredigion. After being forced back at Llanrwst, Owain ap Hywel gave up trying to take Gwynedd, and with his son Einion attacked Morgannwg in 960, 970 and 977. In 983, Aelfhere of Mercia and Hywel ab Ieuaf of Gwynedd attacked Einion ab Owain and were repelled 'with much slaughter'. Einion was soon killed in Gwent in 984.

From 956, Aelfhere had been Earl of Mercia, and in 967 had ravaged the lands of Iago and Ieuaf. Civil war next broke out in Gwynedd, with Iago taking his brother Ieuaf prisoner in 969. In 973 Edgar the Peaceful, King of Wessex came to Chester and invited other kings to meet him and submit to his authority. Eight kings – including Iago ab Idwal of Gwynedd – attended and submitted, but never went to his court. William of Malmesbury recorded that in 973,

> the rigour of Edgar's justice was equal to the sanctity of his manners, so that he permitted no person, be his dignity what it might, to elude the laws with impunity. In his time there was no private thief, no public freebooter, unless such as chose to risk the loss of life for their attacks upon the property of others. How, indeed, can it be supposed that he would pass over the crimes of men when he designed to exterminate every beast of prey from his kingdom; and commanded Judwall [Idwal], king of the Welsh, to pay him yearly a tribute of three hundred wolves? This he performed for three years, but omitted in the fourth, declaring that he could find no more.

Iago was defeated in 974 by Ieuaf's supporters or Mercians, but retained Gwynedd. Iago was then captured in 979 by Hywel ab Ieuaf, who became King of Gwynedd until his death in 985, when he was succeeded by his brother Cadwallon in 985. However, just a year later, Maredudd ab Owain of Deheubarth invaded, killed Cadwallon ab Ieuaf and annexed Gwynedd. Maredudd ab Owain ap Hywel Dda also became ruler of Deheubarth upon Owain's death in 988, and was probably ruler of all Wales except Glamorgan and Gwent. Maredudd raided Mercian settlements in Radnorshire, and paid a ransom of one penny a head upon some of his subjects who had been captured in Viking raids. In 987 Godfrey Haroldson had raided Anglesey, killing 1,000 and carrying away 2,000 as captives. Maredudd died in 999 and was described in the *Brut y Tywysogion* as 'the most famous King of the Britons'. Maredudd's reign had been perpetually disturbed by foreign attacks, and by revolts in favour of his nephew, Edwin ab Einion, and the sons of Meurig ab Idwal Foel, who tried to win back Gwynedd for the old line. On Maredudd's death in 999, Gwynedd was regained by Cynan ap Hywel ab Ieuaf, who ruled for six years.

The Eleventh Century

After the death of Cynan ap Hywel ab Ieuaf in 1005, Aeddan ap Blegywryd succeeded at some time, probably by force as he was not in direct line of succession. He reigned in Gwynedd until 1018, when he was defeated in battle by Llywelyn ap Seisyll. Aeddan and his four sons were killed. Llywelyn later gained control of Deheubarth by defeating and killing Rhain at Abergwili in 1022. Rhain was an Irish pretender, claiming to be the son

of Maredudd ab Owain. Llywelyn had married Maredudd's daughter, Angharad, who had no knowledge of Rhain. Unfortunately Llywelyn died prematurely in 1023, but his ambition stimulated his son, the great Gruffydd ap Llywelyn. Some sources state that Llywelyn was killed through the jealous treachery of Madog, Bishop of Bangor. The *Annals of Ulster* named Llywelyn as 'King of the Britons', and the *Brut y Tywysogion* called his reign prosperous; 'there was no one needy in his realm, and there was no town empty or deserted'. From 1023 to 1033 Rhydderch ab Iestyn was King of South Wales, the only part of the nation that had not been under Llywelyn's domination. Anarchy again flared up on the deaths of Llywelyn and Rhydderch, with all the Welsh princes reasserting their independence. Gruffydd ap Llywelyn, who was also Maredudd's grandson (on his mother Angharad's side), had to flee to France, where he stayed for sixteen years.

Gruffydd ap Llywelyn, 1007–63

Brut y Tywysogion records that between 950 and 1100, no less than twenty-eight Welsh princes met violent deaths, and four were blinded. In those 150 years, nearly fifty Welsh rulers were incarcerated, murdered or slain in battle. Wales was racked by internal warfare and invasions by the Mercians until Gruffydd returned from France and beat Earl Leofric (Lady Godiva's husband) at Rhyd y Groes (near Welshpool) on the Severn in 1038. In 1039, he killed Iago ab Idwal to regain Gwynedd and take Powys. He ravaged Cardigan and carried off the wife of Hywel ab Edwin, Prince of Deheubarth. Gruffydd had gathered forces and won a battle at Pencader and sacked Llanbadarn Fawr in 1041 to control Ceredigion for a time. However, Prince Hywel in 1042 defeated a host of 'black gentiles' (Danes based in Dublin) invading Ceredigion at Pwlldyfarch. Gruffydd won another battle at Newport in 1044 to gain South East Wales, Gwent. Also in 1044, he killed Hywel ab Edwin at the Battle of Carmarthen when Hywel had allied with the Danes of Ireland to gain his revenge.

In 1046, Gruffydd allied with Sweyne Godwinsson, Earl of Gloucester, Hereford, Oxfordshire, Somerset and Berkshire, who was the oldest brother of the future King Harold. Sweyne had actually sought peace with the King of Gwynedd, and then joined him on an attack upon Gruffydd ap Rhydderch, King of Deheubarth. The *Anglo-Saxon Chronice* states, '1046. This year went Earl Sweyne [Harold's brother] into Wales; and Griffin [Gruffydd ap Llywelyn], king of the northern men [Gwynedd] with him; and hostages were delivered to him.' Deheubarth fought off that attack, giving hostages, and also fought off many attacks by the Danes until Gruffydd ap Rhydderch was killed by Gruffyd ap Llywelyn in 1055. In 1047, around 140 of Gruffydd's war band were killed in Ystrad Tywi, Deheubarth, so he ravaged through Pembroke and Ystrad Tywi.

Earl Ralph 'the Timid' of Hereford was trying to consolidate his frontier, building castles, when Gruffydd laid waste to a great part of Herefordshire. As a consequence the men of the shire and many Norman mercenaries from the castle went against the Welsh on horseback, not as the national militia or fryd, but as mounted Norman knights. The experiment proved disastrous and the inexperienced English force was routed near Hereford in 1052. The castle was destroyed and the town burnt. These lands, across Offa's Dyke, had been in Saxon possession for 300 years. The *Anglo-Saxon Chronicle* notes,

A.D. 1052 … At this time Griffin, the Welsh king, plundered in Herefordshire till he came very nigh to Leominster; and they gathered against him both the landsmen and the Frenchmen from the castle; and there were slain very many good men of the English, and also of the French. A.D. 1053. It was this year resolved to slay Rees, the Welsh king's brother, because he did harm; and they brought his head to Gloucester on the eve of Twelfth-day … The Welshmen this year slew a great many of the warders of the English people at Westbury.

Gruffydd killed Gruffydd ap Rhydderch in battle to gain the remains of Deheubarth in 1055. Gruffydd was now master of almost all of Wales. With control of South Wales, Gruffydd now turned aggressively on the Saxon invaders. In 1055, Harold of Wessex, son of Earl Godwin, exiled Leofric's son, Earl Aelfgar of Mercia. Aelfgar allied with Gruffydd and Gruffydd in turn married Aelfgar's daughter, Ealdgyth. The allies burned Hereford, and Gruffydd took possession of Whitford, Hope, Presteigne, Radnor, Bangor-is-Coed and Chirk, before heading south.

Bishop Leofgar of Hereford assembled a mixed force of Norman settlers and Saxon-English. He crossed Offa's Dyke, but was killed by Gruffydd and his army destroyed on 16 June 1056 at Glasbury-on-Wye. Gruffydd had by now settled his court at Rhuddlan, an area heavily settled by Mercians, and from this new base in north-east Wales he now regained large parts of the Earldom of Chester over Offa's Dyke, including much of Flintshire and Denbighshire, which would now remain Welsh forever.

In 1056–7 Gruffydd drove Cadwgan ap Meurig out of Morgannwg, to control the last princedom. Gruffydd ap Llywelyn had become the only Welshman ever to rule over the whole of Wales. From 1057 until his death in 1063, all of Wales recognised his kingship. In that year, Aelfgar needed Gruffydd's help to regain Mercia again, and in alliance with the Viking Magnus Barefoot's fleet, they triumphed. However, Harold of Wessex, one of the greatest generals of the time, had been occupied defeating MacBeth in Scotland and uniting Wessex, Mercia, East Anglia and Northumberland for eight years. Harold now turned the Saxon war machine of the House of Godwinson against Gruffydd.

Gruffydd had been brutal in his treatment of rival Welsh royal families. He defended himself thus: 'Speak not of killing. I do but blunt the horns of the offspring of Wales, lest they should wound their mother.' (Walter Map, *De Nugis Curialum*, 1180). Because of this, when Harold and his brother Tostig of Northumbria launched a surprise attack by land and sea, much Welsh support faded away. The other royal houses saw the opportunity to reclaim their princedoms of Deheubarth, Morgannwg, Powys and Gwynedd. It was winter, and Gruffydd's *teulu*, or bodyguard, had returned to their lands for the winter, not expecting any attack. Harold feinted to attack from Gloucester, and raided the South Wales coast with a fleet based in Bristol. Harold then made a long, forced march with lightly armed troops to the north of Wales (similar to his superb march from the Battle of Stamford Bridge in Yorkshire to Hastings three years later). Most of Gruffydd's forces were separated from him, in the south. The fast-moving Saxons had caught him out.

Harold struck so rapidly at Rhuddlan, Gruffydd's seat of government, that the unprepared Gruffydd only just escaped by sea. He was pressed back towards Snowdon, and a reward of 300 cattle was offered for his head. He was killed by one of his own men, by Cynan ap Iago, according to the *Ulster Chronicle* (the son of Iago ab Idwal,

who had been killed by his own men, or by Gruffydd, in 1039). The king's death on 5 August 1063 was said to have been made possible by the treachery of Madog, the same Bishop of Bangor who betrayed Gruffydd's father Llywelyn forty years earlier. William of Malmesbury records, 'Harold too, of the West Saxons, the son of Godwin; who by his abilities destroyed two brothers, kings of the Welsh, Rees and Griffin; and reduced all that barbarous country to the state of a province under fealty to the king.'

Gruffydd's head was carried to Harold, who married Gruffydd's widow Ealdgyth, and made Gruffydd's brothers his regional commanders in Wales. Harold refused to pay the traitor Madog, and Madog's ship was sunk carrying him to exile in Ireland. Harold did not annexe any Welsh land, and in part because of this victory, he was elected King of England over the claims of Edward the Confessor's nephew and rightful heir. Soon the Saxon enemy was to be replaced by a far more powerful force – the Normans. The *Brut y Tywysogion*, the Welsh 'Chronicle of the Princes', lamented Gruffydd as the 'head, shield and defender of the Briton, perished through the treachery of his own men … the man erstwhile thought invincible, the winner of countless spoils and immeasurable victories, endlessly rich in gold and silver and precious stones and purple apparel'. The *Anglo-Saxon Chronicle* recalls Gruffydd ap Llywelyn as 'king over all the Welsh race'. During his reign he extended Welsh territories back into Hereford, over Offa's Dyke, and united the Welsh nation. It is to him that Wales owes its debt of lasting resistance to the Danish-French Normans who soon destroyed the Anglo-Saxons.

Harold went on to Hastings in 1066, and the Saxons of England were completely under the Norman yoke by 1070. (Note that Welsh-speaking British region of Cumbria was only annexed to French-controlled England in 1170. The Welsh-speaking county of Cornwall had been annexed by the Saxons for England in 930.) However, Wales kept its independence against the Normans for two centuries, until the death of Dafydd, and the 1282 Statute of Rhuddlan. From then, the Welsh were relatively subdued until the Glyndŵr war gave independence again for a decade from 1400. Then, in 1485, the Tudors took over the English Crown from the Plantagenets.

From the *Chronicle of Ystrad Fflur*, the relevant entries explain why Welsh support drifted away from him:

1035 Maredudd ab Edwin was slain by the sons of Cynan. Afterwards a cross was raised for him at Carew [which can be seen today outside Pembroke's Carew Castle]. And the Saxons slew Caradog ap Rhydderch; 1039 Iago of Gwynedd was slain. And in his place Gruffydd ap Llywelyn rules who throughout his reign hounded the Pagans and the Saxons in many battles. And first he defeated Leofrig of Mercia at Rhyd-y-Groes; 1041 In this year was the battle of Pencadair where Gruffydd defeated Hywel ab Edwin, and he seized Hywel's wife and took her for his own; 1042 In this year was the battle of Pwlldyfach where Hywel defeated the Gentiles [Vikings]. And in that year Gruffydd was captured by the men of Dublin [Norwegian Vikings]; 1044 Hywel ab Edwin gathered a fleet of the Gentiles of Ireland to ravage the kingdom. And Gruffydd encountered him and there was a mighty battle at the mouth of the Tywi. And there Gruffydd prevailed and Hywel was slain; 1045 In this year there was great treachery and deceit between the sons of Rhydderch, Gruffydd and Rhys, and Gruffydd ap Llywelyn; 1047 About seven score of Gruffydd ap Llywelyn's Teulu [a warband that acted as the king's bodyguard] were slain through the treachery of the leading men of Ystrad Tywi. And thereafter Gruffydd ravaged Dyfed and Ystrad

Tywi; 1049 All Deheubarth was ravaged; 1052 In this year Gruffydd ap Llywelyn fought the Saxons and their French allies [Norman mercenaries] at Llanllieni [Hereford]; 1056 Gruffydd ap Llywelyn took Gruffydd ap Rhydderch's kingdom and his life. And after that Gruffydd moved a host against the Saxons, with Ranulf as their leader. And after bitter, fierce fighting the Saxons turned to flight. And Gruffydd pursued them to within the walls of Hereford and there he massacred them and destroyed the walls and burned the town. And with vast spoil he returned home eminently worthy; 1058 Magnus, son of Harold, ravaged the kingdom of England with the help and chieftainship of Gruffydd ap Llywelyn, king of the Britons; 1063 In this year Gruffydd ap Llywelyn was slain, after innumerable victories, through the treachery of his own men. He had been head and shield and protector to the Britons.

Gwynfor Evans points out that, though for five centuries the people of Wales had shared a common language, culture, history, religion and for the most part a common law, it was only under Gruffydd ap Llywelyn that it had a single sovereign, and thus a measure of political unity. The *Anglo-Saxon Chronicle* relates:

A.D. 1065. This year, before Lammas, ordered Earl Harold his men to build at Portskeweth in Wales. But when he had begun, and collected many materials, and thought to have King Edward there for the purpose of hunting, even when it was all ready, came Caradoc, son of Griffin, with all the gang that he could get, and slew almost all that were building there; and they seized the materials that were there got ready. Wist we not who first advised the wicked deed. This was done on the mass-day of St Bartholomew.

Wales was now in reality three major princedoms – Gwynedd, Powys and Deheubarth. Bleddyn ap Cynfyn and his brother Rhiwallon, the half-brothers of Gruffydd, were given Gwynedd and Powys to rule. Three years later William the Bastard, Duke of Normandy, seized the throne of England from Harold. The new invaders, the Normans, were faced with several rulers in Wales, rather than a dominant lord, which should have made their conquest much easier. Gruffydd ap Llywelyn's sons in 1069 fought the Battle of Mechain against Bleddyn and Rhiwallon to try and regain their lands, but were both killed.

Religion

Welsh bishops had two meetings with St Augustine in 602 and 604, and had been unwilling to evangelise the Germanic tribes. These incomers had violently forced the Britons to the western fringes of the land. However, the Celtic Church eventually conformed to the new forms of the younger Roman Church at the Synod of Whitby in 664. From the 650s onwards, Saxons, Jutes, Mercians and the like were finally adopting Christianity, and the unification of Christianity across Britain gave Rome political and financial power. Over the following century, most churches in the Celtic-speaking lands came to accept the Roman change of the date of Easter. When Bede was writing his *Ecclesiastical History of the English People* in 731, Wales was the only place still refusing to conform to the new Easter, but finally conformed in 768. King Alfred of Wessex

specifically asked for Asser of St David's to come to his court, where Asser became his advisor in 880 and wrote the *Life of King Alfred*. Welsh monasteries all had scriptoria, producing Latin missals and illuminated manuscripts, but nearly all were destroyed in warfare and fires across the centuries. One remaining, the *Book of Teilo*, was taken to England and renamed the *Book of St Chad*, also known as the *Lichfield Gospels*. It is now in Lichfield Cathedral, whose authorities resolutely and wrongly deny that it is of Welsh origin, despite its marginal annotations in Old Welsh.

The greatest tragedy in Welsh history is perhaps the loss of so much written material over the centuries – few other nations in the world have suffered from almost two millennia of warfare. Repositories of learning such as monasteries, churches and libraries were regularly burnt. Across such a small country there were few hiding places. Church records, land deeds, histories have all been lost, leaving Wales with a paucity of materials compared to other countries. When this author was writing *The Book of Welsh Saints*, a primary source was topographical names – mountains, wells, places and fields associated with families of saints. With the EU insistent upon replacing field names with numbers, in Wales we are losing an invaluable history source. The Norman incursions from 1070 onwards were particularly harmful. Land deeds especially were destroyed. Only fifty years or so ago, parchments hidden at the palace of the Princes of Gwynedd, at Abergwyngregyn, were being used to start fires. None remain.

Culture

We have mentioned Gildas (*c.* 500–70), the monk whose *De Excidio et Conqestu Brittaniae* is the only contemporary source for the Anglo-Saxon invasions, making the saint Britain's first historian. Nennius may have been a monk who escaped the massacre at Bangor-is-Coed in 613, and wrote *Historia Brittonum*, based on some lost sources and Gildas' work. Between 650 and 750, Britain's lowlands became firmly Saxon. Even in southern Scotland, most of the Brythonic or Welsh kingdoms came under English or Anglian control. The earliest poems attest to this British fight for survival. Surviving works in Old Welsh date back to the late seventh century, and are thus part of the oldest attested vernacular in Europe. They are by Taliesin and Aneurin and were probably composed in Ystrad Clud, Strathclyde. Aneurin is remembered for *Y Gododdin*, a magnificent 'heroic tradition' poem, which must date from before 638. In that year Oswy of Bernicia destroyed the fortress of Din Eidyn, Edinburgh, and the kingdom of the Votadini or Gododdin collapsed. In the poem, a small band of warriors and their allies fight at the Battle of Catraeth, being defeated by a much larger force of Angles. It was thought to be dated around 600 and is the first work to mention the Welsh warrior-leader Arthur:

> He fed black ravens on the rampart of a fortress
> Though he was no Arthur
> Among the powerful ones in battle
> In the front rank, Gwawrddur was a palisade …

However, in 1997 John Koch drew attention to a poem by Taliesin, 'Gweith Gwen Ystrad', commemorating a battle at Gwen Ystrad around 570: 'The men of Catraeth arise with the day around a battle-victorious, cattle-rich sovereign this is Uryen by name, the most senior leader.'

Catraeth is also mentioned in a panegyric to Cadwallon ap Cadfan, thought to have been composed in about 633: 'Fierce Gwallawc wrought the great and renowned mortality at Catraeth.' Koch identifies Gwallawc with one of the kings who fought for Urien against Bernicia. Koch's research leads him to conclude that the attack on Catraeth is the same as the Battle of Gwen Ystrad. This would date the poem to about 570. Koch believes that the Gododdin fought the Brythons of Rheged and Alt Clut in a power struggle for Rheged, with Angles fighting on both sides. Urien Rheged won the battle. Whatever the actual battle, the poem was composed between 570 and 600. The site was given as Catterick, but Catraeth could mean battle beach, and *gwen ystrad* means white vale, so it could have been fought on a shoreline.

There is also wonderful poem of lament, 'Armes Prydain' (The Prophecy of Britain) which asks for an alliance between the Celtic peoples of Britain and Brittany with the Norsemen of Dublin to overthrow the Saxon invaders of Britain. It was probably composed by a monk in Glamorgan shortly after 937, frustrated with Hywel Dda's alliance with Alfred of Wessex, and expresses a terrible sense of loss. At Brunanburh around 938, a battle was fought between King Athelstan and the alliance described in 'Armes Prydain'. *Canu Llywarch Hen* of the ninth century included a series of poems called the 'Canu Heledd', a magnificent elegy for the misfortunes of Powys. Part of the *Death Song of Cynddylan* remembers Arthur:

Grandeur in battle! Do you see this?
My heart burns like a firebrand.
I enjoyed the wealth of their men and women.
They could not repay me enough.
I used to have brothers. It was better when they were
the young whelps of great Arthur, the mighty fortress.
Before Lichfield they fought,
There was gore under ravens and keen attack.
Limed shields broke before the sons of the Cyndrwynyn.
I shall lament until I would be in the land of my resting place
for the slaying of Cynddylan, famed among chieftains.

Llanhilleth is now dedicated to Illtud, but as originally called – Llanhilledd Vorwyn (Hiledd the Virgin). She was the sister of Cynddylan, who died in battle against the Saxons at Pengwern (Shrewsbury), who then burnt his great palace on the site of the Roman town of Wroxeter. The great saga poem first written down in the ninth century, 'Canu Heledd' or 'Song of Heledd' represents the destruction, especially in the part 'Cynddylan's Hall'. The poem was originally attributed to Llywarch Hen, as part of the *Red Book of Hergest*, but the intense emotions shown mean that it may have been the work of Heledd, making her the first woman poet. The poem probably dates from shortly after 655. Heledd describes an eagle tearing Cynddylan's flesh open on the battlefield:

Eagle of Pengwern, grey-crested, tonight
Its shriek is high,
Eager for the flesh I love.
Eagle of Pengwern, grey-crested,
Tonight its call is high
Eager for Cynddylan's flesh …

It seems absurd that the 2009 discovery of treasure trove in Staffordshire has been trumpeted by all archaeologists and newspapers as 'proof' that the Anglo-Saxons accepted Christianity far earlier than was thought. According to experts, the Christian inscription on the buried hoard indicates a 'Christian Saxon king'. There were 1,500 artefacts found near Lichfield in Staffordshire, the greatest find since Sutton Hoo, found near Lichfield, with around 5 kilograms and 2.5 kilograms of gold and silver items respectively. The largest cross was folded, indicating a pagan burial. A gold strip reads, in Latin, 'Rise Up, Lord – May your enemies be scattered and those who hate You be driven from Your face.' The objects are dated between 650 and 750 CE, which was around the time that the barbarians Penda and Aethelred of Mercia were invading Christian Wales and ransacking royal courts and churches.

A cursory examination of the finds reveals Celtic knotwork designs. The finds are contemporaneous with the sacking of the court of Cynddylan, King of Powys at Wroxeter, and the taking of the other capital of Powys, Pengwern (Shrewsbury). The gold was taken from the destruction of British (i.e. Welsh) monasteries and churches, and its provenance to Welsh gold-mines can probably easily be made. A similar thing happened on a TV documentary analysis of Irish gold – they could not link it to any Irish gold-mines because it was stolen from Wales when the Irish were pagan and the Welsh were Christian. Welsh history is ignored or unknown. Why does no academic seem to realise that the Romans came to Britain to get at the largest gold- and copper-mines in Europe, at Dolaucothi and the Great Orme, mines worked by the Celts for centuries? Welsh slate, copper, gold, silver and lead was exported on a huge scale. Why does no academic understand that there were three Roman legions stationed in Britain, compared to one in each of their other far-flung provinces? Of those, one was in York, safeguarding most of England and Scotland. The other two were stationed on the Welsh borders, at Caerleon and Chester, with the most extensive network of Roman roads in Europe emanating from them to other major forts at Carmarthen and Caernarfon. Little remains in the way of illustrated manuscripts from the perhaps twenty scriptoria across Wales to compare to the *Book of Kells* or the *Lindisfarne Gospels*, but the *Book of St Teilo* has been appropriated by Lichfield Cathedral as the *Gospel of St Chad*. As well as two evangelist portraits of St Mark and St Luke, in its margins are found some of the earliest writings in Welsh, dating from the ninth century.

The Vikings

The Vikings began attacking the coasts of Britain and Ireland in the 780s. Their constant attacks on rich and defenceless monasteries help to explain the decline in the vitality of the Celtic Church. From the ninth to eleventh centuries, Britons and Saxon alike were

under threat from Vikings. From the 830s they settled in Ireland, and used Dublin as a base. Merfyn Frych spent his reign fighting against the Danes and Mercians, and fell at Cetyll against Burchred of Mercia in 844. Merfyn's son Rhodri Mawr unified most of Wales to move it towards statehood, thanks in part to the need to fight this Viking threat. Wales achieved national unity over a century before England, which had to wait for statehood until the coronation of Edgar at Bath in 973. (A columnist named Simon Heffer has received national publicity by stating that Wales has never been a nation. Knowledge of true history is a rare commodity.) Danes settled in Anglesey in 854, and Rhodri won a victory over the Danish leader Gorm or Horm in 856 (possibly near Orme's Head), but was eventually forced into temporary exile in Ireland after being beaten in 876.

In Wales, there is little evidence of Viking settlements, although some places, among them Anglesey, Bardsey, Milford, Skokholm, Skomer, Swansea, Flat Holm and Fishguard, were given Scandinavian names. In England, Scotland and Ireland, the Vikings established settlements and even kingdoms.

Vikings were called 'Gentiles' in the *Annals*, while those who sailed from Dublin were 'Black Gentiles'. The latter settled Ynys Môn, renaming it Ongul's Eye (Ongul's Island, Anglesey). In the 'First Viking Age' of 800–950, Danes became established in Ireland, the Isle of Man, the Wirral and north-west England. They attacked Pembrokeshire, and Rhodri killed Horm in 856 but was defeated in 876. The Vikings wintered in Pembrokeshire in 877–878, slaughtering many people, then moved up the Severn Sea to fight and lose to Ealdorman Odda of Devon at Countisbury Hill in 878.

The Viking invasions smashed the state system of the English. From 878, a treaty with Alfred ceded much of the country to Danish law – the territory of the Danelaw. This included the kingdoms of Northumbria and East Anglia, and the 'five boroughs' of Leicester, Nottingham, Derby, Stamford and Lincoln. Wessex survived and, in the reign of Alfred, a campaign began to bring the whole of England under the rule of the Wessex dynasty. However, from 1016 to 1035, the Danish Cnut the Great (King Canute) ruled over a unified English kingdom, including Wessex, as part of his North Sea Empire, which included Denmark, Norway and part of Sweden. Wales remained independent while England was under foreign rule. A few years later, England would be totally conquered again. English commentators and historians tell us that Wales 'has never been a nation'. Perhaps they define the meaning of a nation by the number of times and the ease by which it has been conquered. Wales was never completely conquered by the Romans, Anglo-Saxons, Danes, Normans or the French kings of England. What is now called England was completely conquered no less than five times, by Rome, Germans, Vikings, Normans and lastly a Welsh army under Henry Tudor. Wales has been conquered once and many have never accepted it. It was in a state of independence, until the murder of Llywelyn II in 1282, for a period of over two millennia. The victory of 1282 was achieved by using foreign troops and expertise, overwhelming numbers and massive loans from Italian moneylenders. Thereafter there were continuous attempts at regaining independence, before a mainly Welsh army took the English throne in 1485 for the Welsh Tudor dynasty.

Hywel Dda had allied with Aethelstan's Wessex against the Vikings, becoming the most influential ruler in Wales. For four decades there was a respite under Hywel, as Vikings established themselves in the north and east of England. However, in the 'Second

Viking Age' of 950–1100, we see raids from from 961 to 1000 on Towyn, Anglesey twice, Holyhead, Clynnog Fawr and St Davids. The *Anglo-Saxon Chronicle* relates,

A.D. 980 … in the same year was Southampton plundered by a pirate-army, and most of the population slain or imprisoned. And the same year was the Isle of Thanet overrun, and the county of Chester was plundered by the pirate-army of the North; A.D. 981. In this year was St Petroc's-stow plundered; and in the same year was much harm done everywhere by the sea-coast, both upon Devonshire and Wales; A.D. 997. This year went the army about Devonshire into Severn-mouth, and equally plundered the people of Cornwall, North-Wales, and Devon.

In 982, there was a battle at Llanwenog in Ceredigion, halting the progress of Godfrey Haroldson, King of the Danes (Vikings) of Limerick. Llanbadarn and Llandudoch were despoiled by 'gentiles', i.e. the Vikings from Dublin or Limerick in 988. Holyhead, Towyn, Penmon, Clynnog and St David's were all attacked and their churches sacked in these years. Anglesey, Llŷn, Dyfed and the shores of the Severn Sea especially suffered, but no part of the coast was secure. Raiders were mainly attracted by the plunder of churches and monasteries, but also in 968 attacked Aberffraw, the royal seat of Gwynedd. Holyhead was despoiled in 961, Towyn in 963, Penmon in 971, Clynnog in 978 and Mynyw (Menevia, the area of St David's) in 982, 988 and 999. In 999 St David's Bishop Morgeneu was slain. His death was said to be because he had been the first of all the long line of successors of Dewi to break the custom of the see and to eat meat. On the night of his death a bishop in Ireland encountered his wounded ghost, wailing with the pitiful cry, 'I ate flesh and am become carrion.' In 988 many monasteries were attacked, including Llanbadarn Fawr, Llandudoch (St Dogmael's), Llanilltud and Llancarfan.

Much of the plunder took the form of saleable captives. Magnus or Maccus, the son of Harold of the Limerick Danes, took slaves from Penmon in 971. His brother Godfrey is noted on four occasions as the leader of a flotilla bound for Wales. In 972 he ravaged across Anglesey. In 980 he helped Cystennin ab Iago in an attack upon Anglesey which was directed against Hywel ab Ieuaf. In 982 Godfrey invaded Dyfed, taking slaves and booty. In 987 in Anglesey he won a victory, killing 1,000 Welshmen and taking 2,000 as slaves for trading. In 989 Maredudd ab Owain ransomed Welsh captives at one penny a head. *Annales Cambriae* records the attacks on Wales of 971, 982, 987, 988, 999 and 1002, and others were noted in 961, 963, 968, 972, 978, 980, 993 and 997. At the end of the tenth century the Viking danger was still present, after 200 years of pillage.

There was an important, and recently excavated Viking site at Llanbedrgoch in Anglesey, which was used from around 800 to 1100. Archaeologists have found important evidence of Viking violence and trading. Metal detectors initially found coins and Scandinavian merchant lead weights, while a full excavation found a 1-hectare enclosure, freshwater spring, hacksilver (fragments of silver to be melted down and treated as bullion), and five skeletons. Their wrists had been tied, suggesting either a violent raid or that the spot had been a place to gather people as slaves. Vikings continued to raid north-west Wales well into the 1130s. Even in the eleventh century parts of Wales remained Norse lands, and it was only the increasing incursions of the Normans that shifted the Welsh perspective on the world from Scandinavian-centred to Anglo-focused.

The People

In the tenth century, Welsh society was divided into two classes. The free, the *bonheddwyr* (those with *bon*, or distinguished ancestry – comparable to *gens*, gentlemen), were landowners because of their descent, and held land, often jointly, through a family group known as *y gwely* (literally meaning 'the bed'). The unfree, *y taeogion* or villeins, were allotted land by their lords, to whom they rendered payment in food and services. The *taeogion* were originally the great majority of people, but by 1300 they had become a minority in most parts of Wales. Wales, like England in their Dark Ages, was still a land of multiple kingships. The nature of the mountains, inhospitable uplands and deep river valleys made unified control difficult. However, the boundary with Saxon England had no great natural defences, so productive lowland areas as well as profitable upland pastures were open to constant attacks. The principal divisions of Wales had been the four – and then three – major kingdoms or principalities. Powys stretched from the borders of Mercia into central Wales. Dyfed in the south-west declined, and Deheubarth absorbed parts of it. Deheubarth was a general name for the whole of South Wales, but by the eleventh century, it was a recognisable kingdom extending from Ceredigion on the west coast to Brycheiniog on the English border. Gwynedd was based on the Snowdonia massif and on Anglesey. Gwynedd had been the major centre of cultural and political resistance to English supremacy, helped in large part by its geography apart from Anglesey. Wales had become a nation because of resistance to the Saxons. The Welsh now called themselves *Cymry* (fellow countrymen). An interesting entry by William of Malmesbury for 901 notes Edward, son of Alfred uniting Mercia and fighting 'all the Britons, whom we call Welsh, after perpetual battles, in which he was always successful'. Indeed, this author agrees with many that the Welsh should shed that word, with its foreign connotations, and wither call ourselves British or Cymry. The Welsh Assembly could have been called the British Assembly, and T-shirts on sale which read 'Welsh not British' should really read 'British not Welsh'.

Remnants of the British Language

There is a fascinating survival of the Welsh language in Cumbria and other English areas with their traditional systems for counting sheep. There are similar systems derived from Ancient British/Old Welsh in Wiltshire, Durham, Lancashire, Derbyshire, Shropshire, Staffordshire, Yorkshire, Essex, East Anglia and Lincolnshire. Just some of these distinctive dialects, each slightly different, have been recorded amongst farmers in the following districts: Borrowdale, Coniston, Eskdale, Westmorland, the Peak District, Weardale, Kirkby Lonsdale, Nidderdale, Swaledale, Bowland, Wharfedale, Teesdale, Lincolnhire, Tong, Derbyshire, Wiltshire, Westmoreland and Wensleydale.

	Ancient British	Welsh	Cornish	Breton	Borrowdale	Southern England	Rathmel
1	Oinos, Oinā (f), Oinom (n)	Un	Unn, Onan	Unan	Yan	Yahn	Yan
2	Dāwū, Dwei (f)	Dau, Dwy (f)	Dew, Diw (f)	Daou, Div (f)	Tyan	Tayn	Taen
3	Trīs, Teseres	Tri, Tair (f)	Tri, Teyr (f)	Tri, Teir (f)	Tethera	Tether	Tethera
4	Petwār, Peteseres	Pedwar, Pedair (f)	Peswar, Peder f.	Pevar, Peder (f)	Methera	Mether	Fethera
5	Penpe	Pump	Pymp	Pemp	Pimp	Mumph	Phubs
6	Swexs	Chwech	Hwegh	C'hwec'h	Sethera	Hither	Aayther
7	Sextam	Saith	Seyth	Seizh	Lethera	Lither	Layather
8	Oxtū	Wyth	Eth	Eizh	Hovera	Auver	Quoather
9	Nawan	Naw	Naw	Nav	Dovera	Dauver	Quaather
10	Dekam	Deg	Deg	Dek	Dick	Dic	Dugs
11	Oindekam	Un ar ddeg	Unnek	Unnek	Yan-a-Dick	Yahndic	Aena dugs
12	Daudekam	Deuddeg	Dewdhek	Daouzek	Tyan-a-Dick	Tayndic	Taena dugs
13	Trīdekam	Tair ar ddeg	Trydhek	Trizek	Tethera-Dick	Tetherdic	Tethera dugs
14	Petwārdekam	Pedair ar ddeg	Peswardhek	Pevarzek	Methera-Dick	Metherdic	Fethera dugs
15	Penpedekam	Pymtheg	Pympthek	Pemzek	Bumfit	Mumphit	Buon
16	Swedekam	Un ar bymtheg	Hwetek	C'hwezek	Yan-a-bumfit	Yahna Mumphit	Aena buon
17	Sextandekam	Dwy ar bymtheg	Seytek	Seitek	Tyan-a-bumfit	Tayna Mumphit	Taena buon
18	Oxtūdekam	Deunaw	Etek	Triwec'h	Tethera Bumfit	Tethera Mumphit	Tethera buon
19	Nawandekam	Pedair ar bymtheg	Nownsek	Naontek	Methera Bumfit	Methera Mumphit	Fethera buon
20	Wikantī	Ugain	Ugens	Ugent	Giggot	Jigif	Gun a gun

5
The Welsh Princes & the Norman Invasion
1066–1283

The *Hailes Chronicle* notes 'dicebatur quod Wallica lingua convertetur ad ipsum si per duos dies ultra Supervlxisset' – 'It was said that had he [Llywelyn II] survived two days, the whole of the Welsh tongue would have turned to him.'

The Coming of the Normans and Gruffydd ap Cynan, *c.* 1055–1137

In 911, Vikings (Norsemen or Northmen) occupied the lower Seine Valley in northern France, founding the Duchy of Normandy. Its leader, Rollo (later known as Robert) had laid siege to Paris, and was granted the land he had conquered in return for vassalage to the King of the West Franks. Rollo developed the political system of feudalism, granting sufficient lands to his followers to enable them to maintain mounted knights and men-at-arms. Normandy became one of the strongest countries in Europe. In 1066 Guillaume, the illegitimate Duke of Normandy, Guillaume le Bâtard, became William I, King of England, defeating Harold near Hastings. William had remained near the coast and his fleet, waiting in Yorkshire for Harold's exhausted Saxon army to return on a forced march from the Battle of Stamford Bridge in Yorkshire. To quell an uprising, William marched to the north of England in 1069, then crossed the Pennines to defeat the last rebels at Shrewsbury. He then built castles at Chester and Stafford. Apart from an uprising in 1071, all of England had been taken in less than four years. Almost immediately after his decisive victory over King Harold and his Saxons, William began establishing a strong, centralised kingdom in England. He set up powerful, semi-independent earldoms on his borders with Wales at Hereford, Shrewsbury and Chester. Each earl was chosen for his aggressive tendencies and William permitted them to raid Wales and carve out feudal lordships. The prospects for the survival of Wales as a separate country were poor.

The situation was not helped by the laws of gavelkind. These ensured that kingdoms and princedoms were constantly being broken up and shared between all male heirs, legitimate and illegitimate. Wales had also been severely weakened because of the death of its recognised leader, Gruffydd ap Llywelyn, in 1063. Civil war had then broken out across Wales as princes tried to reclaim their lands from Gwynedd, allowing the Normans to push into Gwynedd's eastern borders. They were assisted by the killing

of Bleddyn ap Cynfyn, the half-brother of Gruffydd ap Llywelyn, in 1075 by Rhys ab Owain of Deheubarth. Rhys ab Owain was in turn killed after the Battle of Goodwick by Caradog ap Gruffydd of Gwent. Bleddyn's cousin Trahaearn ap Caradog now seized the throne of Gwynedd, but was in turn challenged by Gruffydd ap Cynan, the exiled grandson of King Iago ab Idwal of Gwynedd. The *Ulster Chronicle* states that Gruffydd's father Cynan ab Iago was the man who had killed Gruffydd ap Llywelyn in 1063. Gruffydd ap Cynan sailed from Dublin and landed in Anglesey to reclaim his lands from Trahaearn in 1075. He defeated Trahaearn at the Battle of Waederw and recovered Meirionnydd as well as Gwynedd, but there was a revolt against him because of the conduct of his Irish and Viking mercenaries. Gruffydd left for Dublin, but tried again in 1076, and was forced off Anglesey. In 1081 he returned once more, allying himself with Rhys ap Tewdwr to try and regain his lands, after the depredations of the Earl of Chester and the even more vicious Robert of Rhuddlan.

In 1081, Caradog ap Gruffydd ap Rhydderch, King of Gwent, invaded Deheubarth, forcing Rhys ap Tewdwr to seek sanctuary in St David's Cathedral. Thus Rhys ap Tewdwr and Gruffydd ap Cynan needed each other to form a substantial army. The carnage across Wales only relented with the victory of Rhys ap Tewdwr (of the royal house of Deheubarth), and Gruffydd ap Cynan (of the royal house of Gwynedd) at the Battle of Mynydd Carn in 1081. Both Trahaearn ap Caradog and Caradog ap Gruffydd were killed. As the result of this battle near Fishguard, the Welsh dynasties that were to rule in South, North, and Mid Wales respectively eventually secured their positions. Gruffudd ap Cynan became the established ruler of Gwynedd and Cadwgan ap Bleddyn the ruler of Powys. Rhys ap Tewdwr began to establish himself in Deheubarth. However, in the uplands of the borders and in the south east, members of the old Welsh royal families struggled to retain a degree of authority. Also in 1081 William the Conqueror made a pilgrimage to St David's, where Rhygyfarch probably saw him, demonstrating his strength vis-à-vis the Welsh princes. Later we find Rhys ap Tewdwr, the king in the south, paying £40 rent to the English Crown. This enabled him unfortunately to ignore the increasing Norman threat, and concentrate upon securing Deheubarth against his rivals.

In 1282, Hugh the Fat, the Earl of Chester, bribed Meirion Goch to bring Gruffydd ap Cynan to a meeting, where peace might be arranged between the Welsh and Normans. The unsuspecting Gruffydd ap Cynan was captured and held as a prisoner in chains at Chester for twelve years. Meanwhile, William I had recognised the rule of Rhys ap Tewdwr in Deheubarth and that of Iestyn ap Gwrgant in Morgannwg. He realised that he could not allow his great Marcher barons to become too powerful. However, by 1086 the Earl of Hereford had brought about the extinction of the Kingdom of Gwent. By the same year, the Earl of Shrewsbury had built a castle at Montgomery and had taken much of the Welsh borderlands of Powys into his possession, and the Earl of Chester had struck deeply into Gwynedd. In the Domesday Book, parts of what are now north-east and South East Wales were surveyed as if they were parts of England.

After William died in 1087, Norman–Welsh treaties were ignored, and the Norman invasion started in earnest. Wales is a mountainous country but also one with several points of easy entry for Norman armies and settlers. They could approach across the Bristol Channel, along the southern lowlands, up the major river valleys, in particular the Wye, Usk and Severn, and by sea. The Anglo-Normans built a castle in Anglesey,

raided the Llŷn peninsula in the far north-west and installed their candidate as Bishop of Bangor. Forward castles were soon built at Pembroke and Cardigan and especially across South West Wales. In the next century or so, English and Flemish settlers poured into the rich arable coast lands of South Wales, expelled the native Welsh and established large pockets of English settlements all the way from Chepstow to Pembroke. The entire south coast of Wales saw small, defended enclaves appearing – the land was fertile and less hilly, and there were scores of small ports to bring not only supplies, but soldiers if they were attacked. The Welsh princes were still fighting each other. In Deheubarth, 1088 saw an attack by Cadwgan ap Bleddyn of Powys, with Rhys ap Tewdwr escaping to Ireland. Rhys returned with a fleet in the same year and defeated the army of Powys, killing two of Cadwgan's brothers.

The last native King of Glamorgan, Iestyn ap Gwrgant, lived at Llanilltud Fawr. He came into conflict with Rhys ap Tewdwr of Deheubarth, who was encroaching on his lands from the west. As a result, in 1091 Iestyn asked Robert Fitzhamon to bring Norman mercenaries from England to help retain his lands. The battle won, the Normans returned to England and Iestyn sent his warriors back to their fields. However, the Normans turned their boats around on that same night and seized the fertile Vale of Glamorgan. They immediately began a castle-building programme. Iestyn fled to Bristol, and Fitzhamon wrote to William II (Rufus) saying that the conquest of South Wales had been successful. This new and duplicitous Lord of Glamorgan took Boverton, Llanilltud Fawr, Cowbridge, Dinas Powys and Cardiff, and shared the rest of Glamorgan among his Norman retainers. The fertile lowlands of Morgannwg (Glamorgan) were taken and Rhys ap Tewdwr was killed. Brycheiniog was seized. The Earls of Shrewsbury forced through Powys and Ceredigion to southern Dyfed, where they established a castle at Pembroke. In Brecon and Pembroke, more and more castles were constructed.

While Gruffydd ap Cynan rotted in prison, William of Malmesbury tells us of the placing of Flemings in 1091 in Pembroke, Gower and elsewhere by the Normans:

> Immediately he [Henry I] led an expedition, first against the Welsh, and then against the Scots, in which he performed nothing worthy of his greatness; but lost many of his soldiers, and had his sumpter-horses intercepted. And, not only at that time, but frequently, in Wales, was fortune unfavourable to him; which may seem strange to any one, when the chance of war was generally on his side in other places. But it appears to me that the unevenness of the country, and the badness of the weather, as it assisted their rebellion, was also an impediment to his valour. But king Henry, who now reigns, a man of excellent talents, discovered a mode of counteracting their designs: which was, by stationing in their country the Flemings, to be a barrier to them, and constantly keep them within bounds...

Also in 1091, Gruffydd ap Maredudd tried to gain Deheubarth, but was killed at St Dogmael's.

The Normans attacked Pembrokeshire, Carmarthenshire and Ceredigion in 1093, consolidating their gains with a series of permanent castles. The *Bruts* read that in 1093, 'Rhys ap Tewdwr, King of Deheubarth, was slain by the Frenchmen who were inhabiting Brycheiniog ... with him fell the kingdom of the Britons'. A contemporary

chronicler at Worcester wrote that 'from that day kings ceased to bear rule in Wales'. The monk Rhygyfarch ap Sulien (1057–99) wrote his *Lament* at Llanbadarn Fawr shortly after Rhys ap Tewdwr's death:

Alas! that life hath led us to such a time as this, wherein a cruel power threatens to oust from their rights those who walk justly. Free necks submit to the yoke. Nothing is too excellent but that I may be compelled to surrender it. Things once lofty lie despised. Both people and priest are scorned by every motion of the French. They increase our burdens and consume our goods. Parents no longer delight in their children. The youth no more delight in jests, nor pay they any heed to the poet's verse. A stupor has fallen upon the people. Righteous hands are branded with hot iron. Both women and men are mutilated. Prison and slavery are our lot, with lack of ease. Surely, it is because of our sins. So great are these, that our people refrain from taking up arms. Art thou hated of God, O British nation, that thou darest not bear the quiver, stretch the bow, wear the sword, carry the shield, vibrate the spear? Alas! An alien crowd make songs at thee. What remains but to weep, yea, to weep excessively. Such things I, Rhygyfarch, sorrowfully bewail. I mourn the sins of a wretched race. I depict the punishments of their crimes.

These were the darkest days for Wales. It appeared that the whole land would soon be Norman-controlled. Wales was divided between those regions still under native rule, Pura Wallia, and the lordships controlled from the castles of the Normans, Marchia Wallie. The Norman lords of the March were subjects of the English king, but not subject to the law of England. They ruled like independent princes, making their own laws, holding courts, building castles and waging war to increase their lands. Bernard de Neufmarche effectively took over Brycheiniog at this time, and the Normans began attacking the rest of Deheubarth. The March would exist in some form for over 450 years, and its massively powerful lords played a major part in the history of Britain, not just Wales, over those centuries. However there was a resurgence across nearly all Wales from 1094, and by 1100 most of the French conquests had been retaken.

In 1094, the Earl of Chester ordered that Gruffydd ap Cynan be displayed in chains at Chester marketplace so the people could see the fall of the great Prince of Gwynedd. In the bustle of the market, he was rescued by Cynwrig Hir. A blacksmith knocked Gruffydd's chains off and the small rescue party managed to escape to Aberdaron and sail back across to Ireland. Gruffydd soon returned to Wales, with his fellow prince, Cadwgan ab Bleddyn of Powys. They ravaged parts of Shropshire and Cheshire, and defeated the Normans in the woods of Yspwys. William of Malmesbury for 1094 states, 'At that time, too, the Welsh, fiercely raging against the Normans, and depopulating the county of Chester and part of Shropshire, obtained Anglesey by force of arms.'

William II (William Rufus) now invaded Wales in 1095 to restore order, but the Welsh retreated to the hills, and William returned to England. The *Anglo-Saxon Chronicle* relates these years:

A.D. 1095 Among these things it was made known to the king, that the Welshmen in Wales had broken into a castle called Montgomery, and slain the men of Earl Hugo, that should have held it. He therefore gave orders to levy another force immediately, and after Michaelmas went into Wales, and shifted his forces, and went through all that land, so

that the army came all together by All Saints to Snowdon. But the Welsh always went before into the mountains and the moors, that no man could come to them. The king then went homeward; for he saw that he could do no more there this winter. When the king came home again, he gave orders to take the Earl Robert of Northumberland, and lead him to Bamborough, and put out both his eyes, unless they that were therein would give up the castle. A.D. 1096 This was a very heavy-timed year through all England, both through the manifold tributes, and also through the very heavy-timed hunger that severely oppressed this earth in the course of the year. In this year also the principal men who held this land, frequently sent forces into Wales, and many men thereby grievously afflicted, producing no results but destruction of men and waste of money.

In 1096, Gruffydd defeated Norman armies at Gelli Trafnant and Aber Llech. William II led another fruitless invasion in 1097 against Gruffydd and Cadwgan.

A.D. 1097. ... And thereafter with a great army he [William II] went into Wales, and quickly penetrated that land with his forces, through some of the Welsh who were come to him, and were his guides; and he remained in that country from midsummer nearly until August, and suffered much loss there in men and in horses, and also in many other things. The Welshmen, after they had revolted from the king, chose them many elders from themselves; one of whom was called Cadwgan, who was the worthiest of them, being brother's son to King Griffin. And when the king saw that he could do nothing in furtherance of his will, he returned again into this land; and soon after that he let his men build castles on the borders.

1098 saw Earl Hugh of Chester and Earl Hugh of Shrewsbury campaigning against Gruffydd and Cadwgan and invading Anglesey. A Danish fleet hired by Gruffydd was offered a higher price by the Normans and changed sides, forcing Cadwgan and Gruffydd to flee to Ireland in a small boat. Norman cruelty led to a fresh revolt, and just then the Scandinavians descended upon Anglesey. The earls were beaten on the banks of the Menai River by the force led by Magnus Barefoot, King of Norway, who personally killed Red Hugh, the Earl of Shrewsbury. In 1096, the Welsh princes returned. Cadwgan was able to reclaim part of Powys and Ceredigion, on condition of paying homage to Robert, the new Earl of Shrewsbury. Gruffydd now moved to restore and consolidate his Gwynedd power base as the Normans retreated, reigning over Anglesey, Caernarfon and Meirionydd. By 1100 the Normans had been driven out of Gwynedd, Ceredigion and most of Powys. However, the new King Henry I (1100–35) was termed 'King of England and Wales and all the island beside ... the man against whom no one could be of avail save God himself'. From the beginning of his reign, it seemed certain that Wales would be assimilated into England.

Earl Robert fought Henry I in 1102 and was defeated with the assistance of Cadwgan's brother Iorwerth. Iorwerth took his other brother, Maredudd, captive and handed him over to the king. However, many of the lands which Iorwerth had been promised in exchange for his help were given to Norman lords instead, and Iorwerth broke with the king. In 1103 he was arraigned before a royal tribunal and imprisoned, leaving Cadwgan as sole ruler of the parts of Powys not in Norman hands.

William of Malmesbury records for 1106 that

the Welsh, perpetually rebelling, were subjugated by the king in repeated expeditions, who, relying on a prudent expedient to quell their tumults, transported' thither all the Flemings then resident in England. For that country contained such numbers of these people, who, in the time of his father, had come over from national relationship to his mother, that, from their numbers, they appeared burdensome to the kingdom. In consequence he set- tled them, with all their property and connexions, at Ross [Rhos], a Welsh province, as in a common receptacle, both for the purpose of cleansing the kingdom, and repressing the brutal temerity of the enemy. Still, however, he did not neglect leading his expeditions thither, as circumstances required: in one of which, being privily aimed at with an arrow from a distance, though by whose audacity is unknown, he opportunely and fortunately escaped, by the interposition of his firmly mailed hauberk, and the counsel of God at the same time frustrating this treachery. But neither was the director of the arrow discovered at that time, nor could he ever after be detected, although the king immediately declared, that it was not let fly by a Welshman, but by a subject; swearing to it, by the death of our Lord, which was his customary oath when moved, either by excess of anger or the importance of the occasion. For at that very time the army was marching cautiously and slowly upon its own ground, not in an enemy's territory, and therefore nothing less was to be expected than an hostile attack. But, nevertheless, he desisted not from his purpose through fear of intestine danger, until the Welsh appeased the commotion of the royal spirit, by giving the sons of their nobility as hostages, together with some money, and much of their substance.

In 1109, Cadwgan's son Owain fell in love with Nest, the daughter of Rhys ap Tewdwr and the Welsh wife of Gerald of Pembroke. Owain abducted her in a daring raid on the castle of Cenarth Bychan. The justiciar of Shropshire promised members of other branches of the ruling house of Powys extensive lands if they would join in an attack on Cadwgan and Owain. Ceredigion was invaded and Owain fled to Ireland, while Cadwgan made his peace with the king but was allowed to hold only 'one border'. Henry I later allowed him to have Ceredigion back on condition of paying a fine of £100 and promising to have nothing to do with Owain in future. When his brother Iorwerth was killed by Madog ap Rhiryd in 1111, Cadwgan again briefly took over the rule of all Powys, but later the same year Cadwgan himself was also killed by Madog at Welshpool. Madog was able to seize some of his lands, while the remainder fell to his son Owain.

In 1114, Henry I invaded with three armies. In South Wales William Marshall (Strongbow) led a force; in North Wales the troops were led by Alexander of Scotland; Henry himself led invaders against Powys. The *Anglo-Saxon Chronicle* entry for that year reads: 'A.D. 1114. In this year held the King Henry his court on the Nativity at Windsor, and held no other court afterwards during the year. And at midsummer he went with an army into Wales; and the Welsh came and made peace with the king. And he let men build castles therein.' Facing massive odds, Gruffydd ap Cynan was forced to submit to Henry, and promised to give up Gruffydd ap Rhys in order to keep the peace, but Gruffydd ap Rhys quickly fled to Aberdaron. A boat then took him to the safety of the great forest of Ystrad Tywi in Deheubarth. Gruffydd ap Rhys was the son of Rhys ap Tewdwr, the co-victor of Mynydd Carn. The *Chronicle* tells us that Gruffydd had quietly sent a messenger to Pembroke Castle to warn Nest that

her brother's life was in danger. Gruffydd ap Cynan ruled Gwynedd quietly until 1121, when he moved with King Henry quickly to take over Powys, which was riddled with internal disputes. He later took over Deheubarth. His sons Owain and Cadwaladr cemented his grip on most of Wales. Gruffydd ruled over a peaceful Wales until his death in 1137.

The work of some poets of his time is preserved in the *Black Book of Carmarthen*, and the court poetry of his bard Meilyr survives. His biography was written just twenty years after his death, declaring Gwynedd to be the 'primus inter pares' ('first among equals') of Welsh kingdoms. Gruffydd was buried in Bangor Cathedral to the left of the high altar, and his son, the heroic Owain Gwynedd, succeeded peacefully. Gruffydd ap Cynan's daughter Gwenllian was executed by the Normans after the Battle of Maes Gwenllian. Her son, The Lord Rhys, fought alongside Owain Gwynedd against the Normans, and took over leadership of Welsh resistance upon his death. Thus Gruffydd's descendants carried on the fight for Wales for sixty years after his death, to the death of Rhys ap Gruffydd in 1197. Just thirteen years after this, Welsh leadership had passed to Llywelyn the Great, of the House of Gwynedd. In 1485, Gruffydd ap Cynan's descendant, Henry Tudor, became the first Welsh King of England.

Gruffydd ap Rhys of Deheubarth and Gwenllian Ferch Gruffydd ap Cynan

Gruffydd's father Rhys ap Tewdwr had been killed by Anglo-Norman forces in 1093, and Deheubarth had been taken over by the Normans. After initial resistance Gruffydd escaped to Ireland. In 1113 Gruffydd visited Gruffydd ap Cynan at his court of Aberffraw on Ynys Môn. The House of Gwynedd owed an honour debt to the House of Dinefŵr, dating from the 1081 Battle of Mynydd Carn. In Aberffraw, Gruffydd ap Tewdwr met Gwenllian, the king's youngest daughter. The couple eloped and married, and Gwenllian joined Gruffydd ap Rhys on his guerilla campaigns to take back Deheubarth. In 1116 he took Castell Strad Pithyll outside Aberystwyth and the garrison was slain. For several years his poorly equipped troops attacked Norman castles, but they were badly beaten while attacking Aberystwyth. Gruffydd ap Rhys agreed terms with Henry I, being allowed to rule a small part of his father's kingdom, the Cantref Mawr. This was scrubby, hilly area bounded by the Rivers Teifi, Tywi and Gwili of little use agriculturally, but easy to defend and operate from. Despite Henry's peace terms, the Normans kept attacking, so Gruffydd and Gwenllian operated out of the forests of Caio, retaking Welsh land. Gruffydd was forced to flee to Ireland in 1127. However, by 1136 Gruffydd had returned and joined with Owain Gwynedd and Cadwaladr, the sons of Gruffydd ap Cynan, to attack the Anglo-French. He rode to North Wales with his followers to join them, leaving Gwenllian in Dinefŵr Castle with their four sons.

Daughter of the warrior Gruffydd ap Cynan, King of Gwynedd, Gwenllian was born in 1098, when Wales was under unceasing attack from the Normans. Her brother Owain Gwynedd had succeeded his father in leading the Welsh defence against the Marcher lords. On New Year's Day 1136, her husband joined other Welsh forces preparing for an attack upon the Norman invaders. Maurice de Londres, Lord of Cydweli (Kidwelly) attacked the Welsh in South West Wales in his absence. Gwenllian

led an army against two Norman forces, but her son Maelgwn was captured, and she was wounded and captured. Gwenllian and another son, Morgan, were beheaded at Cydweli. On the express orders of de Londres, she had been executed in cold blood. De Londres later founded Ewenni priory, presumably assuming that this would ease his passage to heaven. Following her death, her husband, with Owain and Cadwaladr, gained a crushing victory over the Normans at Crug Mawr near Cardigan.

Gwenllian left a four-year-old son, to be known as The Lord Rhys, the nephew of the great Owain Gwynedd. Gwenllian's daughter Nest married Ifor ap Meurig (Ifor Bach), the Welsh hero who scaled the walls of Cardiff Castle to kidnap Earl William and regain his stolen lands. At Caer Drewyn in 1165, twenty-nine years after Gwenllian's death, her brother Owain Gwynedd and her son The Lord Rhys faced Henry II's invasion army, which retreated in the face of the greatest army Wales had ever assembled. Dr Andrew Breeze (*Medieval Welsh Literature*) believes that the author of 'The Four Branches of the Mabinogi' is Gwenllian, around 1128, making her the first British woman author. The battlefield has still not been fully explored, and must be preserved as a heritage site. In 1137 Gruffydd gained further success in Dyfed, but died shortly afterwards in suspicious circumstances. Gruffydd had four sons by Gwenllian: Maredudd, Rhys, Morgan and Maelgwn. He also had two older sons by a previous marriage, Anarawd and Cadell, and at least three daughters: Gwladus, Elizabeth and Nest. He was followed by his eldest son, Anarawd. Of his other surviving sons, Cadell, Maredudd and Rhys all ruled Deheubarth in turn.

Norman Cruelty

The Normans did anything to get hold of Welsh lands. Hugh Mortimer blinded Rhys ap Hywel in 1148 to take over his territories around Bridgnorth. Blinding was a common Norman practice – King Henry II was said to have personally taken out the eyes of his child hostages, the two sons each of Owain Gwynedd and The Lord Rhys. In 1175, William de Braose, the Norman Lord of Brecon and Abergafenni, held vast tracts of land that he had conquered in South East Wales. Seisyllt ap Dynwal, Lord of Upper Gwent, held the manor of Penpergwm and Castle Arnold for de Braose, with the Norman being his feudal overlord. De Braose invited Seisyllt and another seventy local Welsh lords to Abergafenni castle for a feast, ostensibly to hear a royal declaration. Hidden outside the banqueting hall were soldiers under the command of Ranulph Poer, Sheriff of Hereford. Seated unarmed during the feast, the Welsh nobles were massacred by Norman troops. Only Iorwerth ab Owain escaped, snatching a sword and fighting his way out of the castle. The antiquary Camden noted that Abergafenni 'has been oftner stain'd with the infamy of treachery than any other castle in Wales'.

William de Braose then raced to Castle Arnold, seized Seisyllt's wife Gwladys, and murdered Seisyllt's only son, Cadwaladr, before her eyes. The *Chronicle of Ystrad Fflur* records the events: 'Seisyll ap Dyfnwal was slain through treachery in the castle at Abergafenni by the Lord Of Brycheiniog. And along with him, Geoffrey his son, and the best men of Gwent were slain. And the French made for Seisyll's court; and after seizing Gwladus, his wife, they slew Cadwaladr, his son. And from that day there befell a pitiful massacre in Gwent. And from that time forth, after that treachery, none of

the Welsh dared place trust in the French.' Norman law stated that conquest of Welsh territories by any means whatsoever was fair. The sole survivor, Iorwerth ab Owain led his men to Abergafenni, forcing De Braose to flee to his stronghold in Brecon Castle. In 1182, Seisyllt's kinfolk managed to scale the high walls of Abergafenni and took the castle, but unfortunately de Braose was absent. Seisyllt ap Eudaf had told the constable of the castle that he would attack the castle at a certain angle in the evening. The Normans waited all night for the attack, and were all asleep at dawn, whereupon the Welsh threw up their scaling ladders in the area that Seisyllt had said, took the castle and burnt it to the ground.

Ranulph Poer and de Braose marched to Dingestow (Llandingat) near Monmouth to begin building another castle. The Welsh attacked and Poer was killed in 1182 with many of his knights. De Braose only just escaped with his life. This battle is known from the descriptions of the capacity of the bowmen of Gwent. Arrows could penetrate a width of four fingers of oak. One arrow passed through a Norman's armour plate on his thigh, through his leg, through more armour and his saddle, killing his horse. Another Norman was pinned, through armour plating around his hip, to his saddle. He wheeled his horse, trying to escape, and another arrow pinned him to the saddle through the other hip. Like his king, the Norman Marcher Lord de Braose was notable for blinding and torturing any Welshman he could lay his hands on. In 1197 he pulled Trahaearn Fychan through the streets of Brecon behind a horse, until he was flayed alive. Maud de Valerie, de Braose's huge wife, also enjoyed seeing prisoners tortured. With the death of The Lord Rhys, de Braose pushed even more into Welsh territories. However, he fell out of King John's favour, and escaped to France in 1204, leaving his wife and eldest son behind. John took them to Corfe Castle and locked them up with just a piece of raw bacon and a sheaf of wheat – this was this Angevin king's favourite form of execution. After eleven days they were found dead. King John even murdered his nephew Arthur, the son of Geoffrey of Boulogne.

De Braose was known to the Welsh as 'the Ogre', and all the great lords brutalised the Welsh – the Laceys, Carews, Corbets, Cliffords, Mortimers, Despensers, Baskervilles and Turbervilles were all vicious, murdering brutes. It was said of Robert of Rhuddlan that he spent fifteen years doing nothing but trying to take Welsh lands and kill its rightful owners – 'Some he slaughtered mercilessly on the spot like cattle, others he kept for years in fetters, or forced into harsh and unlawful slavery.' The Normans and Angevins left a legacy in Wales of cheating, torturing, raping and stealing that is barely recorded in British history. The Marcher Earl Warrenne murdered the two eldest sons of Gruffydd ap Madog when he died in order to take the lordship of the eldest. This was Glyndyfrdwy, a 17-mile-long valley of the River Dee, taking in Llangollen, Llandysilio, Llansantffraid and Corwen. However, for some reason he granted this land in 1282 back to Gruffydd Fychan, the surviving third brother. Eventually, Gruffydd's great-grandson took over the lordship, the great Owain Glyndŵr.

Castles

For those interested in Welsh castles and castle sites, please study the website castlewales.com. Wales is more densely populated with castles than anywhere else in

the world, in all stages of preservation. They were often within sight of each other, so one could help another in the event of attack. The first was built on the river crossing at Chepstow in 1067, as the starting point for ingress into the rich lowlands and ports of Monmouthshire and Glamorgan. From Gloucester, South and South East Wales were easily accessed along relatively flat lands following the Roman road, which is now the A48, through Newport, Cardiff, Neath, Loughor and Carmarthen to Pembroke. Great castles were built at these towns and inland from them.

From the Marcher Earldom of Chester, Anglo-Norman forces made their way down the Dee Valley, though Ruabon, Llangollen to Bala and then along the Roman road to Dolgellau and the Cardigan Bay coastline where castles were built at Harlech, Aberystwyth and Cardigan. They also cut across the North Wales coast towards Anglesey, where Aberlleiniog Castle was built. From Shrewsbury the Normans linked with forces from Chester and, while building Powys Castle, followed the Severn to Newtown, Llanidloes and then down the Wye to Builth and across to Aberystwyth. Following this route, they could also access the Teifi Valley from Tregaron via Lampeter to Cardigan. The Tywi Valley from Carmarthen to Llandeilo and Llandovery was another invasion route, heading north. From Ludlow, there is a relatively easy passage to Knighton and Builth. Heading west from Hereford, Hay and Brecon lay along the invasion route, and heading south Abergafenni, Monmouth, White, Skenfrith and Goodrich could reinforce each other. Pembrokeshire was easily settled from the sea, and populated in its rural south by Flemings. The first castles were wooden forts on a motte-and-bailey design, but the Earls of Hereford built great stone castles at Chepstow and Monmouth as the launching pad for their attacks in Glamorgan and Gwent. In 1075, the fortified stone bridge over the Wye with a hall-keep was built at Chepstow, and is Britain's oldest datable secular stone building. A fightback by the Welsh during the 1090s forced the Normans out of many of their possessions, and they now concentrated upon holding Marchia Wallie, the Marcher lordships. Welsh princes were forced to follow the Norman lead in building stone castles across their lands.

There are hundreds of motte-and-bailey sites across Wales, made of earth and timber and being quick and easy to construct. Many were later buttressed with stone. Welsh castles are often simpler than the later Norman constructions. From the castlewales. com website, we read,

> Above all these considerations, however, there was the overriding difference in the two cultures. In Wales, the bonds between a lord and his followers were essentially those of kinship; in England, authority was very largely maintained by fear and force of arms … These differences are directly reflected in the development of distinctive castle styles. The castles of the Welsh princes have a variety of common character-istics which distinguish them from their English equivalents. Ingenuity was one of the Welshman's greatest attributes successfully applied to castle-building. One Welsh advantage against effective invasion was the rugged topography of their homeland. So, the castle-builders relied on the conveniently inhospitable terrain of the Welsh countryside as their primary means of defence. Consequently, Welsh strongholds were isolated, frequently perched high on rocky outcrops, protected by sheer cliffs, and defended by deep-cut ditches. Additionally, Welsh castles tended to be smaller and erratic in plan; generally consisted of only one ward; depended on a two-storied

keep as the main source of refuge and accommodation; and, most notably, incorporated a new design – the apsidal tower.

This elongated D-shape was a strategically intelligent combination of two more vulnerable designs (the round tower and the rectangular keep), and was technically more useful. The rounded end opened up the defender's field of fire and was less susceptible to undermining, while the squared-off side allowed the expansion of interior rooms for more living – and breathing – room. Interestingly, while many English castles used spiral staircases to move between levels, most Welsh strongholds contained straight flights of steps set into the interior walls. Curiously, most Welsh castles made little use of one particularly formidable defensive asset – the fortified gatehouse (Cricieth being the one glaring exception), a structure successfully employed in many English castles. However, the precarious location of Welsh castles would have afforded long-range observation and timely preparation for invasion.

Even today, their massive piles dominate such centres of urban settlement as Cardigan, Pembroke, Caernarfon, Conwy, Brecon, Cardiff, Caerffili and many others. Caerffili is one of the greatest castles in the world, only surpassed in size in Britain by Windsor, which never saw battle. If one takes Caerffili's great water defences into account, it is possibly the largest castle in the world. Every Welsh castle seems to have witnessed war – they were not built as stately homes. There are also many medieval churches with strong defensive towers across Wales. It is one of the few lands where you can see its history all over the landscape.

Religion

The monk Rhigyfarch probably succeeded his father Sulien in 1091 in charge of the see of St David's. Rhygyfarch wrote his *Vita of St David* around 1093, noting the independent traditions of the Welsh church and nation, and protesting against Norman interference and violence. Written six centuries after St David's death, Rhigyfarch's *Vita* may have led to David's canonisation by Pope Callistus II in 1123. In 1093, Anselm had become Archbishop of Canterbury, and began to interfere with the authority of St David's. He even suspended and replaced its archbishop, Gruffydd (known as Wilfrid) in 1115. Gruffydd was succeeded for a few months by Deiniol, but he in turn was replaced by the Norman Bernard, also in 1115. Bernard was the first bishop to submit to Canterbury. Rhigyfarch's assessment was proved correct. Rhygyfarch's *Lament* records,

> People and priest alike are crushed by Norman word, heart and deed.
> They extort new taxes and burn our belongings;
> One foul Norman enslaves a hundred by command and glance…
> We are mutilated, condemned, enchained;
> The honest hand is burnt with the thief's brand,
> A woman's nose sliced off, a man's testicles…

Of course, Norman-French invaders and their successors could buy pardons for torture, rape and murder from the Roman Church, one of its main sources of income. Thereby

the lords and their followers would go to heaven, whatever their deeds. In the parts of Wales they controlled, the Normans faced a Welsh Church which had hardly altered in line with Roman demands. Many of the larger churches had been originally native monasteries or *clasau*, often set within circular churchyards, on sites founded by fifth- to eighth-century saints. Many smaller ones were originally dependent chapels of a mother church or monastery, or the private chapel of a local Welsh lord or noble. Welsh Christian settlements had grown up organically around the areas of the families of nobility and Celtic saints, so there were no traditional dioceses with official geographical boundaries. Welsh clergy also married, and their families served the church. Despite the best efforts of Rome, many Welsh clergy were married with families until the sixteenth century.

In 1107, the Norman Urban of Llandaf was the first bishop in Wales to swear an oath of allegiance to Canterbury, and by 1150 the other Welsh bishops had followed him. With the Normans came the establishment of formal monasteries. The first Benedictine monastery was founded at Chepstow in 1071, shortly after the building of its castle, and the order became closely allied with the Anglo-French. However, in the middle of the twelfth century the Cistercians arrived in Wales and within three decades these 'white monks' were closely identified with the Welsh princes, the people of Wales, its language and culture.

Gerald of Wales recorded in 1194, 'As I can bear witness, the Welsh pay greater respect than any other people to their churches, to men in orders, the relics of the saints, holy books and the Cross itself.' Wales had its own Christian tradition rooted in the early Celtic Church. Monks lived in independent religious communities, *clasau*, led by influential abbots. Monasteries sometimes specialised as educational establishments or as scriptoria, and others were famous for their spiritual devotion. Some Welsh traditions, like allowing abbots to marry, or having hereditary positions in the church, were prevalent in Pura Wallia. However, in Norman-controlled areas, these practices halted. Continental orders like the Benedictines and the Augustinians took over the local monasteries in the Marches, and Welsh priests and bishops were excluded. The Norman Church was profoundly hostile to the Welsh.

Fortunately, in the late twelfth century, the Welsh princes began to be served by the Cistercian order. The order was based in Burgundy, beyond the control of Norman kings. Their religious ideals of simplicity and devotion were similar to those of the traditional Welsh Church. By 1202, the Cistercians had spread from Whitland and Strata Florida in Deheubarth to Valle Crucis in Powys Fadog. With generous princely patrons and no sons to divide the inheritance, the Cistercian monasteries soon controlled massive estates; for instance, Aberconwy Abbey held over 40,000 acres. Cistercian monks developed large-scale sheep farming and are credited with pioneering the Welsh woollen industry. Their need for skilled craftsmen also stimulated the Welsh economy. The Cistercians provided Welsh princes with a source of educated clerks, and many retired to churches; for example, Owain Cyfeiliog, the twelfth-century poet and warrior-prince of Powys, became a monk at Strata Marcella. The ailing Llywelyn the Great became a monk at Aberconwy before his death.

The Cistercians supported Welsh princes and the Welsh people until the Dissolution of the Monasteries. The Lord Rhys supported Cistercians, which was an important development in the secular and religious life of medieval Wales. By 1200 all the major

Welsh princes had a monastery of the order of Cîteaux. Cistercian abbeys like Strata Florida and Vale Crucis provided meeting places and burial grounds for the rulers, and it is in their stone buildings that most of what has survived of the literature of early medieval Wales was protected. Over the centuries the Normans destroyed the scriptoria and their contents. Fortunately, the Hendregadredd Manuscript was only found in a mansion near Pentrefelin in 1910, allowing the compilation of the lost *Brut y Tywysogion*. The *White Book of Rhydderch* was probably compiled in Strata Florida Abbey. Among the few remaining Welsh treasures of medieval literature are the *Red Book of St Asaph*, the *Book of Teilo* (from Llanbadarn Fawr), the *Black Book of Carmarthen* and the *Red Book of Hergest*.

The Normans wanted full control of the Church in Wales, to more easily control the people. They suppressed the *clasau* of the Celtic Church and made many of them tributary churches of ecclesiastical centres in England or France. Hundreds of churches were rededicated from Welsh saints to foreign saints, and Norman lords supported the Benedictine order with new monasteries. One of the measures employed by Normans to exterminate 'Welshness' was to rededicate hundreds upon hundreds of churches away from their Celtic founders to foreign saints (for example, St David's was rededicated to St Andrew). Thousands of place-names were renamed, simplified or otherwise Anglicised, such as Brychdyn to Broughton. The country was divided into parishes and was obliged to accept the discipline of Roman canon law. The Benedictines were more closely allied to Rome and money-gathering than the more spiritual Cistercians. Other French monastic orders were brought to Wales: those of Cluny, Tiron, Savigny and Cîteaux. Welsh dioceses were reorganised with defined boundaries. All four Welsh bishops became subject to Canterbury – and thereby Rome – and new cathedrals were built.

Language and Culture

The Saxon language was quickly abolished from law and government in England, to be replaced by Latin or Norman French, but the Welsh language flourished in the Marches and west of Offa's Dyke. The Norman overlords seem to have despised the Saxons whom they had so easily subdued, but they seemed to have had much more respect for the Welsh. The latter's Cymric language was probably much more intelligible to them than that of the barbaric Saxon of the English. Even today, few people realise the extent of the French language upon English. More than 10,000 French words found their way into English – words associated with government, law, art, literature, food, and many other aspects of life. About three quarters of these words are still used, and words derived directly or indirectly from French now account for more than a third of English vocabulary. In fact English speakers know around 15,000 French words, even before they start learning the language.

Welsh literature grew in confidence in the twelfth century. The language had survived the Norman invasion and gained new links with Europe. Wales started to export its literary tradition, most notably the stories of King Arthur and his knights. Geoffrey of Monmouth, by giving Arthur so much space in his *Historia Regum Britanniae* (1120–9), made the Arthurian legends the most fashionable stories

of medieval Europe. The tales became the basis for a whole new European literature of Arthurian romance. Giving the source for his history as the Welsh writer Walter Map, Archdeacon of Oxford, Geoffrey gives us the tradition of Arthur presiding over a chivalric court in a kind of golden age of the British Isles before the arrival of the Saxons. Geoffrey's writings provided the people of Wales with a claim to the sovereignty of the whole island of Britain, a claim of which the Tudors later took advantage. In 1152 Geoffrey became Bishop of St Asaff.

Welsh literature covered not only writings on history, but also on law, medicine and healing, geography, the lives of the saints and theology. The *Mabinogion* is Wales' greatest contribution to European literature. Its tales may have been first written down in the eleventh century, involving figures and places from Celtic mythology. The title was first used by Lady Charlotte Guest in her remarkable translation, aided by Carhuanawc and others, published between 1838 and 1849. The texts are preserved in the *White Book of Rhydderch* (written in the mid-fourteenth century) and the *Red Book of Hergest* (written slightly later).

There was also a flourishing of the court poets, celebrating successes against the Normans. The main poetic form was the *awdl*, the short, mono-rhymed piece involving a structure of intricate metres. Dominant poets were Cyndelw Brydydd Mawr (Cyndelw the Great Poet), Llywarch ap Llywelyn, Gwalchmai, Hywel ap Owain Gwynedd, and Gruffudd ap yr Ynad Coch. The *Brut y Tywysogion* records for 1176 that 'at Christmas in that year The Lord Rhys ap Gruffydd held court in splendour at Cardigan (Aberteifi) … And he set two kinds of contests there: one between bards and poets, another between harpists and crwth-players and pipers and various classes of music-craft. And he had two chairs set for the victors.' The above entry is the first known mention of the eisteddfod, the 'chairing' that has become part of Welsh culture and tradition.

Urbanisation

In 1000 there were no urban areas, but over the next three centuries scores of towns were founded, the last 'created' medieval town being Bala in 1309. With the Normans came the first recognisable towns, and by 1170 there were around fifty, all centred on castles for protection. Over time, the more important were converted to bastides, fortified trading places like Aberystwyth, Flint, Cowbridge, Conwy, Caernarfon, Cardiff, Chepstow, Tenby and Monmouth. The Norman invasion coincided with an improvement in the climate and a growing population. Boroughs were established in the Marcher lordships, generally settled by incomers from England. Towns became central to the growing economy, but townspeople made up probably less than 10 per cent of the population. With an improving climate and a developing economy, the population of Wales probably doubled between 1050 and 1300. By 1300, Cardiff, with perhaps 2,200 people, was probably the largest town in a population of around 200,000. Although most Marcher lordships were inhabited in the main by the native Welsh, all of them had Englishries – areas within easy reach of the borough and its castle settled by immigrants. Norman incursions introduced new social relationships. In places like the Vale of Glamorgan, the land was organised into a series of knights'

fees, each capable of maintaining a mounted warrior and supported by a manorial system sustained by villeins, who were often incomers. Cistercian abbeys and lordships exported wool, leather, sheep and cattle and in return Wales imported salt, cloth and iron. Ports became centres of population.

From 1000 there were changes in native Welsh society, particularly the growth of the concept that a crime is an offence against the ruler, rather than against the kin. There was also an increasing replacement of renders of food and services, by payments in money. There was a more intense use of land, with extensive clearing of forests, the development of villages, the building of mills and the growth of a more sophisticated social structure. Economically Wales was undeveloped, lacking large towns and major trade. The country was dominated by tribute-gathering military nobility. England was a far richer, urbanised, more monetised and commercially advanced neighbour. It could either starve the Welsh into submission or exploit it economically and politically as a colonial annexe. However, the very fragmentation of Wales could be turned to its advantage.

Gerald of Wales, 1146–1223

Born at Manorbier Castle to a Norman father and Welsh mother, Gerald was the leading Welsh cleric of the age. In the late twelfth century his campaign to elevate St David's to an archbishopric was frustrated by Canterbury, yet he remains an important figure thanks to his writings about religion and politics in Wales and Ireland. Giraldus Cambrensis served as administrator at St David's and clerk to the court of Henry II. At various times he turned down the offer of being Bishop of Bangor, Llandaff, Wexford, Ossory and the Archbishopric of Cashel. He was at one time Bishop of St David's, but King John refused to confirm his appointment. Gerald was repeatedly nominated as Bishop of St David's, but upon three occasions was refused the post because he wished it to be an archbishopric independent of Canterbury. He accompanied Prince John to Ireland and Archbishop Baldwin on his journey through Wales, preaching the Crusade. His two books on Wales are his most important, the *Itinerarium Cambriae* and the *Descriptio Cambriae*. Gerallt Cymro (Gerald the Welshman) observed how a Welshman at Pencader had retorted defiantly to Henry II (1154–89), that no one but a Welshman would answer to God for the little country that was Wales. Giraldus wrote (of the Welsh), 'If they would be inseparable, they would be insuperable.' In his *Description of Wales* (1193), he devoted one chapter to the ways in which the English king might achieve the total conquest of Wales. In another, he tells the Welsh how they should set about resisting such a conquest.

Gerald of Wales recorded in 1194 that

> the Britons who were left alive took refuge in these parts when the Saxons first occupied the island. They have never been completely subdued since, either by the English or the Normans ... Sound the horn for battle and the peasant will rush from his plough to pick up his weapons as quickly as the courtier from his court ... The Welsh are passionately devoted to their freedom and to the defence of their country: for these they fight, for these they suffer hardships, for these they will take up their weapons and willingly sacrifice their

lives … light and agile, fierce rather than strong and totally dedicated to the practice of arms and passionately devoted to their freedom, their sole preoccupation is the defence of their fatherland.

As a Franco-Welshman, he disliked the English and wrote, 'They are the most worthless race under heaven. In their own country they are the slaves of the Normans, and in Wales they serve only as cowherds and cleaners of sewers.'

The Marches

Many Norman lords followed William the Bastard in his risky invasion of Britain in 1066, as they could see long-term gains. Normandy was small, and expansion difficult. The borders of England offered the opportunity of gaining huge estates. The best land went to the king and his inner circle and so it was in Wales and Scotland (and then Ireland via Pembroke) that the most ambitious lords found their and opportunity. The Angevin kings also realised that their authority could only reach into central Wales through the power of their own nobility, often without the Crown's consent. However, in order to subdue the native population, these lords would have to raise and maintain a significant military presence and build powerful castles to defend it. Over time, these ambitious and ruthless lords of the March came to be a grave and lasting threat to the throne of England.

While their barons were trying to conquer Wales, the French kings of England mainly concentrated upon their Angevin lands in Normandy and France. They were lost in King John's reign. The crown only intervened on the Welsh borders when it felt was necessary, as any lands taken by the advancing barons remained in their possession only by the grace of their king. Conquest was a piece-by-piece affair, with land often being regained by the Welsh. By the reign of Henry III (1216–72), Wales could be called a 'half-conquered country'. Incidentally it was not until Henry III's reign that the first government documents were published in a form of English. With the Norman lords came thousands upon thousands of Anglo-Saxons to settle the Marcher and Crown lands. By the time of Edward I's invasion of 1276, Wales had become divided into three regions. The outer one, along the south coast and traditional English border, belonged to the Marcher lords, descendants of the first frontier Norman barons and the Crown itself. They were the first line of England's defence against Welsh invasion back into its lands, and also controlled trained armies for their own and royal invasions into central Wales. The Marches enjoyed their own laws. The central area of Wales kept changing hands. A strong Welsh prince could, with help from rival princes, hold it. On the other hand, so could a strong king. With a strong English king or aggressive Marcher lords, the native Welsh princes were often pinned back in Gwynedd, where there was a continuation of a separate Welsh society, with its own traditions, customs and Welsh laws.

By 1200, the March of Wales consisted of the fringes of Flintshire and Montgomeryshire, most of Radnorshire, Breconshire and Glamorgan, most of Monmouthshire, southern Carmarthenshire and all of Pembrokeshire below the Landsker line of castles. The leading Marcher lords were de Braose, Mortimer, Fitzalan

and Marshall. The major Welsh leader figures of twelfth-century Pura Wallia – Madog ap Maredudd of Powys, Owain Gwynedd and The Lord Rhys of Deheubarth – had died. Powys had been divided between two branches of its ruling family. The northern part (eastern Meirionnydd and southern Denbighshire and Flintshire) became known as Powys Fadog, the southern part (Montgomeryshire) as Powys Wenwynwyn. Deheubarth was also on the verge of division, as the sons of The Lord Rhys fought each other as well as the Normans. Gwynedd also looked like falling apart from civil war, although Llywelyn ab Iorwerth, grandson of Owain Gwynedd, re-established the power of his grandfather.

The End of Powys – Madog ap Maredudd ap Bleddyn ap Cynfyn

Pembroke and South East Wales had quickly become Marcher territories, and the next-easiest area to invade was Powys, which had also withstood the brunt of Germanic attacks. Wales is only just over 30 miles in its centre, between Shropshire and the coast of Ceredigion, with the English territorial bulge reflecting Germanic and then French progress in taking British lands. Madog succeeded his father as the last king of all of Powys in 1132. Alongside Owain Gwynedd's brother Cadawaladr, he led a large army of Welshmen at the Battle of Lincoln in 1141, supporting the Earl of Chester. In 1149 he took Oswestry back from William Fitz Alan's Normans, but was under pressure from Owain Gwynedd, although Madog had married Owain's sister, Susanna. Madog was forced into an alliance with Ranulf of Chester but defeated by Owain at Coleshill in 1150. Owain confiscated his lands in Iâl (Yale near Wrecsam) but in 1157 Henry II helped Madog regain most of his lands, and he returned Oswestry to Fitz Alan. Madog was buried in 1160 at St Tysilio's church in Meifod, and shortly after his son Llywelyn was killed, Powys being divided. Owain Cyfeiliog, Madog's nephew, took most of southern Powys, which became known as Powys Gwenwynwyn after Cyfeiliog's son. The northern part was taken over by Owain Gwynedd, and became known as Powys Fadog. After hundreds of years, the ancient Kingdom of Powys had in effect ended with Madog's death.

The Welsh Courts

Traditionally the rulers in Wales had been known as kings, but in the twelfth and thirteenth centuries they began to use the title of prince. 'In Wales, no one begs,' wrote Gerald of Wales, because guests were always welcome in the princes' courts and a stranger could soon become a guest if he acted appropriately. Each Welsh prince had his own court with its officers. The *ynad* ran the court, the *distain* (steward) organised the meals, the *gwas ystafell* looked after the bedchamber and the prince's wardrobe, the *bardd teulu* was the prince's house poet and the *pencerdd* was the chief poet, who travelled more widely. Court life had rules governing who sat where at mealtimes and on how to behave. Meals were a time to reward followers with gifts and plunder and a time to reaffirm communal bonds. The court moved with the prince on his travels. While on his *cylch* (journey) the prince could ensure each locality would stay loyal in times of trouble.

The court had a vibrant cultural side. The *pencerdd* trained for many years, and would sing the praises of the prince, his warriors and their predecessors as an example to follow. These poets were rooted in a tradition going back to the days of Aneurin and Taliesin. Owain Cyfeiliog, the twelfth-century Prince of Powys, was a poet in his own right, writing *The Long Blue Drinking Horn*. A prince had to have royal blood, so genealogy was important. All sons were heirs in Wales, so brothers were often rivals, and no prince could dominate till he had dealt with his brothers. Honour and reputation on the battlefield were vital qualities. The prince had his *teulu* – a band of fighting men of noble status, the *uchelwyr*, led by a loyal relation of the prince, the *penteulu*. In times of war, the prince could also call on his freemen to serve in his army, the *llu*.

Owain Gwynedd – Owain ap Gruffydd ap Cynan, 1109–70

Effective and sustained English domination in Wales was mainly confined to areas of intensive English settlement. Since these were few and restricted, so was secure English control. Beyond the areas of intensive English settlement in South Wales, the barons generally operated as informal overlords. Welsh princes were allowed to retain their authority and status as long as they acknowledged the ultimate supremacy of the Crown and stayed peaceful. For generations Normans and Welshmen of the same relative social status would meet as equals, a situation practically unknown in England. While the Marcher lords consolidated their supremacy over much of the southern lowlands and the borders, Madog ap Maredudd (d. 1160) ruled Powys, Owain ap Gruffydd (d. 1170) controlled Gwynedd, and Rhys ap Gruffydd (The Lord Rhys, d. 1197) was master of Deheubarth. Rhys also acted as a protector for the smaller Welsh dynasties of northern Glamorgan and the uplands between the Wye and Severn valleys.

During the 200 years of battles with the Normans, Angevins and Plantagenets, three political entities in Wales remained fairly stable and relatively independent: the princedoms of Powys, Deheubarth and Gwynedd. Gruffydd ap Cynan's son, Owain Gwynedd, extended his possessions over Offa's Dyke into England, and down into the other two princedoms. This ensured the predominance of the Princes of Gwynedd, Rhodri Mawr's descendants, in the continuing Welsh fight for national independence. From his accession to the Crown of Gwynedd in 1137, Owain Gwynedd was faced with major problems from his brother Cadawaladr, but Owain's sons Hywel and Cynan defeated Cadwaladr and forced him to flee to Ireland. In 1145, Owain lost his favourite son Rhun and fell into a long period of grieving. However, Hywel Hir and Cynan took the mighty Norman fortress of Mold (Wyddgrug) and razed it to the ground, restoring his spirits and showing him that there was a war to be won. The castle had been thought to be impregnable. In 1149 Madog ap Maredudd, Prince of Powys, joined the Norman Earl of Chester to gain lands off Owain. Their army was slaughtered in a battle in the woods of Consyllt (Coleshill) in 1150, but Madog escaped to cause further trouble.

In 1156, Owain's brother Cadwaladr joined with Madog ap Maredudd and encouraged Henry II to invade Wales to exterminate Owain. Henry II's first campaign against Owain ended in a truce in 1157. Owain, with his sons Dafydd and Cynan, had waited

for Henry's army in the woods at Coed Eulo (Cennadlog) near Basingwerk, on the Dee Estuary. They almost took Henry prisoner, and the Earl of Essex threw down the royal standard and escaped through the woods. Knights from Henry's fleet ravaged Anglesey, trying to destroy the grain crops to starve Owain's people into submission. However, the invaders were driven back to their ships, and one of the king's sons was killed while Henry waited for reinforcements at Rhuddlan.

The *Chronicle of Ystrad Fflur* for this year reads,

> In this year Henry II, king of England, led a mighty host to Chester, in order to subdue Gwynedd. And Owain, Prince of Gwynedd, gathered a mighty host and encamped at Basingwerk and raised a ditch to give battle. And the sons of Owain encountered Henry in the wood at Hawarden and gave him a hard battle so that after many of his men had been slain, he escaped to the open country. And the king gathered his host and came as far as Rhuddlan and Owain harassed the king both by day and by night. While those things were happening the king's fleet approached Anglesey and plundered the churches of Mary and of Peter. But the saints did not let them get away for God took vengeance upon them. For on the following day the men of Anglesey fell on them; and the French, according to their usual custom, fled but only a few of them escaped back to their ships. And Henry, son of king Henry, was slain. And then the king made peace with Owain; and Cadwaladr received back his land. And the king returned to England.

With the 1157 truce, Owain gave King Henry hostages, promising not to attack England, and allowed the king to keep the land around Rhuddlan. In 1160, with the death of Madog ap Maredudd, Owain attacked Powys and extended his influence in the east. In 1166, the Council of Woodstock tried to make the Welsh princes vassals, and there was an uprising by led Owain, and his nephew Rhys ap Gruffydd (The Lord Rhys) in South Wales. A monk of St David's wrote, 'All the Welsh of Gwynedd, Deheubarth and Powys with one accord cast off the Norman yoke.' Henry II tried again to subjugate Wales in 1164, but failed, and Owain's son Dafydd captured the important royal castles of Basingwerk and Rhuddlan in 1166 and 1167.

Henry's forces were vast, composed of Normans, Flemings, Gascons, impressed Welshmen and Scots as well as English. Henry recaptured the castles, and set up to invade from a base in Shrewsbury. With his brother Cadwaladr back on his side, and The Lord Rhys, Owain called his forces to Corwen. Apart from Owain and Cadawaladr and the men of Gwynedd, Henry faced and retreated from Rhys ap Gruffydd and the men of Deheubarth, Owain Cyfeiliog's supporters from Powys and the Gwent army of the sons of Madog ab Idnerth. Henry moved through the damp Berwyn Mountains, cutting a road through the heavy forests in Glyn Ceiriog to keep away Welsh archers and raiding parties. Even today the road is called 'Ffordd y Saeson' (The English Road). Welsh guerilla attacks and bad weather defeated the Angevin army, and they retreated back to the shelter of Shrewsbury (Pengwern). One violent attack by the Welsh guerilla forces took place at a place now called 'Adwy'r Beddau' (The Pass of the Graves). The Welsh victory at Crogen in Dyffryn Ceiriog is recorded in no English history books.

In 1165, *Brut y Tywysogion* tells us of Henry II's mission, which was

to destroy all Britons ... The king was greatly angered; and he moved his host into Duffryn Ceiriog, and he had the wood cut down and felled to the ground. And there were a few picked Welshmen, who knew not how to suffer defeat, manfully encountered him in the absence of their leaders. And many of the doughtiest fell on both sides. And then the king, and the advanced forces along with him, encamped on the Berwyn mountains. And after he had stayed there a few days, he was greatly oppressed by a mighty tempest of wind and exceeding great torrents of rain. And when provisions failed him, he withdrew his tents and host to the open land of the flats of England.

On his return, he destroyed all in his path and ordered all his Welsh hostages to be blinded and castrated. Henry had four very important hostages – Rhys and Cadwaladr, two sons of Owain Gwynedd, and Cynwrig and Maredudd, two sons of The Lord Rhys of Deheubarth.

'He blinded them ... and this the King did with his own hand', according to the *Chronicles*. Few Welsh people know of this terrible event, and it is hardly recorded in any British history books. One wonders what would have been written if the Welsh had ever done this to English princes. As Cicero stated, 'To know nothing of what happened before you is to remain forever a child.' Giraldus Cambrensis tells us of Owain's restrained behaviour towards the burning of churches and the blinding of twenty-two hostages taken in 1163, including his sons. He had been urged to burn English churches in retaliation, but replied, 'I do not agree with this opinion: rather we should be grateful and joyful because of this. For we are very unequal against the English unless we are upheld by divine aid; but they, through what they have done, have made an enemy of God himself, who can avenge the injury to himself and to us at the same time.' Owain then despoiled all the castles that the French had built in Wales, including the mighty Rhuddlan Castle.

In 1168, diplomatic relations were established between Owain Gwynedd and King Louis VII of France, to King Henry's impotent fury. Owain's ambassador to France offered Louis help against the English. When he died in 1170, after thirty-three years as Prince of Gwynedd, Owain was hailed as 'the king and sovereign and prince and defender and pacifier of all the Welsh after many dangers by sea and land, after innumerable spoils and victories in war ... after collecting together into Gwynedd, his own country, those who had been before scattered into various countries by the Normans, after building in his time many churches and consecrating them to God'. The *Chronicle of Ystrad Fflur* notes that 'at the end of this year Owain ap Gruffydd ap Cynan, Prince of Gwynedd, the man who was of great goodness and very great nobility and wisdom, the bulwark of all Wales, after innumerable victories, and unconquered from his youth, and without ever having refused anyone that for which he asked, died after taking penance and communion and confession and making a good end'.

His chronicler states also that his kingdom 'shone with lime-washed churches like the firmament with stars'. Owain's reign saw the strongest Norman attacks on Wales – his whole reign was focused upon protecting Wales from the Marcher lords. He was also known as Owain Fawr, 'Owain the Great', and repulsed the invasion by Henry II so easily 'that no other Plantagenet king attempted to subjugate Wales until his death'. His nephew Rhys ap Gruffydd, Prince of Deheubarth, now took the mantle of chief

defender of Wales against the invading Normans. Gwalchmai, Owain's *pencerdd* (chief household bard) wrote in *The Triumphs of Owain*,

> Owain's praise demands my song
> Owain swift and Owain strong;
> Fairest flower of Rhodri's stem,
> Gwynedd's shield, and Britain's gem …
> Lord of every regal art
> Liberal hand and open heart …
> Dauntless on his native sands
> The dragon-son of Mona stands.

Under Owain Gwynedd and Madog ap Maredudd, the kingdoms of Gwynedd and Powys were gradually freed from Norman influence and became re-established as major political units under Welsh rulers, enjoying Welsh law, and where the Welsh language flourished. Though eventually Owain was forced to recognise Henry's control over lands to the east of the River Clwyd (Tegeingl, part of the old Earldom of Chester), he refused to acknowledge the authority of the Archbishop of Canterbury in Wales, holding the consecration service for the new Bishop of Bangor not in Wales, but across the Celtic Sea in Ireland. Owain had encouraged monasticism, especially in Gwynedd, but he died excommunicated because he refused to divorce his wife, his cousin. Archbishop Baldwin of Canterbury, when he visited Bangor Cathedral in 1188, thus spitefully ordered Owain's bones to be moved from the Cathedral to the churchyard. In full control of the whole of native Wales, Owain took as his title 'Prince of Wales' (Princeps Wallensium). Poets sang the praises of brave princes; Cynddelw Brydydd Mawr wrote *In Praise of Owain Gwynedd* in the late twelfth century, part of which is translated as

> I praise a patron high-hearted in strife,
> Wolf of warfare, challenging, charging,
> In arms against Angles in Tegeingl's lands,
> Blood spilling in streams, blood pouring forth,
> Dragons encountered, rulers of Rome,
> A prince's heir, red their precious wine.
> In strife with the Dragon of the east,
> Fair Western Dragon, the best was his.

The Lord Rhys – Rhys ap Gruffydd ap Rhys ap Tewdwr, 1132–97

Following the death of Henry I in 1135, England entered a period of disorder. This provided an opportunity for the native Welsh princes, and his military and political abilities saw Rhys ap Gruffydd acknowledged as the pre-eminent Welsh ruler of the twelfth century. He was the grandson of Rhys ap Tewdwr, who was slain by the Normans at Brycheiniog in 1093. His father was Gruffydd ap Rhys, who was named 'Gruffydd the Wanderer' from his days in hiding in the great forest of Ystrad Tywi. Gruffydd died

in mysterious circumstances soon after his wife Gwenllian was executed at Cydweli, so their remaining children were brought up by Gwenllian's brother Owain Gwynedd. Rhys grew up in the shadow of his uncle Owain Gwynedd, but from Owain's death in 1170 he was the acknowledged Welsh leader, based in the castle he built at Dryslwyn and his principal residences at Cardigan and Dinefwr.

After Gruffydd ap Rhys's death in 1137, his remaining sons worked together to consolidate Deheubarth. Morgan ap Gruffydd had been executed at Cydweli, alongside his mother, Gwenllian. Maelgwn ap Gruffydd was taken there and disappeared from history. Anarawd ap Gruffydd became Prince of Deheubarth, and in 1138 he and his brother Cadell joined Owain Gwynedd and Owain's brother Cadwaldr to attack the French-held Cardigan Castle. The assault was aided by a fleet of Viking ships, but an agreement was reached and the siege lifted. In 1140 Anarawd again supported Owain Gwynedd, this time in his dispute against Canterbury about the appointment of the Bishop of Bangor. However in 1143 Anarawd was treacherously killed by the men of Owain's brother Cadwaladr. Cadwaladr himself was suspected of having ordered the killing in order to push further into a leaderless Deheubarth. This angered Owain, as Anarawd was his ally and was about to marry Owain's daughter. Owain sent his son Hywel to strip Cadwaladr of his lands in Ceredigion in punishment.

Cadell ap Gruffydd succeeded Anarawd in 1143, holding part of the Kingdom of Deheubarth, with the remainder in Norman hands. He had fought at Cardigan and now began to win back parts of Deheubarth, in 1146 taking the castles of Llansteffan and Carmarthen and in 1147 defeating Walter Fitzwiz. In 1150 he retook southern Ceredigion from Hywel ab Owain Gwynedd. Out hunting in 1151, Cadell was attacked by a Norman force from Tenby, who left him for dead. Too badly injured to rule, he passed the leadership of Deheubarth to his younger half-brothers Maredudd and Rhys. Maredudd was only six years old when his mother, brother and then his father were killed. At the age of sixteen he helped Cadell to expel the Normans from Ceredigion. He then successfully defended Carmarthen Castle against a Norman assault, hurling down the scaling ladders. In 1151 he took a prominent part in winning back the northern part of Ceredigion from Gwynedd. Prince Maredudd died in 1155, leaving the throne of Deheubarth to his younger brother Rhys. Of Rhys' five brothers, four were dead and one crippled for life.

Walter de Clifford, Lord of Clifford and Bronllys castles, inherited a castle at Llandovery from which to dominate Cantref Selyf in central South Wales. However, Walter had lost it in a resurgence of Welsh power about 1140. A prominent member of the retinue of Roger, Earl of Hereford, Walter worked to assist Roger's attacks from the southern Marches from 1143 onwards. As a result, by 1158 his position in South Wales was restored, and he recovered Llandovery. The *Brut y Tywysogion* reports that in that year Clifford raided the lands of The Lord Rhys, who, after his complaint about this to Henry II went unheeded, retaliated by besieging and capturing Llandovery. Rhys also burnt Cydweli Castle in 1159 to avenge his mother's execution, but rebuilt it thirty years later, when he was in total control of his lands. Clifford carried on attacking Welsh lands, and in 1163 killed Cadwgan ap Maredudd. The castle at Aber Rheidiol at Aberystwyth was next seized by Rhys from Roger de Clare in 1164. Rhys demolished the castle. His reason was that de Clare had paid Walter ap Llywarch, a servant of Einion ab Anarawd, Rhys' nephew, to murder Einion in his sleep. However, from this

time, there was heavy pressure upon Rhys from Henry II's own forces. Cantref Bychan, Ceredigion and Llandovery Castle were restored to their Norman lords, but Rhys successfully attacked Llandovery again in 1162.

Annales Cambriae states that Henry came to Oswestry in 1165 with Anglo-Saxons, Normans, Irish, Scots, and troops from Aquitaine. The Pipe rolls confirm that among the troops brought across the Channel were *coterelli*, mercenaries who had to be provided with clothing and arms. The castles of Shropshire – Shrewsbury, Bridgnorth, Church Stretton, Shrewardine, Oswestry, Knockin, Chirk and Caus – were manned in readiness. The Pipe rolls also refer to the transfer of Welsh hostages from London to Shrewsbury, and to the expenses of keeping hostages in Worcestershire and at Bridgnorth. These were probably the hostages taken by the king in 1163. Spears, arrows, shields, hauberks, picks, axes, iron and rope had to be purchased and transported to Wales. Regarding supplies of food, for corn supplies alone, payments were made in Gloucestershire for 849 horse-loads of corn, in Lincolnshire for 235½ sesters of corn (equivalent to almost 3,000 bushels), in Oxfordshire and Berkshire for 1,000 horse-loads at Worcester, and in Worcestershire for 509 horse-loads carried to Shrewsbury.

Gwenllian's efforts and death had served to build bonds between rival Welsh princes, rather like Jeanne d'Arc in France. In 1165, the princes of Gwynedd, Powys and Deheubarth had united, putting aside their normal quarrels. Their army, led by Lord Rhys and Owain Gwynedd, halted an invasion force at Caer Drewyn in the Berwyn Hills. The aggressors were made up of armies from England, Scotland, Flanders, Anjou, Gascony and Normandy, supported by a Danish fleet and financed by London merchants. The English could not believe the large army that faced them, and slowly retreated, being ambushed at Crogen. King Henry II personally blinded two of Rhys' hostage sons in revenge, along with two of Owain Gwynedd's sons. They were children at the time. They had been taken hostage in a truce made in which the Welsh promised not to invade England, so Rhys and Owain did not expect this action, as Henry had invaded Wales. (Henry II was a French-born, French-speaking 'English' king, the first of the Plantagenets, responsible for the murder of Becket.)

This victory brought the whole of Wales together. Faced with a united force, the great English army had retreated in disarray. In 1165, Rhys took Cardigan Castle 'by escalade', with Cadifor ap Dinawal of Castell Hywel being first to scale the ramparts. Rhys took over leadership of Wales upon his uncle Owain Gwynedd's death. However, as with Hywel Dda with the Saxons, Rhys realised the necessity of friendship and accommodation with the Normans to preserve Welsh independence. Rhys therefore diplomatically stopped any aggression against the Marcher lords and crown estates. He allowed Henry through Wales on his way to Ireland in 1171, and Henry in turn officially recognised Rhys as ruler of Deheubarth. Ceredigion and other territories were restored to the house of Deheubarth. On Henry's return, he appointed Rhys Justiciar of South Wales in return for Rhys' support. This gave Rhys effective overlordship of most of South Wales, including Glamorgan and Gwent. Rhys held the first eisteddfod that can be authenticated in Cardigan in 1176 (where his father is also said to have held this great event), and twelve years later entertained Giraldus Cambrensis and Archbishop Baldwin of Canterbury. Also know, as Rhys *Mwyn Fawr* ('The Greatly Courteous'), The Lord Rhys established the abbey of Ystrad Fflur (Strata Florida) in Ceredigion in 1186.

After Henry II's death, Rhys gained more of Wales back from the Norman Marcher lords, beginning to campaign constantly. In 1196, Normans from the east encroached on his territories, under Roger Mortimer and Hugh de Say. Rhys defeated them, capturing Painscastle and burning Maes Hyfaidd. Rhys died aged around sixty-five in 1197, hailed as the chieftain who did more than any to preserve South Wales from the Normans. He was also renowned as a patron of bards and monks, and was commemorated as 'the head, and the shield, and the strength of the south, and of all Cymru; and the hope and defence of all the tribes of the Britons'. One of Britain's greatest heroes, like his uncle Owain Gwynedd and his mother Gwenllian, he is unknown in British history books. The tomb effigy of The Lord Rhys is in St David's Cathedral, along with that of Giraldus Cambrensis. Rhys ap Gruffydd's effigy is the recumbent figure of a knight in the north presbytery. Strangely enough, just like Owain Gwynedd, he died in a state of excommunication, mainly because of a quarrel with Bishop Peter. However, the Welsh Church still buried him in a cathedral, like Owain Gwynedd, despite the wishes of Canterbury. *The Sunday Times* in 2000 placed Rhys ninety-fifth in their 'richest of the rich' list of the last millennium, with a fortune made from 'land and war' worth £4.5 billion. When Rhys, Owain and Gwenllian begin appearing in British history books, we will begin restoring reality and fact to that branch of education, but it will not happen in this author's lifetime, if ever.

The major problem for Deheubarth is that Rhys left too many sons. Maelgwn ap Rhys (*c.* 1170–1230) was prince of part of the kingdom and was at the siege of Tenby in 1187, and may have gone on Crusade. In Rhys' last years a feud had developed between Gruffydd and his brother Maelgwn, both supported by some of their other brothers. In 1189 Rhys was persuaded to imprison Maelgwn, and he was given into Gruffydd's keeping at Dinefwr. Gruffydd handed him over to his father-in-law, William de Braose. In 1192 Rhys secured Maelgwn's release, but by now he and Maelgwn were bitter enemies. In 1194 Maelgwn and another brother, Hywel, defeated their father in battle and imprisoned him in Nanhyfar (Nevern) Castle, though Rhys was soon released by Hywel. On Rhys' death in 1197, Maelgwn was in exile and Gruffydd was recognised as his successor. Maelgwn, helped by troops supplied by Gwenwynwyn ab Owain of Powys, attacked and captured the town and castle of Aberystwyth, taking his brother Gruffydd prisoner.

Maelgwn handed Gruffydd over to Gwenwynwyn and took possession of Ceredigion. Gwenwynwyn gave Gruffydd to his English allies, who imprisoned him in Corfe Castle. In 1198 Gwenwynwyn threatened the English holdings at Painscastle and Elfael, and Gruffydd was released from captivity to try to mediate in the dispute. His efforts failed, and in the ensuing battle Gwenwynwyn was defeated. This opened Powys to attack by Llywelyn ab Iorwerth, Prince of Gwynedd. Gruffydd was set free and in 1199 took Cilgerran Castle. He now recaptured most of Ceredigion from Maelgwn, except for the castles of Cardigan and Ystrad Meurig. Maelgwn came to an agreement with King John, selling Cardigan Castle to John, and taking possession of the remainder of Ceredigion himself. The *Brut y Tywysogion* commented, 'Maelgwn ap Rhys, for fear and hatred of his brother Gruffydd, sold to the English for little profit the key and keeping of all Wales, the castle of Aber Teifi [Cardigan].' In July 1201 another brother, Maredudd ap Rhys, was killed, and Gruffydd took over his lands. On 25 July Gruffydd himself died of an illness and was buried in Strata Florida. This enabled Maelgwn to

seize Cilgerran, but in 1204 he lost it to William Marshall, Earl of Pembroke. In 1204 Maelgwn's men attacked his brother Hywel, leaving Hywel with wounds of which he later died. In 1205 according to *Brut y Tywysogion*, Maelgwn caused a certain Irishman to kill Cedifor ap Gruffydd and his four sons with a battle-axe after they had been captured.

All these problems in Deheubarth weakened it against the forces of Gwynedd. Also, in 1207 Maelgwn's ally Gwenwynwyn of Powys disputed with King John, and his lands were taken by the Crown. Llywelyn ab Iorwerth took advantage of this to annex the northern part of Ceredigion from Maelgwn and to give the lands between the Rivers Ystwyth and Aeron to the sons of Gruffydd. Maelgwn helped King John to force Llywelyn to come to terms in 1211 but these lands were not returned to him, and this induced him to throw in his lot with Llywelyn instead of the king. However when Llywelyn redistributed the lands formerly under the rule of The Lord Rhys in 1216, Maelgwn was still only allowed the southern part of Ceredigion.

Llywelyn the Great – Runnymede

Dolbadarn Castle had been built by Llywelyn's father, Iorwerth ab Owain Gwynedd, around 1170, and it was there (or Nant Conwy) that Llywelyn was born in 1173. He never claimed the title of Prince of Wales, but was content to be overlord of Wales, being recognised as Prince of Gwynedd, or Prince of Aberffraw and Lord of Snowdon. Professor T. Tout has called Llywelyn 'certainly the greatest of the native rulers of Wales … If other Welsh kings were equally warlike, the son of Iorwerth was certainly the most politic of them … While never forgetting his position as champion of the Welsh race, he used with consummate skill the differences and rivalries of the English … Under him the Welsh race, tongue and traditions began a new lease of life.' Under his strong and determined leadership, Wales was once more united as a single political unit. Llywelyn was ultimately successful in resisting English influence in Wales, and the charismatic leader eventually received homage from the other Welsh princes.

Llywelyn gained possession of part of Gwynedd in 1194, when Richard I was King of England. Aged only twenty-two, Llywelyn had defeated his uncle Dafydd at the Battle of Aberconwy. On the death of his cousin Gruffydd in 1200, Llywelyn gained the rest of Gwynedd. Llywelyn wished to push out from his Gwynedd power base, to take over the kingdoms of Deheubarth (after the death of The Lord Rhys), and Powys. To help his plans, Llywelyn first allied with King John, who became king in 1199, and he married John's daughter, Joan in 1205. Equally, John wished to limit the ambitious Gwenwynwyn of Powys. Powys was traditionally the weakest of the three major princedoms of Gwynedd, Deheubarth and Powys, squeezed between the other Welsh houses and the English Marcher barons. Llywelyn overran Powys while John captured Gwenwynwyn at Shrewsbury. Llywelyn also pushed Gwenwynwyn's ally, Maelgwn ap Rhys, out of northern Ceredigion. Llywelyn then took the Marcher Earl of Chester's castles at Deganwy, Rhuddlan, Holywell and Mold. From this position of control of North Wales, Llywelyn ab Iorwerth could then assist John on his invasion of Scotland in 1209.

Llywelyn had expanded his power as far south as Powys by 1208. However, by 1210 John saw Llywelyn as an overly powerful enemy, and allied with Gwenwynwyn and

Maelgwn to invade Wales in 1211–2. Llywelyn, deserted by other Welsh nobles, fell back towards his mountain base of Gwynedd, trying a scorched earth policy to starve John's army. However, he eventually was forced to sign an ignominious peace treaty that only left him his original lands of Gwynedd. The lesser Welsh rulers at first preferred an absentee overlord rather than a native Welsh ruler, but the situation changed when they saw John build new castles near Aberystwyth, near Conwy and in Powys. This renewed threat of subjugation reunited the Welsh under Llywelyn in 1212, and John's castles were attacked and taken. Pope Innocent III gave his blessing to the Welsh revolt, and King Philip of France invited Llywelyn to ally with him against the English. John now hanged all his Welsh hostages, including the seven-year-old son of Maelgwn ap Rhys. By 1215, Llywelyn had captured many Norman castles and was in control of Pengwern (Shrewsbury), returning it to Welsh hands. Llywelyn joined the English barons at Runnymede, and his power was one of the major factors that persuaded John to sign the Magna Carta in that year.

At Llywelyn's parliament at Aberdyfi in 1216, he adjudicated on claims from rival Welsh princes for the division of Welsh territories under his overlordship, and Llywelyn was recognised as their nominal leader, a true Prince of Wales. His decisions were universally accepted, and this was probably Wales' 'first parliament'. Known in the future as Llywelyn Fawr (Llywelyn the Great), Llywelyn felt secure enough to pay his respects to the Henry III at John's death in 1216. In 1218 Llywelyn's pre-eminence in Wales was recognised by Henry III at the Treaty of Worcester. By 1218, Llywelyn had taken Cardigan, Cilgerran, Cydweli (Kidwelly), Llansteffan and Carmarthen castles, and was threatening the Marcher lords' castles of Swansea, Haverfordwest and Brecon. However, William, Marcher Earl of Pembroke, seized the castles of Carmarthen and Cardigan in 1223, as the English barons banded together to force Llywelyn back to Gwynedd. Hubert de Burgh, Justiciar of England, pushed into Powys but was decisively beaten by Llywelyn at Ceri in 1228. Hubert now concentrated on consolidating his hold on the Marcher lordships, so by 1231 Llywelyn was forced to go on the offensive again, marching to South Wales and burning Brecon and Neath. Pembroke and Abergafenni were also taken. Henry III invaded Wales to support Hubert, and was lucky to escape with his life when Llywelyn launched a night attack on Grosmont Castle. By the Peace of Middle in 1234, Llywelyn was once more recognised by the English as pre-eminent in Wales, calling himself Prince of Aberffraw and Lord of Snowdonia.

Now at the height of his powers, *Annales Cambriae* records, 'The Welsh returned joyfully to their homes, but the French (i.e. the Norman-English), driven out of all their holds, wandered hither and thither like birds in melancholy wise.' Llywelyn had been very much helped in his dealings with the English through his marriage to Joan, the daughter of King John, and spent his later years building up the prosperity of Wales. Llywelyn helped religious foundations and supported a great flowering of Welsh literature. The earliest-known text of the *Mabinogion* was written down, and the brilliance of the bards can still be read today. They praised the strength and peace their lord had brought Wales against the 'French' king and his Norman barons. Dafydd Benfras wrote that Llywelyn was 'his country's strongest shield', Einion ab Gwgan hailed him as 'the joy of armies … the emperor and sovereign of sea and land', and Llywarch ap Llywelyn wrote, 'Happy was the mother who bore thee, Who are wise and noble.'

Aged sixty-eight, this great Lord of Snowdon died as a monk at Aberconwy Abbey in 1240, worn out and crippled. Llywelyn ab Iorwerth ab Owain Gwynedd had inspired a revision of the Laws of Hywel Dda, reorganised the administrative machinery of Wales, maintained cordial relations with the Pope and the English Church, and brought peace and prosperity to a united Wales. He had also ensured that Henry III recognised his son by Joan, Dafydd, as rightful heir. His remarkable diplomatic and military skills were celebrated by all the Welsh poets of the times. *Annales Cambriae* refers to his death: 'Thus died that great Achilles the Second, the lord Llywelyn whose deeds I am unworthy to recount. For with lance and shield did he tame his foes; he kept peace for the men of religion; to the needy he gave food and raiment. With a warlike chain he extended his boundaries; he showed justice to all ... and by meet bonds of fear or love bound all men to him.'

Years later, Llywelyn's great stone sarcophagus was removed from Conwy Abbey, as King Edward I symbolically built his castle over the abbey. It went to the Gwydir chapel in the church of St Grwst in Llanrwst. The present chapel is said to have been designed by Inigo Jones. However, Llywelyn's bones were not allowed to be taken away, and were left under the new castle of Conwy. His bard, Dafydd Benfras, wrote this moving lament at his death:

> Where run the white rolling waves
> Where meets the sea the mighty river,
> In cruel tombs at Aberconwy
> God has caused their dire concealment from us,
> The red-speared warriors, Their nation's illustrious son.

Dafydd ap Llywelyn, *c.* 1211–5 to 1246

Llywelyn suffered a paralytic stroke in 1237, and Dafydd had taken an increasing role in government. His elder brother Gruffydd was Llywelyn's son by Tangwystl, who may have died in childbirth. Gruffydd had been one of the hostages taken by John as a pledge for his father's continued good faith. On Llywelyn's death in 1240 he would under Welsh law been entitled to consideration as his father's successor, but Llywelyn had excluded him from the succession and had declared his son Dafydd, by his second wife, Joan, to be heir to the kingdom. Llywelyn went to considerable lengths to strengthen Dafydd's position, probably aware that there would be considerable Welsh support for Gruffydd against the half-English Dafydd. Llywelyn had Dafydd recognised as his named heir by Dafydd's uncle Henry III in 1220, and also had Dafydd's mother Joan declared legitimate by the Pope to strengthen Dafydd's position. Llywelyn had probably realised that Dafydd's royal English links would be important for Welsh survival. Gruffydd was held a prisoner by his brother Dafydd when the latter took over Gwynedd. Following the successful invasion of the Welsh borders by Henry III in 1241, Dafydd was obliged to hand over Gruffydd into the king's custody, and he was imprisoned in the Tower of London. Gruffydd's wife, Senena, agreed to pay Henry 600 marks for the release of her husband and their eldest son, Owain, and to hand over her two youngest sons, Dafydd and Rhodri, to the king as hostages to ensure that she kept her part of the bargain. Henry took the money, but dishonestly kept Gruffydd and his son imprisoned

as 'guests' because this continued to give him the possibility of using Gruffydd as a weapon against his brother.

Within a month of his accession in 1240, Dafydd was forced to surrender much of his father's gains to Henry III. Dafydd was the only son of Llywelyn and Joan (Siwan), the daughter of King John, born in Castell Hen Blas, Coleshill (Bagillt, in Flintshire). Henry III accepted Dafydd's claim to rule Gwynedd, but did not want him to retain his father's conquests outside Gwynedd. The situation deteriorated, and Dafydd sent ambassadors to Louis IX of France, and possibly to Scotland. In August 1241 Henry III invaded Gwynedd, and after a short campaign Dafydd was forced to submit, signing the Treaty of Gwerneigron. The treaty gave Henry much of Flintshire, and Dafydd's half-brother Gruffydd was taken as a hostage. As he was a rival claimant to the princeship, Henry could always use Gruffydd as an excuse for invasion. Importantly, Henry III also became Dafydd's heir in case the latter died without living offspring. King Henry's treachery meant that Norman Marcher lords took Welsh territories, Gruffydd ap Gwenwynwyn took his realm back, and the king claimed the territories of Tegeingl, Carmarthen, Cardigan and Cydweli.

Gruffydd, Dafydd's elder brother, was still imprisoned in the White Tower in London. He died on St David's Day 1244, trying to escape on a rope of knotted sheets. Dafydd now felt free to regain his lands, entering into an alliance with other Welsh princes to attack English castles and territories in Wales. By March 1245, Dafydd had recovered Mold Castle and his lands in Flintshire, and possibly also Dyserth Castle. Dafydd appealed to Pope Innocent IV for help, offering Wales as a vassalship in return for protection against the Norman-English. He called himself Prince of Wales, the first to use that title. In August 1245 Henry again invaded Gwynedd, but his army suffered a defeat in a narrow pass. An English army was recalled from Ireland to lay waste to Anglesey. There was fierce fighting around Deganwy, with the Welsh capturing some of Henry's supplies. A truce was agreed and Henry's army withdrew in the autumn. The truce remained in effect throughout the winter, but the war was effectively ended by the sudden death of Dafydd in the royal court of Garth Celyn at Abergwyngregyn in February 1246. It is strongly suspected that he had been poisoned on the orders of Henry III, who now regarded himself as the heir to Gwynedd. Dafydd was buried with his father at Aberconwy Abbey. A Norman army now pushed up through the south, conquering Ceredigion, Meirionnydd and Deganwy.

Llywelyn II

Llywelyn's father, Gruffydd, had been imprisoned as a hostage by King John from 1211–5. Then Llywelyn the Great saw Gruffydd as a problem for Dafydd's succession and locked him up in Deganwy castle from 1228–34. From 1239 to 1241 both Gruffydd and his son Owain Goch were held by Dafydd in Cricieth Castle. Finally, after Dafydd's defeat by Henry III, poor Gruffydd was to spend his last three years in the Tower of London. So Gruffydd ap Llywelyn Fawr ab Iorwerth was imprisoned by King John for four years, by his father Llywelyn the Great for six years, by his step-brother Dafydd II for two years, and then by King Henry III for three years, when he died trying to escape. From 1211 to 1244 Gruffydd spent fifteen years imprisoned. This sad history

affected his son, Llywelyn ap Gruffydd, in his view of Norman-Welsh relations, for the rest of his life.

Dafydd's marriage to the daughter of William de Braose seems to have failed to produce an heir. The leaderless men of Gwynedd immediately accepted Llywelyn ap Gruffydd and his eldest brother Owain Goch as rulers of Gwynedd. Owain had been imprisoned in the Tower of London with their father, Gruffydd. However, after three years of warfare, the brothers had reached a point where the starving population could no longer support an armed force, and sued for an armistice. Despite their bravery and prowess in battle, their armies had to yield to superior forces. In 1247, at the Treaty of Woodstock, East Gwynedd was ceded to Henry. In 1254 the English king granted control of all the Crown lands in Wales to his young son, Prince Edward. In April 1247 Llywelyn and Owain were confirmed as lords of Gwynedd uwch Conwy (that part of Gwynedd west of the Conwy River and north of the Dyfi) and the status of Gwynedd was reduced to an English vassalship, conforming to the matters of status of an English lordship. In this year, Matthew Paris recorded that 'Wales had been pulled down to nothing'.

By 1255, Llywelyn ap Gruffydd ap Llywelyn Fawr had won back total control of Gwynedd. He had defeated and imprisoned his two brothers at Bryn Derwen. Poor Owain Goch was incarcerated in Dolbadarn Castle for twenty years to ensure stability, but Dafydd ap Gruffydd managed to escape to England. ('Red Owen' thus spent twenty-three years incarcerated, eight more than his father). In 1256, *Brut y Tywysogion* records that 'the gentlefolk of Wales, despoiled of their liberty and their rights, came to Llywelyn ap Gruffydd and revealed to him with tears their grievous bondage to the English; and they made known to him that they preferred to be slain for their liberty than to suffer themselves to be unrighteously trampled on by foreigners'. Llywelyn now pushed out all over Wales, beating back Henry III's army, while the men of Deheubarth beat royal forces near Llandeilo in 1257. He undertook campaigns similar to those of his grandfather. He secured the allegiance of the lords of Powys Fadog, seized Powys Wenwynwyn and ensured that authority in Deheubarth was in the hands of those loyal to him. He became not only the leader of Pura Wallia but also its lord. The ruling houses of Powys, Glamorgan and Deheubarth acknowledged Llywelyn as their lord in 1258, as he had not only pushed the Normans out of Gwynedd, but also out of most of Wales. By 1258, he was referring to himself not as Prince of Gwynedd but as Prince of Wales. To give full substance to his title he also needed to have influence in Marchia Wallie.

Until 1262 there was a fragile truce, but Llywelyn went back on the attack to gain more of Wales, first from Roger Mortimer, and then part of the lordships of Brecon and Abergafenni. In 1263 he led his forces into the heart of the Marches and was welcomed by the Welsh of Brecon, Abergafenni and upland Glamorgan. His advance was assisted by the Barons' Revolt in England, whose leader, Simon de Montfort, allied with Llywelyn in 1264. Simon de Montfort was now in control of England after defeating the king at Lewes. By the Pipton Agreement, de Montfort recognised Llywelyn, on behalf of the Crown, as Prince of Wales and overlord of the other great men of Wales. The English chronicler Matthew Paris wrote that 'the North Welsh and the South Welsh were wholly knit together, as they had never been before', and praised the courage and vigour of Llywelyn, saying, 'Is it not better, then, at once to die (in battle) and go to

God than to live (in slavery)?' Henry III was forced, by the Treaty of Montgomery in 1267, to recognise Llywelyn as Prince of Wales, who in return recognised the suzerainty of the English Crown. Llywelyn now had more control and influence in Wales than any prince since the Norman Conquest of England. The prince was to be overlord of the lesser Welsh rulers. He was allowed to retain a chain of lordships extending from the borders of Powys to Brecon and gained an ill-defined authority over the Welsh of upland Glamorgan and Gwent. However, where his relations with the devious Henry had always been poor, he was soon to come up against a new King of England who simply resented Llywelyn's very existence.

When Edward I succeeded to the English Crown, Llywelyn, fearing the normal Norman-French treachery, did not attend the Coronation. His father had died in the Tower of London. Llywelyn also refused to pay tribute to Edward I, and built a new castle and town, Dolforwyn, against Edward's wishes. Llywelyn had sent a letter to Edward in 1272, stating that 'according to every just principle we should enjoy our Welsh laws and custom like other nations of the king's empire, and in our own language'. Another letter, dated 11 July 1273 and sent from Dinorben Castle, regarded Edward's prohibition of Llywelyn building a castle at Dolforwyn:

> Llywelyn, Prince of Wales, Lord of Eryri, to King Edward, I have received the letter written in your name, dated at Westminster June 20, forbidding me to construct a castle on my own land near Aber-Miwl, or to establish a town or market there. But I am certain that this letter did not come forth with your knowledge, and that if you were present in your kingdom, such a mandate would not be issued from your chancery. For as you well know the rights of my Principality are entirely separate from the rights of your realm, although I hold my principality under your power. And you have heard and in part seen that my ancestors and I had the power within our boundaries to build and construct castles and fortresses and [set up] markets without prohibition by anyone or any announcement of new work. I pray you, do not listen to the evil suggestions of those who try to exasperate your mind against me.

However, Llywelyn was declared a rebel and Edward invaded. Edward and his barons used violence to provoke rebellions all over Wales which were brutally crushed, while he pursued and harried Llywelyn, even forcing him to move, starving, from his mountain stronghold of Gwynedd. The king had gathered the largest army seen in Britain since 1066. By August 1277 his forces were in the heart of Gwynedd. In Anglesey, the traditional breadbasket, they confiscated the harvest, thus depriving the prince and his army of sustenance. By 1277, Edward had an amazing number of 15,600 troops in Wales, and Llywelyn was humiliated with the Treaty of Aberconwy when he sued for peace. No less than 6,000 of Edward's 15,000 infantry were Welsh, conscripted by the Marcher lords. Llywelyn was stripped of his overlordship granted at the Treaty of Montgomery. In 1278, King Edward felt secure enough to release Elinor de Montfort, Llywelyn's fiancée and daughter of the great Simon de Montfort, from prison. He then attended her wedding to Llywelyn in Worcester Cathedral. Years previously, Elinor had been captured with her brother on her way to marry Llywelyn – the Plantagenets feared a dynasty that would be more popular than theirs.

There was peace of sorts. However, in 1282, Llywelyn's brother Dafydd attacked Hawarden (Penarlag) Castle and burnt Flint, sparking off another war. Ruthin, Hope and Dinas Bran were quickly taken by Dafydd. Llywelyn had the choice of assisting his brother, who had been disloyal to him before, or supporting him. He fatefully chose the latter option, agreed at a Welsh *senedd* (senate) at Denbigh. Days before, Elinor had died on the birth of their first child, Gwenllian. Llandovery and Aberystwyth were soon taken as war spread across Wales. Edward I now assembled 10,000 soldiers at Rhuddlan, including 1,000 Welsh archers. Navies with archers moved to the Dee and from Bristol. Other armies advanced under the Marcher lords. The war first went well for the Welsh. The Earl of Gloucester was defeated by Llywelyn near Llandeilo, an English force in Anglesey was smashed, and Edward was forced back from Conwy to winter in Rhuddlan. However, more English reinforcements arrived, including 1,500 cavalry and Gascon crossbowmen.

In 1282, a Welsh detachment of eighteen men was entrapped at Cilmeri, near Llanfair-ym-Muallt (Builth Wells). At this place on 11 December, Llywelyn was killed. His nearby leaderless army was then annihilated, possibly by Welsh bowmen in English pay. Llywelyn's head was cut off and sent to Edward at Conwy Castle, and later paraded through London with a crown of ivy, before being stuck up on the Tower of London. His coronet was offered up to the shrine of Edward the Confessor at Westminster Abbey. The Croes Naid of his ancestors, believed to be a fragment of the 'True Cross', and perhaps the Welsh equivalent of Scotland's Stone of Scone, was taken to Windsor Castle and vanished during the English Civil War. There is no understanding of how Llywelyn came to be so far detached from his main force in his Gwynedd stronghold or his smaller army in Mid Wales. Edward had offered him exile and an English earldom in return for unconditional surrender. Archbishop Pecham of Canterbury had been negotiating between Llywelyn and Edward on the terms of an end to the war, and the documentation still exists. According to Pecham's later letters, a document was found on Llywelyn inviting him to go to the Irfon Bridge, sent by the Marcher lords. The *Dunstable Chronicle* states that Llywelyn was invited by the sons of Roger Mortimer to meet him, and they ambushed and killed his small band of retainers. This document disappeared, and also a copy sent by the archbishop to the chancellor. It is certain that Llywelyn was killed by Norman treachery – 'the treachery on the bridge' is a recurrent theme in Welsh literature, and for centuries the inhabitants of Builth were known as traitors in Wales. ('Bradwyr Buallt', 'Builth Traitors' became a common term of abuse.) Also according to Archbishop Pecham, the wounded Llywelyn lived on for hours, asking repeatedly for a priest, while his army was being slaughtered a couple of miles away. He was refused one, while his captors waited for the Marcher Lord Edward Mortimer to come to the scene. According to the *Waverley Chronicle*, he executed Llywelyn on the spot. Probably he also took possession of the letter in Llywelyn's pocket at this same time.

There is an intriguing entry in *Brut Tywysogion* for 1282 – 'and then there was effected the betrayal of Llywelyn in the belfry at Bangor by his own men'. There is evidence, on the basis of rewards given by the king, that Madog ap Cynfran, Archbishop of Mon (who took the place of Bishop Arian in his absence) and Adda ap Ynyr may have been plotting against Llywelyn, luring him south to the ambush set by the Mortimers. The same entry records that

he left Dafydd, his brother, guarding Gwynedd; and he himself and his host went to gain possession of Powys and Builth. And he gained possession as far as Llanganten. And thereupon he sent his men and his steward to receive the homage of the men of Brycheiniog, and the prince was left with but a few men with him. And then Roger Mortimer and Gruffydd ap Gwenwynwyn, and with them the king's host, came upon them without warning; and then Llywelyn and his foremost men were slain on the day of Damascus the Pope, a fortnight to the day from Christmas day; and that was a Friday.

Roger le Strange had succeeded Roger Mortimer in command of the royal forces near Builth, and won the 'battle' of Orewin Bridge. He was married to Hawyse, the sister of Gruffydd ap Gwenwynwyn, who collaborated with the Mortimers and was present at Llywelyn's death. Gruffydd ap Gwenwynwyn was given lands in 1283 as his reward for opposing Llywelyn, and had been the only prince in Wales not to swear fealty to Llywelyn. Powys Wenwynwyn was the only area of Wales to become part of the March without conquest.

The Hagnaby chronicler, an important source for the events of the day on which Llywelyn died, was quite definite: 'Roger Mortimer, he says, but, more correctly, his brother Edmund Mortimer, drew the prince there by beseeching him to come to the neighbourhood of Builth to take his homage and that of his men. Along with other lords he hatched a plot to corner Llywelyn and kill him.' The plaque on his roadside granite monument at Cilmeri simply proclaims 'Llywelyn ein Llyw Olaf' – 'Llywelyn Our Last Leader'. His mutilated body probably lies in the atmospheric remains of the Cistercian Abbey Cwmhir (Abaty Cwm Hir), which had a 242-foot nave, the longest in Britain after York, Durham and Winchester Cathedrals. In 1282, Gruffydd ab yr Ynad Coch's magnificent elegy to Llywelyn tells us

> Great torrents of wind and rain shake the whole land,
> The oak trees crash together in a wild fury,
> The sun is dark in the sky,
> And the stars are fallen from their courses,
> Do you not see the stars fallen?
> Do you not believe in God, simple men?
> Do you not see that the world has ended?
> A sigh to you, God, for the sea to come over the land!
> What is left to us that we should stay?

Upon Llywelyn's death, his brother Owain Goch was imprisoned and died that year, and his brother Dafydd was later captured and executed. Their children were imprisoned for their rest of their lives in an attempt to extirpate the House of Gwynedd. However, one brother, Rhodri, was living in England and his grandson is remembered as Owain Llawgoch. In 1183, a clerk in Edward I's service wrote from Orvieto, 'Glory to God in the highest, peace on earth to men of good will, a triumph to the English, victory to King Edward, honour to the Church, rejoicing in the Christian faith … and to the Welsh everlasting extermination.'

The Loss of Independence & the Time of Llawgoch, Glyndŵr & Henry Tudor

1283–1485

Academics and historians write off Wales and Welsh resistance to English rule after the cruel and treacherous murders of Llywelyn II and Prince Dafydd. However, there were wars in 1283, 1287, 1294, 1317, 1400–20 and so on until a Welsh army made the last successful invasion of England in 1485. This is by a country lacking resources against a powerful, aggressive neighbour with around fifteen times the Welsh population, helped by European mercenaries and better weapons, and in possession of massive castles and garrisons across the nation. Wales is not, as portrayed, a nation which had lost its nationhood with the murder of Llywelyn II.

The Defence of Dafydd and the Fate of the House of Gwynedd, 1283

After the killing of Llywelyn II, his brother Dafydd kept fighting, with declining manpower as the news of his brother's death travelled to Gwynedd. On Llywelyn's death, Dafydd III pronounced himself Prince of Wales and survived for ten months, using guerilla tactics against Edward's forces in Snowdonia. Dafydd ap Gruffydd escaped from Dolwyddelan Castle before its capture, probably moving down to Dolbadarn Castle. Then for a month Dafydd operated from Castell y Bere and the Cader Idris foothills. Near Abergynolwyn in Gwynedd, Castell y Bere was built by Llywelyn the Great, on a great rock dominating a valley floor. It was the last castle to fall to Edward during the war of 1282–3. Dafydd was said to have been hunted down and is often stated to have been captured at Castell y Bere, near Cader Idris, on 23 April 1283. However, just before 4,000 troops under William de Valence surrounded and took Castell y Bere, Dafydd escaped to Dolbadarn. The net was closing in on him. An army from Anglesey and a force of Basque mercenaries moved to encircle Snowdonia. With his younger son Owain, Prince Dafydd had made his way back to near his royal court of Garth Celyn. He was badly injured when taken at Nanhysglain, a secret hiding place in a bog by Bera Mountain, above Aber Garth Celyn Falls, on the night of 21/22 June 1283. He was possibly trying to kill Edward I, who had set up his court at Garth Celyn, above Abergwyngregyn. On 28 June, Llywelyn ap Dafydd was captured with the remaining members of Prince Dafydd's family. Upon 30 September, Dafydd ap Gruffydd was given a show trial at Shrewsbury and condemned to death. After 200

years of struggle, the French-speaking Normans, with their Saxon troops and foreign mercenaries, had overcome the nation of Wales. It had taken them just months to overcome England.

Henry III had invented the punishment of hanging, drawing and quartering for treason, but the person was hanged and dead before being cut apart. His son Edward I specifically refined the execution for Prince Dafydd, and it became enshrined in English law as punishment for treason. Upon 3 October, Dafydd ap Gruffydd was slowly killed, Geoffrey of Shrewsbury being paid 20 shillings for carrying out the gruesome task. For treason, the already injured Dafydd was bound and dragged along the ground by horses through the streets of Shrewsbury to the place of execution. Naked and with his skin flayed and bleeding, Prince Dafydd III of Wales, for killing English nobles, was hanged. While still alive, for killing those nobles at Easter, Dafydd was eviscerated and his entrails burnt in front of him. The executioner's skill lay in trying to keep the victim alive as long as possible during the torture. For conspiring to kill the king in various parts of the realm, his body was then quartered and his joints distributed to York, Winchester, Bristol and Northampton for display. The representatives of York and Winchester disputed over which city should have the honour of receiving the right shoulder – it went to Winchester. Dafydd's head was led on a pole through the streets of London, with a crown of ivy, to the sound of horns and trumpets. It was spiked on the White Tower in London, next to his brother Llywelyn's. Both heads were tarred to keep off birds and preserve them as long as possible as a warning against rebellion.

Conwy Castle was symbolically built on the tomb of Llywelyn the Great. In 1317, Aberffraw, the traditional home of the princes of Gwynedd, was obliterated by the English – the last of the Welsh royal palaces to be demolished. Being used as an administrative headquarters by the English, much of Garth Celyn, Abergwyngregyn survived. With Dafydd's capture, the English tried to destroy the entire dynasty. Llywelyn's only child, the year-old Gwenllian ferch Llywelyn ap Gruffydd (1282–1337), was incarcerated for the rest of her life in Six Hills monastery in Lincolnshire. On 19 June 1282 Eleanor de Montfort, Lady of Wales, had died at Garth Celyn, giving birth to Gwenllian ferch Llywelyn. The orphan and her nurse were taken to England to ensure that the bloodline of the princes of Gwynedd would die out. Edward at first wanted to kill the baby, but was prevailed upon to spare her as she was his relative. After her father's death, her uncle Dafydd had cared for her, so she was less than two years old when Edward wanted her killed. She was made a nun at Sempringham in Lincolnshire. The nuns noted her as Wencilian as they could not pronounce her name. In 1327, when Gwenllian was aged forty-five and well past child-bearing age, Edward III granted her a pension of £20 a year. She died unmourned on 7 June 1737, after fifty-four years in captivity, with no family, friends or visitors. Her cousin Gwladys had died in her nunnery at Sixhills the year before. The Gwenllian Society placed a plaque at Sempringham in 1993, commemorating this lost Princess of Wales. It was vandalised in 2000, the heavy Welsh slate capping being smashed. Repaired, it reads 'Teyrnged I'r Dywysoges Gwenllian (1282–1357) Unig Blentyn y Tywysog Llywelyn ap Gruffydd Arglwydd Eryry, Tywysog Cymru – GWENLLIAN – A Tribute to the Princess Gwenllian (1282–1337) Only Child of Prince Llywelyn ap Gruffydd, Lord of Snowdonia, Prince of Wales.'

Dafydd's wife Elizabeth de Ferrer was imprisoned and never allowed to see their children again. Dafydd's baby daughter Gwladys was, like Gwenllian, imprisoned in a

nunnery in England for the rest of her life. She died in 1336, after fifty-three years in captivity. Dafydd's sons, the princes Owain and Llywelyn, spent the rest of their lives in solitary confinement in prison. Llywelyn ap Dafydd was five when imprisoned and died of malnutrition five years later. Owain ap Dafydd was seven when imprisoned and still living twenty years later, when the king ordered that his imprisonment should be made more secure, so he was locked up in a cage for the rest of his life. After thirty years in prison, a letter survives where Prince Owain ap Dafydd implores Edward II to allow him to go and 'play' within the walls of the castle. He was then thirty-seven years old. He was known to be still alive in 1320, after almost forty years of incarceration. All of the line of Gwynedd was incarcerated or killed, except Llywelyn II's brother Rhodri, who had opted to stay out of the wars, living upon an estate in Surrey. His descendant Owain Llawgoch would later be assassinated by the English in France.

The Statute of Rhuddlan, 1284

In 1284, the Statute of Rhuddlan was enacted on 3 March and promulgated on 19 March at Rhuddlan Castle, one of the 'Iron Ring' of castles built by Edward I. The series of laws formally 'united and annexed' the conquered nation of Wales to England. Edward I more or less left the great Marcher lordships alone for their help in defeating the Welsh, but created counties under the English court justice system, with the common laws of England applied. English law was imposed across Wales, except in areas affecting land claims. This was purposefully omitted to give the English lords more opportunities to gain Welsh lands without recourse to law. However, the Welsh practice of settling disputes by arbitration was retained. Interestingly, the act 'legally annexed' Llywelyn's 'Principality of Wales' to 'the kingdom of England', but not the whole country. It appears that one can 'legally annexe' a part of land which does not belong to a country by invading it, a practice later followed by Hitler in Poland and elsewhere. This author strongly believes that the English annexation of Wales under this Act, and the Tudor Acts of Union three centuries later, are illegal.

The statute provided the constitutional basis for the government of what was called 'The Land of Wales' or 'the king's lands of Snowdon and his other lands in Wales', which was later called the 'Principality of North Wales'. The princedom of Gwynedd was divided into the counties of Anglesey, Caernarfonshire, Flint and Merionethshire. Flintshire was administered, with the palatinate of Chester, by the Justiciar of Chester. The other three counties were administered by the Justiciar of North Wales from Caernarfon. The Chamberlain of North Wales was also based there, collecting revenues. A system of sheriffs, coroners and bailiffs was set up to administer justice and collect taxes. The Welsh system of commotes became hundreds, but their customs, boundaries and offices were little changed.

Edward I erected four new Marcher lordships in the north-east, at Bromfield and Yale, Chirk, Denbigh and Duffryn Clwyd; and one in Carmarthenshire for Cantref Bychan. For his help in betraying Llywelyn, Gruffydd ap Gwenwynwyn was restored to the principality of Powys Wenwynwyn. Gruffydd and his son Owen ap Gruffydd held it as a Marcher lordship, the only Welsh family to benefit from the conquest. Owen altered his name to the more acceptable Owen de la Pole, and he and his father had tried

to assassinate Llywelyn in 1274. After fleeing to England they had used Shrewsbury as a base to lead English attacks upon Llywelyn. Some members of the House of Deheubarth, Glamorgan and Powys Fadog were allowed much-reduced landholdings. Carmarthen and Ceredigion became counties governed by the Justiciar of West Wales, who was based in Carmarthen. Nearly all of South Wales from Pembrokeshire to the English border was already held by Marcher lords, who were little affected by the Statute of Rhuddlan, and the royal lordships of Builth and Montgomery also retained their existing institutions. All business, administrative and legal matters were carried out in Anglo-French. Many Welsh longbowmen, the finest in Europe, became a crucial element among the many foreign mercenary groups serving with the English army.

English settlers were sent to live in the newly created borough towns and bastides developed around English castles, particularly in the south and east of Wales. Over the next few centuries, the English dominated these garrison towns, from which the native Welsh were officially excluded. The trade of the surrounding countryside was controlled by town-dwellers recruited from outside Wales, a situation fraught with tension. The settlers called themselves 'the English burgesses of the English boroughs of Wales', proclaiming that the new towns had been raised 'for the habitation of Englishmen', and excluding 'mere Welshmen' from any privileges as they were 'foreigners' in the English plantation colonies. R. R. Davies commented, 'Nowhere was the spirit of conquest and of racial superiority so vigorously and selfishly kept alive as in the English boroughs. It was little wonder that they were the most consistent target of Welsh resentment throughout the fourteenth century.'

Some Welsh nationalists have an ambivalent attitude to the density of castles across Wales, especially Edward I's ring of great fortifications around Gwynedd. Wales has easily the highest density of castles in the world, and this author sees them instead as a sign that England could never completely defeat the country. The English were never safe in their captured colony. No less than seven of Edward I's ten earls possessed Marcher estates in Wales, including the powerful Mortimer, Fitzalan, Bohun and de Clare families. Edward had to be careful in not alienating them, while also reducing their capability to oppose him, or fight amongst themselves. A strong king won their respect, and a weak one was always in danger from them. Continued rebellion in the north of Wales, most notably in 1294, where many of the new but half-finished castles quickly fell, demonstrated the vital position of the Marcher lords in keeping Wales quiet.

The Iron Ring of Castles

Edward, more than any other king, tried to extinguish the idea of Wales as a separate nation, attempting to eradicate Welsh national identity. After Ireland, it was England's first colony. Wales' most treasured national artefacts were taken to London, including the royal insignia and Y Groes Naid, said to be a fragment of the true cross on which Christ was crucified. In July 1284 Edward held a round table and a tournament at Nefyn, one of the courts of the princes of Gwynedd, trying to appropriate the symbolism of Arthur. In 1283 he took the Croes Naid to Windsor Castle. In 1284, he took the skull of St David and other holy relics, which in 1285 were led in a triumphal procession

from the Tower of London to Westminster. His policy was to contain any future revolt by establishing fortified settler towns known as bastides, and to build more and more castles. Edward strongly encouraged English migration to Wales, with all administrative and other offices being only allowed to be given to non-Welsh people. All court proceedings were in Anglo-French, with Welsh lands and homes being confiscated arbitrarily. English settlers, enticed by free land-grants and the jurisdiction of their own laws, arrived by the thousand. They destroyed native churches, rebuilt others, and gradually brought Wales into the orbit of Canterbury. Thus they denied the Welsh their claim to appeal directly to the Pope. Bards were not allowed to move around the country, spreading news.

Edward extended the castle-building of his father Henry III. Over much of Wales and the March he strengthened strategically placed castles, to a great extent rebuilding Builth, Montgomery, Cardigan, Carmarthen and Aberystwyth. Because of the strong presence of his Marcher lords in Pembroke, Glamorgan, Monmouthshire and Carmarthen, Edward still saw North Wales as the greatest danger. Every castle west of Chester had suffered from Welsh attacks. He repaired and rebuilt some castles, but also decided to build new, state-of-the art fortifications. Henry III's important castles of Deganwy and Dyserth were not repaired, but replaced respectively by great castles at Conwy and Rhuddlan. Flint was his first castle, rebuilt in 1277 to take the place of both Hawarden and Mold. Rhuddlan was also rebuilt in 1277 at the end of the 'First Welsh War'. The stupendous castles at Conwy, Harlech, Caernarfon and Beaumaris were built from 1283, after Edward had killed off the House of Gwynedd.

This castle-building programme was Europe's most ambitious and concentrated medieval building project. Brand-new castles at Caernarfon, Conwy and Harlech were followed by the masterpiece of Beaumaris. This group of four colossal castles, including the town walls of Caernarfon and Conwy, was the work of 'Master James of St George', the greatest military architect of the age, and is now accorded World Heritage Site status. Edward I commissioned Jacques de Saint-Georges d'Espéranche, from his dukedom of Savoy in the late 1270s, as an *ingeniator* (engineer) and *mazun* (mason). Records indicate that he was master mason at Flint and Rhuddlan between 1278 and 1282, and he was involved with Aberystwyth and Builth as well. He was appointed Master of the Royal Works in Wales around 1285, drawing a wage of 3 shillings a day. This is around £700,000 a year in today's earnings. His four castles are the most elaborate strongholds to be built anywhere in thirteenth-century Europe. Each of these castles was integrated with a bastide, the idea being borrowed from Gascony, where Edward I was duke. The town and castle were mutually reliant on each other for protection and trade. Each new borough was defended by its castle, and each castle was accessible by sea. The bastides were always populated with English settlers, and the Welsh were permitted to enter the town during the day but not to trade and certainly not to carry arms. The ring of stone reflected the realisation that castle strongholds were the only way to control a dissident rural population.

Caernarfon Castle is built on the site of the cell of St Peblig (Publicius), said to have been the Romano-Welsh uncle of Emperor Constantine the Great. He was the brother of Princess Elen (Helena), mother of Roman Emperor Constantine, who was said to be born here. Tradition has it that Constantine the Blessed

was buried here. Nennius recorded that he saw an inscription to Constantine at Segontium (Caernarfon), and in 1283 Edward I ordered that 'the Emperor Constantine' be transferred to Llanbeblig. Edward wanted Caernarfon Castle to be a royal residence and seat of government for North Wales. It is on the site of what was a Norman fort and then a Norman motte-and-bailey dating from 1090, in Welsh hands from 1115 until 1283. It is possibly the finest example of military architecture in Europe, its main gate being designed for no fewer than six portcullises, with assorted 'murder holes' above them. The arrow slits were designed for three archers to fire in rapid succession. There are two gatehouses, nine towers and walls 20 feet thick. Its appearance, with the banded towers and eagles, was based upon Edward's experience of the Crusades, having seen the fortifications of Constantinople. Overlooking the Menai Straits, it was strategically important, allowing easy access to the other coastal castles of Harlech, Conwy and Beaumaris. Glyndŵr besieged it unsuccessfully in 1403 and 1404, and its royalist defenders surrendered it to parliamentary forces in 1646.

Caernarfon has 800 yards of town walls, but Conwy has 1,400 yards, with twenty-one towers and three double-towered gateways. A statue of Llywelyn the Great stands in Lancaster Square, and he endowed Conwy's Cistercian abbey, where he was buried. Four decades after his death, Edward I symbolically chose Conwy as the site for his greatest castle after the murder of Llywelyn's grandson. The monks were moved to Maenan Abbey. The walls contain over 200 listed buildings, surviving with little alteration. Conwy thus is not only the best example of a medieval walled town in Britain, but it also has the finest example of an Elizabethan town house. The walls are 35 feet high and 6 feet thick, and the finest example of town walls in Britain. Notable is the row of twelve privies near the Mill Gate, built because Edward I based his royal secretariat there in the mid-1280s. Conwy Castle and town walls were completed in 1287 in a superb strategic position. Eight-towered Conwy was called 'incomparably the most magnificent castle in Britain' in a 1946 British Academy report. Specially designed curves in the castle walls led attackers to a literal dead end in the West Barbican, where missiles and molten lead could be poured down from the murder-holes and machicolations above. As the guidebook states, 'forced entry is a virtual impossibility'. The distinctive elongated shape, with its two barbicans, eight massive towers and great bow-shaped hall, was perhaps determined by the narrow, rocky outcrop on which the castle stands. Edward I held out there in 1295 against the revolt of Madog ap Llywelyn. Shakespeare was wrong when he placed Flint Castle as the place where Richard II was betrayed to Henry of Lancaster – it was at Conwy Castle in 1399.

Harlech Castle, begun in 1283, was effectively completed in 1289, standing proudly upon the cliff edge that used to form the coastline. The concentric castle stands 200 feet up on a cliff overlooking Cardigan Bay. Harlech is probably the most stirring of the World Heritage-listed castles in Wales, and once painted a dazzling white to impress the population. Following the capture of Castell y Bere in 1283, around 1,000 men were used in Harlech's construction. It was besieged by Madog ap Llywelyn in his rebellion of 1294, and the site was formerly associated with the tragic *Mabinogion* tale of Branwen, the daughter of Llŷr. In the Glyndŵr Liberation War, it fell after a prolonged siege to Owain Glyndŵr, who made it his main headquarters and court in

1404. He summoned a parliament here. A long siege under Henry of Monmouth with 1,000 men and great cannon followed from 1407 to 1409. In 1408–9, the most terrible winter in living memory led to the starvation of the garrison and the death of Edmund Mortimer, the son-in-law of Glyndŵr. The castle fell and Glyndŵr's wife, daughters and grandson were incarcerated until their deaths. The fall of Harlech effectively sealed victory against Glyndŵr, although the war lasted until 1415.

In the Wars of the Roses, Sir Dafydd ap Ieuan ap Einion held out for the Lancastrians for eight years under a Yorkist siege, inspiring the stirring song 'Men of Harlech'. 'Black William of Raglan', Lord Herbert, eventually took the castle, but Dafydd had responded to his summons to surrender by saying, 'Once I held a castle in France till all the old women of Cymru heard about it. Now I'll hold this castle till all the old women of France hear of it.' On the point of starvation, they marched out with flags flying and music playing, having surrendered on honourable terms. Only famine had forced surrender and Dafydd handed the castle to Lord Herbert and his brother Sir Richard Herbert. It was the last castle of Edward IV to hold out against the Yorkist rebels, and one of its survivors was the twelve-year-old Lancastrian, Henry Tudor (later Henry VII). Henry was taken into captivity at Raglan Castle. His uncle Jasper Tudor had escaped through the besieging forces, giving the Lancastrians one last hope of victory. Seventeen years later, Jasper and Henry ended the Wars of the Roses at Bosworth Field. Harlech's fifth major siege was in the Civil War, defended by royalists under Colonel William Owen against the parliamentarians. History repeated itself as it was the last royalist castle to hold out, its fall ending the First Civil War in 1647.

Beaumaris in Anglesey was the final link in the iron chain of castles around Gwynedd, and although uncompleted, is probably the most sophisticated example of a concentric castle (with ring-within-ring defences) in Europe. The most technically perfect castle in Britain, it was built on a flat swamp, 'Beautiful Marsh' in Eastern Anglesey, where high tides sweep around its walls. Begun in 1295, it was the last of Edward I's castles in Wales, on an entirely new site, in response to the rising of Madog ap Llywelyn in 1294–5. It is unfinished because funds dried up for the master builder Master James of St George. Its six huge inner towers are only rivalled in size by William Marshall's tower at Pembroke Castle and by William ap Thomas's tower at Raglan Castle.

Begun in 1277, Flint is another masterpiece of James of St George. The walls of the Great Tower are 23 feet thick, possibly a world record. It is unusual that this strongest tower, or donjon, is only linked to the rest of the castle by a drawbridge. The River Dee used to run between the two buildings, so this was contrived to protect supply ships. It may have been called 'Flint' to symbolise it was the striking point for Edward's conquest of Wales. 2,300 men worked on the castle and its associated fortified town, or bastide. In 1282 it was besieged by Dafydd, the brother of Llywelyn the Last, and another attempt in 1294 was more successful. The constable of the castle burnt the castle and its bastide to prevent their use by the Welsh. The castle was then repaired. It was slighted by parliamentarians in 1647 after a three-month siege. Flint's closeness to the border and inward migration means that only 18 per cent of the population identify themselves as being Welsh.

On the seafront, the remains of Aberystwyth Castle are near the site of Castell Tan-y-Castell, built by Gilbert de Clare in the early twelfth century, which was taken several times by the Welsh. Aberystwyth Castle was then built by Llywelyn the Great, on a

promontory next to the Rheidol estuary. It was rebuilt by Edward I as a link in his iron chain of castles, beginning in 1277. In 1282, the incomplete castle was taken by Llywelyn ap Gruffydd's forces, so James of St George came to personally oversee its building. Aberystwyth Castle needed 176 masons, 14 carpenters, 5 smiths, 2 plumbers and 1,120 other workmen, and could be provisioned from the sea. By 1289, £4,300 had been spent building the huge concentric fortress, and a Welsh siege in 1294 was finally beaten off, as reinforcements and supplies arrived by shipboard. After a long siege, Glyndŵr took the castle in 1404 and held it until 1408. In this siege, it was the first castle in Britain to be subject to attack from great cannon. It was badly slighted by the parliamentarians in the English Civil War, but was once one of the finest Welsh castles, on a par with any.

Built by Llywelyn the Great, Cricieth was refortified by Edward from 1283 to 1290. In *Brut y Tywysogion* we find that Llywelyn the Great's son Gruffydd had been imprisoned here from 1239 by his half-brother Dafydd. Llywelyn II began another building phase in the 1260s, including a curtain wall. In 1294 it withstood a siege by Madog ap Llywelyn. Supplies from Ireland enabled the garrison to hold out for months. The castle was built on the site of a Celtic hill-fort, and is still dominated by the twin-towered gatehouse built by Llywelyn the Great. It was remodelled by Edward I from 1283 to 1290 and Sir Hywel ap Gruffydd, Hywel of the Battleaxe, was appointed its constable for his services at Crecy. Owain Glyndŵr, with the assistance of a French naval blockade, starved it into submission in the 1400–15 war and burnt the castle. It was not rebuilt, but remains impressive, overlooking the beach.

In 1277, Edward I accepted Llywelyn II's submission at Rhuddlan. For his new Rhuddlan Castle, in the 'ring of iron', Edward canalised the River Clwyd to enable it to be supplied from the sea. The river was rerouted and straightened by 1,800 'ditchers', from its estuary at Rhyl to where it passes the castle, 3 miles inland. The castle was built from 1277 to 1282, with James of St George taking charge of the works. Edward also laid out a new town nearby, upon which the present street pattern is based, and tried unsuccessfully to have the bishopric moved from St Asaff to Rhuddlan. The castle was attacked by Madog in 1294 and by Glyndŵr's followers in 1400, when the town was overrun, but the castle was not taken. A royalist castle in the Civil War, it was slighted by parliamentarians in 1648. The earthen motte of Gruffydd ap Llywelyn, known as Twt Hill, is just south of the thirteenth-century castle's remains.

In southern Wales, Pembroke was one of the very few castles that never fell to the Welsh, being founded by Roger de Montgomery in 1093. Gilbert 'Strongbow', Earl of Pembroke later owned the castle, building the Great Keep around 1204, the largest and most impressive for that period in Britain. It is still 75 feet high, and the walls at its base are 20 feet thick. Under the castle is the Wogan Cave, where supplies could be brought in at high tide. In 1457 Henry Tudor was born at the castle. In the Civil War, it was besieged by the parliamentarians and damaged, but still remains a wonderfully impressive building, despite Cromwell blowing up the barbican and the fronts of all the towers.

Many of the northern Welsh towns that we know today grew up beside the castles, which are heavily walled for protection, with many placed along the coast or navigable rivers to allow trade and re-supply in times of war. In Glamorgan, Caerffili could not be supplied, but had magnificent water defences. It is the earliest example of concentric architecture in Britain, possibly the largest castle in Europe apart from Windsor, but one

which (unlike Windsor) saw continuous fighting. Caerffili was built mainly between 1268 and 1271, after Llywelyn ap Gruffydd destroyed the previous Norman castle. 'Red Gilbert' de Clare built it to defend his territories from Llywelyn, who by the Treaty of Montgomery (1267) had been acknowledged Prince of Wales by Henry III. Its 30 acres of water defences are unequalled in Europe, featuring a flooded valley, with the castle built on three artificial islands. The dams are a superb engineering achievement, with the south and north lakes deterring any sort of attack.

The east wall is effectively a huge fortified dam, and together with the west walled redoubt, defends the central isle. This central core has a double concentric circuit of walls and four gatehouses. The depth and width of the moat was controlled from within the castle. It was the first truly concentric castle built in Britain, and its concentric system of defences was copied by Edward I in building his 'iron ring' of castles around Gwynedd. Llywelyn held it for a time in 1270. It was attacked in 1294–5 and 1316, and Queen Isabella besieged it from 1326–7 to try and capture her husband Edward II. A gatehouse was damaged in the Llywelyn Bren siege, and Caerffili fell briefly in Glyndŵr's uprising of 1400–1415. Its leaning tower, at 10 degrees tilt, out-leans that of Pisa, possibly being damaged during the Civil War fighting. One of the most important fortresses in Europe, when Lord Tennyson first encountered it he exclaimed, 'This isn't a castle. It's a whole ruined town!' Caerffili is the only castle in the world with full-size replicas of four different 'siege-engines'. On certain days they are demonstrated, with huge stones being hurled into the lakes. The de Clares built many castles in their lordship, including one at Llangibby in Monmouthshire which is hardly known. Tregrug Castle has a roughly rectangular bailey, 163 yards long by 87 yards wide and is one of the largest single-enclosure castles in Britain.

Carmarthen was the largest town, and main port, in Wales. It was given permission for *murage*, to become a walled town, in 1223, probably the first in Wales. The medieval town walls, four gates and the Augustinian priory and Franciscan monastery have all disappeared. Carmarthen is an important strategic site. On a prominence above the River Tywi, the castle's first name was Rhyd y Gors, mentioned in 1094. A Norman castle was built on the site by 1104, and in Crown ownership it became the administrative centre of South West Wales. In the twelfth and thirteenth centuries it was the scene of many battles between the Welsh and Normans, destroyed by Llywelyn the Great in 1215. Edmund Tudor, the father of Henry VII, died in prison here in 1456. Gruffydd ap Llywelyn defeated a Danish force led by Hywel ap Edwin, and killed Hywel at Carmarthen in 1044. In April 1215, Llywelyn the Great attacked and took the castles of Carmarthen, Cydweli, Llansteffan, Cilgerran and Cardigan (Aberteifi). There were also battles recorded here at Carmarthen Bridge, 29 August 1220; Carmarthen, 26 April 1223; Carmarthen, 1 August 1233; end of March 1234; and at nearby Coed Lathen in 1257. The *Chronicle of Ystrad Fflur* tells us that in 1258 all the Welsh nobles made a pact to ally together, upon pain of excommunication, but Maredudd ap Rhys went against his oath: 'And Dafydd ap Gruffydd and Maredudd ap Owain and Rhys ap Rhys went to parley with Maredudd ap Rhys and Patrick de Chaworth, seneschal to the king at Carmarthen. And Patrick and Maredudd broke the truce and swooped down on them. And then Patrick was slain, with many knights and foot-soldiers.' There was a battle in 1405 on Glyndŵr's march through South Wales to invade England, and the castle was taken.

The Costs of War

The true monetary costs of Edward's wars against Wales are impossible to assess. Over twelve years he spent £93,000 (around £1.5 billion in today's terms), more than ten times his annual income, on building castles and walled towns at Conwy, Caernarfon, Harlech, Beaumaris and refurbishing Llywelyn II's castle at Cricieth. The cost of the fighting and colonisation of Wales was over £240,000, including monies spent on the 'Iron Ring' of castles. This equates today to £160 million using the retail prices index, but the more relevant average earnings index makes the sum £3.34 billion today. If we remember that these sums were spent in a small nation with a small population and little international trade, we will have a better idea of the true cost of conquering Wales, which would be something around 100 billion pounds. (To put it into context, the two aircraft carriers being built by the French for Britain are costing well over £2 billion, the bloated London Olympic Games cost over £12 billion, and the cost of doctors' pensions is £67 billion). However, Edward I was totally dependent on his victory, not only upon treachery, but upon massive loans from the Crown's bankers, the Riccardi (or Riccardi) of Lucca, and upon parliamentary grants from heavy taxation. Edward's income came from customs duties, lay subsidies from parliament and money lending. In 1277, severe financial pressures caused by his war forced him to levy a poll tax of 4 pence per head on the population. It was soon replaced by a graduated version, but it only brought in around £50,000 a year, about half of what was expected. The imposition of the tax led to the Peasants' Revolt of 1281.

The Ricciardi were Edward's bankers from his accession in 1272 until their collapse in 1294, and were associated with his recoinage of 1279–81. From 1275, the Ricciardi collected the newly created customs duty on exports of wool, hides and wool-fells, worth around £10,000 per year, as well as receiving money from other sources of royal revenue. In return, they advanced significant sums in cash to the king and made payments to third parties on the king's behalf, as and when ordered by royal letters. In total, between 1272 and 1294 the Ricciardi were involved in the collection and disbursement of around £20,000 per year, equivalent to roughly half of the king's ordinary annual income. The Italian bankers managed the revenues from customs duties as a reward for their service as money lenders to the Crown, which helped to finance the Welsh Wars. When Edward came to war with France, the French king confiscated the Ricciardi's assets, and the bank went bankrupt. After this, the Frescobaldi of Florence became the Crown's bankers.

England's Jews were the king's personal property, and he taxed them at will, but by 1280, they had been taxed almost to oblivion. They had made profits from being allowed to practice usury, money lending, a practice forbidden to Christians. Many people were indebted to Jews, causing popular resentment. In 1275, Edward outlawed usury and encouraged the Jews to take up other professions. In 1279, he arrested all the heads of Jewish households in England and executed around 300 of them. In his 1290 Edict of Expulsion, he ordered all Jews out of England, generating revenues through royal appropriation of Jewish loans and property. Wales was punitively taxed to pay for the wars. Taxes were collected in coin for the first time, with the burden of tax falling hardest on the poor, leading to even more discontent. Because of the Welsh – and later the Scots – wars, the role of parliament was fundamentally altered. New campaigns and

castles needed internal funding, and foreign loans had to be paid for, so regular grants of taxation were needed by the Crown. Edward was forced to regularly call a parliament, extending its membership, and therefore those who paid tax, to the commoners as well as the nobles and clergy. In time, the Welsh would also be summoned to the English parliament. This necessity probably did more than anything else in the Middle Ages to forge a sense of unity and identity in the native Welsh.

The Bards of Wales

Without the bards' Celtic oral tradition, much of Welsh history and heritage would have been lost forever. There has been a strong oral tradition that 500 Welsh bards were slaughtered after the death of Llywelyn II, because they may have inflamed the Welsh back to rebellion against their new conquerors, the French kings of England. As well as the 'rounding up' of bards and the imprisonment and execution of their employers, Henry IV, in 1403's Ordinance de Gales, forbade their existence. Thus truth becomes hidden. One of the most famous and popular Hungarian poems celebrates this story, written by the famous poet Janos Arany (1817–82). He was Professor of Hungarian Literature at the Nagy-Koros College, a notary, actor, editor and one of the founders of modern Hungarian poetry. The Austrian Emperor Franz-Josef defeated Hungary in its War of Independence (1848–9), then made his first visit there. He asked Janos Arany to write a poem to praise him, and this was the poet's nationalistic response. (The reference to Milford Haven is to the 'Mab Darogan', the 'Son of Prophecy', Henry VII.)

A Walesi Bardok
Edward kiraly, angol kiraly
Leptet fako lovan
Hadd latom, ugymond, mennyit er
A velszi tartomany

The Bards of Wales
Edward the King, the English King,
Astride his tawny steed
'Now I will see if Wales,' said he,
'Accepts my rule indeed.
Are streams and mountains fair to see?
Are meadow pastures good?
Do wheat-fields bear a crop more pure
Since washed with rebels' blood?'
'In truth this Wales, Lord, is a gem,
The fairest in your crown:
The streams and fields rich harvest yields
The best through dale and down.'
Edward the King, the English King,
Astride his tawny steed:

A silence deep his subjects keep
And Wales is mute indeed.
The castle named Montgomery
Ends that day's travelling;
And the castle's lord, Montgomery,
Must entertain the king.
With game and fish and every dish
That lures the taste and sight
A hundred rushing servants bear
To please his appetite.
With all of worth the isle brings forth
Of splendid drink and food,
And all the wines of foreign vines
Beyond the distant flood.
'You lords, you lords, will none consent
His glass with mine to ring?
What? Each one fails, you dogs of Wales,
To toast the English king?
Though game and fish and every dish
That lures the taste and sight
Your hand supplies, your mood defies
My person with a slight!
You rascal lords, you dogs of Wales,
Will none for Edward cheer?
To serve my needs and chant my deeds,
Then let a bard appear!'
The lords amazed, at him they gaze,
Their cheeks grow deathly pale;
Not fear but rage, their looks engage,
They blanch but do not quail.
All voices cease in soundless peace,
All breathe in silent pain;
Through the door bold, a harper, old,
Enters with grave disdain.
'Lo, here I stand, at your command,
To sing your deeds, O King!'
And weapons clash and shields crash
Responsive to his string.
'Harsh weapons clash and shields crash,
And sunset sees us bleed,
Raven and wolf our dead engulf
This, monarch, is your deed!
A thousand lie, beneath the sky,
They rot beneath the sun,
And we who live shall not forgive
This deed your hand has done!'

'Now let him perish! I must have'
(King Edward's voice is hard)
'Your softest songs, and not your wrongs!'
Up steps a youthful bard.
'The breeze is soft at eve, that oft
From Milford Haven moans;
It whispers maidens' stifled cries,
It breathes of widows' groans.
You maidens, bear no captive babes!
You mothers, rear them not!'
The fierce king nods. The boy is seized
And hurried from the spot.
Unbidden then, among the men,
There comes a dauntless third.
With speech of fire he tunes his lyre,
And bitter is his word.
'Our bravest died to slake your pride
Proud Edward, hear my lays!
No Welsh bards live who'll ever give
Your name a song of praise.
Our harps with dead men's memories weep.
Welsh bards to you will sing
One changeless verse – our blackest curse
To blast your soul, O King!'
'No more! Enough!' – cries out the king.
Enraged, his orders break:
'Seek through these vales all bards of Wales
And burn them at the stake!'
Soldiers ride forth to South and North,
They ride to West and East.
Thus ends in grim Montgomery
That celebrated feast.
Edward the King, the English King
Spurs on his tawny steed;
Across the skies red flames arise
As if Wales burned indeed.
In martyrship, with song on lip,
Five hundred Welsh bards died;
Not one was moved to say he loved
The tyrant in his pride.
'God's Blood! What songs this night resound
Upon our London streets?
The Mayor shall feel my irate heel
If any that song repeats.'
Each voice is hushed; through silent lanes
To silent homes they creep.

'Now dies the hound that makes a sound;
The sick king cannot sleep.'
'Ha! Bring me fife and drum and horn,
And let the trumpet blare!
In ceaseless hum their curses come
I see their dead eyes glare…'
But high above all drum and fife
And trumpets' shrill debate,
Five hundred martyred voices chant
Their hymn of deathless hate …
Not one was moved to say he loved
The tyrant in his pride.

Wales as a Nation

Edward I declared before his final invasion of Wales that it was time 'to put an end finally to the matter'. He moved into the palace of the princes of Gwynedd at Garth Celyn to administer Wales while the great castles were built. He destroyed their other courts. In 1283 he took Llywelyn's crown and the Croes Naid to Windsor Castle. In July 1284 Edward held a round table and a tournament at Nefyn, one of the courts of the princes of Gwynedd, to try to appropriate the symbolism of Arthur. In 1284 and 1285, he took the skull of St David other holy relics and Welsh regalia in a triumphal procession from the Tower of London. He attached them to the shrine of the patron saint of the English monarchy, Edward the Confessor, at Westminster Abbey. He even designated his own son as Prince of Wales. The Welsh poets vividly recorded the downfall and despair of the nation.

However, Wales was not assimilated institutionally, politically or fiscally into England. No Welsh MP sat at Westminster. No English-type taxes were collected in Wales and judicially and legally, the country remained separate from England. English settlers in Wales kept themselves to themselves and paraded their exclusive Englishness. In turn, the Welsh remained firmly Welsh. Excluded from membership of anything English, Wales kept its separate identity. In law, this lasted until 1536 when Welsh law was formally abolished. However, the language, culture, customs and perhaps above all, historical memories were preserved. Because of this, the vast majority of people across Wales, from Monmouthshire to Anglesey, and even many living in the border counties of Hereford, Cheshire and Shropshire, supported Glyndŵr when he proclaimed himself Prince of Wales in September 1400. Wales was still a nation, wanting its independence returned. The great castle-building programme of Edward and his Marcher lords somehow forged a sense of unity and identity in the people forever. Welsh people are not English and do not wish to be Anglicised even to this day.

The First English Prince of Wales

There is a myth that Edward I promised the Welsh lords a prince who spoke no English, and then presented his infant son to them, invented in the sixteenth century.

Both Edward I and Edward II and their courts spoke French rather than English. Edward II's brother Alfonso was still alive when he was born and Alfonso would have been appointed Prince of Wales, not a younger brother. Edward II was in Lincoln when he was given the title in 1301 at the age of sixteen. He acceded as Edward II on 8 June 1307. Edward II's elder brother was Alphonso or Alfonso of Bayonne, who was still alive when Edward 'of Caernarfon' was born. Alfonso died on 19 August 1284, aged eight. Two other brothers, John and Henry, had died aged five in 1271 and aged six in 1274, so Edward II was the fourth son of Edward I. Edward II was born at Caernarfon Castle upon 25 April 1284. Following tradition, if Alfonso had lived, one of today's nine royal princes – Charles (Charles Philip Arthur George); Andrew (Andrew Albert Christian Edward); Edward (Edward Antony Richard Louis); Richard (Richard Alexander Walter George); Prince Edward Duke of Kent (Edward George Nicholas Paul Patrick); Michael (Michael George Charles Franklin); William (William Arthur Philip Louis) or Harry (Henry Charles Albert David) – would have been an Alphonso or Alfonso. Interestingly, the vast majority of the Christian names are French.

In 1301, Edward I made his surviving son Edward Prince of Wales and Count of Chester at the parliament of Lincoln. Ever since that date, these titles have been automatically conferred upon the first-born son of the English monarch. There was never a ceremony of presenting his infant son to the people at Caernarfon as 'their' Prince of Wales, as officially 'replicated' with the crowning of Charles of Schleswig-Holstein-Sonderburg-Glücksburg, Battenburg, Wettin and Saxe-Coburg and Gotha (aka Windsor) in 1969. This was not a commemoration of any event, but a costly charade of propaganda for an alien royal family. Indeed, the Plantagenets spoke Norman French in preference to English, and English was not the language of the English king's court until a century or so later. Later 'English' kings, the Hanovers, preferred to speak German from 1714–1901, with even Queen Alexandrina (aka Victoria) preferring to speak her own German language at home. There is a mythology and subservience accruing to the English royal family which is unnecessary in the modern world. Y gwir yn erbyn y byd, eto.

Religion and Literature

The disaster of 1283–4 brought the church in Wales under the control of Canterbury, although the Glyndŵr War threatened this supremacy. In the following century, Welsh clerics complained strongly that all major posts and most lucrative benefices were given to mainly absentee English clerics. Little ecclesiastical preferment came the way the Welsh nobility. The only person to gain any promotion in the Welsh Church was Llywelyn ap Madog ab Elise of Edeirnion, who was Dean and, from 1357, Bishop of St Asaff. Most of the Church's revenues went to England, and Welsh churchmen were prominent in Glyndŵr War of 1400 to 1415. John Trefor, Bishop of St Asaph worked as a diplomat for the Welsh, and the Bishop of Llantarnam was killed on a battlefield. Plague and the consequent decline in population badly affected the monasteries, with fewer monks and a lessened influence on Welsh culture. Scriptoria had been destroyed in wars, and there were fewer monastic chroniclers of the times.

The earliest Welsh literary tradition is that of the Cynfeirdd, the earliest poets such as Taliesin and Aneurin, which included the poets of the Welsh-speaking kingdoms of southern Scotland. The Gogynfeirdd, the not so early poets, belonged to the period 1100 to 1300 and received the patronage of the Welsh princes. The 'Elegy of Gruffudd ab Yr Ynad Coch to Llywelyn ap Gruffydd' is probably the finest of the poems of the Gogynfeirdd. Resentment was apparent in Welsh poetry in the century after 1282. It is manifest in the literature of the period, particularly in the prophetic poetry (*y canu brud*) that speaks of the deliverer who is to come. It finds expression in the revolt of Rhys ap Maredudd in 1287, of Madog ap Llywelyn in 1294 and of Llywelyn Bren in 1316.

After the death of Dafydd ap Gruffydd, the last Prince of Wales, there were no princes left to act as patrons for bards. Their place was taken by landowners, the Welsh gentry. With a declining court or monastic influence, poetry now dealt with secular themes away from religion and praise of lords and princes. Increased contact with France and French literature encouraged Welsh poets to emulate such works as *Roman de la Rose*. Dafydd ap Gwilym (1320–70) was the most distinguished of medieval Welsh poets, with poems extolling nature, beautiful women, and the fullness and joy of life itself. His contemporary Llywelyn Goch (1350–90) wrote 'Marwnad Lleucu Llwyd' (The Death of Lleucu Llwyd), one of the finest love-poems in Welsh. Iolo Goch (1320–98) records that this was always one of the first poems asked for when young people assembled. The passionate, moving poem bids farewell to a wife who had died while the author was away from her. Iolo Goch was one of the first of the 'Gentry Poets' or 'Poets to the Nobility', who were renowned for writing eulogies to the gentry. Iolo had experienced the terror of the Black Death, and wrote poetry that showed his concerns for social disintegration and the necessity of preserving order. His finest work is perhaps 'Y Llafurwr' (The Labourer).

A new form of poetry developed in the mid-fourteenth century, the *cywydd*, a much more flexible form than the *awdl*. The *awdl* is a long poem in one of the twenty-four strict metres of Welsh poetry, using *cynghanedd*. The cywydd consists of a series of seven-syllable lines in rhyming couplets, with all lines written in *cynghanedd*. One of the lines must finish with a stressed syllable, while the other must finish with an unstressed syllable. The rhyme may vary from couplet to couplet, or may remain the same. Poets still wrote in strict metre, but embellished with *cynghanedd*, the intricate system of sound-chiming, characteristic of Welsh poetry. There are four forms of *cynghanedd*, and it involves the use of stress, alliteration and rhyme all within one line of a poem. Gerard Manley Hopkins and Dylan Thomas have both been heavily influenced by Welsh poetry of this period. *Cynghanedd* (harmony) still plays a major part in the production of Welsh poetry. The mid-fifteenth century, following the defeat of Glyndŵr, saw a return to prophetic poetry calling for an overthrow of the hated overlords, symbolised by the poetry of Guto'r Glyn and Lewis Glyn Cothi. The radical preacher Sion Cent wrote poetic sermons on the mortality and vanity of all earthly things, and had a lasting effect upon the themes of later Welsh poets.

Increasing numbers of the nobility began to send their sons to Oxford and Cambridge, but Welsh culture lived on with the bards and the preaching of native Welsh clergy. Prose writings included the *Mabinogi* cycle of stories, considered to be the Welsh people's greatest contribution to European literature, and a mass of religious,

historical and mythical writings. In the *White Book of Rhydderch* and the *Red Book of Hergest*, composed in the mid-fourteenth century, are preserved the anonymous texts we now call the *Mabinogion*. Not translated into English until the mid-nineteenth century, under the supervision of Lady Charlotte Guest, these masterpieces date back to before the Norman Conquest, using much earlier material. The cult of King Arthur had been used by Edward I to justify his claim to rule all Britain, and was renewed in Wales, with 'Merlin's prophecy' that one day Wales would again rule England. In music, Giraldus Cambrensis in the 1190s noted that the greatest skill of the Welsh was their ability to sing in harmony.

The Rhys ap Maredudd Revolt, 1287–8

Rhys ap Maredudd was Prince of Cantref Mawr in Deheubarth from 1271. His father had submitted to Llywelyn ap Gruffydd, but Rhys had not done so. Indeed, Rhys was among the first Welsh noblemen to submit to the English Crown during the Anglo-Welsh war of 1276–7. This he did to try to claim back his grandfather's lands of Maenordeilo, Mallaen, Caeo, Mabelfyw, and the ancestral home, Dinefŵr Castle. Rhys wanted to make Deheubarth a unified kingdom once more, no longer under the control of Gwynedd. Later, Rhys was the only Welsh nobleman from Deheubarth not to support Llywelyn and Dafydd in 1282–3. He supported Edward I during this second war with Llywelyn II, being given Dryslwyn Castle and extra landholdings for his services. Edward, however, refused to deliver to Rhys the long sought-after castle at Dinefŵr. Rhys thus made Dryslwyn Castle his main residence, substantially rebuilding. He stayed loyal to Edward I in the hope he may be restored to more of his former patrimony, but no such offers were forthcoming from the king. Instead, Edward I forced Rhys to grant Dinefŵr castle to him in October 1283.

In 1287, Rhys was again wronged, this time by the new Justiciar of South Wales, Robert de Tibetot. Rhys now led a revolt and took back the ancestral home of Dinefŵr Castle. He then took the superbly sited Carreg Cennen Castle and then Llandovery Castle. He took his army south through Carmarthen, burning Oystermouth Castle and taking most of Ystrad Tywi, the heartland of Deheubarth, then headed north to take Llanbadarn Castle in Ceredigion. English armies totalling 20,000 men were sent to take Rhys, who was besieged in Dryslwyn Castle for three weeks by 12,000 of them. With Edward I out of the country, Earl Edmund of Cornwall had formed an army at Carmarthen, after writs were despatched to the Marcher lords to bring their forces. Many of these troops were Welsh, the lords controlling much of Wales at this time. On 9 August, Earl Edmund set out from Carmarthen at the head of 4,000 men, some raised in England and the others assembled locally under Robert de Tibetot.

On 15 August, this force was joined outside Dryslwyn Castle by a 6,700-strong army, gathered under Reginald Grey in Chester and Roger l'Estrange from Montgomery. Some of the men coming from Chester were taken from the building of the Iron Ring of castles, and they built a trebuchet to hurl enormous rocks at the castle walls. The siege machine was made from timber, hides, rope and lead, costing £14. Twenty quarrymen and twenty-four carters shaped and transported the huge stone balls to fire at the castle. They also tunnelled through rock under the castle walls, and a group

Left: 1. The parents of St Cadog of Llancarfan were the saints Gwladys and King Gwynlliw, remembered in this window in the twelfth-century Chapelle de Saint Cado on the Étel estuary in Brittany. An effigy of Cadoc, who founded the chapel, is annually carried from the church on a boat. The deaf can be cured by lying upon his stone 'bed' in the chapel. *Above*: 2. The sapphire stone in St David's Cathedral was believed to be carried by St David as an altar and a pillow. He was said to been given it by the Patriarch of Jerusalem, and many miracles were attributed to it.

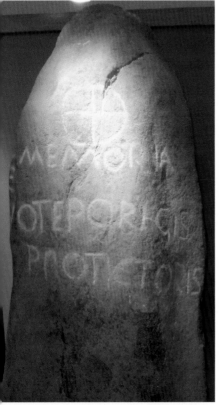

Left: 3. The Voteporix Stone replica in Carmarthenshire Museum at Abergwili. The originals of many such stones are in the National Museum in Cardiff. Its Latin inscription reads '*Memoria Voteporigis Protictoris*' (Monument of Voteporigas the Protector). The ogham inscription carries only the Goidelic form of his name, Votecorigas. He may be the early-sixth-century King of Dyfed despised by Gildas. *Above*: 4. St Gildas' chapel in Brittany, near St Nicholas-des-Eaux, remembers this son of Caw, who in the sixth century possibly wrote *De Excidio* there. Educated at the great monastery of Llanilltud Fawr (Llantwit Major), Gildas was the first British historian.

Above Left: 5. The interior of St David's Cathedral, Pembrokeshire. Giraldus Cambrensis and Bishop Peter were excused from going on the Third Crusade in order to complete the twelfth-century nave and screen. Inadequate foundations and the effects of a thirteenth-century earthquake have caused the walls at the west end of the nave to lean outwards, hence the wooden ceiling rather than a stone vault.

Above: 6. St Non's Well, near the remains of her chapel, just outside her son's foundation of St David's. The niche held candles, and pilgrims sat on the stone bench to wash and purify themselves. People still throw money in the well.
Top: 7. Twr Llywelyn is the tower at Pen-y-Bryn, Abergwyngregyn, a palace of the Princes of Gwynedd, used by Edward I during his castle-building programme of the 1280s. It stands within Garth Celyn, a double-bank and ditch. Its owner, Katherine Pritchard Gibson, has been fighting for recognition of its national importance since 1988. *Left*: 8. Dinefwr Castle has the senior breed of the ancient White Park cattle in Britain. The laws of Hywel Dda measure fines and payments in numbers of these white cattle with coloured points, and in the Dimetian code of laws it is recorded that fines were paid to the Lords of Dinefwr in these cattle. A similar herd at Faenol in Gwynedd is now semi-feral.

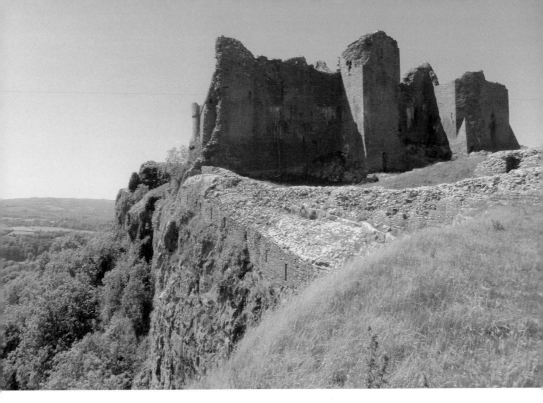

9. Carreg Cennen Castle near Llandeilo is one of the most spectacularly situated of all Welsh castles, on the site of a castle of the Princes of Deheubarth, taken by the English in 1277. It was demolished in 1462 during the Wars of the Roses. In mid-picture is the passageway to its cave.

Above left: 10. The Lord Rhys, Rhys ap Gruffydd ap Rhys ap Tewdwr, Prince of Deheubarth, lies in effigy in St David's Cathedral. Known in his lifetime as 'Prince of the Welsh', he was the dominant power in Wales after the death of Owain Gwynedd in 1170. *Above right*: 11. Passageway at Carreg Cennen Castle, leading to a limestone cave in the heart of the crag. There is some water there, but not enough for a siege. It is thought that the passageway was walled and blocked off to prevent mining during a siege. There are pigeon-holes in its wall, for fresh meat or homing pigeons.

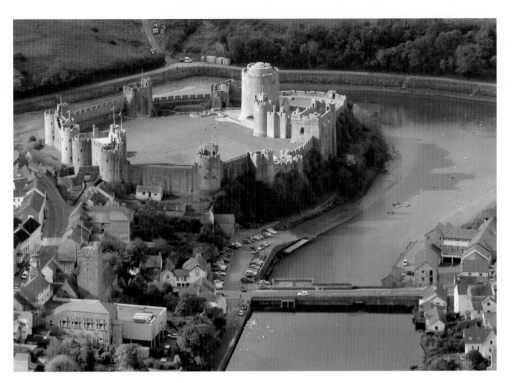

15. Pembroke Castle from the air. Castell Penfro is the birthplace of Henry Tudor, and until the English Civil War was never captured. There has been a castle of the site for the Marcher Earls of Pembroke since 1093, and constant Flemish and English settlement helped south Pembrokeshire become known as 'Little England Beyond Wales'. (Picture courtesy Fly Heli Wales)

Opposite top: 12. Cannon outside Tenby Castle pointing to St Catherine's Island. Tenby is the same word in Welsh, dinbych, as Denbigh. Din, or dinas is a fortress, and bych is a form of bach, meaning little. Tenby in Welsh is Dynbych-y-Pysgod, little fortress of the fish, referring to its fishing port. *Opposite centre*: 13. Inside Tenby's walled town. Tenby was colonised around 1093, but destroyed by Llywelyn ap Gruffydd in 1260. The Earls of Pembroke walled the town from 1264, and the outer barbican tower for the west gate can be seen here, the so-called 'Five Arches'. 14. Chirk Castle was completed in 1310, the last Welsh castle from the reign of Edward I that is still lived in today. The Marcher fortress has a medieval tower and dungeon, a seventeenth-century Long Gallery and grand eighteenth-century state apartments, servants' hall and historic laundry.

IN MEMORY OF
ROBERT RECORDE,
THE EMINENT MATHEMATICIAN,
WHO WAS BORN AT TENBY, circa 1510.
TO HIS GENIUS WE OWE THE EARLIEST
IMPORTANT ENGLISH TREATISES ON
ALGEBRA, ARITHMETIC, ASTRONOMY, and GEOMETRY:
HE ALSO INVENTED THE SIGN OF
EQUALITY = NOW UNIVERSALLY ADOPTED
BY THE CIVILIZED WORLD.
ROBERT RECORDE
WAS COURT PHYSICIAN TO
KING EDWARD VI. and QUEEN MARY.
HE DIED IN LONDON,
1558.

16. Robert Recorde's monument in St Mary of Liberty, Tenby. Recorde (*c.* 1510–88) was the polymath who introduced the = and + symbols into mathematics. Physician to Edward VI and Queen Mary, this Tenby native was also a noted astronomer and wrote ground-breaking books on algebra and geometry.

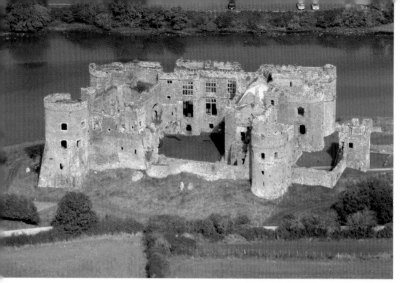

17. Carew Castle from the air. Carew was the site of Britain's last great tournament in 1507. One can take a thirty-minute helicopter trip from Haverfordwest over Carew, Pembroke, Manorbier, Picton and Haverfordwest castles, over what has been voted 'the best coastline in Europe'. (Picture courtesy Fly Heli Wales)

18. Nant-y-Moch is an area of unspoilt upland beauty in northern Ceredigion. It is at threat, with nearby Artists' Valley, of having 115 giant wind turbines, roads and pylons placed upon it. It is the site of the Battle of Hyddgen in 1401, an event which made Glyndŵr a national leader.

19. Oak internal wall, called a 'dais partition', at Cefn Caer, where Glyndŵr probably signed the Pennal Letter to Charles VI of France in 1406. The table is laid out for a medieval banquet, with bread acting as dishes.

20. Llansteffan Castle stands on a headland overlooking the sand-flats of the mouth of the River Tywi. The Normans established a ring-work inside an Iron Age fort and then fortified it in stone. The castle was held briefly by Owain Glyndŵr's men in 1405–6.

Above left: 21. Llywelyn ap Gruffydd Fychan's 16-foot-tall, stainless steel statue of remembrance stands outside Llandovery Castle, where he was hanged, drawn and quartered in 1401. Llywelyn's sons were fighting for Glyndŵr and he refused to lead the usurper king to find the Welsh troops. *Above right*: 22. Thomas ap Rees of Scotsborough was High Sheriff of Pembrokeshire in 1610. This is the tomb in St Mary of Liberty, Tenby, of his wife Margaret, who died in the same year. The ruins of Scotsborough House outside Tenby may date back to the thirteenth century, but it was abandoned in 1824.

Above left: 23. Erddig Hall outside Wrecsam was built between 1684 and 1687 and is one of Britain's finest stately homes, voted the UK's 'favourite historic house' in 2007. It has one of the most important surviving formal eighteenth-century gardens in Britain. *Above right*: 24. 1809 memorial in St Mary's at Liberty, Tenby from her clients to Peggy Davies, 'a bathing woman for 42 years', who died, aged eighty-two, of apoplexy in the water. Wealthy visitors arrived in Tenby by stagecoach or by sea via Bristol for the season, which extended from May to October. There were balls, horse racing, bowls, archery, billiards, card rooms, a theatre and sea bathing with attendants such as Peggy Davies.

Above left: 25. The picture is taken from a balcony of the Chain Bridge Hotel, Llangollen. The River Dee is used by canoeists, the Llangollen steam railway is still running, and there is a road bridge. Also, the Llangollen Canal runs immediately adjacent to the other side of the hotel, giving four types of transport in one location. *Above right*: 26. Georgian town houses in Tenby. While staying here, Mary Ann Eliot (1819–80) was said to have been inspired to write her first novel, *Adam Bede* (1859), published under the pseudonym of George Eliot.

Above: 27. Estate workers' latrine at Llanerchaeron near Aberaeron, an eighteenth-century Welsh gentry estate designed by John Nash in the 1790s. The manor house and gardens are virtually unaltered, with a service courtyard with dairy, laundry, brewery and salting house, and walled kitchen gardens. *Right*: 28. One of Cardiff's famous arcades, the three-storey Castle Arcade is Grade 2★ listed. Cardiff is known as the 'City of Arcades', with the highest concentration of Victorian, Edwardian and contemporary indoor shopping arcades in Britain. The Royal Arcade dates from 1858, followed by High Street 1885, Castle 1887, Wyndham 1887, Central Market 1891, Morgan 1896 and Duke Street 1902.

Above: 29. Tenby – St Catherine's Island, Ynys Catrin, is cut off at high tide. Formerly owned by Jasper Tudor, its tiny medieval church was demolished when replaced by the fort in 1867. Once a private residence and then a zoo, there are plans to renovate and reopen the fort as a visitor attraction. *Centre*: 30. The trading floor sometime after 1912 at Cardiff's Coal Exchange, Mountstuart Square. The first million-pound deal was signed here, and the exchange is surrounded by the former offices of banks, trading houses and shipping companies. (Picture courtesy of Mike Johnstone). *Below right*: 31. Drawing-room at Portmeirion. This represents Edwardian tranquillity in the hotel in the Italianate village designed by Cough Williams-Ellis. The Portmeirion Hotel dates from 1850 and was rescued from oblivion in 1926. The hotel and buildings in the grounds are wonderful places to stay.

Above left: 32. Aberglasney Elizabethan cloister garden is extraordinary, and the gardens may date to the thirteenth century. On three sides, vast arcaded stone structures support a broad parapet walkway. The ruined house itself stands a little apart as the fourth side, loosely closing off the rectangle. Investigation in the late 1990s revealed that the parapet walkway was a unique survivor of a style of garden architecture that is now only found in records of lost gardens. *Above right*: 33. Spillers Records is the oldest record shop in the world, established in The Hayes, Cardiff in 1894 by Henry Spiller. It has traded from the same shop ever since, and is near the famous Wally's Delicatessen, which has been trading from the Royal Arcade for over sixty years.

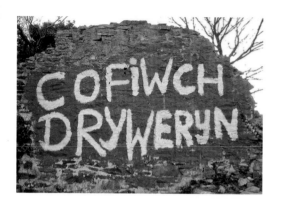

Above left: 34. This 'Remember Trywerin' slogan, painted across a ruined cottage wall in 1965 in Troed-y-Rhiw, is now listed with the RCAHMW, but is often defaced, the last time being in 2011. Villagers repaint the wall, commemorating the disgraceful drowning of Capel Celyn in 1965 against the wishes of the Welsh people and their representatives. The event triggered an upsurge in nationalist feeling, which has petered out owing to lack of leadership and a feeling of impotence against enforced undemocratic change. *Above right*: 35. St David's, Cardiff has been expanded in 2009, with a grand arcade and the largest John Lewis store outside London, to become the eleventh-largest shopping centre in Britain, with around 35 million shoppers each year. (Copyright Golley Slater)

Above left: 36. The famous snack bar in Hayes Island, Cardiff, is unspoilt by the adjacent new shopping centre, and in a pedestrianised area near the market. The building dates from 1911, when it was a parcel office, but has been a café for sixty years, serving the best bacon rolls in Cardiff. *Above right*: 37. Bunner's Ironmongers is a Montgomery institution, attracting customers from far and wide. The store inside is a wonderland for hardware, typical of the type of shop which proliferated across the country before the rise of the DIY hypermarkets.

38. The SWALEC Stadium was opened for Glamorgan Cricket Club in Cardiff in 2008, and holds 16,000 spectators, enabling it to be a venue for Test match cricket. The game is the drawn first test, England playing against Australia in July 2009. (Copyright Huw John)

39. Millennium Centre and Theatre, Cardiff Bay, the home of the Welsh National Opera, is an iconic building, completed in 2009. Nicknamed 'the Armadillo', it was brilliantly designed by Jonathan Adams to represent 'Welshness' with a copper roof and multi-coloured Welsh slate, and has superb acoustics and sight-lines.

40. Blue Lagoon, Abereiddi in Pembrokeshire is a flooded slate quarry and small dock, reached via a pathway past ruined quarry buildings and slate workers' cottages. Abereiddi beach is famous for its black sand full of tiny fossils.

Above left: 41. Cooking ranges in the kitchen of the Bishop's Palace at Abergwili. Bishop Barlow moved his palace from St David's to Abergwili outside Carmarthen in 1547, sending the monks at Abergwili to Brecon. He stripped the lead from the roof of the Bishop's Palace at St David's for his new home, effectively ruining the building. *Above right*: 42. Chalk drawing of around 1840 by J. C. Rowland. Welsh costume, with the tall 'stove-pipe' hat for women, is an adaptation of eighteenth-century peasant dress. Traditional colours of women's woollen shawls and skirts varied between areas, but were usually a mixture of black, brown, white and red. The colour depended on the availability of local natural dyes.

43. The Senedd Building opened in 2006 in Cardiff Bay. The National Assembly for Wales debates in this building, constructed from Welsh slate, Welsh oak and sustainable materials. It uses natural ventilation and passive systems to heat and cool the building.

Above left: 44. Watercolour by J. C. Ibbetson (1759–1817) of coracle fishermen at Cilgerran. The *cwrwgl* has been used since before the Romans came to Wales, and can be carried upon a fisherman's back. Unfortunately, the rise of angling and the buying up of rivers has meant that coracle fishermen have been denied licences for decades. Each river in Wales once had its own design of *cwrwgl*. *Above right*: 45. Massive inglenook fireplace at Cefn Caer, built on the site of a Roman fort overlooking Pennal, near Machynlleth. The Grade 2★ listed Hall House dates from before the fifteenth century, with its inglenooks dating from the fourteenth and fifteenth centuries. The flags of Glyndŵr are on the wall.

CARDIFF & LONDON

In One Day!!!

The Public are respectfully informed, a new and elegant Fast Four-horse Coach

'ST. DAVID!'

LEAVES THE

ANGEL INN,

CARDIFF, every

TUESDAY, THURSDAY, & SATURDAY MORNING,

. AT SIX O'CLOCK;

NEWPORT,	-	at a Quarter past **7**;
CHEPSTOW,	- -	**9**;
NEWNHAM,	- -	**11**;
GLOUCESTER,		Half-past **12**;
AND		
CHELTENHAM,		Half-past **1**;

AND ARRIVES IN

LONDON at **9** o'clock the same Evening.

BRADLEY & Co., Proprietors.

☞ On the arrival of this Coach at CHELTENHAM, the Railway Train starts for **Worcester, Birmingham,** and all Parts of the North; and returns from Cheltenham, MONDAYS, WEDNESDAYS, and FRIDAYS, at Half-past **12**, after the arrival of the Railway Trains from Birmingham, &c.

W. PAINE, PRINTER 127, HIGH STREET, CHELTENHAM

46. Late-eighteenth-century stagecoach poster. Journeys were undertaken by stages of 10–15 miles, when the horses would be changed. Coaching inns provided accommodation and refreshment to travellers, as well as stabling and smithies for the horses.

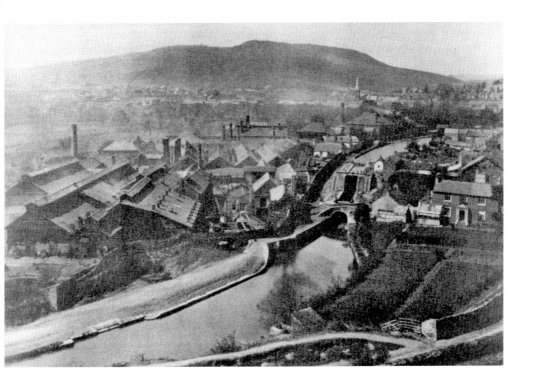

Above: 47. Brown Lenox Newbridge Works, *c.* 1900. Brunel wanted George Lenox to be photographed alongside him, but Lenox refused, so Brunel wrote, 'I wanted Mr Lenox to stand with me but he would not, so I alone am hung in chains.' This refers to the famous picture of Brunel in 1857, with a top hat and cigar against a background of chains. *Right:* 48. Typical ironworkers' cottages at Cefncoedycymer, near Merthyr Tydfil, shortly before they were pulled down in the early 1970s. It was originally a 'dormitory' village dependent on the Cyfarthfa Works and the nearby quarries for employment. The village in the 1880s consisted of 600 houses with a population of 2,500.

49. Chainworkers and strikers celebrate the semi-Jubilee in 1914 at Brown Lenox Newbridge Chainworks, Pontypridd. The well-dressed man in the top left is Arthur Pearson (1897–1980), who worked there from 1913 to 1925, and later became Pontypridd's MP from 1938 to 1970.

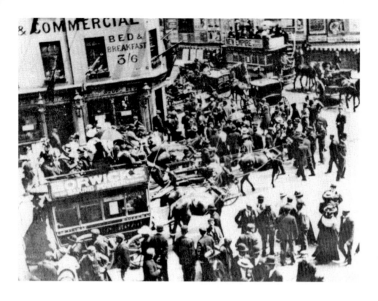

50. The excitement at the Relief of Mafeking is shown in this picture, taken on 18 May 1900 at the corner of St Mary Street and Mill Lane in Cardiff.

51. 'Peerless' Jim Driscoll (1880–1925) photographed at Ninian Park, Cardiff, during a training break before his last fight. He lost only three of seventy-seven fights and was the finest featherweight of his generation.

52. The six salmon were caught within two hours by Evan Lewis (Lewi) Thomas in June 1965, in the pool in the Teifi next to Pontllwni bridge. The largest is 19.5 pounds, and two much larger ones got away. Lewi's wife Velma is standing, Iant Evans is on the right and the boy is Lewi's nephew, Peter Thomas.

of nobles inspecting the work, including the Earl of Stafford, were crushed to death when a wall collapsed. The castle was captured by 5 September, and although Rhys ap Maredudd escaped, his wife and son were captured. Over 100 arrowheads have been recovered from the site, many with long, sharp points deliberately made to penetrate armour and chain-mail.

After his break-out, Rhys was involved in a running fight through Cardigan and Newcastle Emlyn. The rebellion was thought to be over by the autumn of 1287, but broke out again in November. It was ended after a ten-day siege of Rhys' last stronghold, Newcastle Emlyn Castle. Rhys escaped, possibly to Ireland, but was captured in 1291. In 1292 Rhys was executed at York, in the same barbarous manner as Dafydd, the brother of Llywelyn the Last. Notably, the bards called Rhys 'the defender of Wales … shield-shorn like Arthur', demonstrating that the Welsh were still looking for independence. His son, Rhys ap Rhys ap Maredudd, was arrested after the execution, and was himself imprisoned in Bristol Castle and then Norwich. He was still alive in 1340, but the main bloodline of the princes of Deheubarth was extinguished with his death in prison.

The Madog ap Llywelyn National War of Independence, 1294–5

The last great national rising against English rule in the thirteenth century came in 1294, as the impact of the great 1290 tax demand fell on the Welsh – at the same time as Edward demanded soldiers to fight for him in France. Llywelyn ap Maredudd was the last Lord of Meirionnydd, who was deprived of his lands for opposing Llywelyn II in 1256 at the Battle of Bryn Derwen. He left for exile in England. His eldest son, Madog, was probably born in exile, and received substantial sums from Edward I in 1277. Madog used the money to sue Llywelyn for the return of Meirionnydd to his lordship. Madog returned to Gwynedd after the death of Llywelyn in 1282 and received lands from Edward I in Anglesey. There were constant calls in Wales for taxes and conscription for Edward I's wars in Scotland and overseas, and the Welsh were unhappy with their meagre resources and the constant demands upon them. Madog's war of independence had been planned across Wales. It was to begin when Edward I sailed to France with an army. The leaders were Morgan ap Maredudd of Gwynlliwg in Glamorgan, Cynan ap Maredudd in Brycheiniog, Maelgwn ap Rhys in Ceredigion and Madog ap Llywelyn in Gwynedd. In autumn 1294, Madog became leader of the national uprising in response to the actions of new royal administrators in the north and west of Wales, and the imposition of taxes such as that levied on one fifteenth of all moveables.

Madog was of the line of Owain Gwynedd, and declared himself to be the lawful successor to the executed Dafydd ap Gruffydd. He assumed the royal titles of his predecessors, including 'Prince of Wales', as can be seen in the Penmachno Document. Cynan ap Maredudd led the rising in Brycheiniog and Deheubarth with Maelgwn ap Rhys, who was killed in 1295. He besieged Builth Castle for six weeks and took Cefnllys Castle. After the collapse of the revolt in the summer of 1295, Cynan was captured, apparently at Hereford, and executed. Morgan ap Maredudd ('Morgan the Rebel') was the son of Maredudd ap Gruffydd, the last Welsh Lord of Caerleon and Machen. When his family was deprived of its estates by Gilbert de Clare, Earl of Gloucester,

Morgan claimed to be at war only against the Lords of Glamorgan. In 1283, he had supported Dafydd, Prince of Wales, and led the Glamorgan rising in 1294–5 during the war of Madog. Morgan took the castles of Kenfig, Llangibby and Morlais, besieged de Clare's Caerffili Castle and burnt the town. At the end of the war, Morgan submitted to Edward I and in 1297 he became an esquire of Edward's household and his agent in South Wales. His claim that his fight was only against the rapacious de Clares, and not the Crown, was fortunately accepted.

It is little known that in North Wales, Madog took the great Caernarfon Castle on 30 September, killing the castellan, and later took the massive fortresses at Hawarden and Denbigh in co-ordinated attacks. For several months his men laid siege to Harlech and Cricieth, which were supplied by sea from Ireland. Cardigan Castle was taken, and in Ceredigion, Morgannwg and Brycheiniog, many castles and manors were sacked. Henry de Lacey, Lord of Denbigh, led a march to that the castle after it was besieged. De Lacey was ambushed outside the town on 11 November, and in the ensuing battle his force was routed by the rebels. Reginald de Grey placed massive garrisons in the castles at Flint and Rhuddlan, which held out against Madog's men. Other castles across Wales, such as Castell y Bere, were besieged and several towns burnt. The Sheriff of Anglesey was killed. Unfortunately, prevailing winds meant that Edward had not sailed to France as expected, and his levies were mustered in Shrewsbury on 30 September. He told his lords to pacify their lands, and gathered great armies at Chester, Montgomery and Gloucester.

The Edwardian castles of North Wales had been nearing completion when war broke out. Their garrisons were depleted by the king's expedition to Gascony. Several, including Cardigan and Caernarfon, were besieged, but the English control of the sea restricted the spread of the revolt. The castles could hold out as long as provisions could be brought by ship. Aberystwyth, Conwy, Cricieth and Harlech were provisioned from Bristol and Ireland. During the winter, Edward I's forces marched into Gwynedd. Caernarfon was relieved, and in the spring of 1295 work began on the last of Edward's castles, Beaumaris.

In December 1294 Edward took his enormous invasion army of 35,000 men into North Wales, halting at Wrecsam, Denbigh and Abergele en route to Conwy Castle. He brought his French invasion force up to Conwy and then moved to Bangor but lost his baggage train in an ambush and was forced to return and shelter in Conwy Castle. He reached there shortly before Christmas. If Madog had a fleet, he could have taken several castles such as Aberystwyth by stopping their supplies. Harlech had only thirty-seven men left to hold it, and Edward was himself surrounded at Conwy Castle until relieved by his navy in 1295.

Madog now moved south, looking for support from Powys, when he was attacked by the Earl of Warwick at Maes Madog, near Caereinion in 1295. Warwick had used the king's funds to hire Glamorgan and Gwent longbowmen, who broke the back of Madog's small army, mainly composed of North Wales spearmen. Madog had drawn his men up in a traditional schiltron (porcupine formation), favoured by the Scots against English knights, and the English cavalry had little success. However, Madog's men were showered with arrows from the Welsh archers and beaten badly. Five days later, the king's forces came on the remnants of the exhausted Welsh army and slaughtered 500 of them in a night attack. Madog and his son managed to escape

the slaughter, becoming fugitives until Madog's unconditional surrender to John de Havering in Snowdonia in July or August 1295. He was imprisoned in London and was last recorded as still being alive in 1312.

As usual, hostages were taken – 236 from various parts of Wales – and the descendants of Ednyfed ap Fychan were imprisoned at Shrewsbury. The war of 1294–5 further restricted the civil rights and economic and social opportunities of the Welsh, with more punitive laws being passed. Ironically, this war led to the crowning of the first son of the English king as Prince of Wales, the most honoured title in an independent Wales. Subsidies were levied across Wales for the cost of the war. Despite the crushing of the under-resourced Welsh, just twenty-one years later there was yet another rebellion, this time led by the Lord of Senghenydd, aided by some Marcher lords.

Welsh Archers

With defeat at home, the Welsh infantry retained and increased their place at the heart of royal armies, Lodwyk van Veltham wrote of Welshmen serving in Edward I's army in Flanders in 1297: 'In the very depth of winter they were running about bare-legged. They wore a red robe. The money they received from the king was spent on milk and butter. They would eat and drink anywhere. I never saw them wearing armour … Their weapons were bows, arrows and swords. They had no javelins. They wore linen clothing. They were great drinkers … Their pay was too small and so it came about they took what did not belong to them.' Welsh mercenaries remained, however, disobedient and riotous soldiers, on one occasion almost killing Edward I himself in a camp dispute in Scotland. Undisciplined in combat, the Welsh mercenaries often murdered, rather than captured, opponents with ransom value. They would not have received any reward themselves, so it was only natural to kill someone who had just been trying to kill you. The gradual rehabilitation of the Welsh gentry helped restore their discipline, as the Welsh soldiers only really obeyed their own native officers.

We have seen that Welsh archers were the deciding factor in many battles, being levied by the English to fight against their fellow countrymen. There was no alternative for these men. If they refused to fight, the consequences could be dire, at the very least being forced off their lands and out of their homes. England, having suffered itself from Welsh longbowmen, realised their use. (It is a strange oxymoron – 'the English longbow' – it is a Welsh innovation, recorded as being used by the Welsh before other European nations.) In the First War of Scottish Independence, the Battle of Stirling Bridge occurred in 1297. William Wallace's Scottish army waited as the English knights and infantry made slow progress across the bridge. They had held back earlier in the day when many of the English and Welsh archers had crossed, only to be recalled because the English commander had overslept. When the vanguard of 5,400 English and Welsh infantry plus several hundred cavalry had crossed the bridge, the Scots attacked, knowing that reinforcement could only cross the bridge two at a time. The Scottish spearmen now cut off the vanguard from the rest of the army. The English and Welsh were almost annihilated, with de Cressingham's body being flayed to make a baldrick for Wallace's sword.

There were plentiful supplies of men from Wales – the country was destitute, and Welshmen came to be increasingly important in royal armies. They made up no less

than 10,000 of the 12,000 footsoldiers led by Edward I at Falkirk in 1298. Wallace's Scots bowmen were quickly wiped out, but the Scottish schiltrons held firm, with knights and their chargers being forced back from the forest of long spears. Edward assessed the difficult situation and used the Earl of Warwick's tactics from Maes Madog in 1295. The Welsh archers had overcome the Scottish bowmen, and all their fire-power now fell on the shiltrons, supplemented by crossbows and slingshot. Unable to retreat or attack, the battle was lost for the Scots almost as soon as the first arrows began to fall. When the Scots ranks had thinned sufficiently, Edward ordered his knights to charge, killing MacDuff and breaking the Scots army, who fled into nearby forests. Wallace escaped, but Falkirk was a timely victory for the king. His people and nobles were unhappy after previous defeats by Wallace and with the terrific costs of Edward's wars in France and Wales.

In 1314, there were about 5,000 Welsh soldiers at Robert the Bruce's victory at Bannockburn. Peter Reese writes that 'only one sizeable group of men – all foot-soldiers – made good their escape to England'. This was a force of Welsh spearmen under Sir Maurice de Berkeley, and the majority of them reached Carlisle. Reese notes that 'it seems doubtful if even a third of the foot-soldiers returned to England'. Out of 16,000 infantrymen, this would give a total of about 11,000 men killed. The battle made the Norman Robert the Bruce a hero in Scotland, but he never fought for Wallace, twice broke his oath of fealty to the English Crown, and murdered John Comyn, a patriot claimant to the Crown of Scotland, in a church, for which he was excommunicated. He was absent from Wallace's battle at Stirling Bridge, and one chronicler puts him on the English side at Falkirk. Wallace was of British stock, from Strathclyde, known as William Wallensis (William the Welshman).

The Second War of Independence saw the Battle of Dupplin Moor in 1332. Most of the footsoldiers on the English side were Welsh archers provided by Edward III. The Scots schiltrons were enticed into a valley lined by bowmen and were destroyed. The Scots losses have been estimated at 13,000 men, the English at just thirty-three. In 1333 Edward himself now led an invasion army north and met the Scots just north of Berwick at Halidon Hill. Edward was perfecting his use of Welsh archers, who decimated the Scots, with the survivors being wiped out by English cavalry. The *Lanercost Chronicle* reports 'the Scots who marched in the front were so wounded in the face and blinded by the multitude of English [sic] arrows that they could not help themselves, and soon began to turn their faces away from the blows of the arrows and fall'.

In European battles, until Crécy in 1346, the nobility fought each other on horseback, as chevaliers or knights. The French expected to fight the knights of the smaller English army, but the English had been perfecting a different method of fighting against the Scots. They now brought down men on horseback with archers. Most of the English army dismounted to do battle with the French, which was not the normal method of combat. Armoured knights on horseback could be easily taken down by longbows, and despatched by knives through chinks in their armour as they lay helpless on the floor. The Welsh longbow altered European warfare, having an effective range of up to 300 yards and an incredible penetration power. Different arrowheads were used, dependent upon the effects required, much as the use of different bullets today. For example, knights' horses became very vulnerable to a special type of arrow called the broadhead, similar to the barbed hunting arrow but much larger. The arrow had a large

barb on it which would be almost, if not impossible to remove from a horse's flesh. Once embedded it could work its way in but not out, leaving the animal to bleed out and die.

The Welsh archers at Crécy fired their arrows in an arching trajectory into the air. The descent of the arrows was given added velocity from the acceleration due to gravitational force, enabling them to more easily pierce armour. The longbow was as tall as the man who used it, anything up to 6 feet high. Arrows fitted with a bodkin (metal tip) could pierce chain-mail at 100 paces if they contacted their target perpendicular to the body. The crossbow had a shorter range than the longbow and had a less rapid firing rate. The French at Crecy used about 6,000 Genoese crossbowmen in their frontal attack and literally ran them down as their own knights charged forward.

3,000 Welsh archers loosed 10–20 arrows each per minute, and more arrows were brought forward or archers moved back to collect another supply. In the words of one commentator 'arrows fell like snow'. This mass volley of arrows was a new method of fighting and was first tried at Crécy by Welsh archers in their green-and-white uniforms. The battle at Crécy lasted eight hours, with French and Genoese casualties estimated at 5,000–10,000 and the English at several hundred. In five minutes at Crécy the archers loosed more than 30,000 arrows and 1,500 French knights and their squires were cut down. For 200 years the longbow and infantry were placed to the fore in any battle, replacing the position of the cavalry.

In 1356, Edward the Black Prince began a great raid north from the English base in Aquitaine, in an effort to relieve allied garrisons in central France, as well as to raid and ravage the countryside. Upon receiving reports of the French army on the move, Edward decided a retreat was in order. The French caught up to the English a few miles south-west of Poitiers. Edward copied the tactics he has seen at Crécy, with the Welsh longbowmen placed in a V-formation on both flanks. Froissart writes that the French armour was so invulnerable to arrows that the arrowheads either skidded off the armour or shattered on impact. The armour on the horses, however, was weak on the sides and back, so the archers moved to the sides of the cavalry and shot the horses in the flanks. The results were devastating. With heavier, better armour, French knights had to mount their horses with the help of many more squires, and probably a set of pulleys. An unmounted knight was little more than a beetle squirming on its back, and archers knifed them through chinks in their armour. Armour-piercing arrowheads were now developed, with stocks of thousands of arrows being built up in the Tower of London in preparation for war.

Edward II

In 1307, the dying Edward I was told of a Welsh prophecy: 'The people believe that [Robert the] Bruce will carry all before him, exhorted by false preachers from Bruce's army ... For these preachers have told the people that they have found a prophecy of Merlin, that after the death of le roy coveytous [Edward I] the people of Scotland and the Welsh shall band together and have full lordship and live in peace together to the end of the world.' His son Edward II reigned from 1307–27 and feared a union between his Scots, Irish and Welsh enemies. He faced horrific debts from his father's

wars, and after the Scots' victory at Bannockburn, fighting for independence spread to Ireland. The Welsh lords received some encouragement from Robert the Bruce to rise up once more. These three constant threats against England enabled the new king to move against Roger Mortimer, probably the most powerful Marcher lord, who led the the opposition of lords who wanted reform. Mortimer brutally ruled Carmarthen and south-central Wales in such a manner that his Welsh subjects became more loyal to the Crown. In 1322 Edward II arrested Mortimer, but Mortimer escaped from the Tower in 1324 and fled to Paris, becoming the estranged Queen Isabella's lover.

They invaded England, and forced Edward's flight into Wales. The king first took refuge in Gloucester, then fled to South Wales to make a defence in the lands of the Despensers, Mortimer's greatest enemies. However, he was captured near Tonyrefail on 16 November by Henry of Lancaster, and the elder Despenser was hung and beheaded at Bristol. Reprisals against Edward's allies began immediately thereafter. The younger Despenser, Hugh, was brutally executed in a public spectacle. He was dragged from his horse, stripped, and Biblical verses engraved on his skin. He was then dragged into the city's market square, to the presence of Isabella, Mortimer and the Lancastrian leaders. He was then condemned to be hung as a thief, castrated and then drawn and quartered as a traitor.

In September 1327, a Welsh plot to free Edward II from Berkeley Castle was discovered by William Shalford, Roger Mortimer's deputy justice of Wales. The plotters included Rhys ap Gruffydd and Gruffydd Llwyd. The chronicler Thomas Walsingham wrote with reference to Edward II at the end of the fourteenth century that 'the Welsh in a wonderful manner cherished and esteemed him, and, as far as they were able, stood by him grieving over his adversities both in life and in his death, and composing mournful songs about him in the language of their country, the memory of which lingers to the present time, and which neither the dread of punishment nor the passage of time has destroyed'.

In 1328 Mortimer became the first Earl of March, and ruled England with the queen until the legitimate heir, Edward III, removed him in 1330. Edward II's deposition and death, as legend has it, by a red-hot poker up the rectum (his ornate tomb rests near the Welsh border in Gloucester cathedral), showed that even the Crown was no longer sacrosanct. Only the Welsh seemed to mourn him, and the chronicler Walsingham noted 'the remarkable way in which he was revered by the Welsh'.

The Murder of Llywelyn Bren, *c.* 1265–1317

Llywelyn's father Gruffydd ap Rhys had been illegally dispossessed of the lordship of Senghenydd and Meisgyn in 1267 by Gilbert de Clare and imprisoned in Ireland, never returning to Wales. The Normans found it far easier to subdue these flatter and richer southern parts of Wales, where reinforcements from the sea were available during their slow and uneven conquest. Lord Payne de Turberville of Coity Castle advocated the expulsion of Welshmen from the Glamorgan lordship. Hugh Despenser, acting for Edward II, had appointed de Turberville to be Custodian of Glamorgan upon the death of the Earl of Gloucester, Gilbert de Clare the Younger, in 1314. Sir William Berkerolles of East Orchard Castle was Despenser's sub-lord, given full powers over

the estates of Llywelyn Bren. This had been done to evict Bren from his rightful possessions across Glamorgan. The unfortunate people of Glamorgan, starving during the Great Famine of 1315–7 and beaten and extorted of money by de Turberville's armed rent-collectors, suffered terribly. The young Gilbert de Clare, Lord of Glamorgan had been killed at Bannockburn in 1314, along with several hundred men he had impressed from Glamorgan to fight there. The people were rebellious and there was an uprising in Glamorgan in 1315. *Vita Edwardi Secundi* records for 1315 that 'the Welsh habit of revolt against the English is an old-standing madness … and this is the reason: the Welsh, formally called Britons, were once noble crowned over the whole realm of England, but they were expelled by the on-coming Saxons and lost both the name and the kingdom. The fertile plains went to the Saxons, but the sterile and mountainous districts remained to the Welsh. However, from the sayings of the prophet Merlin they still hope to recover their land. Hence, it is that the Welsh frequently rebel, hoping to give effect to the prophecy.'

The young Earl of Gloucester had thought highly of Llywelyn and granted him the estates of his father. However, on de Clare's death Payn de Turberville removed Llywelyn's authority from Senghenydd and treated him with contempt. This led a furious Llywelyn to tell a room full of his supporters that 'the day will come when I will put an end to the insolence of Payn and give him as good as he gives me'. De Turbeville charged Llywelyn with sedition, and he was summoned to Lincoln by the king to meet a charge of treason. However, Llywelyn had no intention of going to Lincoln when it would probably result in his gruesome execution, and instead prepared for war. On 26 January 1316 – the day before Edward II arrived in Lincoln to open parliament – Llywelyn attacked the great stronghold of Caerffili, built by the Earl of Gloucester's father Gilbert 'the Red' in the 1270s. Although he could not penetrate the inner ward of the impregnable castle, he burnt the outer ward, taking the custodian captive, killing some servants and wounding others. The revolt spread throughout Glamorgan. Llywelyn and his many supporters, carried off Payn de Turberville's goods into the mountains where they were based, and Llywelyn threatened to kill the hated official.

The news took a few days to travel the more than 200 miles from Caerffili to Lincoln, and when Edward II finally heard on 7 February, he immediately sent men to capture Llywelyn, exclaiming, 'Go quickly, and pursue this traitor, lest from delay worse befall us and all Wales rise against us.' Edward ordered the Earl of Hereford, the Earl of Lancaster and Roger Mortimer to raise forces. Troops came from Cheshire, North Wales, and also some Welsh soldiers from West Wales. William Montacute alone took 150 men-at-arms and 2,000 footmen, at Edward II's expense, and the royal treasury, as usual, was in difficulties. Trouble also broke out elsewhere in Wales, thanks to the long-running feud between Edward's chamberlain John Charlton and his wife Hawise Gadarn and her uncle Gruffydd de la Pole over the Lordship of Powys. In March 1316, Edward told Chancery, 'If this riot be not hastily quenched much greater evil may come in other parts of Wales', and sent his steward John Cromwell to 'bridle the evildoers and staunch the riots', granting him ten pounds for his expenses.

Llywelyn rode to his home of Castell Coch, which the Normans had taken, and they refused to hand it over. Gathering around 1,000 supporters, he scaled the castle walls. He destroyed the castles at Kenfig, Llantrisant, Sully, Barry, Old Beaupré, Kenfig,

Llangibby, St George's-super-Ely, West Orchard and possibly East Orchard at St Athan. Thousands of Welshmen then attacked the more powerful castles at Cardiff, Caerleon and Dinefŵr, but Llewelyn made the grave mistake of becoming bogged down trying to besiege the enormously powerful Caerffili Castle. In March, forces advanced from Cardiff and in a brief battle at Castell Morgraig forced Llewelyn and his men to break off the siege of Caerffili after six weeks. The Welsh retreated higher up the north Glamorgan plateau, where two armies under Hereford and Mortimer were moving south from Brecon.

Llywelyn Bren was cornered near Ystradfellte. To save his followers he surrendered, knowing his fate, saying, 'It is better for one man to die than for a whole population to be killed by the sword.' He knew that Edward needed his men to fight against the Scots, so he had ensured their safety. Hereford and the Mortimers were impressed with Llywelyn's bearing and courage and asked the king to show him and his followers leniency. Edward sent Llywelyn, his wife Lleucu, his seven sons and five others 'under safe custody at the king's expense' to the Tower. Edward also removed Payn de Turberville from office and replaced him with the more moderate John Giffard.

By June 1317, only Llywelyn and two of his sons, Gruffydd and Ieuan, are mentioned as prisoners in the Tower, the others presumably having been released. Llywelyn Bren was removed from the Tower by Hugh Despenser sometime in 1318, dragged through the streets and executed at Cardiff Castle by the order of Despenser to Berkerolles. Berkerolles owed Llywelyn Bren his life, as Llywelyn had previously protected him in a Welsh attack, where thirteen Norman soldiers on Berkerolle's bodyguard were killed. Without any trial, Llywelyn was hung, drawn and quartered for treason and his lands seized by Despenser. Despenser had no authority to commit such an act. There is no known record of Welshmen torturing or killing prisoners in this way. Hugh Despenser, the new Lord of Glamorgan, had insisted on this disgusting execution of this rightful heir to most of Glamorgan. After the execution, de Turberville moved all Welsh from the Vale of Glamorgan and the mid-Glamorgan plains to the hillier and more unproductive grounds of northern Glamorgan.

Llywelyn's death united the local Welsh and the Marcher lords. In 1321 a baronial revolt led by the Earl of Hereford and others petitioned the king to dismiss Despenser, the murder of Llywelyn Bren being prominent in their list of complaints. When the king refused, an alliance of local Welsh men and Marcher lords raided Despenser's lands in Glamorgan over some ten days. It may have been then that Lleucu and her sons were freed, as Hereford took all of Llywelyn's sons into his service around this point. Llywelyn's widow Lleucu and sons are known to have attacked the castles of Cardiff, Caerphilly and St Quintin's. Edward was forced to exile the Despensers for a time until he gathered enough forces to defeat the barons at the Battle of Boroughbridge in 1322, where the Earl of Hereford died. With the Despensers' return to Edward's court Lleucu and her sons were again imprisoned (now in Bristol Castle). However, the Despensers' arrogance and actions led to more fighting. In October 1326, Roger Mortimer led a successful rebellion against the Despensers and Edward and they were forced to flee to Glamorgan. They understandably failed to raise any troops, and were captured in November. With the overthrow of Edward II, the estates in Senghenydd were restored in 1327 to Llywelyn Bren's sons: Gruffydd, Ieuan, Meurig, Roger, William and Llewelyn.

According to Rice Merrick in 1566, Hugh Despenser was executed near the Black Tower of Cardiff Castle, and was said to be buried in the adjoining Greyfriars Monastery ruins, alongside Llywelyn Bren. The full charge against Despenser reads 'that he did wrongfully adjudge Llywelyn Bren, causing him to be beheaded, drawn and quartered to the discredit of the King and contrary to the laws and dignity of the Crown'. Roger Mortimer wanted Despenser 'to suffer a death every bit as horrible as his killing of Llywelyn Bren in 1317'. Despenser was actually executed at Hereford and his limbs dispersed to Bristol, Newcastle, York and Dover, with his head going to London to be spiked. Berkerolles was judged innocent in the tragic affair, and kept his castle at East Orchard. According to Ian Mortimer in his biography of Roger Mortimer, 'People were starving to death … in Wales the plight of the people was just as extreme. But there they found a leader who not only inspired them; he inspired his enemies as well. His name was Llywelyn Bren.' Norman kings and their lords were almost universally illiterate. Llywelyn Bren's possessions included books in Latin, French and Welsh, at a time when the English kings still spoke French and were illiterate. Not until 1362 was it decreed that all proceedings in court must be conducted in the English language. Llywelyn Bren ap Rhys ap Gruffudd ap Ifor Bach had his library confiscated after his murder.

The Black Death, 1348–69

The Welsh climate deteriorated after 1300. Wet summers, disease among domestic animals and soil exhaustion caused agricultural problems. By 1320, the population was in decline and would not return to the level of 1300 for another 250 years. There was famine across all Europe in 1315–22 and 1330–1, with poor crops and disease. Y Farwolaeth Fawr (the Great Mortality) was caused by the Black Death, spread by rats, and was followed by pneumonic plague spread by people. In 1359–62 there was the 'Second Pestilence' and in 1369, another severe outbreak. The plague did not reach Wales until early 1348 or 1349, probably carried from southern England. It killed around a third of the population of Europe. The weather had grown colder in the last century, and with the pressure of the English conquest and the subsequent altered social make-up of Wales, more displacement and death may have occurred there than in other places. Records indicate that about 30 per cent of the population died, despite Wales being more rural than other nations. In 1300 there were 300,000 people in Wales, but by 1400 the number had dropped to under 200,000. From 1373, the Marcher lords led by Bolingbroke began imposing community fines upon their Welsh tenants to try and make up for the loss in income.

The Black Death caused massive social change across England and Wales, including the 1381 Peasants' Revolt in England, caused by government legislation against wage increases. In Wales, the falling population and continued machinations of the Marcher lords led to calls for internal reforms of the Welsh land laws and the gwely landholding system. By now, this effectively repressed the Welsh in their own land. It was based on the practice of *cyfran*: equally dividing estates between male heirs, thereby constantly reducing their size and income. This landholding system collapsed after 1350, greatly aided by the impact of the plagues. The Welsh economy now focused on sheep farming

and profitable wool exports, later aided by the development of steam power. Fewer people were available to work the land, and many of those that remained fled to England to be free of excessive taxation in Wales. The economic life of Wales thus suffered severely in the fourteenth century. At Whitchurch, an inquest into the death of one John le Strange revealed that John had died on 20 August 1349. His oldest son, Fulk, died 2 days before the inquest could be held on 30 August. Before an inquest could be held on Fulk's estate, his brother Humphrey was dead too. John, the third brother, survived to inherit a shattered estate, in which the three water mills that belonged to him were assessed at only half their value 'by reason of the want of those grinding, on account of the pestilence'. His land was deemed worthless because all its tenants were dead 'and no-one is willing to hire the land'.

The Welsh poet Jeuan Gethin, who himself died in 1349, paints a vivid picture of the fear the plague engendered in its victims:

> We see death coming into our midst like black smoke, a plague which cuts off the young, a rootless phantom which has no mercy or fair countenance. Woe is me of the shilling in the arm-pit; it is seething, terrible, wherever it may come, a head that gives pain and causes a loud cry, a burden carried under the arms, a painful angry knob, a white lump. It is of the form of an apple, like the head of an onion, a small boil that spares no-one. Great is its seething, like a burning cinder, a grievous thing of an ashy colour. It is an ugly eruption that comes with unseemly haste. It is a grievous ornament that breaks out in a rash. The early ornaments of black death.

There were three main social groups: the *uchelwyr* – the upper class, the *bonheddwyr* or *boneddigion* – the freemen; and the *taeogion* – the unfree peasants. Each group had its role in society. The *taeogion* (villeins) lived in compact villages in the fertile lowlands. Organised by the *maer y biswail* (the mayor of the dunghill), they supplied the needs of the princely court. They also had to do farm work for the prince each year. Tied to the land, they could not leave their own village. Their arable crops were vital for Wales. Edward I realised this and, in his 1277 invasion, his forces quickly took Anglesey and seized the grain harvest. The lowlands were linked to the hills economically. Farming communities moved from the hendref, their main settlement in the lowlands, to the *hafod* with its upland pastures each summer. The upland farmers were generally *bonheddwyr* (freemen) who lived in kinship groups, each looking after its own gwely (clan land). They performed military service for the prince, but did not do menial tasks like the *taeogion*. The upland farms were also vital to Wales. They enabled the Welsh to keep their economic and political independence when the Marcher lords occupied the fertile lowlands.

While the traditional view is that the Welsh were not an urban people, over eighty towns had been established in the period 1100–1300. Towns did develop more in the Marcher lordships because these areas were richer, but the Welsh princes also encouraged the development of towns, often near their castles. Trade increased in tandem with these new towns and Wales exported primary goods like cattle, skins, fleeces and cheese. Imports included necessities like salt, wheat and iron, but reliance on these imports would be a weakness against an aggressive King of England. The population collapse after the Black Death had far-reaching consequences. Deaths among

the *taeogion* created a demand for free labourers, thus undermining the differentiation between the free and the unfree. Deaths among the boneddigion slowed and reversed the dividing up of their holdings. Many of them sought to hold their land according to English law, thus allowing them to bequeath their entire property to the eldest son, a process which encourages the growth of extensive landed estates. Distinction based on descent began to give way to distinction based on wealth.

The Assassination of Owain Lawgoch, 1330–78

During the later years of the Black Prince's rule, the English authorities in Wales were face to face with the danger of concerted action on the part of the French and a noted Welshman named Owen ap Thomas ap Rhodri. The latter, a descendant of the royal line of the old Welsh princes, subordinated his domestic troubles to questions of national importance. He was to some extent favoured in this by the current and popular hope, entertained by the Welsh people, of expected relief from their social and political discontent by a chieftain from over the seas. There being no deliverer at home, the medieval Welsh found it convenient, and not altogether dispiriting, to speak and think of one as coming from abroad. As early as 1360, we find special bowmen sent from Chester to the castle of Beaumaris with a view to thwarting the sinister movements of the 'enemies from France'. The position was aggravated by the outbreak of war between France and England in 1369. Early in the May of this year, the castles of North Wales were strongly fortified, and on 10 November, a special survey was made of the respective garrisons on the pretext that 'our enemies from France and other adherents' were about to invade the kingdom of England. A similar invasion was apprehended in 1370, but none took place. Two years later, Owen of Wales (who was engaged in fighting English forces in France) issued his famous proclamation, coupling the redress of his personal grievances with a proposed restoration of the kingship of Wales. Propositions of this kind were apt to be popularly received in Wales at this time, when the native bards began to revive their military song, but Owen's attempt ... came to nothing. Some of his North Welsh adherents suffered for their loyalty to his cause by losing their lands. Dangers from the parts of France were again feared in 1377, but Owen's tragic death in the next year, at once gave a permanent check to his personal efforts, and a temporary blow to the practical expression of that national sentiment which was being gradually imbued into the Welsh peasantry through the teaching of the local bards.

Edward Arthur Lewis, The Medieval Boroughs of Snowdonia, 1912

Across Wales, unrest was widespread in the 1340s and again in the 1370s, when Owain Lawgoch, the grandson of Llywelyn's brother, Rhodri, sought to obtain French assistance in asserting his ancestral rights in Wales. Owain Lawgoch fought for the King of France against the English. He was hailed by Welsh poets as a deliverer but was betrayed and killed in 1378. Owain ap Thomas ap Rhodri was known in Wales as Owain Lawgoch (Llaw Goch meaning Red Hand), and on the continent as Yvain de Galles. Owain was the sole heir of the princes of Gwynedd. Born about 1330 on his father's estate at Tatsfield in Surrey, his father warned him that the family might be targeted as the last in the line of Gwynedd, and encouraged Owain to flee England.

In 1350 Owain bound himself to the service to Philip VI of France, and became his protégé. Owain now constantly proclaimed himself the true heir of Aberffraw, and only du Guesclin features more highly in French literature as an enemy of the English at this time. Described by Edward Owen as 'possibly the greatest military genius that Wales has produced', he crossed back to England in 1365 to claim his Tatsfield inheritance (his father had been executed in 1363), but was unsuccessful and was forced to return to France in 1366. His lands in England and Wales were confiscated in 1369.

Many Welshmen followed him, including Ieuan Wyn, who took over Owain's company of soldiers after his death. Owain still features in the folk literature of Britanny, France, Switzerland, Lombardy and the Channel Islands. 'Owen of Wales' had been brought up at the court of King Philip VI of France, and became one of the most noted warriors of the fourteenth century. Described as 'high-spirited, haughty, bold and bellicose' (Barbara Tuchman, *A Distant Mirror*), he had fought heroically against the English at Poitiers in 1356, somehow surviving against all the odds. Owain campaigned in the Lombard Wars of the 1360s, for and against the Dukes of Bar in Lorraine, and with the great Bertrand du Guesclin in the campaigns of the 1370s. In 1366, he had led the Compagnons de Galles (Company of Welshmen) to fight Pedro the Cruel in Spain.

An Anglesey man, Gruffydd Sais, was executed and had his lands confiscated by the Crown in 1369 for contacting 'Owain Lawgoch, enemy and traitor', and in the same year Charles V gave Owain a fleet to sail to Wales from Harfleur. It was repulsed by storms. The French king now gave Owain 300,000 francs, another fleet and 4,000 men to win back his land. Owain proclaimed that he owned Wales 'through the power of my succession, through my lineage, and through my rights as the descendant of my forefathers, the kings of that country'. Taking Guernsey from the English, Owain captured the legendary Captal de Buch, the Black Prince's comrade, hero of Poitiers and one of England's greatest soldiers. Owain had taken a Franco-Castilian landing party to the Channel Islands, and overpowered him at night. Such was the Captal's reputation that King Charles V kept him in prison in the Temple in Paris without the privilege of ransom. Both King Edward of England and delegations of French nobles repeatedly asked Charles to ransom the great Captal, if he promised not to take up arms against France, but the king refused and the noble Captal sank into depression. He refused food and drink and died in 1376.

Owain prepared to invade Wales after his seizure of Guernsey, but sadly a message came from the French king to instead help the Spanish attack the English-occupied La Rochelle in 1372. Owain responded and fought again against the English. Owain never had another chance to return to Wales. In 1375, he took part in the successful siege of Saveur-le-Comte in Normandy, where for the first time cannon had been used really successfully to break the English defences. He then took a contract from the great Baron de Coucy to lead 400 men at a fee of 400 francs per month (with 100 francs per month going to his assistant, Owain ap Rhys). Any town or fortress taken was to be yielded to De Coucy. The capture of Duke Leopold of Austria was to be worth 10,000 francs to Owain, who attracted 100 Teutonic knights from Prussia to his banner. With the Treaty of Bruges, English knights also came to offer their services under the leadership of Owain, who was the King of England's son-in-law. Probably around 10,000 soldiers eventually formed an army for De Coucy and Owain. The

knights wore pointed helmets and cowl-like hoods on heavy cloaks, and their hoods were called *gugler* (from the Swiss-German for cowl or point) gave their names to the the Gugler War.

The companies making up the army plundered Alsace, and took ransom of 3,000 florins not to attack Strasbourg as Leopold retreated, ordering the destruction of all resources in his wake. Leopold withdrew across the Rhine, relying on the Swiss to stave off the attack, although the Swiss hated the Hapsburgs almost as much as they hated the Guglers. The invaders were allowed entrance to Basle, but their forces became increasingly scattered as they sought loot in the wake of Leopold's depredations. Near Lucerne, a company of Guglers was surrounded by the Swiss and routed. On Christmas night, a company of Bretons was ambushed by citizens of Berne, city of the emblem of the bear. On the next night, the Swiss attacked the abbey of Fraubrunnen, where Owain was quartered, setting fire to the abbey and slaughtering the sleeping 'English'. Owain swung his sword 'with savage rage' but was forced to flee, leaving 800 Guglers dead at the abbey. Ballads tell of how the Bernese fought '40,000 lances with their pointed hats', how 'Duke Yfo (Owain) of Wales came with his golden helm' and how when Duke Yfo came to Fraubrunnen, 'The Bear roared "You shall not escape me! I will slay, stab and burn you!" In England and France the widows all cried "Alas and woe!" Against Berne no-one shall march evermore!'

The following details are fully recounted in *Froissart's Chronicles*. In 1378, Owain was conducting the siege of the castle of Mortagne-sur-Mer in the Gironde on the Atlantic coast. As usual, early in the morning, he sat on a tree stump, having his hair combed by a new squire, while he surveyed the scene of siege. His new Scots manservant, James Lambe, had been taken into service as he had brought news of 'how all the country of Wales would gladly have him to be their lord'. But with no-one around, Lambe stabbed Owain in the back, and escaped to Mortagne – the English king had paid £20 for the assassination of the person with the greatest claim to the Principality of Wales, the last of the line of Rhodri Fawr. Norman and Angevin policy had always been to kill Welsh male heirs and put females of the lineage into remote English monasteries, as we can see in the case of Llywelyn the Last (Llywelyn Olaf).

Owain Lawgoch was only second in valour to Bertrand du Guesclin in Europe through these years, a mercenary operating away from home compared to a national hero. His is an amazing story, yet he is unknown to 99 per cent of Welshmen. His importance to King Edward III of England is shown in a payment of 100 francs and in the Issue Roll of the Exchequer dated 4 December 1378: 'To John Lamb, an esquire from Scotland, because he lately killed Owynn de Gales, a rebel and enemy of the King in France ... By writ of privy seal, &c., £20.' However, with Owain Lawgoch's death, the prior claim to the heritage of Llywelyn the Great and Llewelyn the Last passed on eventually to another Owain; Glyndŵr, another 'Mab Darogan' ('Son of Prophecy') of the Welsh bards. When Owain Glyndŵr, in 1404, requested French help against England, he reinforced his case by referring to Owain Lawgoch's great service to the French crown. It seems that some of Lawgoch's battle-hardened veterans returned to Wales to fight for Glyndŵr. It may be that Owain had a son, as a minor chevalier named Eduart d'Yvain was noted towards the end of Owain's life. If so, the heirs to the House of Gwynedd may be alive in France. A monument has been erected in 2003 to Llawgoch by Cymdeithas Yvain de Galles, at Mortagne-sur-Mer.

The doings of Owen ap Thomas ap Rhodri or Owen Lawgoch in foreign lands, flattered the oppressed tenantry of North Wales into the belief that he was their long-expected deliverer. Owen's shameful murder gave rise to many poems of lament by the national bards. Racial hatred in local circles was seemingly intensified by the fact that the perpetrator of this infamous deed was an Englishman. A spirit of hatred towards the Saxon enters the native poetry of the period at this point. The contemporary poems of Iolo Goch, the national bard, breathe a military strain hitherto unknown since the fall of Llywelyn the Last. Another bard, one Llywelyn ap Kynfrig Ddu of Anglesea, the island nursery of Welsh nationalism during this period, whilst deploring Owen's murder, inspired the people with the hopes of another Owen, a deliverer who was biding his time. When he really came there was to be war throughout Wales.

Edward Arthur Lewis, The Medieval Boroughs of Snowdonia, 1912

The War of Independence of Owain Glyndŵr, 1400–1420

It is evident from what was going on in North Wales that the Welsh peasants were preparing for some great event. The old Edwardian ordinances were entirely set aside. Congregations and secret meetings in desolate and mountainous places were frequent. The Welsh populace were arming themselves in the hope of help from Scotland, and also from the conviction that the Owen of their expectation had arrived. The position, in the eyes of the local chamberlain, was a most critical one. The North Welsh castles were ill-equipped and under-manned, and, much to the disgust of the English townsmen, the local farmers made a promiscuous sale of their cattle in order to buy arms. The object of the revolt, in Owen's words, was 'to deliver the offspring of Wales out of the captivity of our English foes, who have for a long time past oppressed us and our ancestors'.

Edward Arthur Lewis, The Medieval Boroughs of Snowdonia, 1912

This author has written a book upon Wales' greatest hero. *The Sunday Times* ran a poll of 100 world leaders, artists and scientists, published on 28 November 1999, asking for the names of the most significant figures in the last 1,000 years. In seventh place was Owain Glyndŵr. (The list started with Gutenberg, Shakespeare, Caxton, da Vinci, Elizabeth I and Faraday in the first six places. Newton, Lincoln and Galileo followed Glyndŵr in the top 10.) Thus even today he is regarded above Churchill, Mandela, Darwin, Bill Gates and Einstein. Among the voters were President Clinton and Boris Yeltsin. Even Fidel Castro has paid tribute to Glyndŵr in pioneering guerilla warfare against incredible odds. The Welsh Assembly government ran a poll of the greatest Welshman of all time. Glyndŵr won it, but despicably, the results were altered to give Nye Bevan first place. The government did not want to arouse nationalist feeling, preferring mendacity to veracity, political correctness to historical accuracy.

However, for many Welshmen like myself, Millennium Day was 16 September 2000, Glyndŵr's Day, 600 years since a company of nobles gathered in his manor at Glyndyfrdwy to proclaim Owain Glyndŵr Prince of Wales. No other Welsh leader is referred to simply by his surname. Owain Glyndŵr is the Welsh leader *sans pareil*, the name a rallying cry for all things Welsh. The group of people who sometimes set alight English holiday homes in remote areas of Wales from the 1960s to the 1980s

called themselves Meibion Glyndŵr, 'The Sons of Glyndŵr'. Glyndŵr not only lit up Wales with a united rebellion against overwhelming odds, but also his mysterious disappearance from history left an unbeaten feeling in Welsh hearts. He was the last 'Mab Darogan', 'Son of Prophecy' for the Welsh bards, before Henry Tewdwr (Tudur, or Tudor) took the English Crown in 1485 from the last of the Angevins, Richard Plantagenet.

There are numerous Welsh legends about Glyndŵr's birth. They include the fact that his father's horses were standing in blood up to their fetlocks in their stables, and that the baby would cry at the sight of a weapon, and only stop when he could touch it. The legends are referred to in Shakespeare's *Henry IV, Part 1*:

> At my birth
> The front of heaven was full of fiery shapes;
> The goats ran from the mountains, and the herds
> Were strangely clamorous to the frighted fields.
> These signs have marked me extraordinary,
> And all the courses of my life do show,
> I am not in the roll of common men.

Glyndŵr could trace his heritage back to Rhodri Mawr, who was head of the royal houses of Gwynedd, Powys and Deheubarth. He was born around 1353, and some say he was educated at Oxford. It is known that he studied for seven years at the Inns of Court in Westminster. Later he became squire to the Earl of Arundel and Henry Bolingbroke, later Henry IV. Fluent in Latin, English, French and Welsh, he served King Richard II in his 1385 Scottish campaign as his shield-bearer. He also may have fought on the Continent for the English king, but records are incomplete. Aged around forty-five, after a life of service to the Crown, it appears that he returned to Wales to retire to his great family estates at Glyndyfrdwy (an area of the Dee Valley, between Llangollen and Corwen), and at Cynllaith on the other side of the Berwyn Hills. (Glyndyfrdwy means valley of the River Dee, and was shortened to Glyn Dŵr, valley of water). At Sycharth, in Cynllaith, was Glyndŵr's chief house, protected by moats, with nine guest rooms, resident minstrels and bards, fish ponds, a deer park, dovecot, vineyard, orchards, mill, wheat fields and peacocks. His income from his estates, around £200 a year, had enabled this faithful servant of the English Crown to settle down in 1398 with his wife Margaret, and nine or so children.

But just four years later, in 1402, the English had burnt down both the manor houses at Sycharth and Glyndyfrdwy of this fifty-year-old nobleman. It is difficult to describe the desolation Glyndŵr must have felt about the destruction of Sycharth in particular – all that is left is the moat, in one of the most beautiful parts of Wales; his family bard Iolo Goch (who died about 1398) has left us a full description of his manor. 1399 had been the turning point in Glyndŵr's existence. King Richard II had sailed to Ireland when he heard that the exiled Henry Bolingbroke, son of John of Gaunt, had landed in England. Richard returned via Milford Haven and made for Conwy, choosing Wales as his base for a battle. However, he was met by Henry Percy, Earl of Northumbria, who assured him that Bolingbroke meant no insurrection, and merely wanted to inherit his father's lands and title. Richard rode to Conwy Castle to listen to Bolingbroke's request,

but was ambushed, and was forced to 'abdicate' in favour of Bolingbroke, who became Henry IV. King Richard was spirited away to Pontefract Castle and disappeared from history. Richard's royal baggage train, still at Conwy, was seized by Henry's troops, but then 'liberated' by local Welshmen, who recognised treason when they saw it. Henry IV therefore was not overly enamoured of the Welsh, and it also appears that Glyndŵr might have been a squire to Richard II.

King Richard's abduction and murder ruined Glyndŵr's idyllic existence after just one year of retirement. His income from his estates was around 200 pounds a year, but in 1399 Reginald Grey, Lord of Ruthin, stole some of his Glyndyfwrdwy lands. Glyndŵr was legally trained, and decided to fight Grey with a lawsuit in the English parliament. A proud and loyal man of royal blood, extremely tall for his times, he wore his hair down to his shoulders against the prevailing fashion of cropped hair in London. His case was dismissed with the comment, 'What care we for barefoot Welsh dogs!' However, even Shakespeare referred to Glyndŵr as a brave and cultivated man: 'a worthy gentleman/Exceeding well read, and profited/In strange concealments, valiant as a lion/And wondrous affable, and as bountiful/As mines of India.' We can see that Owain Glyndŵr was not the type of man to be thrown out and treated like a dog by an ignorant French-speaking 'English' parliament. The new king, Henry IV, now raised taxes in Wales, and his aggressive and illiterate Marcher lords like Grey urged him to settle the growing unrest there. Henry was preoccupied with Scotland, however, and instructed his barons to offer free pardons to lawbreakers, hoping to defuse the situation. Lord Grey offered a pardon and a position as master forester to Gruffydd ap Dafydd, who had stolen some of his horses. The Welshman gave himself up, as requested, at Oswestry, but was lucky to escape alive.

He sent a letter to Grey about the betrayal: 'I was told that you are in purpose to let your men burn and slay in any land which succours me and in which I am taken. Without doubt as many men as you slay for my sake will I burn and slay for yours. And doubt not that I will have bread and ale of the best that is in your Lordship.' Lord Grey sent a copy to the Prince of Wales, the future Henry V, together with a copy of his reply to Gruffydd, threatening him: 'I hope we shall do thee a privy thing, a rope, a ladder, and a ryng [noose], high on gallows for to hang. And thus shall be your ending.' Grey could not be trusted, as we shall see – he desperately wanted more land in Wales. When Henry IV summoned each noble to bring a quota of men to fight in Scotland, Grey did not pass on the message to Owain Glyndŵr. His absence from the army, just after the parliamentary slighting, would hurt Glyndŵr's standing further in Henry's eyes. Henry's army was badly beaten. The king now allowed Grey to fight against his 'treacherous subject', Glyndŵr. Lord Grey decided that a frontal assault was unlikely to succeed, and therefore arranged a meeting to discuss Glyndŵr's grievances. Glyndŵr agreed, but knowing Grey's record, asked for only a small band of men to accompany the Marcher lord. Grey agreed, and arrived to open discussions at Sycharth. Luckily, Iolo Goch, the famous house-bard of Glyndŵr, was told of a much larger band of Lord Grey's horsemen, hidden in the woods outside the house, waiting for the signal to attack. Iolo Goch entertained the host, and singing in Welsh alerted Glyndŵr to the threat. Owain made an excuse and fled his beloved Sycharth to his other estate, further west at Glyndyfrdwy, just before Grey's troops arrived.

Here on 16 September 1400, Glyndŵr took the 'Red Dragon' of Cadwaladr and Wales as his standard. This is now celebrated as Glyndŵr Day in a few places across Wales, with events and the wearing of red and gold ribbons – his heraldic colours. Glyndŵr symbolically altered the flag of the House of Gwynedd from four passant to four rampant lions, signifying aggression. Aged almost fifty, he was proclaimed Prince of Wales by Welshmen flocking to Glyndyfrdwy. Students from Oxford and Cambridge, labourers, noblemen and friars came to support him, resenting English wrongs. On 18 September, Glyndŵr's small, poorly armed force rode into Lord Grey's base of Ruthin, looted the fair and fired the town. No one was killed, but fourteen rebels were captured and hanged. Glyndŵr's band soon learned about fast-moving warfare. By 24 September, they had fired and looted Denbigh, Flint, Hawarden, and Rhuddlan, and were moving on to Welshpool. However, the Sheriff of Shrewsbury had raised men from the Border and Midlands, and beat Glyndŵr's little force decisively on the banks of the Vyrnwy River. On 25 September, Henry IV arrived in Shrewsbury with his army, and dismembered Goronwy ap Tudur, a local nobleman, sending his limbs along the Welsh borders to Chester, Hereford, Ludlow and Bristol, as an example to those thinking of supporting Glyndŵr.

Glyndŵr was now in hiding when his aggrieved cousins, Goronwy ap Tudur's kinsmen on Anglesey, Gwilym and Rhys Tudur, started a second rebellion. Near Beaumaris, at Rhos Fawr, the Tudur army was defeated but managed to melt away before it was destroyed. Henry IV then destroyed Llanfaes Abbey, as its Franciscan monks had supported the Welsh rebels. Henry next marched to the coast at Mawddwy and then returned to Shrewsbury. Glyndŵr's small Welsh army watched him all the way, not strong enough to face the Plantagenet force. Henry offered a pardon to Glyndŵr's brother, Tudur, which he accepted. However, Owain Glyndŵr was excluded from terms, and all his lands given to the Earl of Somerset, John Beaufort. It looked as if Glyndŵr's days were numbered at the end of the year 1400. The Marcher lords were allowed to take any Welsh land that they could by force of arms or subterfuge. On top of this, in 1401, the English parliament passed laws that no Welsh person could hold official office, nor marry any English person. The Welsh could not live in England, and had to pay for the damage caused by the 1400 rebellions. This racial purity enforcement enraged the Welsh of all classes.

Glyndŵr was back now at Glyndwfrdwy, isolated and with few supporters, as Gwynedd had accepted the royal pardon. Other noble Welsh families sent envoys to King Henry, complaining about the brutality and taxes of the Marcher lords. The situation looked bleak until the Tudur brothers once more decided to change the rules of the game. They emerged from hiding in their Anglesey stronghold. While the garrison of Conwy Castle was at church outside the walls, on Good Friday 1401, two of their men posed as labourers, gained access to the castle and killed the two gatekeepers. Gwilym and Rhys Tudur, with a band of just forty men, fired the town and took control of Conwy Castle. Henry Percy, nicknamed Hotspur, controlled North Wales, and needed to get them out of the castle. After weeks of negotiations, the Welsh were starving. Both sides agreed to a sad compromise. The Tudurs were guaranteed free passage back to Anglesey upon the giving up of some of their force. It is said that Gwilym selected them in their sleep – they were later drawn, hanged, disembowelled and quartered while alive by Hotspur, their remains being scattered about Wales as a warning against further rebellion.

However, this piece of history may be later propaganda. Many Welshmen again started returning from England to Wales, and were backed by supporters of King Richard (by now probably dead) with donations to the Welsh cause. A man called William Clark had his tongue pulled out for daring to speak against Henry IV, then his hand cut off for writing against him, and then he was beheaded. By May 1401, another small band of men had joined Glyndŵr but he was routed by Hotspur near Cader Idris. He was forced to move south to the slopes of Pumlumon and raised his standard again, where Nant-y-Moch reservoir now exists. With around 400 men only, he rode down to loot and burn Llandrindod Wells, New Radnor, Abbey Cwmhir and Montgomery. Welshpool resisted and Glyndŵr returned with the remains of his little band (just 120 men, according to Gruffydd Hiraethog), to the safety of the Pumlumon (Plynlimon) foothills and caves.

Unknown to him, an army of 1500 Flemings from the settlements in South West Wales – the Englishry south of the Preseli Hills – was marching to exterminate this threat to their livelihoods. They surrounded him and charged downhill at Glyndŵr's trapped army at Hyddgen on the Pumlumon foothills. Glyndŵr's small band knew that they either died there and then, or would be slowly disembowelled if captured. The incentive was enough, and they halted and reversed the Flemings' charge. News spread all over Wales that the Welsh had won a real battle at last. On these marvellous unspoilt peat uplands, it is planned to place dozens of wind turbines, each higher than the Great Pyramid and almost as high as the Blackpool Tower, along with pylons, substations and roads. What other country would allow the defining battlefield in its history to be desecrated?

Hotspur, disillusioned by a lack of support from Henry in Wales, now took his North Wales peacekeeping army back to Northumberland. This was Glyndŵr's opportunity to traverse all Wales, hitting Marcher lord possessions and those of their sympathisers. Sir John Wynn in his *History of the Gwydir Family* describes these years:

> Beginning in Anno 1400, continued fifteen years which brought such a desolation, that green grass grew on the market place in Llanrwst … and the deer fled in the churchyard … In 1400 Owain Glyndŵr came to Glamorgan and won the castle of Cardiff and many more. He also demolished the castles of Penlline, Landough, Flemingston, Dunraven of the Butlers, Tal-y-Fan, Llanbleddian, Llanquian, Malefant and that of Penmark. And many of the people joined him of one accord, and they laid waste the fences and gave the lands in common to all. They took away from the powerful and rich, and distributed the plunder among the weak and poor. Many of the higher orders and chieftains were obliged to flee to England.

The king saw that Wales was turning to Glyndŵr, and that his Marcher lords could not control any parts of the country. In October 1401, Henry marched to Bangor in north-east Wales, then west to Caernarfon in Gwynedd, then south, looting the abbey at Ystrad Fflur (Strata Florida) near Aberystwyth. Henry carried on to Llandovery, butchering any Welshman he caught, while Glyndŵr's men picked off his outriders and made constant assaults on his baggage train. Outside the ruins of Llandovery Castle, Henry publicly hung, drew and quartered Llywelyn ap Gruffydd Fychan for

refusing to betray Glyndŵr's whereabouts. A marvellous stainless steel memorial has been erected to this loyal Welshman – it is time that Wales celebrated its heroes – how many people know that this event occurred?

While his supporting bands harried the King's army, Glyndŵr unsuccessfully attacked Caernarfon and Harlech castles. Facing a professional army with mere volunteers, and holding no castles of consequence, Glyndŵr made overtures to the Scots, Irish and French for desperately needed assistance against their mutual 'mortal enemies, the Saxons'. He even asked Hotspur to try to arrange a peace with Henry IV. The king was inclined to agree, but Lord Grey hated Glyndŵr, and Lord Somerset wanted more Welsh estates, so they agreed to use peace talks as a device to capture Glyndŵr. Fortunately, Hotspur, being an honourable northerner, refused the Norman request to be part of this treacherous charade. 1402 started well for Owain Glyndŵr. On 31 January he appeared before Ruthin Castle, challenging Grey to fight. Grey was captured, trussed up and carried away to be imprisoned in Dolbadarn Castle. Perhaps Glyndŵr should have killed the man who was the cause of all his troubles, but he quickly ransomed him for £10,000. Some money was raised immediately, and Grey's son was given in surety for the rest. Raising this ransom effectively ruined Grey, who signed an agreement never again to attack the man he had made an outlaw. If positions had been reversed, the Norman Lord Grey would have tortured Glyndŵr before hanging, drawing and quartering him. The Welsh did not believe in such bestiality. We can also see that when Glyndŵr captured Lord Mortimer in battle, Mortimer eventually married Glyndŵr's daughter in captivity, and died fighting for him against the English.

Soon after, Glyndŵr survived an assassination attempt by his cousin, Hywel Sele of Nannau, probably on the orders of King Henry. The armour under his jerkin deflected an arrow, and Hywel Sele was killed and placed in a hollow oak tree. Throughout the rest of the year, Glyndŵr ravaged North Wales (leaving alone Hotspur's estates in Denbigh), and then moved against Powys, controlled by the great Marcher earls, the Mortimers. On St Alban's Day, 22 June 1402 at the Battle of Pilleth (near Knighton), Edmund Mortimer's English knights and Herefordshire levies charged uphill at Glyndŵr's army. Mortimer's Welsh archers poured volley after volley of deadly arrows into the English charge, apparently in an unrehearsed expression of support for Glyndŵr. (Much of western Herefordshire and Worcestershire was Welsh-speaking at this time). Up to 2,000 of Mortimer's troops were killed on the slopes. Rhys Gethin, Rhys the Fierce, had drawn up his men hidden behind the top of the hill, so Mortimer had underestimated the Welsh force of 4,000, as well as having been unable to control his Welsh archers. Mortimer was captured in the battle, but Henry IV accused him of treason and would not ransom him. Hotspur, Mortimer's brother-in-law, was incensed that a villain like Lord Grey could be ransomed, whereas Henry had set his mind against the innocent Mortimer.

In Shakespeare's *Henry IV, Part 1*, a horrified courtier recounts

> the noble Mortimer,
> Leading the men of Hereford to fight
> Against the irregular and wild Glendower,
> Was by the rude hands of that Welshman taken;
> A thousand of his people butchered,

Upon whose dead corpse there was such misuse,
Such beastly, shameless transformation
By those Welsh women done, as may not be,
Without much shame, retold or spoken of.

Forget this propaganda against Welsh women – after this event Henry IV passed legislation banning English men marrying Welsh women. Who would have wanted to marry such harridans if the atrocity stories were true? English corpses would have been stripped of their clothing, weapons and armour, and left for foxes, badgers, ravens, kites, buzzards and crows to clear them. When faced with corpses, animals go first for the genitals and eyes. The Welsh army would not have wanted to stay so close to the English borders while burying the bodies of their enemies.

Lloyd tells us that

Glyndŵr at last had freedom to do whatever he wanted – he attacked and burnt Abergafenni and Cardiff, and the ruins of his sacking of the Bishop's Palace at Llandaf in Cardiff can still be seen. He besieged Caernarfon, Cricieth and Harlech castles. This forced Henry IV to totally ignore his Scottish problems and assemble three armies, totalling a massive one hundred thousand men, on the Welsh borders. The bards had been singing of Glyndŵr's supernatural powers, and during Henry's advance into Wales, appalling weather conditions forced all three armies to return to England by the end of September. It was thought at the time that Glyndŵr could command the elements, and well as possessing a magic Raven's Stone that made him invisible – even the English troops ascribed magical properties to this guerilla partisan.

Again, this is referred to in *Henry IV, Part 1*: 'Three times hath Henry Bolingbroke made head/Against my power. Thrice from the banks of the Wye/And sandy-bottomed Severn have I sent/Him bootless home, and weather-beaten back.'

A 1402 entry in *Annales Henrici Quarti*, the English recording of the times, reads that Glyndŵr 'almost destroyed the King and his armies, by magic as it was thought, for from the time they entered Wales to the time they left, never did a gentle air breathe on them, but throughout whole days and nights, rain mixed with snow and hail afflicted them with cold beyond endurance'.

In 1402, the imprisoned Edmund Mortimer married Owain Glyndŵr's daughter, Catrin. Mortimer's nephew, the young Earl of March, had a far better claim to the English throne than Henry IV, and no doubt Glyndŵr was hoping that Henry Bolingbroke would be killed and Wales made safe with an English king as an ally. His big problem was that Hotspur captured the Scots leader, the Earl of Douglas, at the Battle of Homildon, securing England's northern border. With his Scottish problems solved, this allowed Henry IV to plan to finally subdue Wales. Glyndŵr, on his part, wanted complete control of Wales before Henry struck. Strata Florida Abbey had become the base of Henry IV and his son, later to become Henry V, from 1401 during the early years of the war. They expelled the monks who had sympathised with Glyndŵr and the abbey was plundered by the English army as a punishment. From 1402 the abbey was held in the king's name under the Earl of Worcester and served

as a military base for the further campaigns of 1407 and 1415 when it would have been occupied by several hundred men-at-arms and even more archers, footsoldiers and foreign mercenaries enlisted in the royal armies.

In 1403, Owain Glyndŵr kept up his blockade of the northern Welsh castles, while attacking Brecon and Dinefwr and trying to displace the Flemings from Pembrokeshire. Glyndŵr's able lieutenants were Rhys Gethin (the Fierce), Rhys Ddu (the Black), and Rhys ap Llewellyn. The latter had real reason to hate the invading English – it was *his* father, Llewelyn ap Gruffydd Fychan, who had been slowly killed in front of Henry IV at Llandovery in the dark days of 1401, for refusing to lead the king to Glyndŵr. Late in 1403, Lord Thomas Carew beat a Welsh army at Laugharne. Glyndŵr also sadly learned of the deliberate demolition of his manors and estates at Sycharth and Glyndfrdwy by the Prince of Wales, Henry of Monmouth, who later won undying fame at Agincourt. Hotspur, meanwhile, wanted to ransom the Earl of Douglas, but Henry demanded Douglas for himself as a prisoner in order to take the ransom. Coupling this insult with the argument over Edmund Mortimer's ransom, Hotspur allied with Edmund Mortimer, Douglas and Glyndŵr. However, at the bloody Battle of Shrewsbury, Hotspur was killed by the royal army, despite the havoc wrought by his Chester archers. This tragedy happened before he could link up with Glyndŵr. Henry then went to Northumberland to suppress a small uprising by Hotspur's father, Earl Percy of Northumberland. Glyndŵr ravaged Herefordshire in Henry's absence.

The enraged King Henry now passed legislation that any Welshman found in any border town would be executed. He marched through South Wales to Carmarthen, but as with the previous invasion, Glyndŵr would not fight a fixed battle against superior odds. Henry returned to England and within a week Glyndŵr had taken Cardiff, Caerphilly, Newport, Usk and Caerleon. Some French troops were assisting Glyndŵr by now, and his army had grown to at least 10,000 men-at-arms. By 1404, Owain Glyndŵr's main focus was the taking of the seemingly impregnable 'Iron Ring' of castles in North Wales. He won over the starving Harlech garrison by pardons or bribes when it had only sixteen men left. The great castles of Cricieth and Aberystwyth then fell, and at Machynlleth, in the Parliament House, Owain Glyndŵr held his first parliament. Envoys came from France and Spain, and an ambassador was sent to France. Dafydd ap Llewelyn ap Hywel, Davy Gam ('squint-eyed') tried to assassinate him here for Henry IV, and was surprisingly imprisoned rather than cut to pieces. (This again demonstrates the humane Welsh attitude of the times towards prisoners. Davy Gam later was said to be knighted by Henry V, as he lay dying at Agincourt.) A Welsh parliament was held in Dolgellau in 1404.

Glyndŵr now took a small army to again pillage Herefordshire, but the Earl of Warwick captured his standard at Campstone Hill near Grosmont Castle. Glyndŵr just escaped capture. Fortunately, the English did not pursue the defeated troops, which regrouped and then beat Warwick at Craig-y-Dorth, 3 miles from Monmouth, and chased them back into the fortified town. Glyndŵr was in the south-east of Wales awaiting a French invasion fleet of sixty vessels under the Count of March, who for some reason never landed. Glyndŵr now returned to his court at Harlech. In Anglesey, Owain's forces were beaten at the Battle of Rhosmeirch, and also lost Beaumaris castle. In 1405, Rhys Gethin burned Grosmont Castle in Monmouthshire, but was then decisively beaten by Prince Henry, using Welsh archers. Glyndŵr sent his almost

identical brother, Tudur, and his son Gruffydd to restore the situation by attacking Usk Castle, where Prince Henry had established himself. In the Battle of Pwll Melin, 2 miles away, Tudur and Abbot John ap Hywel of Llantarnam were killed. Gruffydd ab Owain Glyndŵr was imprisoned in the Tower of London in disgusting conditions until he soon died. 300 prisoners were beheaded in front of the citizens of Usk, as an example *pour les autres*. At some time, it is believed that Henry IV took 2,000 Welsh children as slaves to England, never to return. It was an attempt to break the will of the people.

After the Welsh defeats at Grosmont and Usk, Henry now offered a pardon to those who renounced the rebellion, and thereby regained full control of South East Wales. He then gathered an army of 40,000 at Hereford to advance into Mid and North Wales. Another English force took Beaumaris and control of Anglesey in the far north. At this time, Archbishop Scrope of York led a rebellion in the north of England. Henry diverted his forces to Shipton Moor where he beat back the northern rebels. This gave Glyndŵr some breathing space, and he gathered 10,000 men in Pembrokeshire to wait for an invasion fleet of 140 French ships. Around 5,000 Frenchmen arrived at Milford, joined with Glyndŵr and sacked the English/Fleming town of Haverfordwest, but could not take the castle. They next looted Carmarthen and then took over Glamorgan, leaving Glyndŵr back in control of most of Wales again. In August 1405, he moved on to attack England, its first invasion since 1066. Again, this is something omitted from British history books. Henry raced to Worcester to face the threat of Glyndŵr, who was camped on Woodbury Hill. There were some skirmishes, but Glyndŵr had no lines of supply, so he retreated back to Wales, following a scorched earth policy. Henry's starving army was forced to call off the pursuit, freezing as the bitter winter took hold. Again, the terrible weather was blamed upon Glyndŵr's supernatural powers. This had been Henry's fifth invasion of Wales, and still Glyndŵr seemed untouchable.

1406 began with a treaty between the dead Hotspur's remaining Percy family of Northumberland, Earl Mortimer and Glyndŵr. This 'Tripartite Indenture' divided England and Wales between the three houses, with Glyndŵr possessing Wales and gaining a 'buffer zone' on its borders. At his second Machynlleth parliament, Glyndŵr wrote to Charles VI of France, asking for recognition, support and a 'Holy Crusade' against Henry for pillaging abbeys and killing clergymen. In turn, Glyndŵr promised the recognition by St David's of the French-based Pope Benedict XIII. (Welsh parliaments were also held in Pennal, Harlech and Dolgellau.) Glyndŵr also asked papal permission to place two universities, one each in North and South Wales, to build a future for his country. This letter was signed 'Owain by the Grace of God, Prince of Wales', and is in the French National Archives. However, Henry IV was wasting away through syphilis or leprosy, which enabled his son Henry of Monmouth, Prince of Wales to take control of the Welsh campaigns. He beat a Welsh army, killing yet another of Glyndŵr's sons in March, and retook South Wales, fining the landowners heavily to support his thrust into North Wales. North Wales, being fought over for five years, had neither financial nor manpower reserves to support Glyndŵr, but he still held around two thirds of the land of Wales, and castles at Aberystwyth and Harlech.

In 1407, Prince Henry besieged Aberystwyth Castle with seven cannon. One, 'The King's Gun', weighed 4.5 tons. Rhys Ddu held out and Henry returned to England. Glyndŵr reinforced the castle, while England unfortunately signed a peace treaty with

France. In this year, Owain's great ally, Louis of Orleans, was murdered in mysterious circumstances in Paris. It may have been the work of English spies. 1408 saw another blow for Glyndŵr. His ally, the old Earl of Northumberland, Hotspur's father, was killed at the Battle of Braham Moor by Prince Henry's forces. The prince then re-entered Wales, finally bombarded Aberystwyth into submission, and by 1409 had also taken Harlech, Glyndŵr's last bastion, capturing his wife and family. Edmund Mortimer, the former enemy who became his son-in-law in captivity, died (probably of starvation) in Harlech, fighting for Glyndŵr. Owain had just managed to escape from Harlech as the besiegers moved in. It must have been a difficult decision to leave his family there, while he tried to round up support rather than be cornered. A sad footnote has been the discovery noted in John Lloyd's 1931 book *Owen Glendower* – he 'left behind him in the castle one little personal relic which has recently been unearthed in the course of excavations, viz. a gilt bronze boss from a set of horse harness, bearing the four lions rampant which he had assumed as Prince of Wales'.

The last gasp of Glyndŵr's revolt occurred near Welshpool Castle when a raiding party under Phillip Scudamore, Rhys Tudur and Rhys Ddu was beaten and the leaders captured. After the usual revolting, slow, barbarous executions, Scudamore's head was placed on a spike at Shrewsbury, Rhys ap Tudur's at London, and Rhys Ddu's at Chester. In 1413, the Plantagenet Prince of Wales succeeded as Henry V, and in 1415 offered a pardon to Glyndŵr and any of his men. In 1416, he tried again, through Glyndŵr's remaining son Maredudd, who himself accepted a pardon in 1421. It thus appears that Glyndŵr was still alive a few years after his last recorded sighting. Gruffydd Young, in the Council of Constance in France, was still working for Owain Glyndŵr in 1415, stating that Wales was a nation that should have a vote in ending the papal schism. Glyndŵr would have been around sixty-five years old at this time, having spent his last fifteen years in constant warfare against the English Crown.

Some say Owain died in a cave in Pumlumon (Plynlimon), where it all started, mourning the death of all but one of his six sons. Other believed he ended his days with his daughter Alice and her husband John Scudamore in Golden Valley in Herefordshire. The present owner of the Great Hall of Kentchurch, Jan Scudamore, has been besieged with people asking permission to search her estate for the remains of Glyndŵr. Many identify him with Sion Cent of Kentchurch, a poet, magician and mystic whose grave can still be seen, half-in and half-out of Grosmont church. Other stories have him dying at Monnington Court, near Kentchurch, at Monnington-on-Wye in 1415, in the deep oak-woods of Glamorgan and on a mountain ridge in Snowdonia. The bards raided Arthurian legend to put him sleeping with his men in a cave to be awakened again in Wales' hour of greatest need. One bard stated that Glyndŵr 'went into hiding on St Matthew's Day in Harvest (1415) and thereafter his hiding place was unknown. Very many say that he died: the seers maintain that he did not.'

Glyndŵr's greatest problem had been that he was up against the greatest soldier of his age, Henry of Monmouth, who within a few years was to win at Agincourt with Welsh archers, and be recognised as the future King of France. Henry cut his teeth against a massively under-resourced Glyndŵr, who had no incomes to pay his troops and relied on volunteers against a vastly superior professional force. However, Owain could still point to his setting up his own law-courts and chancery, trying to found the first Welsh universities, summoning parliaments, sending envoys to foreign courts

and nominating bishops. Repressive laws were enacted after the rebellion to stop any future threat from Wales to the English Crown. No one with Welsh parents could buy land near the Marcher towns, own weapons, become citizens of any towns or hold any offices. 'In lawsuits involving a Welshman and an Englishman, the Englishman decided the verdict and the sentence. Gatherings of Welsh people were forbidden, and an Englishman marrying a Welsh woman became legally Welsh, forfeiting all his rights of citizenship. No Welshman could be a juror.' These and many more impositions, on top of the already harsh regime of the Statute of Rhuddlan of 1282, ensured Henry Tudor great popular support in his move to gain the Crown of England in 1485. The penal laws of 1401–2 had given the Welsh inferior legal status, which along with the grievances of the fourteenth century gave the people a lasting sense of a separate and different identity from the English.

Massive taxes were raised to pay for the invasions of the two Henrys, but Welshmen were not allowed to help each other to harvest their fields, causing major food shortages. If merchants of any towns were robbed in Wales and the property was not returned within a week, they could retaliate upon *any* Welshman that they could seize. The best summary of Glyndŵr is by the noted English historian, G. M. Trevelyan: 'This wonderful man, an attractive and unique figure in a period of debased and selfish politics.' The French historian, Henri Martin, calls Glyndŵr a man of courage and genius. Most English encyclopaedias do not mention him – one of the truly great, principled and forward-thinking men in British history. Welsh schools have not taught the history of Glyndŵr in any depth whatsoever for over a century, but his name still inspires Welshmen all over the world.

J. E. Lloyd puts Glyndŵr into his proper perspective in the Welsh national psyche:

> Throughout Wales, his name is the symbol for the vigorous resistance of the Welsh spirit to tyranny and alien rule and the assertion of a national character which finds its fitting expression in the Welsh language … For the Welshmen of all subsequent ages, Glyndŵr has been a national hero, the first, indeed, in the country's history to command the willing support alike of north and south, east and west, Gwynedd and Powys, Deheubarth and Morgannwg. He may with propriety be called the father of modern Welsh nationalism.

Although Glyndŵr had briefly won political, cultural and ecclesiastical independence before final defeat and the harshness of the laws of vengeful English king, the wars had been a personal disaster for him. His closest brother Tudur had died at the Battle of Pwll Melyn in 1405. His son Gruffydd was captured there, and spent the remainder of his years imprisoned in the Tower of London and Nottingham Castle. Some sources say that he died of the plague in the Tower of London in 1410 – he just vanished from history, like so many other captured descendants of Welsh princes. Glyndŵr's wife, two daughters and three granddaughters were taken into imprisonment after the fall of Harlech Castle. His son-in-law, Edmund Mortimer, with a good claim to the English Crown, died at Harlech. Mortimer's wife, Owain's daughter Catrin, died in prison with two of her daughters, and all were buried in St Swithin's church in London around 1413. Her son Lionel, Owain's grandson and a claimant for both the Welsh and English Crowns, died; where or when is unrecorded. Owain Glyndŵr's closest lieutenants and

comrades-in-arms, Rhys Ddu, Rhys ap Llywelyn, Rhys Gethin and Phillip Scudamore had been tortured to death. It appears that only one relative survived the carnage, his son Maredudd, who had hidden with him when the rebellion was crushed. The wanted warrior and Lollard Sir John Oldcastle was in contact with Maredudd at this time, looking for support, before he was captured. When Maredudd ab Owain eventually accepted the king's pardon upon 8 April 1421, it had been twenty years and six months since Owain Glyndŵr had proclaimed himself Prince of Wales. These two decades of fighting against overwhelming odds, of reclaiming Cymru from the Normans, are neglected in all British history books. This British hero has been excised from the history of Britain even more effectively than William Wallace was.

His disappearance from history, rather than his capture and execution, gave the poets and gives the nation a hope for the future – Glyndŵr is the Welsh hero *par excellence*. His is a story of culture, humanity, nobility, treachery, courage, bitter defeat, glorious resurgence and a mysterious finale. Can anyone think of a better story for a Hollywood epic? It was not until 1948 that a Parliamentary act declaring Glyndŵr to be a proscribed traitor was repealed. Perhaps a blockbuster film could start with this scene. Hundred of years passed before the significance of the war was fully realised. From the late eighteenth century onwards, Glyndŵr has been recognised as the greatest hero in the history of the Welsh people, with his revolt being seen as central to the growth of Welsh nationality. The successful first Battle at Hyddgen was the turning-point in the history of Wales as a nation, but looks as if it will be covered with concrete and turbines forever. It was also not, as it has been called, 'the last and longest Welsh war of independence'.

The last war came in 1485, when all of Wales rose behind Henry Tudor. Without Welsh support, the Tudor dynasty would not have occurred. Today's historians persist in calling Glyndŵr's war a revolt or rebellion – it was anything but that. A revolt or revolution is an attempt to overthrow the power of the state. The English state – which took over its colony of Wales by force and governed with violence – was never recognised by the Welsh rulers or people as owning Wales. With Glyndŵr died the personification, if not the spirit, of Welsh national identity: 'Very many say he died; the prophets insist he did not.' There had been six separate massive invasion armies into Wales. In 1431, the penal code for Wales was reaffirmed by parliament, and in 1433 John Scudamore was dismissed from all offices for having a Welsh wife, in this case one of Glyndŵr's daughters. 'Cofiwch Glyndŵr' means 'Remember Glyndŵr' and should be slogan for the Welsh Nationalist movement – he still lives. Glyndŵr is the undefeated symbol of Wales, with his red dragon of Cadwaladr – he is the equivalent of Jeanne d'Arc and William Wallace and El Cid for Welsh people everywhere.

Unsettled Wales

By 1300, 300,000 people lived in Wales. In the early years of the century, the system of villeinage had almost disappeared, and many English colonists took up land grants after Edward I's wars ended in Wales. However, there was famine across the Continent from 1315 to 1318 because of poor weather. It was followed by plague outbreaks in 1347–50, 1361 and 1369, and the population of Wales fell. It would not reach 300,000

again until around 1550. With partial recovery after the Black Death, there was a movement towards landed estates and extremely wealthy lords. Thus famine, plague and depopulation led to unrest across Wales. Compulsory and constant calls were regularly made on Welshmen for military service, in France or Scotland. Their families at home suffered in consequence. Gruffydd ap Dafydd ab Elise of Edeirnion was one of the Meirionnydd men who raided Ruthin with Sir Gruffydd Llwyd in 1322, and the Lord of Mawddwy was accused of an armed raid on the court of Meirionydd, where its sheriff was killed in 1339. As early as 1330 there had been a formal complaint to Edward III from the 'men of the commonalty of the land of North Wales' complaining of oppressions by of the Justiciar of Wales. In 1331, Gruffydd de la Pole, Lord of Mawddwy, was removed from the shrievalty of Merioneth when it was ruled that any office of sheriff in Wales should be reserved for Englishmen. The English burgesses at Rhuddlan Castle and town were attacked in 1344 by Welshmen coming from St Asaff's Fair. Rhys and Dafydd ap Madog of Hendwr stood surety for their nephew, Hywel ap Goronwy, one of the ringleaders, after the murder of Henry de Shaldeford in 1345. Henry de Shaldeford was the royal minister in North Wales, the representative of the Earl of Arundel, Justiciar of North Wales. Hywel was a cleric who succeeded Sir Gruffydd Llwyd's son as Archdeacon of Anglesey; he and his brother Tudur seem to have been the ringleaders in the Shaldeford killing.

From an article in *Welsh Outlook*, August 1933 we read,

> And in truth there was great reason for this bitterness on the part of the Welsh, for the measures taken against them were peculiarly harsh, degrading, and offensive to a sensitive people unwilling to accept the obligations of a feudal system. They were for instance at one time debarred from buying land not only in the three Royal Boroughs of North Wales, but in English towns on the border, and also from holding judicial office of any kind in their own country. From time to time the repercussions of this bitterness were felt in Caernarvon. Henry de Shaldeford, a deputy appointed by the Black Prince, was robbed and slain on his way to Caernarvon by a band of armed Welshmen, who all managed to escape unpunished. The English inhabitants of the towns were at this time acutely aware of the perils of their position in a country seething with discontent and lawlessness. After de Shaldeford's murder, the [English] burgesses of Caernarvon addressed a desperate petition to the Prince.

De Shalderford had been hated for his rapacity and brutality, but the English burgesses recalled

> great damage done by the Welsh, to the utter destruction of his English ministers and burgesses in North Wales. They recalled the felonious attack on John de Huntyngdon, sometime sheriff of Merioneth, and the base robbery of his records and other personal chattels, and detailed the similar treatment of other bailiffs and English burgesses there. 'The Welsh,' they say, 'are so proud and malicious against your English people that they dare not move for fear of death; and now, good Lord, show their malice against Henry de Shaldeford, your attorney in those parts, as he was walking towards Carnarvon on Monday, the feast of St Valentine last past, to fulfil the duties of his office, at the particular instigation of Tudor ap Gronow, and his brother Howel ap Gronow.' The Carnarvon burgesses

go on to say: 'For the salvation of your castles, towns, and English burgesses, be pleased, sovereign Lord, to order immediate remedy, or else we shall be forced to quit the country.' The said Tudor and Howel, they further suggest, are so powerful that no Welshman dare indict them of the death of the said Henry, nor of any trespasses which they daily commit to the disturbance of the peace. Accordingly, the burgesses naively ask the Black Prince to supply an inquest of Englishmen to find the truth of the matter. Contemporary petitions from the burgesses of Conway and Rhuddlan relate the circumstances of the same event with more or less detail.

Edward Arthur Lewis, The Medieval Boroughs of Snowdonia, 1912

Following Glyndŵr's war, there was a massive impetus for new fortifications and repairs of military buildings. The war meant utter devastation for two decades across Wales, following hard upon the massive depopulation of the plague- and famine-ridden fourteenth century. Chroniclers reported that Glyndŵr 'brought all things to waste' and the English king 'proclaimed havoc in Wales'. After the extensive destruction, at least a generation passed before the economy began recovering. The Welsh gentry, many of whom had supported Glyndŵr, began to co-operate with the English authorities.

A pattern of trade based on cattle and sheep grew. Drovers took cattle across Wales to the great fairs of the English cities, and cattle sales became the chief way of introducing money into rural areas. Fleeces were spun into yarn, and, with the development of fulling mills, it was woven into flannel (one of the very few Welsh words in the English tongue). Flannel was sold at the markets of the English border towns, Shrewsbury in particular, and began to be exported to the Continent.

The Wars of the Roses and Wales

'The Wars of the Roses were to a large extent a quarrel between the Welsh Marcher lords, who were also great English nobles, closely related to the English throne,' wrote G. M. Trevelyan. Between the 1450s and the 1480s, the houses of Lancaster and York fought for the English Crown. The Lancastrians were descended from the third son of Edward III. The Yorkists were descended, via the Mortimers, from Edward III's second and fourth sons. Very briefly, in 1460 Henry VI, grandson of Henry IV, was replaced on the throne by the Yorkist Edward IV. In 1485, Edward's brother, the usurper Richard III, was replaced by the Lancastrian Henry Tudor, Henry VII. Henry married the Yorkist Edward IV's daughter, and their son, Henry VIII, was representative of both houses. The wars had a major impact on Wales. Initially it was a Lancastrian stronghold, while the March, particularly the Mortimer lordships, was important for the Yorkists. Henry Tudor was a descendant of Edward III on his mother's side, and of Welsh and French descent on his father's side. He represented himself as Welsh, connected to princely houses of Wales, to gain the support of the Welsh gentry.

Owain Tudor's cousins fought for Glyndŵr in his war against the usurper Henry IV. As a Welshman, he was subject to the penal laws, which forbade the Welsh from carrying arms and from living in incorporated boroughs. In the late 1420s, Owain was a member of the bodyguard of the dowager queen Catherine of Valois (daughter of Charles VI, King of France), whose husband, Henry V, had died in 1422. Owain

and Catherine married secretly in 1429. Their two sons, Edmund, Earl of Richmond and Jasper, Earl of Pembroke, were the half-brothers of Henry VI, and fought for the House of Lancaster in its struggles with the Yorkists. (A third son became a monk.) The House of York was descended through the Mortimer family to Llywelyn the Great. Edmund Tudor married Margaret Beaufort, the great-granddaughter of John of Gaunt, the progenitor of the house of Lancaster. Jasper became the virtual viceroy of Wales, controlling most of it through various offices. Edmund was captured by the Yorkist William Herbert in 1456, and died of plague that year in Carmarthen Castle. In 1457, his fourteen-year-old widow gave birth to a son, Henry Tudor, at his uncle Jasper's castle of Pembroke.

The Devereaux family of Hereford and the Herberts of Raglan fought for the Yorkists. Richard, Duke of Gloucester (later to be Richard III) and the Earl of Warwick lost at Ludford Bridge near Ludlow in 1459. Jasper Tudor's Lancastrians were defeated at Mortimer's Cross in 1461 by Edward, Earl of March, and contingents belonging to Devereaux, Herbert and the Vaughans of Brecon. This was mainly a Welsh battle and resulted in Edward becoming Edward IV. Henry Tudor spent his childhood at Raglan Castle, under the care of the leading Yorkist, Sir William Herbert, as the Lancastrian cause suffered. Following the murder of Henry VI and his son, Edward, in 1471, Henry Tudor became a major figure of importance for he was, as Edward IV put it, 'the only imp now left of Henry VI's brood'. As the fourteen-year-old Henry was the last Lancastrian with a claim to the throne, his uncle Jasper took him to safety in exile in mainland Europe. Fourteen years later, Henry and Jasper sailed from the mouth of the Seine to the Milford Haven Waterway, a voyage which led to Henry's victory over the House of York at Bosworth and his coronation as Henry VII.

Jasper Tudor

Jasper fought in Henry VI's army at the Battle of St Albans in May 1455, where the royal army was beaten and Henry himself captured. Jasper survived the battle and attempted to reconcile the warring factions. He was briefly successful as the rebel lords renewed their oaths of allegiance to King Henry, but fighting soon broke out again. In 1456 his brother Edmund Tudor was captured by the Yorkists and died of a plague contracted in prison, leaving his young widow with an unborn child, Henry Tudor. War resumed in 1459 when the Duke of York returned from exile in Ireland. Jasper was ordered to seize Denbigh Castle to block York's lines of communication between England and Ireland, which he did successfully. However, the Yorkists defeated Henry's forces at Northampton in 1460, leaving Jasper isolated at Denbigh. He refused to surrender, but the Yorkist army stormed Denbigh. Jasper managed to escape and join up with Lancastrians in Wales. He then left for France to seek aid and, returning, probably landed at Milford Haven and reached Herefordshire in time to take part in the Battle of Mortimer's Cross in 1461.

The Duke of York had been ambushed and killed by Lancastrian forces at Wakefield and his army wiped out. The Lancastrians then marched south and defeated another Yorkist army at St Albans while Jasper Tudor helped to gather an army in Wales. In early 1461 the Welsh force, which included Jasper's father, Owen Tudor, marched to

the borders of Herefordshire to face an army led by the Duke of York's son Edward. The Battle of Mortimer's Cross was noted for the appearance of three suns in the sky. Jasper's army was defeated, and the Yorkists adopted the image of the sun as a symbol. Jasper's father Owen, the husband of Catherine of Valois, was captured and executed in the marketplace at Hereford. His last words were, 'This head shall lie on the block that once lay in Queen Catherine's lap.'

Soon after Mortimer's Cross the main Lancastrian army was exterminated in a bloody battle at Towton in Yorkshire. Edward marched to London and was crowned King Edward IV, while Jasper fled to Ireland and spent the next few years living as a hunted fugitive. Jasper had escaped from Mortimer's Cross in disguise, and shortly afterwards was in Tenby, writing letters in an attempt to rally resistance in North Wales. Later in the year he was a fugitive in Snowdonia. He escaped after a further defeat near Caernarvon, was hunted for two years in Ireland and was later in Scotland. Jasper reappeared in 1468, landing in North Wales to try and relieve Harlech Castle. This defence of the garrison was the inspiration for the song 'Men of Harlech'. Jasper was attainted. William Herbert was created Earl of Pembroke in Jasper's place, his patent stating that he had that honour for expelling 'Jasper the rebel'. The custody of Jasper's nephew Henry was taken over by William Herbert. On three occasions before his last exile in Brittany, Jasper returned to Wales and attempted to revive opposition to Edward IV. On the first two occasions he escaped by boat from near Harlech, where he appears to have had friends among the local gentry. Finally, in the invasion of 1470, Jasper again landed in Wales.

The Earl of Warwick, the 'Kingmaker', now rebelled against Edward IV, allowing Jasper Tudor to return to Wales during the brief restoration of Henry VI from 1470–1. Edward IV's soldiers deserted him and he was forced to flee abroad. Henry VI was brought out of imprisonment and restored as king. Jasper was restored to the Earldom of Pembroke, but Henry VI was mentally unstable. Henry VI's restoration was short-lived as in 1471 Edward returned with a new army. The war was finally decided by two dreadful battles at Barnet and Tewkesbury, which resulted in the virtual destruction of the Lancastrian cause. Jasper lost his earldom a second time, and on it being surrendered by the second William Herbert to Edward IV, that king gave it to his son Prince Edward, who enjoyed it during life. Henry VI was murdered soon after his son Edward, Prince of Wales, had died at Tewkesbury. Jasper had gathered a Welsh army but had failed to reach Tewkesbury in time for the second great defeat of the Lancastrians. He fled to Chepstow, and somehow extricated his young nephew Henry from his semi-imprisonment under William Herbert. Jasper and his mother Catherine had cared for Henry before he was taken by the Yorkists. With a mixture of fortune and bravery, Jasper managed to take Henry, the sole surviving Lancastrian claimant to the throne, with him to Brittany.

Richard, Duke of Gloucester, usurped the Crown upon his brother Edward IV's death in 1483, as Richard III. The new king shut up his brother's sons in the Tower of London, declared them illegitimate and had himself crowned. They were never seen again, and even now Yorkist supporters refuse to believe that he had 'the Princes in the Tower' killed. Richard also had the leading members of their mother's family, the Woodvilles, executed without trial for treason. Meanwhile, Jasper was effectively preparing the groundwork for Henry's successful invasion of 1485, and was restored to

all his former titles, including Knight of the Garter. He was created Duke of Bedford and married the sister of Queen Elizabeth Woodville and widow of the Duke of Buckingham. In 1486, he helped suppress the Stafford revolt near York. In 1487, he fought at the Battle of Stoke, and in 1488 took possession of Cardiff Castle. In 1492, he fought in France and was made Earl Marshal.

William Herbert, 1423–69

William was Jasper Tudor's main rival in the War of the Roses, later being made Earl of Pembroke in Jasper's place, and being called 'the first statesman of a new era'. He was the son of William ap Thomas ap Gwilym ap Jankyn, a minor member of the Welsh gentry, who had married Elizabeth Bloet, widow of Sir James Berkeley, around 1406. She was the only daughter and heiress of Sir John Bloet, whose family had held Raglan since 1174. Her son James owned Raglan Castle, which William ap Thomas held as a tenant. Elizabeth died in 1420, and in 1425 James agreed that William ap Thomas, who had sided with the English against Owain Glyndŵr, could hold the castle for the rest of his life. By this time, William ap Thomas had married Gwladys ferch Syr Dafydd Gam. She was called by the bard Lewis Glyn Cothi, 'y seren of Efenni', 'the star of Abergafenni'. 'Davy' Gam had not only tried to kill Glyndŵr, but had fought at Agincourt, possibly being knighted by the king as he lay dying. The first husband of Gwladys, Sir Roger Vaughan, had also died in 1415 at Agincourt.

By 1421, William was steward of the lordship of Abergafenni. By his marriages to Elizabeth and then Gwladys, William ap Thomas had acquired lands and wealth, and was knighted by Henry VI when the king was just five years old. It was unusual for a Welshman to be knighted, but this border family was seen very much as a 'buffer' against future Welsh insurgencies. William ap Thomas was now known as 'Y Marchog Glas o Went', 'The Blue Knight of Gwent', and in 1432 bought Raglan Castle outright for 1,000 marks from his stepson James. He rebuilt the castle on a grand scale to match what he had seen while fighting in France, in the same contingent as Davy Gam and Sir Roger Vaughan. Through his family connections to the Duke of York, William became the chief steward of his estates in Wales in 1442–3. As sheriff of the counties of Cardigan, Carmarthen and Glamorgan, William was now a powerful man. He died in London in 1445, being buried in the Benedictine priory church of Abergafenni, and Gwladys died in 1454. The legend goes that she was so loved that 3,000 knights, nobles and peasants followed her body from Coldbrook House to the Herbert chapel at St Mary's priory church. The mighty Raglan Castle passed to William ap William.

William ap William Anglicised his name, and was known as William Herbert after a remote Norman ancestor. The Herberts became an important dynasty in Britain. He married Anne Devereux and had four children. A prominent Yorkist, he was raised to the peerage as Lord Herbert of Raglan by Edward IV for his help in raising him to the kingship. For a Welshman born of Welsh blood, this was unique in these troubled times of the Wars of the Roses. His power in holding Wales for the Yorkists enabled Edward to put down rebellion in the rest of his kingdom. However, Jasper Tudor, Earl of Pembroke, was Henry VI's half-brother from Owen Tudor's marriage to Catherine de Valois. Jasper had custody of his nephew Henry Tudor, Earl of Richmond. In 1468,

William Herbert took Harlech Castle from Jasper Tudor and Gruffudd Fychan of Corsygedol, and captured with it Henry Tudor, the Lancastrian claimant to the English throne. William sent Henry to be confined at Raglan Castle. Jasper fled to Brittany, and William was rewarded with the great title of Earl of Pembroke. He now controlled Wales for the Yorkists.

The bard Guto'r Glyn urged Herbert to now unite Wales and free it from English rule:

Na ad arglwydd swydd i Sais	*My Lord, don't give the English office*
Na'l bardwn i un bwrdais;	*Nor pardon to a burgess;*
Barna'n iawn, brenin ein iaith	*King of our language, be aware*
Bwrw yn tan ein braint unwaith...	*Their rights were once thrown in the fire...*
Dwg Forgannwg a Gwynedd	*Join Glamorgan and Gwynedd,*
Gwna'n un o Gonwy i Nedd.	*Unify from Conwy to Neath*

Herbert's rise to power paralleled that of the Woodville family, the relations of Edward IV's wife Elizabeth. In 1466, Herbert's son and heir married Elizabeth's sister, and their daughter Maude was put forward as a possible bride for Henry Tudor, to bring Henry of Lancaster into the Yorkist fold. Herbert was created first Earl of Pembroke in 1468. With the Lancastrian insurrection of 1469, Edward IV commissioned the Herberts to suppress the rebels. The Lancastrian army was superior to Herbert's but the Welsh refused to be pushed back. On 23 July, a cavalry force led by the Earl of Devon and by Richard Herbert, William's brother, met a superior northern contingent, and after fierce fighting, fell back. They joined Herbert's main force at Banbury. King Edward did not reinforce Herbert, and Lord Rivers refused to help. After heavy casualties on both sides on 25 July, the disaffected Richard, Earl of Warwick suddenly appeared on the scene with his army and sided with the rebels. The Yorkist Earl of Devon fled with his army, leaving William Herbert, Earl of Pembroke, and his brother Sir Richard Herbert of Coldbrook, alone at the Battle of Banbury (also known as the Battle of Edgcote Moor), on 26 July 1469. Already facing superior odds, Lord Rivers, the Earl of Devon and Edward did not support them, and Warwick turned upon the brothers. Their position was utterly hopeless.

The chronicler Hall wrote,

Pembroke behaved himself like a hardy knight and expert captain; but his brother Sir Richard Herbert so valiantly acquitted himself that with his poleaxe in his hand he twice by fine force passed through the battle of his adversaries and returned without mortal wound. When the Welsh were on the point of victory John Clapham, esquire, servant of the earl of Warwick, mounted on the eastern hill with only 500 men and gathered all the rascals of Northampton and other villages about, bearing before them the standard of the Earl of Warwick with the white bear, crying A Warwick! A Warwick!

Terribly outnumbered, the 18,000-strong Welsh army of the Herberts was defeated. Around 170 Welshmen of note were killed and the Herbert brothers were unlawfully

executed by the vindictive Warwick. They were summarily beheaded at Northampton on 27 July.

William had pleaded with Warwick, the 'Kingmaker' to save Richard. Hall wrote, 'Entreaty was made for Sir Richard Herbert both for his goodly person which excelled all men there, and also for his chivalry on the field of battle. The earl when he should lay down his head on the block said to John Conyers and Clapham "Let me die for I am old, but save my brother which is young, lusty and hardy, mete and apt to serve the greatest prince in Christendom." This battle ever since has been, and yet is a continual grudge between the northernmen and the Welsh.' Sir Richard's body was brought to the Herbert chapel, and he was interned in the place meant for his brother William. Their tomb-effigies can be seen today at Abergafenni. Herbert's half-brother, Tomas ap Rhosier, was also slain. His home was the mansion of Hergest, in Welsh-speaking Herefordshire. Another patron of bards, he was the keeper of the great *Llyfr Coch Hergest* or the *Red Book of Hergest*.

The cream of Welsh aristocracy was killed or executed at Banbury (Edgecote Moor). Guto'r Glyn wrote, 'Let us hasten to the North to avenge our country. My nation is destroyed, now that the earl is slain.' Lewis Glyn Cothi said 'this greatest of battles was lost by treachery; at Banbury dire vengeance fell upon Wales'. H. T. Evans called Herbert 'the first statesman of a new era, and the most redoubtable antagonist of the last and most formidable of the old'. William Herbert was said to be more fluent in Welsh than English, and a noted patron of bards and harpists. On his death, the bards sang 'Raglan was our tongue's vineyard'. Earl Rivers' support at Banbury could have swung the battle – he was captured at Chepstow and executed with his son at Kenilworth on 12 August. The Earl of Devon was taken in Somerset and also beheaded at Kenilworth. Warwick seized King Edward near Kenilworth. Edward IV later managed to depose Henry VI and Warwick was slain at the Battle of Barnet, on Easter Day 1471. With Edward's forces was the eighteen-year-old William, the son of William Herbert, who had succeeded to become Earl of Pembroke. Guto'r Glyn called for national rejoicing and said that the death of Warwick was just retribution for Herbert's execution. William Herbert, the eighteenth Earl of Pembroke, lives at Wilton House near Salisbury and is worth around £150 million.

Henry Tudor's Path to Bosworth

Many Welsh supported the Lancastrian cause in the Wars of the Roses, and at Mortimer's Cross in 1461, one of the Welsh captains, Owain ap Mareddud ap Tudur (Owen Tudor), was captured. He was beheaded by the Yorkists, and his head placed on the steps of Hereford Cathedral. Here 'a mad woman combed his hair and washed away the blood from his face, and got candles and set them round his head, all burning, more than a hundred'. This may have been an act of clairvoyance, because Owen Tudor's grandson, Henry, founded the Tudor dynasty that united England and Wales. Henry's father, Edmund, had died in Yorkist imprisonment in Carmarthen just three months before Harri Tudur was born in 1457.

Born in Pembroke Castle, of royal Welsh descent, one of Henry's ancestors was Llewelyn the Great's justiciar, Ednyfed Fychan, whose heraldic arms were three

severed Saxon heads. Brought up by a Welsh nurse, Henry Earl of Richmond was lucky to be alive even before he raised the Red Dragon of Cadwaladr upon Bosworth Field. He had been born posthumously to Edmund Tudor, his mother being Margaret Beaufort, the sole inheritor of the Lancastrian claim to the Crown of England. Harri Tudur was only fourteen in 1471, the year that the Lancastrian King Henry VI was murdered and his son Prince Edward killed. Suddenly Harri was the prime Lancastrian claimant to the English Crown in the continuing Wars of the Roses. His uncle Jasper Tudur (the Earl of Pembroke) only just managed to help him flee to Brittany, then still a country independent of France, and with a similar language to Welsh. Mayor Thomas White of Tenby had hidden young Henry in cellars, which can still be seen. The new king, Edward IV, asked several times for Henry to be handed over, after paying for several assassination attempts.

In 1483, Harri Tudur pledged his small band of followers that he would marry Edward IV's daughter Elizabeth of York and thus unite the warring Lancastrian and Yorkist factions. His own lineage went back through his grandfather Owain's marriage to Catherine, widow of Henry V, to the royal houses of Gwynedd and Gruffydd ap Cynan, and that of Dinefŵr and Rhys ap Tudur. In 1483, the Duke of Buckingham turned against Richard III and led a revolt aimed at restoring the House of Lancaster, in the person of the Henry Tudor, to the throne. The plan was to stage uprisings within a short time in southern and western England, overwhelming Richard's forces. Buckingham would support the rebels by invading from Wales, while Henry came in by sea. Bad timing and weather wrecked the plot. An uprising in Kent started ten days prematurely, alerting Richard to muster the royal army and take steps to put down the insurrections. Richard's spies informed him that Buckingham was raising an army at Brecon, and the king's men captured and destroyed the bridges across the River Severn. When Buckingham and his army reached the river, they found it swollen and impossible to cross because of a violent storm that broke on 15 October. His starving soldiers deserted. Buckingham was trapped and had no safe place to retreat; his Welsh enemies seized his home castle after he had set forth with his army. The duke abandoned his plans and fled to Wem in Shropshire, where he was betrayed by his servant and arrested by Richard's men. On 2 November, he was executed. Henry had attempted a landing on 10 October (or 19 October), but his fleet was scattered by a storm. He reached the coast of England (at either Poole or Plymouth) where a group of soldiers hailed him to come ashore. They were Richard's men, however, and Henry returned to Brittany, abandoning the invasion. Without Buckingham or Henry, the rebellion was easily crushed by Richard. William Brandon and his brother Thomas were involved in the Buckingham Plot, and joined Henry in France.

Rhys ap Thomas, the most powerful lord in South Wales, had declined to support Buckingham's revolt. When Richard III appointed officers to replace those who had joined the revolt, he made Rhys ap Thomas his principal lieutenant in South West Wales. Rhys was told to send his son Gruffydd ap Rhys to the king's court at Nottingham as a hostage. However, he excused himself from doing so by claiming that nothing could bind him to his duty more strongly than his conscience. The support of Rhys ap Thomas was crucial to an invasion, and it appears that at this time he was in contact with Henry Tudor.

In September 1484, Henry was warned that a group of Breton nobles were going to take him to Richard III. With hours to spare, he and Jasper Tudor crossed the border into France. With the Earl of Oxford, the Bishop of Ely and the Marquis of Dorset, Henry prepared to invade Britain. The survivors of the failed uprisings fled to Brittany, where they openly supported Henry's claim to the throne. At Christmas, Henry Tudor swore an oath to marry Edward IV's daughter, Elizabeth of York, to unite the warring houses of York and Lancaster. Henry's rising prominence made him a great threat to Richard, and the Yorkist king made several overtures to the Duke of Brittany to surrender the young Lancastrian. Francis refused, holding out for the possibility of better terms from Richard. In mid-1484, Francis was incapacitated by illness and while recuperating, his treasurer took over the government. Landais reached an agreement with Richard to send back Henry and his uncle Jasper in exchange for military and financial aid. John Morton, a Bishop of Flanders, learned of the plot and warned the Tudors, who fled to France with hours to spare. The French court allowed them to stay; the Tudors were useful pawns to ensure that Richard's England did not interfere with French plans to annex Brittany.

On 16 March 1485, Richard's queen, Anne Neville, died and rumours spread across the country that she was murdered to pave the way for Richard to marry his niece, Elizabeth. The loss of Elizabeth's hand in marriage could unravel the alliance between Henry's supporters who were Lancastrians and those who were loyalists to Edward IV, so Henry assembled approximately 2,000 Welsh, British and French troops and set sail from France on 1 August. The little expedition landed at Mill Bay, Dale in Pembroke, where Glyndŵr's French allies had also landed and actually managed to invade England. The force marched to Haverfordwest, the county town of Pembrokeshire. Richard's lieutenant in South Wales, Sir Walter Herbert, failed to move against Henry, and two of his officers, Richard Griffith and Evan Morgan, deserted to Henry with their men. Another Welsh contingent was led by Rhys Fawr ap Meredydd, who had travelled from his mansion at Foelas, outside Ysbyty Ifan, Conwy. He probably met up with Henry or Rhys ap Thomas near Welshpool and was present at the capture of Shrewsbury. At the Battle of Bosworth, Sir William Brandon, Henry's standard-bearer, was killed, and Rhys picked up the standard, holding it until the battle had ended. One tradition dictates that Rhys ap Meredydd killed Richard III at Bosworth.

Henry's most important supporter in the early stages of his invasion was Rhys ap Thomas, the leading figure in West Wales. Richard had appointed Rhys lieutenant in West Wales but it seems that Henry had successfully offered the lieutenancy of all Wales in exchange for his fealty. Henry marched north along the Ceredigion coast to Aberystwyth before heading north-east to Welshpool. Rhys took a more southerly route, recruiting 500 more Welshmen before reuniting with Henry. On 15 August, at the Long Mynd in Shropshire, Rhys ap Thomas of Dinefwr joined with 2,000 men. From the south-east, the Herberts joined. Richard ap Howel from Mostyn and William ap Griffith from Penrhyn joined, bringing men and food supplies in the form of herds of cattle. Richard ap Howel, or Richard of Mostyn, is said to have brought a levy of 1,600 Flintshire men. Around 15 or 16 August, Henry's army had crossed the border, heading for the important town of Shrewsbury. Since 22 June Richard had known of Henry's impending invasion, and had ordered his lords to

maintain a high level of readiness. News of Henry's landing reached Richard on 11 August, but it took three to four days for his messengers to notify his lords of their king's mobilisation. On 16 August, the Yorkist army began to gather. The Duke of Norfolk headed for Leicester, the Yorkist assembly point. Simultaneously the Duke of Northumberland had gathered his men and ridden to Leicester.

After resting in Shrewsbury, London was Henry's target, but he did not head directly there. His forces went eastwards and picked up Gilbert Talbot and other English allies, including deserters from Richard's forces. Although its size had increased substantially since the landing, Henry's army was not yet large enough to contend with the numbers Richard could muster. Jasper Tudor slowed down the pace of the army through Staffordshire, trying to gather more recruits. Both Yorkists and Lancastrians sent messengers to the powerful Stanley brothers, asking for help. Henry had been communicating on friendly terms with his kinsmen the Stanleys for some time before setting foot in England, and the Stanleys had mobilised their forces on hearing of Henry's landing. They ranged themselves ahead of Henry's march through the English countryside, meeting twice in secret with Henry as he slowed his march through Staffordshire. At the second meeting, at Atherstone in Warwickshire, they conferred 'in what sort to arraign battle with King Richard, whom they heard to be not far off'. On 21 August, the Stanleys were making camp on the slopes of a hill north of Dadlington while Henry encamped his army at White Moors to the north-west of their camp. On 20 August, Richard reached Leicester, joining Norfolk. Northumberland arrived the following day. The royal army proceeded westwards to intercept Henry's march on London. Passing Sutton Cheney, Richard moved his army towards Ambion Hill and made camp on it. The actual site of this great battle of Bosworth Field is still disputed.

7
Welsh Resurgence Under the Tudors
1485–1603

As regards the place of Wales in the 'British' Isles, a letter in the *Western Mail* from K. Vivian of Garnant pointed out that 'the English and Scots were known as the English and Scots prior to the 16th century; only the Welsh have always been Britons. In view of the desire expressed in the English press for explicit national identities, perhaps the [Welsh National] Assembly should be known as the British Assembly.' Around 731, the English churchman and historian Bede called the Welsh 'Britons'. Not until the Age of Elizabeth did John Dee of Beguildy use the term to include English people.

The Successful Invasion of England and the Battle of Bosworth Field, 22 August 1485

Lord Thomas Stanley was Henry Tudor's stepfather, and his wife had been planning her son's invasion since at least 1483. Thomas and his brother Sir William had been in secret contact with Henry when he was in France, and after he landed. Henry's strategy of landing in Wales and heading east into central England depended on the reactions of Sir William Stanley, as Chamberlain of Chester and North Wales, and those of Lord Thomas Stanley, who owned much of Cheshire and Lancashire. Learning of the invasion, Richard III ordered the Stanleys to raise the men of their region to fight Henry. Richard's scouts informed him that Henry was marching across Wales unopposed, so Richard ordered Lord Stanley to join him instantly. According to the *Crowland Chronicle*, Lord Stanley then excused himself from court on the grounds of 'sweating sickness', and returned north. His son Lord Strange made an unsuccessful bid to escape from court, and then confessed that he and his uncle, Sir William Stanley, had conspired with Henry Tudor. Richard proclaimed him as traitor, and let it be known that Strange's life was hostage for his father's loyalty in the coming conflict.

Henry's ill-equipped army of French, Breton and Welsh contingents had gathered support from Lancastrians as it marched through Wales to Shropshire, crossing the Severn near Shrewsbury, before heading towards London. It had swollen from 2,500 to 4,500 soldiers on its journey across Wales, including 500 given by the Earl of Shrewsbury. Between 300 and 500 of Henry's followers were Lancastrian exiles who had fled from Richard's rule, and the remainder were Talbot's men and recent

deserters from Richard's army. There may have been 1,800 French mercenaries, led by Philibert de Chandée. There were a few Scottish troops in the army, but the main portion was made up by the recruits picked up in Wales and Cheshire. Rhys ap Thomas's Welsh force alone was described as being large enough to have 'annihilated' the rest of Henry's force. Many Welshmen believed that Harri Tudor was the promised 'Mab Darogan' or 'son of prophecy' to free Wales from the English. Glyndŵr's rebellion had paved the way for this nationalist upsurge.

Richard's mounted scouts watched the force straggle through Lichfield and into Leicestershire. From the east of England, Lord Norfolk's loyalist army of 4,000 men was approaching in the opposite direction. Percy of Northumberland was bringing Richard's 3,000 troops from the north. Richard with 6,000 followers was hurrying from the south, and another two Yorkist armies of the Stanley brothers also arrived at the same time. Richard III intercepted Henry's army, south of Market Bosworth. Henry's kinsmen Sir William Stanley and Lord Thomas Stanley brought 2,500 and 4,000 men respectively to the battlefield, but held back, considering which side to support. Thomas Stanley had married Henry's mother Margaret, Countess of Richmond, in 1482. Richard had taken family members, including Lord Stanley's son, as hostages to ensure their support. Even without Stanley support, Henry's 4,500 Lancastrians faced a potential 13,500 Yorkists. If the Stanleys helped Richard, as they had pledged, Henry's small force of 11,000 would be facing 20,000 men. Because of this, Henry had a fresh horse near him, ready to flee the battlefield and fight again, probably upon Jasper Tudor's instructions.

As Henry's army advanced, Richard sent a message to Lord Stanley, threatening to execute his son, Lord Strange, if Stanley did not join the attack on Henry immediately. Stanley replied that he had other sons. Incensed, Richard gave the order to behead Strange but his officers waited, saying that battle was imminent, and it would be more convenient to carry out the execution afterwards. Henry had also sent messengers to Stanley asking him to declare his allegiance. The reply was evasive. The Stanleys would 'naturally' join him, after Henry had given orders to his army and arranged them for battle. Henry had no choice but to confront Richard's forces alone. It may be that, seeing Henry's force was smaller than expected, that they decided to sit on the fence until there was an opportunity to enter the battle upon the 'right' side. Aware of his own military inexperience, Henry gave command of his army to the experienced Earl of Oxford and retired to the rear with his bodyguards. Oxford had escaped England to join Henry in 1484. Seeing the long line of Richard's army strung along the ridge of the hill, Oxford decided to keep his men together instead of splitting them into the traditional three battles (troop formations) of vanguard, centre, and rearguard. He ordered the troops to stray no further than 10 feet from their banners, fearing that they would become enveloped in small groups among a much larger enemy army. Individual groups therefore clumped together, forming a single large mass flanked by horsemen on the wings. The Lancastrians were harassed by Richard's cannon as they manoeuvred around the marsh, seeking firmer ground. Once Oxford and his men were clear of the marsh, Norfolk's army and several contingents of Richard's group started to advance. Hails of arrows showered both sides as they closed. Oxford's men proved the steadier in the ensuing hand-to-hand combat. They held their ground and several of Norfolk's southern English recruits fled the field.

Lord Thomas Stanley now led his 4,000 men towards Northumberland's position on a nearby hill. It may be that Thomas Stanley and Northumberland communicated by envoys with each other at this time, for both held back their forces. Northumberland now took no action when signalled to assist Richard. It is possible that he could not advance through Stanley's men, and the land only otherwise allowed a long, difficult flanking movement. This would expose him to attack, so he held his troops. After thirty minutes or so of fighting, Richard saw Henry and Jasper Tudor under the Red Dragon banner, on the slopes behind Oxford's men. Henry had ridden off towards the Stanleys, and seemed isolated. Richard obviously feared that the Stanleys would join Henry, and saw the opportunity to kill Henry and end the battle. Richard now charged with 100 knights or more past William Stanley's army, towards Henry and Jasper. Richard personally unhorsed Sir John Cheyne, who had been Edward IV's master of horse, and who was Henry VII's personal bodyguard. Henry's standard-bearer, William Brandon was killed, the flag going down with him. Brandon's brother Thomas fought in Henry's bodyguard, and Brandon's son was later made Duke of Suffolk. In the midst of the fighting Henry was almost killed, but his Welsh bodyguards surrounded their master and succeeded in keeping him away from Richard. William Stanley saw that Richard and his knights were separated from the main Yorkist army. William's men therefore charged in behind Richard to assist Henry. Lord Thomas Stanley held his 4,000 men back, as did the Earl of Northumberland with his 3,000-strong army. They watched the battle develop around Richard's small and diminishing force.

Richard's standard holder lost his legs but held the Yorkist banner aloft until he was hacked to death. Richard's horse became mired in the soft ground and he was forced to continue the fight on foot. His followers offered him their horses to escape but Richard refused. Overwhelmed by the masses of Welsh spearmen around him, the last Yorkist king died on the battlefield. Richard's forces disintegrated as news of his death spread. Northumberland and his men marched away to the north upon seeing the king's fate, and Norfolk was killed. The forces of Henry and William Stanley quickly overcame Norfolk's dispirited Yorkists. Rhys ap Thomas was said to have been knighted on the battlefield for killing Richard with his great battle-axe, and supposedly put Richard's crown on Henry's head. Other sources say that Rhys ap Meredydd killed Richard III, but the circumstances, description, position and logistics of the battle are still unclear. (The superbly carved medieval bed of Sir Rhys ap Thomas can be seen in St Fagan's Castle, at the National History Museum, St Fagan's.) It seems that William Gardiner, a mercenary who married Jasper Tudor's illegitimate daughter, served Rhys ap Thomas and was the man who killed Richard, with a poleaxe. Gardiner's son was later Henry VII's secretary, Bishop of Winchester and Lord Chancellor to Mary I.

The historian G. M. Trevelyan pointed out the influence of Bosworth Field and the Tudors: 'Here, indeed, was one of fortune's freaks: on a bare Leicestershire upland a few thousand men in close conflict foot to foot … sufficed to set upon the throne of England the greatest of all her royal lines, that should guide her through a century of change down new and larger streams of destiny.' After the battle, Richard's royal circlet was found and brought to Henry, who was crowned king at the top of Crown Hill, near the village of Stoke Golding. According to Polydore Vergil,

Henry's official historian, Richard's fallen coronet was found under a hawthorn bush, and placed by Lord Stanley on his stepson's head before his cheering troops, thereby emphasising the critical role the Stanleys had played in bringing Henry Tudor to the throne. Vergil tells us that the hawthorn bush would not be part of Henry's coat of arms if it did not have a strong relationship to his ascendancy. In Vergil's chronicle, 100 of Henry's men, compared to 1,000 of Richard's, died in this battle. The last Yorkist king's corpse was stripped naked and strapped across a horse. His body was brought to Leicester and openly exhibited in a church to show his death. After two days, the corpse was interred in a plain, unmarked tomb. Henry's success had been largely due to Welsh support, and the emissary for Venice reported to the Doge that 'the Welsh may now be said to have recovered their independence, for the most wise and fortunate Henry VII is a Welshman'. Francis Bacon later commented that 'to the Welsh people, his victory was theirs; they had thereby regained their freedom'.

The Tudor Dynasty

Henry dismissed the mercenaries in his force, retaining only a small core of Welsh soldiers to form the 'Yeomen of his Garde', today's 'Beefeaters'. Parliament reversed his attainder and recorded Richard's kingship as illegal, although the Yorkist king's reign remains official in the annals of English history. Henry asked parliament to date his reign to the day before the battle, effectively enabling those who fought against him at Bosworth Field to be declared traitors. Northumberland, who had remained inactive during the battle, was imprisoned but later released and reinstated to pacify the north in Henry's name. The proclamation of Edward IV's children as illegitimate was also reversed, restoring Elizabeth of York's status to a royal princess. The marriage of Elizabeth, the heiress to the House of York, to Henry, the head of the House of Lancaster, marked the virtual end of the fighting between the houses of Lancaster and York. Thus ended the War of the Roses, the red rose of Lancaster merging with the white rose of York to make the bi-coloured Tudor rose. The wedding was delayed until after Henry's Coronation on 30 October 1485, and he had established himself strongly enough to halt any further attempts on the kingship from Elizabeth's relations.

Henry's mother Margaret and Elizabeth of York's mother Elizabeth Woodville had agreed Henry should move to claim the throne, and once he had taken it, he would marry Elizabeth of York, uniting the two rival houses. In December 1483, in Rennes Cathedral, Henry had sworn an oath promising to marry her, and had begun planning his invasion. Elizabeth of York is the only English queen to have been a daughter (of Edward IV), sister (of Edward V), niece (of Richard III), wife (of Henry VII), mother (of Henry VIII) and grandmother (on the paternal side of Edward VI, Mary I and Elizabeth I) of English monarchs. Henry and Elizabeth married on 18 January 1486. Their first son, Arthur, was born on 20 September 1486, and titled in Welsh the same as Llywelyn the Great: 'Tywysog Cymru ac Arglwydd Eryri'. Henry had Elizabeth crowned queen consort on 25 November 1487, over two years after Bosworth Field.

Henry rewarded the Stanleys by making William his chamberlain and giving Thomas gave the Earldom of Derby. The Earl of Oxford was restored to his lands

which had been confiscated by the Yorkists. He was also appointed Constable of the Tower of London and Admiral of England, Ireland and Aquitaine. Jasper Tudor was made Duke of Bedford. Henry returned to his mother Margaret Beaufort, Countess of Richmond, the lands and grants stripped from her by Richard, and empowered her to run her own estates. She became extremely influential at court. Possibly the most pragmatic of English kings, Henry rewarded his supporters only in the short term. Soon he would appoint and promote those who best served his interests. Henry VII annulled Henry IV's penal laws on Welshmen, to the annoyance of English burgesses in Wales.

The House of Tudor ruled England, Wales and Ireland from 1485 to 1603. Henry VII showed some favour to Wales, and his granddaughter Elizabeth I had a strong Welsh presence at court. Henry VII maintained the Council in the Marches, established at Ludlow by Edward IV. Perhaps the dream of Welsh supremacy over the whole of Britain would at last come to pass. By descent, Henry VII was a quarter Welsh, a quarter French and half-English. Henry VII was descended in direct male succession from Ednyfed Fychan, seneschal (steward) of Llywelyn the Great. The Tudor surname first appeared in the ancestry of Henry VII in the 1420s, when Owain ap Maredudd ap Tudur ap Goronwy ap Tudur ap Goronwy ap Ednyfed Fychan abandoned the Welsh patronymic system and adopted a fixed surname. Had he, as was generally the custom, adopted his father's name, the English throne would have been occupied for a century by the Maredudd dynasty. The Tudors of Penmynydd in Anglesey had started the Glyndŵr War. The historian David Powel claimed in 1584 that Henry VIII inherited England from his father, heir to John of Gaunt and Edward III, and Wales from his mother, heiress to the Mortimers and Llywelyn the Great.

Rebellion

The first open rebellion to Henry's rule was in 1487. Lambert Simnel pretended to be the twelve-year-old Edward Plantagenet, Earl of Warwick, who had been imprisoned in the Tower as a potential rival to the Crown by Richard III and was still there. The Earl of Lincoln also had a claim to the throne, being named by Richard III as his heir. Lincoln went to France and Ireland, looking for support for a rebellion in Simnel's name. Simnel, whose real name is unknown, had been trained in courtly ways. A rumour was started that Warwick had escaped from the Tower. Lincoln's Yorkist army of 8,000 included German and French mercenaries and 4,500 Irishmen, and on 4 June 1487 his army won a major skirmish at Bramham Moor. Northumberland next employed delaying tactics, while Henry and Jasper Tudor gathered an army with Lord Strange. On 16 June, Henry's vanguard, commanded by the reliable Earl of Oxford, found the Yorkists on the brow of a hill surrounded on three sides by the River Trent at the village of East Stoke near Newark. Lincoln surrendered the high ground by immediately going on to the attack. The battle was bitterly contested for over three hours, but eventually the lack of body armour on the Irish troops meant that they were cut down in increasing numbers. Unable to retreat, the German and Swiss mercenaries fought to the last. Lincoln was killed at the Battle of Stoke Field,

and Simnel captured. He was pardoned by Henry in a gesture of clemency as Henry realised that Simnel was merely a puppet for the leading Yorkists. The Irish nobles who had supported Simnel were also pardoned, as Henry needed their support to govern Ireland effectively.

The next Yorkist pretender, known as Perkin Warbeck, was the most dangerous threat to Henry VII. He claimed to be Richard, Duke of York, the younger of the princes in the Tower. He said that he had not been murdered like his 'brother' Edward V, but had been spared by the killer and allowed to escape. Warbeck first appeared, aged around seventeen, in Cork in 1491, having spent four years in Portugal, where he was known as the 'White Rose'. Before that he had been in Flanders, and Edward IV's sister, Margaret of York, and others were part of the plot. In 1492 Charles VIII invited Warbeck to France, keeping him at court until he moved to stay with his protector Margaret, Duchess of Burgundy, in Brabant. A small fleet was assembled slowly with Imperial and Burgundian funds, preparing to invade England at some point in 1495.

Henry's spies had already infiltrated the pretender's 'court' at Malines, and at the end of December 1494 Sir Robert Clifford, a confidant of the pretender, was persuaded to reveal all he knew for a payment of £500. Possibly, he was a double-agent. Among the names he revealed was that of Henry's own chamberlain, Sir William Stanley, who had vaguely expressed a willingness to back Warbeck if he knew him to be genuine. Henry, although shocked and reluctant, made an example of Stanley and other chief conspirators by executing them. By the spring of 1495 the conspiracy had been broken in England, and was never to revive. The pretender's invasion in July, with fourteen small boats, ended in slaughter on the beach at Deal, while Warbeck himself sailed swiftly away.

Next, James IV of Scotland and Warbeck invaded Northumberland in September 1496. The pretender, sickened by the bloodshed, fled after two days. In July 1497, however, with Henry's armies marching against him, James sent Warbeck away by sea, intending him to invade England from the south-west. Some 8,000 Cornishmen in this discontented corner of England joined Warbeck. They besieged Exeter, in Devon, but failed to take the city, and after marching to Taunton the pretender panicked and fled. When he surrendered to Henry VII at Taunton, in October 1497, he put his signature to a confession that stated that he was, in fact a Fleming, 'Piers Osbeck', but that name was also false. Henry pardoned his closest English supporters, but they started plotting again on 'York's' behalf two years later. Henry had taken Warbeck into his court 'at liberty' and treated him like a captured nobleman, to the amazement of contemporaries. Warbeck was allowed to see his wife, though not to sleep with her, to avoid the risk of prolonging his claim. A new combination of plotting involving the imprisoned Earl of Warwick, the last true Yorkist heir, as well as Warbeck, eventually persuaded Henry to execute both of them in 1499. In his treatment of prisoners, Henry throughout his reign was an exceptionally merciful king.

Henry asked chroniclers to portray his reign as a 'modern age' with its dawn in 1485. He had effectively ended the Wars of the Roses and laid the basis for a stable constitutional monarchy. The Elizabethan antiquary George Owen called Henry 'the Moyses who delivered us from bondage'. By the Treaty of Étaples, he took money

from the French in return for not fighting them. Despite threats from Scotland and the Continent, he refused to engage in war, instead building up the royal coffers to ensure stability when his son succeeded. Because of his new and high taxes, there was insurrection in Meirionnydd, and Harlech Castle was attacked in 1498. Troops were sent and a heavy fine imposed upon the community. Financial stringency meant that accumulated arrears of £2,000 had to be written off in the Staffordshire lordship of Brecon. Henry built trade and alliances, and under his Royal Commission John Cabot reached Nova Scotia in 1497.

Henry VII had sent a letter to the Welsh gentry, seeking their support before Bosworth 'to free this our Principality of Wales of such miserable servitude as they have long piteously stood in'. Welshmen at last were elected to bishoprics. Henry VII had brought up his eldest son and heir, Arthur, as a Welsh speaker, living in the Marcher administrative capital of Wales, Ludlow. Arthur was married with great ceremony to Catherine of Aragon in 1501, cementing the Spanish alliance. Arthur's untimely death gave the nation Henry VIII and changed the course of British history – without it Britain would probably still be a Catholic country – and Henry VIII's daughter Queen Elizabeth I oversaw the greatest flowering of culture in the British Isles under the Tudor dynasty. For the first time Britain became a player on the world stage in the arts. Bosworth Field marked the end of medieval England and the beginning of more modern government, with a conscious attempt to integrate Wales into England. Aged only fifty-two, Henry Tudor died at Richmond in 1509, leaving a peaceful country, full treasury and an uneventful succession. The 'founder of the new England of the sixteenth century', Francis Bacon called him 'a wonder for wise men'.

Sir Rhys ap Thomas, 1448–1525

In the process of his kinsman Henry Tudor becoming Henry VII, Rhys became the most powerful man in South Wales, the most influential native Welshman in South Wales since the great Lord Rhys 300 years earlier. From 1485 to 1525 Rhys of Newton, Dinefŵr was the principal lieutenant in South Wales to two kings, Henry VII and Henry VIII. When the Wars of the Roses broke out in 1455 the family of Rhys ap Thomas had supported the Lancastrian faction of the reigning king, Henry VI. However, in 1461 the Yorkist Edward, Duke of March became Edward IV of England when he seized the throne from the Henry VI. Rhys's grandfather Gruffydd ap Nicholas was killed at the Battle of Mortimer's Cross in 1461, and for their support of the defeated Lancastrians his sons forfeited the family's lands in the Tywi Valley. Gruffydd's sons Thomas and Owain held Carreg Cennen Castle against a Yorkist onslaught of 200 men in 1462, only surrendering after a siege. To ensure no such resistance occurred again, Carreg Cennen's great fortifications were destroyed afterwards. It has never been occupied since. Henry VI briefly regained his throne in 1470 but promptly lost it again in 1471 when he, along with his son and heir to the throne, were killed at Tewkesbury. Edward IV was now largely secure on the throne, although Jasper Tudor was still active in North Wales. When Rhys ap Thomas returned from exile to Wales, probably early in the 1470s, his family

was still eclipsed during Edward IV's restored regime. Rhys had accompanied his father Thomas into exile at the Burgundian court after the Yorkist victory at Carreg Cennen in 1462. Rhys returned to Wales in 1467, and on the death of his father in 1474 took his estates.

In 1483 Henry Stafford, Duke of Buckingham and Lord of Brecon, rebelled against the newly enthroned Yorkist Richard III, but Rhys declined to join in on the side of Stafford, probably because Henry Tudor had not been able to get to Britain. The rebellion was crushed and Buckingham executed. Richard III made an annuity of 40 marks, and Rhys swore fidelity, but this did not prevent him from communicating with Henry Tudor, who was in exile in Brittany. The oath he was supposed to have made to Richard was, 'Whoever ill-affected to the state, shall dare to land in those parts of Wales where I have any employment under your majesty, must resolve with himself to make his entrance and irruption over my belly.' The story is told that after Henry Tudor's return, Rhys eased his conscience by hiding under Mullock Bridge, Dale, as Henry marched over, thus absolving himself of his oath to Richard. His biography states that Richard III also demanded the surrender of Rhys's only legitimate son, Gruffudd, as a guarantee of his loyalty. The combined forces of Rhys, Henry Tudor and others joined outside Welshpool around 16 August, marching to Bosworth in Leicestershire, which they reached on 22 August. Even before they met, Henry seems to have indicated that Rhys would be his chief lieutenant in Wales if Richard III were defeated. Henry's favour to Rhys immediately after Bosworth, and their close relationship throughout his reign, suggests that their collaboration in 1485 was well prepared.

A biography of Rhys written around 1620 by Henry Rice lists Rhys's full titles as: 'Rice ap Thomas, Knight, Constable and Lieutenant of Breconshire; Chamberlain of Carmarthenshire and Cardiganshire; Seneschall and Chancellor of Haverfordwest, Rouse and Builth; Justiciar of South Wales, and governor of all Wales; Knight Bannerett, and Knight of the Most Honourable Order of the Garter; a Privy Councellor to Henry VII, and a favourite to Henry VIII.' Only three months after the success of Bosworth, Rhys was permanently appointed the king's lieutenant and steward of Brecon, steward of Builth, and Chamberlain of South Wales, all highly lucrative positions. In 1486, Sir Thomas Vaughan of Tretower attacked and ransacked Brecon Castle (he had also done so in 1483) because of his dislike of the new lord, Jasper Tudor. This Yorkist insurrection was put down by Sir Rhys ap Thomas. He was a strong-arm man for both Henry VII and Henry VIII, helping suppress the Brecon rising of 1486, Simnel's rebellion in 1487, the Cornish rising of 1497, and Perkin Warbeck's rebellion of October 1497. He also accompanied Henry VII on his French expedition in October 1492 and fought for Henry VIII in France in 1513, aged sixty-five. Rhys' son, Gruffydd ap Rhys, was also the close friend of Henry VIII's son, Prince Arthur, and a leading mourner at his funeral.

Rhys ap Thomas owned several households and estates throughout West Wales, the most sumptuous being Carew Castle near Pembroke. The family home at Newton (Dinefŵr), Llandeilo, was at that time a rather small manor house which was enlarged several times by later descendants. He had half a dozen mistresses and at least a dozen children, who were married into gentry houses of South Wales. In 1507, he held the last great tournament to be held in Britain at Carew Castle, to

symbolise the reconciliation of Wales and England. Rhys ap Thomas died in 1525 and his tomb can be seen today in St Peter's church, Carmarthen, after being moved from Carmarthen priory where he was originally buried. The remains of Henry VIII's own grandfather, Edmund Tudor, also had to be removed from Carmarthen priory, to St David's Cathedral during the Dissolution of the Monasteries.

However, within six years of his death, his grandson and heir Rhys ap Gruffydd (1509–31) had lost everything. Rhys's estates and offices were taken by the Crown and given to Lord Ferrers for life in 1531. Rhys ap Gruffydd was later beheaded by Henry VIII in that year for treason after fighting Ferrers and provoking civil unrest amongst the citizens of Carmarthen, who were still angry about the disinheritance. Five generations of rule by this Llandeilo family effectively came to an end. In the Middle Ages the leading families of Wales were virtually a law unto themselves. They ruled more or less as they pleased, free from any constraints from English kings and their leading families, who were often occupied by military campaigns in France during the Hundred Years War (1337–1453) and later by dynastic struggles at home. Ellis Gruffudd was a Flintshire historian who knew Rhys ap Gruffydd, and had been present when Rhys been hauled before a London court for various affrays in Carmarthen. Ellis Gruffudd wrote,

> And indeed many men regarded his death [i.e. Rhys ap Gruffydd] as Divine retribution for the falsehoods of his ancestors, his grandfather, and great-grandfather, and for their oppressions and wrongs. They had many a deep curse from the poor people who were their neighbours, for depriving them of their homes, lands and riches. For I heard the conversations of folk from that part of the country that no common people owned land within twenty miles from the dwelling of Sir Rhys ap Thomas, that if he desired such lands, he would appropriate them without payment or thanks, and the disinherited doubtless cursed him, his children and his grandchildren, which curses in the opinion of many men fell on the family, according to the old proverb which says – the children of Lies are uprooted, and after oppression comes a long death to the oppressors.
>
> *Ralph A. Griffiths, Sir Rhys ap Thomas and His Family*

The Acts of Union of 1536 and 1543

The Wales that had been under the authority of Henry VII in 1485 was a divided country. Less than a half of it constituted the Principality, the territories which, before Edward I's conquest in 1282, had consistently been under native Welsh rule. Most of the east and much of the south constituted the March. This network of semi-independent lordships had resulted from piecemeal invasions of Wales by Norman knights and from grants made by Edward I following the conquest. The Marchia Wallie (the Norman-controlled part) of late-fourteenth-century Wales had been dominated by a handful of families, such as the Mortimers, Fitzalans, Bohuns, Beauchamps, Despensers and Mowbrays. In subsequent years the English Crown gradually acquired all the Marcher lordships.

The accession of Henry Bolingbroke in 1399 meant that the Lancaster lordships also became Crown territories. When Edward of York seized power in 1461, the

massive Mortimer lordships also passed into the possession of the Crown. In 1489, Ludlow, the *caput* (head) of the one-time Mortimer lordships, became the seat of what evolved into the Council of the King in the Dominion and Principality of Wales and the Marches. In that year, the end of the Earldom of March united the March with Wales, and paved the way for the 1536 legislation. Henry VIII acquired further lordships. Newport and Brecon were taken following the execution of Edward Stafford, Duke of Buckingham, in 1521. By the 1530s, of the major lordships only those of Abergafenni, Chepstow and Gower were outside the direct control of the English Crown.

The first of the Acts of Union took place in 1536 to ensure the political annexation of Wales to England, abolishing the remaining parts of the Marcher lordships. The Act gave notice that part of its intent was 'to utterly extirpate all and singular the sinister usages and customs differing from the same [English laws].' It was now possible for a Welsh-speaking defendant to be hanged without understanding a word of the case against him. The Act authorised the appointments of many of the Welsh gentry as Justices of the Peace, abolished any legal distinction between citizens of Wales and those of England, and settled the border by the creation of new counties out of the old lordships. Importantly, it gave Wales representation in the Westminster parliament. English law would be the only law recognised by the courts of Wales. The law of England was to be the only law of Wales and, to administer it, Justices of the Peace were appointed in every county. Wales was to be represented in parliament by thirteen county MPs and thirteen borough MPs.

In addition, the administration of Wales was placed in the hands of the Welsh gentry, and thus a class was created who would use English in all legal and civil matters. Before very long, this Welsh ruling class would be divorced from the language and the common folk of their own country. There were seven new counties: Monmouth, Glamorgan, Pembroke, Brecon, Radnor, Denbighshire and Montgomery. These were added to the existing six counties of Caernarfon, Ceredigion, Carmarthen, Meirionnydd and Flint. The new border followed much of Offa's Dyke, but some Welsh-speaking areas such as Archenfield and Oswestry were made English. Even now in these areas Welsh place-names and surnames abound. To walk around some cemeteries such as Kilpeck is to think one is in the heart of Wales. From now until 1689, Wales was governed by the Council of Wales, which was based in Ludlow, Shropshire.

The Act of 1543 established the Courts of Great Session, a distinct Welsh system of courts based upon four three-county circuits: Anglesey, Caernarfon and Merioneth; Flint, Denbigh and Montgomery; Cardigan, Carmarthen and Pembroke; Radnor, Brecon and Glamorgan. As Monmouthshire was not part of the pattern, a notion arose that it had been detached from Wales. The number of Welsh MPs was increased to twenty-seven through the granting of a member to the borough of Haverfordwest. Because the statute had abolished partible inheritance (division of legacy amongst heirs) and enthroned primogeniture (inheritance by the first-born son), the Welsh gentry's efforts to built up their estates were eased. Welshmen excelled in the teaching of law at the premier English universities; they were prominent in the Inns of Court, in the military and even in parliament itself. Edmund Burke said of the Acts in 1780, 'As from that moment, as by a charm, the tumults subsided ... peace, order and

civilisation followed in the train of liberty.' After 1536, the Welsh were English in the eyes of the law, yet as John Davies tells us, 'as there was no longer any advantage in boasting the condition of being English', everyone living in Wales was considered as Welsh. This had a profound effect on the history of Wales.

Is the Act of Union Legal?

The Act of 1536, and its corrected version of 1543, was passed without consultation or consent by the Welsh people, who had no central authority or parliament to represent them. The 'Act of Union' was not known as such until 1901, when the historian Owen M. Edwards made tentative use of the title. This is misleading, as it suggests that the statute was of the same nature as the statutes which united Scotland with England in 1707, and Ireland with Britain in 1801. These statutes expressed the will of two partners. What was accomplished was not the union of two nations, but of the Principality and the March. The Welsh 'Act of Union' was passed solely by the parliament of England, a body lacking representatives from Wales. Furthermore, the preamble to the statute claimed that Wales was already 'incorporated, annexed, united and subjecte to and under the imperialle Crown of this Realme as a very member ... of the same'. It was not, in any legal sense. The administrative system established in the Principality in 1284 was extended to the new counties carved out of the March, and it came to be considered that the Principality embraced Wales in its entirety. Central to the statute was the abolition of any legal distinction between the English and the Welsh. Welsh law, the 'Law of Hywel Dda', still existed in some parts of Wales.

Religious Upheaval

In 1496, Rhys ap Thomas had become only the third Welshman to be appointed to be a justiciar in Wales, and John Morgan was appointed to be Archbishop of St David's, the first Welshman since 1229. There was a great devotion to the cult of the Virgin Mary. Fine churches were built in Cardiff, Tenby, Wrexham and elsewhere. Henry VII's heir, the cultured Prince Arthur, died at Ludlow in 1502, altering the course of history as his younger brother Henry married Arthur's widow, Katharine of Aragon, the aunt of the Holy Roman Emperor Charles V. In the 1520s Henry VIII's quarrel with the Pope over his wish to divorce in order to marry Anne Boleyn eventually led to England and Wales leaving the Roman Catholic Church. The Protestant Reformation had been underway in Germany since 1517, but in breaking with Rome Henry did not intend to embrace Protestantism. All he sought was to end the power of the Pope in his kingdom and to take those powers himself. By 1535 Henry, aided by his chief minister, Thomas Cromwell, had secured a series of statutes that abolished the authority of the Pope in the territories of the English Crown and gave the king the status of 'Supreme Head of the Church of England'.

Protestants were still persecuted, with Thomas Capper of Cardiff dying at the stake in 1542. Yet Henry did follow some semi-Protestant policies, in particular with

regard to monasticism. Between 1536 and 1540, all religious houses were suppressed. There were forty-seven in Wales, if we include cells, hospices, monasteries, nunneries and friaries. Monastic life had long been in decline. By 1536, the thirteen Cistercian houses of Wales had only eighty-five monks between them. The monasteries were dissolved, basically to fill the king's treasury. Hundreds of thousands of acres of Welsh land were bought by the gentry from the Crown. The Mansel family took Margam Abbey and its lands, and the Somerset family of Raglan took Tintern. Many Benedictine abbey churches survived as much smaller parish churches, but most of the monasteries fell into ruin. Many monasteries had been Welsh-speaking repositories of Welsh culture, and there were no educational institutions to replace their loss. The lead and slate from their roofs was sold, as was any precious glass, carved wood and the like. Some was fortunately transferred to nearby churches, especially to those favoured by the landed gentry.

This freeing up of land formerly owned by the monasteries gave new opportunities for ambitious members of the Welsh gentry to increase their estates. Owning land could be a complicated business for a Welshman due to old Welsh property law dating back to the tenth century. Many Welsh nobles petitioned for the right to literally become 'English' and be governed by English law. Such tendencies coincided with the wider Tudor concerns of enforcing administrative uniformity throughout the kingdom in the face of possible threats from anti-Reformation forces on the Continent. Many of the gentry who gained from the Dissolution of the Monasteries remained Catholics. As the Protestant Reformation progressed in Wales and England under the Tudor dynasty, except during Mary's reign, Catholics began to face persecution. In Wales, one poet's response was to label the new order *'fydd Saeson'* (faith of Saxons), and there was a strong feeling that the Welsh were being forced to abandon the old religion due to English demands. A number of Welsh Catholics were to be martyred, although many embraced their fate joyfully. At Tyburn the Welsh priest Edward Morgan was reproved by a minister on the scaffold for being too cheerful at the prospect of going to heaven.

There were Catholics who passively resisted the changes by staying away from the new church services. These non-attenders were termed recusants, and legislation passed against them. They faced substantial fines for non-attendance as well as incurring the suspicion of the authorities.

The first book in the Welsh language was a collection of religious texts, *Yn Llyvyr Hwnn* (In This Book), published by Sir John Price of Brecon in 1546. It consisted of the Creed, the Lord's Prayer and the Ten Commandments. Thus Welsh began its faltering career as a published language. The first book actually printed in Wales itself may have been *Y Drych Gristianogawl* (The Christian Mirror), a counter-Reformation text secretly produced in a cave at Llandudno in 1585. The pioneer of publishing in Welsh was William Salesbury, who wrote a Welsh–English dictionary in 1547 to help Welsh people understand the Bible until he could work toward translating it into the 'more perfect' language of Welsh. Salesbury said that his mission was 'to obtain the holy scripture in your own tongue as your happy ancestors, the ancient British, had it'.

In 1551 William Salesbury's *Kynniver Llith a Ban* was printed, a translation of the main texts of the English Prayer Book undertaken at the request of Edward VI's advisers. The effects upon the Welsh language are incalculable, for the book was

followed by the translation of the whole Bible into Welsh, in the reign of Elizabeth. John Penry had pleaded passionately in parliament to have the Bible translated so that the Welsh people might better learn English; the queen and her advisers were more interested in completing the Protestant Reformation throughout Britain than in granting any favours. One of the quickest and surest ways to accomplish this was to give the Welsh people a Bible in their own tongue. An Act of 1563 had stated that the English Bible should be placed alongside the Welsh Bible so that the Welsh, somehow dealing in both languages side by side, could master English.

Thus the bishops of Wales and Hereford (where Welsh was still widely spoken) were commanded to make sure a Welsh version of the Bible and the Prayer Book would be available in every parish in Wales by 1 March 1567. Although the Welsh language had been banned by Henry VIII for secular matters, it was approved in religion. A major reason was that Catholicism was still widespread in Wales, and the Welsh Bible would take away dependence upon priests for religious knowledge. Whatever the intent, the Welsh language was given an unintended status and a place of honour by being used as a medium for the Holy Scriptures. Salesbury's New Testament and Common Prayer Book (Y Testament Newydd a Llyfr Gweddi yn Gymraeg) was published in 1567, the beginnings of his attempt to translate the whole Bible into Welsh.

The Welsh bishops entrusted the task of translation mainly to Salesbury, who had prepared the way with his earlier translation of the Prayer Book. Unfortunately he fell out with his co-translator Bishop Richard Davies of Abergwili. William Morgan, parish priest of Llanrhaeadr-ym-Mochnant, and later Bishop of Llandaf and St Asaph, took over. With a group of fellow scholars including Richard Davies, Morgan completed his work in 1588. Its influence upon the subsequent religious direction of the Welsh people was expected, but it also had enormous effects upon their language and literature. The Bishop Morgan Bible of 1588 was comparable in its effects on the Welsh language to the King James Bible on the English and the Luther Bible on the Germans. It was so successful, a copy having been placed in all the parish churches of Wales, that a new edition by Dr John Davies of Mallwyd was published in 1620. The Bishop Morgan Bible became the foundation and inspiration for all the literature written in Welsh, and many historians believe that it was this book alone that prevented Welsh from becoming nothing more than a bundle of provincial dialects or of even disappearing altogether. Welsh was the only non-state language of Protestant Europe to become the medium of a published Bible within a century of the Reformation. Perhaps it is due to this early publication that much of the strength of present-day Welsh is owed, compared to Irish (which did not get its own Bible until 1690), and Scots Gaelic (which had to wait until 1801).

Generations of Welsh children learned to read and write from the Welsh Bible, or more correctly from the cheaper, smaller version published in 1630, Y Beibl Bach. It was the only book that many families could afford. The Welsh came to believe that Protestantism was the re-embodiment of the beliefs of early Welsh Christianity, whose purity had been defiled by the Romish practices imposed upon it following St Augustine's arrival at Canterbury.

Wales under Edward VI and Mary I

King Edward VI was only nine upon his ascension to the throne in 1547, and was a strict Protestant. He was the son of Henry VIII and Jane Seymour. His uncle Edward Seymour was Lord Protector, and controlled England until overthrown by Northumberland. Edward reigned only until 1553, and the mass was replaced by communion service, a definite rejection of Catholicism. The marriage of clerics was permitted. In 1549 the Book of Common Prayer was published and a more Protestant version was adopted in 1553. In 1551 the Denbighshire scholar William Salesbury published a Welsh translation of the main texts of the Prayer Book. Edward's premature death saw the short-lived attempt by the supporters of Lady Jane Grey to take the Crown, but Edward's half-sister Mary I reigned from 1553. Mary was Catherine of Aragon's daughter and a firm Catholic, returning England to the rule of Rome, and attempting to rescind the changes of Henry and Edward. 'Bloody Mary' sent to the stake 280 heretics, including White at Cardiff, Nichol at Haverfordwest and Ferrar, Bishop of St David's, at Carmarthen.

The Welsh, a conservative people, probably supported Mary's efforts. Had Mary lived longer, Wales might well have become a stronghold of renewed Roman Catholicism. She had married Philip of Spain in 1554, and the Glamorgan Gaol File for 1555 reads, 'Philip and Mary, by the Grace of God King and Queen of England, France, Naples, Jerusalem and Ireland, Defenders of the Faith, Princes of the Spains and Sicily, Archdukes of Austria, Dukes of Milan, Burgundy and Brabant, Counts of Haspurg, Flanders and Tyrol, unto the Sheriff of Glamorgan Greeting, &c ...' A strange case in the Gaol File for 1557 notes that eighteen persons were tried for feloniously slaying Ann Manxell, widow, as found by a coroner's jury. Among the accused were George Herbert of Swansey, knight, and William Herbert of London, gentleman. Most of the others were from Swansea. All pleaded pardon and allowance.

Mary died in 1558 from influenza, being succeeded by her half-sister Elizabeth, the daughter of Anne Boleyn. Mary had been the first woman to successfully claim the throne of England, despite competing claims and determined opposition, and enjoyed popular support and sympathy during the earliest parts of her reign, especially from the Roman Catholic population. Mary's policies failed not because they were wrong but because she had too short a reign to establish them and because of natural disasters beyond her control. However, her marriage to Philip was unpopular among her subjects, and her religious policies resulted in deep-seated resentment. The military losses in France, including losing Calais, poor weather and failed harvests increased public discontent. Philip spent most of his time abroad, while his wife remained in England, leaving her depressed at his absence and undermined by their inability to have children. After Mary's death, he sought to marry Elizabeth, but she refused him.

The Elizabethan Age

By the reign of Elizabeth I, the Justices of the Peace were almost all drawn from the ranks of the Welsh gentry. The contemporary commentator George Owen of

Henllys (Pembrokeshire) wrote that the Tudors 'gave to the Welsh magistrates of their own nation'. A modification of the 1553 Prayer Book was adopted in 1559 and the Church of England's 'middle way' between Roman Catholicism and advanced Protestantism was set out in the Thirty Nine Articles of 1563. The Welsh warmed to the this new approach to religion, partly because of the dissemination of the idea that originally the Christianity of Wales had been Protestant and that its purity had been defiled by the 'Romish' practices imposed upon it. However, elements within Welsh society remained faithful to Roman Catholicism. On Elizabeth's accession, about fifteen Welsh priests fled to mainland Europe to plan the restoration of their country to Rome. Other Welshmen involved themselves in the plots to replace Elizabeth with her Catholic cousin, Mary, Queen of Scots. However, the huge majority of the people became adherents of the state church, a marked contrast with Ireland. More radical Protestantism had little success. The Puritan John Penry of Breconshire, a vehement opponent of bishops, was hanged in 1593 and became the founding martyr of Welsh Nonconformity. He was only thirty-four when arrested and executed upon a false charge.

In the Glamorgan Gaol Files for Elizabeth's reign, we have some idea of justice and sentences of the times: 1564: Hoell Mathewe of Kayre (Caerau), gentleman, was indicted for trespass and riot. Rice Jones of Cardiff, gentleman, was indicted for trespass and affray. Gwenllian Morgan of Cowbridge, spinster, and Jane Thomas of Eglwysbrues (Eglwys Brewis), spinster, were sentenced to be burnt for murder and treason. In 1576, a coroner's inquest on the body of Rice Jones of Cardiff, gentleman, found that he was feloniously slain by Rice Herbert of St Andrews, gentleman. The latter received a general pardon. Also in 1576, we have the first record of the prosecution of 'recusants', Catholics who refused to satisfy the law by an occasional attendance at Protestant worship in the parish church. Thus, the Bishop of Llandaff presented persons within the jurisdiction of his court, for example, 'William Bylson, clerk, in the County of Glamorgan, for that he contumaciously absents himself from the celebration of divine service, and from his parish church, for four years past.' There is also in this year a long schedule of persons presented in the Bishop's Court for fornication and adultery: 'Joan Powell, of Cardiff, hath not any lands, neither exerciseth any lawful merchandise, craft or industry, whereby she may gain her livelihood, nor can give a reason or account in what manner she useth to gain her livelihood, against the form of the statute in the like case published.' The clerk of the court marked the case with 'Vagrant. To be flogged and branded.'

Joan Raffe, with five other women and two men at Cardiff, and a large number in other parts of the country, were similarly adjudged vagrants and sentenced to be flogged and burned on the hand: 'Jane vergh [ferch] Thomas, formerly of Llangonoyd [Llangynwyd], for petty larceny. Judgment, that she be placed in the stocks for two hours in Cardiff market ... Morgan ap Morgan, formerly of Laleston. Judgment, that he be flogged in Cardiff market.' In 1585, Rise Jones of Kellygaer and others were prosecuted 'for playing at tennis in the time of the Service'. Margaret Thomas of Cardyff, a widow, was prosecuted for 'bawdry' in her house, and eleven persons were presented for non-attendance at church. In 1591, John David, a yeoman of Whitchurch, was again presented before the court 'for absence from church', and

in the same year Richard Longemeade of Cardiff was hanged for stealing a horse. In 1594, Rosser James of Cardyff was presented for the sale of bad beer, and 'Antonius Coxe de Cardyff for kyllynge of fleshe in ye Shambles to ye infecc'on of the towne of Cardyff'. In the same year, 'Jevan Richard and Morgan John, formerly of Whitchurch, yeomen, at Whitchurch aforesaid, by force and with arms in and upon one David Richarde made assault and affray, and with a reaping-hook called "a welshe hooke", of the value of two shillings, which the said Jevan Richarde held in both his hands, cruelly beat and wounded and ill entreated the said David Richarde, in such sort that his life was despaired of'. 1595 saw a coroner's inquest finding that Llewelyn David was murdered by Rise Wastell, baker, of Cardiff, who was pardoned.

Prison conditions were appalling. In 1597, twelve prisoners died in Cardiff gaol. The coroner's inquest returned a verdict of death 'by the visitation of God'. Later that year twenty-one prisoners died, with the verdict as before. In 1598, fourteen prisoners died; one of them was James Turbervill of Newton Nottage, a gentleman committed for recusancy. Again that year, another four prisoners died in Cardiff gaol. One of them was Lewis Turbervill of Llysfronydd, gentleman, committed for recusancy. (The county gaol at this time was crowded with Catholics.)

The Welsh in Power – the Cecils

In 1561, William Herbert of Raglan was appointed to parliament as Baron Herbert, the first full-blooded Welshman to become part of the English aristocracy. Welshmen were found in strategic positions in legal, military and professional circles. They were in the forefront of England's colonial enterprises and filled leading positions in the Welsh Church (for the first time in many centuries). MPs from Wales first attended parliament in 1542. The gentry considered membership of the House of Commons as a way of emphasising their prestige in their home community. They were generally supporters of the Crown and when, in 1642, Charles I raised an army to resist the claims of parliament, Welsh opinion was broadly royalist.

The most influential family in the Tudor court were the Cecils. The family name was Anglicised under the Tudors from Seisyllt, and William Cecil (1520–98) entered Henry VIII's parliament aged just twenty-three in 1543. He served under Edward VI, but refused an offer to serve Queen Mary, later becoming Elizabeth's chief councillor and secretary, a post he held for forty years. Before Elizabeth became queen, Cecil ensured that she came to no harm, sheltering her at Hatfield House from the court of her Catholic half-sister. He became Lord High Treasurer under Queen Elizabeth, and is known as 'the architect of Elizabethan England'. Queen Elizabeth's most valued advisor and friend, as Lord Burghley built the greatest Elizabethan building in Britain, Burghley House. The Spanish ambassador summed up his value to Elizabeth as her chief administrator, statesman, economist and diplomat, calling him 'the man who does everything'. A consummate master of Renaissance statecraft, he was rightly famed across Europe and the only man who Elizabeth ever completely trusted. Without Burghley there could have never been an 'Elizabethan Age'. The son of William, Robert Cecil (*c.* 1563–1612) was groomed

by his father to succeed him as Elizabeth's secretary in 1596. His half-brother was made Earl of Exeter, and Robert was made first Earl of Salisbury by King James I after organising his smooth succession to the throne.

John Dee, 1527–1608

At Cefn Pawl near Beguildy was born Ieuan Ddu, John Dee, Black Jack, who became Elizabeth I's tutor, a man respected at court who was also a noted mathematician, astronomer, geographer and astrologer. 'John Dee' was however better known back in Powys as a magician and practitioner of the Black Arts than as a court adviser to Queen Elizabeth. Dee was a foundation fellow of Trinity College, Cambridge in 1546, and moved to Louvain (Leuven) in modern-day Belgium because science and mathematics were better established there. There he mixed with great minds such as Mercator, Ortelius and Gemma Phrysus. He lectured at Paris to huge audiences when he was twenty-three and returned to London to be taken into the heart of Elizabeth's court. 'An astounding polymath … the lectures of this twenty-three-year-old at Paris were a sensation; he was to be courted by princes all over Europe.' He had returned to England with navigational devices like the balestila (cross-staff), and was taken up personally by the queen, the retinue of the Earl of Leicester and the Sidneys, being at the heart of the Elizabethan Renaissance. A brilliant mathematician like Robert Recorde of Pembrokeshire before him, he published an augmentation of Recorde's *Grounde of Arts*, a mathematical textbook which ran to twenty-six editions by 1662, and wrote his own seminal preface to the English edition of Euclid, which has been called a 'landmark in mathematical thought'.

Dee claimed descent from Rhodri Mawr, and invented the term 'The British Empire' for Queen Elizabeth to prove her right to North America, which had been 'discovered' by the Welsh prince Madog ap Owain Gwynedd. Madog supposedly discovered the New World in 1170 when he brought his little fleet into what is now Mobile Bay, Alabama. The legend of Madog has him exploring the Mississippi Valley and founding the 'white' Mandan tribe, the remnants of whom were said to revere a white ancestor from over the sea. Elizabeth's court officials eagerly seized the legend, promoting attempts to find the Northwest Passage to India as justification for their war against the Spanish and proof of their legitimate claims to the Americas. This 'established' the Brythonic Celts, or the British, as the founders of her 'British' empire. Dee was the first man to call the English 'British' and conceive of a 'British Empire'. 'With his remarkable library at Mortlake, (Dee) became the thinker behind most of the ventures of the English in their search for the North-East and North-West Passages to Cathay, pouring out treatises, maps, instructions, in his characteristic blend of technology, science, imperialism, speculation, fantasy and the occult' (Gwyn Alf Williams, *Welsh Wizard and British Empire*).

Dee's first wife died on 16 March 1575 when

> the Queen's Majestie, with her most honourable Privy Council, and other her Lords and Nobility, came purposely to have visited my library: but finding that my wife was within four houres before buried out of the house, her Majestie refused to come in; but willed to fetch my glass so famous, and to show unto her some of the properties of it, which I did; her Majestie being taken down from her horse by the Earle of Leicester, Master of

the Horse, at the church wall of Mortlake, did see some of the properties of that glass, to her Majestie's great contentment and delight.

He was imprisoned by Queen Mary for allegedly trying to 'enchant' her, and a London mob sadly sacked his fabulous library in 1583 as the den of a black magician. He is said to have been the model for both Shakespeare's white Prospero and Marlowe's black Faust. The original 'Black Jack', Dee was considered 'the Magus of his Age'.

Language and Culture

In 1536 significant numbers of the Welsh gentry already spoke English. The proportion rose rapidly thereafter, but more than 200 years passed before English almost wholly ousted Welsh from the homes of the landowners. The language became confined to the working and lower middle classes, a development central to public attitudes to the language. English was to be the only language of the courts of Wales, and those using the Welsh language were not to receive public office in the territories of the King of England. Outside south Pembrokeshire, south Gower, parts of the Vale of Glamorgan and some areas along the border, the mass of the population had Welsh as their only language. Thus, it proved impossible to exclude Welsh from the courts, and interpreters had to be used on a considerable scale. It is unlikely the English authorities sought the extinction of Welsh, as this was to come later, with the introduction of the 'Welsh Not'. What the Crown wanted was uniform and peaceful administration, and implicit in that was the creation of a Welsh ruling class fluent in English.

Between 1546 and 1660, no less than 108 books were published in Welsh, compared to only four books in Scottish Gaelic and only eleven in Irish. The Welsh language, Welsh literature and the Protestant religion were immeasurably helped by the publication and widespread dissemination of the Welsh Bible. In 1584, David Powel published *Historie of Cambria, Now Called Wales*. This closely followed the arguments of antiquarian and mapmaker Humphrey Lhuyd's adaptation of the ancient *Brut y Twysogion*. It was one of many books to answer the claims of the Italian Polydor Vergil, who had cast doubts on the authenticity of Geoffrey of Monmouth's stories of King Arthur. In 1602 George Owen wrote his *Descriptions of Wales* to chronicle all the features of the country, an attempt helped by the Humphrey Lhuyd map of Wales of 1573. In his *An Apology for Poetry* of 1595, the English poet and courtier Sir Philip Sydney had lavishly praised the continuance of the poetic tradition in Wales. Two eisteddfodau at Caerwys in Flintshire, in 1525 and 1567, marked changes in the crafting of Welsh poetry. The 1567 eisteddfod saw changes in Welsh prosody, including the replacement of the old bardic system of twenty-four strict metres by that of free metres. Across Wales, thirteen endowed grammar schools were built between 1541 and 1616, and civic buildings such as market halls were being built. In 1571, Jesus College was Oxford's first Protestant foundation. Following the establishment of many grammar schools in Wales, it was founded by Dr Hugh Price of Brecon to cater to the needs of Welshmen anxious to continue their education, especially in law.

The Welsh Nation

The 'Act of Union', although it can be seen as an arbitrary act of annexation, brought about a single citizenship in Wales, while the Irish were still treated as second-class citizens in Tudor times. The Act united the country within itself, thus unintentionally promoting the notion of a viable Welsh nation. More settled conditions brought about through Tudor legal and administrative agencies ensured the growth of the economy. Carmarthen was probably the largest town in Wales in Tudor times. The 1548 South Wales chantries certificate informs us that 'there is in the Castle of Karmrthen a chapel called the King's Majesty's Free Chapel. 1100 houseling-people. The same Towne of karmrthen ys a fayre Merkett Towne, having a fare haven, and the ffarest Towne in all South Waills and of most Scevillytre.' The Cardiff Great Sessions 1548 chantries certificate for 'the parish of seynt Jones [John's] in Kardif' tells us, 'The Towne of kardif afforsaid is the Shyre Towne, being also a market Towne, walled about and sore charged with a Bridge, being vppon the water of Toof [Taff], by reason of the great rage of the streme there, and with the Repayring aswell of their Walles as also the key [quay] adyoyning to the same Towne the whiche is there edified and made for the safeguard of Shippes and other Vessells repayring to the sayd Towne.'

In Elizabethan times, the median age was around twenty-two, compared to today's thirty-nine, and there were many young men roaming the nation, with violence being endemic. The Poor Law was passed in 1572, authorising every parish to raise rates to maintain the poor, to apprentice orphan children and to punish 'rogues, vagabonds and sturdy beggars'. Its basic purpose was to get rid of 'roaming vagabonds' rather than to alleviate poverty. The penalty for vagrancy or begging was to be 'grievously whipped, and burnt through the gristle of the right ear'. Because of plagues and economic vicissitudes, there were thousands of impoverished and homeless men, women and children wandering across Britain, looking for work and food. In the past, religious fraternities had ministered to the poor. The state wished these people to stay *in situ*, but realised that there had to be some economic provision for them. The law called for the registration of all the poor, as well as an assessment of all other inhabitants, so they might contribute to their relief via a 'weekly charge', i.e. a tax.

Parishes were given the responsibility, and JPs were appointed to appoint overseers and assessors to run the new system. Different classes of poor were distinguished. The 'deserving poor' were divided into 'impotent poor' (widows, children and the disabled); and 'labouring poor' who would be helped in times of unemployment and shortage. The 'undeserving poor' were idlers, to be put into houses of correction and forced to work. Not until 1700 was the system universal across England, and it took about a century more for all the Welsh parishes to comply with a system of workhouses and 'outdoor relief'. People were restricted to their own parishes. Wales had no large towns, but the second largest cities in Britain were Bristol and Norwich, with about 12,000 each. London had 100,000 people. The Plague of London in 1563 killed 17,404 Londoners, and the influenza epidemic of 1557–9 had killed around 5 per cent of the British population. The government-sponsored lottery of 1567 had a first prize of £5,000, equivalent to a labourer's wages for a thousand years.

Industry and Agriculture

At the beginning of the sixteenth century Wales had around 260,000 inhabitants, compared with perhaps 300,000 in 1300. With a reviving economy came better housing, such as the half-timbered buildings of Hereford and the borders. Ports grew with trade. Haverfordwest was situated at the first opportunity to ford the Western Cleddau, where Henry VII's army had crossed from Dale on its way to Bosworth Field. In Elizabeth's day, it was also the highest tidal point on the river, and was a thriving port importing salt, iron, wines and apples from as far as the Forest of Dean. The second-largest port in Wales, it exported coal, slates, butter, hides, wool, oats, wheat and barley.

By the 1530s, Cardiff, Brecon, Carmarthen, Wrexham and Haverfordwest had a population of around 1,500 each, with an overall population still of only 275,000, of which 85 per cent lived in the countryside (compared to about 20 per cent today). Rural people were mainly dependent upon sheep and cattle, and drovers were responsible for many east–west drovers' trails. Wales traded animals, meat, leather, milk, butter, cheese, horn and fleeces. The population rose rapidly to around 360,000 in 1620 and to perhaps even 500,000 by 1750. However, in the sixteenth century at least, population growth probably outpaced economic growth, lowering the standard of living of the masses. There was a fourfold rise in prices between 1530 and 1640, which made the situation worse. There was also increasing landlessness caused by the estate-building activities of the English-speaking gentry. The abject poor probably constituted 30 per cent of the population, dwelling in one-room hovels lacking windows and chimneys. They were subject to the Statute of Labourers of 1563, which assumed that those without property were inherently unfree. There was some lead-mining, coal-mining, iron smelting and a wide range of crafts and professions. About half the population was made up of the lesser farmers and smallholders. In fertile areas such as the Vale of Glamorgan a smallholder could be relatively prosperous, but in the famine years of 1585–7, 1593–7 and 1620–3, many lived on the edge of destitution. Members of the professions, merchants and the more substantial craftsmen and yeomen represented about 15 per cent of the population. This was a class whose power and wealth was increasing.

Most people lived in single-storey, single-room thatched huts with beaten-earth floors, and smoke passed through the roof as there was no chimney. The huts had shutters, not windows, which in winter were normally closed to keep heat in. Candles were too expensive for most people. Faeces were thrown into an open cesspit, or people sat on a bench over a stream. This author stayed as a child at the isolated Radnorshire farm of his uncle's brother-in-law. Drinking water was taken from a hill stream above the house. Below the house was a rude hut placed above the small stream, with a plank inside for sitting upon. This was the only toilet. There was no electricity, just candles, and the old feather beds sank in the middle. This was less than sixty years ago. In agriculture, the average sheep in Elizabethan England weighed between 40 and 60 pounds, roughly a quarter the size of today's sheep. The average cow was around 350 pounds, or between a quarter and a third of a modern cow's weight. People did not bathe, just rinsed their faces and hands with water. The Venetian ambassador recorded that Elizabeth I had a bath every month 'whether

she needs it or not'. The property of women now legally belonged to their husbands, after the Acts of Union, and a husband could legally beat his wife as long as he did not actually kill her.

Lime kilns can be seen all over Wales, and many date back to Elizabethan times. George Owen (1552–1613) wrote,

> This limestone, being dug in the quarry in great stones, is hewn lesser than the bigness of a man's fist ... and being hewn small the same is put into a kiln made of walls six feet high, four or five broad at the rim but growing narrower to the bottom, having two loopholes in the bottom which they call kiln eyes ... In this kiln first is made a fire of coals or rather culm (which is the dust of the coals) which is laid in the bottom of the kiln, and some few sticks of wood to kindle the fire. Then is the kiln filled with these small hewed pieces of limestones and then, fire being given, the same burneth ... and maketh the limestones to become mere red and fiery coals, which being done and the fire quenched, the lime so burned is suffered to cool in the kiln and then is drawn forth through these kiln eyes, and in this sort is carried out to the land where it is laid in heaps. And the next shower of rain maketh it to moulder and fall into dust, which they spread on the land ... This trade of liming hath been more used within these thirty or forty years than in times past and it destroyeth furze, fern, heath and other like shrubs growing on the land, and bringeth forth a fine and sweet grass.

Welsh Surnames

Until the sixteenth century the Welsh never used the method of surnames practised by the English. Many English surnames stem from trade, e. g. Carpenter, Farmer, Taylor, Woodman, Carter, Fletcher, Bowman, Smith, Butcher, etc. Instead, the Welsh employed a system of patronymics (from the Latin *pater*, father) whereby a son would carry his father's Christian name after his own, with the word *ab* or *ap* (from the Welsh *mab*, son). Thus Rhys ap Thomas means Rhys, son of Thomas. Rhys's own son Gruffydd was thus Gruffydd ap Rhys ap Thomas and so on. With the accession of the Welsh Tudors to the throne of England, many status-seeking Welshmen Anglicised their patronymics into English-style surnames which have come down to us today. Thus ab Owen (son of Owen) became Bowen; ab Evan, Bevan; ab Einon, Beynon; ap Harry, Parry; ap Huw, Pugh; ap Rhys, Preece and Price; ap Richard, Prichard; ap Henry, Penry; and ap Robert, Probert. Others in time adopted the English style of surnames, but based them on Christian names, giving rise to the large number of people in Wales named Jones (John), Evans, Edwards, Davies (David), Williams, Thomas, Griffiths, Rees, Jenkins and the rest.

The Welsh Character of Archenfield

Across all the border counties with England, and indeed across the West Country, we can see origins of the original British language. Today one can visit graveyards in Kilpeck, Ganarew and the like in Herefordshire, and see many Welsh surnames, or

families who have been there for many centuries. In *The Population of the Welsh Border* by Melville Richards, published 1971, we read that the Domesday Book acknowledged the peculiarly Welsh character of Archenfield (Ergyng in Welsh), and that its much of its population remained Welsh and Welsh-speaking until the sixteenth century. 'Welsh was still commonly spoken here in the first half of the nineteenth century, and we are told that churchwardens' notices were put up in both Welsh and English until about 1860 ... Welsh was spoken by individuals until comparatively recently.' With the incorporation of Welsh lands into the English state in 1536/42, the old English county of Herefordshire was extended westward. The boundary between the Welsh and English lands had been the River Wye, but part of the course of the River Mynwy became the boundary between the new shire of Monmouth and Herefordshire.

It has been suggested that Offa's Dyke here was a demarcation line rather than a defensive wall and ditch. This theory is backed by the break in the dyke in Archenfield, which, although a Welsh territory, was possibly regarded as neutral territory both by the Welsh and the English. It was populated by the Welsh, but it was under Mercian control. Existing names across the area are resonant of Welsh origins. Bryngwyn, Penrhos, Llyndu, Mynydd Brith, Pencoed, etc., all based upon topography, can be visited. However, what is really noticeable in this non-exhaustive list is the prevalence of Celtic saints and their *llannau*. This is because the churches were used from the sixth century onwards. Dewsall (Dewi's Well) was probably Ffynnon Dewi or Ffynnon Ddewi. The following are English place-names, suffixed by their Welsh origin: Abbey Dore (Abaty Daur); Ballingham (Llanfuddwalan); Bridstow (Llansanffraid); Clodock (Clydog); Little Dewchurch (Llanddewi); Much Dewchurch (Llanddewi Rhos Ceirion); Dingestow (Llanddingad); Foy (Llandyfoi); Ewyas (Euas); Garway (Llanwrfwy); Golden Valley (Ystrad Daur); Ganarew (Castellgeronwy); Hentland (Henllan); Kenderchurch (Llangynidr); Kentchurch (Llangain); Kilpeck (Llanddewi Cil Peddeg); Llancillo (Llansylfwy); Llancloudy (Llanllwydau); Llandinabo (Llanwnabwy); Llanfrother (Llanfrodyr); Llangunnock (Llangynog); Llanrothal (Llanrhyddol); Llanveyno (Llanfeuno); Llanwarn (Llanwern Teilo a Dyfrig); Longtown (Y Dref-hir); Marstow (Llanfarthin); Michaelchurch (Llanfihangel Cil Llwch); Michaelchurch Escley (Llanfihangel); Moccas (Mochros); Nantgaran (Llangarren); Peterstow (Llan-bedr); River Frome (Afon Ffraw); River Lugg (Afon Llugwy); Sellack (Llansulwg); St Devereux (Llanddyfrig); St Weonards (Llansainwenarth); Treferanon (Trefranwen); Trelasdee (Tre-Lewis-Du); Tretire (Rhyd-hir); Vowchurch (Eglwys-fraith); Welsh Bicknor (Llangystennin Garth Brenni); Whitchurch (Llandywynnog) etc.

8
Wales, the Stuarts & Civil War
1604–1707

In 1621, John Davies wrote, 'It is a matter of astonishment that a handful of the remaining Britons, in so confined a corner, despite the oppression of the English and the Normans, have for so many centuries kept not only the name of their ancestors but also their own original language to this very day, without any change of importance, and without corruption' (*Antiquae Linguae Britannicae*).

Government

Mary had become Queen of Scotland when only nine days old upon the death of her father, James V, and was married to Francis II of France until his death in 1560. James Stewart was the only son of Mary, Queen of Scots. His father was her first cousin and second husband, Henry Stewart, Lord Darnley. Both Mary and Darnley were great-grandchildren of Henry VII through Margaret Tudor, the elder sister of Henry VIII. Darnley's downfall was caused by his involvement in the murder in 1566 of David Rizzio, a favoured Italian courtier who had allegedly impregnated Mary. Darnley was himself murdered in 1567, and James Stewart may well have been the child of Rizzio rather than Darnley. The Earl of Bothwell, responsible for killing Darnley, married Mary in 1567, a month after his acquittal for the murder, but an immediate uprising forced Mary to abdicate in favour of her son James Stewart, who became James VI of Scotland. Mary tried to regain the throne, but was forced to flee to England to the protection of Elizabeth I. Unfortunately, Mary had previously claimed Elizabeth's throne as her own and was considered its legitimate queen by many Catholics. Elizabeth thus had Mary confined in a number of castles and manors in England. After almost nineteen years in custody, Mary was tried and executed in 1587 for her involvement in plots to assassinate Elizabeth.

Elizabeth Tudor died heirless in 1603, and James Stewart (later known as Stuart) succeeded her as James VI of Scotland and James I of England. Scotland and England were now run as individual sovereign states, with their own parliaments, judiciary and laws, though both were ruled by James 'in personal union'. He was proclaimed 'James the First, King of England, France and Ireland, Defender of the Faith' in London, but a year later issued a proclamation at Westminster changing

his style to 'King of Great Britain, France and Ireland, Defender of the Faith, etc.' Wales was not included. Henry VIII's last will and testament had excluded the Stuarts from succeeding to the English throne, so the accession of James could have been illegal. If Rizzio was his father, this would also have made his accession invalid. James married Anne of Denmark when she was fourteen. In 1610, James's son Henry Frederick Stuart was invested as the Prince of Wales and Earl of Chester, probably giving Wales an Italian-Scottish-Danish figurehead, but died of typhoid fever aged eighteen. His brother Charles became heir to the Crown. James ruled Scotland from London, but kept the Council of Wales to control Welsh law and administration.

Industry and Agriculture

Neath Abbey was gutted in the Reformation, stripped of windows, roof and wood, and in 1584 a great copperworks was founded there, using Cornish ore. Local forests were used for charcoal, and new works at Cwmfelin and Melyncrythan followed. By the early seventeenth century, the Swansea area had become the centre of the British copper industry, and readily available local coal replaced charcoal from the rapidly disappearing woodlands. Woodlands were also lost as agriculture expanded, and sheep enclosures virtually wiped out the centuries-old strip field system. Lime kilns were increasingly built all over Wales to burn the abundant limestone into ash, to spread and improve the fertility of the soil. Slate quarrying in North Wales and lead-mining in Ceredigion and Flint became major industries. The owners of great estates now actively looked for new incomes from mining. Coal had been exported from ports in Pembrokeshire, Swansea and Flintshire, from pits at much as 100 feet deep, from the early sixteenth century. By 1607, 3,000 tons of coal a year was being sailed out of the port of Swansea. In the seventeenth century, pits up to 400 feet deep were being sunk in the massive Glamorgan and Monmouthshire coalfields. Coal extraction was also ramped up in Denbighshire and Flintshire.

In 1650, the largest town in Wales was Wrecsam with around 3,000 people, possibly followed by Brecon and Carmarthen. The Welsh population had gradually risen, after the famines and wars of the fifteenth century, to around 250,000 in 1530. However, it now grew rapidly with peace and consequent economic growth and reached 360,000 in 1620. It then rose much more slowly to 370,000 in 1670 because of the Civil Wars. In the seventeenth century, as in this, there was a widening of the income gap. Great manor houses such Tredegar House were built as wealth accumulated at the top layers of society through rents on their huge estates and mining concerns. Leading landowners came to dominate the House of Commons, and their desire for more independence and freedom from taxes was one of the leading causes of the Civil War. The Williams Wynn family of Wynnstay had accumulated 150,000 acres across North and Mid Wales, and its main member was known colloquially as 'The Prince in Wales'. A few lesser gentry and yeomen lived in houses, but the general population lived in huts with turf or thatch roofs. Because of this, hardly anything survives of the domestic dwellings of the working classes. On farms, labourers slept among rats and livestock in barns. There were terrible harvests in 1622–4 and 1636–7, and in 1639 plague returned. Inflation also caused starvation, and the development of turnpike

roads began to make life unbearable for small tenant farmers and agricultural workers.

Language and Culture

John Davies of Hereford (*c.* 1565–1618) was a 'writing-master' and poet and has been claimed by some to have written the works of Shakespeare. Hereford was still a Welsh-speaking area at this time, although officially in England. This author recently toured Hereford, and was amazed at the number of gravestones with 'Welsh' surnames such as Watkins, Edwards, Jones, Rees and the like. Hereford also has hundreds of Welsh place-names, for instance Kilpeck. *Kil* is the same word as *cil*, the Welsh for a monk's cell, hermitage or retreat, and Kilpeck derives from Llanddewi Cil Peddeg. This means the holy place or church of St David at the Cell of St Pedic or Pedoric. The adjoining castle was built around 1090 as the administrative centre of Ergyng (Archenfield). The *Book of Llandaf* records that 'Kilpeck Church with all its lands around' was given to the diocese around 650. One of the most fascinating Saxon-Norman churches in Britain, a sculpture known as the *Welsh Warriors* on a door column shows costumes unknown elsewhere in twelfth-century sculpture.

All along the Marcher counties, from Cheshire in the north to Gloucestershire in the south, there are Welsh place-names, and the Welsh language was spoken until fairly recent times. The Welsh Bible moved the people towards a standardised national language based on the speech of the north and north-west of Wales, but there are still four recognisable dialects: y Wyndodeg (Venedotian) of the north-west; y Bowyseg (Powysian) of north-east and Mid Wales; y Ddyfydeg (Demetian) from the south-west; and Gwenhwyseg (Gwent and Morgannwg) in the south-east. Today's dialects interestingly coincide with Wales' major and oldest bishoprics, which themselves are based on the old Welsh princedoms, which were themselves founded from the ruling Celtic tribes in the area. Thus the dialects date back 2,000 years. The Puritan Charles Edwards of Llansilin (*c.* 1628–92) believed that the Welsh were God's chosen people, having replaced the fallen children of Israel or having been directly descended from 'the Lost Tribes' themselves. As a literary and religious research theme, people to this day are writing upon the idea. From 1660, Edward Lhuyd of Llanforda published studies that were to have an enormous influence on antiquarian studies in Britain. Lhuyd's interest in botany and geology gained him recognition as the finest naturalist in Europe. Known as 'the father of British palaeontology', Lhuyd published his influential *Archaeologia Britannia* in 1707.

The traditional literary culture of Wales was changed by religion, the printing press and the challenges of the Renaissance. The Anglicisation of the great landowners, the continuing impoverishment of the lesser gentry and changing cultural tastes spelt doom for the bardic order. Large quantities of verse in strict metre continued to be written until at least the early seventeenth century, but the government sought to repress the less reputable elements among the 'Minstrelles, Rithmers and Barthes'. As the ancient literary tradition declined, the urge to preserve evidence of it led to much manuscript copying and collecting. By the eighteenth century, there were efforts to revive the ancient metres, particularly by the Anglesey poet Goronwy Owen. The

attitude towards the Welsh language in England was generally hostile. A flood of anti-Welsh pamphlets were printed in the seventeenth century, such as *Wallography or the Britton Described* by Northampton clergyman William Richards (1682). It wishes the speedy demise of the Welsh language: 'The native gibberish is usually prattled throughout the whole of Taphydom except in their market towns, whose inhabitants being a little raised do begin to despise it. 'Tis usually cashiered out of gentlemen's houses … so that (if the stars prove lucky) there may be some glimmering hopes that the British language may be quite extinct and may be Englished out of Wales.'

Renaissance architecture had reached Wales in the 1570s with the Denbighshire buildings of the Antwerp merchant Richard Clough. In the late seventeenth and eighteenth centuries, Wales was embellished with a number of grand houses, and towns such as Montgomery and Brecon were enhanced with fine house frontages. Formal gardens, for example those at Aberglasney, gave way to picturesque landscaping with copses of specimen trees and curving lakes. Traditional music declined but singing to the harp survived and the beginnings of choral music may be seen. In medieval Wales, education had only been patchily available in monasteries and other religious centres. Universities, particularly Oxford, now attracted Welsh students. Education for the laity was an important feature of the Renaissance and literacy was highly regarded by Protestants. Sons of wealthy Welsh families began to attend English public schools and there were eighteen grammar schools in Welsh towns by 1603. Little was done for the mass of the people until the 1650s, when the Commonwealth set up a school in every urban centre in Wales. That work was continued by the Welsh Trust from 1674 to 1681 and by the Society for the Propagation of Christian Knowledge from 1700. Academies, some of a very high standard, were founded to educate dissenting ministers.

Inigo Jones, 1573–1652

Jones was the first notable British architect, responsible for introducing the classical architecture of Rome and the Italian Renaissance to Britain. Inigo Jones has many houses and bridges attributed to him in Wales. He founded classical English architecture, bringing features of Rome and Renaissance Italy to Gothic England. He designed the Queen's House at Greenwich, rebuilt the Banqueting Hall at Whitehall, and laid out Covent Garden and Lincoln's Inn Fields. He also designed two Danish royal palaces and personally introducing the proscenium arch and movable scenery to the English stage. Between 1605 and 1640, Jones was responsible for staging over 500 performances, collaborating with Ben Jonson for many years.

His father was a Welsh Catholic cloth-worker, and Jones seems to have been apprenticed as a joiner in St Paul's churchyard before he appears in 1603 as a 'picturemaker' in the household accounts of the fifth Earl of Rutland. In 1605 he was employed by Queen Anne to provide costumes and settings for a Whitehall masque. It is fairly clear that by now he had been to Italy, probably visiting theatres in Florence, and had acquired skills as a draftsman and architect. It appears that he lived in Venice at this time, and Christian IV of Denmark induced him to leave Italy and accept an appointment at the Danish Court. Buildings are named as having

been designed by Jones in both Denmark and Italy, but proof is elusive at present. In 1608 he designed the New Exchange in the Strand for the Earl of Salisbury, and a spire for St Paul's Cathedral. His main activity until 1640, however, appears to have been designing stage settings, costumes and decorations for masques for the court, in which he worked with Ben Jonson until an argument in 1631.

In 1611, Jones was appointed surveyor to the heir-apparent, Prince Henry, who died in the following year. In 1613 he was with the fourteenth Earl of Arundel, visiting Italy and the houses of Palladio before returning in 1614. He was made Surveyor of the King's Works in the following year, and as an architect of outstanding skills, changed the focus of the appointment from one of maintenance to one of improvement. He started work on the Queen's House in Greenwich in 1617, and it was not completed until 1635. (King James's wife died in 1619, and the project was put 'on hold' for seventeen years until Charles I married). In 1619 he began building the replacement Banqueting House at the Palace of Whitehall, after fire had destroyed the old one. It was finished in 1622, and Rubens added the ceiling paintings in 1635. The Banqueting House was a setting for formal banquets and court masques, based on the design of a Roman basilica, and is still used as a venue for state occasions.

Inigo Jones's most famous ecclesiastical design was the Queen's Chapel at St James Palace (1623–25, now Marlborough House Chapel). From 1625, Jones worked on converting Somerset House into a residence for Charles I's new queen, Henrietta Maria. He also made major changes to St Paul's Cathedral, but unfortunately it was destroyed in the Great Fire of London in 1666. In 1997, more than seventy stones from Inigo Jones's 'lost' portico of the old St Paul's Cathedral were found beneath the present cathedral. Christopher Wren had used the blocks in his foundations. As the king's agent, Jones influenced the design of London houses and the development of London. He created London's first 'square' or piazza in Covent Garden in 1630, and designed the church of St Paul's on Palladian lines. Other sources state that the first square in London was his design for Lincoln's Inn. Coleshill and Amesbury were amongst the country mansions he designed. It now appears that Wilton House, attributed to Jones, was the work of his personal assistant and nephew, James Webb, and Jones acted as an advisor. Jones was painted by Van Dyck, Charles's court artist. In Wales, the magnificent Gwydir Chapel and the bridge at Llanrwst are attributed to Jones.

The English Civil War in 1642 and the seizure of the king's houses in 1643 meant that Jones was no longer employed. He was among the defenders at the siege of Basing House, from which he was rescued wrapped in a blanket. Jones regained his properties in 1646, and was buried with his parents in the Welsh church of St Benet, Paul's Wharf. Inigo Jones was a master of classical design, who broke the mould of Jacobean architecture in Britain. Most of his architectural drawings and masque designs survive, in collections at Worcester College, RIBA and Chatsworth House.

The First Civil War and Wales, 1642–7

In 1625, James I died, to be succeeded by Charles I, who preferred to rule without parliament, believing in the 'Divine Right of Kings'. Welsh support was to be vital

for his efforts. His government persecuted Puritans, and many Protestants began to support parliament, with most Catholics and Anglicans allying with the king. In Wales, as elsewhere, workers and tenants of royalist landowners were obliged to support the king. Richard Vaughan, the Anglican Earl of Carbery, owned vast estates in Pembrokeshire and Ceredigion, and large numbers of his tenants joined the king's armies. Lord Dacres of Hereford recruited soldiers for the royalists from his tenants across Radnorshire. The Roman Catholic Marquis of Worcester of Raglan Castle was the richest man in Britain, and spent nearly all his fortune supporting Charles I, fearing Puritan prosecution if parliament won power. Because he and his son Lord Herbert were Catholics, Charles was reluctant to give them military positions and antagonise the majority of Anglicans, but they supplied large numbers of troops from Monmouthshire and the borders. The Earl of Denbigh, a member of the Council of Wales, joined the royalists, but his son decided to fight for parliament. This was probably a strategy to retain their lands, whichever side won.

Most large landowners in Wales supported the king, but Thomas Myddleton, MP for Denbighshire, who had massive landholdings around Chirk Castle, was a Puritan and was thus anti-royalist. Another parliamentarian, the Earl of Essex, drew many men from his estates in Carmarthenshire when he became general-in-chief of the parliamentary army at the start of the Civil War. Philip Herbert, Earl of Pembroke, was the largest landowner in Glamorgan and his castle at Cardiff was an important base for parliamentary forces in South Wales. The parliamentarians produced thousands of pamphlets in an attempt to persuade people to support their cause. They had little impact on the Welsh people, being printed only in English.

Business interests also affected political allegiance. To obtain money without calling parliament, Charles I had sold monopoly rights. Only one person now had the right to distribute certain goods such as bricks, salt and soap, making huge profits. These people supported the king, but people who were denied the opportunity of trading in these goods often supported parliament. People in the more economically advanced areas in Wales, such as Haverfordwest, Pembroke, Cardiff and Tenby, tended to favour parliament. These all had strong trade links with the large city and port of Bristol, which was controlled by Puritans. In the rural areas of Wales, little was known of the nature of the underlying arguments against the Crown, and people had very little contact with Puritan preachers. Rural people were influenced by their local clergy and gentry, usually hostile to Puritanism.

On 27 September 1642, the king left his headquarters at Shrewsbury and travelled to Wrecsam, the chief town of North Wales. Messengers were sent out to tell people living in Flintshire and Denbighshire to assemble so they could hear their king explain the reasons for the conflict with parliament. A large number of men agreed to fight for the royalist army. He returned to Shrewsbury to be joined by his nephew Prince Rupert, who had also been recruiting men from North Wales. In South Wales, the Marquis of Hertford had also been recruiting men to join the king. By 3 October, the royalist army was strong enough to seize Cardiff Castle from the Earl of Pembroke. Charles now had an army of about 24,000 men, and most of his foot-soldiers were from Wales. Their officers were generally members of the English nobility, forming an excellent cavalry unit.

On 12 October, the king's mainly Welsh army marched on London, but on 23 October his army was intercepted by the Earl of Essex at Edgehill. Prince Rupert

charged at full tilt at the opposing cavalry. His horsemen kept close together and just before impact his men fired their pistols. The charge was successful, and for the next hour his cavaliers pursued their opponents away from the battlefield. The problem was that the poorly armed royalist footsoldiers relied on the cavalry for support. When Rupert eventually returned he discovered that the infantry had suffered heavy casualties. One eyewitness claimed that nearly 1,000 Welsh royalist soldiers were killed at Edgehill. This was followed by another 1,500 Welsh soldiers killed at Tewkesbury on 16 November, and 2,000 at Hereford on 27 November. The Welsh were poorly armed and were always placed at the front of the royalist forces where they took the main force of the charging parliamentary army. The royalist army continued towards London, and by November reached Turnham Green on the outskirts of the city. London was a parliamentary stronghold, and the way was blocked by a parliamentary army of about 24,000 men. With far fewer troops remaining, Charles retreated to Oxford to recruit more soldiers.

At the outbreak of war, Pembroke was the only town in Wales that declared support for parliament. Charles gave orders for the town to be taken. Richard Vaughan, the Earl of Carbery, lieutenant-general of the king's army in South West Wales, decided to make sure that all other towns in this region were secured, before dealing with Pembroke. He did not begin his assault on Pembroke until the beginning of 1644, but before he could capture the town, parliamentary reinforcements arrived by sea from England. Vaughan decided that his force was not strong enough to capture Pembroke, and withdrew. Rowland Laugharne, the parliamentary commander of Pembroke, now went on the offensive, taking control of Haverfordwest, Tenby and Carew Castle. His forces then marched east and captured Carmarthen and Cardiff. Charles sacked Vaughan as commander of his troops in South West Wales, replacing him with the experienced Colonel Charles Gerard. Gerard's royalist forces soon won back the territory and towns that had been lost. By the summer of 1644 Laugharne and his soldiers had been forced to return to Pembroke.

In North Wales, parliamentary forces had short-term success. Myddleton's Chirk Castle was captured by royalists in January 1643. He was now placed in charge of the parliamentary campaign in North Wales. Major-General Myddelton's main strategy was to cut off the king's military supplies, which were arriving in North Wales from the Continent. After capturing Wrecsam in November 1643, he headed for the ports of Wales' northern coast. However, Conwy, Bangor and Caernarvon were well defended and after 2,500 royalist troops arrived from Ireland, Myddelton was forced to withdraw. Myddelton next turned his attention to Mid Wales. In the summer of 1644 he captured Welshpool and then Newtown. On 18 September the first major battle of the Civil War in Wales took place at Montgomery. The royalists suffered a heavy defeat, with over 2,000 being killed, wounded or captured. Myddelton's troops headed back north and in October captured the great Powis Castle. However, Myddelton was unable to win back control of his own castle at Chirk. As he could not persuade parliament to supply him with any more troops, Myddelton had to abandon his plan to try to regain control of the northern ports.

In 1645, the king ordered Colonel Gerard and 2,700 of his soldiers help the royalist campaign in England. With the royalist forces weakened in South Wales, Laugharne attacked again. The battle was unusual as it was in part decided by an amphibious

assault. On 29 July, Rowland Laugharne took the field with 800 men. On the same day, Admiral Sir William Batten arrived at Milford Haven with his fleet. The two men worked out a plan to defeat the royalists under Sir Edward Stradling. On 1 August, Laugharne faced Stradling on Colby Moor, while Batten sent the frigate *Warwick* to the north-east corner of Milford Haven, where he unloaded 200 seamen, who attacked the already pressed Stradling in the rear, resulting in a major parliamentary victory. Laugharne was next able to capture Carmarthen, and by the spring of 1646 the whole of western Wales was under the control of the parliamentary army. This increased the danger to Charles I, who was himself in Wales at this time.

Charles had suffered a severe defeat at Naseby in June 1645. Amongst those killed after the battle were over 100 Welsh women who had followed their husbands. Later, the parliamentary army justified its action by claiming that as the women spoke a language they did not understand, they assumed they were Irish Catholics. After the Battle of Naseby the king withdrew to Raglan Castle. Charles hoped that he would be able to persuade more Welshmen to join his army. However, Colonel Gerard's treatment of the Welsh after his victories in 1644 had turned them against the royalist cause. To protect themselves against Gerard's royalist troops, men in Glamorgan had formed a 'Peaceable Army'. Charles agreed to meet representatives of this group at St Ffagans on 29 July 1645, to discuss their grievances.

Charles now agreed with them to remove Gerard as commander of the royalist forces in South Wales. Despite this action, Charles still had difficulty recruiting local men into his army. On 14 September the king left Raglan Castle and headed for North Wales. Soon after the king left, Raglan was captured by the parliamentary army and irreparably sacked. Other royal castles at Ruthin, Chirk, Caernarvon, Beaumaris, Rhuddlan, Flint and Harlech fell one by one to the parliamentarian forces. For a while, Charles stayed at Denbigh Castle but after Astley and his royalist army surrendered on 21 March 1646, Charles fled to Scotland. The first Civil War ended with the capture of Harlech Castle by parliamentary forces in March 1647. During the conflict, there was in Wales some support for parliament, in south Pembrokeshire and the Wrecsam area in particular. Wales was called 'the nursery of the King's infantry' and suffered disproportionate losses. The struggle in Wales was mainly concerned with control of the northern and southern coastal routes.

The Second Civil War and Wales, 1647–9

While the First Civil War involved thousands of Welsh soldiers and ended in Wales, the Second Civil War started in Wales and was mainly a Welsh and Scottish affair. After victory over the royalists in March 1647, parliament made plans to disband its army. On 24 December, parliament declared that all soldiers who had enlisted after 6 August 1647 were to be dismissed without pay. Those that had joined at an earlier stage of the war were to receive only two months' wages. Many of its Welsh troops had been unpaid for months, and in 1648, parliamentary soldiers in South Wales mutinied. They had been ordered to disband before their arrears of pay had been settled. Colonel John Poyer, the governor of Pembroke Castle, made speeches to his soldiers attacking parliament's decision to disband the army. Parliament sent Colonel

Fleming to Pembroke in March 1648 to defuse the situation, but Poyer refused to hand the castle over. Instead, he sent a letter to parliament demanding the payment of £1,000 in wage arrears for his men. Colonel Fleming offered £200, which was rejected. Poyer's men then routed Fleming's troops. He marched into Ceredigion, declared for the king on 10 April 1648, and began to recruit troops. The Second Civil War thus started in Pembroke. Encouraged by Poyer's declaration for the king, ex-royalist soldiers began joining Poyer in Pembroke. Parliamentarian officers and the royalist gentry of Pembrokeshire also joined with Poyer and the disaffected soldiers.

The two most senior army officers in South Wales, Major-General Rowland Laugharne and Colonel Rice Powell, went to join Poyer. Laugharne, parliament's commander in South Wales during the First Civil War, took command of the rebel army. Both Laugharne and Poyer confidently expected help from the fleet under the command of Charles, Prince of Wales, but it never arrived. When Poyer heard that Cromwell was to march against him, he boasted that he would 'give him a field and show him fair play, and that he will be the first man that will charge against Ironsides; saying that if he had a back of steel and breast of iron he durst and would encounter him'.

Parliament was deciding what to do in Pembroke when it heard that Charles I had come to an agreement with the Scots. In 1648 Charles agreed to the establishment of the Presbyterian religion in Scotland, in return for the support of a Scottish army. The parliamentary commander, General Fairfax, sent Colonel Thomas Horton with one regiment of foot and two of horse, along with Colonel Okey's regiment of dragoons, to deal with South Wales. There were skirmishes around Carmarthen and Brecon in May. Laugharne and nearly 8,000 rebels left Pembroke and engaged Horton's parliamentary force of 3,000 at St Ffagans in Glamorgan. Although outnumbered, Horton's experienced and well-disciplined army was able to defeat Laugharne's poorly armed soldiers on 8 May 1648. Horton had around 1,500 horse compared to Laugharne's 500-strong cavalry. Laugharne was wounded during a last desperate charge with his reserves. The royalist army was routed. Over 200 of Laugharne's men were killed and another 3,000 were taken prisoner, many sent to Barbados as slaves. Many of Laugharne's men had been locally recruited in Glamorgan, fighting with agricultural implements. However, perhaps half of the rebel force managed to escape with Laugharne to regroup at Pembroke Castle, held by Colonel Poyer. Despite the defeat at St Ffagan's, the revolt spread to other parts of Wales. Richard Bulkeley and the people of Anglesey declared their support for the king, and Sir John Owen attempted to take Denbigh Castle from the parliamentary army. In the south of the country Colonel Rice Powell and 500 troops had taken control of Tenby and Sir Nicholas Kemoys and other local royalists had captured Chepstow Castle. Colonel Horton marched west to besiege Tenby Castle.

The situation was in the balance, until parliament decided to send Oliver Cromwell and three regiments of foot and two of horse to Wales. He had reached Gloucester when St Ffagan's was won. Cromwell occupied the town of Chepstow on 11 May, but Sir Nicholas Kemoys resolutely held the castle for the king. Leaving Colonel Ewer to conduct the siege, Cromwell marched on through Cardiff and Swansea to join Horton in the siege of Tenby, arriving on 23 May. Cromwell left Horton to besiege Tenby while he took his main force to Pembroke. Cromwell burnt Carmarthen

Castle, and laid siege to Pembroke Castle, commanded by Poyer and Laugharne. Colonel Ewer took Chepstow Castle by storm on 25 May, with Kemoys being killed in fierce fighting. The walled town of Tenby was taken and the castle was starved into submission. Colonel Powell surrendered and was taken prisoner on 31 May.

The great medieval fortress of Pembroke is situated on a rocky promontory to the west of the walled town and surrounded on three sides by the tidal River Cleddau. Its landward side was defended by a deep ditch and walls up to 20 feet thick. Cromwell arrived to supervise the siege on 24 May. He found that the artillery he had brought with him was inadequate to breach either the town walls or the immense walls of the castle. An attempt to take the town by storm on 4 June failed because the parliamentarian siege ladders were too short for the 80-foot-high walls, and a second attack was driven back on 24 June. Under the direction of Major-General Laugharne, the defenders sallied out and raided the parliamentarian siege works, killing thirty of Cromwell's soldiers. Heavy siege artillery was then sent from Bristol by sea, but initially the transport vessels were driven back by storms. Only on 1 July were the huge cannon finally landed at Milford Haven and brought up to Pembroke. It was one of the strongest fortresses in Europe.

Attempts at storming the castle failed and so Cromwell was forced to wait and starve the rebels into submission. Under intense bombardment, breaches were opened in the town and castle walls. Cromwell wrote to parliament forecasting that the castle would be forced to surrender in about two weeks. However, he was initially unaware that the castle had its own excellent water supply. The garrison was running short of food and ammunition and the soldiers were becoming mutinous when Cromwell issued a final summons on 10 July. He would give no quarter unless the castle was surrendered. Poyer and Laugharne surrendered the next day, after seven weeks of fighting. (According to a later story, Pembroke surrendered after Cromwell was informed of a way to deprive the defenders of water by cutting a conduit pipe.) Upon entering the town, Cromwell ordered that Pembroke's defences should be demolished. The town walls, the barbican and castle towers were brought down by mining and gunpowder.

Cromwell now marched north to deal with a royalist Scottish army which had invaded as far as Preston. With an army of 9,000, Cromwell's Roundheads won a brilliant victory against an army twice as large to virtually end the war by August 1648. While Cromwell hurried north to deal with Langdale's rebellion, Laugharne, Poyer and Powell were sent to London. Cromwell had dealt leniently with former royalist soldiers. His anger was directed towards the three men who had previously been high in the parliamentary army. In April 1649, the three men were court-martialled and all condemned to be executed by firing squad. Thomas Fairfax ruled that the sentence would be carried out on only one of them, to be decided by drawing lots. The three men refused to take part in the lottery to decide who would be executed. The military authorities chose a young child to draw the lots. The papers drawn for Laugharne and Powell read, 'Life Given by God.' Poyer's paper was blank and he was shot in front of a large crowd at Covent Garden on 25 April 1649.

The Second Civil War sealed the fate of Charles I. He was executed in January 1649 and two Welsh MPs were among the signatories of his death warrant. During the era of the Interregnum (1649–60), Wales saw significant developments in religion

and education but the Welsh gentry remained pro-monarchy. The war destroyed major houses like Caer-Gai, Raglan (with its great library) and Mathafarn. Llandaf Cathedral was sacked and hundreds of churches stripped. Newcastle Emlyn and Aberystwyth castles were blown up, and Caernarfon and Conwy unroofed. Wales had been royalist and suffered for it.

Religion

In 1617, we see that in Cardiff alone twenty-three people were prosecuted by the Crown for recusancy, including a Turberville of Sker. In 1622, twenty-seven persons of both sexes were prosecuted for recusancy. They belonged to Newton Nottage, Cadoxton-juxta-Neath, Colwinston, Ewenny, Margam, Pyle and Kenfig, Gellygaer, Eglwysilan, Llanfabon and Llanblethian. The list is headed by the names of Mathew Turbervile of Newton Nottage, gentleman, and Alice Turbervile, of the same place, spinster. (The Turbervilles of Sker were staunch Catholics, and one or other member of the family was almost continually in prison for his religion during the reigns of Elizabeth and James I.)

1625 saw nine inquests in Cardiff, with the verdict of 'by the visitation of God' on the bodies of persons who died through disease at Cardiff; two of these were deaths in the gaol. The gaols at this time were hotbeds of fever, and imprisonment for any considerable length of time practically meant death. Contagion sometimes spread from the prisoner's dock to the judge on the bench. The Cardiff Grand Jury presented that Thomas William of Colwinston, yeoman, uttered these treasonable and seditious Welsh words: 'Mae dy vrenyn yn drewy ger bron Duw yn y bechod val ddoyt tithe William hoel.' ('Thy king doth stincke before God in his sin as thou dost, William Howell.') Such records are incredibly important, as indictments for libellous, slanderous and treasonable writing or speech are almost the only class of public records which furnish specimens of the Welsh language. It was necessary to set forth the precise words complained of, hence the employment of the vernacular in these documents. They therefore thus possess a great value for students of Welsh, and all the more so because the Welsh they contain is often remarkable for interesting dialectic forms.

Across Wales there was a culture of absentee churchmen, leading to the rise of itinerant preachers. The movement of the leading Welsh gentry to London and the royal court helped the rise of Nonconformism across Wales. Also, the rise in literacy following the translation of the Bible helped the spread of new ideas. After the execution of Charles I in 1649, parliament wanted to provide sufficient ministers of the gospel to reach those areas of the country they deemed sufficiently in need, especially the 'dark corner' of Wales. The 1650 Act for the Better Propagation and Preaching of the Gospel appointed many prominent Puritan government officials as commissioners in Wales. The commissioners' task was to investigate complaints against the resident clergy, who had mostly supported Charles and the doctrine of Divine Right. The act also created sixty-three new schools that taught children to read and write, although English was the sole medium of instruction. Wales was still largely monoglot Welsh-speaking at the time.

The commissioners' work was not renewed in 1653, but 'suitable' ministers continued to be selected by the agents of parliament, and many gifted preachers arrived in Wales to live and work. Huge influence came from the zeal of evangelists. Vavasor Powell of Radnorshire came to prominence as a particularly enthusiastic enforcer of the new religion. Powell first advocated public hymn-singing, and was the most dynamic preacher and recruiter of them all. From the efforts of such tireless and inspired workers came the founding of the first 'gathered church' of independents in Wales in 1639. Walter Cradock of Llangwm, Monmouthshire, William Wroth of Abergafenni, William Erbery of Roath, Morgan Llwyd of Maentwrog, Henry Walter of St Arfan's, Jenkin Jones of Llandetty, John Miles (possibly of Swansea) and Vavasor Powell of Cnwclas (Knucklas) were recognised Puritan leaders who were responsible for the later Welsh Nonconformist congregations, whether Presbyterian, Baptist, Quaker or Congregationalist.

Cradock (*c.* 1606–59) was an Anglican curate at Peterston-super-Ely in Glamorgan, who became curate to Erbery, the vicar of St Mary's in Cardiff. William Laud expelled the two of them from the church, along with William Wroth, for unorthodox preaching in 1633. They also demanded strict abstinence from all sports on the Sabbath, against the teaching of the Book of Sports, which specified activities which people could undertake. In 1634, Cradock was in Wrecsam as an evangelical preacher, converting Morgan Llwyd (1619–59). Llwyd became influential under Cromwell's rule, and was probably Wrecsam's first Nonconformist minister. Cradock was forced to move away to Herefordshire, where he met Vavasor Powell. In 1639, Cradock, with William Wroth and William Thomas, an early Baptist, founded with Congregationalists the first Nonconformist chapel in Wales, at Llanvaches, Monmouthshire. Cradock went to Shrewsbury, then was sheltered in Herefordshire in 1639 before founding an independent congregation at Llanfair Waterdine, just over the Welsh border in Shropshire.

At the outbreak of Civil War, the Llanvaches congregation moved with Cradock to Bristol, where there was an independent church. Royalist forces then occupied Bristol. In 1643, Cradock moved with some of his followers to London, where he preached at All-Hallows-the-Great, In 1641 Cradock was in the group of preachers for Wales authorised by the Long Parliament. In 1646, Cradock, Henry Walter and Richard Symonds received funding to preach in Welsh. (Cradock had preached in Welsh to captured royalist Welshmen after Naseby in 1645.) Cradock was one of the 'Welsh saints', along with Vavasor Powell and Jenkin Jones, who commanded troops of the parliamentarian major-general Thomas Harrison. (Samuel Pepys attended the hanging, drawing and quartering in 1660 of the regicide Harrison.) Cradock was the regular preacher to the Barebones parliament, and supported Cromwell's Protectorate against Vavasor Powell's criticisms.

Vavasor Powell (1617–70) lived at Cnwclas near Llanfair Waterdine and was converted to the Puritan understanding of the Bible by Cradock. From 1639 he preached around Wales, twice being arrested, before preaching in London during the Civil War. He was funded to return to Wales to evangelise, although he had refused to be ordained by Presbyterians. He actively ousted churchmen whom he deemed incompetent, and in 1653 was asked to become a pastor in London. He denounced Cromwell for taking the title of Lord Protector, and was imprisoned.

At the Restoration, he was again imprisoned for preaching and spent nearly all of the remaining ten years of his life in prison, dying there. William Wroth (1576–1642) was the Anglican vicar of Llanfaches from around 1617, and a direct influence upon Cradock. In 1633, Charles I, advised by William Laud, Archbishop of Canterbury, reissued the 'Declaration of Sports', the sports permitted on Sundays and other holy days, to counteract the growing Puritan calls for strict abstinence on those days. Wroth, Craddock and Erbury all defied the instruction to read the Declaration to their congregations, and in 1634 the Bishop of Llandaf reported Wroth, seeking to remove him from his position. In 1635 the bishop admonished Erbury and suspended Craddock. Wroth had inscribed on his churchyard stile,

> Who Ever hear on Sonday
> Will Practis Playing At Ball
> It May be before Monday
> The Devil Will Have you All.

In 1638 Wroth and Erbury both resigned, but Wroth continued to preach and to gather followers. At Llanvaches in Monmouthshire, people travelled Breconshire, Radnorshire, Glamorgan, Hereford, Somerset and Gloucestershire to hear Wroth, and he had to preach in the churchyard because the church was too small. By 1639, although he had not formally left the Church of England, Wroth was ejected from his living at Llanvaches and in response set up an independent chapel. His new chapel in Llanvaches was organised 'according to the New England pattern', i.e. Congregationalist. This marked the real beginning of Nonconformism in Wales. William Erbery (1604–54) was a radical Independent theologian, ejected in 1638 by the Bishop of Llandaf from St Mary's in Cardiff for being a 'schismatic'. In 1642 he was a chaplain in the parliamentary army, preaching that the New Model Army was 'the army of God, as public persons', representing the people.

Erbery wanted a parliament of 'saints' to carry out God's will, and asked Cromwell to abolish tithes and the state church. He argued with Presbyterians and Baptists, and thought that the system of churches was tainted, denying the divinity of Christ. John Miles (*c.* 1621–83) was part of a Reformed Baptist church in London, and returned to Ilston in Wales, serving as a minister from 1649 to 1662. This became the earliest recorded Baptist church in Wales. He also 'tried' and recommended ministers for the parliamentary government. During the 1650s he built on this success, establishing chapels elsewhere across South Wales as well as being posted to official positions, yet the Restoration brought this progress to an abrupt end. Upon the Restoration, Miles left with followers from Islton for the Plymouth Colony in America in the 1660s. He worked with the Congregationalist state church in Rehoboth before his group was told to leave the town for their Baptist views. With his congregation (largely from Ilston), Miles then founded the town of Swansea in Massachusetts and the First Baptist Church of Swansea. In 1681, William Penn was given proprietary rights to Pennsylvania. In a letter to his friend Robert Turner, one day after being granted his lands in North America, Penn gave his reasons for not calling the area New Wales. He chose Pennsylvania instead, with the translation as 'Head Woods', as a play upon his name.

These preachers planted a new religious consciousness in Wales that had an enormous impact on the future political, social and cultural development of the nation. Nonconformist chapels sprang up everywhere in their wake, such as those of the Independents, Baptists, Quakers and others, creating a heritage that until very recently was still regarded as an integral part of the Welsh character. However, the forces of Nonconformity were moving too rapidly after the Restoration of the Monarchy. The new king, Charles II, and his new parliament pushed for the Act of Uniformity of 1662. This required all ministers to assent to the rites and liturgy of the Established Church, restored with the accession of Charles II in 1660. Then the Clarendon Code, which consisted of four acts passed from 1661 to 1665, imposed severe penalties on those who refused to conform to the Act of Uniformity. Whole congregations such as those at Ilston moved from Wales to the New World. They became instrumental in setting up such settlements as the Commonwealth of Pennsylvania, which was established by Welsh Quakers.

In 1664, the Conventicle Act prohibited groups of more than five persons from assembling for religious worship, other than that prescribed by the Established Church. It had the effect of furthering emigration to North America, where Welshmen became prominent in municipal government and the universities. In 1667 Charles Edwards of Llansilin published *Y Ffydd Ddi-Ffuant* (The Sincere Faith), proposing that the Welsh were the chosen of God, having replaced the Israelites or having been descended directly from 'the lost tribes of Israel'. His book deals with the history of the Welsh people, the history of the Christian religion and the spiritual condition of individual Welshmen. With the arrival of the Methodist preachers in Wales, demand grew for printed works to educate the common people. Much seventeenth-century Welsh literature was designed to preach the Gospel. Preacher-poet Rhys Pritchard published his *Canwyll y Cymry* (The Candle of the Welsh) in 1681. The book contained simple, moral verses that later became the source of many Welsh hymns, and helped keep the language alive as one of the only books available for children.

More and more acts ensured that such sects as the Quakers and Baptists were forced to meet in secret or join their brethren across the Atlantic Ocean. Although the Toleration Act of 1689 allowed Dissenters to worship in their own chapels, it did nothing to keep them from being excluded from municipal government and the universities. In the American colonies, Welsh people quickly became prominent in both fields. In Wales the Quakers in Montgomeryshire became the targets of persecution. One of the most famous cases involved the Lloyds of Dolobran, a prominent and much-respected old family. Members were thrown into jail as a consequence of their beliefs.

Charles II was not ill-disposed towards the Catholics – he converted to the faith on his deathbed. However, when money had to be raised to pay for his public and private extravagances, he was always willing to propitiate the Puritans by a fresh persecution and fines on 'Papist Recusants'. In 1661, at Cardiff, eighteen Catholics from the parishes of Cadoxton-juxta-Neath, Llanharry, Llanharan and Llancarfan were indicted for absenting themselves 'from their respectiue parish churches or chappells to heare divine seruice & performe their duties there upon Sundayes & other holy dayes for the space of these three moneths last past contrary to the Lawes

& statutes'. Among the recusants at Cadoxton-juxta-Neath was Watkin Richard, a harper. Even widows and labourers are included in the list, together with Mathew Gibbon and Hugh Jones, both gentlemen of Llancarfan. The others were yeomen.

In 1679 we see documents in connection with the trial of two Catholic priests, Father Philip Evans, a Jesuit, and Mr John Lloyd, a secular, both Welshmen. These two priests were executed as traitors at Cardiff on 22 July 1679, the mode of execution being as follows. First they were dragged on hurdles to the gallows. Then they were hanged for a few moments. Before they were dead they were cut down, disembowelled alive, and dismembered. Although these men underwent the terrible punishment for high treason, it is important to learn, from the indictments, that what they were charged with was simply that they, being Catholic priests, 'proditorie came, were and remained' in this country, against the form of the statute. The simple addition of the word *proditorie* (treasonably), made the priests traitors. No attempt was made at their trial to convict them of actual treason, their *proditio* being purely constructive and technical.

Among the witnesses against Father Philip Evans sworn before John Arnold, Esquire, Justice of the Peace at Abergavenny was Mayne Trott, who tendered the most important evidence of the accused's having exercised the functions of a Catholic priest. This man was deformed, and had been successively Court Dwarf to the Kings of Spain and England. He had professed himself a Catholic and married a relative of the Jesuit Father David Lewis, who, principally on Trott's evidence, was hanged, drawn and quartered at Usk this same year. Trott was a tenant and servant of Justice Arnold, who was a priest-hunter, and supplied Arnold with information as to the private affairs of the Catholics in South East Wales. Shortly after the execution of Father David Lewis, Mayne Trott fell dead in a street in London. Catholics ascribe his death to a divine judgement on the dwarf for his large share in the death of their priests. In August 1703, the following indictments were recorded:

> Wee Doe present upon the Oath of Lawrence John & John Thomas, Evan William of the parish of Pentirch for playing on the Harp on the Lord's Day Commmonly Called Sunday being the 25th of July past in ye church yard of ye chappel of Llaniltern Contrarie to her Majesties Lawes in that case made & provided … Item Wee Doe present upon the oath of the said Lawrence John & John Thomas, Rees John & John David of the pariish of Pentirch & Richard John of the parish of St ffagans for playing tennis on severall sundaies within these 3 monthes last past in the church yard of the chappell of Lanilterne Contrarie to her Majesties proclamation & the Lawes of this Realme.

The cases indicate the rapid rise of Sabbatarianism in Wales.

The Glorious Revolution

James II succeeded his brother Charles II as king in 1685, but had converted to Catholicism in exile in France. Charles II had in reality wed the Welsh Lucy Walters, and their 'illegitimate' son, the Duke of Monmouth, was the true heir to the throne.

DNA has testing proved that Charles was his father, and their wedding was known about and recorded at the time. James put down the Monmouth Rebellion and Monmouth was executed with seven or eight blows of the axe in 1685. James is best remembered for his belief in the Divine Right of Kings, and tried to create religious freedom for both Catholics and Nonconformists. Parliament was opposed to the doctrine of Divine Right, which they could see was being accepted in other European countries and leading to dictatorial royal houses. It also opposed the loss of legal supremacy of the Anglican Church. These differing views made James's four-year reign again a struggle for supremacy between the English parliament and the Crown. This resulted in his fleeing to exile in France, an event ruled by parliament as being his de facto abdication. His daughter Mary had married the Protestant William of Orange. When William landed in Devon in 1688 he had 500 ships, 20,000 mariners and 20,000 soldiers. To accompany his entry into Exeter, he had '200 blacks brought from the Netherlands' plantations in America, wearing embroidered caps lined with white fur, and plumes of white feathers'. With the bloodless 'Glorious Revolution' of 1688, the reign of the Protestant monarchs William and Mary, and the Bill of Rights Act, at last began an era of religious toleration which was to last.

The People

The Stuarts were restored in 1660 with the accession of Charles II. Despite the Restoration, parliament had won the upper hand. For a century and more, power in Wales lay with the great families, twenty at most, who controlled the country's parliamentary representation. Elections were nearly always decided through private deals between landowners. Between 1660 and 1714, less than 10 per cent of the constituency returns of Wales were decided by the casting of votes. Political allegiance was determined by attitudes to the Stuart monarchy, with the Whigs supporting both the dethronement of James II in 1688 and the accession of the Hanoverian dynasty in 1714. The Tories accepted those changes more reluctantly. By the mid-eighteenth century, the failure of Jacobite plots to restore the exiled Stuarts meant that there was little to choose between the parties. Landed families still considered themselves as either Whigs or Tories, however.

In 1617, the Cardiff Gaol records give us the following instructive crimes and sentences: 'Miles Edwards was this year in the County Gaol, committed on a charge of clipping coin. He was condemned to death, but reprieved ... John Philips, committed for feloniously stealing a cow. Being convicted, he asked for a book, but could not read. Was sentenced to be hanged ... The like in the cases of John ap Owen, for manslaughter, and David John for burglary ... Elizabeth Gunter, committed for theft, pleaded guilty to the value of 10*d*. Sentenced to be flogged. John ap Jevan of Cardiff to be flogged for stealing a ewe.' A very strange case occurred in 1619, where John David of Tythegstone was indicted for castrating a ten-year-old boy: 'for cutting or gelding the privie members of John Wm a chield of abouts xen yeere oulde'. An entry for 1705 tells us that the River Taff in Cardiff was full of salmon at this time: 'John Mathews of Llandaff, gentleman, and Howell Richard, of Whitchurch, labourer, were presented for unlawfully fishing in the river Taff, in the

parishes of Whitchurch and Radyr, with nets and certain engines called "piches" and "butts," and taking 100 trout, 100 salmon and 1,000 seed of salmon, against the form of the statute.'

Thomas Morgan – the Unknown General

Thomas Morgan (1604–79) was one of four brothers born in Llanrumney Hall, Cardiff, a cadet branch of the Morgans of nearby Tredegar House. Of his brothers, Robert Morgan farmed locally and was the father of Sir Henry Morgan. Edward Morgan became a general in the royalist army, whereas Thomas was a general for the parliamentarians. This seems to have ensured that, whatever happened, Llanrumney Hall and its estates would stay in the Morgan family after the Civil War. The eldest brother, William, stayed out of the war. Thomas was Welsh-speaking, and left to become a soldier at the age of sixteen. Thomas enlisted in Sir Horace Vere's Protestant volunteer expedition which fought in the Thirty Years' War. Morgan fought in the Low Countries and in particular assisted the Dutch in the decisive victory at the Battle of the Slaak in 1631, and then under Fairfax in the Thirty Years' War. He fought in German, French and Dutch armies, and served Bernard of Saxe-Weimar in the Thirty Years' War, but returned upon the outbreak of the First Civil War to offer his service to General Fairfax and the parliamentary cause. He served as a captain of dragoons under Fairfax. (Oliver Cromwell himself was of Welsh origin, and signed his early documents as Cromwell alias Williams.)

Morgan took part in the siege of Lathom House in 1644, under Fairfax. Morgan was promoted to major after distinguishing himself at the Battle of Nantwich in January 1644 and the following year was made a colonel on the recommendation of Lord Fairfax. Thomas Morgan was known as 'The Warrior', and was described by Sir Thomas Fairfax to parliament as 'an expert in sieges'. In June 1645, Morgan became governor of Gloucester, an isolated parliamentarian stronghold in the royalist Welsh marches. Morgan succeeded in gaining the respect and co-operation of unruly parliamentarian troops and of the citizens of Gloucester. He was active in reducing royalist strongholds, assisting at the siege of Berkeley Castle in September 1645, capturing Chepstow and Monmouth during October, and collaborating with Colonel Birch in a surprise attack to seize Hereford in December 1645. Despite suffering from gout, he shared the same facilities as his troops, and always charged in the vanguard of any assault. When Lord Astley marched for Oxford with the last royalist field army in March 1646, Morgan joined forces with Birch and Sir William Brereton to intercept and defeat Astley at Stow-on-the-Wold, the final pitched battle of the First Civil War.

In April 1646, Morgan had been appointed commander of parliament's forces in Gloucestershire, Herefordshire and Monmouthshire with orders to reduce remaining royalist strongholds in the region. Although he was driven back from Worcester, Morgan captured Hartlebury Castle in May and negotiated the surrender of Raglan Castle in August, after a three-month siege. He captured Chepstow Castle and Monmouth in the same year. As the war drew to a close, Morgan's troops became mutinous over parliament's proposals for disbandment without settling arrears of

pay, and Morgan himself seems to have fallen from favour. He was superseded as governor of Gloucester in January 1648 and was not given a command in the army sent to Ireland. He retired to the Yorkshire estate of his wife, whom he had married in August 1644.

Morgan returned to military service in 1651 when Cromwell asked him to serve in the expedition to Scotland, remaining with General Monck when Cromwell pursued Charles II's army into England. Morgan was present when Monck captured and sacked Dundee in September 1651. When Monck returned to England to recover his health early in 1652, Morgan stayed in Scotland. He took over command at the siege of Dunnottar Castle, defended by Sir George Ogilvy, which surrendered in 1652. Morgan was then based at Inverness during Glencairn's Uprising (1653–4), commanding all Commonwealth forces north of the Tay. He co-operated with Monck, who returned to Scotland in April 1654, to intercept Major-General Middleton's Scots-Royalist army in the Highlands. Morgan defeated Middleton at Dalnaspidel near Loch Garry in 1654, ending Highland resistance forever. On Monck's recommendation, Morgan was promoted to major-general in February 1655.

In 1657, Cromwell chose Morgan to lead the army to assist the French in Flanders against the Spanish. Wounded at the siege of St Venant, Morgan led a successful attack on Spanish forts around Gravelines in April 1658 and effectively commanded the English contingent at the Battle of the Dunes on 4 June. After the capture of Dunkirk on 25 June, Morgan led the four English regiments that continued to serve with the French army throughout the summer of 1658. The great Cardinal Mazarin, Chief Minister of France, and other distinguished persons sought meetings with 'this famous warrior'.

In 1658, returning to England, the new Lord Protector Richard Cromwell knighted Morgan and gave him control of the Highlands again. Richard Cromwell was deposed by Major-Generals Lambert and Lilburne, who wanted a military republic. Only General Monck opposed them. Both sides courted the most capable soldier in Britain, Thomas Morgan. In 1660, Morgan transferred his allegiance to those seeking the restoration of the monarchy. Morgan's coming was 'a great accession to Monck's party, and a great encouragement to all then officers and soldiers: for he was esteemed by them to be, next to the general, a person of the best conduct on any then in arms in the three nations, having been nearly 40 years in arms and present in all the greatest battles and sieges in Christendom for a great part of that time'.

Morgan was acknowledged as the greatest cavalry leader in Britain, and Monck's cavalry was his weakest link. Morgan supported Monck during the political manoeuvring that brought about the Restoration in 1660, keeping command of the army in Scotland while Monck marched on London. With Morgan's support, Monck restored Charles II to the monarchy. Morgan personally fired off the huge cannon, Mons Meg, in the celebration of the Restoration in Edinburgh. King Charles immediately awarded Sir Thomas Morgan a baronetcy. He commanded the infantry in an English expeditionary force to assist the Portuguese against Spain in 1662 and was appointed governor of Jersey in 1665. War with Holland broke out in 1665 and Morgan was sent to build defences at Jersey as its governor. Morgan, the uncle of the great privateer, is unknown but without him Britain might be a republic.

Admiral Henry Morgan, *c.* 1635–88

Henry was the son of Glamorgan squire Robert Morgan, who was the fourth and youngest son of the landowner Thomas Morgan of Llanrumney Hall. The oldest brother, William, had the estate, while the two middle brothers fought on opposite sides in the Civil War. Henry was probably born at Llanrumney Hall or Pencarne Manor, as he called his plantations in Jamaica by these names. Charles II was almost as unlucky a king as his father. Always in financial trouble and with his grip on the Crown less than firm, his reign saw the Great Plague, the Great Fire of London. To make things worse, the Dutch sailed up the Medway in 1667 and destroyed his fleet, taking the flagship. It is still Britain's worst naval defeat. The Dutch War ended with favourable terms to the Dutch. The only good news for his unsettled nation was 'the Sword of England', Admiral Henry Morgan. He was not only the greatest privateer of all time, but the greatest general of his times, successfully leading six inland invasions of Spanish territories.

As the son of the fourth son on a landed estate, Henry Morgan had no desire to follow his father into farming. His uncles had been prominent in the Civil War, and Henry set sail from Bristol in 1654 on the ill-fated Penn-Venables Expedition. It was supposed to take Hispaniola (now Haiti at its west end, and the Dominican Republic at its east end) for the Protectorate. After a shambles involving two defeats on that island, the English force took the hardly defended Jamaica from Spain instead. Morgan stayed in Jamaica, seeking his fortune. Jamaica now served as a base for free-booting European privateers to operate against Spanish America. Privateering was the practice of the state commissioning privately owned ships to attack enemy merchant ships. It came into its own with the sea-dog captains of the Elizabethan age, men such as Drake, Hawkins, Frobisher and Raleigh. Legally sanctioned, it was fundamentally different from piracy, which preyed on all shipping, in that it focused upon enemy ships only. The Crown often sold privateering licences in return for a cut of the spoils. Many of the privateers who fought the Spaniards in the seventeenth century became known as buccaneers, from the French *boucaniers*, meaning sun-dryers of meat.

Morgan was so successful a privateer that within two years his share of the booty enabled him to buy his own ship. Aged just twenty-nine, he now used Jamaica as his base, and from here he harassed the Spanish on the American mainland and built up an enormous treasure trove. When the Spanish started attacking British ships off Cuba, the governor of Jamaica asked Morgan to return from sea and scatter the Spanish fleet. Morgan was then made Admiral of the Jamaican fleet of ten ships and 500 men, because of his courage and success. By 1665, Morgan had made enough money to marry his first cousin Elizabeth, the daughter of Edward Morgan of Llanrhymney, deputy-governor of Jamaica since 1664. From 1666, Morgan allied himself with Edward Mansfield, the famous buccaneer, and on Mansfield's death was elected 'admiral' of his buccaneer fleet. Governor Modyford of Jamaica gave Henry Morgan commissions to attack the Spanish.

Well documented is Morgan's sacking of Puerto Principe (now Camaguey in Cuba) in 1668. In the same year, he looted and ransacked the largest city in Cuba, Porto Bello, and Maracaibo in Venezuela. On his return to his Jamaican base,

Morgan had lost just eighteen men, and plundered 250,000 pieces of gold and silver coins, jewellery, silks, spices, munitions, weapons and slaves. Captain Morgan was just thirty-three years old, with a reputation that had attracted seafarers from all over the West Indies to join his flag. After his sacking of Porto Bello in Panama, Morgan attacked a French ship. It appeared that the French had given 'notes of exchange' to an English ship previously, in return for provisions. These notes had not been 'honoured' when presented for payment in Jamaica. Morgan positioned his flagship, the *Oxford*, in a bay in south Haiti, waiting for a sighting of the French ship. When it appeared, he invited the captain and officers to dine with them. Over the meal, he rebuked them for their treatment of the English ship, and imprisoned them. Morgan and his crew commenced carousing, firing guns into the air in their drunken dancing. Unfortunately, a spark of gunfire lit the powder magazine, and there was an explosion. 300 crew and the French prisoners were blown to bits.

Morgan and his officers were at the stern of the ship, and survived, being furthest away from the explosion. He returned to the site later in the *Jamaica Merchant* to try and salvage the ship, during which the *Jamaica Merchant* also sank. Also in 1669, the Spanish Capitan Pardal swore vengeance upon Morgan. After making a small raid on a Jamaican village, he left the following note pinned to a tree near the smouldering village hall. 'I, Capitan Manuel Pardal, to the Chief of Privateers in Jamaica. I come to seek General Henry Morgan, with two ships and twenty-one guns. When he sees this Challenge, I beg that he will come out and seek me, that he may see the Valour of the Spaniards.' Within weeks, Pardal was caught near the east coast of Cuba, and shot through the neck in battle.

On his return to Jamaica, Morgan was put in charge of thirty-five ships and 2,000 men. Still aged only thirty-five, he decided to break the power of Spain in the West Indies by attacking Panama, their largest and richest town in the Americas. Meanwhile, Britain and Spain had negotiated peace in London and orders were despatched to him to call off any attacks on Spanish colonies. Morgan ignored the orders, reached the mainland in 1670, and marched across the Isthmus of Panama towards the city. In the course of this devastating raid, Morgan and his men succumbed to the heat and disease as they hacked their way through the jungle, destroying every fort and church in their path. By the time he reached Panama, in January 1671, Morgan had only half of his original 2,000 men left, but he attacked the defending force with such venom that they fled the city. 150 mules were needed to take the booty back to the ships.

The Spanish put a price on Morgan's head, and as the raid had occurred in peacetime, he was arrested and extradited to London in 1672. Governor Modyford had already been sent home to answer charges. Luckily for Morgan, the peace did not last and he was released after paying out a huge part of his treasure to the Crown. King Charles II knew he could not imprison the greatest hero of his reign when his own position was still precarious. To Spanish fury, Charles knighted Morgan and sent him back to Jamaica as lieutenant governor of the island, where Morgan died a successful planter, at the age of fifty-two in 1688. He was buried in Port Royal on 26 August 1688. The publishers of the English-translation of Esquemeling's contemporary book, *The Buccaneers of America*, were sued by Morgan for calling him a 'pirate' and questioning his upbringing in 1685. This was the first-ever recorded case of damages being paid and apologies being made for libel. Subsequent editions feature the publisher's apologies.

9
The Eighteenth-Century Welsh: The Effects of Education, Religion & the Industrial Revolution

The Wales and Berwick Act of 1746 created a statutory definition of 'England' as including England, Wales and Berwick-upon-Tweed. This definition applied to all Acts passed before and after the Act coming into force, unless a given Act provided an alternative definition. Thus an arbitrary Act of an undemocratic English parliament somehow transformed Wales into part of England.

The Rise of the English Entrepreneur

English manufacturers began to come to Wales and use its mineral riches, with innovations over the next two centuries placing Wales at the centre of the Industrial Revolution in Europe. Among them was the pioneering John ('Iron-Mad') Wilkinson, who had an ironworks at Bersham, near Wrexham, from 1761. Most of the cylinders for Watts' steam engines and cannon for the American War of Independence were manufactured at Bersham. British iron-making had begun on this site in 1670, and smelting iron ore with coke had started in 1721. In 1765 Anthony Bacon (1717–86) rented 4,000 acres of mineral-rich land around Merthyr for around £100 per annum. By 1850 the lease was worth £20,000. He opened a massive blast furnace at Cyfarthfa in 1767, having taken over the nearby Plymouth Ironworks to supply pig iron to Cyfarthfa. Cyfarthfa made bar iron, and Bacon also leased the Hirwaun ironworks. In 1773, the cannon made by Carron in Scotland were withdrawn from service as being too dangerous. Bacon offered four cannon to the army for trialling. Three were made with charcoal, coke and mixed fuel respectively, along with a more expensive, but far better 'cast solid and bored' cannon, which was accepted.

John Guest (1775–1852), with Isaac Wilkinson, founded the Plymouth Ironworks on leased land at Merthyr in 1763, but despite producing fine metal, it was transferred to Bacon in 1765. Guest became manager of the Dowlais Ironworks, Merthyr in 1767. Dowlais had been founded in 1759 as a partnership between Thomas Lewis, Isaac Wilkinson and others. Dowlais later moved into Guest family ownership, and under John's grandson Josiah (the husband of Charlotte Guest, Lady Llanofer), it became the largest ironworks in the world. Samuel Homfray (1762–1822) took over the lease of Anthony Bacon's cannon foundry at Cyfarthfa, before founding the

Penydarren Ironworks nearby in 1784. Homfray and his brother Jeremiah had stiff competition from Cyfartha and Dowlais, and Jeremiah moved to set up an ironworks at Ebbw Vale. Samuel Homfray subscribed £40,000 of the £103,000 cost of the 1795 Glamorgan Canal, which allowed the transport of heavy manufactured iron to Cardiff docks. In 1804 Samuel won a 1,000-guinea wager with Richard Crawshay as to which of them could first build a steam locomotive for use in their works. Homfray employed Richard Trevithick for this purpose and his locomotive won the bet, successfully hauling five wagons, carrying 10 tons of iron and seventy men, at a speed of 5 mph. This was a quarter of a century before Stephenson's *Rocket* won the Rainhill Trials and was acclaimed as the world's first locomotive.

In 1783, Henry Cort's iron puddling process was invented. By 1784 it had been adopted across Merthyr and Ebbw Vale, vastly speeding up the rate of iron production. Because of Wales' predominance in making iron, it became known as 'the Welsh method'. The method ensured that the industry was no longer reliant on coke. Enormous local supplies of bituminous or semi-bituminous coal ensured that Merthyr kept its lead in production and innovation.

After Abraham Derby's experiments of the 1730s, coke had begun to replace charcoal for smelting iron, so industrialists wished to place their smelting works near abundant supplies of coal. Alexander Raby, in partnership with his brother-in-law Thomas Hill Cox, proprietor of the Monmouthshire Canal, invested in copperworks and collieries in the Neath area. Raby is said to have first taken an interest in Llanelli around 1792 when he considered leasing coal under land belonging to Sir John Stepney. There was an old iron furnace on the Stradey Estate, dating back to 1750, and Raby persuaded ironfounders to come to Llanelli, where they began to build an iron furnace and foundry on land at Cwmddyche (later known as Furnace). Raby now invested heavily in his new industrial empire, modernising and expanding the ironworks at Cwmddyche, installing steam engines and an extra furnace. He started to build a railway, which connected his ironworks with the new pits he had sunk, and the shipping place he formed at Llanelli Flats, now known as Seaside. He built Carmarthenshire Dock in 1799 on the River Lliedi at Llanelli as a shipping point for his coal and iron. It was known as 'Raby's Shipping Place' and was served by a tram road from Raby's Furnace at Cwmddyche. In 1802 Raby's works produced armaments and ammunition for the Napoleonic Wars and his furnaces were said to have been kept busy day and night.

Industry and Agriculture

Rapid industrialisation and economic progress led to a population in Wales of 370,000 in 1670 rising to 489,000 in 1750, more than double the population in Tudor times. It increased again to 530,000 by 1780. This was despite the Little Ice Age of the 1690s, which had led to starvation and labourers leaving the land for towns. Wales was still mainly a rural country in 1750, but there was an expanding industrial base across the nation. In rural areas, there was frequent famine. In Newborough, Anglesey in 1757, several men were charged with riot and assault during food riots. They included William William and William Williams, tailors; John Prichard and Evan Thomas,

labourers; Richard Roberts, weaver; and Evan Williams and William Prichard, shoemakers. Interestingly, two carpenters who were arrested gave their true Welsh names: Hugh John ap William and John ap William. Larger towns led to outbreaks of frequently fatal smallpox, and deadly typhus epidemics from the early eighteenth century. At the same time, more land enclosure acts led to dispossessions across rural Wales, and greater pressures upon towns and living conditions by displaced families looking for work. Most industries had been established in the time of Elizabeth I, but there was an upsurge in manufacturing as landowners looked to make more money from their estates. In the eighteenth century, iron-making prospered in Pontypool and Bersham, as did coal-mining in west Glamorgan and Flintshire, lead and silver-mining in Flintshire and Cardiganshire, and copper smelting in Neath and Swansea.

The Roman copper workings in Anglesey reopened in 1761 and near Amlwch the copper deposits of Parys Mountain were exploited from 1768, when the 'Great Lode' was discovered. The mountain is one of the earliest mining sites in Europe, later exploited by the Romans. In the 1780s it dominated the world's copper market, being easily the largest mine in Europe, with 1,500 men working in terrible conditions. Its copper was used to 'copper-bottom' or sheath the hulls of naval vessels to protect the wood from being waterlogged by the teredos worm, and also slowed down by barnacles and seaweed. Ships were able to patrol longer at sea, no longer having to dock constantly for maintenance on their hulls. The consequent increase in speed and manoeuvrability enabled the victory at Trafalgar, and the building and protection of the British Empire, with the strongest navy in the world. Parys Mountain at Amlwch used up to 15,000 tons of gunpowder a year to extract copper ores at the height of production from 1790 to 1815. Thomas Williams, the 'Copper King' of Llanidan, Anglesey, controlled the world copper market from around 1788 until his death in 1802.

The copper industry, which began at Holywell in Flintshire around 1750, could now use Welsh ore from Anglesey. Huge copperworks were built first at Holywell in the north and then at Swansea by Thomas Williams. Swansea became the chief copper producer of Britain, if not the world. By 1750 Swansea was smelting 50 per cent of Britain's copper, and by 1799 over 90 per cent, giving it the name of 'Copperopolis'. Morriston copperworks opened in the late eighteenth century, and by end of the century Swansea was the largest town in Wales. In copper making, the Welsh process was acclaimed as one of the finest examples of skilled metallurgical art. Neath also became an important smelting area for copper and lead, and from 1710 tramways were manufactured there. Wales controlled half of the world's copper production by the end of the century. Coal from the Welsh Valleys provided a solution to the scarcity of charcoal, and was available in enormous quantities. An influx of experienced ironmasters and their workers came mainly from the Midlands to supply the technical know-how to produce high-quality iron. In South East Wales, the coming of industry completely changed the landscape and the way of life.

In the middle of the eighteenth century there was an explosion of mining, quarrying, iron manufacturing and all their related industries. In the north-west of Wales, the huge Mona and Parys copper mines transformed the economy and the landscape. In Caernarfonshire and Meirionnydd, huge quarries employed thousands

of men to quarry the slate that roofed houses and municipal buildings throughout Europe and even America. By the end of the eighteenth century, Holywell had many industrial workings, including copper and brass foundries, along with woollen and flannel mills. In North Wales, there were collieries at Flint and Bagillt; iron foundries at Mostyn, on the Dee Estuary; and the beginnings of extensive coal mining at Llay, Gresford, and Point of Ayr. Around 1750 there were 2,000 lead miners in Ceredigion, along with perhaps 800 in Flint. In north Glamorgan and Monmouthshire, iron, coal and limestone were being heavily exploited. The tin-plate industry grew, with Pontypool becoming famous for imitation lacquer Japanware.

There had been iron smelting at Bersham and Pontypool from 1730, and then massive works were built at Merthyr Tydfil. The development of a new form of energy through the steam engine accelerated the Industrial Revolution, and ironworks rapidly adopted the new invention. The first experiment in locomotion was made in Merthyr and Welsh coal came in even greater demand, for steam engines. Deep pits were opened, with tonnage rising from 220,000 tons in 1750 to 760,000 tons in 1775. Much was exported, first through Swansea, and then increasingly from Cardiff Docks. Docks and lighthouses were built all around the Welsh coast, and there was an influx of workers from outside Wales. Cardiff became a wealthy town. Corporate shindigs at taxpayers' expense are nothing new. To celebrate Nelson's victory at the Battle of the Nile in 1798, in Cardiff Corporation records we find details of a celebration at the old Cardiff Arms Hotel:

> The Corporation of Cardiff to Edward Thomas. 1798 Octr 25. To forty six Dinners 2/6d, £5 15s. To 4 Bottles of Sherry wine 18s. To 4 Doz. & 2 Bottles of Port £8 15s. To 2 Doz. & 2 Bottles of Lisbon £4. 11s. Desert 11s. 6d. Ale & Porter £1 3s. ordered the servants 5. 0 TOTAL £2. 18. 6 ... Mr. T. Morgan, You will be kind enough to pay the bill. B. Williams. Cardiff Oct. 28th/98. 80 Bottles wine. [Endorsed] Mr Thomas, Cardiff Arms. Nelson's victory. £21. 18. 6. The elumenation night Cardiff. Nelson's victory.

This sum amounts to around £1,800 using today's Retail Price Index, but £22,800 using average earnings.

The agricultural economy was also developing, with the adoption of crop rotation, the use of lime, the enclosure of wasteland and the development of proto-industrial production, especially in the woollen industry. Looms began to appear in farm outbuildings, and by the 1770s there were fifteen fulling mills near Dolgellau. A fulling mill, or *pandy* in Welsh, was located near water and cleaned and bulked up cotton and woollen fabric. The cloth was held on great frames by tenterhooks, and cleaned and beaten with wooden hammers. In earlier times, stale urine was used to whiten cloth. The process of enclosing common land was speeded up following 1793, as parliament passed almost 100 acts authorizing the enclosure of 200,000 acres of land in Wales. These lands, belonging to the people of Wales, came into the possession of those such as the Duke of Beaufort, who is covering his large, unvisited lands in South Wales with wind energy plants. The eldest son of Beaufort, also known as the Earl of Worcester, is known as the Earl of Glamorgan. Welsh people were forced off the land to emigrate overseas or move to rapidly growing industrial districts. One wonders about the legality of enclosures of German lands, with hundreds of thousands of acres

accruing to a small number of families in Wales and Scotland.

Livestock went to England on drovers' roads, and produce was generally shipped. In upland Wales there was a shortage of winter feed for animals, so animals were sold to drovers and their agents at early summer fairs. Sheep, cattle, pigs and geese were then driven in the autumn to markets in England. Much of the livestock from Mid Wales passed via Oxfordshire to London. The same long-distance drovers' routes, over open and enclosed moorland, are incorporated into today's roads and lanes. In 1794, a government report on agriculture in Ceredigion recorded that farm labourers were badly paid, overworked, underfed and lived in hovels. In 1793, several hundred copperworkers and colliers had marched on Swansea protesting the high price of grain, cheese and butter and demanding higher wages. One of the consequences of poverty was crime, and the new colony of Australia took two men and two women convicts from Wales in the 'First Fleet'. Before then, the medical officer on Captain Cook's *Discovery* had been Dafydd Ddu Feddyg (Black David the Doctor). In the 1830s more convicts arrived, including Lewis Lewis, sentenced following the Merthyr Riots, and John Frost, following the Newport Rising. Perhaps the most famous of all the Welsh immigrants to arrive 'Down Under' was Joseph Jenkins, who left Wales because of a nagging wife. His exploits earned him the nickname of 'the jolly swagman' of the popular song.

Transport

The north-east, served by the ports of the Dee Estuary, and close to Lancashire, was the first region of Wales to be integrated into the main system of turnpike roads. The deep southern valleys presented greater problems. Merthyr Tydfil was linked to Cardiff by packhorses carrying pig iron in panniers. Anthony Bacon at Cyfarthfa then built the road in the 1760s, but the major innovation of the eighteenth century was the canal network. To link the ironworks of Merthyr to the port of Cardiff, canals began to be constructed in the 1790s. By 1800, the towns of Swansea, Neath, Cardiff and Newport had all been linked to coalfields by canals. In North Wales, the completion of Telford's 1,007-foot-long Pontcysyllte Aqueduct, a wonderful feat of engineering and now a World Heritage Site, carried the Shropshire Union Canal across the River Dee at a height of over 120 feet. Its leak-proof, cast-iron trough was supported by nineteen great piers. The success of the 1794 Glamorgan Canal was followed up by other canals linking the ports of Newport and Swansea to their neighbouring inland industrial areas of Ebbw Vale in 1796 and the Swansea Valley in 1798. The use of thousands of Irish 'navvies' to dig the canals hastened the decline of the Welsh language.

Roads were poor, and increasing tolls made transport of cereals too expensive; 'black cattle are all taken to Kent and Essex, the pigs and salt butter to Bristol; and the barley and oats to Bristol and London'. Until the eighteenth century, parishes were responsible for the upkeep of public roads, and with increasing road usage, parishes were increasingly reluctant to bear the costs of road repairs. This led to parliament passing many private Turnpike Acts, giving responsibility for upkeep to local landowners. The trustees of these roads were allowed to impose tolls upon road

users. In Ceredigion, for example, the first Turnpike Act in 1770 divided the country into two parts along a line from Aberaeron to Lampeter. A 1783 Act enabled the Carmarthen-Lampeter Trust to build a new road linking the Teifi and Towy Valleys. In 1791, a trust was allowed to build a turnpike road from Lampeter to Aberaeron, replacing the existing road from Llanrhystud through Talsarn. Lampeter became an important centre for trade, with another turnpike road from Aberystwyth and Cardigan meeting there. From 1786, tolls were charged upon carts carrying lime, the essential soil additive to counter acidity on farmlands and smallholdings. The roads were seen as income-earners by local landlords, much like today's wind farms, and public discontent simmered into rebellion in the next century. Because new turnpike roads were built alongside the industrialisation of Wales, this in turn led to more and better bridges. In 1756 William Edwards built the longest stone arch in Europe over the Taff at Pontypridd. He and his sons built road bridges elsewhere in Wales. The growth of the North Wales slate industry was ensured by the building of a road from the inland quarries to the coast at Port Penrhyn, near Bangor by Richard Pennant in 1790. Expanding ports also helped in the growth of the Welsh maritime industry, an important part of the country's economy, especially in the export of the products of the growing Welsh woollen industry. In the next century, the early railway age was a huge boost to the Welsh economy, as many of the new industrial growth regions were difficult to access.

Education

In 1674, a charitable organisation had been set up in London by Thomas Gouge to establish English schools in Wales and also to publish books in Welsh. Over 500 books were published. Many of these were translations of mainly Protestant tracts that encouraged private worship and prayers. Along with the six major editions of the Bible that appeared during the same period, they had the unpredicted effect of ensuring the survival of the Welsh language. The Society for the Propagation of Christian Knowledge (SPCK), the oldest Anglican mission agency, had been founded in 1698 by Sir John Phillips of Picton and Humphrey Mackworth of Neath among others. It set up a network of charity schools in Wales. Unlike similar schools set up in Scotland, where the use of Gaelic was for a long time forbidden, those in Wales, begun between 1700 and 1740, condoned the use of the Welsh language. The SPCK published many books, mostly translations of religious works, including Ellis Wynne's *Gweledigaetheu y Bardd Cwsc* (The Vision of the Sleeping Bard) in 1703. *The Vision* became one of the most popular and enduring of the Welsh classics.

Griffith Jones started evening classes across Wales for the labourers, farm workers and those who worked in the trades, and these 'circulating schools' were an enormous success in spreading literacy in Wales. It is claimed that Wales had the highest proportion of people who could read and write, and therefore became 'the most literate nation in Europe'. In publishing his *Welsh Piety* in 1740, Griffith Jones stressed the need for the people of Wales to be able to read the Scriptures for themselves. He was married to the sister of John Philips (one of the founders of SPCK), and tirelessly and selflessly helped to set up schools in almost every parish in Wales, as

well as his evening classes for illiterate workers. John Davies has pointed out that Empress Catherine of Russia commissioned reports on the schools in Wales in 1764, as did UNESCO in 1955, as paradigms of successful teaching. It has been estimated that perhaps as many as one third or more of the population of Wales could read their scriptures by the time of churchman Griffith Jones's death in 1761. 200,000 people, almost half the inhabitants of Wales, achieved a level of literacy through his efforts. Griffith Jones's circulating schools were copied by Thomas Charles of Bala after his death. In 1784 Thomas Charles set up the successful Sunday School movement in North Wales, which had huge influence on the language and culture of the area. Under Charles' leadership, the British and Foreign Bible Society published the standardised text of their first Welsh Bible, and the SPCK its edition of the New Testament.

Religion

Democratic and religious movements developed in Wales. However, in 1746, legislation was passed that in all future laws, references to 'England' would by default include Wales. The same attitude was true of religion. Wales was, by definition, 'England' and did not matter, and the Welsh language was not needed. Emphasis upon the importance of the Bible and reading had been the most crucial factor in keeping the Welsh language alive. An increasing problem in the survival of Welsh was the continual appointment of monoglot Englishmen to Welsh bishoprics. Welsh was excluded from church services, to which problem Lewis Morris referred in a letter in 1764: 'What can you expect from Bishops or any other officers ignorant of a Language which they get their living by, and which they ought to Cultivate, instead of proudly despising. If an Indian acted thus, we would be apt to call him Barbarous. But a Scot or Saxon is above Correction.' This was written to Evan Evans, a Welsh poet-curate who could not obtain a living in Wales, only a curacy under an absentee English rector. From 1715 to 1870, no Welshman was appointed a bishop in Wales and many vicars were still absentee Englishmen.

In 1766 an ailing, seventy-year old English monoglot was given the living of Trefdraeth and Llangwyfan in Anglesey. Only five of the 500 parishioners spoke any English. In 1768, the churchwardens brought a case of unfitness against the Englishman upon the grounds that he spoke no Welsh. In 1773, Canterbury decided in favour of the wardens, but the English rector kept the job. The argument used by the rector's counsel in court should be read by all Welshmen:

> Wales is a conquered country, it is proper to introduce the English language, and it is the duty of the bishops to endeavour to promote the English, in order to introduce the language … It has always been the policy of the legislature to introduce the English language into Wales … The English language is, by act of parliament, to be used in all courts of judicature in Wales, and an English Bible to be kept in all the churches in Wales that by comparison with that of the Welsh, they may the sooner attain to the knowledge of English.

The attitude of the Anglican Church to the Welsh language helped other Christian faiths to prosper. Roman Catholicism had its strongholds, particularly in Monmouthshire and Flintshire. However, following the anti-papal hysteria of 1678–9, Catholicism in Wales languished until the nineteenth century, with its large-scale Irish immigration. Following the Restoration evangelical Protestants suffered some persecution, to some extent alleviated by the Toleration Act in 1689. In 1676, probably one in twenty people attended dissenting services and even by 1716 Wales only had around seventy chapels, compared with almost 1,000 parish churches. The breakthrough leading to the Methodist Revival now came from the literacy campaigns of Griffith Jones from 1734 to 1771. The Methodist and other evangelical groups generally had Welsh-speaking ministers. In 1735, Howel Harris (1714–73) converted to Methodism, and because of his tireless zeal in converting others, he is called 'the father of Methodism in Wales'. Harris worked closely with other religious enthusiasts such as the Calvinistic Methodist Daniel Rowland (1713–90), William Williams, Peter Williams and the English evangelist John Wesley.

Welsh Methodists developed their own administrative structures. Unlike the Methodist movement in England, they embraced a strict Calvinist theology, and their followers were encouraged to constantly read and study the Welsh Bible. The Toleration Act 1689 had allowed free worship, previously practised in secret, but only in licensed meeting-houses. Chapel-building by dissenters such as Quakers and Wesleyans began. In 1742, the first Methodist chapel was built at Groeswen near Caerphilly, but soon after the congregation defected to the Independents. The second, at Aberthin near Cowbridge, is now a village hall. Hundreds of Methodist chapels were built over the next 150 years. By 1750 there were 428 seiadau or Methodist fellowship meetings in Wales. Methodist leaders at first saw their movement as a renewal force within the Established Church, denying that they wished to establish a separate denomination. They originally wished to change the Established Church from within. They attracted increasing numbers of adherents, and this encouraged other Nonconformist denominations such as Baptists and the Congregationalists to widen their evangelical appeal. The Welsh were quickly becoming a predominantly Nonconformist people. The eighteenth century in Wales was 'the century of Methodism'. This new preaching zeal, with its emphasis on individual salvation and especially on 'the word', brought home the need for literacy and education. This, in turn, increased the demand for more printed works. The number of books printed in Welsh, nearly all religious, had increased rapidly after the Restoration of the Monarchy in 1660, and now accelerated. There are three figures always associated closely with the Methodist Revival: Howel Harris, Daniel Rowland and William Williams 'Pantycelyn' (1717–91). Williams was the great hymn-writer of the revival, composing almost 1,000 hymns in both Welsh and English. His most famous hymn is 'Cwm Rhondda', beginning with the words 'Guide Me Oh Thou Great Jehovah'. He travelled thousands of miles, preaching and selling his hymn books, and supported himself by selling goods such as tea. In 1762, Williams published his *Caniadau y Rhai Sydd ar y Mor o Wydr* (Songs of Those That Are on the Sea of Glass), a collection of 130 inspirational hymns.

Culture

The Anglican priest Theophilus Evans was disturbed by the forces of Nonconformity sweeping through Wales and threatening the authority of the Established Church. He worked to keep alive some of the ancient Welsh traditions. His most important work, first published in 1716, is *Drych y Prif Oesoedd* (Mirror of the First Ages), in which he tells the history of the Welsh people from the Tower of Babel to the death of Llywelyn ap Gruffydd in 1282. In the same vein, Lewis Morris, concerned that the traditional patrons of Welsh culture were increasingly turning to English books and culture, wrote *Tlysau yr hen Oesoedd* (Treasures of the Ancient Ages) in 1717. Henry Rowlands was an Anglican priest, and his *Mona Antiqua Restaurata* of 1723 not only surveyed the antiquities of Anglesey, but also attempted to prove that the ancient order of Druids had originated there. His book revived an interest the Druids, influencing London Welshmen at the end of the century.

In 1764 Evan Evans published *Some Specimens of the Poetry of the Ancient Welsh Bards*, following his research into ancient manuscripts. He was responsible for the preservation of priceless medieval Welsh literary works such as the *Red Book of Hergest*. Evans (Ieuan Brydydd Hir) discovered and published Taliesin and Aneurin's *Y Gododdin*, previously unknown to the literary world. John Parry (Parri Ddall of Rhiwabon, *c.* 1710–82) was blind from birth. The Griffiths family of the Cefn Amwlch were his patrons and gave him a Welsh triple harp. Parry became harpist to Sir Watkin Williams-Wynn at Wynnstay, Rhiwabon, becoming a master at High Baroque pieces. He sometimes played in London, and inspired Thomas Gray to to write his 1757 poem, *The Bard*. It is claimed that Parri dictated to his fellow compiler Evan Williams, in his manuscript *Antient British Music* (1741), a then-unnamed aria subsequently published and named 'Nos Galan' (New Year's Eve). It is now known as 'Deck the Halls with Boughs of Holly'. In 1792 Sir William Jones (whose study of Sanskrit led him to discover the link between Welsh and other Indo-European languages), announced the discovery of America by Prince Madoc 300 years before the voyages of Columbus. Jones praised the so-called Welsh Indians, calling them 'a free and distinct people, who had preserved their liberty, language and some traces of their religion to this very day'.

An article in *The Gentleman's Magazine* of October 1792 noted the following: 'This being the day on which the autumnal equinox occurred, some Welsh bards, resident in London, assembled in congress on Primrose Hill, according to ancient usage.' Present was Edward Jones, who had published his *The Musical and Poetical Reelicks of the Welsh Bards* in 1784 in an attempt to try to preserve native Welsh traditions. These were being stamped out by the new concept of muscular Methodism, which despised people enjoying themselves with alcohol, music, dance and familiarity between the sexes. In 1802, Edward Jones continued his attack upon the Nonconformity which was uprooting Welsh culture:

> The sudden decline of the national minstrelsy and customs of Wales is in a great degree
> to be attributed to the fanatic impostors, or illiterate plebeian preachers, who have too
> often been suffered to over-run the country, misleading the greater part of the common
> people from their lawful church, and dissuading them from their innocent amusements,

such as singing, dancing and other rural sports, with which they had been accustomed to delight in from the earliest times ... The consequence is, Wales, which was formerly one of the merriest and happiest countries in the world, is now become one of the dullest.

Welshmen of Note of the Eighteenth Century

'Black' Bart Roberts, or Bartholomew Roberts was born John Robert in Casnewydd Bach, Pembrokeshire. One will not find Roberts in the *Dictionary of National Biography*, but he was by far the most successful pirate of all time, single-handedly almost stopping transatlantic shipping. This author has written his biography, and discovered that he is far better known in America than Blackbeard and Captain Kidd. They took less than thirty ships between them. Roberts took over 400 documented vessels, including a heavily guarded treasure ship of the Portuguese Armada. Black Bart has recently been called 'the real Jack Sparrow'. He was taken from a slave ship by another Welsh pirate, Howell Davis, and on Davis' death commanded multinational crews including freed black slaves and senior pirates who called themselves 'The House of Lords'. Ranging across the seas from Europe to the Americas and back to Africa, 'The Great Pyrate' was a teetotal Christian who dressed in red silks from head to toe, wore the tremendous diamond cross of the King of Portugal, and ordered his musicians to play hymns on Sundays. His death in battle against the Royal Navy in 1722 was followed by the greatest pirate trial of all time, yet he is hardly known in Wales. This author has been rebuked for 'glorifying' a Welshman who became a pirate, but pirate ships were floating democracies. Roberts was elected captain, for his navigational skills, shortly after being captured. He was reluctant, but became a great commander and courageous leader of men, and from his mouth we have the term 'A short life and a merry one shall be my motto'. Naval and merchant ships were terrible places, full of impressed crew members, whipped at an officer's whim. Bart was a marvellous character who should be remembered and celebrated across Wales. Pirate ships were the most democratic places on Earth in the eighteenth century.

Richard Price of Llangeinor (1723–91) was a moral philosopher, author and preacher, best known for his *Observations on the Nature of Civil Liberty* in 1776, in which he fervently supported the right of the American colonies to independence. For his work, Price was honoured in England, France and America, where he was offered citizenship. On 6 October 1778, the American Congress resolved 'that the Honourable Benjamin Franklin, Arthur Lee and John Adams ... to apply to Dr. Price, and inform him that it is the Desire of Congress to consider him as a Citizen of the United States, and to receive his Assistance in regulating their Finances.' Price's ideas were revolutionary. He urged that governments create a surplus of revenue over expenditure, allow it to build at compound interest and retire the public debt. He also promoted the then-revolutionary idea that British MPs were simply trustees to carry out the wishes of their constituents, and those communities such as Wales had the right to govern themselves. He was visited in London by Tom Paine, Benjamin Franklin, Thomas Jefferson, John Adams (second President), Prime Minister Lord Shelburne, David Hume, Adam Smith,

William Pitt and other leading politicians and thinkers. In 1781, solely with George Washington, Price received a law doctorate from Yale University (itself founded by a Welshman). He was officially mourned in France.

The essays of David Williams of Eglwysilan (1738–1816) were published in 1782 as *Letters on Political Liberty*, in which he advocated radical political reform. Its publication in French led to his being offered citizenship of that country. Many of Williams' ideas were later adopted by the Chartists in the mid-1800s. A philosopher, preacher and friend of Benjamin Franklin, he founded the Royal Literary Fund.

The greatest scholar of early modern Wales was Edward Lhuyd (1660–1709). He established the links between the Celtic languages and offered considered theories concerning the antiquities, botany and geology of Wales. In 1707, Lhuyd published the first volume of *Archaeologia Britannica: an Account of the Languages, Histories and Customs of Great Britain, from Travels through Wales, Cornwall, Bas-Bretagne, Ireland and Scotland*. Lhuyd noted the similarity between the two Celtic language families: Brythonic or P-Celtic (Breton, Cornish and Welsh); and Goidelic or Q-Celtic (Irish, Manx and Scottish Gaelic). He argued that the Brythonic languages originated in Gaul (France), and that the Goidelic languages originated in the Iberian Peninsula. Lhuyd concluded that as the languages had been of Celtic origin, the people who spoke those languages were Celts. From the eighteenth century, the peoples of Wales, Ireland, Brittany, Cornwall, the Isle of Man and Scotland were known increasingly as Celts. Edward Lhuyd began a resurgence of interest in Welsh history, culture and language. Theophilus Evans followed up his works.

Two Welsh societies started up in London. Lewis Morris, from Anglesey, with his brothers Richard and William founded the Honourable Society for Cymmrodorion in London in 1751, trying to establish the British tradition prior to the arrival of the Angles, Saxons, Jutes and other Germanic tribes. The advance of Welsh scholarship was one of its aims. In the 1770 the Gwyneddion Society revived the the eisteddfod, with Edward Williams of Flemingston (Iolo Morganwg, 1747–1826) creating its ceremonies. Iolo was friendly with Thomas Paine, Thomas Hardy, Joseph Priestley, David Williams, prime ministers and many noted intellectuals, and was not criticised by any of them in his lifetime. Williams and many of the London Welsh were influenced by the success of the American colonies in winning their independence from the English Crown. They began to make known their wish for recognition of a separate identity for Wales. This activity led to the collection of surviving manuscripts, culminating in the publication of *The Myrvyrian Archaiology of Wales* from 1801 to 1807. It was apparent to Edward Jones and to Iolo Morgannwg that a comprehensive body of cultural traditions needed to be re-established and set down in writing. Iolo came up with many innovative ideas, among them the institution of the Gorsedd (the assembly of bards) that, ever since its introduction into the Carmarthen Eisteddfod of 1819, has played such a prominent role in Welsh cultural affairs. He reawakened interest in music and literature, with the revival of the national eisteddfodau in 1701, the last known having been being held in 1567. In 1789, three major eisteddfodau were held in Bala, Corwen and Llangollen. Iolo, Edward Jones and William Jones of Llangadfan disliked the effects of Methodism, with its deleterious effects upon folk singing, dancing, music and traditions, and attempted to stem the tide of religious disapproval of traditional entertainment.

The Last Invasion of Mainland Britain, 1797

While Napoleon Buonaparte was busy campaigning in Central Europe, The Directory (Revolutionary Government) in Paris decided that the poor British peasantry needed to be liberated. The Irish-American General Tate led the invasion force, intending to head up the Bristol Channel and spark off a 'peasants' revolt' in England, but strong winds forced him to land instead on the Pembroke coast. His force largely consisted of released prisoners, with a few regular soldiers. Tate's plan had been to land and gather supporters near Bristol (England's second largest city, its wealth swollen by the slave trade), march through Wales and follow the borders into Chester and Liverpool. When the first of four French warships was spotted from the now-ruined fort overlooking Fishguard Bay, a single shot was fired from one of the cannons that still are in position. The fort only had three live rounds, so it fired a blank which warned the vicinity, but this also persuaded the fleet's captains to withdraw to Carreg Wastad, a steep headland. There, on a small sandy beach near Llanwnda, disembarked the 1,400-strong force. The invading troops had been issued British uniforms captured at Quiberon that were dyed deep brown, earning them the title of the 'Légion Noire', the Black Legion. Each soldier was issued with only 100 rounds for the duration, and provisions were to be furnished, willingly or not, by the country through which they travelled. It was genuinely believed that the poor people of the country would rally to the Black Legionnaires as liberators and swell their numbers. Men, arms and gunpowder were unloaded at night, and by 2 a.m. on 23 February, the last invasion of Britain was completed. The ships returned to France to report a successful landing. Unfortunately for the Directory, the convicts rapidly ran out of enthusiasm, especially after finding the impounded wines and spirits of a recently grounded Portuguese ship. Tate's ragtag army drank itself senseless, and the invasion had collapsed within two days.

In the main square of the town of Fishguard (Abergwaun) is situated the Royal Oak Inn, where you can view a copy of the treaty that ended the invasion by a body of French troops led by Irish-American General Tate. The troops had landed from three frigates at Carreg Wastad but were apparently frightened into surrendering by the militia of Lord Cawdor, aided by a troop of local Welshwomen who looked like Grenadier Guards in their red cloaks and tall, black hats. One local townswoman, the fearsome Jemima Nicholas (or Niclas) with her trusty pitchfork, was personally credited with capturing fourteen French soldiers. Harri Webb wrote *The Women of Fishguard*, a poem of which the final verse is:

> I'll make the proclamation
> Though a conqueror I am,
> You can conquer all creation
> But you'll never conquer MAM.

Fishguard is the only battle honour earned on British soil, awarded in 1853 to the Pembrokeshire Yeomanry in recognition of the defeat of the French Landing. The most interesting and long-lasting effect of this invasion was the run it caused on the Bank of England. Investors panicked and wanted to recover their gold sovereigns

from the bank, which was forced, for the first time, to issue paper banknotes, to the value of £1 and £2.

Eighteenth-Century Court Cases

There is something about education and Welsh Labour politicians that seems to be missing. The Kenyan-South African Peter Hain might be excused, but George Thomas, Neil Kinnock, Kim Howells and many, many others seem ignorant of Welsh history. This author's higher education was in economics and marketing, with a career in electronics, manufacturing, marketing, consultancy and academia, working for twenty-eight years outside Wales. How is it that someone who does not represent the people knows so much more than their representatives about Wales? In 2001 Wales' First Minister, Rhodri Morgan, a Cardiffian member of the *crachach*, with a brother who was a professor of Welsh history, addressed a delegation from Canada. He told them that Cardiff had not been a Welsh-speaking town since the arrival of the Normans in 1100. The cases below from previous centuries prove differently. In 1847 there was an official quote that 'Welsh is still predominant amongst the working class', and at that time, in the area which today forms the whole city, thirty-three of the thirty-eight places of worship held services in Welsh. The growth of the coal trade and the arrival of thousands of newcomers from England and Ireland had started to overwhelm the language, however. Thus Rhodri was only 750 years out. All the places around Cardiff were Welsh-speaking, also. The Church consistory court records from 1700–1820 showed that in 65 per cent of slander cases heard, the language used in Cardiff was Welsh. Estate and tithe maps, from the eighteenth and nineteenth centuries, record that 89 per cent of the hundreds of place-names in Cardiff were Welsh.

The following are instructive of the types of cases and sentences of the period. Slander cases regularly occurred at Cardiff Great Sessions and we can see that Welsh was the common tongue in the region. In 1702,

> In the matter of Elizabeth Pierce, spinster, a pauper, versus William Gibbon, both of St Bride's Major, the defendant was prosecuted for slandering the plaintiff. John Jones, Doctor of Law, Vicar General of the Bishop of Landaff, and Surrogate, declares that the said defendant has by such his offence incurred the sentence of Greater Excommunication in the Spiritual Court. The slander consisted of these Welsh words: 'Puttein Robert Lewis wyt ti; mi a'th brwfo di yn buttein iddo, ag mi a ddawa a digon o ddynon y brwfi dy fod di yn buttein iddo' (thou art the whore of Robert Lewis, and I will bring plenty of men to prove it).

Another action for slander was Gwenllian William, spinster, against Elizabeth David, widow, of St Bride's Minor. The words complained of were: 'Whore cobhomovon wyt ti; wyt ti yn Kadw bawdyhouse ar ben yr hewl im mrawd' (thou art a common whore, and dost keep a bawdy-house at the end of the lane, for my brother). In 1706 there was a case in the Bishop's Court at Llandaff by John Thomas against Griffith ap Evan, who had cited him for slanderously uttering the following concerning him

and his wife: 'Nid iw Griffith ap Evan ddim Gwr mor honest am fi, nag iw gymmeryd yn wr honest, o achos fe ddygodd ddefaid rhai eraill ag a Ciceifwydd hwynt, ag fe gummerodd i wraig ef yr Gwlan, a Slutt front iw hithe' (Griffith ap Evan is not as honest a man as I am, nor to be taken for an honest man; for he stole others' sheep and sheared them, and his wife took the wool, and she is a foul slut).

In *Custom House Records: Order Book, 1686–1733*, we discover that in 1712 a French vessel laden with wine and brandy ran ashore at Sully, and her cargo was seized by the Customs officers. The country folk assembled with guns and pistols and endeavoured to take the brandy, 'whereupon Mr Morgan, the Comptroller of Cardiff, went with some of his officers and some dependents of the Lady of the Manor of Sully, and dispersed the mob'. In Cardiff Sessions records we find for 1727:

> True Bill against Mary the wife of James Jones, of St Athans, for attempting to poison her said husband with a pancake mixed with ratsbane [rat poison, probably arsenic triox-ide], and for therewith poisoning her father-in-law. No True Bill against John Williams, of Flimston, [Flemingston] for instigating the crime. ... Evan John, of Cilybebyll, mason, having been at Neath market, went for the night to an inn called Ty'nyrheol, at Cadoxton juxta Neath. At dead of night he was taken out of bed into another room, where were a number of men and women. There they pretended to try him for his life, as a thief, and so condemned him to be executed. They actually hanged him for a short space of time, but then let him down and made him sign a paper purporting 'to release them for such their outrageous doings'.

An inquest in 1738 was held at the house of Evan Jones of Llantrisant. Evan Prichard, coroner, viewed the body of William James, a collier from Coychurch. Prichard found that the deceased 'going down by a certain rope into a certain coal pit of Katherine Evan and Margaret Phillip of Llantrissent, widows, called Brun Cradock, in the parish of Llantrissent, it so happened that the damp being then in the said coal pit, suffocated the said William James; by which damp the said William James instantly died'. It is interesting that the small pit was owned by two women.

In 1748, a rare form of legal procedure occurred at Cardiff, and we find a paper headed 'Names of the Jury of Matrons between our Lord the King and Catherine Llewelin singlewoman to Inquire whether she be quick with Child or not'. Twelve matrons (wives and widows of tradesmen) were sworn, including Catherine, the wife of Michael Brewer, peruke-maker (wig-maker); Margarett, the wife of Thomas Mossip of the 5 Bells; and Frances Lewis, hall-keeper's wife. After the list of names comes the record: 'The Jury find that Catherin is quick with child.' Execution of the sentence of death was thereupon postponed upon the expectant mother until after the child's birth. The prisoner had stolen money and clothes at Llangynwyd. In 1753, for stealing seven pounds of Scotch snuff from a shop at Swansea, Jane the wife of John Morgan was sentenced to be 'whipt'. In the same year, Moses David alias Morgan of Roath, labourer, was sentenced to transportation for stealing from the house of Martha Lewellin, at Roath, some handkerchiefs and penknives.

In 1754 Alice, wife of Thomas Van of Cardiff, victualler, was convicted of stealing four gold guineas. She was sentenced 'to be hanged by the neck', but these words at foot of the indictment have been struck through with the pen. In 1756 we have

reference to the fact that local inhabitants were responsible for the upkeep of roads: 'Jurors present the highway leading from the Black Weir to the Great Heath, Cardiff, to be very ruinous and out of repair; and that the same ought to be repaired by the inhabitants of St John's Parish.' The Turbervilles are one of the great houses of Glamorgan, so the following is a surprising entry: 'Yet Christopher Turberville of Aberavon, labourer, was found guilty of highway robbery, or, as the Indictment words it, for that he (and another man) at the parish of Baglan, with force and arms of and from one James Carson (and another person) did demand money with divers menaces, using these Welsh words: "Sefwch, God dammoch chwi, efe ceiswch arian chwi" (Stand, God damn you, I want your money!).'

A coroner's inquest at Cardiff in 1759, on view of the body of Edmund Fflaharty, found that 'several sailors of the crew belonging to the ship called the Eagle Galley of Bristol, armed with pikes, swords, cutlasses, pistols and muskets, had in a street in the said town of Cardiff, called Homanby Street, an affray with the crew of the Aldbrough man-of-war, who were similarly armed, and that several pistols and guns were fired, and several blows & wounds given; and that the deceased was then shot by a person unknown'. Womanby Street is near the Arms Park. A fascinating and unlucky occurrence was recorded in 1765, when the

> inquest on the body of William Bonvil found that the deceased one night fishing with a net in the sea at the parish of Merthyr Mawr, and with two other persons drawing the said net ashore having therein only one little flat fish called a sole, about five inches in length, did (as usual by fishermen), in order to take the said fish out of the net, being there entangled, take hold thereof by the head with his teeth; and afterwards inadvertently loosening his hold, the said fish slipt forwards into his mouth and throat so far that the same could only be felt by the tail; by which position of the said fish the breath of the said William Bonvil was stopt, and thereupon he languished for about twenty minutes and then and there died.

In 1766, for stealing a sheep, Thomas Richards was sentenced 'to be hanged by the neck till dead'. In 1770,

> The Grand Jury present that Henry Knight of Laleston in the county of Glamorgan, Esqre challenged Thomas Bennet of the same parish, Esqre, to fight a duel, by writing him the following letter:- Respect to the Company prevented my taking the Proper Notice of the Insolence of your Language yesterday at Ewenny, but it were Disrespect to myself not to resent it now. I therefore acquaint your self-Importance that you behaved like a Fool and spoke like a Liar – which I am ready to make good as a Gentleman ought, when and wheresoever you think proper to appoint. Hen: Knight.

1774 saw local lawlessness: 'The Jury present that Daniel Thomas, Rees Thomas and Gamaliel Davies, of Cowbridge, printers, assaulted Jacob Thomas, one of the Serjeants at Mace of the Borough of Cowbridge, and rescued the said Daniel Thomas out of the said Jacob Thomas' lawful custody. April 1777.'

Coal was being worked at this time: 'Coroner's Inquest on view of the body of Jane Thomas, found that the deceased was accidentally killed by a fall of coal in a mine at

Merthyr Tydfil.' In 1779, there were 'Inquisitions, signed by Henry Thomas, Coroner, on the bodies of eleven men killed by choke-damp [also known as blackdamp, caused by the absorption of available oxygen by coal seams] in a mine called Winch Pond Mawr, in the parish of Cadoxton-juxta-Neath. All but two of the victims were of the surname Richard.' In 1781, Jane William was convicted of picking the pocket of Morgan Richard and stealing seventeen guineas in gold and about twenty shillings in silver, at Llanbleddian:

> Thomas Morgan of Welch St Donats in ye said County maketh Oath that on Tuesday night ye 16 Instant he in Company with Jane William heard Morgan Richard in a Close adjoining ye Road leading from Cowbridge to Aberthin crying out in great distress – that he went over a fenced place into ye close with ye said Jane William – Morgan Richard desired deponent to button his Breeches – could not do so, his hands benumbed. Thomas Morgan upon this desired Jane to button his breeches, being then in the close with him. Morgan Richard asked when Jane touched him, whether she was the deponent's daughter – was answered, no; she is a stranger – heard Morgan Richard say 'paid ferch a dodi dy law yn'm pocket i' [Do not put thy hand into my pocket, girl].

1796 saw John Watkin convicted of stealing, out of a mail coach, 500 guineas, the property of William Morgan of Carmarthen, Esquire, at Swansea. He was sentenced to seven years' transportation.

Nineteenth-Century Wales: A Centre of Global Industrialisation, Riots & Politicisation of the Working Classes

Thomas Carlyle visited Merthyr in 1850 and wrote, 'Such a set of unguided fierce and miserable-looking sons of Adam I never saw before. Ah me! It is like a vision of Hell, and will never leave me, that of these poor creatures toiling all in sweat and dirt, amid their furnaces, pits and rolling mills. The town might be one of the prettiest places in the world. It is one of the sootiest, squalidest, and ugliest; all cinders and dust-mounds and soot.' The same could also be said of the other four major South Wales Valleys.

Transport

By the mid-nineteenth century it was obvious that it was more economical to concentrate industry in coalfields, where steam engines could readily be supplied with fuel. Thus, while industries grew enormously in the coal-bearing regions of Wales, other areas experienced industrial expansion which eventually fell away. Better roads, canals, railways etc. were fundamental to the growth and success of the growing industrial areas. By the early 1800s, all the main valleys of the southern coalfield had been linked to ports via canals. There were fifty-one locks in the 25-mile Merthyr to Cardiff Glamorganshire Canal, which was started in 1790 and completed in 1794. Its primary purpose was to enable the Merthyr iron industries to transport iron goods, and it later served the coal industry. Sadly, it closed progressively between 1898 and 1951. The Aberdare Canal ran from Aberdare to a junction with the Glamorganshire Canal at Abercynon, opening in 1812, and served the iron and coal industries for nearly sixty-five years. The Swansea Canal was constructed between 1794 and 1798, running for 16.5 miles from Swansea to Abercraf, with thirty-six locks, to transport coal, iron and steel. The Crumlin to Abercarn arm of the Monmouthshire & Brecon Canal was built in 1794 to connect Crumlin and its associated industrial tramways with Newport Docks. With the completion of Fourteen Locks north of Newport in 1799, the canal was completed. The Llangollen Canal was begun in 1795, and links with Hurleston in Cheshire via Ellesmere, Shropshire. In 2009 an 11-mile section of the Llangollen Canal, including the Horseshoe Falls, Chirk Aqueduct and the Pontcysyllte Aqueduct, was declared a World Heritage Site.

The Brecon, Abergafenni and Monmouthshire Canal was completed in stages between 1799 and 1812, allowing simpler and cheaper transportation of farm produce as well as industrial goods to Newport Docks. The Kidwelly and Llanelly Canal was built to carry anthracite coal to the coast for onward transportation by coastal ships. It began life as Kymer's Canal in 1766, serving a dock near Cydweli. Thomas Kymer's canal and quay were the first in Wales, completed by 1778, and its combined canal-and-railway system was the first in the world. As the estuary silted up, an extension to Llanelli was authorised in 1812. The new canal was linked to a new 1820s harbour at Pembury, until the harbour at Burry Port was completed in 1832. A single canal boat could handle as much coal or iron as 200 packhorses. At this time, there were also 1,800 miles of tram roads in South Wales coalfields.

However, the docks infrastructure was inadequate for the increasing trade. The Marquess of Bute had to build a massive masonry dock at Cardiff in 1839, after which the town mushroomed in size and importance. His West Bute Dock was the largest masonry dock in the world. The world's first steam locomotive ran from Penydarren to Abercynon in 1804. The first regular passenger rail service in the world was opened from Swansea to Oystermouth in 1807. By 1841, Bute had linked his docks to Merthyr by the Taff Vale Railway, so Cardiff became a major exporter of coal as well as iron. Similarly, Swansea and Newport Docks quickly became served by railways. Railways now began to take over much of the burden of transporting the raw materials to the ports and centres of production, beginning to displace canals but giving a huge boost to the Welsh economy. The Conwy Suspension Bridge of 1826 and the Menai Bridge of 1819–26 further improved communications and transport. This boom in construction and industry led to an incredible population rise between 1780 and 1850, from 530,000 to 1,189,000. Immigrants and former agricultural workers were drawn into building canals, roads, docks, bridges and working in the coal, copper, tin and iron industries. Between 1850 and 1870, 1,400 miles of railways were built in Wales, with over 4,000 miles constructed before the start of the First World War.

Coal

The first wave of the Industrial Revolution was based upon metals, such as iron and copper. But by the middle of the nineteenth century, coal-mining was beginning to take off as the fuel demand for furnaces, railways and steamships began to rise. 'Black Gold' originally referred to Welsh Black cattle, when they were herded to England in the Middle Ages onwards. The discovery of vast amounts of the 'Black Diamond' or this other 'Black Gold' effectively changed the nature of much of Wales forever. The beautiful, wooded valleys of Rhondda Fach and Rhondda Fawr were suddenly filled with tightly packed terraced communities made up of workers from all over Britain and Ireland. Walter Coffin (1784–1867) was born into a tanning family in Bridgend and went to Cowbridge Grammar School. In 1809, at the age of twenty-four and bored with the tanning industry, he began to prospect for coal at his father's farm land at Dinas, in the Lower Rhondda Valley. Coffin opened at least five levels in the area. Coffin is recognised as the first person to exploit the rich coal fields of the Rhondda on an industrial scale, pioneering the growth of one of

the most wealthy coal mining areas in the world. He was buried at the Unitarian church graveyard, Park Street, Bridgend, but in 1972 the church's trustees removed his impressive gravestone and covered the grave with tarmac.

Demand for coal was driven by the great ironworks at Blaenafon and Merthyr, as well as being export-led. Wars and the Industrial Revolution increased the need for iron, which then accelerated the demand for coal which had replaced timber, charcoal and coke in the furnaces. Later in the century, Welsh coal was tested and found to be the best for steam ships, supplying navies and merchant fleets across the globe. 'Smokeless anthracite' was also favoured in the major cities such as London for home heating. By 1828, South Wales coal production was 3 million tons and by 1840 had risen by 50 per cent. In the early 1800s, fewer than 1,000 people lived in the Rhondda Valleys, but by the 1920's, with Rhondda coal being considered the best in the world, there were forty pits and 160,000 inhabitants. There were also important mining areas in the north-east and south-west of Wales. Welsh coal had become the preferred fuel for the world's navies and merchant fleets, now changing over from sail to steam.

At the Ynyscedwyn Works, Ystradgynlais, in the Swansea Valley, in 1837 David Thomas of Neath utilised a hot blast to smelt iron ore with anthracite coal. His success not only opened up the Swansea Valley to industry, but also led to Lehigh Valley becoming the chief centre of the world's iron industry shortly after Thomas's arrival in Pennsylvania in 1839. From 1880 up to the First World War the coal industry dominated the Welsh economy. Over 250,000 men worked in the mines, but Welsh coal was now almost entirely dependent upon the world market. Poor working conditions in the industry, where wages were kept deliberately low, meant that there were new attempts to revive the trade union movement. In response, the eighty-five companies owning over 200 mines formed a united front against the unions. The Monmouthshire and South Wales Coal Owners' Association (MSCA) was founded in 1873. In 1875, the association introduced the 'the sliding scale' system of payment, with wages tied to the selling price of coal.

In 1877, the Cambrian Miners' Association, founded in the Rhondda Valley, began to organise strikes as their only resource against the MSCA. It wanted collective bargaining over wages. As representative of the miners, William Abraham (Mabon) was elected Lib–Lab MP for Rhondda in 1885. He believed that the interests of capital and labour were identical, and supported the sliding scale to avoid conflict and retain jobs for the miners. Abraham managed to keep the peace between coal owners and miners for twenty years, and in 1888 was able to win some concessions for his workers. These included alterations to the sliding scale of 1875 and a holiday on the first Monday of each month, known as Mabon's Monday. Mabon became the first president of the South Wales Miners' Federation (the 'Fed'), set up in October 1898 after a major strike caused by the owners' refusal to accept a minimum wage. He had now abandoned his support of the sliding scale. 1889 saw the founding of the Miners' Federation of Great Britain at Newport. This argued for the creation of a Board of Arbitration to replace the sliding scale and the restriction of the workday to eight hours. A few months later, the Fed joined the Miners' Federation.

The massive profits pouring into Cardiff saw shipping, coal, iron and steel companies needing a central exchange, and the Cardiff Coal Exchange was built

between 1884 and 1888. In the 1880s, Cardiff had exported 25 per cent of the world's supplies of coal. The world's first million-pound deal was said to have taken place at the Coal Exchange. Huge congestion at Cardiff, which handled 72 per cent of Welsh coal exports, led to David Davies' successful petition in 1884 for a new dock at Barry, enabled by building a causeway from the island to the mainland. There followed a rapid increase in population, making Barry the fastest-growing town in Britain, and Barry Dock broke Lord Bute's virtual monopoly. The McKinley Tariff in 1891 brought an end to American dependence on Welsh tin-plate, creating wholesale reductions in the Welsh workforce and depression in those areas that produced it. However, the future of the Welsh coal industry, employing one third of the Welsh male labour force, seemed secure.

Working conditions were horrifying in the nineteenth century. Children under eight years old spent hours in the pitch-black, opening and closing the trapper doors of ventilation tunnels. If aged over eight, they dragged baskets of coal to the bottom of the shaft. In 1825 at Cwmllynfell fifty-nine men and children were killed in an explosion. In 1840, six-year-old Susan Reece said, 'I have been below six or eight months and I don't like it much. I come here at 6 in the morning and leave at 6 at night. When my lamp goes out or I am hungry I go home. I haven't been hurt yet.' Her job, six days a week, was to open and close the ventilator at Plymouth Colliery, Merthyr Tydfil. The boys who, with chains around their waists, pulled trucks of coal through galleries too low for pit-ponies were called 'carters'. James Davies, an eight-year-old carter, reported that he earned ten pennies a week, which his father took from him. John Saville, a seven-year-old carter, said that he was always in the dark and only saw daylight on Sundays. From the age of six, many boys and girls worked in the pits for a few pence a day, and women worked there for fourteen hours a day.

In 1842, parliament under Lord Shaftesbury forbade the employment underground of women, girls and boys under ten years old as miners. The mine-owners opposed the Bill and there was little inspection carried out. As a result we saw in 1844 at Dinas Middle Pit, Rhondda, twelve men and boys killed. In 1844, forty men, women and boys were killed in Garden Pit at Landshipping on the Cleddau River when disaster struck and the pit was flooded. In 1849 in Lletyshenkin, Aberdare, fifty-two men and boys were killed in an explosion. 1852 at Middle Duffryn, Aberdare, saw sixty-five men and boys killed in an explosion. In 1856 at Cymmer, Porth, 114 were killed. Seven of the 114 were under the age of ten, seven were ten, and seven were eleven years old. So much for legislation to protect children. In 1867 and 1869, separate explosions killed 178 and 60 colliers at Ferndale. In 1880 at Naval Colliery, Rhondda, ninety-six died in an explosion, and in 1885 at Maerdy, eighty-one died in an explosion.

Among the lethal gases underground were methane, or firedamp; carbon monoxide, or afterdamp; carbon dioxide, or blackdamp; and hydrogen sulphide, or stinkdamp. The first 'colliery firemen' were covered with water-soaked rags and crawled towards seepages with a naked flame on a long stick to explode the gas. Some survived. In 1889 there were no major disasters, with only 153 dead. Among them, four thirteen-year-olds, eight fourteen-year-olds, six fifteen-year-olds, four sixteen-year-olds and eleven seventeen-year-olds met their deaths by roof falls or by being crushed by trams. In 1892 at Parc Slip, Bridgend, 114 miners were killed in a gas blast, and the school had a half-holiday so children could mourn their parents and brothers.

In 1849 in Merthyr, Dowlais and the Rhondda, 884 people were killed by cholera. In 1893 a health report on the Rhondda Valleys stated 'the river contained a large proportion of human excrement, pig sty manure, congealed blood, entrails from slaughterhouses, the rotten carcasses of animals, street refuse and a host of other articles – in dry weather the stink becomes unbearable'. In 1894 at Albion Colliery, Cilfynydd, 290 miners were killed of the 300 on the shift. Eleven could not be identified. One miner's head had been blown 20 yards from his body. 'All through the darkness the dismal ritual of bringing up the dead continued, illuminated only by the pale fitful glare of the surrounding oil lamps … each arrival of the cage quenched the glimmer of hope that lived in the hearts of those who waited.' A court case was brought against the mine owners and managers, but all serious charges were dropped.

In 1878, there were reports of people starving in the streets as poverty caused great suffering in Rhosllanerchrugog. In the previous three years several collieries and brickyards had closed, resulting in about 1,200 men being made unemployed. A symbol of Rhos' coal mining and labour movement heritage is seen in the 'Stiwt', the Miners' Institute of Broad Street. This fine structure was erected and paid for by the miners as a social and cultural centre for the community. It was built during the general strike of 1926. These miners' institutes were built across Wales, and served an important purpose as libraries and meeting-places for their communities.

Industry

Major growth in heavy industry had been fuelled by the Seven Years' War (1756–63), the American War of Independence (1775–83), the French Revolution (1793–1802) and Napoleonic Wars (1803–15). In 1794, Richard Crawshay acquired Bacon's Cyfarthfa ironworks, and the Crawshays virtually ran Merthyr until the twentieth century. Richard's nephew, the ironmaster Crawshay Bailey (1789–1872), is still remembered in a rugby song this author remembers singing through interminable and increasingly lewd verses:

Crawshay Bailey had an engine
It was always needin' mendin'
And dependin' on its power
It could do four miles an hour.
Did you ever saw
Did you ever saw
Did you ever saw
Such a funny thing before?

One clean verse recalled with relish, as a lifelong supporter of Cardiff, was

Oh, I've got a cousin Rupert,
He plays outside half for Newport
And they think so much about him
That they always play without him...

Along with his elder brother, Joseph Bailey, Crawshay started in the iron industry in 1811 at Nantyglo, and then at Beaufort, Ebbw Vale. He also ran the Rhymney ironworks, building a tramway from Rhymney to Bassaleg outside Newport. Bailey bought large areas of coal-rich land in the Rhondda Valleys, and developed them as some of the richest coal and iron ore deposits in the world. In 1845 he was instrumental in setting up the Aberdare Railway, along with Sir John Josiah Guest, and used it to transport coal from new collieries and iron from new blast furnaces. Strongly against trade unions, by 1867 he owned ironworks, blast furnaces, coal mines, tramways, railways and brickworks across South East Wales. In 1804, Edward Martin of Morriston obtained a patent for making pig and cast iron with raw 'stone coal' (anthracite), then of little value. However it was not until 1837, when David Thomas used the hot blast to smelt iron ore with anthracite, that the Swansea Valley began to utilise its industrial potential.

In 1818, a chain cable company was established at Newbridge, Pontypridd. Philip Thomas of Neath and Samuel Brown had invented and patented a new process in 1816 for wrought iron chain production. This enabled the building of Telford's suspension bridges at Menai and Conwy. Later known as Brown Lenox, the company made cables in 1857 for the *Great Eastern*, the largest chains ever made. They then made chains for battleships, the *QE2* etc., until production ceased in 1968, after 150 years of production.

The peaceful valleys of South Wales began to be filled with cramped workers' housing. There were about 500,000 people in Wales in the 1750s, rising to over 1,200,000 in 1851 and to 2,500,000 before the First World War. The growing global demand for iron led Merthyr into overtaking Swansea as the largest town in Wales in the early nineteenth century, with Cyfarthfa, Penydarren and Blaenafon producing a major share of British iron. In 1811, Cyfarthfa ironworks had seven furnaces producing 18,000 tons of iron per annum, the most productive in the world. By 1851, Dowlais employed 5,000 men, the largest labour force in the world on one site, now surpassing Cyfarthfa in size. Dowlais alone made practically all the iron rails for the American railroad industry. By 1827, Monmouthshire and east Glamorgan were already producing half the iron exported by Britain. Merthyr's largest of its four iron companies at Dowlais was producing 75,000 tons of iron a year, compared to the Hanbury works at Pontypool a century earlier making 400 tons. However, industry in Wales was concerned with the creation of capital rather than consumer goods. The iron-making centres produced iron rather than things made of iron; the metallurgical crafts so important to the prosperity of Sheffield and Birmingham struck few roots in Wales. This reliance upon a few heavy primary industries made recession in Wales deeper than in places with more mixed economies.

Between 1801 and 1841, Monmouthshire was the most rapidly growing county in Britain, and Glamorgan ranked third. It seems difficult to believe that before this period, Monmouthshire had a huge majority of Welsh speakers. In the nineteenth century Glamorgan's population grew from 70,000 to 860,000, with the Rhondda Valley rising from a few hundred to 114,000. The Rhondda Valley was still being described in 1847 as 'this solitudinous and happy valley … where a Sabbath stillness reigns'. However, by 1851 Merthyr Tydfil was Britain's first industrial town, with over

46,000 people, and there were now eighteen towns in Wales with a population of over 5,000. In Aberdare, the population grew from 6,471 in 1841 to 32,299 in 1851, while the Rhondda grew from 3,035 in 1861 to 55,632 in 1881, peaking in 1921 at 162,729. Much of this population growth was driven by immigration. In the ten years from 1881 to 1891, net migration to Glamorgan was over 76,000, 63 per cent of which was from the non-border counties of England. This proportion increased in the following decade. By the 1851 census, Wales could lay claim to being the first industrialised nation in the world, as the numbers working in industry were more than twice those working in agriculture. In this year, of the 110,000 in the Welsh workforce, about 12 per cent were English, and another 20 per cent were Irish, escaping the Potato Famine. The working population of immigrants had gone from virtually nothing to a third in two decades. However, Bristol, Chester and Shrewsbury were still the only real commercial centres, all outside Wales.

Economic development had taken off in the Llanelli-Swansea-Neath area, in Amlwch with its copper mine, and in Snowdonia, where slate quarrying overtook copper mining. In north-east Wales there was the greatest range of industries. By the late eighteenth century there were already nineteen metalworks at Holywell and fourteen potteries at Buckley. There were cotton mills at Holywell and Mold, and many lead and coal mines. Bersham, where the Wilkinson family pioneered the use of coke rather than charcoal in the smelting of iron, was one of Europe's leading ironworks. *The Times* in 1866 noted the prevalence of English entrepreneurs (ignoring that they had initial capital unavailable to men such as David Davies): 'Wales … is a small country, unfavourably situated for commercial purposes, with an indifferent soil, and inhabited by an unenterprising people. It is true it possesses valuable minerals but these have chiefly been developed by English energy and for the supply of English wants.'

90 per cent of Britain's copper production came from Neath, Cydweli and Port Talbot, with its hub being Copperopolis, Swansea. North Wales copper mines had had the largest production in the world in 1801. Because of copper, Amlwch had 5,000 people to Cardiff's 1,800, becoming the biggest copper-exporting harbour in history. Swansea, Copperopolis, had the biggest copperworks ever seen. Llanelli, Swansea and Neath now dominated world production of tin-plate and copper. Llanelli was known as Tinopolis from 1825 as food canning expanded. As copper sources in Wales were exhausted, zinc and nickel took their place, with the largest nickelworks in the world at Clydach from 1902. However, the American government passed the McKinley Tariff in 1891 to promote home industries. 75 per cent of the products of the Welsh tin-plate industry had been imported to the United States, and the passing of this protectionist tariff was a severe and lasting blow to Welsh industry.

In Anglesey, the richest seams of the Mynydd Parys mines were already exhausted by 1802. The resulting scarcity of copper ore led to a severe decline in the industrial areas of North Wales, not only at Amlwch itself after riots in 1817 where the population fell rapidly, but also at towns such as Holywell that depended upon Anglesey ores. The advent of peace in 1815 after Waterloo was a disaster for the Welsh iron industry, which had been heavily dependent upon supplying munitions for the long wars against Napoleon. In agriculture conditions were no better, with falling prices and high rents causing many to leave the land with no longer any promise of employment

in the coal fields and ironworks. Depression also hit the lead and iron industry, with the famous Bersham works of John Wilkinson closing in 1826. The government and the ruling Hanover dynasty became increasingly worried about the threat of insurrection being brought on by widespread unemployment and famine.

In the slate industry, after 120 years of production, the Penrhyn Quarry was the largest hole made on the planet by the late 1800s. In 1859 the Pennant family's net annual income from the mine was around £100,000. This is the equivalent of £7.8 million using the retail price index, but an astonishing £60.9 million using average earnings. By the 1880s there was a workforce of over 16,000 men in the North Wales slate quarries. By 1898, 70 per cent of British slate came from North Wales, and the Dinorwig and Penrhyn quarries were the biggest in the world. The slate industry began to prosper with the coming of peace after the Napoleonic Wars, with high-quality Welsh slate being in demand to roof many of England and Europe's finest buildings. Wales was the world's main producer of slate, exporting all over the world. However, appalling working conditions and low pay led to the Penrhyn Strike of 1900–1903, the longest industrial dispute in Britain's history.

In textiles, Welsh flannel was exported globally, with the Royal Welsh Warehouse at Newtown housing the world's first mail order company. In 1859, businessman Pryce Pryce-Jones began to cater to the needs of many of his rural customers by offering goods for sale through the mail. Many of the area's farmers lived in isolated valleys or in mountain terrain and had little time or suitable transportation to come into town. The Pryce Jones mail order business started, succeeding because Post Office reforms in the 1840s had made the mail service cheaper and more reliable. His Newtown warehouses, packed with goods, began a service that quickly caught on in the United States, with its even greater distances and scattered population. In parts of central Wales, factory methods were replacing domestic production in the woollen industry.

The 1842 royal commission into the employment of young children reported that some miners were employing children as young as three to hold their candles for them as they cut the coal. Miners had to buy their own candles. From early morning until late at night, these children worked alongside their fathers, until 'when exhausted, they cradled upon the coals'. The report showed that seventeen out of thirty children in six Welsh pits were aged between five and nine. Young boys and girls crawled naked on their hands and feet, pulling wagons of 2 to 5 hundredweight. They buckled large leather straps around their waists, which were attached to the wagons. Other children kept the air-way doors open. When ten years of age, children took care of the horses at the bottom of the mine shafts, working from 6 a.m. to 6 p.m. They had a half-hour off to eat some dry bread for dinner down the pit, and their supper was usually a small piece of fatty bacon and some potatoes. In the iron industry, blast furnaces worked around the clock, seven days a week. At Ynyscedwyn Iron Works, Ystalyfera, there were over 500 adults and sixty children, of whom twenty-eight were under the age of thirteen, and five were young girls. The report spoke of these 'patch girls': 'Hardy and exposed to all kinds of weather, they work as hard as the men, from whom they differ but little in dress and quite equal in grossness.' In 1870 an American commented that he had seen in the iron mills of Wales: 'young girls, with their heavy shoes and short woollen dresses, wheeling iron, cinder, coals,

etc., at night, among the half-naked puddlers, doing the work done by men and boys in our mills, and receiving for a week's wages what we [American workers] receive for a day'. It was the same in other industries. Even in 1890 the *London Iron and Steel Trades Journal* was reporting that the great obstacle to tin-plate-making in the USA was the entire absence of cheap female labour, so necessary in the industry, 'and so abundant in Wales'.

With industrialisation, the long valleys of Glamorgan and Monmouth quickly filled up with factories, mills, coal mines, iron smelting works (and later, steelworks), roads, railways, canals, and above all, people. The crowded towns lacked adequate water supplies, sanitary or medical facilities and were surrounded by an environmental wasteland. Because of the Industrial Revolution and its natural resources, the population of Wales grew from around 1 million in 1851 to nearly 2 million by 1900. By 1891, the once-empty Rhondda Valleys had 128,000 people living there, and by that same year only half of the people spoke Welsh, because over 40 per cent of its workforce was made up of incomers.

With Wales' place at the forefront of the Industrial Revolution across the world, Wales also came to the front in scientific investigation. In 1848 the British Association for the Advancement of Science chose Swansea as the venue for a meeting of scientists from across Europe. Its Royal Institute of South Wales was chosen, despite Swansea having no rail connections, no university and no medical school. The great Michael Faraday arrived after a coach journey from London to Bristol and then a six-hour crossing by steam-packet to Swansea. Others took the steam-packet to Cardiff and then took a stagecoach to Swansea. Ronald Rees' *Heroic Science* tells of this remarkable event, alongside the biographies of some of the leading Welsh scientists who gave presentations. Among them, John Henry Vivian FRS was a leader in copper technology across the world; Lewis Weston Dillwyn MP FRS was not only the 'hero of British zoology' but the founder of Swansea porcelain; John Gwyn Jeffries FRS was the first British conchologist; Sir Henry de la Beche FRS was the first president of the Geological Society and the first director of the Geological Survey of Great Britain; Sir William Edmond Logan FRS FGS became Canada's greatest scientist and the first director of its Geological Survey; Dr Thomas Williams FRS was a pioneer of microbiology and William Robert Grove FRS was the inventor of the fuel cell.

Agriculture

The counties of Wales were divided into eighty-eight 'hundreds'. As late as 1811, seventy-nine of these had a majority of inhabitants still directly dependent upon agriculture for their livelihood. By the 1870s, 27 per cent of Welsh cultivated land was being used for cereal, green or root crops, but American and Australian imports from the 1880s undercut prices, causing severe agricultural depression. There was a flight from the land, which has been exacerbated by late-twentieth-century EU farming policies. Less than 7 per cent of Welsh land is now used for crops. There had been severe food riots from the 1790s onwards across Wales. There were poor harvests from 1815, and there were the increased costs of using toll-gates and turnpike roads

to send animals to market. With the growing practice of enclosing open lands and strip cultivation into hedged fields, troops had to be sent to Aberystwyth, Lampeter and elsewhere in 1816 to quell disturbances by starving people. Landlords were hated. In 1833 toll charges were again increased, one of the factors leading to riots in the late 1830s and early 1840s.

An interesting entry in the diary of twenty-two-year-old Thomas Jenkins of Llandeilo, for 12 August 1835, gives us the insight of a travelling fair in rural Wales: 'Went to the Fair, several shows. Saw a Giantess, a Hottentot woman, a flaxen-haired negro, 2 serpents, crocodile, alligator, porcupine, lemon-crested cockatoo, sand sloth, jackal, Muscovey cat, American sea-serpent, boa constrictor, etc. Saw a woman raise 300 lbs by her hair.'

Medical care in these times is also recorded in his diary:

1844, Dec 25, George (Thomas Jenkins' son) went with Edward Price to the park and returned shivering. Dec 26, At 12 noon my poor boy went to bed very ill with scarlet fever. Dec 27, George worse, sent for Walter Jones, Surgeon. Dec 28, Worse. Red pustules began to appear. Dec 29, Still worse. Sent for Dr. Prothero who ordered his head to be shaved and bathed with cold salt water and leeches applied to his temples. Continued bathing his heading from 2 p.m. til –. Dec 30, 6 a.m. Inflamation reduced. Swallowing difficult. Continued bathing his throat with hot flannels 'til 5 p.m. I went to bed at 8 p.m. 1845 – Jany 3, It pleased God for some wise end to relieve my dear boy from his suffering at 11.30 p.m. I shall never see his like again. God grant that I may become resigned. Jany 4, Peter made his coffin of inch oak, covered with grey cloth. Jany 7, The remains of my dear boy were laid in earth at 4 p.m. near Uncle Thomas Lott's grave in the upper churchyard. Aged 4 years and 6 months yesterday. (Thomas Lott was the chemist and druggist of Llandeilo 1776–1816.) Sarah was taken ill in scarlet fever last Saturday the 4th. (Sarah, his daughter, recovered eleven days later.)

This was not the end of Jenkins' sufferings:

1848 – Jany 1, Morning fine, frost evening, rain and thaw. Ann [his wife] was put to bed at 3 p.m. attended by Dr. Rees and gave birth to a boy at 9.30 p.m. Jany 2, Sunday. Went at Ann's request to Doulaugleision, she having promised Mrs. Davies that I should dine there today, Sarah having been sent there yesterday. Returned at 4 p.m. Soon after I returned my poor Ann was attacked with severe pains in the right leg. Sent for Drs. Prothero and Rees to attend her, at 10 p.m. pain less severe. Jany 3, Ann very ill. Jany 4, Same. Jany 5, Worse. Jany 6, After a night of intense suffering my dear Ann left me at 10.30 a.m. alone in the world. Jany 8, I was taken very ill with the influenza. Jany 9, Worse. Jany 10, No better. Little James very unwell. I was obliged to nurse him all day, he would go to no one else. The remains of my dear girl were laid in the same grave as our little George. I was not resigned to his death 'til now I've lost his dear mother. I was too ill to follow her to her last resting place. Jany 11, No better. Put the poor baby out to wet-nurse at Rhosmaen with Jane – at 2/6*d* per week.

Livestock prices crashed in the early 1840s, and butter, cheese and milk prices fell. Towards the end of the nineteenth century, steam-powered threshers, binders,

mowers, diggers and reapers began to reduce the majority of farm labourers to a quarter of its previous total. There was an exodus to rapidly growing towns looking for work. Early modern Wales was an overwhelmingly rural country. Although the country had fifty-four centres with had some claim to urban status, most were little more than villages. Those with the fullest functions were the capitals of the four regions of Wales: Carmarthen, Brecon, Denbigh and Caernarfon. The 1881 census for the parish of lower Llanfihangel-y-Creuddyn in Ceredigion gives us an insight into the activities of rural women aged sixteen and over. Their occupations are listed: Wife 104; Servant 44; Daughters-at-home 33; Housekeepers 29; Dressmaker 15; Farmer 5; Pauper 3; Publican 2; Lead mine worker 2; Other 5 (governess, widow, sub-postmistress, scholar, visitor).

Unrest

Such were the deprivations of rural life that the industrial areas attracted a constant stream of migrants from the countryside. The 1815 Corn Laws kept the price of bread artificially high to benefit the landed interests and wealthy farmers. Until the mid-nineteenth century, the bulk of the immigrants into industrial areas came from rural Wales, so the urban working classes were largely Welsh-speaking. There was lethal danger working in the mines and furnaces, and epidemics threatened the lives of men, women and children. A high proportion of these incomers, often forced off the land by starvation or rents, consisted of young men. Without families to care for, or discretionary spending power to be able to afford to marry or save for a house, these men questioned the status quo. In an attempt to better conditions, workers tentatively began to form unions, but their members were treated harshly. At the Abbey Works in Neath, for example, in the 1820s, when fifty men tried to form a union they were immediately fired. With no future and desperate working and living conditions, an atmosphere of desperation grew, not only in work but in meetings outside work. However, to disclose one's identity as a dissident would mean that one might never work again. The southern coalfield was now disturbed by the Scotch Cattle unrest of the 1820s, the Merthyr Rising of 1831 and the Chartist upheavals of 1839. All the Glamorgan and Monmouthshire coalfields came to a halt in 1816, 1822, 1830 and 1832; Scotch Cattle emerged to fight bailiffs, the Daughters of Rebecca formed to destroy toll-gates, toll-houses and workhouses; other secret organisations rebelled against strike-breakers in the slate, coal and iron industries. The government genuinely feared a revolution similar to that of France, so were quick to repress and punitively punish any signs of worker power.

In 1800, there were riots about the high price of corn in Caernarfon, Pembrokeshire and West Wales. In 1801, two miners (Samuel Hill and Aaron Williams) were hanged after a disturbance about prices in Merthyr Tydfil. In Llandeiniolen in 1809, there were protests over enclosures of common land and wasteland. This followed by similar protests in 1812 at Mynydd Bach, Ceredigion. There was a riot in Merthyr Tydfil and Tredegar during a miners' strike in 1816. In Merthyr, the iron baron John Josiah Guest barricaded himself into his home, Dowlais House, and William Crawshay took refuge in a farmhouse. Troops were brought in to disperse about 8,000 workers. In Tredegar,

troops were sent in and one worker was killed, but the threat of wage reductions was withdrawn. Troops fired warning shots in Aberystwyth as protests took place over enclosures. There were four weeks of unrest in Amlwch in 1817, caused by high food prices. This followed on from the run-down of the copperworks at Parys Mountain. When the copperworks were in full production, Amlwch had a population of about 10,000. In 1818, troops were used against a crowd in Carmarthen who were trying to stop the export of food. Further protests stemming from this cause occurred at Abermiwl (1819), Maenclochog (1820), Mynydd Bach, Ceredigion (1820–7, the 'War of the Little Englishman'), Dryslwyn (1826) and Llanwnda (1827). During the 'War of the Little Englishman', about 600 men under Dai Smith opposed an Englishman seeking to enclose the land.

In 1822, the army opened fire in Gwent during a miners' strike. As a direct result, secret societies of colliers were set up, mainly in Monmouthshire in the 1820s and 1830s. They enforced community sanctions against blacklegs and profiteers by direct action. The colliers wore masks and cattle skins and were led by a man rigged out with a horned bull's head. The idea was a solid group (a herd) of men who wished to 'scotch' the unfair subservience of the working class. The members were sworn to secrecy. It was known therefore as the Scotch Cattle movement, and from 1832 to 1834 the protest was at its peak. John Davies calls it 'a reaction to the unrestricted power of the employers and to the uncertainty of employment in the coalfield'. There were mass meetings to protest the continuation of the 'Truck system', whereby workers were only paid in tokens for exchange in company shops charging excessive prices (truck or 'Tommy' shops). The despicable practice was not abandoned until the Anti-Truck Act of 1831. Employers' property was destroyed across Monmouthshire with widespread unrest. In 1834, Edward Morgan was hanged in Monmouth Jail for being a member of this organisation, which is much less well known than either the Chartist Movement or the Rebecca Riots. The Wareham Riots of 1830 were sparked by coal miners having to purchase overpriced goods in the pit-owners' stores, the so-called 'Tommy Shops'. The miners in Rhosllanerchrugog near Wrexham had rioted against this system and the militia was called in to put the riot down.

Early in 1831, beginning as a popular protest against deplorable working and living conditions, the Merthyr Rising quickly grew into a full-scale, armed uprising. Miners and ironworkers joined the political radicals and disgruntled tradesmen. The crowd raised the red flag of rebellion, a white blanket dipped in lamb's blood, the first time it was used in Britain. Incensed by the lowering of wages by William Crawshay, and by the debtors' court's confiscation of property, a large crowd faced a troop of Scots Highlanders. The troop had been sent from Brecon Barracks to restore order. When large crowds appeared outside the Castle Inn in Merthyr, the troopers opened fire. In the resulting panic, over two dozen workers were killed and hundreds wounded. It took a week to bring order to the area. Punishment was severe. For his part in the rebellion, Richard Lewis (Dic Penderyn) was hanged on 31 July 1831. Forty years later, Ieuan Parker of Cwmafan, a Welshman living in the United States, confessed to the charges that had condemned Lewis. The Merthyr Rising was hardly mentioned in English newspapers, yet the so-called Peterloo Massacre, at Manchester in 1819, in which considerably fewer people lost their lives, had been reported as 'the most outrageous and wicked proceeding ever heard of'. The Poor Law Amendment Act

of 1834 now ensured that each parish built a workhouse for the homeless poor, virtual prisons with such poor conditions that they actually acted as a deterrent to the very people who needed them.

Excerpts from the *Master's Journal* for Lampeter Workhouse are as follows:

Dec. 1881 That two tramps Charles Marshall and Thomas Raibon were on Saturday 28th committed for 7 days imprisonment for having disobeyed the Workhouse rules viz. refused to take a warm bath; 10 March 1882 That 5 chldren of Samson and Eliza Price (Travelling Grinders) were admitted in the House. Price and his wife were on that day taken into custody for drunkenness, and the children were then left without any place to go or anyone to take care of them, and they were brought to the House by P.S. Lyons. Price and his wife were committed to Carmarthen Gaol on the 12th instant for 14 days ... Price's wife said she would not return for the children; 3 December 1883 That Christina Higgins, a vagrant, a native of Manchester, was delivered of a male child on the 19th ultimo, this being the first child born in the workhouse since the date of its construction in the year 1876; January 1887 That a tramp named James Sullivan who was admitted into the casual ward on the 7th instant absconded from his work on the following morning. He was captured by me, and taken before Mr John Fowden, and sentenced to seven days hard labour.

On 13 May 1839, toll-gates at Efailwen, near Carmarthen, were destroyed by around 400 local people led by Thomas Rees (Twm Carnabwth). The rioters disguised themselves in women's clothes, protesting against the high fees charged at toll-gates for the transportation of farm goods, lime and animals. In Genesis we read, 'And they blessed Rebekah and said unto her, thou art our sister, be thou the mother of thousands of millions, and let thy seed possess the gates of those which hate them.' For thirteen days after Efailwen, men destroyed toll-gates in Carmarthenshire and Pembrokeshire, and by 1842, six counties were affected. In July and August 1843, there were riots around Lampeter, when the toll-gates at Pontfaen, Maesyfelin, Cwmann, and those on the Llanfair Clydogau and Cellan roads were burnt. Workhouses and fishing weirs were also attacked by hungry workers – fishing was also subject to control by landowners. The 'Rebecca Riots' continued for some years in South West Wales. The authorities had the utmost difficulty in trying to discover the men responsible.

The diary of Thomas Jenkins of Llandeilo has the following entries for 1843: 'July 9 – A detachment of the 4th Light Dragoons arrived here having been sent for owing to people breaking down the turnpike gates in the neighbourhood under the name of Rebeccaites.' These troops were quartered at the Cawdor Arms Hotel and were later replaced by the 41st, a foot regiment, who used the old vicarage as a barracks. For nearly two years during the Rebecca Riots, Llandeilo became a military post. 'July 10 – Father came here in a phaeton [carriage] with Mr. H. Williams and returned in the evening.' This comment is deliberately cryptic. Thomas Jenkins' father was noted as a champion of the oppressed, and the solicitor Hugh Williams of Carmarthen was a leader of the Rebecca Riots. These increased in strength in the next five weeks and the Walk Gatehouse at Llandeilo was destroyed. 'Aug 9 – The Walk Gate and house was taken down to the ground by the Rebeccaites with

soldiers billeted at The White Hart and Walk on both sides, so much for soldier vigilance.'

The industrialist Amy Dillwyn's novel, *The Rebecca Rioter* (1880) draws on the real events of the summer of 1843, when 'Rebecca and her Daughters' (as the rioters called themselves) were out in force, eluding authorities which included Amy's father and uncle. They now not only destroyed toll-gates but set fire to gatekeepers' houses. An attack on Pontardulais gate was ambushed by the police and magistrates and in the fight that followed, Amy Dillwyn's father and uncle helped arrest, and later convict, the first and only Rebeccaites ever apprehended. They were deported to Tasmania. However, in the novel, it is the rioters that are the heroes, rising up against the greed and arrogance the ruling class and shooting dead a magistrate. It was not until a government commission recommended reduction of tolls, especially on lime and other agricultural products, that the riots ended. The scale and intensity of the rioting and farmers' discontent meant that road boards were established to take over the trusts. Tolls were reduced and some gates removed. In the 1860s parliament began legislation handing responsibility for roads over to public authorities.

The rise of the movement known as Chartism was an even more serious threat to public order. The Chartists were part of a new popular movement named after Williams Levett's Bill, known as The People's Charter, of May 1838. The Chartists believed that by demonstrations they could bring about a democratic parliament and an enfranchised working class. Their aims were universal male suffrage, vote by secret ballot, equal electoral districts, annual parliaments, abolition of the property qualifications for election to parliament, and payment for members so that parliament could be open to all classes. The government took measures to suppress such radical ideas.

Llanidloes was a leading centre of the Welsh woollen industry, and a 1939 Chartist meeting there turned violent. Members ransacked some public buildings and threatened the local magistrate. The local militia had restored order, and many protesters were deported for life. Newport was the site chosen for a major Chartist rally in 1939. Over 5,000 miners and labourers entered Westgate Square in three columns, one led by John Frost. The military was waiting inside the Westgate Hotel, their weapons primed and ready, behind closed shutters. The marchers were soaked from heavy rain, tired from their long walk down the valleys, and a volley from the soldiers of 'the gallant 29th' soon ended the Newport Rising. Twenty-two workers were killed instantly, and many more badly wounded. Thirteen Chartist leaders were indicted for 'waging war against the monarch'. Harsh sentences followed the arrest of the Chartist leaders. John Frost was found guilty of high treason along with William Jones and Zephaniah Williams. A few months earlier, Williams had escaped transportation for hijacking a colliery owned by two of the most powerful men in South Wales. All three were sentenced to hanging, drawing and quartering, their bodies to be thrown on the town's rubbish dump, but after public protests the sentence was later commuted to one of life imprisonment. The Chartist John Rees (Jack the Fifer) had previously fought in the Texas War of Independence, narrowly escaped being executed by Santa Ana and was also sentenced to death in his absence but escaped. (See John Humpries, *The Man from the Alamo*, 2004).

The Newport Chartist Riot of 1839 was described by *The Times* as 'for seizing the whole of South Wales to erect a Chartist kingdom'. The *Morning Chronicle* blamed the language for the Chartists organising in secret: 'In no part of the country could an organisation be formed, with so little interruption, as in a district where the lower classes speak almost universally a language unknown to the educated classes.' Because of police and troop dispositions and the fear of revolution, in the 1840s Wales was 'the most militarised zone in Britain'. By 1858, the year of the final national Chartist convention, the movement began to fade away. That year an Act was passed declaring that property qualifications were no longer necessary for a seat in parliament, and thus the first great democratising point of the Charter had been conceded by the government. The Corn Laws had been repealed in 1846 and bread was a little cheaper; people were less inclined to armed revolt. The Great Reform Bill of 1867 finally ended the Chartist Movement, for in that year nearly 1,000,000 voters were added to the register, almost doubling the electorate. Forty-five new seats were created and the vote given to many working men. Frost returned to Newport in 1877 to a hero's welcome after being imprisoned for almost forty years. Aged ninety-three, his pioneering work, alongside that of the other Welsh Chartists, had not been in vain.

In 1887, violent protests against the Established Church's imposition of tithes took place around Denbigh, Clwyd where thirty-one men, 'the Martyrs of Llangwm', were summoned. Riots at nearby Mochdre also led to many injuries. The secretary of the Caernarfon branch of the Anti-Tithe League was the solicitor David Lloyd George. In 1891 the troubles eased when responsibility for paying the tithe was passed from the tenant to the landlord.

Birth of Political Power

By the eighteenth century growing numbers of doctors, lawyers, estate agents and government officials made up a significant bourgeoisie, and their substantial houses became an attractive feature across Wales. The more successful of these, lawyers in particular, tried to move into the ruling class, that 5 per cent represented by the landed gentry. A favourite method was to marry an heiress. Other ways were accruing money through office, nepotism, royal favour or in a commercial venture. Some, lawyers especially, could break a less wealthy opponent through relentless litigation, could usurp the property of the church or the Crown, or land-grab from the unrepresented poor. Through such methods, men of avarice rose in society, and the great families constantly added to their property. By the nineteenth century, twenty Welsh families each owned at least 20,000 acres.

The Acts of Union had granted Wales twenty-seven members of parliament, which remained the same until the Reform Act of 1832. Welsh MPs made up 7 per cent of the membership of the House of Commons, a percentage which in 1536 had been roughly the Welsh proportion of the population of England and Wales. In the county constituencies, the vote was given only to freeholders owning land. In the boroughs, its burgesses were generally the voters. Almost all boroughs were controlled by estate owners and it is they who decided who became burgesses. Both

county and borough systems were open to manipulation by landed families buying votes, and the small group of around twenty landed families controlled parliamentary representation in Wales. Fewer than one in twenty males had the vote, so bribery was rampant by estate owners. A local election was generally decided not by the casting of votes, but by private arrangements that ensured the emergence of a single, unopposed candidate. In the general election of 1830, for example, not one of the Welsh constituencies was contested. Government repression undermined the efforts of political reformers, along with a sense of religious fatalism whereby one's reward for living a good life would come in heaven.

The urgent need for democratic reform surfaced through newspapers such as the *Swansea Cambrian* (founded 1804) and some Welsh-language Nonconformist periodicals that began to be published in the 1820s. Also industrialists, aware of their contribution to the economy, were now prepared to attack the power of the landowners. The Reform Act of 1832 was a modest step towards more democracy. It only increased the proportion of the adult male population having the right to vote from about 5 per cent to 8 per cent. It was regarded by the working classes as 'the Great Betrayal', but this first move by the British ruling class to reform itself helped Britain towards a non-revolutionary journey to democracy. The Act gave Wales five more MPs.

The great Robert Owen's visions of improving factory conditions, shortening the long hours of arduous labour and educating factory children had led him to set up 'villages of co-operation'. His first was in New Lanark, Scotland and then in New Harmony, Indiana. His main legacy was the creation of the Grand National Consolidates Trades Union (GNCTU) in 1833–4. The union became a major influence on the future development of trade unionism in Britain, its Commonwealth and the United States. In 1834, six of its members, the 'Tolpuddle Martyrs' were found guilty in a show trial of 'administering illegal oaths' and transported to Australia. Owen is little known in his native Wales, and this author has often read of him as being Scottish, although he hailed from Newtown, Montgomeryshire. He was the founder of utopian socialism and the Co-operative movement, endeavoured to improve the health, education, well-being and rights of the working class, and inspired reformers across the world.

Disraeli's second parliamentary Reform Act of 1867 gave the vote to every male householder in the boroughs, and to every male householder in the counties with premises rated at 12 pounds or more. It was known as the 'Great Reform Act'. In addition to the tenants of small farms, many workers in the Welsh industrial towns now had the vote. The new voters dominated the general elections of 1868 and 1880 in Wales, beginning an era completely dominated by the Liberals for the next sixty years. Major Liberals were Tom Ellis, Sam Evans, Ellis Griffith, William Jones and David Lloyd George. The Liberals were supported by the shopkeepers and traders of Wales, by its popular press, and above all, by the workers in the industries of coal, tin-plate, iron, steel and shipping. In the 1868 general election Henry Richard stood against two Liberal industrialists, who were expected to win easily. However, Richard, a radical Dissenter and secretary of the International Peace Society, was elected as an MP. The Marquess of Bute's chosen Tory candidate was defeated in Cardiff, so he founded the *Western Mail* to inculcate the virtues of conservatism in the new voting class.

In 1871 the secret ballot was introduced, partly because of the persecution suffered by Liberal-voting Welsh tenants at the hands of their Conservative landowners. Changes to the electoral system meant that, by the end of the nineteenth century, a Welsh presence was being felt in British politics. In 1881, the Sunday Closing Act was the first piece of parliamentary legislation that granted Wales the status of a distinct national unit. The 1884 Third Reform Act gave county voters the rights already possessed by borough dwellers. The 1885 Redistribution Act increased the number of urban and industrial seats at the expense of rural counties and small market towns. As a result Wales now had thirty-four MPs: twelve for the north, fourteen for Glamorgan and Monmouthshire, and eight for the rest of South Wales. Tom Ellis of Bala worked hard to bring social equality, individual freedom and universal education to Wales. With some eminent London Welshmen, Ellis helped found the Cymru Fydd movement (Wales of the Future) in 1886, inspired by the renewal of Gaelic in Ireland, the efforts of Irish MPs and by the revival of small nations elsewhere in Europe. However, Ellis left the movement in 1892 to join the government and its impetus faltered. Lloyd George took over leadership of the movement but other Welsh MPs did not support him. In a meeting at Newport in January 1896, Lloyd George was howled down by those who did not wish to see 'the domination of Welsh ideas'. He had tried to unite the North and South Wales Liberal Associations. The sentiments expressed at this meeting, showing the bitter divide between North Wales and the heavily populated South East Wales, as well as Ellis' early death in 1899, unfortunately led to the rapid decline of the movement.

Language

In 1834 the Revd Thomas Price (Carhauanawc) optimistically advocated that all teaching should be in Welsh, stating that English would become a disused language like Latin, and 'be known only in musty parchments and records, and that the ancient language of this island will again be the universal language of its inhabitants'. The 1870 Education Act made no provision at all for the teaching of Welsh in elementary schools in Wales. During the last quarter of the nineteenth century and the first quarter of the twentieth century, Welsh children were punished for speaking Welsh. They had to wear a block of wood around their neck with the letters WN (Welsh Not) carved on it. Only when a child wearing the Welsh Not heard another speaking Welsh could it be passed on. This would continue throughout the school day and the child wearing the Welsh Not at the end of the day would be punished by the teacher before being sent home. As Alf Williams commented, 'It was not very effective, but it enormously reinforced the image of Welsh as an inferior and gutter tongue.' The use of a small wooden clog in Brittany served the same effect. By the end of the century, the Welsh community in the South Wales Valleys was unable to absorb the vast influx of non-Welsh speakers into its own language culture. This decline was abetted by a report of the Commissioners of Inquiry for South Wales in 1844 that lamented the fact that 'the people's ignorance of the English language practically prevents the working of the laws and institutions and impedes the administration of justice'.

At the 1885 National Eisteddfod, Aberdare, Dan Isaac Davies and Henry Richard

helped the Society for the Utilisation of the Welsh Language (now known as Cymdeithas yr Iaith Gymraeg, the Welsh Language Society), envisioning a bilingual Wales. Davies aimed to have 3 million bilingual Welsh people in the next century. Davies' report, promoting the use of the Welsh language in elementary education to the Cross Commission, led to some concessions to the teaching of Welsh which were to prove important. By the end of the nineteenth century, English was the language for getting on in the world, its use encouraged by successful industrialists such as David Davies. Wales saw an emerging middle class, the owners and managers of the new iron and coalworks, who were mainly English-speaking. Ambitious working people copied the manners, ways and language of the middle class. They saw little point in transferring the old language to their children. This caused a rapid decline in the number and percentage of Welsh speakers throughout the twentieth century. At the start of the nineteenth century, 70 per cent of the people spoke only Welsh, 10 per cent spoke Welsh and English, and 30 per cent spoke only English. By the end of that century, only half the population could speak Welsh. The Bishop of Avila reported to Queen Isabella of Spain in 1492 that 'language is the perfect instrument of Empire'. In Wales, the second colony of the English empire after Ireland, the future for the language was poor.

Religion

The great Methodist Revival was dominated by a Calvinist approach to religion. The Calvinistic Methodists had become a denomination in 1811 and there was an incredible wave of new chapel building by them, Congregationalists, Unitarians, Wesleyan Methodists and Baptists. The majority of Welsh congregations began to worship outside the Established Anglican Church, and Wales became a Nonconformist nation. The Methodists used the Welsh language to convert and to continue preaching their faith. Leadership of the Methodist movement passed to Thomas Charles (1755–1814). From Carmarthen, Charles settled in Bala, and set about making the town the centre for Methodism in North Wales. He revived the circulating reading schools of Griffith Jones, which for many Welsh people had made possible their active involvement with religion. Sixteen-year-old Mari Jones walked from Llanfihangel y Pennant to Bala and back. Her journey of 40 miles to obtain a copy of the Bible had inspired Charles to help found the British and Foreign Bible Society at the beginning of the nineteenth century. Charles took the Welsh Methodists out of the Church of England in 1811, a move which aligned them with the other Nonconformist movements in Wales.

A second wave of preachers emerged as Wales underwent the beginning of the Industrial Revolution. Christmas Evans (1766–1838) of Llandysul became a minister with the Baptists, and has been called the 'Bunyan of Wales'. During the nineteenth century it has been estimated that a chapel was being built every eight days. By the 1851 census, nearly all Welsh people saw themselves as Nonconformists. Methodists still disapproved of eisteddfodau and traditional dancing and singing, but the other denominations thankfully accepted the cultural revival. A religious census was held in 1851. It revealed that, of the 898,442 sittings available in Welsh places of worship,

the percentages of the various denominations were as follows: Established Church 32 per cent; Calvinistic Methodists 21 per cent; Congregationalists 20 per cent; Baptists 13 per cent; Wesleyans 12 per cent; and others 2 per cent. The Baptists were the largest denomination in Monmouthshire, the Congregationalists in Glamorgan, Carmarthenshire and Breconshire, the Established Church in Pembrokeshire, Radnorshire, Montgomeryshire and Flintshire, and the Calvinistic Methodists in the five other counties.

John Elias of Abererch (John Jones 1774–1841) was part of the Methodist Revival, a powerful preacher who is once said to have preached to 10,000 people, 'as if talking fire down from heaven'. On one occasion it is said he preached to a crowd of 10,000 people. A High Calvinist, he believed in the literal truth of the Bible, and at one stage argued strongly for the controversial doctrine of Elected Salvation, meaning that salvation was pre-ordained for a select few. He came to be known as Y Pab Methodistaidd (The Methodist Pope), and opposed any political radicalism. He vehemently disagreed with many Nonconformists that 'the voice of the people was the voice of God'. As a preacher, he was 'undoubtedly the most popular and powerful of the age in Wales'. A celebrated clergyman of the Church of England wrote in his diary, 'To-day, June 15, was buried the greatest preacher in Wales, and, perhaps, the greatest in the kingdom. May the Lord have mercy upon his church, and favour her again with such a minister as Elias was, like a flaming seraph in the pulpit.' 10,000 people are estimated to have attended his funeral.

In Rhys Davies' *The Story of Wales* (1943), we read,

> The bleak-sounding Nonconformist movement was full of intense spiritual dramas, as it was abundant in the wild poetry of eager young blood. From it came the great preachers of Wales, the seasonal preaching congresses reminiscent of bardic meetings, and that singing or chanting eloquence known as hwyl, and also those hurricane waves of religious ecstasy which have periodically swept across the country. From his pulpit John Elias, auctioneering the souls of drunkards to Satan, could bring the crackling of the flames and the smell of brimstone into the chapel. Elias knew the value of dramatic effects. Prior to one meeting he had candles so arranged in the chapel that during his sermon on Belshazzar's Feast the black shadows of his twitching fingers could write those words of dreadful doom on the whitewashed walls. On another occasion he described God speeding an arrow into the heart of evil and the congregation swerved apart to escape the weapon's passage.

Elias died 105 years before this author's birth, but this type of preaching lingered. My best friend lost his father and mother in a short period of time in the 1980s, and the second funeral service was held at Calfaria Welsh Baptist church in Barry. The preacher was bouncing up and down behind the pulpit, denouncing those who did not attend his church upon a regular basis. I lived over 140 miles away at that time, but was condemned with the rest of the mourners to the 'fiery pits of Hell' for not attending that particular church. My friend was distraught upon leaving the chapel that the service for his remaining parent should have been sacrificed to a sermon upon the evils of not going to church.

People flooded into the valleys of South Wales to find work, creating new

communities in the process. As new pits were sunk, new chapels were rising in the industrial areas at a far quicker rate than Anglican churches. Nonconformity thus impressed itself strongly on the culture of Wales, particularly in these valley towns. Alcohol was despised by the chapels in these areas, as the miners had only one day off in a week, the Sabbath. A sustained period of campaigning saw the passing of the Sunday Closing Act in Wales in 1881. Chapels became the centres of cultural activity in these new towns, and much of the tradition of Welsh choral singing dates from this period. This was helped by the introduction of the sol-fa musical system, which enabled large numbers of people to take an active part in choir singing. From the 1840s choral singing became important, and by the 1870s Welsh choirs were winning English choral competitions. A major motive in encouraging music-making was to keep people out of pubs in what little spare time they had. Chapels helped continue the tradition of a literate working class eager for reading material and highly supportive of the nation's poets, especially those who competed at the eisteddfodau. The success of the first truly national eisteddfod, at Aberdare in 1861, led to the institution becoming an integral part of Welsh culture in localities and schools.

Democracy and free speech was engendered by chapels, which led to demands for the disestablishment of the state church in Wales. The Anglican Church had a cumbersome parish structure, over-politicised English bishops and clergymen often either absent or lacking in zeal. Because of this, the Established Church was forced to move to become competitive. Thomas Burgess, Bishop of St David's from 1803 to 1825, established a college at Lampeter to train Welsh clergymen. He learnt the Welsh language and associated the Church with Welsh cultural activities. Supporters of the Established Church laboured to create a network of elementary schools which taught Anglican doctrines. By 1870, Wales had 1,000 such schools compared with 300 non-denominational ones. Hundreds of dilapidated Anglican parish churches were now rebuilt and efforts made to ensure that Anglican worship was available in the growing industrial areas. The Conservatives, the traditional defenders of the Church of England, refused to accept that Wales could go it alone on such a sensitive issue, and came to be viewed as an anti-Welsh party. The opposing Liberal Party became the natural choice of the Welsh Nonconformist voter. By 1880, Nonconformity claimed 80 per cent of the Welsh population.

From the mid-nineteenth century onwards, Anglican power had been progressively dismantled. Church rates ended in 1870 and the tithe was reorganised in the 1880s. The 1884 Reform Act meant that most men now had the vote (although women had to wait until 1918), and the Nonconformists were now in a position to make political gains. A Methodist deacon from Denbigh saw the potential and founded a publishing business, Gwasg Gee, to help the Nonconformist cause. His weekly/biweekly newspaper, *Baner ac Amserau Cymru*, acquired a campaigning reputation. The issue became particularly bitter when violence broke out over the issue of tithes. A tithe was a traditional payment which entitled the Anglican Church to a tenth of people's annual income, which it was entitled to claim whether or not a person went to church. With Wales a predominantly chapel-going country, confrontation was inevitable and took place across the country. 'The Tithe Wars' were disturbances involving Denbighshire farm labourers in running battles with the local police. This led to the deployment of a troop of lancers to protect the tithe collectors.

An Anti-Tithe League was formed to campaign across the country, and in South Caernarfonshire its secretary was a young solicitor, David Lloyd George. By 1890 he was MP for Caernarfon, one of a number of young Liberal MPs who seemed to embody the values of Welsh Nonconformity. The great Liberal leader William Gladstone said in parliament that 'the Nonconformists of Wales are the people of Wales'. However, hopes for disestablishment were temporarily ended following the defeat of the Liberals in the 1895 election. Gladstone had strong links with Wales, retiring to the family seat at Hawarden.

Patagonia and Emigration

1865 saw the establishment of Y Wladfa (The Homeland) in Patagonia with traditional Welsh laws and Welsh as the official language. It was the first society in the world to give votes for women. It was originally promised independence by Argentina, and the presence of the colony meant that Chile did not take over the most southern area of South America. It has retained much of its cultural identity, even surpassing the Welsh towns at Utica, New York and Scranton, Pennsylvania. The Argentine government, anxious to control a vast, unpopulated area over which it was in dispute with the government of Chile, was willing to grant 100 square miles for the establishment of a Welsh state and to protect it militarily. A Welsh emigration committee, under the leadership of Michael Jones of Bala, met in Liverpool (where there was a large Welsh population) and decided that here was a chance retain Welsh identity, language and culture. A group of nearly 200 Welshmen and women sailed away from Liverpool in 1865 in the *Mimosa*, a brig of 447 tons. The ship arrived safely at what is now Puerto Madryn and after a period of considerable hardship, the settlement began to thrive. The first eisteddfod took place in 1876 at Beti Huws' farm, and became firmly established at Trelew in 1900. In nearby Gaiman, Welsh tea-houses still cater to visitors.

Education

Sir Hugh Owen, a pioneer in education in Wales, wrote an open letter to the Welsh people in 1843 urging the acceptance of the schools of the British and Foreign Schools Society. Over 300 schools were set up in Wales. Owen then began efforts to secure a university, fulfilling the wishes of Owain Glyndŵr. In 1872 Aberystwyth University opened, thanks to voluntary contributions from all parts of Wales and from all walks of life after the government had refused financial help.

Following the public disturbances in Wales during the 1830s and 1840s, the government commissioned a number of reports, the most famous of which was an examination of the education system. Popularly known as the Blue Books, it resulted in uproar when it was published in 1847.

One commissioner wrote, 'Evil in every shape is rampant; demoralisation everywhere is dominant. The people are savage in their manner and mimic the repulsive rudeness of those in authority over them. Everything centres in and administers to the idolatry of

profit.' In 1846, an inspection had been carried out of the Welsh-speaking Nonconformist schools by three English barristers and seven Anglican assistants. The lawyers had little knowledge of Wales or its language. Their report became known as Brad y Llyfrau Gleision (The Treason of The Blue Books), as it called standards deplorable, blaming the Welsh tongue as 'the language of slavery'. The report concluded that the Welsh language condemned the Welsh to intellectual backwardness, encouraged depraved sexual habits, and had produced 'no Welsh literature worthy of the name'. As well as criticising the dirtiness, laziness, ignorance, superstition, promiscuity and immorality of the Welsh, it lamented the effects of the Nonconformist religion and stated that 'the Welsh language is a vast drawback to Wales and a manifold barrier to the moral progress and commercial prosperity of the people. It is not easy to over-estimate its evil effects.' Writing of the significance of the report almost 150 years later, Gwyn Alf Williams comments that 'the Education Report of 1847, accurate enough in its exposure of the pitiful inadequacy of school provision, moved on to a partisan, often vicious and often lying attack on Welsh Nonconformity and the Welsh language itself as a vehicle of immorality, backwardness and obscurantism. The London press, led by a racist *Morning Chronicle*, called for the extinction of Welsh.'

The Welsh language was blamed for Wales being a 'very backward' nation:

> The Welsh language is a vast drawback to Wales, and a manifold barrier to the moral progress and commercial prosperity of the people. It is not easy to over-estimate its evil effects. It is the language of the Cymri (*sic*), and anterior to that of ancient Britons. [This demonstrates the lack of knowledge of the non-Welsh-speaking commissioners. The Welsh language is the language of the ancient Britons, the original language of the British people.] It dissevers the people from intercourse which would greatly advance their civilisation, and bars the access of improving knowledge to their minds. As proof of this, there is no Welsh literature worthy of the name … [Gildas, Nennius, *Mabinogion*, Dafydd ap Gwilym etc. were never considered].

English papers then reported that the Welsh were settling down into savage barbarism, with the habits of animals. *Chambers Edinburgh Journal* of 1849 stated that the use of the Celtic tongue was a 'national discredit'. In 1852, the Inspector of Schools announced that it was 'socially and politically desirable that the language be erased'. English-only board schools were imposed to hasten the decline of Welsh. By 1847, only three out of 1,657 day schools in Wales taught any Welsh. By 1899, Welsh was being examined in only fifteen out 1,852 elementary schools. The effects were dramatic, and it looked as if the language could never recover from this official onslaught. In 1801 Meirionnydd was totally Welsh-speaking, closely followed by Gwynedd. By 1881, just 12 per cent of the population spoke only Welsh. By the same year, only Anglesey had significant strength in Welsh speakers, where for 40 per cent it was their sole language. The process of Anglicisation had been quickly accelerated by the 'Welsh Not', which had been hung around the necks of Welsh speakers in many schools for half a century.

This 1847 report had stated that Welsh was a 'peasant tongue, and anyone caught speaking Welsh were to be severely punished'. The 'Welsh Not' was a ban upon the speaking of Welsh in schools, and was carried out with some vehemence, in yet another attempt to exterminate the language. A wooden placard had to be worn around the

neck, passed on to anyone heard speaking Welsh, with the last child at the end of the day being thrashed by the teacher. This piece of wood on a leather strap was called a *cribban*, and Irish and Breton children had their languages thrashed out of them in a similar manner. In other Welsh schools, a stick was passed on to the same effect. In others, the child was fined half a penny, a massive sum for poor parents. At the same time, the prominent Welsh industrialist David Davies was saying that Welsh was a second-rate language – 'If you wish to continue to eat barley bread and lie on straw mattresses, then keep on shouting "Bydded i'r Gymraeg fyw am byth" (May the Welsh language live forever, the chorus of the National Anthem). But if you want to eat white bread and roast beef you must learn English!' The English poet and schools inspector, Matthew Arnold, declared in 1855 that the British regions must become homogeneous; 'sooner or later the difference of language between Wales and England will probably be effaced … an event which is socially and politically desirable'. In 1865 *The Times* called the language 'the curse of Wales … the sooner all Welsh specialities vanish off the face of the earth the better'. In years to come, older people would boast of how many times they had been caned for wearing the 'Welsh Not' at the end of the day.

Next, the 1870 Education Act made the English elementary school system compulsory in Wales. Many children refused to speak English, so learned nothing at school; for instance Sir Owen M. Edwards, a distinguished educationalist of the early 1900s, who would have remained semi-literate but for the Welsh-speaking Sunday schools. Board schools, in which basic skills would be taught to children of the 'lower classes', were set up throughout Wales. In them, all teaching was to be carried out through the medium of English, and religious instruction was strictly Anglican. In 1871, a number of people led by the Liberal MP Osborne Morgan petitioned the Lord Chancellor to appoint just one Welsh-speaking judge, as the majority of Welsh people spoke mainly Welsh, and there were substantial monoglot communities. The Lord Chancellor replied that 'there is a statute of Henry VIII which absolutely requires that legal proceedings in Wales shall be conducted in English, legal proceedings had been in English for 300 years, and, moreover, the Welsh language is dying out … probably the best thing that can happen for Wales is that the Welsh tongue should follow the Cornish language into the limbo of dead languages'.

In 1881, the Aberdare Commission reported that provision for intermediate and higher education in Wales lagged behind those in the other parts of Britain. It suggested that there should be two new Welsh universities, at Cardiff and Bangor. In 1889, the Welsh Intermediate Education Act authorised public money to be spent on schools higher than the elementary level. The county schools came into being, later known as county grammar, grammar or grammar-technical schools. Welsh people from all backgrounds were to receive a sound education, only in English and only in the arts, at the expense of technical and commercial subjects. The Welsh Intermediate Act of 1899 gave the new county councils the power to raise a levy (to be matched by the government) for the provision of secondary schools. The Central Welsh Board was founded in 1896 to oversee schools. At last, thousands of Welsh children from all levels of society could receive education at a secondary level. This helped the continued decline of the status accorded the Welsh language, for the new secondary schools were thoroughly English, only very few even bothering to offer Welsh lessons. In much of Wales, children grew up knowing nothing of the Welsh language.

Culture

In 1792 Iolo Morganwg had established a meeting of Druids, a Gorsedd, at Primrose Hill in London, with orders of bards and ceremonies celebrating achievement. By 1819, he had managed to integrate the Gorsedd into the Carmarthen Eisteddfod, since when it has remained an integral part of the proceedings. Iolo has been disliked and traduced by the further reaches of the church and some North and West Walians, for several reasons. He was a Vale of Glamorgan man, and much of his research and obsessive gathering of documents placed South Wales in its proper place as a cultural genesis. Llanilltud Fawr was possibly the oldest Christian monastery in the British Isles. The first saints were in the south-east. The last struggles of Gwynedd and then Glyndŵr against the Anglo-French had the influence upon thinking that North Wales was the last bastion of 'Welshness' and its culture. However, to Iolo, the early takeover of the wealthy southern lowlands of Wales disguised its ancient influence upon Christianity and culture. South East Wales was more heavily populated as its lands were easier to work than those in much of North Wales. There is also the still extant feeling that the North Wales language is purer than that spoken across South Wales. However, there were four dialects of Welsh, equally ancient.

The extremist Church hated Iolo and his colleagues for trying to preserve and reinstate Welsh folk customs, dance and music. In its eyes, enjoyment was a sin in the current life but a joy in the afterlife. For many and various reasons, Welshmen have railed against Iolo since his death, focusing on one particular aspect of his life. Iolo took laudanum, and I have watched Professor Prys Morgan (Rhodri's brother), call him an eighteenth-century 'junkie' whose word could not be relied upon. The problem is that the purple syrup laudanum, Thomas Sydenham's opium tincture, had from the 1660s become the aspirin of the age. In 1840, Elizabeth Barrett wrote to Robert Browning, asking, 'Can I be as good for you as morphine is for me, I wonder, even at the cost of being as bad also?' Elizabeth Barrett Browning is never constantly accused of being drug-addled, nor Coleridge, Shelley, Byron, President Lincoln's wife or George Crabbe. Chopin passed away while sipping laudanum through a straw to alleviate the pain caused by tuberculosis. Poppy 'cures' such as laudanum, morphine and opium were widely used to help pains, and Iolo lived to be seventy-nine, still walking Wales and collecting manuscripts for the greater good. Iolo took laudanum for chronic asthma, brought on by his constant travelling and sometimes sleeping in barns and fields. He died in relative poverty. Laudanum continued to be a wildly popular drug during the Victorian era. It was an opium-based painkiller prescribed for everything from headaches to tuberculosis. Laudanum was used in home remedies and prescriptions, as well as a single medication. Of all the millions of people who took laudanum, from America to Europe, Iolo Morganwg has been the only one permanently criticised as being a 'druggie'. Sometimes the Welsh are their own worst enemies.

Only one Welsh hymn writer was able to match the intensity and power of William Williams, and this was Ann Griffiths, who recited her compositions to her maid Ruth Evans on their long walks from Dolwar Fach to Bala to attend religious services. Ann died in 1805, and a year later her hymns (from Ruth's memory) were published as *Casgliad o Hymnau* (Collection of Hymns). At an eisteddfod in Carmarthen in 1819 the Gorsedd was first introduced. This assembly, created in London in 1792 by Iolo

Morganwg, provided a way to bring the ancient eisteddfod to the more populated areas of the South. Iolo invented the emotional triple cry of the Archdruid: 'A Oes Heddwch?' (Is there peace?). Lady Llanofer (Charlotte Guest, 1802–96) helped massively with the redevelopment of Welsh heritage. She championed the Welsh triple harp and retrieved almost forgotten folk dances and music. In the 1834 Cardiff Eisteddfod, her presentation of different Welsh costumes across Wales led to a refreshed interest in folk costume. From 1838–49, the *Mabinogion* was published in English. She had been intrigued by the Welsh language spoken by the workers at her husband's ironworks at Dowlais, and was responsible for publishing the twelve folk tales. She was aided by John Jones (Tegid) and Thomas Price (Carnhuanawc) in bringing this important collection of late medieval Welsh literature to the attention of the literary world. Tourism began in Britain in the Wye Valley, followed by the mountainous areas of Wales. Wales was promoted as Gwlad y Menyg Gwynion (the Land of White Gloves). This referred to the habit of presenting a circuit judge with white gloves when there were no cases to try. It was also promoted as Cymru lan, Cymru lonydd (Pure Wales, Peaceful Wales).

Robert Owen, 1771–1858

In 1771, Trenewydd (Newtown) in Mid Wales produced a man who changed society across the world with his thoughts and actions. Karl Marx and Freidrich Engels both paid generous tribute to him in the development of their theories. Engels wrote that 'every social movement, every real advance in England on behalf of the workers links itself on to the name of Robert Owen'. When Robert Owen took over the cotton mills in New Lanark in Scotland in 1800 he improved housing and sanitation, provided medical supervision, set up a co-operative shop and established the first infant school in Great Britain. Owen also founded an Institute for the Formation of Character and a model welfare state for New Lanark.

His example was largely responsible for bringing about the Factory Acts of 1819, forcing through this the first law limiting the hours of work for women and children. However, disappointed at the slow rate of reform in England, Owen emigrated to America in 1821 to set up another model community. From 1817 Owen had proposed that 'villages of co-operation', self-supporting communities run on socialist lines, should be founded, to ultimately replace private ownership. He took these ideas on co-operative living to set up the community of New Harmony, Indiana, between 1824 and 1828, before he handed the project over to his sons and returned to Britain. The USA community failed without his inspiring idealism, but he carried on encouraging the fledgling trade union movement and co-operative societies. In 1833 he formed the Grand National Consolidated Trades Union. From 1834, Owen led the opposition against the deportation of the Tolpuddle Martyrs, a group of Dorset farm labourers, who had stopped working in a cry for higher living wages. Because of his criticisms of the organised religion of the day, where clerical positions were granted as favours, he lost any support from those in power, whose families benefited from the system.

He wrote about the barbaric nature of unrestrained capitalism in *Revolution in Mind and Practice*; and recent banking scandals and consumer goods being made in totalitarian regimes under semi-slave labour are relevant to his work. Owen wanted political

reform, a utopian socialist system, with a transformation of the social order. All people were equal, so there should be no class system, and individuals should not compete but co-operate, thereby eliminating poverty. Robert Owen was a forerunner of the co-operative movement, a great inspirer of the trade union movement, and possible the modern world's first socialist. Those that followed his teachings, who called themselves Owenites, gradually changed their name to socialists, the first recorded use of the term. Owen is a Welshman of international stature who is hardly acclaimed in his own land, but his socialism is a thread that runs through Welsh history from the Laws of Hywel Dda in the tenth century, to the election of the first Labour MP in Britain in 1910, to the whole-hearted support for the miners' strike in 1984, to the permanent state of left-wing support in Wales.

As the pioneer of co-operation between workers and consumers, his understanding of the 'value chain' and wealth creation has not been equalled until the works of Michael Porter in recent years. The overriding problem in Western society is that political leaders are insulated from the communities they represent – they are always several orders of magnitude richer than the common man, and do not understand the basic nature of wealth creation. Wealth comes from something being dug out of the ground, altered and transported, with value being added along the route. Every service is parasitic upon this process. It seems that Mrs Thatcher never realised that marrying a millionaire was not an option for most of society. In April 1840, an editorial in *The Cambrian* referred to Robert Owen:

> The discontent of the lower and working classes has assumed a new form which threatens to become far more mischievous than mere political agitation, however fiercely carried on. We allude to the institution and spread of Socialism. Under pretence of improving the condition of the poor, Socialism is endeavouring, permanently, to poison their happiness, by depraving their morals, and depriving them of all those consolations flowing from the principles of religion. It is of little use to show that Mr. Owen is a lunatic.

In *The Witch Doctors*, a 1997 'global business book award-winner', we have reference to Robert Owen as

> a Scottish mill-owner who thought there was money to be made by treating workers as if they were human beings (he would not employ any child under ten years old). Owen thus has been deemed to be 'the pioneer of personnel management' (quote from Urwick and Breech, quoted in Clutterbuck and Crainer) … Peter Drucker's enthusiasm for the well-being of workers led Rosabeth Moss Kantner to compare him to Robert Owen, the nineteenth century Scotsman who ordered his factory managers to show the same due care to their vital human machines as they did to the new iron and steel which they so lovingly burnished.

The authors of *The Witch Doctors*, with other eminent management writers, all claim Owen to be Scottish. No wonder no-one knows about Wales on the world stage. Just some of the epithets applied to Robert Owen are 'the Founder of Socialism', 'the Founder of Infant Schools', and 'the Most Popular Man in Europe'. His son, Robert Dale Owen, was prominent in the abolitionist movement in the USA, writing *The Policy*

of Emancipation and *The Wrong Slavery*. Robert Dale Owen became a congressman and ambassador to India, but (like his father) returned to Newtown and died in 1858. Hiraeth is a strong emotion. A memorial museum is now in the house where his father was born.

Davies the Ocean

The most successful Welsh industrialist of the century was the little-known David Davies (1819–90). Born the eldest of nine children in Llandinam, Mid Wales, a wonderful statue of David Davies is placed outside the Docks Offices in Barri, and a replica is in Llandinam. His is the story of our only major Welsh industrialist of the nineteenth century. His father ran a small sawmill, and Davies' nickname from working there stayed with him all his life – Dai Top-Sawyer. Later, as a contractor then financier, he took part in the building of seven Welsh railway lines, thereby earning another soubriquet, Davies the Railway. In 1865, he bought mineral rights in the heavily wooded Rhondda Valley, looking for coal. He sank the two deepest coal shafts ever made at that time anywhere in the world. Running out of money, he addressed the workers, saying that he only had a half-crown piece left (about twelve pence in modern money), and could not afford to pay them any more wages. A man shouted, 'We'll have that as well', and Davies threw him the coin. The men promised to work just one more week without wages, and in March 1866 a coal seam was found at the unheard-of depth of 660 feet – it became one of the richest in the world.

Tired of delays and the monopoly charges at the Scottish Lord Bute's Cardiff Docks, Davies built a railway line to Barri, and had built the most modern docks in history by 1889. (Incidentally, the Marquis of Bute became the richest man in the world through his control of Welsh coal, docks and shipping.) Barri became possibly the busiest port in the world, shipping coal everywhere. His Ocean Coal wagons rolling down to Barri Docks gave him his third nickname, Davies the Ocean. A Liberal MP and philanthropist, his granddaughters Gwendoline and Margaret were responsible for the bequest of Impressionist Art, which made the National Museum of Wales at Cardiff the envy of many other European museums. His grandson David Davies, first Baron Llandinam, was the major benefactor of the first Welsh university and the National Library of Wales at Aberystwyth, as well as a chain of hospitals across Wales. A close ally of David Lloyd George, Baron Llandinam strongly supported the League of Nations, and erected the Temple of Health and Peace in Cardiff. He also founded the New Commonwealth Society and campaigned strongly for an international police force.

Court Cases

There is a case involving death by bread in Spring 1801: 'Coroner's Inquest taken at Cardiff Guildhall before the Bailiffs, William Prichard and Henry Hollier, on a view of the body of William Hopkin, found that he met his death through injuries received at the hands of Morgan Hopkin of Cardiff, labourer, who threw a twopenny wheaten loaf at the deceased and thereby inflicted a mortal blow upon his private parts, resulting

in death a few days after such assault.' In the same year John Quin, a private in the 'Iniskillen' Dragoons, violently robbed James Morgan of Cardiff, labourer, at night on Cardiff Bridge, and stole from him two half-crowns and five shillings. Again in 1801, there are depositions regarding the death of Rees Rees, late of Neath. They show that the deceased was shot by Allen Macdonald of Bristol, the guard of the mail coach, as the coach was being driven through the town of Neath. Rees was running after the coach, and the guard, who appears to have been drunk, took his blunderbuss and fired at him, killing him on the spot.

In Spring 1802, among the prisoners under sentence in Cardiff Gaol was James Carrol, aged nineteen, convicted of obtaining money under false pretences. His punishment was '6 months Imprisonment and twice whipped at Cardiff'. Spring 1811 saw a bitter dispute between two of the great iron and coal dynasties, the Guests and the Homfrays:

> The Jurors present that Josiah John Guest, gentleman, Thomas John Harry and Evan Evans, yeomen, all of Merthyr Tydvil, and other persons, unlawfully assembled themselves and made an assault upon William Harry and Robert Ward, whom they then and there 'unlawfully, riotously and routously did beat, wound and ill treat'; which wrongs were done by them 'with an intent unlawfully to assist each other in the opposing and preventing certain persons', servants in the employ of Thomas Homfray, Samuel Homfray, William Forman and Henry Forman, from proceeding in their work as miners, at Merthyr Tydvil aforesaid.

Rachel, wife of Henry Harry of Llandaff, labourer, was committed in autumn 1916 for having stolen, at the parish of Saint John Baptist, Cardiff, two prayer-books, three velvet pincushions, three Bibles, one Russia leather purse, one pewter inkstand, one metal inkstand, three Johnson's dictionaries, two odd volumes of *Scientific Dialogues*, seven spelling books, one metallic pocket-book and pencil, one book commonly called *Ready Reckoner*, two paper books commonly called the *Death of Abel*, three children's reading books and the third volume of Young's works; all being the property of John Davies Bird of Cardiff, bookseller. She had also stolen a number of articles from the shop of John South, ironmonger, of Cardiff. In the same year, for conspiracy in uttering forged ten-shilling notes of the Merthyr Bank, John Smith and three confederates were sentenced to two years' imprisonment and to stand in the pillory at Cardiff on two market days.

A number of persons were convicted of rioting at Merthyr Tydfil in Spring 1817. The Riot Act had been read after the mob had begun to demolish the Penydarren Ironworks. In spring 1820, William Mathew of Llanrhidian, yeoman, was robbed of his silver watch by two footpads in the White Stile Fields, near Swansea. One of the robbers held a pistol at Mathew's head, and cried, 'Stand and deliver!'

In 1826, John Westmacott of Fairwater testified about certain suspicious circumstances observed by him when he 'went to a Pie' at the house of Anne Evans at Ely, where he saw two shepherds who were accused of sheepstealing, 'drinking together with a China Man and other persons'. Charles Hardyman, one of the shepherds, was convicted of this crime and sentenced to death. In 1828, a sentence of death is recorded on Elias Jones, collier, aged twenty-nine, for having broken and entered a shop at Margam and stolen a piece of brown cloth and various other articles. Death sentences in the sessions were also passed on John Rosser for stealing two lambs at Llansannor, and on Elias John for complicity in the Rosser's felony.

The Twentieth-Century Decline of Wales

A letter in The *South Wales Echo* (9 October 1996) from a Mrs Keenan reads, 'Although born and educated in Wales, I spent many years in England. It was disconcerting to discover that we are perceived as a backward nation, clinging to an esoteric tongue, and spending our leisure time watching rugby. Are there no local politicians with the courage to influence a referendum on the language issue? Let's be rid of the signs, the bilingual correspondence and the teaching of this useless language in schools.'

Initial Prosperity

From 1880 to 1914 Wales as a nation, if not its workers, prospered through being at the forefront of industrial manufacturing. From this period we see architecturally important and grand town halls, hospitals, civic centres, mansions and schools across the land. 90 per cent of all copper smelted in Britain in the nineteenth century had come from the area between Neath and Cydweli. Between 1914 and 1918 the Swansea area produced 75 per cent per cent of Britain's zinc. The biggest nickelworks in the world were built in Clydach, near Swansea, by Sir Alfred Mond in 1902. The tin-plate industry was created in West Wales. Just before the First World War, eighty-two factories from Llanelli to Port Talbot were producing 823,000 tons of tin-plate, 544,000 tons of which were for export. In 1898, 70 per cent of all British slate was quarried in North Wales. The Penrhyn and Dinorwic quarries were the biggest in the world.

Coal, of course, saw the most dramatic expansion. By 1911, 14,500 men were employed in the North Wales coal industry in Denbighshire and Flintshire. In 1913 there were 485 collieries in Wales, from 323 in Glamorgan to nine in Pembrokeshire. In 1885 the Rhondda pits produced 5,500,000 tons of coal, and by 1913 this had risen to 9,500,000 tons. 41,000 miners were employed in the Rhondda pits alone. South Wales was now producing about one third of world coal exports. In 1901, 46 per cent of Britain's coal exports went from South Wales to Europe, South America and the Middle East. The great coal-exporting ports of Cardiff, Swansea, Barri and Newport were known across the world. This economic growth was matched by population growth in industrial Wales. People moved into the South Wales coalfield

at an immigration rate only exceeded in the United States. The population of the Rhondda Valleys in 1861 was 12,000, but by 1891 had risen over tenfold to 128,000. Glamorgan's population of nearly 1,250,000 in 1911 was more than that of the whole of Wales in 1851. Swansea was close behind, demonstrating the growth of a real commercial and business infrastructure.

Language

In 1901, of a population of 1,864,696, those who returned themselves as monoglot Welsh were 280,905; as monoglot English 928,222; and as speaking both languages, 648,919. The most significant fact is that half the population could not speak Welsh, but 1,577,141 could speak English. There had been an increase in monoglot English from 759,416 in 1891 to 928,222 in just ten years, and a decline of monoglot Welsh from 508,036 to 280,905 in the same short period. Despite the rapid industrialisation and associated immigration into South Wales in the nineteenth and early twentieth centuries, there were still around 1 million people could speak Welsh in 1921, or 40 per cent of the population. The north-west counties of Anglesey, Caernarfon and Meirionnydd were strongholds, followed by Ceredigion, north Pembrokeshire (above the Landsker) and Carmarthenshire. However, Welsh use was beginning to disappear in many areas, especially among children, who were being actively encouraged to speak English and were only taught in that medium. This led Ifan ab Owen Edwards to found Urdd Gobaith Cymru (The Welsh League of Youth) in 1922. In 1896 Owen M. Edwards, Ifan's father, had himself founded Urdd y Delyn (Order of the Harp) for Welsh children. This attracted thousands of children to speak and sing Welsh at summer camps, weekly and monthly meetings, and at school activities. The Urdd took over many of its activities, and is still popular today, with an annual Urdd Eisteddfod.

BBC broadcasts began in Britain in 1922, but even the head of the BBC station in Cardiff ignored protests from the million people who wished to hear Welsh language programs. In the face of complete apathy from the mainstream political parties centred in London, Saunders Lewis helped form the new political party, Plaid Cymru (the Party of Wales), in 1925. The process of Anglicisation meant that more and more people considered themselves as Anglo-Welsh rather than Welsh. The blame for this can be laid upon an educational and media system that was focused upon producing loyal British royalists, knowing only the 'Stubbsian version' of history. Radio Eireann broadcast the only regular Welsh-language material, from Eire, beginning in 1927. Reluctantly, the BBC studio at Bangor, in Gwynedd, began broadcasting Welsh-language programs in 1935, and in July 1937 the Welsh region of the BBC finally began to broadcast in Welsh on a separate wavelength.

To counter the threat to the continuance of the Welsh language caused by massive immigration from England, a small, private Welsh-medium school was established at Aberystwyth during the Second World War by Ifan ab Owen Edwards. However, it was not until the Llanelli Welsh School was established in 1947 that the concept that Welsh-speaking children could be taught in Welsh began to be accepted. In 1953, Trefor and Eileen Beasley refused to pay a rate demand in English, had to face

twelve court cases and their property was seized six times. Not until 1960 did they win a bilingual rate demand. In 1956, Liverpool City Council sponsored a private bill in parliament to develop a reservoir in the Trywerin Valley in Meirionnydd. It was to drown historic Capel Celyn, and force its Welsh-speaking community to leave. The opposition to the dam formed a national groundswell of opinion that undoubtedly helped the Welsh language and identity survive, and caused an upsurge in support for Plaid Cymru.

The census showed a decrease in Welsh speakers from 36 per cent in 1931 to 29 per cent in 1951 and 26 per cent by 1961, out of a population of around 2.5 million. Anglesey, Meirionnydd, Carmarthen and Caernarfon still averaged a 75 per cent concentration of Welsh speakers, but there had been major decreases in Flint, Glamorgan and Pembroke, mainly because of incomers and educational policies. BBC Wales was producing a minimal six hours a week of Welsh-language programmes in 1962. Infuriated, in 1962 the writer and poet Saunders Lewis gave a radio speech called 'Tynged yr Iaith' (the Fate of the Language), predicting the extinction of Welsh unless there was direct action by Plaid Cymru. Lewis asked his listeners to make it impossible for local or central government business to be conducted in Wales without the use of the Welsh language.

In 1963, at Trefechan Bridge, Aberystwyth, dozens of members of Cymdeithas yr Iaith Gymraeg (the Society for the Welsh Language) assembled. They sat down in the road to stop all traffic. Undeterred by their forcible removal, arrests, and prison sentences for disturbing the peace, the society began a campaign of protests and civil disobedience that was to last for the next twenty years. Cymdeithas pressed for the right to use Welsh on all government documents, from television licences to income tax forms. As recently as 1965, a Mr Brewer-Spinks had tried to enforce an 'English Only' language rule at his factory at Blaenau Ffestiniog. Three staff resigned, and he only rescinded the rule after a meeting with the Secretary of State for Wales. Eventually, the government established a committee to examine the legal status of Welsh. The Welsh language had not had equal legal status since 1536. The Hughes-Parry report of 1965 recommended equal validity for Welsh in speech and in written documents, both in the courts and in public administration in Wales. The Welsh Language Act of 1967 did not include all of the recommendations, and full recognition and use would not come until 1993. Other campaigns led to the provision of adequate television facilities in Welsh and road signs and traffic directions in Welsh as well as English.

In 1971, in response to a heavy demand, Sefydlu Mudiad Ysgolion Meithrin (the Welsh Nursery School Movement) came into being in many areas of Wales. In many totally English-speaking areas, many parents sent their children to such nursery schools, themselves going to evening classes to learn the necessary phrases to continue Welsh at home. The success of such schools has helped stop the rapid decline of the language. In 1977, BBC Radio Cymru and BBC Radio Wales were established, the first broadcasting in Welsh, and the second in English. For various reasons, the campaign for a Welsh Assembly was defeated in a 1979 referendum, so in that year the Conservative government reneged upon its promise of the Welsh-language television service. This led to over 2,000 Plaid Cymru members refusing to renew their television licence fees in 1980, despite the threat of imprisonment. Plaid

Cymru president Gwynfor Evans threatened to go on hunger strike, the government relented, and the Welsh Fourth Channel, S4C (Sianel Pedwar Cymru) was launched in 1982, the day before Channel 4. *Pobol y Cwm* (People of the Valley) is the longest-running television soap opera produced by the BBC. (*Eastenders* was first transmitted in 1985.) *Pobol y Cwm* was transmitted on BBC Wales television from October 1974, transferring to S4C when that station opened in November 1982. Apart from rugby internationals, *Pobol y Cwm* is consistently the most watched programme of the week on S4C, and its importance in sustaining the language should be more recognised.

Until recently, the Welsh national rugby team always called its line-out ball 'throw-in' in Welsh; usually some alphanumeric code is needed to disguise where the hooker is throwing the ball. The Royal Welsh Fusiliers in the recent Bosnia peacekeeping mission also communicated in Welsh over the radio, thereby preventing interception of messages. However, even as late as November 1996, *The Times* was still criticising minority languages in a leader article, this time the use of the Irish language, which drew a speedy response from Gerry Adams in its letters column. In many parts of Wales there is still a strong feeling against the use of the language. At the beginning of the twentieth century almost 50 per cent of the population of Wales was Welsh-speaking, close on 1 million people. By the end of the century, the number of Welsh speakers had dropped by almost half and the loss in proportionate terms was even greater: 1901 – 929,800 (49.9 per cent); 1951 – 714,700 (28.9 per cent); 1971 – 542,400 (20.8 per cent); 1991 – 508,098 (18.6 per cent). However, the 2001 census showed an upturn in the number and percentage of Welsh speakers to 575,640 (20.5 per cent).

Not until the Welsh Language Act of 1993 was the Welsh language placed on an equal basis with the English language in the public sector. The Act also set up the Welsh Language Board, not only to promote the use of Welsh, but to ensure compliance with other provisions, such as the right to speak Welsh in court proceedings. However, 600,000 people came to live in Wales in the 1980s from England alone, pushing the population up to 3 million. Despite claims by the respective authorities, offices, committees and quangos, the proportion of Welsh speakers is dropping all the time. Massive in-migration has been mainly to the unspoilt, coastal and Welsh-speaking areas. The definition of a Welsh speaker should be one who uses it most of the time, not someone who can say hello and state the weather conditions. It is amazing the number of people who settle here for decades and have no interest or idea in the language, or even in what place-names mean.

A letter in the *Glamorgan Gem* complained about new signs in the 1990s. The person lived in Boverton, Trebeferad, outside Llanilltud Fawr. A new sign read, 'Welcome to Boverton – Croeso i Drebeferad.' He queried why the Welsh name had been altered, as well as complaining about the cost of bilingual signage. 1994 saw Ansells Brewery sacking three student bar staff for speaking Welsh in a North Wales pub, and it had to sign a language accord. In 1997, chef Gwilym Williams won an industrial tribunal after being unfairly sacked for quarrelling with a colleague in a restaurant in Welsh, and refusing to tell the English owner what the row was about. The author is surrounded by English retirees, one of whom retired forty years ago to live in rural Wales. He pointed out to me that he remembered the names of the family in the farm thirty yards from his house,

because their Christian names all began with 'e'. The names are Ifan, Aelonwy, Elgan and Emyr.

According to a 1997 report by Cymdeithas yr Iaith Gymraeg, only twenty-one villages and towns could be classified as Welsh-speaking by 2001. This report took 75 per cent of Welsh speakers as meaning a Welsh community. The report blamed English immigration, attracted to rural Wales by house prices, which remain low while those in England rise rapidly. The Welsh Language Board believes that the language is 'safe' because of the number of new learners in South East Wales. However, a critical report has pointed out that 'if it is to survive, the Welsh language must keep its community base, its foothold as a community language. Otherwise we would go the way of the Irish, with lots of speakers on paper, but which does not exist as a community language except in a very few areas ... The Welsh language will not survive unless there is an environment where people can communicate through Welsh, can live their lives through Welsh, rather than as individual Welsh speakers'. The survival of Welsh as a generally spoken language will be a massive struggle. In the 1991 census, 62 per cent of Anglesey residents said they were fluent in Welsh. In 2000 a survey of 1,000 islanders found only 54.2 per cent were fluent, because of inward migration. According to the 2000 survey, the top ten places in Wales where visitors were most likely to hear the Welsh language spoken are Bala, Llanrwst, Caernarfon, Porthmadog, Pwllheli, Carmarthen, Llandeilo, Gwendraeth, Tregaron and Lampeter. Most of these towns and surrounding areas now have a very substantial English population.

Industrial Unrest

In 1900, the Taff Vale Railway case involved the Taff Vale Railway against the Amalgamated Society of Railway Servants (ASRS). It was upheld held that a union could be sued for damages caused by the actions of its officials in industrial disputes. The intended outcome was to eliminate strikes, but opposition to the verdict massively helped the growth of the Labour Party 1900. In Wales, what became known as the Great Unrest began in 1900. In the north, many of the most productive slate quarries were owned by Lord Penrhyn. The quarrymen had traditionally worked through the 'bargain' system, by which an agreement with the management gave them some measure of autonomy as contractors. In order to retain these rights, the workers struck on 22 November 1900 in what was to become the longest-lasting dispute in British history. It ended in complete defeat for the quarrymen. The strike totally divided the Welsh-speaking community, and thousands left the area, never to return.

In South Wales, the real value of the miners' wages had been declining drastically due to inflation. In order to save money, pit owners would not invest in labour-saving machinery and safety measures. The Liberal government of 1906 to some extent nullified the 1900 Taff Vale Railway case, leading to bitter industrial action across the coalfields. A dispute in 1909 involving Noah Ablett led to the formation of the Central Labour College in London, which was patronised by the South Wales Miners Federation ('the Fed') and the National Union of Railwaymen. The Tonypandy Riots, or Rhondda Riots of 1910 and 1911, were symptomatic of the time. In 1910, the Naval Colliery opened a new coal seam at the Ely pit in Penygraig. To

determine the future rate of extraction, the owners ran a short test, but claimed that the miners deliberately worked more slowly than they could. The seventy colliers involved retorted that the new seam was more difficult to work than others because of a rock stratum that ran through it. Pitmen were paid by the ton of coal produced, not by hours of work, so working slowly could gain them no advantage. The owners closed the site to all 950 workers, not just the seventy at the newly opened seam. All of the Ely pit miners went on strike, and the Cambrian Combine began to call in strike-breakers from outside the area.

The miners picketed the pit and in November all miners in the South Wales coalfield were balloted for strike action by the South Wales' Miners' Federation (the Fed). All 12,000 miners at the mines owned by the Cambrian Combine went on strike. The strikers found out that the owners were going to use strike-breakers to keep the pumps and ventilation going at the Glamorgan Colliery in Llwynypia, and fought to stop them entering when picketing failed. Hand-to-hand fighting began between miners and police. After repeated baton charges, the police drove the strikers back towards Tonypandy Square just after midnight. Then, between one and two in the morning of 8 November, a demonstration was dispersed by police sent from Cardiff using their truncheons, resulting in casualties on both sides. Glamorgan's Chief Constable and the Cambrian Combine asked the Home Secretary, Winston Churchill, to send troops to the area.

Instead, Churchill sent Metropolitan Police officers, both on foot and mounted, and some cavalry troops were despatched to Cardiff. Early on 9 November, orders were sent to despatch a squadron of the 18th Hussars to reach Pontypridd at 8.15 a.m. Contingents patrolled Aberaman and Llwynypia all day, and in the evening reached Porth as a disturbance was breaking out, keeping order until the arrival of the Metropolitan Police. Nearly eighty police and over 500 citizens were known to have been injured, but many kept quiet for fear of being blacklisted or imprisoned. One miner died of head injuries said to have been inflicted by a policeman's baton. Thirteen miners from Gilfach Goch were arrested and prosecuted for their part in the unrest. The trial of the thirteen occupied six days in December, during which they were supported by marches and demonstrations by up to 10,000 men who were refused entry to the town. The strike finally ended in August 1911, with the workers forced to accept the 2s 3d per ton negotiated by William Abraham MP prior to the strike. The workers returned to the pits on the first Monday in September, ten months after the strike began and twelve months after the lockout which started the confrontation. The presence of troops prevented the possibility of the strike ending early in the miners' favour, and also ensured that trials of rioters, strikers and miners' leaders would take place in Pontypridd in 1911. The ill-feeling in the Valleys engendered towards Churchill, and the militancy of the miners, was worrying for the British government at the start of the First World War.

At the new Central Labour College in London, Welshmen James Griffiths, Aneurin Bevan, Ness Edwards and others worked upon methods of breaking the power of the Cambrian Combine. They formed the Unofficial Reform Committee at Tonypandy in 1911. There followed strikes in the coalfields and the demand of the miners for legislation to ensure their rights to a fair wage for working difficult mines. The Miners Federation of Great Britain, to which the South Wales Miners'

Federation belonged, persuaded their members in all British coalfields to join the strike in 1912. This led to the government passing the Minimum Wage Bill in 1912.

Britain's dependence upon older industries such as mining, shipbuilding, cotton manufacture, etc., led to economic problems following the Great War. There was low investment in these industries, and export markets dried up. From the 1890s onwards, smaller unions had begun to amalgamate to try and concentrate power against employers. The National Transport Workers' Federation was created in 1910 to co-ordinate the actions of trade unions representing dockers, seamen, tramwaymen, etc. In 1912 the National Union of Railwaymen was formed. In 1914, the rail and transport unions came together with the Miners' Federation of Great Britain to form the Triple Alliance, an informal vehicle for united action by the largest and most powerful industrial groups. Post-war Britain was strongly affected by industrial unrest.

In 1919, roughly 2.4 million British workers went on strike. Problems were severe in two of the industries still largely under government control, the railways and the mines. They had been taken over by the state in wartime and not immediately returned to private hands. The Triple Alliance and united strike action were seen by trade unionists as a defence against the threat of wage reductions occasioned by the onset of post-war economic depression. Lloyd George's Coalition-Liberal government did not want to impose wage reductions, as this would provoke strike action with inevitable political consequences and defeat at a forthcoming election. Reductions for miners were therefore postponed until the mines were de-controlled on 31 March 1921. Miners who refused to accept the reductions were locked out of employment.

It was thought that the transport and rail unions would strike in support of the miners. However, on 15 April 1921, known as Black Friday, it was announced that they would not recommend strike action. Despite the decision against fully fledged strike action, transport and rail workers were ordered not to handle imported coal. Transport and rail leaders were widely criticised for their actions, with Newport-born Jimmy Thomas of the NUR and Swansea-born Robert Williams of the NTWF being singled out for particular criticism. For their part, union leaders pointed to the difficulties of resisting wage reductions in a period of unemployment. In 1925, the government agreed to grant a temporary subsidy to the mining industry so as to avoid wage reductions, and the day on which the decision was announced became known as Red Friday, in imitation of Black Friday.

However, Britain was paralysed from 3 to 12 May 1926, when a strike was started by the miners in dispute over the proposals of the Samuel Commission. They were now backed by transport, railway and other unions. However, on 12 May the Trades Union Congress announced the end of the general strike, as Baldwin's Conservative government offered better terms. The Miners' Union rejected the terms and stayed on strike until 19 November, when it finally ended in Wales. Miners' families were starving and colliers were forced to return to work and accept the terms and conditions of the pit-owners, on longer hours and worse pay than the terms offered in the previous May. To help alleviate miserable conditions in industrial areas, Baldwin began a programme of social reform to appease working-class opinion. The Widows, Orphans, and Old Age Health Contributory Pensions schemes extended the Act of 1911 and insured over 20 million people.

1984 saw the last miners' strike, after Mrs Thatcher announced the insane closure of many of Britain's coal mines. The bitter strike lasted almost one year, and was remarkable for police, political and media mendacity over events. Police television footage taken at Orgreave Colliery showed violence beginning with miners, and was shown on national TV and in all media. Later it was revealed that the footage had been reversed – the miners were defending themselves against an initial police charge. No-one was prosecuted in the police force, despite some extreme brutality against miners. Because local police were known to be sympathetic to miners, policemen were taken from non-mining parts of Britain to deal with strikers. The Metropolitan Police gained a particular reputation for hostile actions. The 1984 strike is a notable and under-researched part of British history, with the Welsh miners being the last to return to work.

Mabon and Ablett

William Abraham, known as Mabon (1842–1922), was born in Cwmafan. He was tin-plate worker and then a miner, and aged twenty-eight was elected a miners' agent, playing a prominent part in the fight to draw up a sliding scale of wages in relation to prices and profits in 1875. From 1892 to 1898 the South Wales miners did not work on the first Monday of each month, a scheme to limit output in order to maintain wages. The day, known as 'Mabon's Monday', was also used to hold miners' meetings. In 1885 he was elected Lib–Lab MP for the Rhondda division, remaining an MP until his death in 1922. He was associated with the radical wing of the Liberal Party until 1906 when the Labour Party became a separate political organisation. Mabon's importance lies in the history of trade unionism in Wales. In 1898 the South Wales Miners' Federation was formed, and Mabon became its first president. A terrific orator in English and Welsh, Mabon tried to exert a moderating influence, but could not prevent the series of disputes which produced the first general miners' strike in 1912.

Noah Ablett (1883–1935) was born in Porth. As a miner, he went for a period to the Central Labour College, and then became a check-weigher at Maerdy Colliery. He was elected a member of the executive committee of the South Wales Miners' Federation in 1911, and then a member of the executive of the Miners' Federation of Great Britain. In 1918 he was appointed a miners' agent at Merthyr Tydfil, which he remained until his death. Ablett was a main leader of the opposition to older miners' leaders like Mabon, whose position was based upon the principles of trade union organisation and interests. Ablett, a follower of Marxism and Syndicalism, believed that there was an irreconcilable conflict between owners and workers in a capitalist society. He opposed any move to conciliate or compromise with the mine owners. Ablett wanted to strike not only for an improvement in working conditions and pay, but to eliminate the owners altogether. He therefore advocated general strikes, to bring the workers together in a battle of class warfare. He was prominent in the violent Tonypandy Riots, trying to establish a guaranteed minimum wage. Ablett issued a manifesto to the miners in favour of a general strike, and opposed accepting the terms of the owners. After its collapse, he pleaded for the formation of one

vast industrial union, advocating workers' control and ownership of industry. He was usually a lone dissenter on the councils of the Miners' Union, which adopted nationalisation of the mines as its policy rather than Ablett's syndicalism.

Industrial Disasters

There is no space in this book to recount all the terrible times in the history of the industrialisation of Wales, and the fact is that they have been almost airbrushed out of history. If Aberfan had happened in England, it would be a national shrine, commemorated every year. The Welsh still seem to be treated as – and accept being treated as – second-class citizens. There is an emphasis upon the amount of space given to these disasters, because they have affected the national psyche more than we realise. The Welsh keep accepting whatever is thrown at the nation, lacking any political leaders to unite against wrongs. The following are representative of the curse of capitalism in Wales.

Just one man, crippled and insane for the rest of his life, survived the 1901 explosion at Universal Colliery, Senghenydd, when eighty-one miners died. The company, Lewis Merthyr Consolidated Collieries Ltd, had been forewarned of problems, but all charges against it were dismissed. There was no compensation paid out to the families of the victims. A simple incident indicates the horrors of underground working at this time. In 1901, Morgan Morgans died in a fall at Cymmer Colliery, Porth, which pushed him onto a pick axe, which went through his head. His son, Dai Morgans, aged thirteen, witnessed the accident and was so traumatised that he never worked again. He had to rely upon his family to support him – there were no benefits in these days. In 1905, at the National Colliery, Wattstown, 109 were killed, and the first major disaster at Cambrian Colliery, Clydach Vale saw thirty-one killed.

The demand for Welsh steam coal was tremendous, particularly because of the wartime demand for its fleet, and for those of foreign allied navies and merchant shipping. Thus coal output peaked in 1913–14, with an increasing number of accidents. St Ilan's church, on top of Mynydd Eglwysilan between the Taff and Aber Valleys, is a medieval church with a huge graveyard. Dedicated to a sixth-century saint also commemorated in Brittany, there is an extremely rare eighth- to tenth-century sandstone slab carved with a warrior. The 1100 *Book of Llandaff* refers to the site as Merthyr Ilan. Eglwysilan was in the cwmwd (commote) of Senghenydd, in the cantref (hundred) of Brenhinol, later called the hundred of Caerffili, and once was the mother church of the region. It is a place that resonates history. However, the graveyard is full of Welsh inscriptions on the gravestones of many of the 439 men and boys who died at the second major Senghenydd pit explosion, featuring fathers and sons and brothers. It occurred at the Lancaster Pit on 14 October 1913. The Welsh-speaking community was totally devastated by the tragedy. A contemporary poem reads:

> The collier's wife had four tall sons
> Brought from the pit's mouth dead,
> And crushed from foot to head;

When others brought her husband home,
Had five dead bodies in her room.

The Universal was known as a 'fiery' pit, full of hidden methane-filled caverns. A miner went to the lamp room to light his wick, a roof-fall nearby released methane ('firedamp') into the tunnel, and the explosion disturbed and ignited the massive amounts of coal dust in the air and on the floor. The fire caused a massive second explosion that roared up the Lancaster section of the pit, smashing through the workings. The shock-wave ahead of the explosion raised yet more coal dust, so that the explosion was effectively self-fuelling. Those not killed immediately by the fire and explosion would have died quickly from 'afterdamp', suffocation caused by lethal quantities of toxic gases. The pit cage was blown right out of its shaft into the air. The fires could not be put out for a week, during which all but eighteen of the survivors died of carbon monoxide poisoning.

Aged a little over fourteen years, Harry Wedlock's first day as a colliery boy was spent in tears, with cracking timber pit-props falling away around him. An older miner, Sidney Gregory, held him in the thick smoke in pitch-black, 2,000 feet under the management offices. They were the lucky ones. The dead included eight children of fourteen years, five children of fifteen years, ten children of sixteen years, forty-four youths aged from seventeen to nineteen, and 377 other miners. Eight bodies were never identified and twelve could not be recovered. Not one single street in Senhenydd was spared from death. Forty-five of the dead came from Commercial Street, forty from the High Street, thirty-one from Caerphilly Road, twenty-two from Cenydd Terrace, twenty from Stanley Street, nineteen from Grove Terrace, fifteen from Parc Terrace and so on. In twelve homes, both father and son died.

Some women lost their husbands in 1901 and their sons in 1913. Mrs Benjamin of Abertridwr lost her husband and both her sons, aged sixteen and fourteen. At 68 Commercial Street, the widowed Mrs Twining lost each of her three sons, the youngest aged fourteen. 'When Edwin John Small died with his 21 year-old son, it left his 18 year-old daughter Mary to rear 6 children, the youngest 3 years old.'

Richard and Evan Edwards, father and son, of 44 Commercial Street, were found dead together.

Half the village rugby team died, and it changed its strip from black and white to black: 'For weeks, there was no rugby on Saturday ... only funerals.' A survivor, William Hyatt, recalled, 'My father always said that there was more fuss if a horse was killed underground than if a man was killed. Men come cheap ... they had to buy horses.' The owners of the mine, Lewis Merthyr Consolidated, had again ignored warnings of the dangers in the mine, but its pit manager was found guilty on eight charges of breaches of the 1911 Coal Mines Act. He was fined £24, or twopence a corpse. There was again no compensation, and all charges against Lewis Merthyr Consolidated Collieries were of course dismissed. However, upon appeal the company was fined £10, with costs of five guineas. It was the greatest loss of men underground in recorded history.

Upon St David's Day 1927 at Marine Colliery, Cwm, Ebbw Vale, fifty-two men were killed. Between 1837 and 1934 there were more than seventy disasters in Welsh mines, and in eleven, more than 100 people (women and children also worked

underground) were killed in a single day. These terrors were not confined to the South Wales coalfields. On 22 September 1934, the bells of Gresford parish church joined in with the sirens at the local colliery to announce an explosion and fire had ripped through the Dennis section of Gresford Colliery near Wrexham. Apart from six men who escaped the blast, along with a few men at the pit's bottom, all the men working that day were killed, a total of 266 miners. Such was the force of the explosion and the following fire that the Dennis section of the pit was sealed off and 255 miners were forever entombed where they died. Only eleven bodies could be recovered from the mine and buried. Over 160 widows were left in the surrounding villages to provide for over 200 children. A shot-firer had warned of gas in the Dennis deep section, half a mile underground. A report highlighted management failures, a lack of safety measures, bad working practices and poor ventilation in the pit. No independent person was allowed to enter the mine to discover the cause of the explosion. In 1937 David Rhys Grenfell, Labour MP for Gower, condemned the management of the colliery in the House of Commons, stating the miners' testimonies had told

of lamps having been extinguished by gas, blowing the gas about with a banjack [jack-hammer] of protests and quarrels about firing shots in the presence of gas. There is no language in which one can describe the inferno of 14's. There were men working almost stark naked, clogs with holes bored through the bottom to let the sweat run out, 100 shots a day fired on a face less than 200 yards wide, the air thick with fumes and dust from blasting, the banjack hissing to waft the gas out of the face into the unpacked waste, a space 200 yards long and 100 yards wide above the wind road full of inflammable gas and impenetrable for that reason.

The mine manager was fined £150, but the owners assembled an expensive legal team to escape punishment. The wage packets of the dead colliers, who ranged in age from just twelve to eighty-seven, were docked quarter of a shift's pay for failure to complete the shift. The week after the explosion, 1,100 Gresford miners signed on the unemployment register. An anonymous broadsheet poem was circulated shortly after the explosion. It was said to be written by John Charles Williams, the leader and only survivor of a four-man rescue team.

You've heard of the Gresford Disaster,
Of the terrible price that was paid;
Two hundred and sixty-four colliers were lost,
And three men of the rescue brigade.
It occurred in the month of September
At three in the morning the pit
Was racked by a violent explosion
In the Dennis where gas lay so thick.
Now the gas in the Dennis deep section
Was packed there like snow in a drift,
And many a man had to leave the coal-face
Before he had worked out his shift.
Now a fortnight before the explosion,

To the shotfirer Tomlinson cried,
'If you fire that shot we'll be all blown to hell!'
And no one can say that he lied.
Now the fireman's reports they are missing
The records of forty-two days;
The collier manager had them destroyed
To cover his criminal ways.
Down there in the dark they are lying.
They died for nine shillings a day;
They have worked out their shift and now they must lie
In the darkness until Judgement Day.
Now the Lord Mayor of London's collecting
To help out the children and wives;
The owners have sent some white lilies
To pay for the poor colliers' lives.
Farewell, all our dear wives and our children
Farewell, all our comrades as well,
Don't send your sons down the dark dreary mine
They'll be doomed like the sinners in hell.

Not until 1982 was a memorial to the dead Gresford miners erected, in the form of the wheel from the old pit-head winding gear. In 1931 at Cilely Colliery, Tonyrefail, John Jones was killed. His wife and four children received £6 compensation. Idris Davies, miner and poet, wrote in his notebook in 1937: 'I looked at my hand and saw a piece of white bone shining like snow, and the flesh of the little finger all limp. The men supported me, and one ran for an ambulance box down the heading, and there I was fainting away like a little baby girl.' Davies understood the sullen slavery of his fellow colliers:

There are countless tons of rock above his head,
And gases wait in secret corners for a spark;
And his lamp shows dimly in the dust.
His leather belt is warm and moist with sweat,
And he crouches against the hanging coal,
And the pick swings to and fro,
And many beads of salty sweat play about his lips
And trickle down the blackened skin
To the hairy tangle on the chest.
The rats squeak and scamper among the unused props
And the fungus waxes strong...

In 1941 at Coedely Colliery, Hugh Jones was killed and his mother received £15 compensation, of which the coffin cost £14 14s. She went to the pit with the £15 and waved it at miners, shouting, 'Look, boys, get out of this pit as quick as you can – because this is all your lives are worth.' With nationalisation of the mines, compensation of sorts began to be paid. In 1947 at Lewis Merthyr Colliery,

eighteen-year-old Neil Evans was suffocated in roof fall. His family received £200 compensation, but the National Coal Board took away their entitlement to free coal in return. Between 1931 and 1948, of the 23,000 men who left mining because of pneumoconiosis, almost 20,000 came out of the South Wales pits. The scandal of the assessment, non-payments and legal mishandling of cases involving 'the dust' would take another book to tell. In 1950 at Maritime Colliery, Pontypridd, John Phillips died but there was no compensation for his family. In 1951, at Wern Tarw Colliery, two brothers, Aaron and Arthur Stephens were killed in a roof fall. Aaron's widow received £200 compensation and Arthur's widow £250. The differential was explained by the fact that Arthur had two children. In 1960 at Six Bells Colliery, Abertillery, forty-five men died, and in 1962 at Tower Colliery, nine were killed. Dai Morris was decapitated. The miner with him reminisced 'when the nurse pulled my shirt off, she pulled away half my skin with it'. Ken Strong also died there. His wife, Mary, was only thirty-two and never left her home for fifteen year years until she died in 1977. 1965 saw another major disaster at Cambrian Colliery, Tonypandy, with thirty-one dead in the explosion.

Now we come to an event which has strongly affected this author's view of authority, competence and justice since the day it happened. In 1961 No. 7 Pantglas Tip was started, on top of a mountain stream, next to six other slag-heaps on boggy ground on the side of a hill. Directly underneath it was Pantglas School. There were local protests. No. 7 Pantglas Tip grew quickly. The National Coal Board – a nameless, faceless, ignorant bureaucracy – used the dangerous site to deposit 'tailings', tiny particles of coal and ash. In 1963, a Merthyr Council official wrote to the National Coal Board, 'You are no doubt aware that tips at Merthyr Vale tower above the Pantglas area and if they were to move a very serious situation would accrue.' When wet, tailings formed a consistency identical to quicksand. On 21 October 1966, after 3 inches of rain in the week, men working on No. 7 Pantglas Tip arrived at work at 7.30 a.m. A 30-foot crater had developed in the centre of the tip. At nine in the morning, the tip slowly started moving. At 9.15, within seconds it rolled down the hillside, over twenty sheep, covered some walkers on the canal bank, smashed through eight terraced houses in Moy Road, and buried the village school. It was just three hours before the half term holiday was to begin at Pantglas Junior School, Aberfan. One in two families in the village was bereaved. 116 children and 28 adults, including 5 teachers, were crushed. The deputy headmaster tried to use the blackboard to shelter the children in his class – all thirty-four were killed. A lady in the village recalled, 'See those rows of white arches? Each one's a child. You can't imagine what it was like. It was as if someone took the roof off your house, filled it up to the top with dust and dirt, and then put it back on. They found 6 of the children still standing up around their teacher, it happened so fast.'

One of the rescue workers recounted, 'My supervisor called me out of the mine and we went to help. A farmhouse near the school had been pushed right through it. I didn't cry until I saw them bring a little baby from the farmhouse, suffocated by the dust.' Apart from the baby, the village lost a three-year-old, seven seven-year-olds, twenty-five eight-year-olds, thirty-five nine-year-olds, thirty-five ten-year-olds, five eleven-year-olds, one twelve-year-old, three thirteen-year-olds and three fourteen-year-olds. A survivor from the school tells us,

I can still remember the noise, a tremendous noise, like a thunder but magnified a thousand times; it sounded frightening Some instinct made me jump from my seat and try to run for the door. After that, nothing, till I came round and found myself buried up to my waist in black slurry. The walls and roof of the classroom had caved in and beside me, under the rubble, was a little boy I knew, lying dead. Another child's hand was hanging above me, poking through from the next class where the wall had given way. I took hold of the hand and squeezed it. I still don't know whose hand it was – a child who was already very probably dead. On that day 116 children were killed, my younger brother Carl, 7, my sister Marilyn, 10, among them. I was eight years old and spent the months following the tragedy in hospital with hip and leg injuries. The world mourned for Aberfan, but the focus was on the children who had been lost rather than those who had survived. Everyone was so busy looking for someone to blame, we were chucked aside, forgotten. It was about 30 years ago, and nobody thought about our traumas and nightmares then. The attitude was that you should be grateful that you were alive. For years I never spoke about what had happened.

At that age I was too embarrassed to talk about how I felt. I thought I would be laughed at. All of us were brought up then to bottle up emotions, to bury what had happened and get on as best we could.

But I needed to get it out of my system. At 12, I wrote it all down in a blue school exercise book, every detail of what I had seen and how I felt at the time and afterwards. Nobody saw it but my family and one teacher. After he had read it he did not even speak to me, he seemed so shocked. My parents were horrified. It was another 20 years before I took it out and showed it to a woman who was writing a book about Aberfan. In the meantime, I had tried to forget and I was shocked at how forcibly it all came back to me. I realised I still had a great deal of suffering inside me, that I needed to talk and to think about how Aberfan had affected all of us who were involved. A lot of people had breakdowns, probably because they were never adequately able to share their grief.

Miners used bare, bleeding hands to remove tons of slurry off the buried children – in the black slime they were afraid of driving a spade into a child's body:

When the tip collapsed on October 21, 1996, Idris Cole had been at work since 7.30am. He recalls that he and his colleagues were struck by an uncanny silence in the air just before the calamity. Here, [thirty years later] he reveals for the first time what happened next. 'Suddenly, someone shouted to my workmates that the tip had collapsed and was on the move. The main water pipe carrying water to Cardiff had been crushed with the weight of the tip and torrential rain, until it was like a wafer, causing the tip to slide down the mountain. We rushed to the school, wading through slurry which had gone through the houses over a large area and on down to the river. The whole tip had moved silently, like a volcano spewing lava, but this was horrible black slurry. The scene as we approached the school was horrendous and frightening beyond description – screams and shouts of mothers and fathers, some of them who had just taken their children to school and had stopped for a chat. It was all so terrifyingly unbelievable. In their panic, people were unable to think what to do.

Their screams have never gone away. My workmates and myself waded on through the slurry and the rubble of the crushed building. I dived down to where I could see

some of the children, the ones who had not been completely buried. Some, like rag dolls, were crushed against a radiator. And a teacher with outstretched arms, as if to protect the little ones. I was one of the first people to get right in the middle of it, and I couldn't believe what I was seeing. I recall one distraught father frantically searching for his two children. He was hysterical and kept pushing me away from what I was trying to do. He was out of his mind with anguish and had to be led away and physically restrained.

I think I went mad myself, from what I was seeing. But I just had to get on with using my skills and trying to keep the slurry back. Some part of the roof was still there, but hanging dangerously.

The skills of the building trade enabled my mates and myself to jack it up to prevent further falls. We worked late in the night by the light of lamps which were brought in. I have never done so much crying as that day; we all did. The slurry was so deep, at one point I almost got sucked down into it. They had to pull me out and strip off my denims and my shirt, but I just wanted to carry on. Eventually, I collapsed from exhaustion and was carried off. I had double pneumonia and was given an injection which put me to sleep for many, many hours. I didn't know where I was by then; all I remember is seeing the doctor bending over me to give me the injection.

I don't think I have ever felt completely normal since that day. I had experienced many horrors during the war, from the beaches of Dunkirk, to a naval battle on the battleships taking us to Malta where I served for three years. Malta was under siege, continuously being bombed, and on very meagre rations. From there, I went to Minterno and Cassino, where we had to bury many of our comrades who were slaughtered. But nothing can ever erase the memory of that fateful morning at Aberfan and the loss of 116 little children. It was much worse, because it was the children who died. Their laughter would never ring out again in that sad, sad, village. I can never forget it. Let no-one ever forget that terrifying, sad day – or the lesson to be learned.'

Most villagers will still not talk about it. Mothers still die of broken hearts. Front rooms are their children's shrines. The greatly honoured chairman of the NCB, Lord Robens, immediately lied that it was not known that the tip was placed on a stream. An appeal fund raised £1.75 million from the British public. The National Coal Board asked for £250,000 from it and accepted £150,000, to meet the costs of clearing the remaining slurry from the hilltops around the town. The families of the bereaved were offered £500 each, regardless of how many children the National Coal Board had killed.

Eventually, the generous NCB gave £1,500 per family from the appeal money it had disgracefully taken from the disaster fund. Other parts of the fund were used to build a new, necessarily smaller, school and make a memorial cemetery. No one in the National Coal Board lost his job, despite a damning report. The shame of the story of Aberfan seems to have been quietly airbrushed from history. This is the saddest place in Wales. The 4,236-page enquiry began legislation to remove all tips from the edges of mining villages. The mine closed in 1989. As part of her Jubilee celebrations in April 2012, Queen Elizabeth visited Aberfan. In 1966, she did not visit until nine days after the event. One believes that if a disaster on such a scale had occurred in Surrey or Hampshire, the queen might have found an earlier space in her packed social diary. There was no counselling for the trauma.

Some readers may think that this entry upon mining disasters is given too much prominence in a history book, but events like this have shaped the Welsh view of the world. Cockneys and Geordies and Irish all have a different perspective, but the Welsh viewpoint is particularly affected by grief and oppression. If any Welshman did not shed a tear over Aberfan, it is difficult for him to understand Welsh history and heritage.

In 2001, on BBC Radio Wales, I was promoting my *100 Great Welshmen*, in a three-way link with Gareth Edwards and Tanni Grey-Thompson, when a caller said that I should have included George Thomas in the book. I replied, fairly soberly, that it was not his sexual persuasion which had led to his exclusion, but the fact that no resident of Aberfan would think that he should be anywhere near a book about great Welshmen. In secret Cabinet papers released in 1996 under the thirty-year rule, it had been revealed that it was George Thomas's recommendation that the publicly raised fund for the villagers should be used by the Labour government to clear the coal-tips. A producer at the BBC congratulated me after the programme, stating that the BBC Wales top brass always laid out the red carpet and a special welcome for Thomas, treating him like royalty on his visits. BBC Llandaf 'went into melt-down' in the words of another BBC worker. I could never, ever understand the near-hagiography of Thomas's admirers, even before the news of his betrayal was released – he was a deeply devious, anti-nationalist, royalist sycophant, and the very antithesis of a socialist. Only in 1997, after thirty years' campaigning by Plaid Cymru, did the Labour government repay the stolen money back into the fund. However, it did not repay the millions it was worth after thirty years of inflation, only the original £150,000. This terrible event, when a whole school was wiped out, seems to have been airbrushed from British history. Today, few people under forty have ever heard of Aberfan, the greatest tragedy to hit the British people since the Second World War. (In the Lockerbie plane bombing in 1988, 250 passengers were killed, of which just forty-three were British citizens). No blame was attached to anyone involved for Aberfan – politicians, the National Coal Board, anyone – and no apology has ever been given to the people of Aberfan. If the disaster had happened in Nottingham or Metz or anywhere else in Europe, it would be a place of pilgrimage. The disaster has been so effectively covered up that it is passing from both written history and human remembrance.

As a footnote, on the evening of the disaster of 31 October, the National Coal Board's chairman, Lord 'Alf' Robens, celebrated his installation as chancellor of the University of Surrey at a party. The 'Lord' began his career as an errand-boy. Miners at the same time were desperately working under floodlights hoping to find survivors, but only digging out the bodies of children. They used their bloodied, bare hands to dig, instead of picks and shovels as they did not wish to harm any body they found. Initially the National Coal Board tried to minimise its responsibility by offering £50 compensation to each of the bereaved families (2012's value is just £730)! It later settled for what it called a 'generous settlement' of £500 for every child killed (just £7,300 in today's value). As noted above, Lord Robens ensured that the NCB recovered nearly all this compensation money by taking £150,000 from the Aberfan disaster fund to pay for the removal of the remaining coal tips. Under the thirty-year rule it was also discovered that the NCB exaggerated the cost of removing the tips,

and obstructed a private contractor's offer to do the work far more cheaply. The 1967 report on the disaster was devastating, but as usual in Britain, no-one was made to suffer, only the villagers: 'The Aberfan Disaster is a terrifying tale of bungling ineptitude by many men charged with tasks for which they were totally unfitted, of failure to heed clear warnings and of total lack of direction from above.'

More information has emerged from a 1999 study by Nuffield College, Oxford, sponsored by the Economic and Social Research Council. Professor Iain McLean stated, 'The Charity Commission and outdated charity law obstructed the Aberfan Disaster Fund in its attempts to help bereaved parents and other victims. At one point the Charity Commission wanted to insist that the fund should only pay grants to those parents shown to have been close to their dead children.' Please re-read that last sentence – the Charity Commission wanted in effect to set up a slide-rule and put grieving parents under scrutiny to see who deserved what from the deaths of their children. The commission also stopped any payments being made to families where children were not injured. The commission would not back the trustees of the disaster fund who wanted the Labour government to remove the remaining dangerous tips overlooking their village. Thus the trustees were literally forced to hand over the exaggerated cost of £150,000 for the removal of those slag-heaps.

Jeff Edwards, a magistrate, was a survivor when the school was covered, and stated in 1999 that it was twenty years before his family received any payment. He had seen his classmates die. In other cases, many families received nothing. He stated, 'Parents of uninjured children also went through the trauma – they had to live with the sleepless nights, the nightmares and the tantrums for years afterwards.' There is a collective consciousness that wants to forget Aberfan – to forget means that it will be repeated, and some politician or official will yet again be in the media stating the pathetic and perpetual mantra that 'lessons will be learnt'. To forget something like Aberfan means that the guilty will always escape justice. To forget breaks one's ties with truth and honesty, and means colluding with the perpetrators of injustice. To forget means that those who died meant nothing. Some may believe that this is an over-long entry in this book, but the purpose of historical non-fiction is not to regurgitate other books, but to question the given version of events and to highlight what is being deliberately lost.

Before he spent over £20,000 on having his rotten, nicotine-stained teeth transformed into humanoid ones and left his wife for a younger model, the novelist and *bon viveur* Martin Amis, was quoted in discussion with A. N. Wilson in *The London Evening Standard*, 17 July 1991: '"The South Waleyans are a particularly bitter and deracinated breed". He began a bad-taste joke about Aberfan causing a "ripple of pleasure" through the mining valleys, but he choked it back with a giggle … Martin does the Welsh voice with an accuracy which reflects real loathing.' To joke about Aberfan is not the action of any civilised human being.

Religion

In 1801 there were around 25,000 Nonconformists in a population of 587,245, or 5 per cent of the population. By 1911, Nonconformists amounted to nearly 42 per cent

of the population. At the start of the century, Evan Roberts led the Great Religious Revival, starting in Ceredigion and quickly spreading throughout Wales. Within a few months over 100,000 people were converted, greatly changing the nature of Welsh society. The Revival became internationally important. The Apostolic Church and the Elim movement sprang from it, and it was boosted by the Temperance movement and the campaign for disestablishment of the Church in Wales. Hymn-singing was important, and there was a temporary reprieve for the language, as much of the new wave of fervent preaching in the Nonconformist chapels was in Welsh. From the nineteenth century onwards, scientific discovery gnawed away at certain Biblical beliefs. The literal 'truth' of the Bible was consequently queried, with the myth and timing of the creation of the world being challenged. Geological and fossil discoveries, the theory of evolution, a greater understanding of the universe and the properties of matter all helped alter man's perceptions of God. Atheism has been slow to take root in Britain, but agnosticism is growing and church and chapel attendances are dropping. Chapels, and then churches, had been the centres of most communal activities.

As regards the state church, the Anglican Church in Wales was becoming less and less popular, especially with Welsh speakers. Before 1920, not a single bishop able to speak Welsh had been appointed to a Welsh see. At St David's Theological College in Lampeter, the training school for Welsh clergy, there was no requirement to be able to read, speak or write one single line in Welsh. For many years, the longest word I knew in the English language was antidisestablishmentarianism. The parliamentary Bill that deprived the Anglican Church of its status in Wales as the state church was passed in 1914, but enactment was delayed because of the First World War. In 1920, the Church in Wales was established with its own Archbishop to officially represent Anglicanism in Wales. The Roman Catholic Church in Wales expanded in the nineteenth and early twentieth centuries because of the numbers of Irish people coming to find work in Wales. Decline in church-going grew after the First World War for various reasons, and by the end of the twentieth century, less than 10 per cent of Welsh people regularly attended a place of worship.

Two World Wars

David Lloyd George from 1914 to 1918 was successively Minister of Munitions, Secretary for War and Prime Minister. Hitler said that Lloyd George was 'the man who won the war'. Over 280,000 Welshmen served in the forces with distinction in both wars. Enormous casualties in the Great War had devastating effects across Wales, as seen in memorials across the land. The loss of life was worst in North Wales, where men had been forced to enlist in huge numbers after being made jobless when the slate industry was declared 'non-essential'. As in the Second World War, coal mining and agriculture were among the 'restricted occupations', where workers did not have to go to war.

While being a cultural and sporting nationalist, this author is not a hagiographer of all nationalists. I was fortunate to be in possibly the first generation never to be called up to bear arms, and take immense pride in the fact that Wales has never

declared war on another nation, despite being the oldest nation in Europe. How many other countries can claim that element of pacifism? Most wars have evil motives, but occasionally there is a 'just war', and the Second World War is one such event. Hitler had to be stopped somehow – a genocidal maniac who might, after the Gypsies, Jews and other minorities would have started on Blacks, Chinese, Irish, redheads – anyone who did not conform to his racial stereotype of the master race. The pacifism of Saunders Lewis and Gwynfor Evans was viewed by many as traitorous in the Second World War. Plaid Cymru had conceded that the defeat of Germany and its allies overrode any other concern. However, Gwynfor Evans refused, as a conscientious objector, even to act as a medical orderly, and the feeling of the people of Barry made life extremely difficult for him. His father owned the town's department store, and he bought his son a smallholding in Carmarthenshire, so Gwynfor had a restricted occupation, allowing him to avoid being imprisoned. Of Barry, it was said that there was a death in every street, as it lost a higher proportion of its population at sea, nearly all on merchant ships, than any other place in Britain, and probably Europe. Swansea, Cardiff, Newport and Pembroke Dock suffered badly from bombing.

Education

Aberystwyth University had been founded in 1872 in a seafront hotel that had become vacant, so Wales' first university was not built at its oldest centre of learning – and possibly the oldest place of learning in the western world – Llanilltud Fawr (Llantwit Major). New universities were built in Cardiff in 1909, Bangor in 1911 and Swansea in 1920, all forming the University of Wales. In 1926, the Hadow Report recommended that every child in Britain should attend secondary school. All the secondary schools in Wales taught their subjects through the medium of English.

In the 1960s, many other schools followed the example set by Llanelli of teaching in Welsh (see Language section above). By 1970, even Cardiff had its own Welsh school, Ysgol Dewi Sant (St David's School), one of the largest in Wales. The huge increase in the number of Welsh primary schools was accompanied by a demand for Welsh secondary education. For the first time in history Welsh children could receive secondary education through the medium of the Welsh language, through methods adopted from Israel. Israel teaches all its immigrants Hebrew solely through the medium of Hebrew. The change in the attitude of the people of Wales towards their language has been dramatic since the early 1960s, when it was though of as being useless (this author took English, Latin, French and Spanish GCE 'O'-levels in 1962, but not Welsh). A bilingual education has been proved to be empirically superior to a single-language education, and there is now a premium on places in schools which teach in Welsh. The Gittins Report of 1967 covered primary education in Wales, recommending that 'every child should be given sufficient opportunity to be reasonably bilingual by the end of the primary stage'. Most Welsh children were monoglot English speakers, so the implementation of the report in some areas created a new generation of those who could speak Welsh before their entry into secondary education. Some education authorities, notably that of Labour-controlled West Glamorgan, refused to participate in the sea change.

Politics

In 1900 in the Taff Vale Railway dispute, judgement was given in favour of the company and against the striking workers, who had formed the Amalgamated Society of Railway Servants. The new union had to pay massive costs, and all unions realised that they needed legislation to ensure the rights of working men. For this, they needed a political party. Unionisation and the Labour Party germinated in Wales. The Labour Representative Committee (LRC) was thus founded in London to promote the interests of trade unions. In 1906, it became known as the Labour Party, but until it grew in strength, it was the Liberal Party which had tried to change Britain into a more democratic society. Keir Hardie was easily elected to parliament in 1900 as the representative of the newly formed Labour Representative Committee, in one of the two Merthyr constituencies. He was the first Labour MP elected in Britain. The Scot had as his electioneering slogan 'The Red Dragon and the Red Flag'. He was the only socialist in the House of Commons, and wore a cloth deerstalker hat to stand out among the top hats of all the other Members. The Labour Party became solidly established first of all – and ever since – in South Wales, which has received little in return.

The Liberal Party had surged into power in Wales with its opposition to landlords and anti-establishment policies, and by the turn of the twentieth century was virtually in total control. The Liberal Party's prime change-maker was David Lloyd George, elected in 1890 for Caernarfon. In the 1906 election, Henry Campbell-Bannerman became the new Prime Minister, appointing the capable Lloyd George as president of the Board of Trade. Lloyd George impressed him so much that in 1908 he was promoted to become Chancellor of the Exchequer. Previously, as Minister for the Board of Trade (1905–8) he was responsible for the passing of three important acts involving merchant shipping, the production census and patents. He introduced Old Age Pensions (1908) and National Health Insurance (1911) when Chancellor of the Exchequer from 1908 to 1915. A fierce opponent of the Poor Law, the Chancellor wanted to 'lift the shadow of the workhouse from the homes of the poor'. The rejection of his budget by The House of Lords, with its Conservative majority, in 1909–10 led to his parliamentary reform and a lessening of the nobility's power. Lloyd George toured the country, making speeches in working-class areas against the 'nobles with no nobility' who were using their privileged position to hurt the poor and stop old-age pensions. He called it a 'war budget. It is for raising money to wage implacable warfare against poverty and squalidness.'

Because of the ensuing unpopularity of the House of Lords, the Liberal government managed to cut its powers in the 1911 Parliament Act. The 1911 National Insurance Act gave the British working classes the first contributory system of insurance against illness and unemployment. All wage-earners between sixteen and seventy had to join the health scheme, the worker paying 4*d* a week, the employer 3*d* and the state 2*d*. In return there was free medical attention and medicine, and workers were guaranteed 7 shillings a week for fifteen weeks in any one year if they were unemployed. The Conservative opposition and the House of Lords declaimed Lloyd George as a 'socialist'. Lloyd George's measures ended the workhouse system and formed the basis of the welfare state that gave a reasonable safety net to

the disadvantaged in Britain. Known to many in England as 'the curse from Wales', Lloyd George had been able to convince his Liberal-led government to pass much important legislation. His radical measures restricted the miners' hours of work to eight hours a day, counteracted the effects of the Taff Vale Judgement, established labour exchanges, and safeguarded the interests of exploited workers.

In 1914, the introduction of the Welsh Home Rule Bill by Pontypridd's E. T. John, MP for East Denbigh, was virtually ignored by the House of Commons. Welsh leaders did not wish to promote a Welsh-speaking community and Welsh culture against a British national identity in a time of war.

A radical Welsh nationalist and a pacifist, Lloyd George had compared the Boers, in their fight against the Empire, to the Welsh. He only moved from pacifism with the invasion of Belgium by Germany in 1914. Even so, with three other senior members of the government, Lloyd George had written to the Prime Minister, Herbert Asquith, that he intended to resign rather than be party to a war declaration. The other three resigned, but Asquith managed to convince Lloyd George to stay on, as the country needed him. In August 1914, the South Wales Miners' Federation proposed an international miners' strike to stop the outbreak of war, and there continued to be an anti-war movement in the South Wales mining areas. A massive increase in food prices coupled with record profits for coal-owners caused a demand for a new wage agreement in 1915, which was refused, so the South Wales miners went on strike. They were opposed by the government, coal-owners, the Great Britain Miners' Federation and the national newspapers, and the government threatened to imprison any strikers. However, the strike was solid. The then-Minister of Munitions, Lloyd George, quickly intervened and settled the strike, acceding to most of the demands of the South Wales Miners' Federation.

As Minister of War from 1915 to 1916, Lloyd George was put in charge of the total war effort, and found it difficult to control the poor and wasteful tactics of his generals of the Western Front. Lloyd George argued strongly with the dinosaur Douglas Haig, commander-in-chief of the British Expeditionary Force, and with General Robertson, chief of the imperial general staff, about their using men as cannon-fodder. When at last Lloyd George's proposal was accepted, that the French and British forces fight under one joint-commander, the war turned decisively the Allies' way. Lloyd George also with great difficulty persuaded the Royal Navy to use the convoy system to ensure adequate imports of food and military supplies. The Coalition government was impressed by Lloyd George's capabilities and began to question Asquith's leadership in these days of crisis. In December 1916, Lloyd George agreed to collaborate with the Conservatives to remove Asquith, a decision which split the Liberal Party. Lloyd George was now Prime Minister, and his Coalition Party won the 1918 general election, Asquith losing his seat. In 1916, Lloyd George was welcomed into No. 10 Downing Steet by Maurice Hankey, later War Cabinet Secretary. 'I congratulated him,' said Lord Hankey later, and he replied slowly, 'You are shaking hands with the most miserable man on earth.' However, Lloyd George was now virtually a prisoner of the Conservative party after the war, and although he promised progressive reforms in education, housing, health and transport, he was unable to effect them. He was defeated in the 1922 election. For the rest of his career he was a campaigner, but with no power base – the Tories did not want change, and

the Liberals distrusted him as the man who broke up their party. Just two months before his death, he received the title Earl Lloyd-George of Dwyfor.

By his forceful policy he was, as Adolf Hitler later said, 'the man who won the war'. One of the 'Big Three' at the peace negotiations, Lloyd George was shown to be a brilliant diplomat. He mediated a settlement with Germany mid-way between Woodrow Wilson and the more punitive actions desired by Clémenceau, as France had lost so much in the Great War. Lloyd George's defeat in 1922 was possibly due to his ceding of 'the Irish Free State'. The modern-day Eire was given its independence by him against strong opposition by the Conservatives in his government. Lloyd George is also notable in world history for approving the Balfour Declaration, promising the Jews a national state in Palestine. Thus Wales has had a world statesman who changed the face of the twentieth century. The only other 'great' British Prime Minister of the twentieth century was a war-leader but no reformer, Winston Churchill. On Lloyd George's death in 1945, Churchill told the Commons, 'He was the greatest Welshman which that unconquerable race has produced since the age of the Tudors. Much of his work abides, some of it will grow greatly in the future, and those who come after us will find the pillars of his life's toil upstanding, massive and indestructible.' A statue of Lloyd George is next to that of Winston Churchill in Parliament Square.

The First World War's massive loss of life affected whole Welsh-speaking communities, and the language fell into a sharp decline. Mainly because of this, Plaid Genedlaethol Cymru (the National Party of Wales) was founded in 1925 to preserve what was left of Welsh culture and to further the aims of self-government for Wales. Saunders Lewis became president of the party in 1926, but it took over forty years for Plaid to gain its first seat in parliament. In 1918, all men over twenty-one – with the exception of conscientious objectors – were granted the vote, a right also extended to women over thirty. At last the Equal Franchise Act of 1928 gave the vote to all women over twenty-one. The 1930s saw the compulsory purchase of 40,000 acres of Stackpole Estate in Pembroke, and compulsory clearance of Welsh speakers from fifty-four farms and smallholdings on Mynydd Eppynt, Breconshire, to make places for troops to practise. The terrible unemployment began to alleviate in the 1930s. New health measures, aided by cheaper food from the USA, led to an increase in population, and then a building boom. However, very few new industries came to Wales. New car plants, electrical goods manufacture, chemicals, etc. were mainly located in the south-east and Midlands of England. Closing coal mines and steelworks led to major emigration from the Welsh valleys into England.

In 1929, the Liberals won a third of Welsh votes, but only ten rural seats, as the rise of the Labour Party gave it 44 per cent of Welsh votes and twenty-five seats, predominantly in the heavily populated industrial south. From this time, Labour dominated parliamentary elections in Wales, because of its support in the more heavily populated south. Protesting against the building of a bombing school at Penyberth on the unspoilt Llŷn Peninsula, Saunders Lewis, D. J. Williams and Lewis Valentine started a small fire in an outbuilding on 8 September 1936. The prominent men of letters promptly reported the matter to the local police. A 'not guilty' verdict was reached by a sympathetic Welsh jury at Caernarfon, so they were sent to trial at the Old Bailey in London for a 'correct verdict'. One is still unsure as to the legality

of this act of overturning a jury's verdict. In London, they were not allowed to testify in their own language and they were convicted.

In 1945, Labour took almost 60 per cent of the vote in Wales, 10 per cent more than in the rest of Britain. Attlee's Labour government decided to try and stop the unemployment of pre-war years from re-occurring. The Distribution of Industry Act of 1945 promoted new industrial estates on disused factory sites across Wales, mainly in the more heavily populated south, and to mop up unemployment in the Valleys. Aided by grants and low-interest loans, light industries arrived to partially replace the reliance upon coal. From 1946, two other Welshmen, James Griffiths and Aneurin Bevan, complemented Lloyd George's far-reaching reforms with the National Insurance Act, compelling all workers to insure themselves against ill-health or unemployment. Two years later, local welfare schemes pioneered in the South Wales coalfield helped bring about the National Industrial Injuries Act. 1948 saw the introduction of the National Health Service, which provided free medical treatment, prescriptions, and prosthetic devices such as eyeglasses and false teeth. 'Nye' Bevan in effect had founded the Welfare State in Britain.

The intense lobbying efforts of James Griffiths finally persuaded the government to form the Council of Wales in 1948, although its duties were purely advisory and it was given no powers. The Parliament for Wales Campaign began in 1950, modelled after a similar movement in Scotland. In 1955 Cardiff was recognised as the capital of Wales. In the 1950s more incomers settled, and the Welsh language suffered. Liverpool Corporation received permission from parliament to drown Capel Celyn with the Trywerin Reservoir; the powerlessness of Wales, its people, and its representatives in parliament was startlingly demonstrated by the drowning of the valley. 1960 saw the death of the truly great Aneurin Bevan (born 1897), a man demonised in the national press, but the most honest politician of the twentieth century. The National Health Service, the jewel that was pioneered in Britain and copied in civilised countries all over the world, was largely based upon the example of a Welsh valley community scheme. Tuberculosis and pneumoconiosis were rife in nineteenth-century Wales, but in the 1890s Tredegar established the Workmen's Medical Aid Society (with its own doctors). Workers paid the equivalent to just over 1 per cent of their income for dentistry services, spectacles and midwives. Its doctors included A. J. Cronin, who wrote about the scheme and its effects in *The Citadel*. In 1923, Aneurin ('Nye') Bevan was elected to the Hospital Committee, allied to the Medical Aid Society.

As Minister of Health just over three decades later, he launched the National Health Service. A leader in the Welsh miners' strike in the general strike of 1926, Bevan had become a Labour MP in 1931, and in the Second World War was frequently a 'one-man opposition' to Winston Churchill. One of the most attractive aspects of Nye's personality was that he never tried to disguise his roots – not for him the claret-smooth old boy networks of miner's son Roy 'Woy' Jenkins. Nye Bevan was unequivocal in his attachment to the working classes: 'No amount of cajolery, and no attempts at ethical and social seduction, can eradicate from my heart a deep burning hatred for the Tory Party … So far as I am concerned they are lower than vermin.' Bevan resigned from the post-war Attlee government over charges being introduced for teeth and spectacles. However, the real reason was the foreign and defence policy of that Labour government. The scale of the arms budget forced upon Britain by

the U.S. government during the Korean War was unsustainable. Even his implacable enemy Winston Churchill later acknowledged that Bevan was right. He was deputy leader of the Labour Party when he died of cancer. This noble and honest man is commemorated in a statue at the west end of Cardiff's Queen Street.

In 1947, there was nationalisation of coal, iron and steel, docks, railways, electricity, gas and road haulage. The most modern steelworks in the world was built at Port Talbot, opening in 1951, unfortunately destroying almost the last vestiges of the great sand dunes of the South Wales coast. Steelworks were also opened at Trostre, Llanelli and Felindre, Swansea. Petrochemical complexes were built at Baglan Bay and Llandarcy. There were also new steelworks in Llanwern and Shotton, and the development of new oil refineries made Milford Haven the most important oil port in Britain. Other industries came and went as Britain began to import rather than make products. Among them were Hoover in Merthyr, Hotpoint in Llandudno, Prestcold in Swansea and British Nylon Spinners at Pontypool. Unfortunately, most of the foreign direct investment that came into Wales also left. The Welsh Development Agency's ads were sung to the tune of 'Guide Me Oh Thy Great Jehovah', with the repeated chorus of 'Made in Wales'. It was memorably lampooned in a sketch on *Not the Nine O'Clock News* with pictures of empty factory sites and the hymn altered to 'Failed in Wales'. The only growth in jobs in Wales has come from government outsourcing, with the Royal Mint being moved to Llantrisant; the Driver Vehicle Licensing Agency and Land Registry to Swansea; Companies House to Cardiff; and the Passport Office to Newport. Wales is even now a wasteland for the private sector.

In 1964, the Labour government reluctantly created a Secretary of State for Wales, with James Griffiths being the first to occupy the position. Unfortunately the subsequent filling of the position has been by party hacks with little or no interest in Wales, merely using the post as a rung on the ladder to advancement. However, this has not diminished the acknowledgement that Wales needed its own Secretary of State to address its own particular concerns. There had been a succession of utterly ineffective and disinterested Ministers for Welsh Affairs from 1951 to 1964: Sir David Maxwell Fyfe (Cons); Gwilym Lloyd George (Cons); Henry Brooke (Cons); Charles Hill (National Liberal) and Sir Keith Joseph (Cons). The post had little power, and with hardly any Conservative presence in Wales, the Conservative government did little to support Welsh aspirations. Three were English, one Scottish, and one Welsh. With the advent of Labour power, the government reluctantly created a Secretary of State for Wales with greater powers, with James Griffiths the first to fill the position. He had campaigned for the post to be created since the 1930s, and the new Prime Minister Harold Wilson asked the capable Griffiths to delay his retirement until after he took on the role. Griffiths was followed by Cledwyn Hughes (Labour, Welsh); George Thomas (Labour, Welsh); Peter Thomas (Tory, Welsh, English constituency); John Morris (Labour, the last Welsh-speaking Secretary of State); Nicholas Edwards (Tory, birthplace unknown); Peter Walker (Tory, English, English constituency); David Hunt (twice – Tory, English, English constituency); John Redwood (Tory, English, English constituency); William Hague (Tory, English, English constituency); Ron Davies (Labour, Welsh); Alun Michael (Labour, Welsh); Paul Murphy (twice, Labour, Anglo-Irish); Peter Hain (twice, Liberal then Labour,

born in Kenya); and Cheryl Gillan (Tory, Anglo-Welsh, English constituency).

It is as well to take a moment and regard these politicians who represent Wales to the world in a little more detail. The competent Griffiths and Hughes were succeeded by former teacher George Thomas, Viscount Tonypandy of Rhondda. As noted above, as Secretary of State for Wales from 1968 to 1970, Thomas advised the Wilson government to claw back £150,000 from the publicly-raised Aberfan Charity Fund, an utterly contemptible act. He took enormous pride in presiding over the investiture of the Prince of Wales at Caernarfon in 1969, as he was fervently attached to the royal family, particularly that inveterate gambler, the Queen Mother. He strongly opposed Plaid Cymru and particularly the Welsh Language Society. In 1976 he succeeded Selwyn Lloyd as Speaker of the House of Commons. After his death, the former Labour MP Leo Abse wrote of Thomas's homosexuality, which did not seem to be at all a secret in South Wales or in Westminster.

An Englishman with an English constituency, Peter Walker was a partner in Slater Walker, an 'authorised bank' which acted as an asset-stripping company and made immense profits until 1975. Because of financial mismanagement, it ran into debt in 1975 and had to be rescued by the Bank of England and was prosecuted. To Margaret Thatcher, Walker was a 'successful businessman'. Both Edwards and Hunt were English public schoolboys, with little knowledge of business, followed by a man variously known as Spock and, by older people, the Mekon. The English John Redwood (born John Charles) in 1995 returned £100 million of Wales's block grant to the UK Treasury unspent. He also famously and insanely refused to apply for European funding for Welsh areas of high unemployment, as this was also against his free-market ideology. Redwood is still thought of as one of the great 'thinkers' in the Conservative Party. His most famous gaffe was his attempt in 1993 to mime the Welsh national anthem at the Welsh Conservative Party Conference.

Redwood was succeeded by another English public schoolboy with an English constituency, William Hague, now Foreign Secretary, who used the position in Wales as a stepping-stone. He became Conservative Party leader, but suffered disastrous results in the 2001 election. He is the first full leader never to have been Prime Minister since 1922. In 2010, a number of national newspapers published stories about Hague's friendship with 25-year-old Christopher Myers, whom he employed as a parliamentary special advisor. Myers resigned from his position in the light of the press allegations. Hague confirmed that he had 'occasionally' shared a hotel room with Myers.

In 1997, Ron Davies was Secretary of State for Wales when he was responsible for paying back £150,000 (without any interest) into the Aberfan Charity Fund. He stated, 'It was a wrong perpetrated by a previous government – a Labour secretary of state. I regarded it as an embarrassment. It was a wrong that needed to be righted.' In 1998, Davies defeated Rhodri Morgan at a special Welsh Labour Party conference to become Labour's candidate for First Secretary of the Welsh Assembly. A month later Davies resigned this post, two days after resigning as Secretary of State for Wales. He stood down citing 'an error of judgement' in agreeing to go for a meal with a man he had met while walking on Clapham Common, a meeting place for homosexuals. He was allegedly mugged at knife-point, but the details are still unclear. Davies later acknowledged that he was bisexual, and said that he was receiving treatment for a

personality disorder that led him to seek out risky situations. In 1999, Davies was elected as Labour Assembly member for Caerffili to the first National Assembly for Wales. Alun Michael refused to give him a Cabinet post. He stood down from parliament at the 2001 general election. Just before the 2003 Assembly elections, Davies was forced to stand down as a candidate as it was revealed that he had often been seen at a well-known gay cruising place, on the road from the M4 to Bath. Subsequently this extremely competent politician joined the now-defunct Forward Wales party, and then Plaid Cymru.

If any politician deserves the words anodyne and bland, it has to be Alun Michael (closely followed by Ieuan Wyn Jones). After a career as a youth and social worker, Michael entered parliament in 1987 and proved to be a particularly inept Deputy Home Secretary. In 1998, following the resignation of Ron Davies, Michael succeeded him as Secretary of State for Wales, being famously favoured by Blair and the Labour Party policy-makers for following the London party line. His appointment to the role was described by Peter Kellner as 'another fix ... to ensure Alun Michael became Labour's leader in Wales'. Kellner continued that the appointment 'offended so many voters that it lost some of its safest seats, including Rhondda, to Plaid Cymru'. Michael was followed by Paul Murphy, who was at that time antagonistic of any powers going to Wales. The son of Irish incomers and a confirmed bachelor, Murphy was involved in the parliamentary expenses scandal. He claimed £3,419 for a new boiler in his Westminster house, stating that with the old one 'the hot water was far too hot'. He also claimed a toilet roll holder, new carpeting and a television, as well as mortgage payments and stamp duty. Murphy was ordered to repay some of the money back, including £2,237 in cleaning costs, mortgage payments and a wardrobe that exceeded the guideline price.

Peter Hain followed Murphy twice as Secretary. His popularity within the Labour movement was shown when in 2007 he ran for its deputy leadership, coming fifth out of six candidates. His failure to declare donations of £103,156 during this contest, contrary to electoral law, led to his resignation in 2008. Only a separate £82,000 was reported. Hain released a statement saying that, being busy with his government jobs, it was simply forgotten about and said it was absurd to think any misconduct took place, and that he would pay back £25,000 of the money. In December 2008 it was announced that Hain would not be charged because Hain did not control the members' association that funded his campaign.

The last Secretary, Cheryl Gillan, was formerly strongly opposed to a National Assembly for Wales. In 2009, Gillan was also criticised for her expenses claims. The *Daily Telegraph* revealed she had claimed for dog food on her second home allowance, and also £305.50 to cure 'noise problems' with her boiler. When questioned, Gillan said the boiler had broken down and that the claim was within the rules. It was also revealed that Gillan had attempted to claim more money for her gas bill than it was actually worth; the Commons Fees Office refused to pay the full amount. It was also revealed Gillan had claimed £8,450 for food and £4,335 for cleaning. Sixty-year-old Gillan employed her eighty-two-year-old husband as her 'Office Manager/Researcher' using her parliamentary expenses. Following Legg's review of MPs expenses, Gillan was also found to have claimed £1,884 more than her mortgage bill was actually worth on a second home in Battersea, and she was ordered to repay

the money. In 2010, it was announced that future MPs from Gillan's constituency – her main home is on the London Underground network – would not be allowed to claim for a second home after the election of that year. Gillan has at least, unlike nearly all politicians of all parties, had a career in the private sector, and seemed a capable politician until her removal in 2012. However, the quality and interests of our Secretaries of State have been extremely variable. The acknowledgement that Wales needed its own Secretary of State was an important breakthrough for Wales, but the later formation of a Welsh Assembly Government for Wales has only been a success in the eyes of those elected to it.

1974 saw the ill-conceived and costly Reorganisation of Local Government Act. The old thirteen counties now became eight new ones; in addition, the old boroughs and urban and rural districts were replaced by district councils. In the sweeping changes, for which no referendum had been held, Flint and Denbigh lost their individual identities, becoming part of the larger administrative unit to be known as Clwyd; Monmouthshire now became Gwent; Pembroke, Cardigan and Carmarthen joined to form Dyfed; Meirionnydd, Caernarfon and Anglesey became Gwynedd; Radnor joined Brecon as Powys; and the heavily populated county of Glamorgan split into three parts: East, Central and South. All the new authorities built themselves glamorous and expensive new headquarters, often, as in Barry, leaving their old, architecturally irreplaceable town halls to rot. Many of the changes have since been reverted, at enormous cost.

A breakthrough for Welsh interest had occurred when Gwynfor Evans of Plaid Cymru was elected as MP for Carmarthen. On 14 July 1966, in the election caused by the death of Lady Megan Lloyd George, Evans of Plaid gained a surprising majority over the Labour candidate. This first victory for Plaid meant that at last the Labour Party was forced to think of something to hold on to its permanent majority in Wales. James Griffiths and Cledwyn Hughes, aided by Elystan Morgan, MP for Cardigan, had lobbied incessantly for an elected assembly for Wales, against implacable Labour opposition. Their efforts had led to a royal commission in 1968 to investigate the topic of devolution for Wales (and Scotland). When Britain became a member of the European Economic Community in 1972, new hopes arose for an elected assembly for Wales, one of Europe's oldest and smallest language communities. The royal commission recommended sweeping administrative changes. It presented the Scotland and Wales Bill of 1976. The government plans for a Welsh assembly, however, gave it no legislative powers (unlike that for Scotland). Labour MPs recommended a referendum, which they felt sure would be defeated. The Welsh Act of 1978 was introduced with the provision that the creation of an assembly would require 40 per cent of the electorate to vote in favour. In 1978 Neil Kinnock and Leo Abse led the campaign against the Devolution Bill for Wales and Scotland, and only 11.8 per cent of the population voted in favour, compared to 46.5 per cent against. The cynical and correct view is that most Welsh people saw that another bureaucratic layer of government, without any powers, was utterly pointless.

One of only six Welsh Labour MPs who voted against devolution for Wales in the 1979 campaign, the Bedwellty MP Neil Kinnock became leader of the Labour Party in 1983 and was widely expected to defeat Margaret Thatcher in the 1992 election. His triumphalist campaign led to a surprise defeat, after which he resigned as leader

of the Labour Party. Thatcher's grateful government recommended him for a post as European Commissioner, which he occupied from 1995 to 2004. The main act he is remembered for is the sacking of Marta Andreasen in 2002. Kinnock insisted upon charges against the European Commission's former chief accountant for going public with information that the EU's accounting procedures leave its massive budget open to fraud. She had said, 'The fundamental issue in this situation is that there is a lack of control in the €95bn [£60 billion] entrusted to the European community.' She had previously complained internally, but no action was forthcoming. As of 2012, auditors are in their eighteenth year of refusing to sign off EU accounts because of institutionalised fraud.

Leaving the EU after serving his two unelected terms, Kinnock became chairman of the British Council in 2004. His son Stephen became head of its taxpayer-funded St Petersburg operation in the same year, where he refused an alcohol test for drunk-driving. He has since been accused of tax evasion by the Danish press. Kinnock's daughter Rachel worked at the Policy Unit at 10 Downing Street for Gordon Brown, and as a 'researcher' in her mother's European office. Kinnock's wife Glenys was an MEP (Member of the European Parliament) from 1994 to 2009. A former teacher, in 2006 she was criticised for attending a conference to discuss world poverty issues in Barbados. Gordon Brown made her Minister for Europe, and Minister of State for Africa and the United Nations in 2009. Northampton-born Mrs Kinnock is now Baroness Holyhead. Always deeply critical of the House of Lords, Neil Kinnock had said he would never become a lord, but took his seat in it in 2005 as Baron Kinnock of Bedwellty. He was accused of hypocrisy by both socialist and conservative politicians and commentators. Neil Kinnock is also president of Cardiff University. He studied for a degree there, but to this day mystery surrounds whether he passed, failed it or retook it.

Neil and Glenys Kinnock attacked a call for the European parliament to be abolished after Jack Straw called it 'a system of political elites leading people by their nose'. In a statement they said 'the parliament ... works amazingly well'. If any reader knows of one single policy that the EU has got right – on agriculture, fisheries, trade, employment, immigration, banking, investment, human rights, etc., etc., please let this author know. Retiring from Europe in 1962, Kinnock made £270,000 over the next three years, then the normal EU pension of £63,000 a year. This is on top of his normal parliamentary and other pensions and income. In 2006 Kinnock was banned from driving for six months for two speeding offences in 2005 and 2006 on the M4 motorway. This took him to fifteen points on his driving licence, having already three speeding offences worth nine points within the previous three years. These five speeding offences in three years may be explained by his conversion to metrication during his lucrative years in Brussels.

Earlier in 2006 Lord Kinnock had written an introduction to a report by the UK Metric Association, stating that that the continued use of miles in Britain was the 'most obvious example of the muddle of measurement units' in the country. He said in the report that imperial road signs 'contradict the image – and the reality – of our country as a modern, multicultural, dynamic place where the past is valued and respected and the future is approached with creativity and confidence'. According to Gwynfor Evans (*The Fight for Welsh Freedom*, 2000), Kinnock said that 'between

the mid-sixteenth century and the mid-eighteenth century Wales had practically no history at all, and even before that it was the history of rural brigands who have been ennobled by being called princes'. So much for Welsh history education and the knowledge of our elected leaders. When all of one's family is in feather-bedded public sector jobs, with gold-plated, inflation-linked pensions and no threat of redundancy, how can a political leader know about the life of the majority of the electorate?

By 1994, political intrigue, mistrust and outright misrule by what is known as the system of quangos (non-elected government bodies) had the effect of helping Plaid into second place among the political parties in Wales. Ron Davies coined the phrase 'Devolution is a process and not an event', by which he meant that the settlement he introduced in 1997 would not be the final one, and more powers would accrue to the Welsh Assembly over time. The Labour Party began to cooperate with the other two pro-devolution parties in that they would make way in key marginal elections in return for a guaranteed Welsh Assembly. In return, Labour would commit itself to holding the first elections to the proposed Assembly on the basis of proportional representation, ensuring a strong presence for both the smaller parties and for rural districts. Many Welsh people showed no interest in devolution. Many believe that the Assembly would simply mean 'jobs for the boys', especially with the Labour 'Taffia' and the Masonic *crachach* 'filling their pockets'. Those who feared yet another layer of bureaucracy, a talking shop of jobsworths, have probably been proved right. Half of the electors could not be bothered to vote. The 1997 referendum on devolution was passed by the narrowest of margins, mainly through the tireless efforts of Labour leader Ron Davies, with 50.3 per cent of a 50.3 per cent turnout voting.

This is only 25.3 per cent of those eligible to vote, and the apathy was once again owing to the fact that the new National Assembly, which became the Welsh Assembly Government, had extremely limited powers. A Labour Inner Cabinet dominated by Scotsmen Blair, Darling, Brown and Irvine had offered the Scots far greater powers than those given to Wales. In 1999 the first elections gave Labour twenty-eight seats, Plaid Cymru seventeen, and Conservatives nine of the sixty seats. Labour has run a minority or coalition government since that time, mainly under Rhodri Morgan. Morgan, as a member of the *crachach*, unfortunately possessed neither style nor substance in his years as leader of the Welsh Assembly Government. He constantly followed the Westminster line, and has since been succeeded by Carwyn Jones, who also looks to London for party guidance. Of the sixty seats, twenty are chosen by proportional representation, allowing party *apparatchiki* to be elected without ever meeting a voter. Most responsibilities of the Welsh Office were transferred to the Assembly, with the Secretary of State for Wales acting as a link with Westminster. A budget of £7 billion was to be managed by the Assembly, to meet in Cardiff. It has been disheartening and depressing to watch its lack of progress, and its belief in spending time on what it calls 'issues' which are of no relevance to the economic future of Wales.

From the 1920s to the current day, Labour has generally been dominant in Welsh politics at local and national levels. This has been a terrible problem for Wales – it has never been worth fighting for by political parties. People vote Labour, so Labour does not have to buy votes with schemes that benefit Wales. The other parties are marginal, and seem to have given up on Wales. When in power, they also give

nothing to Wales. Thus an English public-school former minister, who advertises on the internet for lovers wearing only Y-fronts, is still the MP for Rhondda. Chris Bryant has also disclosed that he was once 'chased around a piano by a randy bishop'. He refuses to name the clergyman, whom he describes as 'supposedly celibate but notoriously lascivious'. People should vote for the best person from their *bro*, someone who understands the area and its problems, and has nowhere to hide, not the outsider that the Labour Party decides to insert. How can someone like Chris Bryant have any empathy with his constituency? If the recent history of Wales shows us anything, it is that constantly voting for the same party gets us nowhere.

Similarly, Montgomeryshire has always been a Liberal constituency, and Lembit Öpik was the MP from 1997–2010. He succeeded the Liberal Alex Carlisle, the son of Polish-Jewish immigrants and notable for being a Burnley football supporter and the first MP to campaign for the rights of transsexuals. Before Carlisle, Delwyn Williams was a Tory MP for one term, following the Liberals Emlyn Hooson (who as a lawyer represented Moors Murderer Ian Brady); the alcoholic Clement Davies; David Davies (grandson of the great industrialist David Davies); Arthur Humphreys-Owen (a great landowner and railway baron); and Stuart Rendel (an industrialist from Devon). The succession of Liberals up to Öpik goes back to 1880, except for one four-year spell. Öpik is an Estonian, brought up in Northern Ireland, whose main concern when a publicity-seeking MP was that an asteroid would destroy the Earth. He was beaten in 2010 by the Conservative Glyn Davies, who at least has some empathy with the thousands of people in Montgomeryshire affected by wind turbines and pylons.

Literature

There was a literary renaissance across the nation, beginning with the publication of *The Welsh People* in 1900 by John Rhys and Brynmor. Owen M. Edwards' *Wales* was followed by the superb *A History of Wales from the Earliest Times to the Edwardian Conquest*, by J. E. Lloyd in 1911. It is a book without peers, still of the greatest importance to any historians of Wales. In 1913, John Morris-Jones had published his seminal *A Welsh Grammar, Historical and Comparative*. Owen M. Edwards (1858–1920) spent his life publishing Welsh books and magazines, reacting to English publications of what he considered to be inferior content. In 1890 he had founded the magazine *Cymru*, and from 1891 to 1920 he published *Cymry'r Plant* (The Children's Wales), selling 12,000 copies a month. A prolific and important author, he also he founded a society for Welsh children, Urdd y Delyn (Order of the Harp). It was the precursor of Urdd Gobaith Cymru, the Welsh youth league founded by his son Ifan ab Owen Edwards in 1922.

There was a huge Welsh population in Liverpool at the turn of the century, drawn by work in the docks and elsewhere. During the First World War, the Merseyside Welsh community staged the National Eisteddfod at Birkenhead in 1917. The winner of the chief Bardic prize was the shepherd-poet Ellis Humphrey Evans (Hedd Wynn, or White Peace), but he had been killed on 31 July at Passchendaele 'with a nosecap shell in the stomach'. On 6 September, the winning poet was called to take the

Bardic Chair for his strict metre poem 'Yr Arwr' (The Hero). The packed Eisteddfod Pavilion was told by the Archdruid that the winning entry was under the nom de plume 'Fleur-de-Lys', but Hedd Wyn had been killed fighting with the Royal Welsh Fusiliers and could not reply to the summons. The chair was then draped in black on the stage, and the assembled Welsh audience wept openly. The event is still referred to as 'Eisteddfod y Gadair Ddu' – the Black Chair Eisteddfod. The Eisteddfod chair had been made by a Belgian refugee who had settled in Birkenhead. Using Celtic and Welsh symbols, he created one of the most impressive Eisteddfod chairs ever made. On 13 September 1917 the chair arrived in Trawsfynydd by train and was carried by horse and cart to Yr Ysgwrn, Hedd Wyn's hill farm. A collection his work, *Cerddi'r Bugail* (Poems of the Shepherd) was published in 1918. The moving 1992 Welsh-language film *Hedd Wyn*, commemorating the story, was nominated for an Oscar. His birthplace is next to Trawsfynydd Lake in Snowdonia, which provided the cooling waters for the appalling remains of a nuclear power station, set in one of the most beautiful spots in Europe. One wonders why there are no nuclear power stations in other national parks in Great Britain.

Edward Thomas (1878–1917) was a superb poet, one of the few Welshmen in history daring enough to disdain the English – his book *Wales*, published in 1905, has been in print ever since. His tragic death at Arras in the First World War in 1917 robbed Europe of a major poet. A line of his that always is remembered, from *Early One Morning*, is 'The past is the only dead thing that smells sweet.' Leavis called him 'an original poet of rare quality'.

One of the founders of Plaid Cymru, D. J. Williams was a miner before studying at Oxford, and his poems despaired at the disintegration of rural society, for instance in his 1934 publications *Hen Dŷ Fferm* (The Old Farmhouse) and *Hen Wynebau* (Old Faces). His contemporary David James Jones (Gwenallt) described Wales as a 'dirty street prostitute', railing at the degradation of the valleys and the injustices done to workers in his poems. The deeply religious John Saunders Lewis, another great nationalist, poet and novelist, despaired that Wales was now 'superficial and materialistic, idolatrous, throne-loving, because she ceased to think in terms of the Sacrament'. His influence as a dramatist, poet, literary historian and critic is unparalleled in Welsh literary history. For over a decade he was president of Plaid Cymru, which he helped found. His writings show his great concern that Wales was losing its sense of vision and moral integrity. Kate Roberts of Gwynedd wrote of the hardships on the slate quarries, and her novel *Traed mewn Cyffion* (Feet in Shackles) tells of four generations of miners, including the horrors of the world war, hunger and unemployment. R. Rowland Hughes worked in the slate quarries at Llanberis, and his *Chwalfa* (Dispersal) describes the Penrhyn dispute, the longest strike in the history of Britain.

At the same time as North Wales was developing generations of Welsh writers documenting social and industrial change, there emerged in South East Wales an Anglo-Welsh school of writing. They developed the idea of the indomitable spirit of Welsh people despite hardships, deprivation, starvation, terrible working conditions and ruthless companies. Jack Jones wrote of the Welsh mining valleys in *Rhondda Roundabout* (1934). His *Off to Philadelphia in the Morning* (1947) was a marvellous biography of Dr Joseph Parry, the Welsh musician and hymn-writer who returned to

Wales after emigrating to the United States, and became the first Welsh Doctor of Music at the newly organised university at Aberystwyth. Richard Llewellyn's *How Green Was My Valley* (1939) was made into a film and showed the Welsh mining predicament to the world at large. Howard Spring is remembered for a series of novels, the most famous being *Fame is The Spur*. George Alexander Graber (1914–97) used the nom de plume Alexander Cordell, and his first successful novel, *The Rape of the Fair Country*, tells of the industrial transformation of Wales.

W. H. Davies (1871–1940) was the 'tramp poet' from Newport who wrote in *Leisure*: 'What is this life if, full of care/We have no time to stand and stare?' A descendant of the French criminal-poet Francois Villon, Davies lost a leg in a railroad accident in 1899 while wandering across the Klondike, and ended up living in doss-houses and selling shoe-laces on the streets of London. The poems of *The Soul Destroyer* in 1905 recount his experiences with hoboes like Frisco Fatty and Red-Nosed Scotty, and with prostitutes like Kitty and Molly. George Bernard Shaw wrote the introduction to Davies' *Autobiography of a Super-Tramp*, which opened the doors of admirers like Vita Sackville-West, Ottoline Morrell and Edith Sitwell to the peg-legged tramp. Davies later married and settled in Gloucester, in a house he named Glendower (the Anglicised version of Glyndŵr). Spurning convention to the last, his pet was a toad called Jim, which he fed saucers of milk. Lines from his *The Kingfisher* are as follows:

> It was the rainbow gave thee birth
> And left thee all her lovely hues.

All was not pro-Welsh, however. Caradog Evans wrote of the failings of the Welsh character. Gwyn Thomas loathed the Welsh language and those who wrote in it, being a well-known novelist and broadcaster. Thomas taught me French and Spanish at grammar school, and on television after retiring from teaching proudly boasted that he never hit a child. He certainly hit me. Perhaps the fact that I was sixteen meant I did not count as a child. There is a blue plaque commemorating Thomas on what remains of my old grammar school, now a pub. Novelist and academic Gwyn Jones wrote novels about the industrial unrest and general strike of 1926 and collaborated with Thomas Jones in a translation of the medieval Welsh *Mabinogion* in 1948. Alun Lewis (1915–44) died of gunshot wounds in Burma, during the Second World War. It seems he slipped after washing and shaving, accidentally shooting himself in the head with his revolver. His poems were read by Dylan Thomas on BBC Radio. Like Edward Thomas, the war took him away too early, at the age of just twenty-nine years. His poems have a recurring theme of isolation and death, and he was indebted to Edward Thomas, to whom he dedicated one of his best poems. Some critics believe that he was the greatest of the Second World War poets.

The poet who stands out in twentieth-century Wales and has reached global recognition is Dylan Marlais Thomas (1914–53). Thomas is by far Wales' most well-known literary figure, and Idris Davies' short 1946 poem on Thomas is the best expression of Thomas' gifts:

He saw the sun play ball in Swansea Bay,
He heard the moon crack jokes above the new-mown hay,
And stars and trees and winds to him would sing and say:
Carve words like jewels for a summer's day.

Dylan is the Welsh poet in essence, throwing words around like confetti, unlike the more restrained (and Christian) R. S. Thomas. Dylan's famous radio play *Under Milk Wood* was later filmed in Lower Fishguard with Elizabeth Taylor and Richard Burton. The boathouse near Laugharne Castle where he wrote much of his work is open to the public. Buried at Laugharne in a simple grave, many visitors go to Browns Hotel there, where Dylan used to become famously drunk. He died, allegedly of alcohol poisoning, on a reading tour of the United States, possibly burnt out as a poet. 1997 evidence points to malpractice by an American doctor not treating Dylan for a diabetic coma as the cause of his death. Probably strongly influenced by Gerard Manley Hopkins, his writings are strongly emotive. The free-form thought processes, refined by dozens of rewrites, have given us poetry that will last forever. Dylan throws thoughts, ideas and words into a magical blender. His 'Do Not Go Gentle Into That Good Night' was recently voted the second-most-popular poem written in English – he asked his dying father to 'rage, rage against the dying of the light', as 'old age should burn and rave at close of day'. In his short life, Thomas kick-started Welsh poetry into wordplays not seen before in the English language since Gerard Manley Hopkins. We see in the first lines from *Under Milk Wood*: 'It is spring, moonless night in the small town, starless and bible-black, the cobblestreets silent and the hunched, courters'-and-rabbits' wood limping invisible down to the sloeblack, slow, black, crowblack, fishing-boat bobbing sea.'

Dying in the same year as Thomas was this writer's favourite Welsh poet, Idris Davies (1905–53). Whereas Dylan had a genteel upbringing with elocution lessons in a better suburb of Swansea, Davies knew what it meant to work for a living, and his poems reflected the times far better than Dylan's bucolic excesses. Rhymney-bred Davies was a miner as a fourteen-year-old who became a London teacher and extramural lecturer. A Welsh speaker, he learned English at school. He was the poet of the valleys, and died of stomach cancer, aged only forty-eight. His *Gwalia Deserta* was published in 1938 with his poems recommended by T. S. Eliot: 'They are the best poetic document I know about a particular epoch in a particular place, and I think that they really have a claim to permanence.' *Gwalia Deserta* shows a socially and politically committed poet, full of the imagery of mining-valley life in the terrible days of the 1930s. Much of his work describes the impact of the Industrial Revolution, and its terrible decline, upon his beloved countryside and people. A Celtic Christian socialist, he epitomised Welsh bardic tradition with a respect for fellow humankind rather than for wealth based upon property. He wrote, 'Any subject which has not man at its core is anathema to me. The meanest tramp on the road is ten times more interesting than the loveliest garden in the world. And instead of getting nearer to nature in the countryside I find myself craving for more intense society.' Davies is the most approachable of all Welsh poets, and verse XV of his *Gwalia Deserta* was set to music by Pete Seeger and also recorded by The Byrds. It begins

O what can you give me?
Say the sad bells of Rhymney.
Is there hope for the future?
Cry the brown bells of Merthyr.
Who made the mine owner?
Say the black bells of Rhondda.
And who robbed the miner?
Cry the grim bells of Blaina…

There is not space for the wonderful writers, especially poets who emerged after the Second World War. A love of Wales and its language is portrayed across the works of R. S. Thomas, Harri Webb, Vernon Watkins, Anthony Conran, Ruth Bidgood, Gillian Clarke, Gwyneth Lewis and many others. As a footnote, Cardiff in 2008 was short-listed to be European Capital of Culture. There are around forty-five recipients of this honour from 1985 to 2016, with multiple winners in some years. Some of the choices have been distinctly odd, such as Thessaloniki in 1997, this author having been working there in that year. No-one, even in the tourist office, could direct me to Pella, Philip of Macedon's capital, where Alexander grew up. I was annoyed when the organisers of the Cardiff bid had a celebratory party when they were informed that the slave port of Liverpool had won the bid. Cardiff had organised the party as they had been told that Cardiff would win, and the food and drinks were already laid out. Being a good Labour council, in a Labour-dominated nation, Cardiff did not appeal, but two members of the committee informed me in confidence that Tony Blair had, at the last moment, succumbed to his Liverpudlian wife's insistence that the title should go to Liverpool. This may be sour grapes or an outright lie, but dispassionately there is absolutely no way that Liverpool has as much culture or cultural history as the Roman fort, Welsh saints, Norman castle, medieval cathedral, theatres, museums and non-slave port of the capital city of Wales. There is an antipathy to Cardiff across much of Wales. The towns around it have seen shops close as people prefer to shop in Cardiff. Welsh visitors see a vibrant, wealthy, attractive city with everything to offer. We return to boarded-up high streets, derelict chapels and churches, wishing that our villages and towns had some of Cardiff's golden pavements. It is a proud show-piece for the nation, but there is the feeling that Cardiff gets everything, while the rest of Wales suffers. Similarly, it is thought that Welsh AMs down the glittering Bay, on high expenses and freebies, do not talk with the people of Wales, or see the reality of life outside the capital city.

Industry

J. C. Edwards was based in Ruabon, Denbighshire, and was active from 1903 to 1956 as a brick, tile and terracotta manufacturer from its works at Acrefair, Rhosllannerchrugog and Newbridge, Denbighshire. The discovery of vast quantities of high-quality Etruria Marl clay in the Ruabon area in the nineteenth century heralded the beginning of tile and terracotta production on a vast scale. J. C. Edwards was the largest ceramic tile manufacturer in the world for thirty years. By the turn

of the twentieth century, several factories employed roughly 2,000 people. Workers produced massive amounts of terracotta, earning the village of Ruabon the nickname Terracottapolis. The area also became famous was for the distinctive red bricks used to build schools, hospitals, universities, law courts, pubs and other key buildings in cities across the country. Dennis Ruabon Tiles owned the Hafod Brickworks. By 1893, a new factory, which became known as the 'Red Works', was constructed, producing ridge tiles, chimney pots, tiles and other products using twenty-four coal-fired beehive kilns. The business flourished at a time when demand for the red bricks and terracotta was high. By 1906, Thomas Dennis is thought to have employed up to 10,000 people in lead mines, collieries and other businesses. Monk and Newell Brickworks closed in the 1920s, but Gwaith Jinks (Jenks Terracotta Works) lasted from 1883 until 1975. The Afongoch & Tatham Tileries, opened in 1860 and closed in 1910, were taken over by Jenks. Nearby was the Wynnstay Brickworks, and there were other large brickworks across the region.

Because of the wealth of coal and iron passing through its port, Cardiff had a sevenfold increase in population from 1860 to 1905 and petitioned for city status, which was granted in 1905. In 1955, Wales at last had a capital city. Cardiff was chosen for its transport links, nearness to London and wonderful civic centre, defeating Aberystwyth, Caernarfon, and Machynlleth. Wales could now think of herself as a real nation with her own capital city, on equal footing with other small nations throughout Europe. However, from the First World War the nation has been in relative decline compared to other parts of the United Kingdom. In the final few decades of the twentieth century, Wales became one of the poorest parts of Europe – a fact ignored not only by its politicians, but by those in power in London. Even war-ravaged Northern Ireland passed Wales in standards of living, GDP per capita and other economic statistics. Before the First World War it was a far different story. Not much of the wealth might have remained in Wales, but the land was an economic and manufacturing powerhouse to rival anywhere in Europe. By the 1920s it was clear that labour-intensive dependence upon older heavy industry was a major problem in Wales. New, growing light industry jobs were being created across England. Wales had a narrow economic base dependent upon the exploitation of declining natural resources, with growing competition globally from cheaper labour countries. In the 1930s the spread of protectionism across the world also hit any chances of an export-led recovery.

The population more than doubled from 1,189,000 in 1850 to 2,523,000 from 1850 to 1914, much of it from outside Wales. There was a heavy density in parts of the Welsh valleys in Glamorgan and Monmouthshire in extremely poor housing. Workmen's Institutes sprang up, funded by the workers, with libraries as a major focus in them. Clydach had the biggest nickelworks in the world from 1902 and in the First World War, 75 per cent of Britain's zinc came from the Swansea area. There were eighty-two tin-plate works stretching from Port Talbot to Llanelli 1914, producing 823,000 tons of tin-plate. Two-thirds were exported. Cardiff and Barry were the two busiest coal-exporting ports in the world. In 1913, Barry Docks exported 26 million tons of steel. My grandfather said that you could walk across the decks of queuing ships for a mile or so. With the opening of the Barry Railway line in 1888, David Davies completed his vision of an integrated company taking his company's

coal via his company's railway line to his company's docks. This broke Lord Bute's virtual monopoly with his wholly-owned pits and his Taff Vale Railway to his own Bute Docks in Cardiff.

After the First World War, Wales went into recession. Coal tonnage dropped from 57.4 million tons in 1923 to 37.7 million tons in 1928. By 1930 it had halved and coal exports declined to one third, as shipping fleets converted from coal to oil. The great, world-leading ironworks at Cyfarthfa closed in 1921, Blaenafon in 1922, Ebbw Vale in 1929, and much of Dowlais in 1930. By 1933, 40 per cent of the 220,000 men employed in coal mining had been dismissed. Those remaining had their wages slashed. In the 1930s, 300,000 youngsters left Wales to look for work. Welsh unemployment rose from 13.4 per cent in 1925 to 27.2 per cent in 1930, at which time it was only 17.9 per cent in Scotland and 15.8 per cent in England. In Pontypridd unemployment reached 76 per cent and in Merthyr 59 per cent. In total 430,000 people were forced to leave Wales between the two World Wars to look for work.

The Forestry Commission was established in 1919, and promptly proceeded to cover the moelydd (natural bare hills) and deciduous valleys of rural Wales with millions of alien Sitka spruce trees. These have caused almost irreversible damage, acidifying the land and destroying landscapes and wildlife. The Forestry Commission somehow owns around 6 per cent of Wales and only recently has begun to place native deciduous trees for a more natural environment. Export of water began with Liverpool's dam on the Vrynwy River from 1881, Britain's first large masonry dam. For Birmingham the Elan Valley dam was built in 1882 and for Birkenhead the Alwen Valley dam in 1911. Wales is covered with reservoirs supplying England, with no benefit whatsoever to the Welsh people. The foreign water companies which own them even charge Welsh consumers more than English consumers. There is a strong case for Welsh water to be taken into nationalised ownership by the Assembly government for the benefit of the people of Wales, but no politician will dare mention the subject.

The coal industry, with 115,000 employees, was nationalised in 1947. The number of pits in South Wales shrank from 115 in 1953, producing almost 21 million tons, to thirty-four in 1981, producing 7.7 million tons. Steel production was also nationalised to form the Steel Company of Wales with manufacturing concentrated at Port Talbot, Llanwern, Ebbw Vale and Shotton. Cold reduction plants were based at Margam, Trostre and Velindre. New petrochemical plants were built around Swansea and Pembrokeshire. Growth in public services and nationalisation meant that 40 per cent of the workforce was employed in the public sector by 1951. On the agricultural side, in 1951 the average income of a Welsh farmer was £346, compared to £1,233 for the United Kingdom. However, the British car industry was opened up to foreign competition, and the demand for Welsh steel slumped, leading to the closure of most of Welsh steel plants. By the 1970s slate employed only a few hundred men in Wales. Lord Beeching cut Welsh railway lines in the late 1960s from 637 to 363 miles. This was an incredibly naïve and short-term view, which damaged the transport and tourism infrastructure forever. The first Severn Bridge opened in 1966, allowing the M4 to snake across South Wales, improving transport to England. Across North Wales, the A55 was developed into a busy dual-carriageway from Chester to Holyhead to spoil the coastal beauty of the area. Both the M4 and the A55 are full of Irish goods lorries, and holidaymakers bypassing Wales on their way to and from Ireland. The

A470 connects North (Llandudno) and South Wales (Cardiff). From the 1970s on, the steel industry contracted, with works at Shotton, Ebbw Vale and East Moors in Cardiff closing and lay-offs elsewhere. Wales attracted an above-average share of foreign direct investment (FDI) into the UK from the 1970s onwards, but many of the new plants established by foreign firms were essentially 'branch factory' assembly operations offering low-wage, low-skill employment opportunities.

One of the main trends after the Second World War was the shift towards service sector employment, which accounted for 60 per cent of jobs by the 1980s, with 42 per cent of the Welsh workforce now female. Jobs in local government, the National Health Service and the Civil Service increased exponentially. Official agencies brought bureaucratic employment in the public sector, mainly to Cardiff, which also is a minor financial services centre. Call centres spread across South East Wales, mopping up unemployment with poorly paid jobs. National regional policy brought Companies House to Cardiff, the Land Registry and Driver Vehicle Licensing Centre to Swansea and the Royal Mint to Llantrisant. The major recession of the 1980s affected Wales far more severely than the rest of Britain. Between 1979 and 1982, Wales lost 130,000 jobs and the employment rate fell to 62 per cent. Recovery started later in Wales, and structural changes left a legacy of high unemployment amongst older men, especially in the Valleys. The disillusioned Gwyn Alf Williams, in *When Was Wales* (1985) stated that 'the Welsh people are now nothing but a naked people under an acid rain'.

Compensation claims for industrial diseases from Turner and Newall's asbestos plant in Rhoose, for silicosis and pneumonoconiosis for miners etc., were delayed and delayed as payouts became less as people died early. All Welsh colliery records were removed to England by the NCB, to make it extremely difficult for NACODS (a mining union) to prove rights to compensation for the survivors. Crooked solicitors took millions out of funds. My Cadoxton friend's Scottish father, Bob Killin, died of cancer caused by working at the Distillers/BP Chemicals plant in Barry, South Glamorgan, weeks after his retirement. Like others, he had been involved in going into tanks of latex and PVC and cleaning them with no safety equipment, breathing in carcinogenic fumes. BP had commissioned a report into the dangers of vinyl chloride monomer gas in the mid-1970s, being aware of deaths in similar plants around the world. The report was completed in 1977 by staff at what was then the University of Wales Institute of Science and Technology. However, its vice-chancellor, the much-honoured Professor Aubrey Trotman Dickinson, agreed with BP to embargo the publication. It took another three years to disclose, during which time BP personnel and other people living nearby undoubtedly contracted major illnesses caused by PVC manufacture. BP at the time was wholly owned by the British government, and was the major employer in the area. No-one was ever held responsible for the delay in publication, and never will be. Bob Killin died a day before Hogmanay, aged sixty-five, blown up like a balloon, weeks after diagnosis. He had developed cancer in his liver, lungs, spleen and brain, plus bone deformities, clubbed fingers and toes. The *South Wales Echo* noted that BP gave 'a five-figure sum' to his widow, with no admission of guilt. The five-figure sum was exactly £10,000. Details like these are never recorded. This is simply a cameo of how working men and women are treated by those in power.

Coal

In August 1914, the South Wales Miners' Federation proposed an international miners' strike to stop the outbreak of the Great War, one of the more pointless wars in history. Unfortunately they were severely abused by the politicians, safe in Westminster, and the hysterical media, but there continued to be an anti-war movement in the South Wales mining areas. A massive increase in food prices, coupled with record profits for coal-owners, caused a demand for a new wage agreement in 1915. It was refused, so the South Wales miners went on strike. They were opposed by the government, coal-owners, the Great Britain Miners' Federation and the national newspapers, and the government threatened to imprison any strikers. However, the strike was solid. The then Minister of Munitions, Welshman David Lloyd George, intervened and settled the strike, acceding to most of the demands of the South Wales Miners' Federation.

Disputes continued, however, and in 1916 the Government took over control of the South Wales coalfield. A year later, all other coalfields were effectively nationalised by the state, and in 1919 a royal commission recommended the continuation of nationalisation, as being in the best interests of the state and miners. After appearing to accept the report, the government handed back control of the industry in 1921 to the coal-owners. The coal-owners demanded lower wages, and on 1 April 1921 began a lock-out of the million miners in Britain who refused to accept the new terms. After three months, the South Wales Miners' Federation accepted defeat after not being supported by the transport workers and railwaymen, who reneged on their promise of solidarity with the miners.

In 1926, the miners refused to work an extra hour a day coupled with large pay cuts of 16–25 per cent. On 30 April 1926, those miners refusing the terms were locked out and the pits stopped producing. On 3 May the general strike, called by the TUC, began. The mood in South Wales was almost revolutionary at this time, and when the TUC called off the strike just nine days later, the Welsh were left to fight on, alone and betrayed. Almost 250,000 men stayed away from the pit-heads. Police were called in from outside Wales to keep order, until the starving miners were forced back to work at the end of 1926. The effects on that South Walian generation solidified a feeling of 'us against the world' for decades. Once again, we return to Idris Davies to sum up the mood of the times, in a verse from *Gwalia Deserta*:

> Do you remember 1926? That summer of soups and speeches,
> The sunlight on the idle wheels and the deserted crossings,
> And the laughter and cursing in the moonlit streets?
> Do you remember 1926? The slogans and the penny concerts,
> The jazz-bands and the moorland picnics,
> And the slanderous tongues of famous cities?
> Do you remember 1926? The great dream and the swift disaster,
> The fanatic and the traitor, and more than all,
> The bravery of the simple, faithful folk?
> 'Ay, ay, we remember 1926,' said Dai and Shinkin,
> As they stood on the kerb in Charing Cross Road,
> 'And we shall remember 1926 until our blood is dry.'

Between 1921 and 1936, investment fell in the industry and 241 mines were closed in South Wales, with the number of working miners falling from 270,000 to 130,000. Just one company owned 80 per cent of anthracite coal production in South Wales, so kept employment conditions poor and wages low. Edward VIII had made a famous visit to the coal-mining valleys in 1936, telling the 200,000 unemployed miners struggling through the Great Depression, 'Something must be done. You may be sure that all I can do for you I will.' Within three weeks he had abdicated, never returning to Wales. H. V. Morton, in *In Search of Wales* (1932), reports a South Wales miner in the 1930s as saying,

> Some of the worst cases of hardship I've known have been in homes where the father was trying to keep six children on £2 5s. a week and was too proud to accept help off anyone … When you're on a shift you fall out for twenty minutes and eat bread and butter, or bread and cheese which your wife puts in your food tin … One day we were sitting like this talking when Bill didn't answer … He'd fainted. So I lifted him and carried him to the pit bottom to send him home, but before I did this I gathered up his food tin. There wasn't a crumb in it! He'd been sitting there in the dark pretending to eat, pretending to me – his pal – Now that's pride.

In the 1960s seventy-four coal mines closed, and by 1985, only thirty-one were left. In 2007, only one deep pit – owned by the workers – was left at Tower, but soon closed. From 1948, with 250 pits employing 113,000 miners, Wales has nothing. In the disastrous 1984 national miners' strike, the Welsh pits were the last to return to work. Maerdy, known as Little Moscow, was the last pit in the Rhondda, and closed in 1990. An Ogmore Vale collier defended the strike – 'Why on earth do they think we're fighting to defend stinking jobs in the pitch-black? There are no lavatories or lunch-breaks, no lights or scenery … We're fighting because our community and our culture depends on it.' Listen to John Evans, a miner aged just forty-seven and looking into darkness:

> I'm glad I haven't a son … It must be a heart-breaking business to watch your boy grow into manhood and then see him deteriorating because there is no work for him to do … I've been out of work now for eight years, and I've only managed to get eleven days work in all that time. Work used to shape the whole of my life and now I've got to face the fact that this won't be so any more. I am really glad I live in the Rhondda. There's real kindness and comradeship here, and that just about makes life worth living. The spirit here in this valley helps to soften many of the hardships of unemployment.

In the Rhondda and other black spots for work were are seeing a third generation of unemployed people in the same families. It is a terrifying indictment of politicians who can argue over trivia but have no idea of how to create and sustain worthwhile employment.

The former abundance of coal has been a terrible blessing for Wales – it attracted people from all over Britain to the unspoilt Welsh valleys, who assimilated into the Welsh culture. It gave jobs, but later generations of miners' children were encouraged to 'improve' themselves and go into teaching rather than go 'down the pit'. There

are still disproportionate numbers of Welsh people in British education at all levels. Production peaked in 1913 with 57 million tons, when a third of the world's coal was being dug by 250,000 Welsh miners. Welsh steam coal had been needed for ships and railways around the globe, but transport switched to the new fuel. The nationalisation of industry in Britain began in 1947 and the National Coal Board closed down all inefficient mines, modernising others. There was contraction in the tin-plate industry, but steel found itself revitalised by new plants at Margam, Shotton and Ebbw Vale. These three plants produced over a quarter of all Britain's steel. The 1947 Agriculture Act introduced the scheme of deficiency payments, grants and subsidies.

After Mrs Thatcher's decision to rely on subsidised foreign coal rather than the most efficient coal-producing industry in the world, employment in the coalfields collapsed. There were only twenty-eight deep pits still open at the end of the 1984 miners' strike, which Thatcher used the police to help break. None are now left, and Britain is dependent on imported coal, often produced by child or slave labour. The pits, which were still productive, were allowed to flood. A natural resource has been buried in the interests of a free-market economy. Tower Colliery remained until its closure in 2007 as the only deep pit left in Wales, after a buyout by its miners, with just 240 employees. There are two drift mines in Betws and Cwmgwili employing around another 220 men. There are some large-scale opencast operations run by Celtic Energy, producing around 2.5 million tons per annum. In the 1930s Wales produced a third of the world's consumption, and there were over sixty-five pits in the Rhondda alone. In 1913, over 250,000 men worked underground; now there are just 1,100 colliers, including overground staff. Subsidised imports from Poland, Vietnam, Colombia or South Africa took over, much of it mined under conditions which would not be tolerated in the Western world. In Colombia children work down the pits. Cardiff and Barry shipped a world record 13 million tons in 1913 – now nothing goes out. The present total output of Welsh pits is minuscule, compared to 57 million tons in the old days. Thatcher, unfortunately, chose as her enemies the most productive sectors of the British economy – manufacturing and mining – sectors that brought money into Britain. She ignored banking and the public sector, with the result that Britain has hardly any British companies left, and a massive public sector which it can only sustain with increasing debts for future generations.

Sport

In the twentieth century, Wales has had far more than its fair share of great sportsmen, champions and world record holders – John and Edwards, the greatest rugby half-back pairing in the world, for example. Rugby is the one sport associated with Wales. The 'golden team' of the 1970s gained six Triple Crowns and three Grand Slams between 1969 and 1979, when there were only five nations in the Five Nations European rugby championship. In fact, in the years between England winning the Triple Crown in 1960 and 1980, only Wales ever won the Triple Crown (seven times). Since 1883, England has won it twenty-three times, Wales twenty times and Ireland and Scotland ten times apiece. England has won twelve Grand Slams, Wales eleven,

France nine, Scotland three and Ireland just two. To be honest, this author has never seen a better rugby player than Barry John in the 1970s, and his scrum-half partner Gareth Edwards is still considered the finest player in history. John was followed, luckily, by the great Phil Bennett. In 1977, Bennett is reputed to have inspired his team mates for the England game with a pre-match speech: 'Look what these bastards have done to Wales. They've taken our coal, our water, our steel. They buy our homes and only live in them for a fortnight every year. What have they given us? Absolutely nothing. We've been exploited, raped, controlled and punished by the English – and that's who you are playing this afternoon.' Wales scored two tries (then only worth four points) and two penalties, against three penalties to win 14-9.

However, another young side, which performed extremely well in the Rugby World Cup in New Zealand in 2011, may be an even better team. It has already won three Triple Crowns and Three Grand Slams in the Six Nations, in 2005, 2008 and 2012. Despite the relative success at international level, being ranked fourth in the world below New Zealand, South Africa and Australia, the regional game is suffering with poor attendances. All four regions – Cardiff Blues, Newport-Gwent Dragons, Swansea-Neath Ospreys and Llanelli Scarlets have major financial problems, and have lost many players to richer clubs outside Wales. Cardiff, in particular, took the inane decision to leave their ground in the heart of Cardiff to share with Cardiff City in Leckwith, with their average crowds halving. They were paying around £25,000 a match to play there in front of crowds of 4,000. They have bought themselves out of the arrangement, but have lost major Welsh players in the process.

However, with limitations of space I wish to concentrate upon two sportsmen, a boxer and a footballer. Jimmy Wilde (1892–1969), whose nicknames include 'the Mighty Atom', 'the Tylorstown Terror', and 'the Ghost with a Hammer in his Hand', was the smallest and lightest world champion ever. Born at Tylorstown, Rhondda, he fought at 98 lbs, having to give away a great deal of weight to his opponents in the ring, some of whom were almost twice his weight. It is claimed that Wilde fought 864 opponents, starting in the boxing booths at the Valleys fairgrounds. The only boxer from Britain to be accepted in the USA as the finest in his division (flyweight), he was rated by four top American sports writers as the greatest boxer ever. During his career, Jimmy averaged one bout every eight days. He had begun fighting as a coal miner. He once stated that the hardest fight in his life was that with his wife Elizabeth after he had lost a huge amount of money gambling with fellow Welsh boxer Jim Driscoll. In today's terms, though he won only two world titles, he would have won five versions of the world championships 'in a week if he'd wanted to' according to famed English boxing reporter Reg Gutteridge.

Wilde's name is inexcusably missing from *The Dictionary of Welsh Biography*, as is that of fellow boxer Freddie Welsh. Born near Quakers Yard, Wilde fought the best flyweights in the world, when there were just eight weight categories, and just one world title in each. His natural weight was only 6 stone 4 lbs, his maximum fighting weight was 7 stone 4 lbs, and nearly all of his opponents weighed around 8 stone. 'He would often weigh in fully clothed, wearing a hat, and carrying weights in his pockets' (*The Western Mail*, 4 November 1998). In 1904, aged just twelve, Wilde went to work underground in a colliery. He turned to boxing in his early teens, but promised to give up boxing for his fiancée. However, the miners' strike of 1911 meant

that Wilde's young wife (both were nineteen) acquiesced to his boxing for money. Despite the interference of the Great War, he fought 151 times between 1911 and 1923, winning 132 (101 inside the distance), drawing two, with thirteen no-decisions and only four defeats. That is the official record, but Wilde had his own record, including booth and exhibition bouts, of 864 fights from 1910. 'On one day, in a booth in Pontypridd, he knocked over seventeen opponents before lunch and, after a cup of tea, demolished another eight opponents.'

Boxing Illustrated, in April 1993, ran an article upon the 'forty hardest punchers, pound for pound in boxing history'. Ranked ninth and eighth were Jack Dempsey and Joe Louis. third and second were Bob Fitzsimmons and Max Baer. Seventy years after his last fight, Jimmy Wilde was rated number one. The great critics Nat Fleischer and Charlie Rose rated Wilde as the 'all-time number one Flyweight', and he was elected in the inaugural class of the International Boxing Hall of Fame in 1990. His other claim to fame is that his is still the longest uninterrupted title reign of any world flyweight champion at seven years and four months. His record reads: fought 864, lost 3, including two of his last three fights. 89 per cent of his wins were by knock-out. His 101 consecutive fights without a loss is an all-time boxing record at any weight. It is fairly easy to make a case for the Welshman being the greatest boxer of all time, yet few have heard of him.

Moving to football, when anyone rates some massively overpaid, tattooed, shaven-headed, illiterate oik among today's players as a 'great player', please photocopy the following and read it out to them. Northern Ireland's George Best, Brazil's Pele, Portugal's Ronaldo and Argentina's Messi all have a claim to be the greatest footballer ever, but none have the all-round attributes of John Charles (1931–94). Welsh politicians are trying to make Wales a 'world leader' in green economics, not realising that no-one across the world except rugby-playing nations has ever heard of Wales. In 1995 the author was working in Italy, trying to explain to several female pensioners at an outside café table in Reggio Emilia, near Bologna, that he was from Wales, in reasonable Italian. Thwarted, he tried the usual litany of Tom Jones, Shirley Bassey and 'rugby', with no joy. At last one of the old ladies realised, and said, 'Ah, John Charles' and the others happily repeated the name, realising that the author came from the same area as *Il Gigante Buono*. This was thirty-five years after John Charles had left a rival club over 100 miles away. Charles rivals George Best and Welshman Billy Meredith as the greatest footballer produced in the British Isles, and could play in attack or defence, standing almost 6 foot 3 inches and weighing nearly fourteen stone. His preferred position was centre forward, but he was equally proficient as a centre half, and may be unique in sometimes playing centre forward for a club and centre half for his country, and vice-versa. He left Swansea for Leeds in 1949 aged just eighteen, being chosen personally by the Leeds manager Major Frank Buckley. Charles was capped for Wales in 1950, aged eighteen. He would have made more than 38 appearances for Wales, but Juventus were always reluctant to release their leading scorer.

This superb Welsh footballer was the first British transfer over £50,000 when he left Leeds in 1957 for a distinguished career with Juventus from 1957, where he was nick-named *Il Sigante Buono*, 'the gentle giant', and is still remembered with affection. £67,000 was a record transfer fee for a British player at the time. Charles

scored winners in his first three matches. Of his 28 goals in his first season, in the toughest league in the world at the time, he scored hat-tricks against Verona, Udinese and Atalanta. He scored 93 goals there in just 155 games, contributing to the winning of three championships and two Italian Cups. Charles scored 28 goals in his first season, being crowned *capocannoniere* (top scorer) in the league. This was in a defensive-oriented game, where goals were hard to score. A statue of him stands outside the ground, and his appearance on the streets of Turin, years after he finished playing, was greeted with spontaneous applause. In 1958 Charles was voted Italy's Footballer of the Year after his first season's performances, and was also one of the few non-Italian players chosen to play in the Italian National League XI. In this year, Juventus valued him at £150,000; over twice what they paid a year earlier, making John Charles the most valuable player in the world. His scoring ratio can never be bettered in a league that was notoriously defensive in nature.

An Italian newspaper headline of 14 April 1959 read alongside a picture of John, 'A Magnificent 6'3" Chunk of Welsh Marble bestriding the pitch in the No. 9 Zebra shirt of Juventus.' A fluent Italian speaker, he was voted Juventus' finest ever foreign player in 1997. His scoring record is incredible, because in the words of Michael Parkinson, 'John Charles was the complete footballer. In Italy they would play him centre forward until he scored, then switch him to centre half to stop the other side scoring. That seems to me the perfect all-rounder.' As Jack Charlton said, 'John Charles was a team unto himself', and he is Charlton's choice of the most effective footballer in history. Major Frank Buckley, the Leeds manager, called Charles 'the best in the world'. In 297 league games he scored 151 goals for Leeds. He joined as a left half, was switched to right-back and then centre half, but was moved to centre forward with the emergence of Jack Charlton. John scored 30 goals in his first season as centre forward in 1952/53, and a club record 42 goals in 1953/54, his second season in the position. In his first season in the old First Division he scored 38 goals, but Leeds were forced to sell him to Juventus because the club was on the verge of bankruptcy after a fire destroyed its main stand. In 2002, Leeds fans voted Charles their best player of all time. England's famous captain and centre half Billy Wright was asked who was the best centre forward he had ever played against. He answered, 'John Charles.' Then Wright was asked who was the greatest centre-half he had played against. He gave the same answer. Charles scored Wales' first ever World Cup goal, in the 1958 1-1 draw with Hungary. He was not fit for the Wales team that narrowly lost in the World Cup quarter-finals in 1958, 1-0 to Brazil. He had been severely and constantly kicked in the preceding game because of his influence on the Welsh team. It is fair to say that if he had been able to play, and get on the end of the constant stream of crosses served up by Cliff Jones, Wales could have won and been known world-wide. Such is the power of football. Brazil went on to win this World Cup in Sweden, starring the young Pele.

Sir Alex Ferguson recently chose his all-time World XI – John Charles was the only Briton to feature, alongside Schmeichel, Santos, Maldini, Beckenbauer, Cruyff, DiStefano, Maradona, Platini and Pele. On his last visit in 2004 to Juventus as an honoured guest John was taken gravely ill, and the club paid his expenses and flew him home in the club jet for treatment. From 1999 he had been battling with cancer,

and in June 2001 was awarded a CBE, not the knighthood he deserved. Juventus wore black armbands after John's death in their next match, against Bologna. 'We are crying for the loss of a great champion and a great man, 'said Juventus vice-president Roberto Bettega. 'He was a person who represented in the best way the Juve spirit and who personified the sport in the purest and most beautiful manner. The thoughts of everyone at Juventus are with his wife Glenda and the children of the unforgettable Gentle Giant.'

Racism

In 1841, William Jones pointed to some of the problems of being Welsh:

> To exist after so many and persevering attempts at their extinction, and to retain the vernacular use of their primitive, nervous and enchanting language, after so many revolutions in their civil and religious circumstances, are facts in which they will ever glory; and no good reason appears why our English neighbours should deny us these facts, or laugh at us, with so much sarcastic malevolence, when the matter is discussed in their society.

Attacks on Welsh culture and language these days take the form of sneering by the intelligentsia, rather than legislation and violence. I have already mentioned the problem of having a neighbour that, by virtue of its size, thinks that it is superior. To 'welsh' on a bet is to refuse to pay it. A 'Welsh pearl' is a fake. A 'Welshman's hug' is an itch. A 'Welsh cricket' is a louse. Another common slur from the master race is the following well-known rhyme from around 1780:

> Taffy was a Welshman,
> Taffy was a thief,
> Taffy came to our house
> And stole a leg of beef.

We rarely hear is the second verse:

> I went to Taffy's house,
> And found him in bed,
> I took a big cudgel
> And hit him on the head.

This old rhyme tells us about the days of lawlessness when the Welsh sometimes went back over Offa's Dyke into their former lands, rustling cattle. The English were then legally entitled to kill the Welsh and burn their house down.

Around the turn of the twentieth century there was considerable anti-Welsh feeling in the English establishment. Prime Minister Herbert Asquith said in 1905, 'I would sooner go to hell than to Wales.' One of Evelyn Waugh's characters in *Decline and Fall* (1928) was made to say, 'From the earliest times the Welsh have been looked

upon as an unclean people. It is thus that they have preserved their racial integrity. Their sons and daughters rarely mate with human-kind except their own blood relations ... I often think that we can trace almost all the disasters of English history to the influence of Wales.' 1999 saw the Scottish public schoolboy Anthony Charles Lynton Blair, who was so ashamed of his roots that he made himself quintessentially English, refer to us repeatedly as 'fucking Welsh'.

According to his spin doctor Lance Price's diaries, the tax-avoiding former Prime Minister made the insult as disappointing results for Labour from the 1999 Welsh Assembly elections came in. The claim was made in a draft version of the diaries, but had to be toned down in the final published version to read: 'TB f-ing and blinding about the whole thing.'

Disparagement still goes on in the media – a Welshman was not chosen as Lewis, the assistant to Inspector Morse in the successful TV series, because the north-eastern English accent was more popular with viewers. Neil Kinnock, as the Welsh leader of the Labour Party, had his undue share of insults from the national press and the Tory Party as 'the Welsh Windbag'. Jeremy Clarkson, in his popular motoring column in *The Sunday Times* (25 August 1996) states, 'I have just come back from a holiday in France – a pretty country spoilt, like Wales, by the people who live there.' He has at various times said, 'It's entirely unfair that some people are born fat or ugly or dyslexic or disabled or ginger or small or Welsh. Life, I'm afraid, is tragic.' He moaned about Wales beating France to win the Grand Slam in 2008, calling us 'sheepsters', and on his BBC2 television show placed a plastic map of Wales in a microwave, and burned it to audience applause. On 4 September 2011, writing in his weekend column for *The Sun* newspaper, he said, 'I think we are fast approaching the time when the United Nations should start to think seriously about abolishing other languages. What's the point of Welsh for example? All it does is provide a silly maypole around which a bunch of hotheads can get all nationalistic.'

However, some of the comments of this chain-smoking wife-cheating 'star' can be shrugged off, much like the Irish ignore racial stereotyping and get on with life. Another lightweight media entertainer is that subject of much cosmetic surgery, Anne Robinson. She despised people speaking Welsh around her mother's market stall, and on the TV Show *Room 101*, wished the Welsh to be disposed of. Her derisive comments about Welsh people included 'what are they for?' and 'I never did like them'. Just try saying that about the English. Writer Neil Ascherson commented that 'Southern views of the Scots over the last hundred years have been faintly sceptical – "chippy, lacking in humour, slow to unbend" – but on the whole affectionate. Contrast English attitudes to Welshness, which, for reasons I am not sure of, are often genuinely hostile.'

More difficult to dismiss are attacks like the following, upon one's heritage. In 1993, the English writer A. N. Wilson (who has a substantially amusing comb-over) wrote in the *London Evening Standard*, 'The Welsh have never made any significant contribution to any branch of knowledge, culture or entertainment. They have no architecture, no gastronomic tradition, no literature worthy of the name.' In *The Daily Mail* of 19 November 1997, Simon Heffer ridiculed Welsh culture, politics and the Welsh language, which 'like so many minority tongues everyone pretends to cherish but nobody speaks'. He continued, 'To describe Wales as a nation is rather

like describing William Hague as a formidable world statesman', not considering that all people with any sound knowledge of British history would see Wales as an old nation in the Middle Ages, with its own borders, language, culture and laws. This was well before England settled down to any status as a country, and then only under a dynasty of Welsh kings and queens. He tells us with the ignorance of misplaced pride that 'the Principality only took coherent shape when it was ruled by the Normans, the Angevins and then the English. It was lucky for the Welsh that they had the English to civilise them, an experiment they happily conducted with varying degrees of success over the next seven centuries.' If civilisation is the brutal attempt to exterminate a far more humane set of laws, to set women's rights back a thousand years, to try to kill an older language, to institute torture, to remove legal rights and to steal land by force of numbers, then the Welsh do not want civilisation. When one reads people like Heffer, one understands why so many people overseas have distaste for England and the English.

The *Daily Mail* only published this article in its English editions, not in England's last colony. Heffer also claimed that Welsh nationalists 'have invented a tradition of Welsh separatism, not built on one' and sneered at 'its neo-Stalinist fringe that went around a few years ago burning the cottages of those English masochistic enough to holiday in that rain-swept country'. The Welsh movement has always been peaceful – compare it to Sinn Fein and to England's takeover of India and elsewhere. Look at Saunders Lewis, who wanted 'any blood spilt to be Welsh blood and not English blood'.

In September 1997, the tiny, bald and dyslexic *Sunday Times* columnist A. A. Gill described the Welsh as 'loquacious dissemblers, immoral liars, stunted, bigoted, dark, ugly, pugnacious little trolls'. He was reported to the Commission for Racial Equality. This CRE said it has no powers to bring a prosecution. Since then he has written that 'you can easily travel from Cardiff to Anglesey without ever stimulating a taste bud', and described North Wales as 'hellish'. The Welsh are easy targets for a master race ideology, and have little access to the condescending London-based national press. The unintelligent abuse carries on to this day. In October 2010, the adulterous Rod Liddle, an associate editor of the *Spectator* magazine, described the Welsh as 'miserable, seaweed-munching, sheep-bothering pinch-faced hill-tribes' in a short post calling for the closure of S4C. On 12 August 2011, Roger Lewis, a columnist for the *Daily Mail*, said of the Welsh language, 'I abhor the appalling and moribund monkey language myself, which hasn't had a new noun since the Middle Ages.'

The above comments betray ignorance, but a major point of this book is that the Welsh are notoriously poor self-publicists – with a massive neighbour with control of all the media and levers of power, Welshmen have survived and kept their culture, attitudes and language by simply keeping their heads down. As such, the best comments about the Welsh nation come from outside sources, not from the succeeding Saxon/Norman/Angevin/Plantagenet/Hanoverian versions of the history of this country. Over a century ago, Ferdinand von Walter of Bonn wrote in *Das Alte Wales*, 'From this point of view, the Welsh outdistance all other people in the Middle Ages ... In Wales justice and right blossomed, founded on the laws of Hywel Dda, into a perfection of beauty unlike anything found among other people in the Middle Ages.' And Jacques Chevalier stated, 'Wales was the only country in Europe

in the tenth and eleventh centuries which had a national literature, apart from an imperial one in Latin. The people of Wales were the most civilised and intelligent of the age.' Racist comments against the Welsh, like all racist comments, are based upon ignorance and arrogance, and 'arrogance is the façade of the charlatan'. If England wonders why the Celtic nations wish to beat them at sport more than any other nation, it is easy to work it out. English people are fine, but are manipulated, like all of us, by the media.

One of the worst experiences living in Wales is English incomers not attempting to pronounce the language, and mocking it. One woman broke out laughing when I mentioned the *Mabinogion* as 'it's such a funny word'. Another complained that I altered the name of my house to a Welsh name as it would 'confuse people'. Many alter the old Welsh names of houses to Dunroaming, Chantry Mead and the like. The British-Welsh language is a treasure, the native language of Britain, not an amalgam of aggressive conquerors' tongues. English did not become the official language of the law courts until 1362. Not until 1399 was there an English-speaking king, Henry IV. Not until after Geoffrey Chaucer died in 1400 was English decreed as the official language of England. When Julius Caesar invaded, the English language did not exist, and the people spoke Brythonic Celtic. The Anglo-Saxons later invaded and kept a tiny fraction of the British language, which remained the language of non-conquered areas. The Vikings also ruled England for some time, and there are over 900 words from this Norse period, including days of the week such as Woden's Day and Thor's Day. When the Norman French invaded, the official languages of their court were French and Latin for around 300 years. English was a mixture of the Germanic and French languages. Today, we could not read this English, but a series of events, including the Black Death and the printing press, brought about the 'great vowel shift' between 1350 and 1500, which transformed Middle English into a form of Modern English. Chaucer was the first great writer to choose to write in English rather than Latin, beginning *The Canterbury Tales* around 1397. Middle English evolved into the language of the time of Shakespeare (1564–1616), which is the first easily understandable form of the English language. Thus the English language we know today exists from around 1600 onwards. Modern Welsh is similar to Middle Welsh of the twelfth century, which developed from Old Welsh of 800, itself coming from Primitive Welsh of 550, which appeared out of the British (Brythonic Celtic) language of pre-Christian days.

A Personal Perspective on the Twenty-First Century

A 2012 survey showed people in the Orkneys to be the happiest in Britain, a measure of social well-being. Among the least happy were those living in Rhondda-Cynon-Taff, Torfaen and Merthyr Tydfil, former industrial areas. Blackpool and County Durham were the least happy places in Britain, followed by Swansea (City of Sanctuary) and Blaenau Gwent. An ancillary question showed around 40 per cent of Welsh people to be anxious, led by Merthyr Tydfil as the most anxious area in Wales, followed by Swansea, Blaenau Gwent, Neath Port Talbot, Torfaen, Rhondda-Cynon-Taff and Wrexham. The areas hit hardest by the 1980s recession have still not recovered.

The Present Day: What Future for the Welsh?

> We were a people wasting ourselves
> In fruitless battles for our masters,
> In lands to which we had no claim,
> With men for whom we felt no hatred.
>
> We were a people, and are so yet.
> When we have finished quarrelling for crumbs
> Under the table, or gnawing the bones
> Of a dead culture, we will arise,
> Armed, but not in the old way.
> *R. S. Thomas, Welsh History*

This is not a happy ending. This is not a normal history book. Any Welsh politician reading it will scorn it. English readers may find it Anglophobic, but it is directed at leaders, not the people. Welsh people in the north will dislike it, because it does not overemphasise the role of the north in Welsh culture. However, Welsh people in the south may think it is too Cymru-centric. No history is totally impartial, but one tries to be realistic. As a result, this author can never find a Welsh publisher – they are reliant on the grants that come with not rocking any political boat, and to be realistic means that politicians must come to account for their shortcomings. To write a book

such as this and my previous works means that one has to conscientiously forgo any possible awards, prizes and honours. Writing the truth does not win preference or friends in high places.

Speaking as an economist and a former businessman and consultant, the economic prospects for Cymru are grim. It is the poorest part of the United Kingdom, even worse than Northern Ireland after its decades of bombings and killings. It is one of the poorest regions of Europe, yet Secretary of State for Wales John Redwood famously refused assistance from EU funds, as it did not fit in with his theory of market forces. Redwood, Thatcher, Blair, Brown, Cameron, Clegg and nearly all Western politicians believe in the economic model of free market economics. It is a none-too-clever illusion. There is no such thing as a 'free market' or 'the laws of the market'. All markets are controlled by individuals and the organisations they serve. It does not matter whether it is petrol, pork, copper or toys. What politicians call the 'free market mechanism' does not exist – it is a shield to cover their lack of economic expertise, a disguise for multinational companies and banks to control their markets, and an opportunity for major politicians, advisers and bureaucrats to jump on the gravy train of corporate wealth after they leave office. Wales has suffered more than most from this so-called 'liberal economics' and from its political devotees in Britain, Europe and America. Swathes of manufacturing jobs have gone to cheap labour nations, never to be replaced, and in some deprived areas of Wales we see the third generation of unemployed people living on state handouts.

In my lifetime I have seen the closing of chapels and churches, followed by public conveniences, libraries, local banks, shops and pubs. There are derelict buildings and dying High Streets across Wales. There is huge unemployment. What employment is available is not wealth-creating, but lies in the poorly paid part-time retail sector or in the local government/Civil Service bureaucracies. The only industry left in Wales is tourism – most manufacturing has gone, and what little is left is all foreign-owned, whereby any profits are transferred out of the United Kingdom by the mechanism of transfer pricing. This author has worked at board level in a British multinational manufacturer which manufactured in Germany, Brazil, Russia and elsewhere, but transfer-priced all its profits to the Netherlands Antilles. Multinationals do not pay British corporation taxes at acceptable levels, so taxation in Britain impinges far, far more upon individuals than upon large companies. Politicians will not act to enforce company taxation, because they know that companies will threaten to leave Britain, leaving long-lasting unemployment behind them.

Wales badly lags the rest of Europe in health, wealth and welfare. Cardiff prospers while the rest falls apart. While the rest of this book is concerned with what cannot be changed, if we honestly examine Wales in the present, at least we have a chance of doing something. We need politicians who have intelligence, business acumen, a record of success in the private sector and common sense. Is this too much to ask? Most have not one of these attributes. When the world population is growing by the size of Wales every week, and while China is putting online a coal-fired power station every week, it is no time for little Wales to think that the 'issues' (a horribly over-used word which should be replaced by problems) can be solved by 'green' policies. The problems in Wales, in no particular order, are in-migration of people who cost the economy in health and social sectors rather than create wealth; unemployment

and especially the lack of any strategy to assist the private sector; over-dependence upon the non-wealth-creating and feather-bedded public sector; poor education at all levels; poor health; and a poor infrastructure outside Cardiff, etc.

There is little point in trying for full independence – it is democratically impossible, owing to the make-up of Welsh population, with around half not being Welsh, and the Welsh population being diluted every year. Also, many of Wales' best hotels, pubs and tourist attractions are owned and run by English and other nationalities. Because of this, any potential rival to the existing parties must represent the interests of the nation of Wales including non-Welsh people, with safeguards for Welsh language and culture. Any policies must be based upon the rights of society at large, not the individual. Civil rights campaigners will throw up their hands in horror, but 'human rights' tramples upon the rights of society, leading to its breakdown in some areas. Much of EU law and red tape has to be thrown out if Wales is to be competitive in any area of the economy. It seems that the EU is not aware that America is incredibly indebted to China, and that European countries must become competitive with China and India, not be wrapped up in pointless legislation. To compete internationally, Wales would have to leave the dreadful failed experiment of the EU and concentrate upon the private sector. While the EU fiddles its books, Europe burns.

A potential business model is a co-operative one. It would be invaluable, but practically impossible to see the utilities – airports, ports, electricity, oil, gas, water, etc., return to public ownership, so that the profits remain in Wales. Government has to retract, including not giving benefits to those who have never worked and have no intention of working. This would include immigrants. There are queues at Calais for only one reason. Benefits for immigrants in France end after three months. In Britain they go on forever, with non-tax-paying immigrants and their families receiving more that British pensioners who have paid tax all their lives. This comment is not racist – it is common sense. Britain is vastly overcrowded, in extremely serious debt and beset with multicultural problems. It has scarce resources, poor prospects in international competition, and cannot afford more overcrowding. This is not a right-wing perspective, but an economic one. British pensioners must take precedence over outsiders.

Thirty years on from the Reagan and Thatcher experiments with monetarism and the free market mechanism, UK unemployment is two and a half times what it was when Thatcher won in 1978. Half of all Americans now live in what is defined as poverty, and those lucky to be in work are working longer for no real extra income. Thirty years of the politics of greed and power have resulted in jobs being taken overseas, a horrendously widening gap between rich and poor, with those in the middle fearful of their jobs, and young people not being able to buy a house or find work. British manufacturing has been reduced to 10 per cent of GDP, which is past the point of having a sustainable major economy. We are held to ransom by a corrupt banking system far more vicious and mercenary than the trades unions ever were, and there is no politician with the imagination to see any alternative economic path for the country. If Wales had a national bank, insurer and mortgage facility, people would be aware that their savings were safe, and that profits were being fed back into the country.

Thatcher famously said that it would be marvellous if Britain could be a service economy. She believed that manufacturing was dirty and controlled by the unions,

so she smashed it and them. Jingoistically, she believed that Britain could get cheap goods from China, India and other poorer countries in return for British expertise in banking, IT etc. She had no idea that concentration upon banking would cost Britain hundreds of billions of pounds. What she did not realise also is that poorer countries are excellent at numerical/intelligence-based services. India excels in software, and China can put people into space. There was never any competitive advantage for Britain. She allowed our manufacturing industry to be taken over for next to nothing, with all the profits being taken overseas. The only manufacturing now is basically assembly jobs for foreign companies. Welsh steel is Indian-owned. The Indian middle class is larger than the population of Europe. The market for cars in China is 20 million a year and will rise to 30 million before 2020. One wonders if Welsh politicians and their expensive advisers, with their costly and inefficient green energy policies, have worked out the effects of these carbon emissions from India and China. Thatcher took out the easy, yet productive targets. She left alone the unproductive public sector because there were too many votes there.

One would hope that capitalism has entered its final days – like religion it has become too complicated. The problem lies with alternatives. Communism and socialism equally are not economic models to be followed because, as in capitalism, the politicians who want and achieve maximum power are the very persons who should not be allowed power. They are deeply flawed, self-serving individuals, capable of anything from taking bribes and jobs for family members to declaring war for no acceptable reason. Trying to think of a 'good' politician across the globe, one who cares for the people and not for personal gain, is virtually impossible except for Aung Sang Suk Kyi of Burma. Any basic economic model for a country the size of Britain has to begin with home-owned manufacturing which will pay normal taxation rates. All private sector services are reliant upon manufacturing, which Germany realises. Generally, public sector employees are parasitic upon private services and manufacturing. Only the import-export surpluses from manufacturing and service industries can pay for the public sector. Politicians, all with no knowledge of private industry, seem to think that creating jobs in the public sector helps the nation. It does not. Their pay comes increasingly out of loans, not from the private sector. As a young man, more taxation was raised by the government from companies than from individuals. The situation has totally and irrevocably reversed. Major companies avoid taxation upon any profits. Multinational companies, whether in services or manufacturing, avoid taxation and the government is powerless to raise enough money to pay for the public sector. It does so, like America, Italy, Spain and other economies, by borrowing money which it can never pay back.

There is no anger in Wales – depression, yes; apathy, yes; acceptance, yes. Thatcher is remembered as having broken the power of the union, but what is forgotten is that the unions she broke – the motor industry, printing, mining, the utilities – were all productive trades, earning money for GB plc. The industries they worked in were sold off, to the long-term detriment of taxpayers and the British economy. The bloated, non-productive Civil Service, local government and the NHS were left well alone. Britain thus has £5 trillion in unfunded pension provisions to look forward to. This is made up of £3.8 trillion for state benefits to current and future OAPs, at today's rates of payment. The other £1.2 trillion will go to pay retired doctors, teachers and

civil servants. This equates to every household in Britain paying £180,000. We can add to this total Britain's official £1 trillion national debt, and hundreds of billions in future payments for Gordon Brown's insane PFI schemes. These were a device to put off necessary spending appearing in the accounts of the British government, to make the economy appear sounder. The Thatcher 'economic miracle' was enabled by global growth, North Sea oil being squandered and profits from denationalisation of what MacMillan called 'the family silver'. It was a smokescreen over the decline of Britain as a whole.

A billion is a difficult number to comprehend, but a billion seconds ago it was 1960. A billion minutes ago it was the year 110 and paper was invented in China. A billion hours ago it was 114,000 BCE and Neanderthal man coexisted with modern humans. A billion days ago it was 2,740,000 years ago, and no-one walked on the earth on two feet. A billion pounds ago was only thirteen hours and twelve minutes, at the rate the British government is spending it. Not one of the following taxes existed 100 years ago when the nation was one of the most prosperous in the world: Stamp Duty, Tobacco Tax, Corporation Tax, Income Tax, Council Tax, National Insurance Tax, Fishing Licence Tax, Petrol/Diesel Tax, Inheritance Tax (tax on top of tax), Alcohol Tax, VAT, Marriage Licence Tax, Property Tax, Airport and Flight Taxes, Service Charge taxes, Social Security Tax, Vehicle Licence Registration Tax, Vehicle Sales Tax, Workers Compensation Tax, etc., etc. A trillion is a thousand billion. The rescue of Britain's banks alone cost £1 trillion.

These debts can only be paid by the balance between exports and imports. The minority of workers in those private jobs (including farming) which contribute to fewer imports and greater exports are rewarded with job insecurity, EU red tape, lower wages and poorer pensions than all the jobsworths in the public sector. Britain currently has 23.2 million private sector workers, of whom only around 5 per cent in 2020 will be in a final salary or defined pension benefit scheme. The public sector is dependent upon the private sector, and is not only paid higher wages, but has inflation-linked pensions. The NHS is the biggest employer in the United Kingdom, yet health services and indicators seem significantly worse than most of Western Europe. The service appears to be manned at doctor- and nurse-level by a high proportion of foreign staff, while there is a bureaucratic mountain of unseen staff. The world's biggest employers are the US Department of Defence with 3.2 million people, and in order the Chinese Army, 2.3 million; Walmart/Asda, 2.1 million; McDonalds, 1.9 million; NHS, 1.7 million; China Petrol Corp., 1.6 million; China State Grid, 1.5 million; Indian Railway, 1.4 million and Indian Army, 1.3 million. The NHS employs almost 3 per cent of the people in Britain, but more importantly over 10 per cent of the working population, yet British health is poor and the health service does not operate effectively or efficiently. No other country in the world uses as much of its working population in the health sector. Much of its management would not be employed in the private sector.

Gordon Brown's attack upon private pensions was a scandal not overturned by the Conservative–LibDem coalition government. As a result, private sector workers earn less than the public sector and have far less job security, and also find it difficult to achieve any worthwhile pension at the end of their working lives. The state pension is the worst in Western Europe, so an unequal society has been built up, favouring

those in feather-bedded jobs with inflation-linked pensions, who do not contribute to the wealth of UK plc. Britain has become possibly the most highly taxed country in the world because it has sold all its assets. Denationalised gas, electricity, telecommunications and water prices are far higher than when in public ownership, leading one in four Welsh homes to experience 'fuel poverty'. (The comparable English figure is only 10 per cent.) A huge proportion of fuel supply is now owned by foreign companies. The price of oil for heating and transport is among the highest, in real terms, in the world. When Britain owned British Petroleum, BP, the price of petrol stayed at six shillings and eight pence, a third of a pound, for many years. American firms such as Esso and Shell could not then operate a high-price cartel.

The black economy now flourishes in Britain, a country where the lowest-paid pay 20 per cent income tax, and where it is more profitable for millions of people not to work. There has been a huge tax swing in the last thirty years from companies which were British-owned (few are left) to British individuals, as it is almost impossible to tax multinational owners of British organisations. 2 million people 'dropped off the radar' when poll tax came in, and Britain has no idea of its true population any more.

We know where each cow is, and paperwork has to be filled in for it to be moved, but there has been illegal immigration for decades. In the 2011 census, carried out in 2010, over 1.5 million households did not fill in the forms. There have been only 120 convictions, with a maximum fine of £1,000, which does not remotely cover court and other costs. In some cities and areas with high numbers of immigrants, fewer than one in four households returned the census form. A government which does not know its population will find difficulty in providing resources. The Welsh Assembly in Cardiff has little idea of the true population of Wales. In its fifteen years in power, all Welsh statistics – health, housing, employment, economy, education etc. – have shown Wales falling back against the UK and the rest of Europe. We do know that in-migration from England is the only factor by which the British Government is forcing Welsh councils across the land to build more houses. Wales is a tiny country, around 30 miles wide at its waist – it does not need extra housing. Houses attract people, but there are no jobs in Wales. With the single exception of Malta, England is the most overcrowded country in Europe. Immigration is responsible for around 55 per cent of the rise in England's population, and has also contributed to the rising birth rate. Net migration, the number of people to the population added because of immigrants, has been around 250,000 for fifteen years. The average household has been 2.4 people for the last twenty years, which means that an extra 100,000 houses a year have to be supplied, even for this official figure. Real immigration figures are higher. The above is the reality of the present day in Wales and England. If any politician wishes to address these problems, his career will be wrecked by the insane political rectitude of the current era.

Education

The Welsh Education Minister, Leighton Andrews, stated in 2012 that Welsh schools 'are simply not delivering well enough' after results of worldwide tests on reading,

maths and science. The 2009 Pisa assessments of fifteen-year-olds show Wales had fallen further behind since the 2006 tests. Welsh teenagers ranked below average, alongside the Czech Republic, in reading. Andrews called the results 'unacceptable' and said everyone involved should be 'alarmed'. Estonia and Latvia outperform Wales in mathematics, for example. Wales was again ranked lowest of the UK countries and is now well below England, Scotland and Northern Ireland. Out of 67 countries taking part, Wales was ranked 38th for reading, 40th for maths and 30th for the tests for science. Scotland was the best for reading and maths of the UK nations, ranked 15th and 21st, while England was top for science in the UK, ranked 16th. Wales is now below average on all three measures and has scored worse than before in every category. Up to 10,000 fifteen-year-olds are tested by the Organisation for Economic Co-operation and Development (OECD) in reading, maths and science. The results are probably mainly due to a funding gap, which has seen £800 more spent per pupil in England each year than in Wales. The centralised and bureaucratic management of schools is another factor.

Also, the ESTYN schools inspectorate report for 2012 found that 40 per cent of Welsh children reached secondary school with a reading ability below their age. The funding gap over, say, thirteen years in school, amounts to a smaller spend of over £10,000 on facilities, teaching and books in Wales. As a result more Welsh children suffer from poor reading, literacy and numeracy skills than their English, Northern Irish or Scottish counterparts. In effect they are given a more difficult start in life. Once, for many Welsh children, the only way to escape work in the slate or coal mines was to achieve a degree, and Wales exported teachers and lecturers all over Britain, to America, Canada and Australia. Once a university degree meant something, when only 3–4 per cent of the population took degrees. Streaming into grammar schools by intelligence favoured the brightest pupils from the working class over middle classes. Universities were more egalitarian and entry requirements were based upon merit. Now, over 43 per cent of youngsters go to universities after taking constantly dumbed-down qualifications. Once in university, they achieve higher and higher qualifications, meeting government targets. Unfortunately, many of their lecturers have come through the failing comprehensive/GCSE system and are also forced to give higher and higher grades.

The University of Wales has suffered a scandal and was broken up after virtually 'selling' degrees to foreign students. The greatest problem, however, of over 40 per cent of the population graduating with degrees, is that there are no degree-level jobs for them. There never have been and there never will be, unless we treat university degrees as a basic literacy/numeracy test. The Welsh Assembly Government subsidises Welsh university courses by around £6,000 per annum over the English model, but it cannot be said that this is cost-effective spending. In 2011, 36 per cent of graduates took lower-skilled jobs, with each graduate position being chased by forty-three applicants. A fifth of graduates are unemployed a year after qualifying. It is pointlessly expensive for 43 per cent of the population to now go to university, when 43 per cent of new jobs do not require graduates. The UK has followed the US pattern of using universities to disguise real unemployment. Some universities give their students six hours of contact time per week, often given by poor communicators, for thirty weeks a year. In turn they expect young people to study by themselves for

thirty-four hours a week. That is 540 hours of actual contact time over three years, charging exorbitant fees to the state and students.

I have had jobs working twelve hours a day for seven days a week for months on end. Assuming I had spent this time attending lectures and seminars, I could have completed the university class contact time for a degree in 6.4 days. Having taught in universities, I know that the system is flawed, with the wrong people teaching the wrong courses to the wrong students in a terribly inefficient and ineffective system which needs a radical restructuring. There is also, as in most of Wales, a marked Masonic bias in university appointments at higher levels. Wales needs grammar schools once again, with independent marking and less emphasis upon coursework assessment leading to qualifications. The problem is that teachers and lecturers have come through a system of not rote-learning the basics like grammar, spelling and mental arithmetic. Other countries such as Germany, Denmark, Sweden, Holland, China and Japan produce a competitive atmosphere in school, not one where no-one wins and spelling and grammar do not matter. A wonderful example of what is wrong with the education system was recently reported. A pupil in England sat his A-level maths paper twenty-nine times before he achieved the grade he wanted, which was noted as 'a prime reason for grade inflation and a drain on school budgets'. A potential employer would not know this. If only the first sittings of candidates' A-levels were counted, with retakes ignored, the proportion gaining A* or A grades would drop from 24.5 per cent to 19.6 per cent, and B grades from 50.3 per cent to 42.4 per cent. Even this ignores the fact that when A-levels were more difficult, and far fewer people took them fifty years ago, the most common grades were C and D. Perhaps 20 per cent of grades were A and B, unlike the absurd figure of 75 per cent now. Everybody has to pass well at school and university level to achieve government targets and achieve better funding. Education must be repositioned towards hard work, merit and achievement, not towards a standard level of mediocrity. Wales especially, more than the more privileged areas of Britain, has to radically alter its educational system to compete.

Partially because of the destruction of grammar schools by socialist experimenters, Britain has the 'worst social mobility in the world', according to a May 2012 report from the All-Party Group on Social Mobility. The MPs quoted an OECD study which stated that 50 per cent of children's prospects are predictable from the position of their parents, even worse than the USA's 47 per cent. In 1981, children from the richest fifth of households were three times more likely than those from the poorest fifth to go to university. By the late 1990s, they were five times more likely to go. This author went to Manchester University with his three closest friends from infant, junior and grammar school. Our mothers did not work and our fathers' occupations were labourer/process worker, labourer, security guard and welder.

In higher education, if the majority of courses offered skills desirable by private employers, it would be better. Unfortunately, statistics show that the United Kingdom approach to an American-style education system merely serves to hide young unemployment figures, leaving many graduates with no job prospects and huge debts. Young people today are not taught by rote to remember things, nor equipped with mental arithmetic or grammatical skills. When I was lecturing in university, the best students, by far, were those from Germany, Holland and Scandinavia. They excelled in

studying, attendance, coursework and examinations because their previous education had not been subject to the 'progressive educational policies' of the UK. As a result our youngsters, when they reach university, are not at the level of specific European countries. The abolition of the grammar schools and competition between students has been a disaster for Britain, as has assessment based upon coursework rather than examinations. To reach government targets, where everyone succeeds, we have seen fifty years of progressively easier examinations. As a university student in 1966, I remember sitting down with two friends and their girlfriends and playing charades in a nightclub. The girlfriends were training to be English teachers, and both had been taught by incoming 'better' methods. They did not know what syllables were. A problem is that many lecturers have come through the same system where spelling and grammar are not important. We have too many universities, too many students, too many lecturers, too many pointless courses and too many administrators.

The following university rankings are from the independent *Complete University Guide*, with five Welsh universities getting worse rankings over the past year. The figures overall are extremely disappointing, especially as the Welsh Assembly is disproportionately spending far more on graduate education on Welsh students than English students are receiving. It goes to show that it is generally more beneficial for a Welsh student to attend an English university.

Rank 2013	Rank 2012	University	Entry Standards n/a	Student Satisfaction 5 max	Research Assess 4 max	Graduate Prospects 100	Total 1000
36	37	Cardiff	431	3.9	2.69	76.1	720
49	54	Swansea	341	3.8	2.43	66.3	615
58	49	Aberystwyth	305	4.1	2.48	52.1	592
66	78	Bangor	293	4.1	2.43	61.9	573
79	68	Cardiff Met.	271	4.0	1.88	52.2	538
91	83	Glamorgan	286	3.9	2.04	54.9	496
100	104	Glyndŵr	212	4.0	1.69	66.9	477
104	92	Trinity St. Davids	244	3.8	2.11	51.1	468
105	89	Newport	257	3.9	2.42	50.0	458

Northern Ireland's two universities were ranked at 25 (31 in 2012) and 60 (52 in 2012). This gives a joint-ranking of 43, better than all but one of the Welsh universities. Northern Ireland has a population density of 315 per square mile compared to 361 in Wales; its population is 1.8m compared to 3.1m; and its area is 5,345 square miles compared to 8,022. It seems strange, then, that Ireland has only two universities compared to nine in Wales. Quality is sometimes better than quantity. There is a proposal to merge Newport, Cardiff Metropolitan and Glamorgan, but it still appears that Wales is over-endowed with inferior higher education.

Since 2008, Cardiff has dropped from 27 to 36; Swansea has dropped from 47 to 49; Aberystwyth has dropped from 43 to 58; Bangor has fallen from 46 to 66; Cardiff Metropolitan (formerly UWIC) has dropped from 74 to 79; Glamorgan has plummeted from 68 to 91; and Newport has fallen like a stone from 65 to 105. Glyndŵr did not exist in the rankings in 2008, and Lampeter, before it merged with

Carmarthen to form Trinity St David's was rated 59, now dropping to 104. This is a terrifying drop in relative standards by every single Welsh institution. Not one improved. The average rating of the eight relevant institutions dropped from 54 to 74, *twenty places*, in just five years from 2008 to 2013. Why has no politician mentioned this? Why are Welsh universities constantly declining in comparable standards?

Cardiff just scrapes into the Russell Group of twenty-four leading universities, in 23rd place, although it is 36th in overall British rankings. To put it into perspective, the top five universities were ranked Cambridge, 1000 (the maximum); LSE, 996; Oxford, 995; Imperial College, 959 and Durham, 912 out of 1000. Of the 116 universities listed in the table, the average Welsh rank is in 76th place, two-thirds down the table. If we omit the original four Welsh university colleges, which are still the top four in Welsh rankings, the rank of the five new universities is 96th in the standings. Something is obviously wrong, not helped by the fact that quality control visits by HEFCW (Higher Education Funding Council for Wales) are known about well in advance. The visiting team sees what and who the university wants it to see. I stopped teaching MBA classes – to mainly Asian students – because the standard of student was below undergraduate level, and eventually resigned, disenchanted with the higher education sector, its management, bureaucracy, inefficient working practices and nepotism. The author has known of students with full-time jobs taking full-time degrees, and has worked with dyslexic lecturers and also lecturers who never read a daily paper. Welsh higher education students pay around £6,000 a year less in fees than their English equivalents. The Welsh government should assess whether this level of subsidy is worthwhile, when too many students are going to too many universities with too few graduate jobs on offer.

There needs to be a dramatic rethink upon what people should receive from their university education, and courses be developed to suit the modern world. Students should always independently assess lecturers, and examinations should be set nationally, with a lesser coursework element. Lecturers must stop telling students what is in the examination papers. It is, of course, easy to have coursework done by someone else. We cannot go back to the past, as the university model generally no longer works except for applied sciences and some assessment of exams. In 2011, the head of Google's top research laboratory made a course he was teaching at Stanford University available online – free. Stanford is one of the finest universities in the world and charges undergraduates over £33,000 a year in tuition fees. His class in artificial intelligence, which had been open to about twenty Stanford students, could now be accessed by anyone with internet access. Professor Thrun announced the project with one single e-mail, and 160,000 people from 190 countries signed up. There would have been more, but Stanford halted the application process.

Around 23,000 students passed, a cohort which would have taken the professor a century to teach in person. None of the top 410 was from Stanford. Following its success, Harvard, MIT, Michigan and Pennsylvania will also be offering free online courses by top academics. Another Stanford professor, Andrew Ng, taught a computer class on machine learning to 100,000 students in 2011. The potential of such learning is extraordinary, but only the best academics in the best universities will thrive. Costs of learning will drop dramatically, and British universities will have to alter their model. Some courses give six to seven hours of learning a week (the rest

is supposedly self-learning), over an academic year of perhaps thirty teaching weeks. The value given to arts and social studies students, especially, is often negligible. There has been a scandal over overseas degrees at the University of Wales, leading to its recent fragmentation. Ongoing reorganisation does not address the fact that universities are not fit for the present age. The vast majority of lecturers have had no outside experience. People teach corporate strategy without ever leaving the college environment. Wales needs to shake apart its university system – it is failing badly, and will not change from internal forces.

The Destruction of Tourism

Dolaucothi Gold Mines, to this author, seems strangely under-resourced and visited. Equally, the National Garden of Wales at Llanarthne has tiny visitor numbers compared to the disappointing, crowded and small Eden Project in Cornwall. Near Llanarthne are the unique lost gardens at Aberglasney, which are usually empty. Castell Carreg Cennen is one of the truly great castles. Like neighbouring Dinefwr and Dryslwyn, it has a terrific story of warfare, and spectacular views. Few people visit. Mighty Dryslwyn is besieged by nettles and Himalayan Balsam. Instructive is the closing of Gwynfynydd Gold Mines, with its tourist centre, in Dolgellau in 1999. Gold from the mine was given to the Queen in 1992 for royal wedding rings, Diana being the first to wear one. Gwynfynydd also was a jewellery maker and tourists could have a guided tour of the mine workings. It closed after a local government reorganisation led to Gwynedd Council restricting the number of long-stay tourist places in Dolgellau's car park. The owner, who had restored the mine at a cost of £400,000 over seven years, had to close the tourist centre, shop and mine, because 'visitors had nowhere to leave their cars when they took the four-hour tour of the mine and the tourist centre'. Tourism operators across Wales have complained to this author about lack of support from local and central government, yet they not only create worthwhile jobs for local people, they attract income into Wales.

This author took part in, and provided poems for the 600th celebration of the beginning of Glyndŵr's War of Independence, at Machynlleth. A replica of his great sword was made. The former rugby international Ray Gravelle and a current television presenter were to hand the sword over to the mayor, but at the last minute were replaced by the French consul for Wales, who made a gracious speech and knew the history of the French support for the greatest of all Welsh heroes. Ray Gravelle and the presenter (whom I cannot name until she retires from media work) were told by the BBC that they would be in trouble if they attended. Ray Gravelle earned from freelance work for the BBC. The BBC did not want to be associated with what they thought was a nationalist celebration. Wales cannot celebrate its heroes any more. There was no Welsh Assembly support for any recognition of the event, no broadcast media coverage, just something in the local press, and not one AM would be involved in the anniversary. The cynicism of these people is breathtaking – our national hero was ignored, yet he is responsible for our sense of nationhood more than anyone. Glyndŵr is known and admired worldwide, but not, it appears by our political leaders, afraid of losing incomers' votes. This was an opportunity to bring in hundreds or thousands

of expatriates, for a national festival of Welsh identity. If the Assembly spent half as much on Welsh identity as it did upon multicultural activities, translations and the like, there would be no such problem. AMs and Welsh constituency MPs should also take a Welsh history examination as they appear to know nothing, and care even less, about the country they represent. The ruling Labour party has always despised Welsh history as being backward-looking. It would rather that everyone Welsh disappears into a socialist melange of multiracial, multicultural equality. Being Welsh is different, and some of us wish to stay different. We wish the Welsh to survive as a nation by understanding its past.

Tourism now accounts for more than 7 per cent of Wales' Gross Domestic Product, compared to 5 per cent of GDP for the UK in general. Unfortunately this is mainly tourism from the rest of the UK. Only 3.3 per cent of overseas visitors to the UK come to Wales, and the majority of them on their way through to Ireland. Welsh spending accounts for only a tiny 1.9 per cent of overseas tourist spending in Great Britain. Tourism is the only industry left in Wales, and needs to be better supported. A British Council survey in 2000 showed the image of Wales overseas to be 'weak, blurred and kaleidoscopic'. Wales was the least-known part of the United Kingdom. In Europe, Wales was best known in the Czech Republic, Italy and Hungary. In Hungary, 7 per cent mentioned bards when asked for an image of Wales, thanks to the poem 'The Bards of Wales'. In Hong Kong, fewer than a third had heard of Wales. The first thing people thought of when imagining Wales were Diana, Princess of Wales, 20 per cent; Prince of Wales, 13 per cent; Royal Family, 8 per cent; Castles, 7 per cent; Rugby, 6 per cent; Beautiful Landscapes, 5 per cent; Football, 4 per cent; Mountains, 3 per cent; Sheep, 2 per cent; Coal Mining, 2 per cent; The Valleys, 2 per cent; and Cardiff, 1 per cent. Bards, bad weather, Welsh cakes, male voice choirs, daffodils and fishing boats all received less than 1 per cent. 16 per cent of people had no image of Wales. So there we have it. After countless millions spent on advertising, 41 per cent of foreigners identify Wales with the royal family, including Princess Diana, who had died three years previously, and 16 per cent can think of nothing. Across the world, 57 per cent of people therefore have no idea of Wales. The royal family's links with Wales have never been more than tenuous.

Wales has not been helped by politicians, with the budget for promoting Wales being a fraction of that spent by Ireland. The Wales Tourist Board was taken into the fold of the Welsh Assembly Government, and any coherent tourism strategy is unknown to this writer at present. Results of the 2011 Wales Visitor Survey show that the natural environment and the friendliness of the people are the two major factors when visitors rate their holiday in Wales. The profile of overseas visitors is heavily skewed towards the ABC1 demographic, with nearly nine in ten in this group. In terms of life stage segmentation, the largest category is empty nesters, which accounts for a third of overseas visitors. Over half of all overseas visitors are new to Wales, with a fifth being lapsed visitors and a quarter repeat visitors. New visitors are highest in South Wales, possibly because of sporting visits associated with the Millennium Stadium. Over a third (37 per cent) rated Wales 10/10 for the attribute 'Wales overall as a place to visit'. Top-performing elements of the trip relate to the natural environment and attractions. Elements that perform less well (but still perform positively) are associated with commercial tourist facilities such as shops and places to eat as well as value for money.

Before the Millennium, the Kenyan-South African Peter Hain, as Minister for Wales, wished to abandon the Welsh flag, the oldest national flag in the world, and one of the most recognisable. He said, 'We will get rid of the stereotypical images. Modern Wales is about Manic Street Preachers and Catatonia rather than women in shawls, leeks, daffodils and rain-sodden valleys … The dragon is very prickly-looking and old-fashioned. Wales lacks self-confidence and this process will help us address that.' The redesign was developed to coincide with the opening of the Welsh National Assembly, and was going to be based upon the red kite or the flag of the Princes of Gwynedd. Thankfully, the Blairite 'cool Britannia' approach was abandoned after widespread protests. One wonders why the voters of Neath keep voting Hain as their MP, a man so out of touch with Welsh feelings and heritage.

While the placing of unwanted and unneeded reservoirs across Wales has been contentious, we can say that at least they are placid areas, capable of being used for tourist pursuits. Some of the alien forests covering Wales also can be used for country pursuits, especially those which at last are being given a deciduous element. However, the spread of wind turbines is only hurting the economy. It is nothing short of disgraceful that the RSPB refuses to condemn them for their known and disastrous effects, especially upon birds of prey – the wing-tip of a turbine blade travels at 182 mph. The blades also kill bats and local wildlife and livestock moves as far as possible away. The RSPB has received money from wind farm interests and the government, like the National Trust, so neither will condemn their paymasters. There is lasting damage upon humans who live within range of turbines also.

One would ask those who disagree with the above statements to try some independent research before going on the attack against this author and others who care about the environment. The peat-rich uplands of Wales are being covered with 1,000-ton blocks of cement for each turbine, access roads across virgin environment and pylons. Their construction will cause and exacerbate flash floods, with less land available to soak up rain. There are, of course, many also planned off the Welsh coast, which will be future eyesores and hazards. A recent letter in the *North Wales Weekly News*, from Brian Christley of Abergele reads, 'Imagine the outcry if someone erected wind turbines in Italy's Lake Como or off the coast of Capri, Amalfi or the French Riviera. Yet First Minister Carwyn Jones seemed quite content to give his nod of approval to forests of wind turbines off the North Wales coast, as though the area is of little value, as no-one important ever goes there, and of course it cannot be seen from his Cardiff office.' The new onshore wind follies are higher than the Blackpool Tower or the Great Pyramid, but not one power station can be closed. One can envisage Lord Carwyn of Swansea in the future.

There is also a commitment to build more and more housing boxes across Wales, many adjoining pretty villages, to accommodate both immigration and in-migration. Councils are obliged to meet building targets, but one fails to see why, for instance, pregnant teenagers are rewarded with free housing and benefits. A friend was contracted stripping out filthy council flats in Llanelli, where tenants had been evicted or rehoused elsewhere. He had almost finished totally refurbishing a two-bedroom flat, putting in all new units, a new floor and disabled facilities with a wet room, according to the contract. A young couple walked in and started looking around. They could not speak English, but the female shook her head and became

agitated upon seeing the wet room. They phoned an interpreter, paid for by Llanelli Council. The interpreter told my friend's boss that the wet room would have to be stripped out, and a standard bath and shower cubicle put in for the youngsters. It turned out that they were Polish, had no jobs, and that Llanelli has a long waiting list of Welsh people waiting for council accommodation. The point is that Wales does not need any more housing. Just as the M25 created traffic, so does new social and other housing create local population explosions. The lack of England's density of population is a major tourist draw for Wales. New, ugly estates are not, and only cause increasing pressure upon an inefficient infrastructure. Seaside resorts have increasingly become centres of people living upon benefits.

Every weekend throughout the year, Mid Wales – that is, anywhere between Trawsfynydd and Llandovery – is invaded by motorcyclists from England, many pushing their bikes to the maximum on largely empty roads. Keith Jones pointed out in a letter to the *Western Mail* (July 2012) that Saturdays and Sundays are the only times locals get to see what is for the rest of the week an invisible police force, with the inevitable overtime payments involved. There are accidents every weekend, with often more than one fatal motorcycle accident. In addition to the payments made to the police, there are the costs incurred by the Welsh Ambulance Service, and hospitals. Perhaps worse, local people are caught up in this mayhem, killed and injured.

The Englishwoman Jane Davidson was vice-president of Ramblers Cymru when she became Minister of Environment in Cardiff Bay. She resigned as vice-president and created a Wales Coast Path for Ramblers, then became president of Ramblers Cymru within two months of stepping down from WAG in May 2011. She never declared an affiliation to Ramblers Cymru, or any conflict of interest, at any time. The perhaps illegal path cut through Welsh-owned land and treated the country as if it was no more than a tourists' playground. It is also extremely dangerous, being in places a foot from the edge of crumbling cliffs. Davidson also championed the cause of English canoeists who demanded the 'right' to go wherever they liked in Wales, unlicensed, no matter what anglers and other river-users thought. Welsh rivers are suffering badly because of fertiliser run-off from fields, and from over-fishing at sea. Numbers and weights of salmon and sewin (sea-trout) are at historically low levels. If we look at Wales from the air, we see great white breakers crashing upon its coasts. Unfortunately these are hundreds upon hundreds of caravan parks. Some caravans are Welsh-owned, but they contribute little to the Welsh economy, apart from greatly benefiting coastal farmers. Holidaymakers will naturally stock up their cars with food and bargain booze before heading into the caravan parks which blight tourist areas. South Wales beaches have been denuded of sand in this author's lifetime, driven by the constant dredging of sand for building from nearby sandbanks in the Severn Sea. Barri Island, Porthcawl, and all the Gower beaches have suffered badly. The dredging companies employ scientists to tell politicians that this is a natural phenomenon. The loss of sand from beaches, according to independent scientists, is a direct result of the demand for concrete. Once a beach has gone, it cannot be replaced.

There is still a strong expatriate network of Welsh clubs around the world. This author's website walesbooks.com was the first and so far only one to list all 200-plus societies, but it is now out of date owing to lack of time. These clubs could be

targeted for tourism if anyone in authority had the wit to do so. In March 2012 the Dewi Sant United Church in Toronto, set up in 1907, was advertising for a Welsh-speaking vicar to take service. The National Festival of Wales occurs annually in various cities in North America, and this author has been fortunate to speak at those in Vancouver and Washington.

Religion and Language

The Church has been a home to the Welsh language for centuries, and Wales was honoured to have a Welsh-speaking Welshman, Dr Rowan Williams, as Archbishop of Canterbury, who will step down at the end of 2012. He has been at the centre of struggle involving the role and acceptance of women and homosexuals in the Church. In 2008 he argued that the adoption of certain aspects of Islamic law 'seems inevitable' and said that it could aid social cohesion. In 2012 he commented that wearing a veil helps give Muslim women strength. It is illegal for women to wear full-length veils in France, a nation which, as in Wales, is losing its battle against the increasing use of English. The United Kingdom already has at least eighty-four Sharia courts, dispensing Islamic Law, and we often unknowingly eat Halal-butchered meat. It seems strange that multicultural policies are practised more in Britain than elsewhere in the world, at the expense of its own culture. This author has worked in the Middle East. If one is involved in a car accident there, it is automatically the foreigner's fault for being in their country.

In the 1991 census, the Welsh language was said to have stabilised at the 1981 level of 18.5 per cent. At the end of the twentieth century it became compulsory for all schoolchildren to learn Welsh up to age sixteen, and this both reinforced the language in Welsh-speaking areas and reintroduced at least an elementary knowledge of it in areas which had become more or less wholly Anglophone. According to the 2001 census the number of Welsh speakers in Wales increased for the first time in over 100 years, with 20.5 per cent in a population of over 2.9 million claiming fluency in Welsh. No less than 28 per cent of the population claimed to understand Welsh. The increase was most significant in urban areas, such as Cardiff and Rhondda Cynon Taf, but to this author this is generally 'school-Welsh'. To understand a language spoken in full flow is far different to translating a written text with a dictionary close by. The dismaying statistic was the decline in the traditional heartland of everyday Welsh. In Gwynedd the number of Welsh speakers dropped from 72.1 per cent in 1991 to 68.7 per cent in a decade, and in Ceredigion from 59.1 per cent in 1991 to 51.8 per cent. Ceredigion in particular experienced the greatest fluctuation, with a 19.5 per cent influx of new residents since 1991. This author lives near the Teifi on the Ceredigion–Carmarthenshire border, and the majority of people he knows in the area are from outside Wales. When house-hunting in 2009–10, I looked at around forty houses in Montgomery, Carmarthen, Breconshire and Ceredigion. Thirty-nine were for sale by English incomers, mainly pensioners or retirees who were looking to downsize or move closer to their children.

The following 2010 statistics from the National Assembly do not seem valid, reflecting the fact that Welsh is taught in schools, rather than being used upon

a daily basis. It is one thing to say 'hello' and comment that it is raining, but not to go in a shop and ask for something in Welsh, or to hear the language being spoken in Cardiff, Swansea or Newport. One is more likely to hear Urdu, Polish, Gujarati or Romanian in major conurbations upon a weekday. As someone who was a former practising member of both the Market Research Society, the Industrial Market Research Association and the European Society for Opinion and Marketing Research, I know that questionnaires can be designed to give the answers which the research commissioners require. As with educational, health, unemployment and other statistics, the public is rarely given a true picture. A privately commissioned poll would show that the number of speakers who regularly use Welsh in preference to English, and importantly, who are proficient in writing Welsh, would be well under 10 per cent.

	Population	Yes, can speak Welsh	No, cannot speak Welsh	% of people who say they can speak Welsh
Gwynedd	117,200	82,700	34,600	70.5
Isle of Anglesey	68,100	41,500	26,600	60.9
Ceredigion	75,600	39,700	35,900	52.5
Carmarthenshire	178,800	83,100	95,600	46.5
Conwy	109,500	36,400	73,100	33.3
Denbighshire	95,100	28,900	66,100	30.4
Flintshire	149,000	37,700	111,200	25.3
Powys	130,500	31,100	99,400	23.9
Newport	139,600	26,300	113,200	18.9
Neath Port Talbot	136,200	25,600	110,600	18.8
Caerphilly	171,900	32,100	139,700	18.7
Torfaen	89,700	16,300	73,400	18.2
Cardiff	337,400	60,100	275,500	17.8
Merthyr Tydfil	55,400	9,800	45,600	17.7
Pembrokeshire	116,300	18,900	97,400	16.2
Swansea	229,800	37,200	192,600	16.2
Vale of Glamorgan	123,600	21,000	102,600	17.0
Wrexham	132,600	22,600	110,000	17.0
Monmouthshire	87,000	14,500	72,500	16.7
Pembrokeshire	116,300	18,900	97,400	16.2
Swansea	229,800	37,200	192,600	16.2
Bridgend	133,100	20,700	112,400	15.5
Blaenau Gwent	67,800	10,500	57,300	15.5
Wales	2,975,800	738,400	2,235,000	24.8

The decline in Welsh speakers in Gwynedd and Ynys Môn is attributable to non-Welsh-speaking people moving to North Wales, driving up property prices to

levels that local Welsh speakers cannot afford, according to former Gwynedd county councillor Seimon Glyn of Plaid Cymru. In 2001 Glyn hit the headlines after making controversial comments about English incomers. Plaid leader Ieuan Wyn Jones was savaged on the BBC *Question Time* programme by Labour MEP Glenys Kinnock for not taking action against Glyn. He had said in a radio interview, 'We are faced with a situation now where we are getting tidal waves of migration, inward migration into our rural areas from England, and these people are coming here to live, to establish themselves here, and to influence our communities and our culture with their own ... in my opinion, it is no use to the community to have retired people from England coming down here to live and being a drain on our resources.' Mrs Kinnock is a millionairess who does not live in Gwynedd, and owes her importance to marrying a politician. The report had warned that 'traditional Welsh communities could die out' as a consequence of immigration. Glyn had little backing from Plaid HQ and leadership, and six years later left Plaid on the issue of school closures to join the new political party Llais y Bobl (the People's Voice). Glyn told the Welsh-language magazine *Golwg*, 'I joined Plaid to defend communities. Now I'm having to leave Plaid to do the same thing.' He referred to the report advocating school closures as 'Plaid Cymru's suicide note in Gwynedd', and Llais y Bobl (now named Llais Gwynedd) did well in succeeding elections, and holds the balance of power in Gwynedd.

In 2012 the think tank British Future was set up to debate the nature of British identity and the future of the UK. Tourism minister John Penrose wrote on its website, 'Officially, "God Save The Queen" is the royal and national anthem of the United Kingdom and the royal anthem of all four of the constituent countries. In addition, each country within the United Kingdom may quite properly have national songs, but none is an official national anthem. So playing favourite national songs, at sporting and other events, is a matter solely for the governing body of the sport or public entertainment concerned, or the owners of the premises.' In fact, 'God Save The Queen' has no greater official status than 'Hen Wlad Fy Nhadau'. Neither have the force of law, and both rely on custom and practice to confirm their role as national anthems. 'Hen Wlad Fy Nhadau' was first performed at Maesteg in 1856, and in 1905 became the first national anthem performed at a sporting event, when it was sung by the crowd before a rugby match between Wales and New Zealand, as a response to the Haka. Whatever Penrose believes, Wales has its own anthem, with wonderful words, not a dirge honouring an over-privileged and fortunate group of people. The second verse of the English song reads,

O Lord, our God, arise,
Scatter her enemies,
And make them fall.
Confound their politics,
Frustrate their knavish tricks,
On Thee our hopes we fix,
God save us all.

The non-threatening Welsh national anthem takes pride in the survival of the language, music and poets.

Water

In 1892, the British government passed the Birmingham Corporation Water Act, allowing the council to compulsorily purchase almost 70 square miles of Wales. This was the water catchment area of the Elan and Claerwen Valleys. The Act also gave Birmingham the powers to move more than a hundred Welsh-speaking people living in the Elan Valley. All the buildings were demolished; these included three manor houses, eighteen farms, a school and a church founded by the Knights Hospitallers. Only landowners were given compensation. There are four main dams and reservoirs (constructed 1893–1904 in Elan Valley, and 1946–52 at Claerwen) with a potential total capacity of nearly 100,000 megalitres. The Claerwen dam was the last to be finished in 1952, is almost twice the size of the other dams in the Elan Valley, and was opened by Queen Elizabeth. Claerwen reservoir is leased for 999 years to the Midlands for 5 pence a year.

Lake Efernwy (Vyrnwy) was constructed in the 1880s in Montgomeryshire, with its stone-built dam being the first of its kind in the world. It was built to supply Merseyside and Liverpool with fresh water. It submerged the small village of Llanwddyn, with its population of 450. Two chapels, three inns, ten farmhouses, and thirty-seven houses were all lost under reservoir. Also lost under the water was Eunant Hall, a large house and estate. It was the largest man-made lake in the world. The people were forcibly moved to new houses down the valley to accommodate its construction, and the village now numbers only 300 people. The reservoir is Severn Trent Water's largest, being 11 miles in circumference. In common with all the reservoirs built across Wales, there was no proper archaeological survey of what was being covered. The Alwen Reservoir in Conwy is a 3-mile-long reservoir built to supply Birkenhead, Liverpool, built between 1909 and 1921.

Faded graffiti, 'Cofiwch Drywerin' (Remember Trywerin), can still be seen in parts of Wales. In the Valley of Trywerin, the village of Capel Celyn was drowned to satisfy the water needs of Liverpool. This was despite the fact that water from a valley of a tributary of the Trywerin could have been taken without destroying any homes. A plaque near Trywerin reservoir car park reads,

> Under these waters and near this stone stood Hafod Fadog, a farmstead where in the seventeenth and eighteenth centuries Quakers met for worship. On the hillside above the house was a space encircled by a low stone wall, where larger meetings were held, and beyond the house was a small burial ground. From this valley came many of the early Quakers who emigrated to Pennsylvania, driven from their homes by persecution to seek freedom of worship in the New World.

All the people of the doomed village marched through Liverpool, but the English parliament voted by 175 votes to 79 in 1979 to kill the community. Thirty-five of thirty-six Welsh MPs opposed the bill, with one abstention, but the bill was passed in 1957. Wales has never had a say in the parliamentary affairs of England. 500 members of Plaid Cymru, led by Gwynfor Evans, badly disrupted the reservoir opening ceremony in 1965, but Capel Celyn is rotting beneath the waters. In 1956, a private Bill sponsored by Liverpool City Council had been brought before

parliament. By obtaining authority via an Act of Parliament, Liverpool City Council would not require planning consent from the relevant Welsh local authorities. This, together with the fact that the village was one of the last Welsh-only speaking communities, ensured that the proposals became deeply controversial. The members of the community waged an eight-year effort, ultimately unsuccessful, to prevent the destruction of their homes. This is similar to every local community fighting against the threat of wind follies at present, with little hope.

When the valley was flooded in 1965, the village and its buildings, including the post office, the school, and a chapel with cemetery, were all lost. Twelve houses and farms were submerged, and forty-eight people of the sixty-seven who lived in the valley lost their homes. In all some 800 acres, 2.5 miles by a mile, were submerged. The opening ceremony lasted less than three minutes, for protesters had cut the microphone wires, and the chants of the hundreds of protesters made the speeches inaudible. In October 2005, Liverpool City Council passed a public apology for the incident. Its full statement reads,

> The Council acknowledges its debt to the many thousands of Welsh people who have made their homes in the City. They have, in so many ways, enriched the life of the City. We know that Liverpool, especially in the fields of medicine and education, has been of real service to the people of Wales. We realise the hurt of forty years ago when the Tryweryn Valley was transformed into a reservoir to help meet the water needs of Liverpool. For any insensitivity by our predecessor Council at that time, we apologise and hope that the historic and sound relationship between Liverpool and Wales can be completely restored.

It is difficult to understand the weasel words of Liverpool's reciprocal value 'in the fields of medicine and education' to Wales in the above apology. It would be wonderful to see Llyn Celyn emptied and used as a national memorial of some sort.

The Clywedog reservoir near Llanidloes was completed in 1967 to supply water to Birmingham and the English Midlands. It is the tallest concrete dam in the UK, with a height of 72 metres and a length of 230 metres. Construction of the dam commenced in 1963 after an Act of Parliament. Local opposition was strong against the construction of the reservoir as it would result in the flooding of much of the Clywedog Valley and the drowning of 615 acres of agricultural land. On top of several disruptions and protests, during construction in 1966 a bomb was detonated within the construction site, setting work back by almost two months. The political extremist group Mudiad Amddiffyn Cymru (MAC) was responsible. Their bomb delayed work by eight weeks, and John Jenkins was imprisoned.

Llyn Brenig was completed in 1976 on the borders of Conwy and Denbighshire, particularly for the needs of Liverpool and its surrounding area. The reservoir has a perimeter of 14 miles. Welsh MPs could not stop any of these reservoirs being built via compulsory purchase. Because of continuing shortages in the south-east of England, there are plans to divert water from the Severn and Wye into England. The third-biggest river in England and Wales, after the Welsh Severn and Wye rivers, the Trent, has had no reservoirs built on it.

It is not realised by the vast majority of people living in Wales that they pay far more for their water than the English consumers who use it. This stems from a contract imposed upon the former publicly owned Welsh Water Authority by the Thatcher government in 1984. Just considering the Elan Valley reservoirs alone, Dŵr Cymru (the private company which took over) is required to supply neighbouring Severn Trent Water with 360 million litres of raw water daily from the Elan Valley, at a small fraction of its real worth. The price is calculated according to the 'no profit, no loss' formula abandoned everywhere else when the water industry was privatised in 1989. Thus Dŵr Cymru could only supply at 3 pence per 1,000 litres, instead of the 20 pence it could charge to other bulk-supply customers. Wales has lost over £3 billion in income from such contracts with Severn Trent thus far. The Welsh Water Authority had offered water at 10 per cent below the cheapest water Severn-Trent could obtain from any other source, but Michael Heseltine imposed the punitive settlement to help Birmingham and the Midlands. In 2002 the receipts for supplying Severn Trent with 130 million cubic tons of water were just £4 million. The British government retained control over Welsh water in the Government of Wales Act of 2006. The Secretary of State for Wales, the perma-tanned Peter Hain, of whom more elsewhere, stated that nothing would be permitted to interrupt the supply to England from Wales. One wonders if his constituents in Neath know that their Labour MP favours inequality? The agreement is designed to last until at least 2073. In this year, a 'special trust fund' set up under the contract to partly compensate Welsh consumers for subsidising those in the Midlands could be worth hundreds of million of pounds. It should be in the order of £10 billion plus, by this author's estimates. These 'hundreds of millions' will revert to Severn Trent if the contract is not renewed. In 2007 this proscriptive supply agreement prevented Dŵr Cymru from accepting from another company, Albion Water, the offer of a higher price for providing a supply from the Elan Valley. This is an utterly disgraceful set of affairs. No-one knows any details of this 'trust fund' for the Welsh people. Water is the only resource not yet stripped out of Wales, but we are being charged more for that than the people we supply. With the covering of the landscape to take Welsh wind as a green gimmick, Wales has nothing left to give.

Health

In the *Western Mail*, 12 July 2012, it was reported that

> the status-quo of NHS finances have been branded 'unaffordable' as the organisa-tion faces major short-term challenges in managing its budget, a finance watchdog has warned today … the pressure to keep meeting annual financial targets, as well as developing plans for longer-term reform, will be unprecedented. Additional funding consisted of a £133m funding uplift to all health boards and a £24.4m advance from 2012–13 funding to four health boards to ensure they broke-even.

All Welsh hospitals and health trusts are in financial difficulty. 'The NHS in Wales urgently needs reform, otherwise services will collapse and patients will suffer.' The

three opposition parties united to table a joint-motion and called on Health Minister Griffiths to resign. Welsh Government funding to enable health boards to manage deficits is unsustainable, the Auditor General has stated. The NHS in Wales faces the prospect of finding another £300 million of savings in 2012 to ensure patients continue to receive treatment. It had already found £290 million of savings in 2011–2, on top of the 'unprecedented' £1 billion of savings since 2005. The government policy of giving free prescriptions to all in Wales (but not in England) is clearly unaffordable.

Health in Wales in the worst in the UK, and there is increasing pressure on hospital budgets because of the population profile. As far back as 1998, the legacy of ill-health in Wales was set out in the *Better Health: Better Wales* consultation paper, published in 1998, which described the inequalities in health status within Wales and between Wales and other countries. This was re-emphasised in the Chief Medical Officer's *Health Status Wales Report* (2005), which highlighted that mortality rates in Wales are among the worst in Western Europe. Death rates from heart disease in Wales, and the UK, are substantially higher than in many Western European countries. Wales has among the highest rates of cancer registrations in Western Europe. Consistently poor health persists in the South Wales Valleys; for instance, in 2000–2 death rates in Merthyr Tydfil were almost 50 per cent higher than in Ceredigion. Wales has a much higher percentage of people reporting a long-term limiting illness than in England, with the highest levels in the South Wales Valleys. Mortality rates from cancers are worse in Wales than in England and Northern Ireland, although better than in Scotland. In the 2001 census, the percentage in Wales reporting that their health was not good was 12 per cent, compared to 9 per cent for England, and all Welsh local authorities had illness rates above the English average. The Welsh government spends a massive part of its budget upon free prescriptions, which is a factor in older people settling in Wales, and should be restricted to those unable to pay. More has to be done upon prevention, rather than cure, especially targeted at younger people and smokers.

On 10 July 2012 Dr Tony Jewell, the Chief Medical Officer in Wales, reported that more than half the population of Wales are overweight or obese, and a third have no or very little physical activity. It is estimated that the number of people with type 2 diabetes will increase by 100,000 between 2010 and 2030 in Wales. BBC TV national news on 19 June 2012 announced that one in four British people are obese and the cost to the nation will hit £40 billion by 2050. 'Child obesity in Wales among worst in world' was a *Western Mail* headline on 9 May 2012. Wales is fourth after the USA, Canada and Greece. Welsh politicians are worried about climate change as their number one priority, when the nation's children lead international statistics of social deprivation, poor health and bad education. The nation's leaders speak constantly about 'the issues' and 'lessons being learnt', but appear to be immobile apart from in the tongue department. The World Health Organisation for Europe also pointed out that children smoking, taking drugs and under-age drinking are problem areas in Wales. More than one in five teenagers and a quarter of eleven-year-olds in Wales are either obese or overweight. This cannot be helped by the fact that the Welsh Assembly had an obese Health Minister from 2007–11, Edwina Hart. In 2009, Hart controversially ruled out a review of NHS spending in Wales, declining a Liberal

Democrat request to review how £1 billion has been spent on NHS services, following evidence to the Welsh Assembly's Finance Committee claiming that £1 billion was 'wasted' in the Welsh NHS each year.

According to *The Lancet* in July 2012, the UK is second only to Malta and Serbia for physical laziness. 63.3 per cent of the British people fail to take the recommended amount of exercise, compared to 41 per cent of Americans. Doctors argue that lack of exercise is a significantly larger threat to health than smoking. From 2009/10 to 2012 there was a 60 per cent decrease in the time devoted to sport as a result of funding cuts for the School Sports Partnerships. School playing-fields across Britain have been sold for housing (along with the green fields which were designed around hospitals, even in cities). This author wrote a book on walks in the Vale of Glamorgan. Upon each of the fifty-two walks, I was lucky to see anyone jogging or walking. The only humans were mainly concerned with taking their dogs for their daily ablutions. Welsh health is amongst the poorest in the developed world, yet there seems to be no strategy to address this at any age level. The savings to the NHS would be immense.

Economy

Wales has been drained of natural resources by outside forces: copper, iron, steel, coal, cheap labour, water, wind power, slate, limestone etc. However, even when John Humphries led the Independence Wales Party ten years ago, it was calculated that the money spent on Wales was less than that paid in all forms of taxes. Even the European Union Regional Fund monies destined for Wales were raided, the government using these grants to substitute for money it had earmarked for Wales, instead of using them as 'additional', as intended. No Welsh politician seems to understand or care to rock the boat about this ongoing situation. One direct consequence of this consistent lack of investment is the weakness of the Welsh industrial base, meaning that Wales never benefits during the boom periods. Successive recent Labour governments at local, national, and Assembly level have only succeeded in dragging Wales further down. No politician seems prepared to state that Wales is a basket case among European economies, with some of the worse health, education, and living standards in the Western world. The truth is always unpalatable. Paradoxically, that may be Wales' only hope. The more straitened our circumstances, the more chance the Welsh will fight for survival.

When Wales first received EU funding in 2000, West Wales and the Valleys was the sixth most prosperous Objective 1 region in Europe, with a GDP per capita of £17,300. By 2009, the region had fallen to 42nd out of 50 regions, with GDP dropping to £15,700. The Canary Islands and the Algarve were more prosperous. The region had the worst growth rate of any disadvantaged area in Europe, despite being given funding of £1.2 billion from 2002 to 2006. In March 2012, GDP figures were released showing that two-thirds of Wales was now poorer than Romania. The relative decline of Wales in the twenty-seven EU member states is not just in West Wales and the Valleys, which can attract an element of EU funding (much of which bypasses Wales). Indeed, the sharpest decline in relative spending power has occurred

outside the so-called Convergence Areas, in the most prosperous East Wales region which covers the rest of the country. In 2004, Wales had a GDP per capita of 95.8 per cent of the EU as a whole. By 2009 it had declined to 79.8 per cent. Over the same period, West Wales and the Valleys declined from 80.3 per cent to 68.4 per cent, and East Wales declined from 122.9 per cent to 99.3 per cent, the first time it has been under 100 per cent. Incredibly, East Wales dropped from 108 per cent in 2008 to 99.3 per cent in just one year. The following figures are the latest from Eurostat for the twenty-seven member countries of the EU, with only rounded figures being issued for 2008. The EU average Gross Domestic Product (GDP) per capita is as follows:

GDP % of EU average	Wales	West Wales and Valleys	East Wales
2004	95.8	80.3	122.9
2005	92.2	79.0	115.2
2006	90.4	77.3	113.2
2007	86.9	73.4	110.3
2008	85.0	71.0	108.0
2009	79.8	68.4	99.3

So much for Welsh economic leadership from Cardiff Bay. In thirteen years, devolution has been an unqualified failure in Wales in all economic indicators. Shortly after the Assembly was set up, its aim was to bring Welsh GDP up to 90 per cent of the UK average by 2010. It has fallen from 88 per cent to 73 per cent. Wales has spent its money on free bus passes for its over-age population, free prescriptions for its over-age population and lower tuition fees for higher education with no jobs to go to. There is simply no wish to discuss the real problem of Wales – its economy. In July 2012, the 'lucky dip' for a backbencher to introduce a piece of legislation of his choice was won by Darren Millar, the Tory AM for Clwyd West. How did Millar take advantage of this golden opportunity to improve the lives of three million people? He proposed a 5p tax on bubblegum.

There is a formula used to share out public expenditure between the nations of the UK. The Barnett Formula followed the HM Treasury 'Needs Assessment' of 1979 (using data from 1976–7): The per capita pending ratios relative needs assessment assumed England at a base of 100, followed by Northern Ireland at 131, Scotland at 116 and Wales at 109. Thus each person in Wales should receive 9 per cent more than England, but considerably less that Ireland or Scotland. However, the actual spending levels in 1976–7 were England 100, Northern Ireland 135, Scotland 122 and Wales 106. Wales was relatively disadvantaged by the Barnett formula from the outset inasmuch as the baseline spending advantage was lower than the needs assessment implied it ought to be. By 2007/08, identifiable public spending was, using the UK as a base of 100: England 97 (or £4,523 per person); Northern Ireland 121 (£5,684), Scotland 121 (£5,676) and Wales 108 (£5,050). At one stage, Northern Ireland was being given 38 per cent more than the UK average. Even before these figures, less was spent upon

Wales than Northern Ireland or Scotland, but for at least the last forty years, statistics prove the relatively lower money given per capita to Wales. Why can politicians not point out that economic and social conditions have changed dramatically in Wales since the last Treasury needs assessment in 1979? On the majority of socio-economic indicators of need, the disparity between Wales and England has grown.

GDP per capita in Wales has fallen from 88 per cent to around 73 per cent cent of the UK average. There is also a major case for higher public spending in Wales, in relation to both the level of demand for public services and the costs of service provision. Relative to the UK average, a far higher proportion of the Welsh population are of pensionable age, reflecting the attractiveness of Wales as a place for retirement for English people. At my local doctor's waiting room in rural Carmarthenshire, sometimes 100 per cent of the patients are English. This places greater pressure on the cost of health care. According to McLean and MacMillan, as far back as 2003, 'Wales has already been a victim, not a beneficiary, of Barnett', because although its prosperity has fallen whereas Scotland's has risen, Wales has enjoyed relatively less beneficial public expenditure outcomes than Scotland. The authors argue that this reflects the fact that Wales is a less credible threat to the union of nations than Scotland. Strict application of the formula has reduced the level of public spending per head in Wales relative to England. One estimate is that from 1999 to 2004 alone the strict application of the formula (the 'Barnett squeeze') has cost Wales approximately £1 billion (ap Gwilym, 2006). Over the years, Scotland and Northern Ireland, richer countries than Wales, have received billions more than Wales, which partially explains its poor economy.

The non-productive public sector is unfortunately the major employer in Wales. In the year ending 30 June 2008, 386,000 people (28.8 per cent of the Welsh workforce) were employed in the public sector. The highest number (49,000) were in Cardiff and the highest percentage of the local workforce (35.4 per cent) in Swansea. Cutbacks in the unaffordable public sector will mean more unemployment in Wales. The Treasury points out that those working in the public sector earn around 18 per cent more than their counterparts in the private sector, plus have excellent inflation-linked pension schemes. A separate pay analysis states that the differential is 14.2 per cent, with the pay gap being 10.8 per cent for men and 17.2 per cent for women. Cutbacks in the public sector therefore affect Wales disproportionately. Proposals that regional civil servants be paid far less than those in London will also hurt the Welsh economy. There is no economic or employment policy, as no-one in the Welsh Assembly has ever had a proper job. Their advisers fall into the same category. They can create non-jobs in the public sector, like a Climate Commissioner for Wales, with zero benefits and only costs, but have no idea whatsoever of private business, especially manufacturing. The only indigenous wealth creator, tourism, is being killed by wind farms across this tiny land. Having directly taken over the Welsh Development Agency, WAG is fairly quiet over the fact that now only 1.3 per cent of inward investment in the United Kingdom comes to Wales, down from 9.4 per cent a decade ago. The most terrible statistic is that 23.7 per cent of the 16–24 age group are unemployed. WAG was also touting the great opportunities of the Olympics coming to Britain for Welsh firms. Its impact has been marginal at most, with 95 per cent of people in a *Western Mail* poll believing that it will have no impact on Wales. The

magnificent Millennium Stadium in Cardiff held a few games of women's football in the bloated and excessive London games.

WAG has a special 'Minister for Aerospace', mainly responsible for overseeing the mainly English facility at Brychdyn (Broughton) outside Chester. In early April 2012, the WAG, British government, press, etc. touted the wonderful news that Broughton was to produce another eleven pairs of wings for the new Airbus. From the massive media coverage, one would have thought that Elvis had been found working in a chip shop in Aberbeeg. The order only represented another six weeks on the order book, not 'an opportunity for hundreds of new jobs'. The news coincided with a visit by David Cameron to the purchasing country, Indonesia. Broughton is a virtual suburb of Chester, and the vast majority of its workers are not Welsh, nor live in Wales. How this Flintshire assembly plant is touted as a 'Welsh success' is beyond this economist.

In February 2012, the last RAF aircraft left St Athan (actually St Tathan – there has never been a saint called Athan). It had been used for seventy-five years as a maintenance base. The Welsh government and Ministry of Defence spent over £200 million in the last decade or so trying to make it an 'aerospace park'. One of the bright ideas was to build the £100 million Red Dragon hangar, with not one customer or forward order. Other state-of-the-art maintenance hangars on the site are also now disused. The nearby BAE engineering hangar at Rhoose Airport was not being used to capacity when the hangar was built, so where were the customers going to come from? Rhoose (Cardiff Wales) airport has a dismal track record in creating business, with Welsh people having to travel to Bristol and elsewhere for holiday and business flights. Around ten years ago, WAG hired consultants for a feasibility study into a new access road for the airport, despite the fact that access is far easier than it is to Bristol Airport, which requires wending through its suburbs. The report concluded that Cardiff would need a dual carriageway to handle up to an expected ten million passengers a year, making Cardiff the fourth largest airport in the British Isles. Cardiff passenger figures, ten years after this report, which was accepted, are only 1.208 million compared to 1.544 million in 2001, a drop of 28 per cent over the last decade. It is the twenty-first most used airport in the UK, with hardly any business travellers. Bristol, where most Welsh people fly from preference, is the ninth-busiest airport, with 5.758 million passengers, almost five times as many as Cardiff.

Despite some EU funding, Welsh GDP per capita was 79 per cent of the European average in 2005, but had dropped to 68.4 per cent in 2009, making Wales one of the poorest parts of Europe, and easily the poorest part of the United Kingdom. The average for Northern Ireland is 83 per cent and Scotland is 107.5 per cent, and the overall figure for the UK is 110.7 per cent. In 2000, when Wales first received European funding, West Wales and the Valleys was the sixth most prosperous Objective 1 region in Europe, with a GDP per capita of £17,300. However, by 2009, the region had fallen to forty-second out of fifty regions with a GDP per capita of 15,700. In 2012 a study found that 40 per cent of Welsh claimants for incapacity benefits were fit for work, with the following local authorities having 45 per cent or over – Caerffili, Vale of Glamorgan, Wrexham, Monmouthshire and Cardiff. Almost 30 per cent of those fit to work have been receiving sickness benefits for over ten years. This dependency culture will kill Wales. In terms of economic 'Value Added', Wales is gradually sinking against the rest of the UK.

Gross Wales Value Added (GVA)		
Year £ million £ per head		Index of £ per head (UK=100)
1989 19,445 6,810		85
1990 20,990 7,335		84
1991 21,724 7,561		83
1992 22,659 7,874		83
1993 23,697 8,218		83
1994 25,049 8,675		83
1995 26,388 9,135		84
1996 27,518 9,517		82
1997 28,672 9,904		80
1998 29,787 10,273		79
1999 30,736 10,596		77
2000 31,898 10,973		77
2001 33,525 11,520		77
2002 35,252 12,074		77
2003 37,262 12,712		76
2004 39,340 13,352		76
2005 40,711 13,784		76
2006 42,697 14,396		75
2007 44,263 14,853		74
2008 45,610 15,237		74

Not many people appear to realise that England is by far the most overcrowded country in Europe, not helped by Labour's 'open doors' policy to cheap labour and immigration, and EU nationals given freedom of movement to work here. The population density of London, the east of England and the south of England grew by 11.6 per cent, 10.5 per cent and 9 per cent between 1997 and 2010. There has been a knock-on effect in Wales of a 3.4 per cent increase in density to 145 people per square kilometre. England's density is three times as much, 401, while Scotland's is only 67. Immigration accounts for two-thirds of projected population increases, and 200 homes a day must be built for twenty years to cope with immigration. It is estimated that the 2011 census of population has missed as many as 2 million people living in the UK, which is almost two-thirds of the population of Wales.

In 2011, £56.9 million of taxpayers' money was given to the Welsh government as a grant for investing in faster broadband across Wales by 2015. Like all successful economies in the twenty-first century, the local, regional and national economies of Wales will depend on fast access to digital broadband, rather than antiquated telephone cabling. Despite the First Minister Carwyn Jones's determination to carpet Wales with wind turbines and their associated infrastructure, the future of Wales will still be based on tourism, which in turn will be based on what will be left of our unspoilt countryside once the he has finished with it. Jones says he wishes to wait for 'the next-generation broadband', whatever that is. He has promised 'all

premises across Wales [to] have access to high-speed broadband by 2015'. As of late 2012, no-one knows whether Jones is considering digital broadband, which is cheaper than landlines, with no disruption to environment and a more consistent signal. He has stated that getting things moving in this sector 'is not quite as simple as that, because you must ensure that a process is followed in relation to the contract'. Why is it not simple? Motorola covered all of Macedonia, mountain to mountain, in three months, and the topography of Wales is very similar, but with smaller mountains. This author had to wait three months for broadband to be reconnected, and for no apparent reason it goes offline every day at around 11 a.m.

On 12 July 2012 it was reported that John Griffiths, Energy Minister said,

> Our recently launched policy 'Energy Wales – A Low Carbon Transition' outlines that energy is a defining issue of our generation and one on which the Welsh Government is determined to lead. Wales has strong assets in virtually every energy source, and specifically wind and marine. We now the have the chance to harness those assets in ways that work with and grow our businesses and our industries, create long term employment, develop our resources rather than simply extract them and ensure the long term viability of our communities ... There is real potential for the marine energy sector to deliver long term, secure, well paid and skilled jobs. This is a huge opportunity for Wales to forge a better future and once again lead an energy revolution.

If the Energy Minister believes that such energy sources create jobs, he should examine research carried out in Spain, the USA and other countries stating that for every job gained, three are lost. Trying to position Wales as a world-leading, low-carbon economy is breathtakingly wasteful of resources. The country is dying. Griffiths is a former solicitor with no scientific or business knowledge.

Plaid Cymru has announced an economic commission in 2012, charged with developing proposals to close the gap in average incomes between Wales and the UK, and the rest of the EU, within a generation. Its discussion paper, *Offa's Gap: Roots and Remedies of the Welsh Growth Collapse* is fine upon causes, and what should be done, but has no answers as to how to achieve growth. Across the EU there has been a tendency towards economic convergence, with the poorest regions in general growing much faster and the richer regions growing more slowly. *Offa's Gap* tells us,

> The Scottish economy's growth rate of 3.1 per cent over this period is almost exactly as predicted by its level of income given the simple convergence equation ... Wales is in the least favourable quadrant of poorer than average regions that are getting even poorer in relative terms. Indeed, Wales' position over this time period as having the worst economic growth of any poorer than average region means it can be legitimately described as the worst performing economic region in the whole EU ... Wales' current trend rate of growth in real GDP per capita of between 1.2 and 1.5 per cent is well below the roughly 2.0 per cent long-run growth rate of the UK and most high-income countries ... what we can say is that the Welsh economy, which now occupies a position towards the lower end among the advanced economies, will likely be overtaken by Russia, Mexico, Turkey and Argentina before mid-century on current trends and cease to be classed as a high-income country, when considered independently, within about twenty years.

Figures suggest an average annual reduction in gross value added in manufacturing of some 18.5 per cent, and a dramatic reversal of Wales' relative position, from approximately 40 per cent above the UK average to 20 per cent below in just five years ... There is strong evidence suggesting the Welsh economy suffered a major economic shock in the latter half of the 90s, the effects of which were to be long-lasting. The roots of this shock lie to some extent in the policy of non-intervention in the currency market that led to what some commentators regarded as an over-valuation in the pound ... The pound appreciated by around 25 per cent for a period of 11 years between 1996 and the onset of the financial crisis. This period of over-valuation – fuelled by the strong performance of the City of London in the export of financial services and in the attraction of inflows of capital and invisible earnings – led to a deteriorating trade balance in goods, and a haemorrhaging of jobs in the manufacturing sector. It was Wales' particular misfortune that this period of over-valuation proved even more painful than a similar period of over-valuation in the early 1980s as it coincided with the entry into first the European Economic Area and then the EU of low-wage but relatively high-skilled former Communist countries in Central and Eastern Europe.

The composition of Welsh goods exports is heavily dependent on petroleum, iron, steel and large-scale turbine equipment. Wales needs a more mixed economy.

Politics

On 2 July 2012 it was reported that the Labour Cabinet in the Welsh Assembly had given each of its nine Cabinet members a ring-binder, worth around £3 if embossed with their names, and probably around a pound if not embossed. When the First Minister, Carwyn Jones, was queried about this by Andrew Davies, a Conservative, he laughed and told him that if Davies ever got into power, he could have his ring-binder. The nine unremarkable ring binders cost £648, no less than £72 each. The First Minister earns £80,000 a year, and AMs earn £54,000 (plus expenses). When in business, I bought my own ring binders, and when in academia I had the same cheap binders as all other members of staff. This seems symptomatic of the cavalier approach to public money of those in government. Other examples of waste are easy to find. Meanwhile, schools are crumbling, high streets decaying, tourist numbers falling, companies closing, hospitals nearing bankruptcy and Wales is in deep financial difficulties.

In the 2012 local government elections, Merthyr, Neath, Newport, Rhondda, Swansea, Torfaen, Cardiff, Bridgend, Blaenau Gwent and Caerffili voted Labour. Powys and Pembrokeshire voted Independent. There was no overall control in Ceredigion, Denbighshire, Gwynedd, Monmouthshire, Vale of Glamorgan, Wrecsam, Flintshire, Conwy and Carmarthenshire. Because of council incompetence, the Anglesey election was postponed until 2013. Plaid Cymru had little impetus despite a new, young leader in Leanne Wood, who was supposed to help turn the Valleys Plaid – it even lost control of its Gwynedd heartland and failed to take Ceredigion. Council seats in Wales were as follows: Labour 576 (47 per cent); Independent 291 (24 per cent); Plaid Cymru 157 (13 per cent); Conservative 105 (9 per cent); LibDem 74 (6 per cent); Llais (all Gwynedd) 13; UKIP 2. Wales is still staying true to its Labour

roots, despite the utter inability or unwillingness of the Blair and Brown regimes to help Wales out of its sinking economy.

Leanne Wood, the new leader of Plaid Cymru, is forty years old and does not speak Welsh, but 'is learning'. She was born in Llwynypia in the Rhondda, and grew up in Penygraig less than 2 miles away. She went to school in Tonypandy, a mile from Penygraig, then attended Glamorgan Polytechnic, 6 miles from Penygraig. She then worked in the local probation service and as a womens' aid support worker until 2000, and lectured in social work from 2000 to 2003 in Cardiff, 18 miles from Penygraig. She still lives in Penygraig, where else? Known as a republican and a socialist, she was a Rhondda Cynon Taf councillor and has been an AM since 2003, when she was thirty-one. According to the BBC, Wood's particular areas of interest are poverty; women's issues; social services; criminal justice; social exclusion; mental health; anti-privatisation; and anti-war. Her Plaid Cymru profile includes her commitment to working 'for Wales to become a self-governing de-centralist socialist republic'. In June 2012 she proclaimed that 'Wales will be independent within a generation and part of a British "neighbourhood of nations"'.

At *walesonline* for 17 March 2012, we read, 'for Ms Wood in 2005, when Labour unearthed a two-year-old document in which she appeared to argue helping constituents was a waste of time because it did not translate into enough votes for Plaid Cymru … She has slept on the streets of Cardiff to raise awareness and on the vexed issue of immigration, turned it on its head by saying Britain does not take in enough refugees.' On 24 April 2012, the *The Guardian* reported, 'Her leadership victory sent a ripple of both excitement and apprehension through her party's collective psyche.' Wood was interviewed by the website *Red Pepper* in 2012:

> Her party faces a steep climb, to say the least – support for Welsh independence has long held steady at around 10 per cent, and after four years of sharing power in Cardiff with Labour, Plaid finished third in the last Welsh assembly elections, behind the Conservatives. But Wood insists that the SNP's success in Scotland proves that politics is now in flux as never before. She didn't manage to repeat the success in the local elections. Plaid lost councillors instead of gaining them, including in Caerphilly, the one Welsh authority where they'd been in control. Labour tapped into concerns about public sector job losses and Plaid's vote suffered as a result. The party isn't going to be turning on its new star just yet though: Wood was only elected six weeks ago and Plaid has barely begun its process of renewal … Camu 'Mlaen (Moving Forward) was an internal review carried out after the 2011 Welsh Assembly elections.
>
> Plaid had just lost seats they won from Labour in 2007 and dropped from being the second to the third party in the assembly (after Labour and the Conservatives). The election results were particularly poor as Plaid had been in coalition with Labour during the previous term. Camu' Mlaen argued that Plaid had not succeeded in distinguishing itself from the Welsh Labour party, and called on the party to define and articulate a vision of decentralised community socialism to contrast with Labour's centralist approach. [What that means in real language is unknown to this reader.] In many ways Leanne Wood's election fulfils the recommendations of this review: there can be no doubt that she offers a vision of decentralised socialism. Her Twitter feed sums up her position: 'Plaid Cymru. Welsh Socialist and Republican. Environmentalist. Anti-racist. Feminist. Valleys.'

In her 'Green Energy' paper, Wood claims that 'the power of our tidal currents, wind, waves and the sun which could be harnessed has led to Wales being dubbed "the Saudi Arabia of renewable energy".'

This author has worked in Saudi Arabia and Iran, and wonders where Wood obtained this laughable idea. I repeat – no-one knows Wales except some of England's former colonies. The affiliations listed on her Assembly website are 'Member of UNISON; Associate Member of the National Association of Probation Officers; Palestine Solidarity Campaign; Amnesty International; Cymdeithas yr Iaith Gymraeg; CAMRA; Abortion Rights; Republic; Cymru Cuba and Bevan Foundation.' This author has worked at high levels across the world in the public and private sectors, having academic and professional qualifications, and has also been a consultant and started businesses. How someone like Ms Wood, who knows little about anything except the probation service, womens' rights, talking shops and committees, can lead Wales to an economically sound future is very difficult to imagine. To be brutally honest, the last person Wales needs as a leader is a young, strident feminist former social worker who only knows her '*bro*' and whose priorities do not include education, health, the inequitable Barnett formula or real jobs. If she could or would pronounce her 'aitches', it might help with her presentation skills. On 19 July 2012, Wood announced at the launch of Plaid's economic commission, 'I want the battle for world-leading Welsh prosperity to become synonymous with the battle for language survival in the past.' World-leading Welsh prosperity? Wales can never approach England's levels, let alone richer countries. If the Welsh economy could grow at 0.5 per cent more than England's for the next fifty years, it would just catch up with its neighbour. (The Gross Value Added per capita now is 73 per cent of the UK average, twelfth of the twelve UK standard regions.)

The Welsh Assembly Government is known as 'The Parish Council on the Bay' by those kindly disposed to it. Others call it a waste of money and far worse. It is seen by many as another layer of ineptitude staffed by people that would be unemployable in the private sector. Anecdotally, from people doing business with it, there is very little productive work undertaken by its hundreds of well-paid civil servants. Because the Welsh Assembly Government has been Labour-controlled, even during its power-sharing years with Plaid Cymru, it has always followed Westminster Labour policies. Its first leader, Alun Michael, was a committed Blairite with no known leadership skills or ideas for Wales to progress. His successor, Rhodri Morgan, was one of the *crachach*, that upper stratum of South Wales society also known as the Taffia, and it is difficult to think of anything beneficial for Wales during his leadership. The latest leader of the WAG is Carwyn Jones, the man who secretly signed off Technical Advice Note 8, the infamous TAN8, allowing wind follies to be built all over Welsh Forestry Commission land. The Forestry Commission, supposedly belonging to the Welsh people, is the largest estate in Wales. Jones's cavalier attitude towards wind energy led other owners of great Welsh land areas, like the Duke of Beaufort, to apply for and receive approval for hundreds more turbines.

It appears that around half of the sixty Assembly members in Wales are not Welsh by birth or parentage, which reflects the population of Wales. It also seems from their abbreviated histories on the Assembly website that no-one has any record of success or managerial experience in private industry. It is worth noting here that

private industry is very reluctant to employ workers who have been employed by the public sector. It is also worth noting that some AMs have little experience of any type of work whatsoever except as local councillors. Some AMs have been touched by scandal – Phil Williams of Plaid Cymru died in bed with a prostitute. Some readers may say that this is traducing the dead, but for a launch of my *100 Great Welsh Women* in Cardiff's Oriel (now sadly disappeared), I had the Welsh crwth-and-singer duo Bragod, a reading by the wonderful poet Ruth Bidgood, and Dafydd Wigley put in a brief attendance. The proceedings were interrupted by Phil Williams repeatedly knocking upon the window to attract Wigley's attention. He could have walked in through the open door but clearly was in an agitated state, wishing to go for a drink with Wigley. Williams was responsible along with Cynog Dafis for Plaid's absurd green energy policies.

The Lib Dem AM Mick Bates became drunk on a night out in Cardiff, fell down some stairs, and then assaulted the paramedics summoned to help him. In 2006, Plaid's shadow Health Minister Rhodri Glyn Thomas, AM for Carmarthen East and Dinefwr, made a speech focusing on the damage caused to non-smokers by smoking in public places. He said, 'The main argument driving forward the smoking in public places ban is not ill health caused to smokers. It is the ill health caused to other non-smoking people through passive smoking.' In 2008 he was asked to leave the Eli Jenkins pub in Cardiff Bay for puffing a large cigar, in contravention of Wales' ban on smoking in public places. The Conservative AM for Monmouth, Nick Ramsay, was so drunk one night in July 2012 that he forgot he was chairing a committee. He had also been banned from a pub in 2011. Also, in 2012 the seventy-one-year-old married Labour AM for Llanelli, Keith Davies was involved in an unsavoury incident with a woman in a taxpayer-funded hotel room in Cardiff Bay. He had been attending a 'freebie', the fortieth birthday party of wind farm lobbyist Daran Hill. Because of a system of proportional representation, some people become AMs who would never be voted for by the electorate. Devolution promised Wales an Assembly to serve Wales, an Assembly of which we could be proud. What we have is now a national embarrassment, filled with time-serving politicians who refuse to govern in the interests of the Welsh people.

In late March 2012, the *Daily Mail* noted the 'popularity' of Welsh politicians. Peter Hain, a South African, was Secretary of State for Wales from 2002 to 2010 and is then shadow Welsh Secretary. The £20 memoir of this Labour MP for Neath for the last two decades, *Outside In*, has sold 500 copies since its publication in mid-January, presumably to libraries. This was despite serialisation in *The Sunday Times* and a favourable review and interview in the *The Guardian*. Such is our affection for our political leaders. The Welsh blogger Dic Mortimer pointed out some widespread disenchantment with the current Welsh leader, the man mainly responsible for the spread of wind turbines:

> It has taken just 13 years along the devolution journey for Wales to produce its first home-grown dangerous tyrant: Carwyn Jones. Last month the poster-boy of knee-jerk British Nationalism said that, when Scotland evicts them from the Firth of Clyde, 'there will be more than a welcome for the UK's nuclear submarine fleet in Milford Haven'. This is the most shocking statement made by any Welsh politician in recorded history

and if Labour Party members in Wales are not right now plotting to topple this wicked bastard then they can have no principles whatsoever left. Wales the home of the world's fourth most fearsome nuclear arsenal? Wales the lair where the British state runs its obscene £97 billion Trident missile programme in violation of the Geneva Conventions, the Hague Conventions, the UN charter and the Universal Declaration of Human Rights?

Wales the depository of 200 nuclear warheads each one of which equivalent to 50 Hiroshimas? Wales the ground-zero of nuclear proliferation? Wales the HQ of war-mongering terror? Wales???!!!??? Wales that has never been an aggressor in all its history, that has never threatened any other peoples, that has been in the forefront of the peace movement, the co-operative movement, the internationalist movement and the socialist movement? Wales where the Greenham Common women started their march, where non-nuclear status was declared over 30 years ago by every Welsh council, where the nuclear rains of Chernobyl poisoned our uplands for generations? Wales???!!!??? And this at Milford Haven of all places! Oil + gas + nukes ... you could not devise a better recipe for Armageddon. Without reference either to standing Labour policy or to Labour's proud history of opposition to nuclear weapons from Aldermaston to CND, and without consulting anybody else in Wales, our First Minister is offering us up as every terrorist's number 1 target, as every rogue state's bullseye, as America's arsehole and as Britain's bitch. Resign Jones. You are not fit to hold office. Perhaps David Cameron will give you a job as his shoe-shine boy (chamois leather not provided). Resign you contemptible, pig-ignorant merchant of death. You are a disgrace to Wales.

Would that more Welsh people had the passion of Dic Mortimer.

Independence and Immigration

The known flow of workers and others from the EU into the UK stems from treaty obligations, and cannot be cut back by immigration policy. The British housing and benefits system is far more open than in France, for example, leading to a greater pressure into Britain. However, for ten years, non-EU known immigration has been running at 300,000 a year but only 100,000 have been leaving. This net immigration accounts for two-thirds of population growth, placing pressure upon public services. The known population of Wales in the ten years to 2011 has grown by 153,000 to 3.06 million, up 5 per cent on the 2001 count when it was 2.91 million. The real population will be somewhat higher, a problem that can only be solved by issuing identity cards. This is the largest growth over 10 years since 1921. Around 90 per cent of growth was due to people moving to Wales, putting pressure upon services and requiring yet more new housing.

Pensions and social security benefits rose 8 per cent as a share of total household income over the period 1984–2009. This shift from primary (earned) to secondary (unearned) income has masked the effect of the deterioration in output growth. However, with both the pension system and the welfare state facing a tighter financial environment, Wales will suffer disproportionately, falling further behind in incomes. With 90 per cent of Welsh population growth coming from outside Wales, it seems

obvious that there are severe implications for pensions and social payments replacing earned incomes in the nation. We see almost 13,900 outsiders moving into Wales every year, while the relative Welsh population is growing by only 1,530 per annum. The true Welsh population is already heading towards a minority in its own land, and this untrammelled growth, fuelled by governmental policies, will eventually mean that Wales will no longer exist as a nation – it will become an English appendage. Some website critics, as politicians cannot express the thought, say that Wales has become England's dumping ground for the ill, immigrants, problem families, ex-convicts, drug addicts and pensioners. Whatever the truth, unless the problem of non-earners moving to Wales is addressed, the nation has no economic future.

Of the local authorities in Wales, Cardiff had both the highest population, at 346,000 people, and the largest growth in population with an increase of 36,000, 11.6 per cent, from 2001. It was also the most densely populated, with 2,500 people per square kilometre, the equivalent of around 25 people on a rugby pitch. Wales also has a higher proportion of sixty-five-year-olds than nearly all the regions of England. When Wales narrowly won a measure of devolution, the number voting against more or less matched the number of English-born immigrants living in Wales. 'White flight' of those choosing to settle in Wales to escape the growing ethnic diversity of their English homelands has been a problem for decades, and one reason for the Cottage Arson Campaign.

England is the most crowded country in Europe, with massive non-EU immigration, leading London to being a place where 300 languages are spoken. When this author lived in Leicester for twelve years, twelve British families moved from the road and twelve Asian families moved in. There are now English enclaves across Wales. Coupled with the dependency culture, this makes any progress towards independence probably impossible. Research reported in the *Daily Mail*, 3 March 2012, revealed that the number of Muslims in Britain rose by an enormous 36.7 per cent in just six years. From 2004 to 2010 it rose from 1.9 million to 2.6 million. In the same period the number of Hindus rose by 43 per cent from 550,000 to 790,000. These figures may be higher in reality. The point is that the native Welsh population is under under 2 million (discounting non-Welsh people living in Wales). There are almost twice as many Muslims and Hindus in Britain as Welsh people, without counting 340,000 Sikhs, 270,000 Buddhists, Eastern Europeans and the like. The number of Muslims and Hindus in Britain rose by around half the population of Wales in just six years. The Welsh are becoming a smaller and smaller percentage of the people living in Britain, with Welsh culture and traditions becoming less and less important as it neighbours probably the most multicultural country in the world. Plaid Cymru's dream of independence is impossible, with some of its elder statesmen such as Cynog Dafis and Dafydd Elis-Thomas advocating a closer relationship with the Labour Party in order to get some semblance of power.

A 2009 analysis of the geography of Welsh surnames found that 718,000 people, or nearly 35 per cent of the Welsh population, have a family name of Welsh origin, compared with 5.3 per cent in the rest of the United Kingdom, 4.7 per cent in New Zealand, 4.1 per cent in Australia, and 3.8 per cent in the United States, with an estimated 16.3 million people in the countries studied having Welsh ancestry. This author's father's father came to Wales from Kent as a collier before the First

World War, and when the industry collapsed worked as a quarryman, and then as a banksman upon road-building schemes to mop up unemployment in the 1930s. He married a Welsh woman whose family had lived in the Old Village, Cadoxton, Barry, before the docks came. However, she was a Hiatt, whose family with an Anglo-Saxon surname had served the Stradlings in St Donat's Castle for centuries. My mother's parents were an Evans from Trefeglwys, and a Watkins from Llanwnog, also in Montgomeryshire. Of my grandparents, only my mother's mother was fluent in Welsh. My parents met in Birmingham because they were sent to work there during the war, and I was thus born there, coming to Wales aged five. My profile is similar to many 'Welsh' people – very, very few, probably well under 10 per cent, have eight Welsh great-grandparents. I consider myself pure Welsh, but from an ethnic view I am not. The point is that this book, which will be criticised for being pro-Welsh, is in fact written by a person who is not pure Welsh, and has mainly been reliant upon English and American companies for work. Intriguingly, many English friends living in Wales say that they are here because they prefer it, and they 'don't want Wales to get like England'.

The *Western Mail* reported upon 12 July 2012 that in Carwyn Jones's Westminster speech, 'organised by the Unlock Democracy campaigning group, he will say: "Devolution is now the settled will of the Welsh people. In common with the vast majority of the people of Wales, I have no interest in independence for Wales." … The Bridgend AM is also concerned that in debates about the country's future the "English voice has yet properly to be heard".' To be brutally honest, everything that has happened to Wales has been organised by English interests. The Welsh Labour Party has to begin thinking about Welsh, not English interests. However, Wales is inextricably linked to England – it seems to be impossible to break this link, owing to inward immigration over the decades. In a February 2012 BBC poll, only 7 per cent of the Welsh population wanted independence. With around half of the population either non-Welsh-born or of non-Welsh parents, this still translates to only around 14 per cent of 'real' Welsh people wanting independence. Plaid has alienated its rural support with its unswerving advocacy of wind follies to appease its green supporters. It seems to be trying to reinvent itself as a party of the alienated masses in the Valleys, but this appears to be a dead-end strategy.

Much Welsh rural property, especially in the 'better' areas, is in the form of second homes for use as holiday homes for non-Welsh people. Many buyers are drawn to Wales from England because of relatively inexpensive house prices. In the coastal village of Newport, Pembrokeshire, house prices rose 25 per cent in the last three months of 1999, driven by buyers from the south-east of England. Local councillor Glyn Rees said that the local population trebles every summer. The rise in home prices outpaced the average earned income in Wales, and meant that many local people could not afford to purchase their first home or compete with second-home buyers. In 2001 nearly a third of all properties sold in Gwynedd were bought by buyers from out of the county, and some communities reported as many as a third of local homes used as holiday homes. Holiday home owners spend less than six months of the year in the local community.

Most new residents do not learn the Welsh language, prompting Seimon Glyn to say, 'Once you have more than 50 per cent of anybody living in a community that

speaks a foreign language, then you lose your indigenous tongue almost immediately.' While Plaid Cymru advocated housing policies to protect the language, Labour, Lib Dem and Tory AMs refuse to do anything, unlike their Scottish counterparts.

In September 2001, the vice-president of Plaid Cymru, Gwilym ab Ioan, was forced to resign when he said that Wales had become a 'dumping ground for oddballs and misfits'. Following the meeting the Plaid Cymru MP for Ceredigion, Simon Thomas, said Mr ab Ioan's comments were unacceptable and distracted the party from its fight to save Welsh-speaking communities. 'The party agrees with him that Welsh-speaking communities are under threat, but it cannot condone the tone of the language he used,' Mr Thomas said. Gwilym ab Ioan stated, 'If it means that Plaid and other parties wake up to the real concerns that people have in this part of the world then the sacrifice is well worth it.' In August Mr ab Ioan was reported, together with former Welsh Language Board chairman John Elfed Jones, to the Commission for Racial Equality (CRE). They were referred to the body after remarks which compared migration into Wales with the foot-and-mouth epidemic. The in-migration row was ignited by earlier comments from Gwynedd Councillor Seimon Glyn, who said English people were 'a drain on resources'. The problem, and it is a massive one, will not be accepted as a problem by politicians higher up the food chain, afraid of compromising their well-paid jobs and pensions.

There are 55,000 incomers a year in Wales, which equates to over half a million every decade escaping the population pressures of England. In February 2012, the Welsh Language Board reported 3,000 fewer Welsh-speakers each year. While some incomers work in Wales, the vast majority are retirees and/or part of the benefits culture. There is an ongoing policy of re-housing English problem families and criminals in Wales. Re-housing led to 'a Cardiff man' according to BBC TV news in 2012, being arrested for killing his neighbour in Rhymney, Cardiff. He was an Englishman, re-housed to Cardiff upon parole after serving twenty-one years for strangling a Sunday school teacher. Also in 2012, 'a Llanllwni man' was arrested for raping and murdering his neighbour. His parents had been re-housed from Scotland and he was staying with them after himself being re-housed nearby several times. A 'Barry man' killed his wife, the sister of the rugby player Terry Holmes, and their family, but he was Scottish. If we make a cursory examination of serious crimes in Wales, there is a pattern which it is not politically correct to speak about.

In the 1960s there began a fresh influx of incomers into Wales. In March 1977, the largest police drugs bust in history cracked a drugs ring based near Tregaron in rural Mid Wales. Lyn Ebenezer from Pontrhydfendigaid became involved with the operation through his work as a journalist. In February 2007 he recounted the effect of the operation on locals living in the Tregaron and Llanddewi Brefi area:

> The logistics speak for themselves: Six million tabs of LSD were recovered by the police, the largest haul of drugs ever known. A squad of 800 detectives were involved. Some 120 people were arrested throughout the UK and France. Stashes of LSD worth £100 million were unearthed. Over £800,000 in money was discovered hidden in Swiss bank accounts. And 17 defendants were jailed for a total of 170 years … it wasn't the size of the operation and the extensiveness of the drugs ring (in fact there were two rings existing side by side) that shocked the rural population of Mid Wales but rather the fact that enough LSD to

meet the needs of half the world had been manufactured and marketed in the sleepy hinterlands of Tregaron and Carno. The early 1970s saw an influx of flotsam and jetsam from the cities to rural Wales … Cannabis taking became a fact of life, firstly among incomers. But it gradually spread and even became an accepted part of rural life. But LSD was another matter. Rumour has it that Princess Margaret was involved with one of the main suspects and that the police hierarchy delayed the swoop until she was well out of the way. [Two of the major suspects escaped and were never arrested.] Disgusted with such tactics, it is rumoured that there were secret calls made to some of the suspects warning them to make themselves scarce. After a suspect – the dealer – was arrested at Llanddewi Brefi, nothing incriminating was found at his home, even though it was known locally that he kept wads of notes in a Corn Flakes packet.

As a result of the seizure it was estimated the price of LSD tabs rose from £1 to £5 each, and that Operation Julie had removed 90 per cent of LSD from the British market. It is thought that LSD produced by the two labs had been exported to over 100 countries. In total, 1.1 million tabs and enough LSD crystal to make a further 6.5 million were discovered and destroyed. The total street value of the LSD would have been £7.6 million. The ringleaders and the vast majority of those arrested were not Welsh.

On the *Jac 'o the North* website in 2012 we read,

On a number of occasions I have drawn attention to the practices of various agencies of bringing into Wales criminals, indigents, problem families and other undesirables. Also, the refusal of the Labour Party Government to do anything about this problem. The time has now come to do more than relay horror stories and rail against the cowardice, or worse, of our politicians. So I am planning to build up a dossier of incidents where the dumping here of people with no connection with Wales has resulted in social disruption or worse. A classic example of what I mean would be the paedophile gang from London housed in Kidwelly by Gwalia Housing … Since then there have been a number of other avoidable tragedies. One was the killing of an eighty-nine-year-old woman from Rhyl by a convicted murderer from Wolverhampton. More recently there was the rape and murder of a sixty-seven-year old woman in Llanllwni, Carmarthenshire by a young thug visiting his Scottish parents who had been relocated and allocated a council house in the village. A comment on my blog yesterday mentioned the family of a paedophile relocated to Cardigan; one of the sons is said to have attacked cars on a garage forecourt and assaulted a teacher.

There are countless, similar stories from all over the country. This is what we are up against and this is what we shall fight. The agencies responsible for bringing these people into Wales are fairly easy to identify: Welsh Local Authorities; 'Welsh' Housing Associations; English Local Authorities; Charities; Probation Service; Private landlords. In the case of Welsh local authorities and 'Welsh' housing associations there is no doubt that they get paid a premium for taking in tenants English social housing providers want to get rid of. Also, there is nothing to stop English local authorities, the Probation service and English charities from buying up property in Wales and shipping undesirables in directly. Often by turning properties in residential areas of our towns into hostels and similar accommodation for ex-convicts and others. I dealt with this in Llanelli – 'Little Beirut' – Ghetto last August.

What I didn't realise then is that in Wales there is no need to notify anyone if a family dwelling is converted into a House of Multiple Occupation (HMO) for up to seven people.

Which means that an English Probation Service can buy a house in a quiet Welsh street and turn it into a hostel without needing to tell anyone. Small wonder that Llanelli is being targeted: cheap property and a complacent – or co-operative? – county council run by a Labour-Conservative coalition. Charities and other agencies can do in Wales what they would not be allowed to do in England, with entirely predictable results – Wales becomes a dumping ground. And of course, this lack of legislation is a godsend for unscrupulous local landlords...

There is no racism involved in this issue (unless from those who encourage the influx). This is about people being murdered, children being raped. It's about extra work for our social services, our police, our courts system. It's about our schools being disrupted and our teachers terrorised. It's about increasing the numbers in Wales dependent on State handouts to provide ammunition for our enemies. It's about Welsh communities being Anglicised and the Welsh language destroyed. And it's all down to the strategy of dumping England's rubbish in Wales. People are dying because our politicians refuse to act. With legislation now being enacted in England, such as benefit caps and reductions in housing benefits, we can expect the tide of human detritus to develop into a tsunami with the potential to swamp us ... unless we start fighting back. That there has been little resistance up to now is because the problem has no clear cause on which to focus. It just seems to 'happen'. But believe me, there is method to it. There is a guiding hand. What we must do from now on is methodically collect the evidence and demand that our 'Welsh' Government acts to stop what is clearly a programme of transplantation.

Included in responses to the above blog was, '300 known paedophiles in Ceredigion! Yes, 300. They're moved there from other authorities.' Other respondents noted,

> Tai Cantref gets brownie points (and income to justify its existence) and landlords like the Marine Hotel in Aberystwyth who advertise in English Midlands papers 'pick up your giro by the sea'... What is happening in rural Wales is essentially ethnic cleansing of the native population. It may be being done via the cheque book and the public purse rather than at the point of a gun but the end result is the same. No doubt the elite and their sock puppets will call any fight back 'racist' – that is how they try to shut down debate on any topic ... A nationalist party who grasped this nettle would actually start to connect with the voters, rather than being seen as part of an elite which doesn't give a damn for real interests of the Welsh people ... Plaid and their middle class controllers won't do anything radical to combat colonisation for fear of losing their new possible voters 'the incomers' and upsetting their chums in the House of Lords.

Since the first elections to the Welsh Assembly in 1999, Wales has had thirteen years of rule by the Labour Party, sometimes in coalition with the Liberal Democrats and Plaid Cymru, but always in charge. In May 2011 the Labour Party could only gain 42 per cent of the constituency vote and 37 per cent of the regional vote in the Welsh Assembly elections. It is therefore a long way short of having a mandate to rule Wales. Yet it has enacted legislation in Wales, and supported legislation affecting Wales made in London that clearly works against Welsh interests and for the benefit of England. When in power in both London and Cardiff the Labour Party introduced in 2006 the Government of Wales Act. This Act specified that the Secretary of State for Wales – then Cheryl

Gillan – has the power to intervene if the Welsh Government does anything she (or others) believes, 'might have a serious adverse impact on water resources in England, water supply in England or the quality of water in England'. It looks like the English understand the value of Welsh water better than the Welsh. We are denied control over one of our most valuable resources by a law enacted by a Labour government in London and supported by a Labour government in Cardiff.

The Welsh Assembly Government has enacted the Homeless Persons Priority Need Order, increasing the 'homelessness' budget by 800 per cent. As recently as 1 May 2012, Huw Lewis, Minister for Housing, Regeneration and Heritage, said in the Assembly about homelessness, 'My statement today addresses one of the biggest challenges facing this government.' 90 per cent of Welsh population growth comes from outside the nation. Genuine Welsh homelessness is a minor, and solvable issue. Labour has turned it into a major and expensive issue with its 'Caring Wales' strategy that has an open-door approach to misfits, drug addicts, paedophiles, illegal immigrants and God knows what else from over the border. The 'Caring Wales' package, apart from impoverishing us and taking money from children's education, only makes Wales more attractive to English and other immigrants, especially the elderly and others coming to be a burden on health and associated services. Here we have 'our' Labour government in Wales making a poor country poorer, just to win the approval of their masters in London. Wales is the only part of the UK that is treated as a 'policy laboratory' as Rhodri Morgan once put it, although he did nothing to stop the process. Scotland and Northern Ireland govern in the interests of their people but Wales is treated as an unimportant English appendage.

In 2002 Edwina Hart said, 'Local authorities have a duty to provide accommodation for people who are homeless, eligible for assistance and classified as in priority need ... I am proud of the fact that we were the first administration in the UK to extend the duties of local authorities to other vulnerable groups ... The Homeless Persons (Priority Need) (Wales) Order 2001 applies only to Wales ... In Wales local authorities will not have any discretion about accepting homeless people in these vulnerable circumstances. This is in contrast to similar legislation proposed in England.' Local democracy overridden and despite this legislation only applying to Wales anyone from England can take advantage of it. The author has just read about a plan for recently released prisoners to be housed in a residential area of Llanelli. This only came to light when someone noticed an advertisement for a worker at this hostel. The locals did not need to be informed because the plan is to house six ex-cons. Any more and the building would qualify as a House of Multiple Occupation, and require extra consent. However, even a hostel with six residents would qualify as a HMO in England, Scotland and Northern Ireland. The Welsh government refuses to implement the legislation that the other countries find necessary. This makes things easier for organisations like Caer Las to import criminals and dump them into unsuspecting Welsh neighbourhoods. Brighton Borough Council is said to have a policy of offering people on their housing waiting list around £3,000 to move to Wales.

New housing plans are being forced on Wales by Wales-based English civil servants, securing the building of new homes for more colonists from overcrowded England and ensuring that social housing allocation rules also encourage colonisation. 90 per cent of the increase in the population of Wales is from England and immigrants. In November 2011, First Minister Carwyn Jones gave a speech at Aberystwyth setting

out three tests whereby further powers for Wales should be judged as desirable: that devolution of responsibility would benefit the Welsh public; that these powers could be accommodated within existing Welsh government structures; and that they would have limited impact on the wider UK. Considering the final proviso, he means that he would do nothing for Wales if it disadvantaged England or the English. To Labour, Wales is just a geographical entity filled with safe votes and they'll do anything to keep it that way, even if it means replacing our native population. Conservatives ignore Wales. Lib Dems and Plaid have no policies to help Wales.

In 2012, BBC Wales television programmes upon homelessness in Swansea, made at the prompting of Shelter Cymru, showed that homeless people are travelling to Swansea from elsewhere in the UK and beyond. Newport has been referred to as 'tramp city'. One professional dosser, originally from Manchester, had been in Bristol when he 'heard good things about Swansea' and decided to come. Labour-controlled Swansea, without any idea about the long-lasting consequences, has positioned itself as a 'City of Sanctuary'. From Swansea Council's website:'City of Sanctuary support can include community centres, charities, social clubs, schools, local services and businesses, as well as refugee organisations and volunteers. Supporting organisations promise to welcome and include people seeking sanctuary in their activities.' Swansea has 10 per cent of the Welsh Muslim population. Other cities of sanctuary are Leeds, Sheffield, Leicester, Bristol and Bradford, all cities with a strong ethnic minority. Among the organisations in Swansea which are part of the initiative, and offering advice, assistance, language translations and work placements to asylum seekers are African Community Centre, Amernsty International Swansea, Asylum Justice, Bonymaen Communities First, Capel y Nant, Centre for Migration Policy Research, City Temple, Discovery, Displaced People in Action, Dragon Arts, Exotica, FAN group, Reaching Wider Partnership, Co-ordinated Action for the Relief of Destitution in Swansea, Union of Congolese People, various churches, etc. One wonders if the Welsh people could have their own 'city of sanctuary', speaking Welsh, where the language was welcomed and people were actively helped to join a benefits culture. One also wonders whether the people of Swansea wish to attract multiculturalism, asylum seekers and homeless people. Surely Swansea should be positioning itself as an attractive place to live, and try to encourage employers and competitive companies, not out-of-work people with few transferable skills. Swansea's target should be to try and rival Cardiff as an excellent place to work and live, not to try and build an economy upon government handouts.

Variously described as a 'man from Gwynedd' and a Welshman by the BBC, a Liverpool fan was prosecuted for racist gestures against a black football player in 2012. The criminal was an Englishman who had been banned from England games, unemployed with five children and a conviction for benefit fraud. A typical 'dumpee' along the North Wales coast, he received a four-year football banning order for the offence. When Dafydd Iwan raised the issue of 'white flight' to Wales he was labelled racist by the Labour establishment in Wales. Interestingly, when Wales played England at football in 2011, England fan Ian Mytton ran across to a group of Welsh supporters quietly queuing outside the ground. He punched Michael Dye of Cardiff, killing him, before running away into the crowd. Dye received a three-year jail sentence, meaning he will serve around a year, and a six-year banning order from watching football. If this had happened (and it never does) with a Welsh supporter killing an English supporter,

there would have been vicious retribution in the national media. As it was, the case was barely reported.

As we saw in the last section on the economy, the horrific costs of English retirees moving to Wales has never been addressed by politicians. Others come here to escape the English environment, some to work, but far more to 'escape to the country', to cheaper accommodation and less crime. I have lost count of the number of reality TV shows where people want to move to Wales (because houses are cheaper) and have a 'couple of acres' with a few pigs, chickens, horses and the like. They retire early and believe that they can live off a tiny small-holding, but end up claiming benefits.

Wales actually made rare headlines across the world in May 2012, with the story of the grossly obese teenager Georgia Davis and her obese mother Lesley. She was referred to as 'the Aberdare teenager' and 'the Welsh teenager' during the massive 'rescue effort' seen on global television and reported everywhere. After enrolling at an academy in North Carolina, Davis had lost nearly half a stone a week. On her return, she told BBC Radio 5 Live about how she lost weight, and why she thought the NHS should now fund her weight loss programme. After her return, her unemployed mother said she 'hadn't had time' to prepare healthy food for Davis, and gave her fish and chips. A short time later, a specialist council team and a fire and rescue crew were involved for several hours in the operation to transfer Davis from the family home to an ambulance. Scaffolding had to be erected outside her home, which had to be partially demolished to get her out and into a special ambulance.

A spokesman said, 'This has facilitated some significant works to the house. South Wales Police are on the scene dealing with traffic issues while medical professionals from Cwm Taf Local Health Board and the Welsh Ambulance Service are monitoring the patient's health.' Workers for Rhondda Cynon Taf Council and South Wales Fire and Rescue Service were also involved in moving the woman. In all, a team of forty, including council workers with scaffolding, spent several hours moving her. She was hoisted across a scaffold bridge, lowered onto a reinforced stretcher and taken away is a specially reinforced ambulance. The operation cost the taxpayer £100,000. The nineteen-year-old English girl weighs 63 stone, having weighed 33 stone (210 kg) when she was fifteen. Davis will be in hospital for at least three months, being 'cared for 24/7 by a team of three nurses and several doctors'.

The mother and daughter were recently relocated from their council property in Kent to a special housing association flat in Wales. Who pays for all the work involved in getting this woman out of her home and into hospital? If some agency dumped these people in Wales, which was it? Will they now be charged? The cost to Wales will roll up to over a quarter of a million pounds in benefits and health treatments for the woman. Drug addicts, alcoholics, problem families, battered wives, prison leavers, problem families, petty criminals, people with behavioural problems and the like are being dumped across Wales and costing its services a fortune. This is without the expense incurred through Wales being one vast retirement home for people escaping from England. Strangely, while we have gross 'Welsh' teenagers, 'Welsh' drug addicts, 'Welsh' murderers, 'Welsh' problem families and the like with no Welsh provenance, BBC TV News on 3 July 2012 mentioned twelve 'men from Rochdale' grooming children for sex. A better description in the interests of veracity would have been twelve Pakistani Muslims living in Rochdale.

There seems to be a policy of prioritising anyone but Welsh people for social housing and other benefits. From Llanelli to Llandudno this system of marginalising the Welsh while simultaneously opening Wales up to further colonisation is obvious. The *Daily Post* in July 2012 noted that the Wales Probation Trust had 439 offenders on its books in Conwy, with 114 of them homeless. The Trust itself said that 900 of the 4,000 people on probation in North Wales had housing needs. Conwy County Councillor said that the homeless figure does not include those in temporary accommodation or state-paid hostels. He said that the Welsh government has made it a priority to house ex-offenders above local people, adding, 'A significant number of incoming tenants often bring with them lifestyles that revolve around abuse of illegal drugs and alcohol, criminality and anti-social attitudes which all impact on our such as Police, Social Services and Education with the attendant rise in expenditure for local Council Tax payers.' The great majority of these people are not Welsh. The *Daily Post* leader commented, under the headline 'Put local people first for housing', 'Our system already appears to give people a perverse incentive to be unemployed rather than working. It would be all the more ludicrous if a spell in prison was rewarded with a council house.'

The Desperation of Wind

One of the most depressing events in this author's life is the loss of independence and impartiality of the BBC. Apart from the absurd lengths it follows for political correctness, it has bent towards the ruling party's perspective upon all news issues. Bernard Ingham for Mrs Thatcher and Alistair Campbell for Anthony Charles Lynton Blair began threatening it with a loss of funding if it did not toe the government line. Also, its bigwigs and managers will not receive their assorted honours if they are seen to be 'not one of us'. As such, it follows the official line upon climate change (formerly global warming, and before that global cooling).

This is an incredibly important issue for Wales, as it is being destroyed by 'green dogma' emanating from the Centre for Advanced Technology near Machynlleth. The centre has never achieved self-sufficiency in energy, but has a disproportionate influence upon Welsh politicians, especially the more innumerate in Plaid Cymru. The largest wind farm in Britain, at Cefn Croes, was described in the *Western Mail* on 24 May 2002 'as the equivalent of the Taleban's destruction of Bamiyan in Afghanistan and a declaration of war against the Welsh countryside'. John Oliver, Bishop of Hereford and environment spokesman for the Church of England said that such a development in an area of outstanding natural beauty 'would provoke national outrage if sited in the Yorkshire Dales or the Peak District'. At the time, Wales already had 44 per cent of the UK's wind turbines, having been assessed as a dumping ground for Blair's green energy policy commitments. Sir George Stapledon, the ecologist, said in 1935 that the Cambrian Mountains were of such beauty that 'any intervention by man would constitute a criminal offence' His view that Mid Wales should be the perfect location for Britain's first national park was shared by the Countryside Commission in 1972, when it designated the Cambrian Mountains a national park 'equal in beauty to existing national parks' and embodying 'the spirit of Wales'. Around 300 turbines are now visible from the summit of the beautiful Pumlumon Fawr.

A decade later, Wales is again to be cursed with another 'UK's largest onshore wind farm', seventy-six turbines, each around 470 feet high, at Pen y Cymoedd between Neath and Aberdare. This is despite universal and lasting opposition over thirteen years from residents of the area. The Campaign for the Protection of Rural Wales also opposed the massive building project. The developers say that the wind farm will add 39 per cent to Welsh supplies of wind-renewable energy. These wind follies are almost the size of the Great Pyramid and the Blackpool Tower, 100 feet taller than the London Orbit, almost the size of the London Gherkin and nearly three times higher than the Niagara Falls. The seventy-six turbines will operate for twenty-five years. The developer, Vattenfall/Nuon, has been involved in major scandals across the world, and claims that the wind farm will be worth £1 billion to the UK economy and 'create 300 jobs'.

It is impossible to know how it arrives at this figure. No long-term jobs will be created except for a few maintenance technicians. If we strip out enormous and ongoing taxpayer subsidies, the cost of pylons, access roads, balancing the National Grid, balancing output from existing power stations and the like, there is no economic benefit. If we attempt to place a cost-benefit analysis upon environmental, archaeological and ecological loss, there is no 'green' gain. The Energy Minister, Charles Hendry, stated apropos the project that 'onshore wind ... is the cheapest form of renewable electricity'. However, Professor David Mackay, chief science advisor to the Department of Energy and Climate Change, has calculated that even if 10 per cent of the whole United Kingdom was covered with wind turbines, it would generate only a sixth of the country's needs, and it would be an intermittent supply. Not one conventional power station would be shut down, and would have to keep operational at all times. One can foresee in a quarter of a century these rusting hulks, with their non-recyclable blades on their mountains of concrete, rotting. An alternative view is that they are precursors of housing estates for the dispersion of England's rapid population growth. The access roads will be widened. There is already an electricity supply from normal power stations to the turbines, otherwise they could not work.

In its centre, Wales is only just over 30 miles wide. Here, there are plans to put even more masses of these huge wind follies across the Cambrian Mountains, the spine of Wales. The area should have been a National Park, but is being despoiled forever. The towers, on their 1,000-ton concrete bases, will be able to be seen and heard from coast to border, chopping up birds and bats, with new access roads, substations and more enormous, snaking pylons completing the picture. Not one coal, gas or other powered station can be closed down, as wind energy is not only inefficient but it is intermittent. In a cold spell, electricity will not be generated. In low or high winds, electricity will not be generated. The National Grid has to constantly balance out its input. Not one wind turbine would be built without massive, ongoing subsidies from the taxpayer. In Wales, irreplaceable peat bogs, archaeological sites, sites of scientific interest and landscapes are being destroyed in response to the green mantra that wind-power is good.

Plaid Cymru announced that its July 2012 summer school 'aims to grapple with some of the key political challenges, questions and conundrums facing today's Wales'. One of the topics is, 'How can Wales be powered renewably?' All of the candidates for the leadership of Plaid Cymru in 2012 were absolutely and fervently in favour of more wind energy across Wales, as it is official party policy. The winner, Leanne Wood, in one of her campaign leaflets stated that climate change is the number one priority for Wales.

The population of the world is growing by 3 million a week, i.e. by the population of Wales, and she is more worried about the impossibly small effect of Wales upon global warming, even allowing for the fact that it is unproven and cannot be attributed to man. Plaid wonders why it lost Ceredigion and is losing members and rural votes. Our poor education, poor health and unemployment should be national priorities not a constantly changing climate. Even if there is global warming, which is still scientifically unproven, there is not a single thing that Wales can do to stop it.

Politicians justify plastering Wales with more and bigger wind turbines to stop sea levels rising. This is in the cause of 'renewable' energy, but energy is never renewable, but transferable with a consequent loss of energy. Apart from the fact that Wales already has five times (yes, five times) the density of wind turbines in our tiny country compared to England, Wales *already* supplies more than half its electricity to England. Wales has no need of any more electricity, and such transferable energy is inefficient. Climate change has always happened and always will happen. For little Wales to destroy its only industry, tourism, while China and India, with 40 per cent of the world's population, are polluting the environment on an incredible scale, is utterly pointless. China now uses 50 per cent of global coal consumption, with little worry about the environment, and has a similar share of the world's copper, nickel, aluminium and zinc. With a 1.3 billion population, 433 times that of Wales, how can we think that Wales can 'save the planet' with what are effectively 'green taxes'? The only future for Wales is to find useful jobs for its citizens, not cripple the country from competing internationally. Where do politicians think that money or wealth originates?

NASA statistics show no global warming for the last fifteen years, and scientists warn of a new Maunder Minimum (the term for the 'Little Ice Age' of 1645–1715). Not only do the Met Office's weather models severely underestimate the effects of the sun's activity and the Earth's different tilts, but the sixty-year water temperature cycles in the Pacific and Atlantic Oceans. Scientifically illiterate politicians (and voters) are wasting public money trying to affect the world's climate. They seem often to confuse the element carbon with the gas carbon dioxide. We know that carbon dioxide makes up only 0.0392 per cent of the atmosphere (by molecular proportion). This is often expressed as 392 volumes per million (vpm). According to the Intergovernmental Panel on Climate Change (IPCC), led by an Indian railway engineer, and which advises world governments, only some 2.9 per cent of this 0.0392 per cent is caused by human burning of fossil fuels. That equals the grand sum of 0.0011 per cent of our atmosphere, which Western governments are spending billions of pounds to reduce. (Meanwhile in China and India, coal-fired power plants are being opened on a weekly basis). There is a vast expansion of CO_2 into the atmosphere *every* summer in the Northern Hemisphere, caused by the natural photosynthesis-respiration turnover of CO_2 from plants, plankton etc. The human addition is trivial. Unfortunately, within the infant science of climatology, there are only a few dozen scientists who understand radiation transfer processes and the 'Greenhouse Heating Effect' (GHE). Despite an expenditure of $100 billion per annum on international research, the science of the GHE has not progressed beyond being a hypothesis. The constituent parts of the Earth's atmosphere are: Nitrogen (N2) 78.084 per cent; Oxygen (O2) 20.946 per cent; Argon (Ar) 0.934 per cent; Carbon dioxide (CO2) 0.0392 per cent; Neon (Ne) 0.001818 per cent; Helium (He) 0.000524 per cent; Methane (CH4) 0.0001745 per cent; Krypton (Kr) 0.000114 per cent; and Hydrogen (H2) 0.000055 per cent.

There is also a far greater and varying amount of water vapour, depending on the altitude and conditions where it is measured. Milanković (or Milankovitch) Theory states that as the Earth travels through space around the Sun, cyclical variations in three elements of Earth–Sun geometry combine to produce variations in the amount of solar energy that reaches Earth. These are the Milanković Cycles, or Milanković Wobbles with which politicians should become equated before they spend the West's capital on inefficient and ineffective renewable technologies. At present, only *precession* is in the glacial mode, with *tilt* and *eccentricity* not favourable to glaciation. This increases the seasonal contrast in one hemisphere and decreases the seasonal contrast in the other hemisphere. This is why the Arctic is melting very, very slowly, and the Antarctic is getting colder. It is not man-made. A few years ago we were threatened with global cooling by scientists. Historians and scientists realise that climate is always changing in cycles.

A letter from Lyn Jenkins to the *Western Mail* of 13 February 2012 asked,

> How can wind turbines supply us with electricity when they do not even operate all of the time, due to lack of wind or too much wind? On February 6th, 3,500 UK wind turbines supplied a laughable 0.1 per cent of UK electricity on one of the coldest days for several years. People will die in the dark of hypothermia if we relied on confounded trivial wind turbines. There will be no industry, no jobs, no office power, no TV, no electricity anywhere … and the UK economy would collapse! … a new fossil fuel gas-fired power station is currently being built at Pembroke which will produce 2000 MW and power Wales on its own, because 2000MW is all we use … We also have a new 800MW gas-fired plant at Uskmouth that will supply England. Our existing Welsh fossil and nuclear [Wylfa] plants already supply England and generate 4000MW, or twice Wales's needs. They include Aberthaw, generating 1500MW.

Wales, in other words, is being used to meet England's targets for green energy.

The new generation of turbines, like the old, cause ill health to humans and animals within a 3-mile radius. They use rare earths from China in their magnets, produced under slave conditions and giving the workers cancers and other fatal illnesses. Their gigantic carbon fibre blades are non-recyclable under any known technology. If they burst into flame because of overheating or lightning, fire crews cannot attend because of carcinogenic gases. They do not create any lasting jobs, but actually lose them, according to all global studies which have not been commissioned by renewable energy companies. Towards the end of their useless lives, the corporations which own them will sell them on to dummy companies and nominees based offshore, which will go into liquidation to save the incredible costs of recycling them. Their 1,000-ton bases will leach into the soil forever, destroying ecology. These bases and access roads will also prevent water soaking in, and run-offs have already led to flash floods and people fleeing their homes. People may read this book in a quarter of a century and wonder how in Heaven's name the British people and their leaders were so gullible.

The Climate Commission for Wales, like many such bodies, owes its existence to proving something exists. If it told the truth, that Wales cannot affect climate change, it would be out of a cosy and well-paid existence. At the enormous Mynydd y Betws wind farm site near Swansea, an important Neolithic stone alignment stretching 750

yards came within twenty minutes of being destroyed, and a digger had to be halted in its tracks. Independent archaeologists forced the stoppage, but the power company said that the significance of the stones had not been verified so work was continuing as usual. The row had already been cut in two places by the wind farm access road. The stone row, associated with around thirty stone cairns, is only one of a number of archaeological features that should have been highlighted by the wind farm company's archaeological survey. It is a 5,000-year-old ceremonial landscape, and one wonders how many others have been 'missed' by surveyors in Wales. The company in charge of building the site is called Cambrian Renewable Energy but it is a front for ESB Energy of Ireland. Many wind energy plants built across Wales initially employ Welsh people upfront and disguise the nature of the ownership and site. ESB commissioned Cotswold Archaeology of Cirencester, Andover and Milton Keynes to carry out the initial survey of the site, which did not find the stones, and one cannot help thinking that a Welsh company would have. The British Archaeological Trust said that their omission was 'incredible' during the planning process. Cambrian Renewable Energy (aka ESB) stated that the claims that the stones had been 'hidden' by gorse until a fire. A leading archaeology lawyer on the council of the British Archaeological Trust said, 'How anyone could say that before the fire the stones would only be visible on hands and knees is astonishing. I could see many of them from the nearby path.' This author has found archaeological sites across Wales, with no training, including two unknown medieval chapels and a pre-Christian religious site. One wonders how many such sites have been destroyed and covered. There will be carved early Christian stones in and near Ilannau, which should be excavated. A friend told me of a Roman mosaic he saw in the basement of a house in Cowbridge High Street, which was quickly covered with concrete to avoid investigation and delays in a refurbishment job.

There have been protests in Mid Wales since Cefn Coch was chosen in 2012 as a place for a substation, for huge pylons taking electricity from hundreds of new wind turbines to join the National Grid in Shropshire. There are no wind turbines in the large county of Shropshire. Pylons were also built across Wales from the new power station in Pembroke to supply English needs. Welsh hills are being despoiled, flood risk is increased, birds and other wildlife killed, so that foreign companies can erect wind turbines to supply England's needs. It is absurd, both logistically and economically. Shropshire is nearer to England's West Midlands conurbation than Powys, so it would be far cheaper to erect the turbines on the Long Mynd, the Stiperstones, the Wrekin and Wenlock Edge. As veteran anti-wind campaigner Lyn Jenkins pointed out many years ago, the wind does not stop at Offa's Dyke. But that would despoil England's green and pleasant land, it would cause mass protests, and never be allowed. It is far easier to dump these things on Wales. Unlike the exploitation Wales knew in the past, this time it does not even come with jobs. Time is fast running out for wind turbines as more and more people see that they are to electricity generation what the Zeppelin was to air travel. Labour, Lib Dems, Plaid Cymru and many others embraced wind power so enthusiastically that it is all but impossible for them to backtrack with dignity or to do so and retain any credibility.

Perhaps 600 more wind turbines, 475 feet high, are planned in Montgomeryshire to supply Lancashire. There is a huge fuss about crossing Shropshire with 250-foot pylons carrying Welsh electricity, but there not a single wind turbine in Shropshire.

There are none in the West Midlands or Herefordshire and only one small turbine in Gloucestershire. Wales already generates virtually 6,000 megawatts of electricity without counting any of its wind energy. Of these 6,000 megawatts, two thirds goes to England with pylons across Wales. There will be extensive road and sewer blockage and damage, as each 475-foot wind turbine requires many lorryloads up to 145 feet long to deliver the parts. The *Cambrian News* states that 60 by 475-foot turbines at Nant y Moch would entail 600 of these loads. There will be flash-flooding; tourism damage; noise pollution, especially at night; scenic desecration, television disruption and light flicker. Hundreds of thousands of birds are being wiped out across the world by wind follies, as the tip moves at around 180 mph on unsuspecting raptors and the like. In 2012, the punitive costs of this lunacy were exposed in a report by Professor Gordon Hughes, professor of economics at Edinburgh University. He has calculated that the bill for wind energy by 2020 will cost consumers £120 billion. Yet generating the same amount of electricity from efficient gas-powered stations would cost only £13 billion. Not one conventional power station will close.

An August 2012 Environment Agency rainfall map of the Nant y Moch hill area west of Pumlumon and east of Aberystwyth in Mid Wales shows the extreme amount of rainfall that fell in twenty-four hours in June 2012. This caused severe flash flooding of Tal y Bont, Dol y Bont, Borth, Aberystwyth etc., as the Rivers Leri, Rheidol and Ceulan burst their banks. The Environment Agency director blamed climate change. Yet, there was similar severe flash-flooding 40 miles down the coast around Cardigan, in June 1993, when the River Mwldan burst its banks. The sand of several local beaches was even temporarily washed away on that occasion. If deep depressions cross the Atlantic in the peak summer month of June, they are bound to be exceptionally heavily moisture-laden, hence there is very heavy rainfall in short periods, so to blame climate change is questionable. However, if the Environment Agency expects such heavy rainfall events regularly in future, how is it that they have supported one of the UK's biggest wind farms, consisting of sixty truly gigantic 475-foot wind turbines across the very area where the heaviest rain fell? The Welsh government Nant y Moch TAN 8 proposal, just west of Pumlumon, will see sixty vast, non-absorbent concrete turbine bases and many supply roads as wide as motorways, replacing highly absorbent peat and moorland right across the hill catchment areas of the Leri, Ceulan and Rheidol. This will greatly exacerbate the risk of even worse flash-floods, which could become annual events. Wind power is a discredited technology, still being imposed on Wales by an English government, for the benefit of England. Apart from a few landowners there are no Welsh beneficiaries. Wind turbines kill wildlife and cause flooding. They are the biggest single cause of 'fuel poverty', which affects the poorest and most vulnerable among us – so why are wind turbines supported by any parties with a socialist conscience?

Wales has to learn to embrace its landscape and transmit its history. Once it has gone, it has gone forever. Wales can build a huge business upon history and Christian tourism, but no politician has the vision. Wind turbines are the death knell of tourism. Many more are planned, including Mynydd y Gwair, Swansea; Brechfa Forest and Mynydd Llanllwni, Carmarthenshire; Pen y Cymoedd from Aberdare to Vale of Neath; Nant y Moch, the site of Glyndŵr's defining Battle of Hyddgen, Pumlumon, Ceredigion; Lake Vyrnwy to Carno, Powys; south of Newtown, Powys; and Clocaenog Forest, Denbighshire. It is worth repeating that there is not one politician who questions the

value or validity of these monsters. A national monument of shame and stupidity should be erected, engraved with the names of all AMs and MPs representing Wales for the last decade or so. One wonders why wind farms are not called 'wind powered intermittent electricity generating stations', or 'wind power plants'. We do not have nuclear farms or coal farms. The word farm is more marketing-friendly. One also wonders why wind is termed 'renewable energy'. Physically, one cannot renew energy. Wind energy can be transformed, with a massive loss in efficiency, to another type of energy. However, again, renewable is a more marketing-friendly word than transferable (with concomitant efficiency loss). In August 2012 the German Energy Minister, Peter Altmaier, announced that Germany is now to build twenty-three massive new coal burning power stations. This is because the 'green' closure of its nuclear plants cannot be replaced by wind follies, which would destroy the German economy.

Postscript

The Romans were the first to strip out Welsh minerals – silver, lead, gold and copper – and all our coal, slate and iron has been ripped out over the centuries. It has been a curse being blessed with mineral wealth. And even now the granite and limestone is being quarried out of hills and mountains. And the sands being taken from the Severn is causing the despoiling of all our southern beaches forever. The sand cannot be replaced within 50,000 years. Valleys all over Wales have been drowned via compulsory purchase, even before the Trywerin and Clywedog affairs, so now we pay more for our water than our English neighbours. The firing ranges in Pembroke, Eppynt and elsewhere were also compulsorily taken by the military. The Forestry Commission has taken our mountains and covered another 5 per cent of Wales with Sitka spruce, blowing up Celtic stones on their way. So Wales has had its land, valleys, hills, and beaches despoiled – overground, underground, and underwater. The only thing we have left is the air, and now Wales has proportionally five times the density of the useless monsters called wind turbines as England. Many more are on the way, in our most beautiful areas and along our coasts, killing what remains of tourism and destroying the environment.

They would not – could not – put wind energy plants (they are not farms) in the tourist areas of the Lake District, the Cotswolds or in the Chilterns. But tourism is the only viable industry we have left in Wales. We have no jobs. We are not only a tiny, tiny country – and the poorest part of Britain – but we cannot take any more despoliation to wreck our only surviving industry. We have to hold on to Wales as a nation. A nation with rights to choose the state of its rivers, valleys, beaches and hills, not to be first treated as a cash cow – and then as a waste receptacle – for the dumping of pensioners and ne'er-do-wells. Wales is dying economically and culturally – one third of the population was not born here. If we define a Welsh person as having eight Welsh-born great-grandparents, it had the highest density of incomers probably in the world, even worse that the forced plantations of Han Chinese in Tibet. The language is not thriving, despite what the quangos tell us. One can travel across Wales, walk into shops, go into pubs, eat in restaurants and not hear a native Welsh voice, let alone the Welsh language. Incoming retirees give Wales the oldest population in the British Isles, with 20% over 65. This is projected at 26% in 2035, which is unsustainable with a broken economy.

Wales is struggling and failing to survive. It is a terrible future for a declining culture. The acceleration in in-migration will irreparably damage the culture and language. Hopefully this book will make Welsh people reflect upon how the nation has been and is being treated. We need to be stronger – firmer – and they are qualities that you cannot ascribe to our elected representatives. We need as a people to think more about the future of the nation if we keep on drifting and allowing ourselves to be trampled upon. There is a Monty Python line – 'What have the Romans ever done for us?' – and I would like to ask, similarly, 'What have the Labour Party, or the English, ever done for us?' The answer is not nothing. But it is not positive either. It is negative – it is not just about destroying our history, it is about traducing our character and still treating us, as the English historian A. J. P. Taylor called us, as one of 'the lesser breeds' ('Every Imperialist believed that Great Britain had achieved the highest form of civilisation ever known and that it was her duty to take this civilisation to "the lesser breeds without the law".') The Labour Party seems to despise British culture but embrace multiculturalism to the detriment of its own nation. Multiculturalism brings enormous costs and a loss of national values. Respect for one's national culture costs nothing, yet is priceless and admired. Real Welsh history has never been taught, and has been deliberately misrepresented. Welsh culture and traditions were almost wiped out by extreme Nonconformism, but were revived by Iolo Morganwg and his allies. Welsh culture is again dying out, with the Welsh people. Remember that without anger there is no democracy. It seems that across Britain the masses have been pacified into a supine acceptance of fifth-rate, time-serving politicians of whom the worst rise effortlessly to the top. Cymru deserves better. 'Y Gwir yn erbyn y Byd.' Cymru Fydd? Cymru am Byth?

Sources

There are only four recent books covering Welsh history in its entirety. The most recent is *The Story of Wales* in 2011 by Jon Gower, presented in a series on television by Huw Edwards, the newsreader. This short book was commissioned with the same title, but delayed and retitled because of the BBC book. In 2007, *A Concise History of Wales* by Professor Geraint H. Jenkins appeared, with an acknowledgement to his personal assistant, who 'cheerfully transformed my long-hand scrawl into an immaculate typescript and helped me in all manner of ways to ensure that the work reached the publishers in a fit and proper condition'. The same age as Jenkins, this author has been using computers since he bought a Ferranti 86 Advance computer in 1984, and the previous sentence demonstrates some of the diseconomies and failings of our university system. John Davies' *A History of Wales* (1994) is an excellent and comprehensive book, totalling nearly 800 pages in its latest 2007 paperback edition. (Davies' *The Making of Wales* of 2009 is also well researched). Gwynfor Evans' *Land of My Fathers: 2000 Years of Welsh History* (last edition 1998) was a notable attempt to cover Welsh history from a non-English perspective. This author has not used the above books in research for this history, but the Davies and Evans publications have been trawled in the past to write other books upon Wales.

Books

Ab Ithel, Revd John Williams, 'Brut y Tywysogion; or The Chronicle of the Princes of Wales 1860' in Arnold, Tom (ed.), *Chronicles and Memorials of Great Britain and Ireland* (1857).

Breverton, Terry, *An A–Z of Wales and the Welsh* (Christopher Davies, 2000).

Breverton, Terry, *The Book of Welsh Saints* (Glyndŵr, 2000).

Breverton, Terry, *The Welsh Almanac* (Glyndŵr, 2002).

Breverton, Terry, *100 Great Welshmen* (Glyndŵr, 2001 and 2006).

Breverton, Terry, *100 Great Welsh Women* (Glyndŵr, 2001).

Breverton, Terry, *Black Bart Roberts – the Greatest Pirate of Them All* (Glyndŵr, 2004).

Breverton, Terry, *Admiral Sir Henry Morgan – the Greatest Buccaneer of Them All* (Glyndŵr, 2004)

Breverton, Terry, *Owain Glyndŵr: The Story of the Last Prince of Wales* (Amberley, 2009).

Breverton, Terry, *Wales: A Historical Companion* (Amberley, 2009).

Breverton, Terry, *Wales' 1000 Best Heritage Sites (*Amberley, 2010).

Davies, R. R., *The Revolt of Owain Glyn Dŵr* (Oxford University Press, 1997).

Davies Norman, *Europe – A History* (Pimlico, 1997).

Gerald of Wales and Lewis Thorpe (trans.), *The Journey Through Wales/The Description of Wales* (Penguin Modern Classics, 1978).

Evans, Gwynfor, *Land of My Fathers – 2000 Years of Welsh History* (Y Lolfa, 1992).

Lloyd, John Edward, *A History of Wales: From the Earliest Times to the Norman Conquest* (1912).

Morris, Jan, *The Matter of Wales* (Penguin, 1984).

Rees, Ron, *Heroic Science – Swansea and the Royal Institution of South Wales 1835–1865* (Glyndŵr, 2005).

Williamson, James A., *The Tudor Age* (Longmans, 1964).

Williams, Gwyn Alf, *When Was Wales* (Penguin, 1991).

Williams, Dr Peter N., *From Wales to Pennsylvania – the David Thomas Story* (Glyndŵr, 2002).

Websites

castlewales.com is a remarkable site, with major contributions from Paul Remfrey and Lise Hull

roman-britain.org is a superb website for researching Celtic tribes and the Roman occupation

wondersofbritain.org/history/otherworks will give a list of primary sources, with websites leading to their translations, such as the *Gododdin*.

Note to the Illustrations

All pictures are by Terry Breverton unless stated otherwise. Please note that Visit Wales, CADW and other governmental organisations charge very high fees for image reproduction; to keep the cost of this book down, they are not used. The pictures of Carew and Pembroke castles are by Fly Heli Wales, based at Haverfordwest Airport. One can charter or take tours in their luxury four-seater Bell Jet Ranger helicopter. Derek Naylor, copyright Millennium Theatre. Swalec Stadium, copyright Huw John. Bryn Terfel, copyright Catherine Ashmore. New Theatre, copyright Magnet Design. St David's shopping centre, copyright Golley Slater. Coal Exchange, copyright Mike Johnstone at the Coal Exchange.

Also available from Amberley Publishing

An intimate history of England's most infamous royal family

'The best introduction to England's most important dynasty' DAVID STARKEY
'A lively overview... Rex is a wry commentator on the game on monarchy' THE GUARDIAN
'Gripping and told with enviable narrative skill. This is a model of popular history... a delight' THES
'Vivid, entertaining and carrying its learning lightly' EAMON DUFFY

The Tudor Age began in August 1485 when Henry Tudor landed with 2000 men at Milford Haven intent on snatching the English throne from Richard III. For more than a hundred years England was to be dominated by the personalities of the five Tudor monarchs, ranging from the brilliance and brutality of Henry VIII to the shrewdness and vanity of the virgin queen, Elizabeth I.

£14.99 Paperback
143 illustrations (66 colour)
272 pages
978-1-4456-0280-6

Available from all good bookshops or to order direct
Please call **01453-847-800**
www.amberleybooks.com